The amateur
photographer
handbook

The amateur
photographer
handbook

The amateur
—————photographer—————
handbook

Newnes Books

This edition first published by Newnes
Books, a division of
The Hamlyn Publishing Group Limited
84-88 The Centre, Feltham,
Middlesex TW13 4BH
and distributed by The Hamlyn Publishing
Group Limited
Rushden, Northants, England

ISBN 0 600 35668 X

Printer in Spain by Printer industria gráfica sa
Sant Vicenç dels Horts. D.L.B. 30156-1983

Contents

Cameras

What Sort
of Pictures
do You Take?

Today there is such a profusion of cameras that you can't hope to know everything about all of them. Faced with row upon row of glittering equipment, how do you choose the item to suit you? If you've already got a camera, don't change it just because there is something new or different on the market. Only get a 'better' one if it offers real advantages in picture quality or versatility. It's a sort of upside-down way of doing things, but we are going to try and explain a bit about choosing the *features* you need rather than the camera, and eliminating those you don't before we discuss each one in any detail. If you don't quite understand the terminology, there is a glossary at the end of the book and it's all explained in detail later on.

Cameras

All cameras take pictures; almost all take acceptable pictures; most take good pictures and many take excellent ones. The quality is as much attributable to film size as it is to camera features. The major difference between the simplest, cheapest models and the most sophisticated, expensive ones is in versatility.

Of course, *you* decide exactly what goes into your pictures. You choose your viewpoint, arrange your subjects, put people in the right mood, wait for the right moment and release the shutter. You do all that whether you're using an old Box Brownie or the latest super-electronic-wondercoated magnificent marketing miracle. The camera you need depends on just when and how you want to take your pictures.

Films

All cameras use film of one sort or another (see p. 41), and most cameras allow you a choice of types.

Colour film comes in two forms — one is processed to make transparencies, and the other to make negatives. The transparencies are little coloured replicas of the scene. You can project them on to a screen, or look at them directly (with a magnifying viewer if they need it). Colour negatives are funny orangey things which seem at first sight to resemble nothing. Paper colour prints are made from them.

Black-and-white film is usually processed to form negatives. You get black-and-white prints from them.

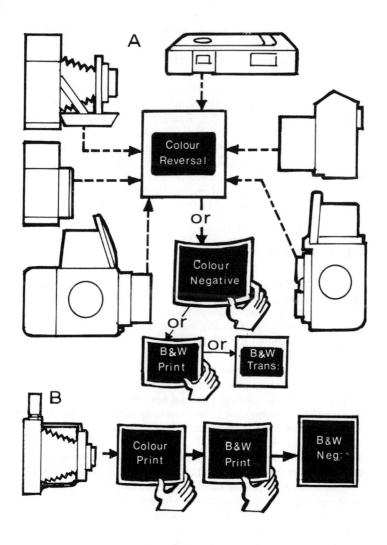

A. The sort of picture you get depends more on the film you use than on your camera. Almost any camera can take colour prints, and most are fine for transparencies. However, more sophisticated cameras increase your range of picture-taking. B. Instant-picture cameras can be more limiting and colour transparency films are virtually unknown.

There are instant picture materials, where the negative film and print material are combined. They go together in specially designed cameras. You get prints (colour or black-and-white) straight out of your camera.

'Colour cameras'. With the exception of a few 'instant' models, all modern cameras can take colour pictures. So can almost all old ones (if you can get film the right size). Really, there is no such thing as a colour camera, just colour films that you can use in any instrument.

Film sizes. Cameras are usually designed for just one size of film (see p. 57). Basically, the bigger the film the better your pictures. However, all can produce quite acceptable results. It's just that you'll really have your work cut out if you want to produce big pictures (say larger than 10×8 in or 25×20 cm) from the smallest negatives; or fill a large screen from a tiny transparency.

Starting photography

Iᴛ you are just beginning, you don't want your pictures spoiled because the camera settings were all wrong. On the other hand, if you are at all interested, you won't want to be confined to shooting only in bright sunlight. Basically, the camera you need still depends on what you want to do with it. However, there are a few extra considerations.

To start with, choose simplicity of operation. Get either a camera with simple exposure controls (such as weather symbols – see p. 127) or one with some aids to getting the exposure right. You are best off with a coupled exposure meter or an automatic exposure camera. It is nice to have manual override, but you can do quite well with a fully automatic model.

If you intend to make your own prints, or have large ones made for your walls, choose a fairly large film size. Pocket cameras (see p. 61) are fine for making pocket-sized prints, and can do wonders in the hands of experts. However, they are too small for the serious beginner. Size 120 roll film is an ideal beginners size – you can get super prints without too much effort (see p. 69). However, automatic-exposure 120 cameras are few and far between and there are very few inexpensive models. To shoot 120, you either pay a lot of money for a modern camera with a coupled meter, or you get an older model (on the used market) that needs rather a lot of concentration on the controls. The concentration pays off in ease of making big pictures really sharp.

However, for most people, the convenience and wide choice of 35 mm (see p.64) outweighs the quality of results on 120 film. As you will see, on a 35 mm camera, you can get virtually any combination of features you might dream up. Negative size is reasonable, and correctly exposed negatives from an automatic 35 mm camera will give you much better pictures than badly exposed ones from a manually-set 120 model.

Snapshots

Most cameras spend almost all their lives in a drawer – or on a shelf. They come out once a year for the holiday (often with last year's film still loaded). If they are used a couple of other times, that's all.
Holiday snaps on the beach – or in the garden – are taken in bright sunny conditions. Come indoors, and you fit a flashgun (if you can). For either, all you need is a tiny-aperture lens and fixed shutter speed. A box camera does perfectly well. Keep the subject more than 2 m (6ft) away, sun over your shoulder, camera still, and that's it. Today, the equivalent of a box camera takes 110 or 126 cartridges. It's a lot lighter and smaller and flash is easier to use, but does just the same job.
If you want a little more versatility, you can get a cartridge-loading camera with a few weather symbols. That is particularly helpful if you go touring. If the sun doesn't shine the day you visit the Eiffel Tower, Mount Rushmore, or the Taj Mahal, you won't get pictures on your basic camera.
To make sure you get pictures – even if it rains – you need more sophistication still. You want a quite large-aperture lens, coupled with an electronic exposure control system. The expensive pocket cameras give you the electronics. Beware, though, some have small aperture lenses (just like the simplest) and just vary the shutter speeds. They are not so good for snapshots. If the weather is dull, the auto exposure system selects a slow shutter speed and anything that moves gets blurred. Camera shake also becomes a severe problem. Really, though, the best snapshot cameras are automatic exposure 35 mm 'compacts' (see p.67). A few of these have fixed-focus lenses, so you don't have to worry about focus either. If you get an automatic compact or a pocket camera with a focusing lens, get one with a range-finder. It makes focusing easier and, *much more important*, it reminds you that you must focus. You can't ignore the double image

the way most of us forget to set the focus scale on a camera without a rangefinder. I find the reminder particularly important on an automatic-exposure camera. Somehow, when I don't have to set anything else, I tend to forget the one setting left.

Travel and holidays

So you want a little more than just a few pocketable snapshots. You want a couple of magazines of slides, and perhaps a few enlargements for your walls. Still the automatic 35 mm compact should suit you, although, you might think about getting one with a few more controls. Perhaps one that lets you choose the aperture, and tells you about the shutter speed — or vice versa. That way you know roughly what is going to come out sharp — and what not.

Better still, get one with full manual override. You might not need that very often, but it can be useful. One particular advantage is that if you want to experiment, you don't need to go out and buy another camera. A simple alternative is to choose a camera with follow-pointer metering. Instead of letting the camera set its own controls, you turn the rings or dials to line up a needle with a pointer or index mark. You have then set the correct exposure just as the camera would have done but have exercised some control over either aperture or shutter speed.

What to you want the manual settings for? Just for those cases when the meter doesn't measure the exposure needed for the most important parts of the scene. I remember two girls taking pictures on the balcony of a monastery. One had an automatic camera, the other a manual one. The automatic camera took a beautiful picture of the countryside with the monks in the shade on the balcony all silhouetted. The manual camera produced a perfectly-exposed picture of the monks — against a grossly over-exposed countryside. Of course, it could have been set to duplicate the auto-exposure picture if that was wanted.

It is not often that an automatic exposure produces the wrong picture, but if you can override yours, you can avoid the occasions when it would (see p. 157).

Travelling round, you may sometimes find scenes that are too close, or too far away, for your camera. Perhaps to get in all the sea front you would have to row out to sea; or maybe that castle on the other side of the valley is just lost in the picture. Either way, you need to alter the

angle of view of your camera. Some compacts and pocket cameras have converters to let you do just that. They are somewhat limited, but may well cover just what you want.

The alternative is to use a camera with interchangeable lenses. The main problem with such cameras is that they are big, heavy and usually expensive. We'll go into changing lenses in much greater detail later (see p. 159.). However, basically, a wide angle lens lets you get in more of the scene without moving. A long focus (telephoto) lens lets you pick out a smaller part of the scene to shoot bigger. Which you find more useful depends on you. If you can change your lenses, best take both a wide angle and long focus lens on your travels.

If you are staying away, try to take a flash with you. Lots of interesting and amusing things go on after dark — or indoors. Even a simple magicube lets you take pictures up to 3 m (10 ft) away. Of course, it is no good for distant subjects. Some people try to use flash for gigantic church interiors, theatre scenes, even the Niagara falls. The flash has *no* effect in such conditions.

Places

Travel and holidays let you picture far away places. Don't forget those nearer home, though. Most towns and villages have some places of interest; and they have one major advantage. You can take your pictures just at the right time. You local churchyard may look pretty under its layer of spring crocuses; but perhaps a bleak winter picture would be more telling. You can choose.

Take pictures of your surroundings: your house and garden, the view from your windows and so on. You will soon get used to choosing the best times of day, weather and even times of year to give you the lighting you want. This practice will also tell you whether you need another camera or a different set of lenses.

Soon, too, you will be looking for other places to photograph. Once you can decide what sort of scenes make the pictures you like, you will find your holiday pictures much easier to take. You won't be one of those who rushes around on the last day 'finishing' the film — and still has six exposures left for next year.

People

People make pictures. It is not too often that you see a really outstanding picture without some people in it. Wait for them to be in the right place, and your holiday scenes come to life. Put a friend just in the corner, and you add scale to a bare hillside or seascape.

However, people are not just 'props' for scenic pictures. They are subjects. The most important, and probably the most difficult subjects you ever meet. You must convince them to pose the way you want them, look right, and act naturally.

Then you have to choose exactly the ideal moment for exposure, and the right camera position and lighting. Go too close, and you get distorted features; too far away and you have a nice picture of the house next door with Tom just there by the apple tree! The lighting? Have strong sun coming from the side, cutting sharply across her face, and you get Mary-Ann looking like a witch. Have flash on your camera and she looks like a featureless pudding (except perhaps for a pair of sparkling red eyes).

The problem with distance is that when you are far enough away for your subject to come out nicely proportioned you are too far away for a close up. To get round that, you need a narrower lens angle. Most 'tele' attachments to fit on the front of fixed lenses are about right for portraits. They are much better than the so called 'portrait' attachments once popular for box cameras. If you can change your lens, then you are better off. For pleasant features, choose a lens nearly twice the normal focal length (80–90 mm on 35 mm, 135–150 mm on 6 × 6). For children, a slightly longer focal length may be better. They are smaller, and will be less disturbed if you can stand well back.

Of course, if you make your own prints (colour or black-and-white) you don't need a special lens for portraits. You just stand back, then enlarge the bit you want.

Lighting is somewhat more difficult. Bright sun is a problem. Coming just over your shoulder it produces very flat lighting (like flash on the camera). Coming from the side, you get deep shadows on one side of the face. Overhead, and eyes disappear into coal-black sockets. The best solution is to wait for light clouds to produce a softer lighting. Failing that, you can use fill-in flash. That restricts your shutter speeds with a focal plane shutter.

For pleasant photos by flash you need at least two flashguns. One to provide the right lighting angle, the other to prevent the same harsh shadows.

So, if you want to concentrate on portraits, you need a slightly long focus lens (or your own printing equipment) and, preferably, the facility to use fairly sophisticated flash equipment. There used to be lots of diaphragm shutter single lens reflexes (see p. 94) that were ideal. Now they have gone. If you want 35 mm you have to choose between a diaphragm shutter compact – easy flash, lens limited to whatever converters you can get – or focal plane 'system' cameras – restricted flash, unlimited lens range. If you use commercial photo-finishers to make your prints, choose the compact that gives you the longest focal length converter, or use a fairly long focus lens on an interchangeable lens camera.

If you do your own prints, what about a 6 × 6 or 6 × 7 camera? A twin-lens reflex (see p. 90) has long been a favourite portrait camera. The low-level viewpoint is particularly good for children. The big negatives make for easy enlargements, and the diaphragm shutter lets you take flash pictures whenever you want.

Action and movement

Things that move tend to come out blurred in photographs (see p. 140). To prevent that, you need to use a high shutter speed. If you are going to take fast-moving subjects, choose a camera with a top shutter speed of at least 1/500 second: 1/1000 can be useful, but you are seldom likely to want 1/2000.

Low light

We've talked about dull days, but maybe you want to take pictures when there is much less light still. You can use flash – as long as your subject is close enough and if it gives the lighting you want. However, if you can't or don't want to use flash, you need to give a lot of exposure. That means leaving the shutter open for a long time and having a large lens opening. Most compacts have reasonable low light capabilities. Some are really good. They let you take pictures in most situations where you can see comfortably. To take pictures of people in really bright domestic lighting you need a lens aperture of f2.8 or more (see p. 123). Any adjustable shutter gives you the speeds you need.

Wild life

Most wild animals are shy; lots of them are tiny as well. You just can't get near enough to take even a reasonable sized picture with a normal camera lens. The 'tele' attachment for your compact won t make much difference either. In fact you need a really long focus lens – perhaps eight times the focal length of your standard lens. Such a lens is big and clumsy. You can't expect to get really sharp pictures without a firm support, and you may well use it no more than a few times.

However, if you need one, there is no alternative. What's more, you can hardly use one without reflex viewing and focusing. Really, such lenses make it imperative that you buy a single-lens reflex. For transparencies, you are limited to 35 mm. You need such big heavy lenses for larger formats that they can be considered entirely for specialists. They are way beyond the average budget anyway.

Sports

Sports photography has much in common with wild-life photography. Your subjects are a long way away. They tend to move more, though. Also, you are much more likely to be shooting in artificial light – indoors. So you often need long focus lenses, especially large aperture ones. Luckily, you don't move around quite so much, so you can use a really steady tripod.

Of course, you can take excellent general views and 'atmosphere' pictures with almost any camera. And small, local events give great opportunities to the compact user.

Close-ups

Once you want to get closer than your standard lens focuses, you need accessories. You can do close-ups with the simplest cameras. In fact, some basic cameras take excellent pictures through close-up lenses – often as good as you can expect from a much more sophisticated set-up. However, close-ups are somewhat fiddly with any camera that has a separate viewfinder. If you want to concentrate on picturing small objects, you need a screen-focusing camera – preferably a single-lens reflex (see p. 94).

Versatility

Really, as we've gone through these few popular photographic categories, we've been talking about versatility. Of course, there are cameras designed just for one purpose or another: panoramic cameras for wide views, long focus cameras for portraits, watertight cameras for sub-aqua or dusty places – and so on. However, for the ordinary photographer, adding the ability to cope with one special circumstance or another usually adds to the general versatility of his equipment.

Undoubtedly the most versatile commonly-used cameras are 35 mm single-lens reflexes (see p. 94). They can be fitted with an enormous range of accessories. Lenses that give you a most extraordinary range of angles, close-up devices, even microscopes and telescopes; not to mention the vast range of other scientific equipment. The viewfinder image is formed through whatever you fit to the lens mount. So you don't need accessory finders unless your equipment interferes with the viewfinder system.

The range of equipment available for single-lens reflex cameras of other formats is less than that for 35 mm models. However, 120 cameras of this type are capable of photographic feats beyond the dreams of most photographers. Pocket 110 single-lens reflexes will soon answer most snapshot needs. We discuss these formats later. However, if you want the most versatile camera, choose a single-lens reflex. Don't buy one, though, if all you need is a compact. With a single-lens reflex, you are paying a lot of money and carrying round a lot of weight for the privilege of changing the lens for almost any accessory you choose. If you never intend to change the lens, you don't want an SLR. You don't need one even if you just want to fit the normal range of wide angle and long focus lenses. You can do that with an interchangeable-lens rangefinder camera (see p. 88). Such a camera can be smaller and lighter than a single-lens reflex. Their lenses can be mechanically and optically simpler, so they should be more reliable and produce better images than equivalently-priced reflex lenses. However, viewing is not quite so convenient. The main problem, though, is availability (see p. 68). Single-lens reflexes now so dominate the 'system' camera market that you must really go out of your way to get a rangefinder model instead.

So if you want a versatile camera, you must think first of a single lens reflex. Which one you choose depends largely on your preferences and your pocket.

Size and quality

As we have already implied, and will discuss in more detail later (see p. 58) picture quality is closely related to film size. Unfortunately, so is cost and weight of equipment. For most people, 35 mm is a good compromise. But, undoubtedly, you can get better image quality from 6 × 6 or 6 × 7 cm cameras. However, if the thing is so heavy you leave it at home whenever possible, you won't be getting any pictures, good, bad or indifferent.

Which one?

Whatever you choose is a compromise. The most superb piece of 35 mm engineering can never approach a 9 × 12 cm view camera for image quality, or image manipulation; but it is much easier to take on safari, and makes action photography a different world. Still, you can't put it in your pocket. A 110 pocket camera won't produce world-shattering image quality, but you can carry one with you up the side of a mountain without any problem.

You must just decide *exactly* what you want your camera to do. Make quite sure you need any sophistications you are contemplating; and – especially – that they won't interfere with the all-important process of composing and picture-taking.

Almost any camera can be used to take this sort of picture – the light is good and the subject not too close to the camera position.

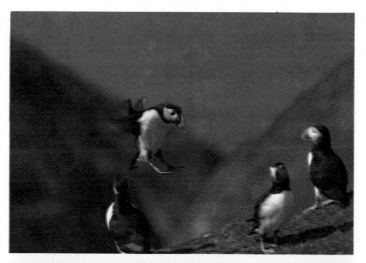

Top a puffin in flight. For nature shots such as this a really long focus lens is essential, and these can only be mounted on single-lens reflex cameras.

Above for portrait work many photographers prefer to use a lens of slightly longer than standard focal length – around 100mm with a 35mm camera.

Page 26 this picture was taken on a technical camera (see page 82) and is reproduced here only slightly larger than its actual size. Quality is superlative, but the cost per picture is high.

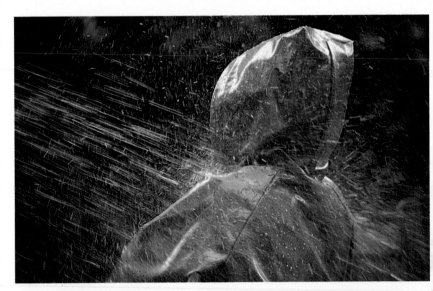

If you use a camera with adjustable shutter speeds you can choose whether to 'freeze' movement (above) or introduce a sense of flow (top).

Up in the air or under the water – suitably adapted the camera can travel just about anywhere.

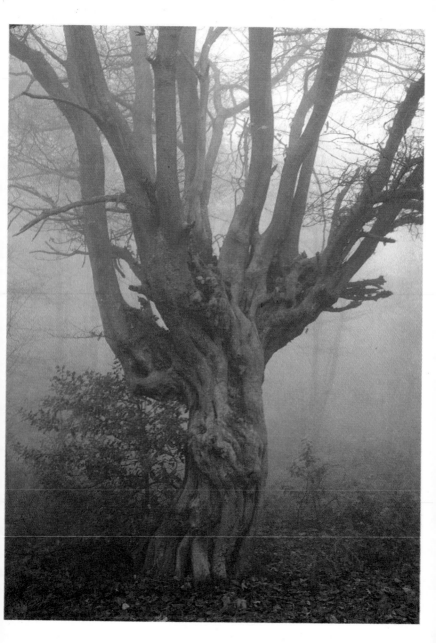

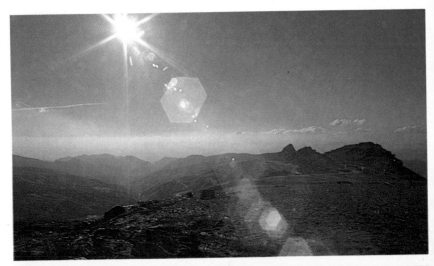

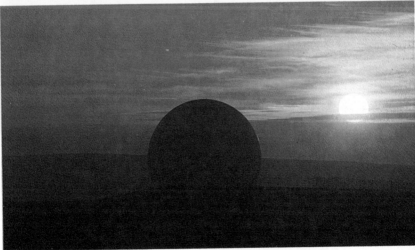

Top any bright light source within the picture area is liable to cause flare. This is the making of some pictures, but sometimes it just spoils them.

Above Fylingdales ballistic missile early warning station. At sunrise and sunset you can make dramatic pictures with even a simple camera, although this was taken with a single-lens reflex.

Page 31 a hornbeam in the autumn mist. You do not have to have brilliant summer sunshine to make effective pictures.

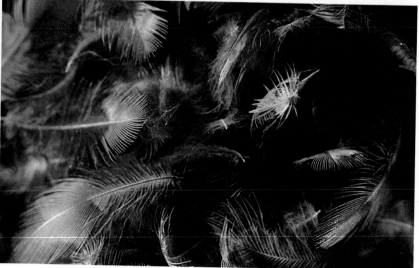

Top for finely textured subjects such as this it is important to use a high quality lens that is really clean.

Above feathers arranged on a piece of black velvet. The lens must be very carefully focused for successful close-ups.

29

What
is a
Camera?

Photography is an integral part of modern life. We see photographs every day. Still pictures in newspapers, books and posters, moving ones on the television or at the movies. Most of us have photographs in our homes, and sooner or later we take at least a few. The camera we use can be anything from a simple box that works only in bright sun, to a sophisticated monster covered with knobs and dials. Operated properly, within its limitations, any camera takes perfectly good pictures.

The word 'camera' once just meant a closed room – it's still used that way for secret trials and similar hearings. Medieval artists used dark rooms or boxes with pinholes or lenses to project scenes. These produced images on walls or on a translucent screen, so that they could draw accurate pictures more easily. The portable 'camera obscura' became part of the landscape artist's equipment. With the development of photography, similar boxes – or cameras – were used to form images on light-sensitive material.

Today, we use cameras developed from the first mahogany and brass photographic equipment. At first glance, they look very different, but they are still essentially the same.

The camera body is a light-tight box. At one end is a lens which projects an image onto the other end. The film is held there, with a mechanism to allow it to be moved on after each exposure, and removed for processing when necessary. Between the lens and the film is a shutter. This stops light getting through until you want to take a picture.

Basically, the body, with lens, shutter and film transport is all you need to take pictures. The body is just a box. Its shape is chosen to suit its components and use.

The lens

Arguably, the most important single component of a camera is the lens. It focuses an image of the scene onto the film. So if yours doesn't work too well, you never get a really good picture.

The simplest lens is a single piece of glass with curved surfaces. Like a magnifying glass. In fact, there are two basic types – positive (convex) lenses, including magnifying glasses, form images; negative (concave) lenses don't. Opticians use positive lenses to correct long sight, and negative ones for short sight. Camera lenses are always positive.

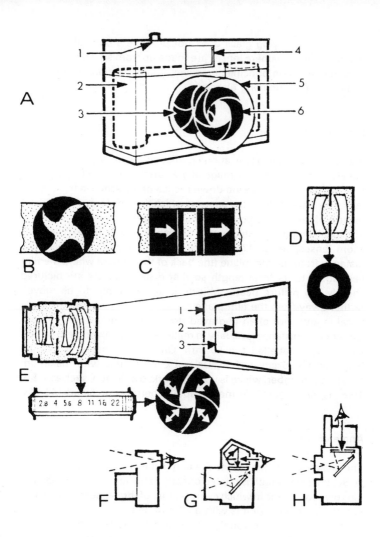

A. All cameras have the same basic features: 1, Shutter release. 2, Film. 3, Shutter. 4, Viewfinder. 5, Lens. 6, Diaphragm. B. Diaphragm type shutter. C. Focal plane type shutter. D. The size of the lens aperture determines the light that it lets through. E. The aperture may be variable, so too may the lens, to cover different fields of view. 1, Wide-angle. 2, Long focus (telephoto). 3, Normal. F. Straight-through viewfinder. G. Single-lens reflex. H. Twin lens reflex.

A simple magnifying glass does not produce a particularly sharp image. So most camera lenses are made up from several differently curved glasses. In principle, however, you can regard all lenses as working like magnifying glasses.

Focal length

If you hold a positive lens at one particular distance from a piece of paper, it projects a sharp image of the surroundings onto the paper. This image is a little upside-down replica of the scene in front of the lens. The distance from the paper at which the lens forms its sharpest picture of far-away objects is its focal length.

The focal length is a fixed feature of each lens (with the exception of zoom lenses, see p. 174). In a camera, the lens is mounted at a distance from the film plane (the back of the camera where the film lies) equal to its focal length so that distant objects are pictured sharply. To picture nearer objects it generally has to be moved farther away from the film plane.

Focal lengths are often engraved on the lens mount. On modern cameras the distance is usually in millimetres. For example, a 50 mm lens may be labelled f = 50 mm. On older cameras, it may be inscribed f = 5 cm or 2 in. Do not confuse this with maximum aperture (f-number) which is usually marked as a ratio, such as 1:3.5. There is much more information about apertures on pages 144-148.

Angle of view

The distance from the lens to the film dictates how large the picture is. So, the focal length is related directly to the image size. A 100 mm lens gives an image in which every feature of the scene is reproduced exactly twice the size it is with a 50 mm one.

Lenses actually form roughly circular images. How much of the image you get in your picture depends on the film size. Obviously, the bigger the film, the more of the circular image you get.

But, how do pocket cameras with their tiny negative size take pictures of whole landscapes just like big roll film jobs?

The camera manufacturer chooses a lens to suit the film size. As a rough guide, the focal length of a 'normal' lens is about equal to the diagonal of the picture frame (on the film).

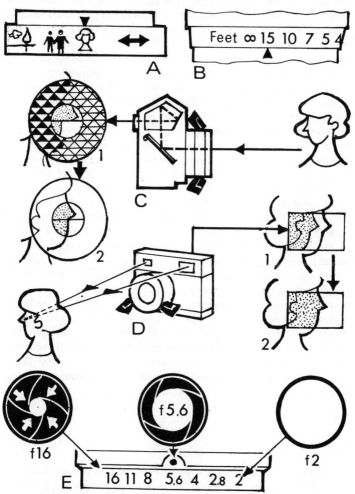

Adjustable lenses must be set to the correct focus distance. Various systems are used. A. Focus ring or slider moves to symbols. B. Focus scale in feet or metres. C. Single lens reflex can have a focusing aid to supplement screen focusing. 1, Unsharp. 2, Sharp. D. Coupled rangefinder projects a second image into the viewfinder. 1, Double image for out-of-focus subject. 2, Coincident image when subject is in focus. E. Lens apertures are calibrated in f-numbers. The *larger* the number, the *smaller* the aperture. Here is a typical f-number scale.

So, each feature of the subject takes up the same *proportion* of film area. If you make prints all the same size (or project transparencies on the same size screen) your subject will come out about the same size. As long as you were using the 'standard' lens, it doesn't matter whether you started with a negative as large as your prints, or with a tiny 'subminiature' one which needed great enlargement.

The relationship between focal length and film size determines the *angle of view* of the camera. 'Standard' lenses cover about 45°–50° on the diagonal. This angle is chosen because it gives pleasing pictures in normal sized enlargements.

For any particular negative size, the shorter the focal length, the wider the angle of view, and the longer the focal length, the narrower the angle. As the angle of view increases, so you get more of the scene into your picture; but the smaller each part comes out.

Most cameras are fitted with a fixed lens. Before you buy one, look through the viewfinder carefully. See if it gives you about the right view of the subject. If it takes in too much or too little, ask the dealer if he has a more suitable one. Don't expect miracles, though. As we've already said, most cameras have a lens that gives more or less the same angle of view, so you're not likely to find enormous differences. Sophisticated equipment usually has interchangeable lenses. This means that you can choose your angle of view. Often you can buy a body and whatever lens you like. Of course, when you have several lenses, you can change them about as often as you wish. There's much more about the effects of different lenses starting on page 159. Movie cameras often have a zoom lens fitted. This lets you change the angle of view at will (between limits set by the lens design). You can buy zoom lenses for interchangeable lens still cameras.

Focusing

When a lens is exactly its focal length from the film, you get sharp pictures of distant subjects. In fact, the lens brings parallel rays of light to focus. That is rays from infinitely distant things. In practice, with a 35 mm camera, anything more than about 10 m (30 ft) away is sharp.

As you go closer to your subject, the picture becomes progressively more blurred. To compensate for this, you must move the lens further from the film. You generally do this by moving a focus ring or slider. On some cameras, you just guess the distance of your subject and set a pointer to a number or symbol. Others have built-in focusing aids.

These are either a ground-glass screen or a rangefinder (or both). How they work is discussed on pages 86-90.

As explained on page 145, the smaller the aperture you use, the sharper 'wrongly' focused subjects become. This fact is used to allow the construction of simple non-adjustable camera lenses. Their small aperture lenses are set so that everything more than 1.5 m (5 ft) or so away comes out sharp enough for normal viewing.

How much light?

The simplest snapshot cameras can be used only in sunlight (or with flash). This is because the lens is small. It lets only a small proportion of the light outside reach the film. One sophistication is to fit a larger lens. This lets in more light, so you can take pictures in less bright surroundings.

But you will also want to take pictures in bright sunlight. So you need a method of *reducing* the light going through the lens. You could put grey transparent plastic (called a neutral-density filter) in front of it, but this is rather impractical for every-day photography. So lenses are fitted with a *diaphragm*. This is just a device to give a variable-sized hole (the *aperture*). It is often made from a number of movable leaves to give a more or less circular aperture; but simpler diaphragms with square – or even irregular-shaped – apertures are quite efficient for most cameras.

f-numbers

The aperture formed by a diaphragm decides how much light can reach the film. If you're going to control this, you need some sort of scale to set it by. The internationally accepted standard is the *relative aperture, f-stop,* or *f-number* scale.

Relative apertures are basically calculated by dividing the focal length of the lens by the diameter of the aperture. They are denoted in a number of ways: $f/2.8$, 1 :2.8 or just $f2.8$. All imply that the diameter of the relative aperture is 1/2.8 of the focal length, or 1/4 for $f4$, 1/8 for $f8$, etc.

This may seem a crazy way of going about things, but really its quite logical. The effect is that at any particular *f*-number, the image of the particular scene is just as bright on the film *whatever lens you use.*

Thus, a simple pocket camera with a 23 mm lens at f8 produces an image neither brighter nor dimmer than a sophisticated SLR with a 500 mm telephoto lens also at f8 (all other things being equal, of course).

This is a very important factor when you come to calculate exposures. See p. 123.

As a by-product of changing your aperture, you also affect the focusing. We'll be looking at that in the sections on apertures – see pages 144-148.

The shutter

Photographic film is highly sensitive to light. It must be kept completely in the dark, otherwise it is spoiled. But, you need to be able to expose it to the light from your subject when you want to. In the earliest days, a photographer just took off the lens cap for a few seconds (or minutes), and put it back on when the material was exposed. Now all normal cameras have a shutter. This keeps light from the film except at the moment of exposure. Then, when you press the button, it opens for a tiny measured time and closes again. On the simplest cameras it stays open for about 1/60 second. On more sophisticated models you can choose how long you want it to stay open; and on many automatic cameras, the machine itself chooses. Later on, we'll discuss the choice of shutter speeds, and the benefits of automation (see p. 140 and p. 149).

Simple shutters

Simple snapshot cameras have the most basic shutters. Just a little metal leaf, driven by a spring. This type of shutter is fitted just behind or in front of a simple lens. Often the spring can be set to give one of two speeds. You usually set a lever to 'cloudy' or 'sunny' to change it. As an alternative to the spring, the speed can be controlled electronically. This produces the type of shutter fitted to the more expensive and versatile models of most pocket camera ranges.

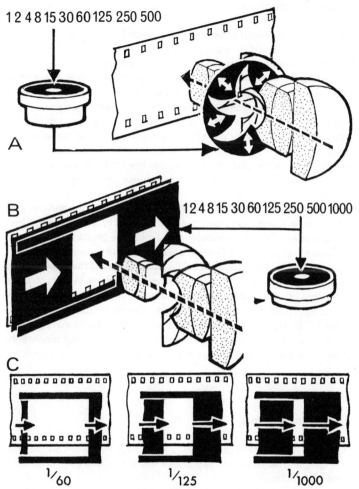

1 2 4 8 15 30 60 125 250 500

A

B

1 2 4 8 15 30 60 125 250 500 1000

C

$^1/_{60}$ $^1/_{125}$ $^1/_{1000}$

A. Between-the-lens diaphragm shutter. The blades open out, then close in again after the pre-set interval. Normally the speeds are set on a dial or ring, and the shortest is seldom faster than 1/500 second. B. Focal plane shutter. A blind moves from one side to the other, revealing the film. A second follows after an interval closing it again. The blinds are then rewound before the next exposure. The interval can be varied with ease, and speeds of up to 1/1000 or even 1/2000 second are common. C. Only at comparatively slow speeds is the entire film exposed simultaneously with a focal plane shutter.

Diaphragm shutters

Shutters often consist of several leaves working together. They open from the centre out, like a diaphragm. Most open fully. Others to a preset point, so acting also as the lens diaphragm.

The shutter may be mounted just behind the camera lens. More often it is built into the lens, fitted in one of the spaces between the elements. Diaphragm shutters can be controlled by springs or electronics. They can have just a few alternative speeds, a whole range, or even be continuously variable. They are almost universally used on good quality fixed-lens cameras, and are found on the most sophisticated professional studio equipment. They are fine for all photography, and especially useful for flash work. You can use electronic flash at any speed.

There is one point though: diaphragm shutters don't open and close instantly. It takes a measurable time for the blades to reach the edge, and to close again. This is accounted for in timing the shutters. You get the exposure that you would if they opened and closed instantaneously – at full aperture. At high speeds (1/125 sec and faster) the opening and closing times are a significant proportion of the whole. When you use a small lens aperture, the blades have to open only a little to uncover the whole light path. So, you get effectively a longer shutter speed. If you want 1/250 at *f* 16, or 22, you should set 1/500. Your camera instructions should explain but if you are in doubt, just close your diaphragm by about half a stop for your two highest speeds with your two smallest apertures.

Focal plane shutters

A shutter at the front of a camera in or near the lens complicates changing lenses. To avoid this problem, the focal plane shutter is just in front of the film.

The shutter consists of two blinds. The first whips away from one side to the other (or from the top to bottom) to leave the film exposed. At an exactly measured time afterward, the second blind closes off the film again.

So the film is exposed sequentially. At fast speeds, the effect is that of a slit rushing across the film plane.

This type of shutter is common on interchangeable lens cameras. Like the other types, it can be controlled by spring tension or electronical-

ly. It has only one problem. It leads to complications with flash photography.

Speeds

The time that the shutter stays open is called the shutter speed. Most times it is measured in fractions of a second, such as 1/30 or 1/500. All shutters take some time to open and close. The calibrated speeds are the times that a perfect (instant open, instant closed) shutter would be open to give the same exposure. Like all the variables in photography, they can be somewhat inaccurate without causing much of a problem.

Film gate

The picture area is defined by a rectangle — the film gate. This is a carefully cut hole in a carefully placed piece of metal or plastic. The film must be held exactly where the lens is focused, and be quite flat. In cartridge-loading cameras, the whole cartridge is pressed against the gate by springs at the back. In other cameras, the film is held by a spring-loaded pressure plate.

The pressure-plate and gate design is important. If the film is not held quite flat, you cannot get a truly sharp picture. However, if the film is held too tight, you may scratch it when you wind on. A few cameras have pressure plates which release the film as you wind. Most, however, depend on a carefully calculated compromise pressure — and very smooth parts.

Film transport

You load a camera with a roll or cartridge of film. This gives you anything up to 72 pictures, according to the type of camera. Between each one you have to wind on the film. Most cameras have a knob or lever to do it.

At one time, you looked at a red window in the camera back and wound on the film until the next number appeared. This rather crude system has been replaced with easier ways of moving the film by the right amount. Now almost every camera winding mechanism stops at the right place. You just wind until you can't wind any more.

The mechanics vary with the film packing. There's more on that in the next chapter.

Double and blank exposure prevention

In the red-window days, there was nothing to stop you winding you way right through a film without taking a picture. Now, you most often have to press the shutter release between each wind-on. Otherwise you can't move the film. This stops you from wasting film. On top of this, most cameras now prevent you from taking two pictures on one frame. Sensible enough, since in most cases if you did, you would just be wasting them both. So, once you have pressed the button, you can't do it again until you have wound on the film.

Shutter tensioning

One way this is achieved is by coupling the shutter tensioning mechanism to the film transport. Once, most shutters had to be tensioned separately, just like winding up a clockwork toy. You pushed a little lever one way, and it shot back when you set off the shutter. Now film wind and shutter tensioning are combined, you cannot forget one of them.

Frame counters

If you've got a roll of film in your camera, you'll need a way to count the pictures. Roll films have numbers on their paper backing. As we've said, you could see these numbers through red windows in older cameras. Cartridge loading cameras still use that system, only the window is not red any more. To find out how many you've used, you just look at the back of your camera. It shows you the type of film as well.

With 35 mm film, however, there's no backing paper. Neither is there for part of the length of a 220 roll. So, you can't have even the tiniest window in your camera back. Instead, a mechanical counter is fitted. The counter shows a number against an index. The number moves on by one each time you wind on the film.

There are two ways it can count – additively or subtractively. Additive counters start at 1, and add 1 for each picture. Most modern cameras have this type of counter. They ususally reset themselves when you

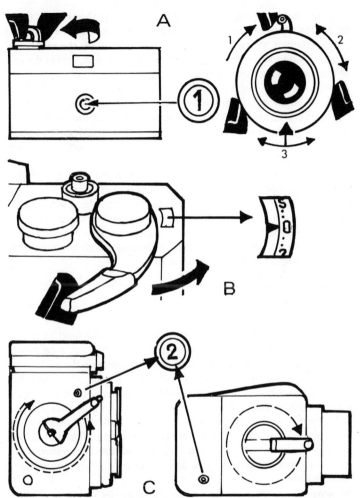

A. Uncoupled film transport systems. Roll films may be wound on just until the next number shows in a window. The shutter is set separately. 1, Set shutter. 2, Lever returns on release. 3, Speed may be set on rim. Cartridge loading cameras have numbers visible in camera back, but shutters are set in film winding, and double exposures are impossible. B. Lever wind usually incorporates double and blank exposure prevention. Exposures are counted mechanically. C. Complex roll-film cameras usually have crank winders and mechanical counters.

open the camera back. So all you have to remember is how many exposures there are on the film. Subtractive counters need a little more attention. When you've loaded the film, you set the number of exposures on the counter. Each picture subtracts one, and at the end of the film the counter reads '0'.

As you have to make a couple of 'blind' exposures on 35 mm cameras, their counters usually take this into account. Additive counters start a couple of notches before 1; and subtractive counters have a mark just past each of the common film packing numbers. If you haven't got either on a manually set counter, don't set it until you've made the blind exposures.

There's not much to choose between counters. The automatic-setting ones make loading a fraction quicker, and you can't forget to set them. They do require you to remember how long your film is, however, and that's not so easy if you put the camera away now and then in the middle of a roll. It's not so easy either when you are using two or more cameras at the same time. Some subtractive counters lock the film transport when they reach zero.

Film reminders

There's another thing to remember. The type of film (and its speed) you have got in your camera — or cameras. If you use a cartridge-loader, there's no problem; you can read the name on the back of the cartridge through the window in your camera back. With any other camera, you need some sort of reminder. The best way is to keep the end of the film-pack with your camera. A few cameras have slots for that, if not you can tape it on or slip it into the case (if you use one). In addition, mechanical reminders abound. Most are dials that let you indicate variously film speed, type, lighting, number of exposures, etc. None of these reminders have any effect on camera operation or performance.

Now its common to have built-in exposure meters, you have a built-in film speed reminder. You must have the right speed set for the meter to work.

Viewfinder

The simplest cameras need a viewfinder; that is, something to show you where the subject is, and what you are going to get in your pic-

ture. Most commonly, modern cameras have separate viewfinders. These are like little telescopes, built into the camera body. They show you a little rectangular picture of the scene. That's all they do, but they do it quite adequately for most subjects.

One problem, however, is that if you wear glasses, you'll have difficulty seeing the corners of the scene. This makes viewing uncomfortable – and may lead to the unexpected – such as Aunt Ethel pictured with a tree growing out of her ear. So, the more sophisticated cameras have viewfinders that cover more than the picture you'll get on the film. Inside, there's a bright frame to show you the extent of the picture. This type of viewfinder is quite nice for moving subjects. You can watch what's going on just outside your picture area, so be ready to press the button just at the opportune moment.

More sophisticated viewfinders have focusing aids, show the view through the camera lens, and so on. In fact, viewfinders are a main classification feature of cameras. They are discussed in detail further on (p. 82).

Viewfinder displays

In addition, many viewfinders now display information. You may well see the meter needle moving along one edge; lens apertures and shutter speeds somewhere else; and even warnings to use flash or a tripod. As cameras use more and more electronics, the viewfinder displays become more sophisticated, with arrays of LEDS giving the information. All this is there so that you can be sure that everything is set right without taking the camera away from your eye. So you don't have to stop concentrating on making a picture.

Other features

These are the basic parts you need to take pictures. Most cameras, though have one or more additional facilities. Most of these are fixing points.

Accessory shoes allow you to fix flash guns or other instruments. The standard design consists of two small rails. You slide the foot of your accessory under them.

Flash contacts fire your flash gun just at the right moment (see p. 288). They may work through plug sockets. The most widespread takes 3 mm (PC) coaxial plugs. Most newer cameras, though, can take

flash equipment directly. Cameras with accessory shoes having a central (hot shoe) contact, simple cameras taking plug-in flash. There are at least five different types of socket: for bulbs (usually AG3B type); flashcubes; magicubes; flip-flashes; or flashbars. Normally, you must use the sort of flash for which your camera is designed. There are adapters to convert from some types to others.

Tripod bushes are small threaded holes. You just screw in the tripod bolt to fix your camera. Be careful, though. Never try to tighten a bolt onto the bottom of the bush. Always make quite sure that the bush is deeper than the full tripod thread requires.

Cable releases are flexible accessories that let you fire the camera without touching it – so reducing the chance of shake. Most fit into a tapered bush in the shutter release button. A few cameras have different, more positive locating mechanisms.

Self-timers fire the camera after a fixed delay. Most are clockwork and operate from a small lever on the camera front. You can use the facility to take self-portraits, or to reduce the chance of camera shake during long exposures.

This shot was taken on a 35mm compact camera with automatic focusing and built-in flash. Such cameras are now relatively inexpensive, and are almost unbelievably simple to use to good effect.

In photography timing is often more important than equipment. This expressive picture could have been taken with more or less any camera.

Page 51 top for interior shots when the light is dim you need a fast film and a lens which has a wide maximum aperture.

Page 51 bottom the use of a telephoto lens has closely linked the elements of this subject, and the result is faintly comic.

Taken on 120 film – the uncropped negative is 2¼in (6cm) square. This is the usual size for twin-lens reflexes and medium-format single-lens reflexes. The picture also illustrates the technique of selective or 'differential' focusing: foreground and background are blurred and do not compete with the main area of interest for the viewer's attention.

Page 53 top for street scenes such as this a small and discreet camera is best – a 110 pocket camera, the new disc-type or a 35mm compact would be ideal.

Page 53 bottom for wildlife you need something much more elaborate – this was taken on a 35mm SLR fitted with a mirror lens (see page 189).

By careful choice of camera position and angle you can exploit the differences in the sizes of objects or people.

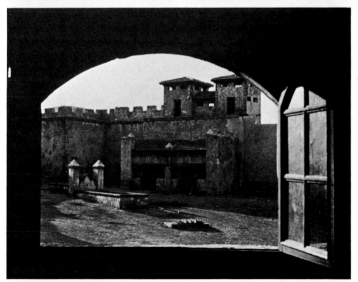

Top focusing on different parts of a scene can alter the emphasis of a picture.

Above expose for the exterior to get a shot of a historical building framed by one of its own windows.

Instant picture formats: Polaroid SX-70 prints are square (*top*) and measure 8.5 × 8.5cm (3¼ × 3¼in). Kodak prints are rectangular and 6.5 × 9cm (2½ × 3½in).

Formats
and
Loading

Most cameras are loaded with strips of film (rolled up, of course). Specialised cameras, though, may be loaded with a single piece of film – or even (though very rarely now) a glass plate – for each shot. Whether or not it's part of a roll, the piece of film you're using must be spread out in the film plane when you take a picture. So your camera must be at least as big as the picture size.

Not so long ago, the majority of photographs were *contact prints*. The negative was just laid on the paper, and held in the light. This made fine pictures, but they were always exactly the same size as the negative. So you had to choose a camera that gave you the picture size you wanted. This led to a vast profusion of cameras of all sizes; and of course, films or plates to go with them.

Since World War II, however, the photofinishing industry has concentrated on providing the same size prints whatever the film size. Now, if you take in a negative film (black-and-white or colour) for processing and printing, you'll get back pictures made on 9 cm ($3\frac{1}{2}$ in) wide paper. If your camera takes square pictures, they'll be 9 cm square. If it takes oblong pictures, the prints will be 12 or 13 cm by 9 cm. These pictures are called *enprints*.

The trend away from contact prints has been even faster among home processors. Where, once, a suitably sized printing frame was the first item you needed, now it's an enlarger.

So now you don't have to think about picture size when you decide on your film size (and thus the type of camera you want). You do, however, have to think about picture quality. When you enlarge from a negative, you blow up the picture, sure; but you also blow up the blemishes. Your negative may be scratched, or have dust embedded in it (it shouldn't, but there are few photofinishers who'll send you back a perfectly clean and unmarked film). Additionally, there's grain.

Grain

Films don't produce entirely smooth pictures. They form pictures made up from a scatter of tiny blotches. This is called grain. It varies from one film type to another and from one process to another, but its always there. Yes, its there in colour as well; blotches of three different colours. You can get an idea of how a picture is made up from dots of colour by looking at a poster. Go up close, and you'll see the dots. Or look at a coloured magazine picture through a magnifier; you'll see them there too.

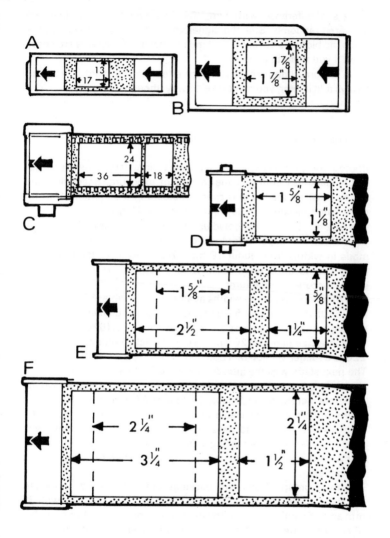

Film formats. Picture size depends on film size, and sometimes on the camera. A. 110 pocket camera cartridge. B. 126 instant load cartridge. C. 135 (35 mm) cassette full and half-frame. D. 828 (Bantam) roll. E. 127 roll 8 and 12 and 16 exposures. F. 120 (and 220) roll, 8 (16) 12 (24) and 16 (32) exposures. Some cameras take 10 shots about 6 × 7 cm ($2\frac{1}{2} \times 2\frac{3}{4}$ in).

There's a difference with film, the dots aren't regular, they are scattered randomly. Still, the bigger you enlarge them, the more obvious the blotches become. That means that small cameras are not so good if you want big prints.

Grain is sometimes emphasised for effect. If you want it, you can always add it later, you can't take it away, though.

Film packings

Photographic film is extremely sensitive to light. It must be kept in absolute darkness until just the instant of exposure. Sheet film and plates must be loaded into special holders in a darkroom. Film for other cameras comes in daylight-loading packings.

The first rollfilms were spooled up with light-proof paper. There were several turns of paper before you came to the film. These films were made in widths from about 10 mm (1/2 in) to more than 125 mm (5 in). Some sizes were fairly widespread, others confined to a single obscure manufacturer.

Now there are only three widths at all easily available: 828, 127, and 120 (620). A fourth 116 (616) has been discontinued recently. Of the existing sizes, new cameras are made only for 120. (620 and 616 are the same size film as 120 and 116, but packed on a thinner spool; 220 is a longer version of 120.)

The next stage was the introduction of unbacked film in cassettes. A short tail is 'fogged' when loading the camera, and therefore wound on before picture taking. Double-perforated 35 mm (movie) film is the only size commonly available in this type of packing. In the past a number of cameras had cassette-to-cassette facilities, some with special cassettes, others taking standard ones. On all current models, you wind the film back into its original cassette before taking it out of the camera.

The third group of still film packings are instant-load cartridges. Basically, these are represented by 126 and 110 films filled with 35 mm and 16 mm wide films. These are the popular sizes, but a number of special cameras and most of the 'subminiatures' take their own cartridges.

Cartridges make for the simplest loading. You just drop them into the film chamber, wind on and there you are. They do, however, introduce plastic complications, and may be detrimental to picture sharpness. Anyway, we'll start with them.

Film size 110

The smallest film size readily available is 110. The film is 16 mm wide, like that used for small movie theatres. It is packed in plastic cassettes. These contain enough film for either twelve or twenty pictures. Picture size is nominally 13 × 17 mm. This is big enough to make reasonable enprints, or to project transparencies on a domestic size screen. The cameras are loaded almost exclusively with colour negative film. However, in some ways, this is the least satisfactory film for them. Black-and-white negative film has a much finer grain, and the grain on colour transparencies is not too obvious on a projection screen.

There is one perforation (hole) for each frame. You just put the cartridge in your camera, and wind on until you can't wind any more. That's when a feeler in the camera engages with the first perforation. When you've taken a picture, you can wind on to the next frame.

On their introduction, 110 films were limited to a single speed (see p. 114). All the films were around 80 ASA – that is medium-speed, general purpose emulsions. Now faster films (400 ASA) have become available. You can use these only in cameras designed for them; there's a knob on the cartridge that won't let you put it in the wrong camera. Suitable electronically-controlled cameras are set automatically by the cartridge to give the right exposure.

Pocket cameras

If you want only a sort of 'pocket notebook', you'll be quite happy with a 110 pocket camera. You just drop in the right type of film, wind on and your camera's loaded up. Even the most sophisticated will go in a large pocket. Almost every month these little cameras get a boost with a new development of one kind or another.

The simplest ones are updated equivalents of the old 'box camera'. They work well outside on sunny days and can use flash for pictures in any light, as long as the subject is no more than 3 metres (10 ft) away. These take quite good pictures on negative film (black and white or colour) but are not so good for slides.

Next in the range come those with two settings – cloudy or sunny. They stretch the flash distance a little, but aren't really much of an improvement for prints. However, the little refinement does let you take much better transparencies. Once up again, and you get four or five

weather settings. This really is an improvement. Outdoors, you can take photos in almost any daylight weather conditions; and your flash range is extended to 5 metres (16 ft) or so.

You won't get sharp pictures of fast-moving subjects, you can't picture distant objects larger, or introduce differential focus; but the five-symbol pocket camera is great for snapshots.

If you want greater refinements, you can have an electronic shutter. This lets you take pictures in any lighting. Get one with weather symbols as well and you have even more versatility. You can get well-exposed pictures almost anywhere. Some models even let you change to a 'telephoto- lens to magnify your subject.

The most sophisticated have a large-aperture lens with focusing scale and built-in rangefinder. One or two give you full manual exposure control (if you want it). You can get wide-angle or telephoto converters, zoom and close up lenses; and even a single-lens reflex; with other refinements 'just round the corner'. All in all, the pocket camera will soon be able to rival in versatility all but the most advanced cameras in other formats.

However, you are still limited by the film size. If you take really super photographs, you won't want to be confined to tiny pictures, so maybe you'd be better off with a camera using larger film.

The next size up uses 35 mm-wide film. This comes in two quite distinct packings. Type 135 metal cassettes loaded with perforated film as introduced with the Leica in 1925, and 126 plastic cartridges introduced with the Kodak Instamatic in 1963.

Film size 126

The 126 cartridge is just like a larger version of the 110 cartridge. The picture size is nominally 28 × 28 mm. This should let you make much bigger enlargements than you can with 110. Unfortunately, although grain is considerably reduced, there is an inherent problem in the 126 format. It has never been possible to ensure that the film sits exactly flat and in the right place. Inevitable manufacturing tolerances between one cartridge and the next mean that you can never be quite certain of getting really sharp pictures.

For this reason, it is probably not advisable to buy a 126 camera now. If you've got one, fine. Go on using it until you want something more versatile, or you find that the size of your enlargements is restricted by lack of sharp negatives. However, with the latest fine-grain films, a

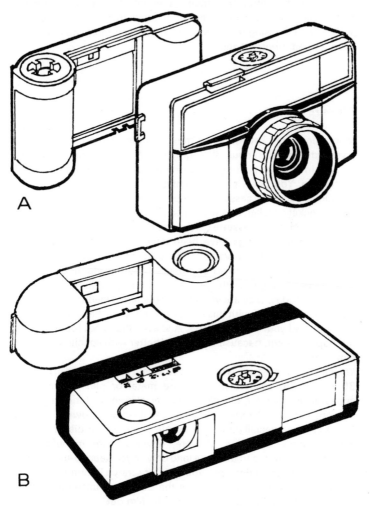

Cartridge-loading cameras. A. 126 camera. Just drop in the cartridge, wind on until the mechanism stops and it's ready. Some are restricted to bright sun. Others have most of the refinements available on 35 mm cameras. B. 110 pocket-camera. Operates just like a 126 camera. This is a 5-symbol example. Others are available from basic bright sun instruments to zoom-lensed single-lens reflexes. The lens cover locks the shutter release when it is closed.

110 camera has virtually as much potential. Once again, remember that no camera makes good pictures. It is you, by framing up the composition and pressing the button just at the right moment, who takes good (or bad) photographs.

Film size 135

More commonly known as 35 mm, 135 film is the current format favoured by most 'serious' photographers. It uses the same width film as 126. In fact, the picture width is reduced by the perforations along each edge. You get a picture nominally 24 × 36 mm (1 × 1½ in). The film is packed in cassettes. It is pulled across the film camera gate by a sprocketed roller, and wound on to a take-up spool. You have to wind it back into its cassette before you can take it out of the camera. A few special loadings have been developed in the past, notably Agfa's Karat and Rapid systems. These let you load one cassette, run the film across the camera and unload another identical cassette. They suffered only from the problem of finding suitable cassettes in the shops. Today, they are virtually unobtainable loaded with film, so if you have a camera with this sort of loading, you'll have to buy film in bulk and load your own cassettes. And even that's not too good with the Rapid system, because that works better with specially stiffened film ends.

You can buy almost any type of film you want ready loaded in ordinary 35 mm (135) cassettes. These are metal or plastic, varying in appearance according to make. However, almost all of them go in any 35 mm camera. Alternatively, you can load your own cassettes. These can be specially made re-usable cassettes, or discarded film manufacturers' cassettes. Beware, however, film manufacturers make their cassettes to take one load only. If you keep re-using them, they may start to let light into your film, or scratch it. Some cassettes – notably those made by Kodak in the USA – are unsuitable for re-use. You have to destroy them to get the film out.

Whatever the cartridge you intend to reload, there are two ways you can buy the film: in single reloads, or in bulk. The reloads *must* be put into cassettes in the dark. With bulk film, you can use a daylight loader, but you have to put the film in the loader in the dark. Bulk film can also in turn work out much cheaper than buying loaded cassettes every time.

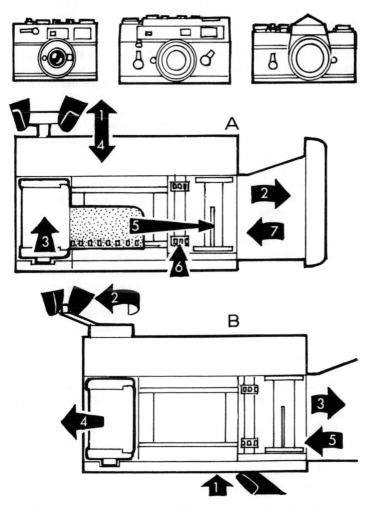

35 mm cameras. Most 35 mm cameras have adjustable shutter speeds, lens apertures and focusing. They may be compact with fixed lenses, or somewhat larger with interchangeable lenses and other 'system' accessories.

A. Loading. 1, Release camera back. 2, Open back. 3, Insert cassette. 4, Push down spindle. 5, Insert tongue in spindle. 6. Wind on till sprockets engage. 7, Close back and make two blind exposures. B. Unloading. 1, Press rewind release. 2, *Rewind film.* 3, Open back. 4, Remove film cassette. 5, Close back.

Loading

Even though the cassettes are designed for loading the camera in daylight, don't push your luck too far. Never let bright sunlight fall on them. If there is no shade, turn your back to the sun and use your own shadow.

To load a 35 mm camera, you open the back (or on some models the base) and put the new cassette into the chamber for it. Commonly this is the left-hand end of your camera, and with most cameras you have to pull up the rewind knob to get the cassette into its space, and push it down to engage the spindle.

Now, pull the free end across the camera, and engage it in the take-up spool. The fixing varies from model to model, but make sure the film's secure. Operate the film transport lever to wind on some film until the sprocket holes engage the drive sprockets. Close the back, and wind on two frames. This gets you past the film exposed to the light while loading. Check as you wind that the *rewind* knob rotates. That shows you that the film is coming out of the cassette as it should. Wind on to the third frame, and you're ready to take a picture.

Once you get to the end of the film, you can't wind on any more. Never force the winding mechanism. You can pull the film out of its cassette, or break it. Either way, you're stuck. Unless you can find *absolute* darkness, you can't open your camera without losing the pictures you've already taken. So, once the winder becomes stiff, rewind the film, and take out the cassette. Then you can put a new one in.

The need to rewind the film is virtually unique to 35 mm. To rewind it, press the rewind button, raise the rewind crank, and turn it until you feel the film come free from the take-up-spool. You can leave the film leader out if you stop then, or wind it into the cassette with a couple of extra turns. Leave it out if you want to pull out the film for processing, or if you're not quite sure the cassette lips seal too well. Pull it in if you want to be sure that you don't put your exposed film back later by mistake for a new one.

35 mm cameras

For the beginner, ordinary 35 mm cameras have two problems. Loading them with film is somewhat complicated, and the cheapest versions have 'old fashioned' controls which need setting. However, you can get a 35 mm camera to approach the versatility of the most expensive 110 cameras for about one-tenth of the cost. Another big

advantage is the enormous range of film types available for these cameras. By changing the film you can make the most basic 35 mm camera capable of taking pictures under virtually any conditions.

The simplest 35 mm cameras come at the bottom end of the camera prices. Even so, they can cope with a range of lighting and film types. So you have to set them for each situation. This isn't too daunting really, although few 35 mm cameras have weather symbols. Instead they're marked with lens apertures and shutter speeds. Just because you don't know about these doesn't mean you can't use the camera. Every film pack has an instruction sheet. This tells you how to set your camera controls to suit various conditions.

Do that, and you'll get properly-exposed pictures. You won't yet be making full use of the possibilities, but you'll probably get better results than you could expect from a cartridge-loading camera. In fact, you'll really be operating your camera almost as if it were a simple weather-symbol model. If you've got a camera with adjustable apertures and speeds, it would pay you to learn a little about them. There's much more detail on page 139.

Most popular 35 mm cameras have an exposure meter built in. This measures the light and indicates how you should set the controls. The next sophistication is in coupling the meter to the controls. You just line up a needle to a mark or a pointer, and your camera is set right. But a small step from there is the automatic camera. Like the more sophisticated cartridge cameras, automatic 35 mm models give accurate exposures under most conditions. However, sometimes they're fooled, so if you're going to want to tackle unusual situations, you need to be able to override any automatic system your camera has.

The 35 mm frame size is large enough to give superb quality prints of almost any size. If you want big pictures, however, you need to take considerable care. Choice of equipment, film and processing can all affect sharpness. However, accurate exposure, spot-on focusing, freedom from camera shake and absolute cleanliness in processing and printing are even more important.

Compact cameras

One of the modern trends in camera design has been to reduce size. This has resulted in the so-called 'compact' 35 mm cameras. These are quite small — almost pocketable. They are fitted with com-

paratively advanced features – wide aperture lenses, a good range of shutter speeds, exposure meters – coupled or automatic – rangefinders, and so on. They take full-frame 35 mm pictures.

If you're not going to change your lens, this is the sort of camera for you. The results from the better compacts are staggeringly good, and the cameras have enough sophistication to make life easy.

Except for the smallest, which are expensive because they are miniaturized, compacts are not too highly priced. Many offer excellent specification and, if you don't want to fiddle with accessories, are as versatile as you can wish. The better ones are optically and mechanically superb.

System cameras

Modern 35 mm cameras in the other major group are typified by their interchangeable lenses. They also draw on more-or-less immense reservoirs of special accessories. On the whole these cameras are much more expensive than their fixed-lens equivalents. Much of the extra cost is directly attributable to the lens interchangeability.

In fact, within a few years of its introduction, the first 35 mm camera – the Leica – was developed to become the world's first system camera. It was the versatility of this camera that lead to the popularity of the film size. Before World War II, the Leica, and its major rival, the Contax, built up a legendary armoury of lenses and other accessories. Today, nearly all the system cameras are single-lens reflexes. These have considerable advantage with specialist lenses, or very close-up, as we'll discuss on pages 93-103. They are, however, relatively big and heavy; and some people don't find them too easy to focus. If you don't want to go outside the normal range of lenses, you might find a rangefinder camera more suitable. Unfortunately, the choice of new models is restricted to fantastically expensive West European machines with every modern development, and amazingly inexpensive East European models, which take excellent pictures rather clumsily.

The SLR designs start at reasonable prices and go up to the price of a top-quality colour television. That is for the basic camera, of course, with just one lens. You can pay what you like for accessories, while some specialized lenses can set you back the cost of an extension to your house.

Because of the convenience and wide range of 35 mm film, and the

sophisticated machinery available, the 35 mm system camera must be the first choice of anvone who is going to take photography seriously.

Film size 120 and 220

The original type of rollfilm survives in − surprisingly − the most sophisticated and 'professional' hand camera format − 120, and its derivative 220. There are no sprockets on these paper-covered rolls. They are just pulled through the camera by winding with the take-up spool.

This format is characterized by the variety of picture sizes. All use most of the width to make one dimension, nominally 6 cm ($2\frac{1}{4}$ in). The other dimension may be 9 cm ($3\frac{1}{2}$ in), 7 cm ($2\frac{1}{2}$ in), 6 cm ($2\frac{1}{4}$ in) or 4.5 cm ($1\frac{5}{8}$ in); for each of these you get, eight, ten, twelve (sometimes eleven) and sixteen (sometimes fifteen) on a roll of 120 film. You get more or less double the number on a roll of 220 film.

The variety of 120 films is immense, but that of 220 very restricted. All suitably sized cameras can use 120, only a proportion of these can take 220. Apart from its length, the major difference is that 220 film is paper backed only at the beginning and end. The middle is naked. So, obviously, you can't use it in cameras with those red holes for counting pictures. In fact, you can't use it in a lot of other 120 cameras either. If you're in doubt about yours, ask a reliable dealer, or the distributor. There is one other film packing you can use in some 120 cameras (the most sophisticated and expensive). That is perforated 70 mm film in a metal cassette.

Loading 120 film

To load a 120 camera, you open the back − or the film magazine if your camera takes these. Take out the film holder if it is separate (as it is in the Box Brownie or Mamiya 645 for example). Remove the exposed film (if there is one) and transfer the empty spool to the take-up position. In most cameras, you need to pull away sprung holders to move the spools, full or empty.

Now, take the paper seal off a new roll of film. Hold tight to make sure the paper doesn't unwind, and put the spool in the take-off chamber. Still maintaining suitable pressure on it, unroll enough paper to reach

the take-up spool. Note that on many cameras (such as the Rolleiflexes) you have to run the paper *between* two close rollers. If you don't you'll just wind right through the whole film without setting the camera to take a picture.

Pull the paper across and through the rollers. Put the tapered end into a slot on the take-up spool, and wind enough round the spool to hold it tight. If there are two arrows or bright marks one each side of the film path in the camera you have to wind on more. Go on winding until black arrows, one on each edge of the backing paper, match these marks. When you have wound on enough (to hold the paper, or match the guide marks), put the filmholder back if necessary and close the camera or film magazine.

Now wind on. If your camera has a red window in the back, wind until you see the figure 1 appear in it. It's further than you think, just preceded by a few arrows and the film's name. Close the cover if there is one, and you're ready for your first picture. However, few recent cameras have red windows. You just wind on until the mechanism stops, and you're ready.

All this may sound a bit of a palaver; but it is really quite easy. It's quite common for people to misload 35 mm cameras, but seldom does it happen with roll film.

Cameras for 120 and 220 film

There are basically four shapes for rollfilm cameras — press, folding, twin-lens reflex and single-lens reflex. We'll discuss them in much more detail in the next chapter.

Once most popular box cameras took 120 or 620 film. There are still a few plastic toy shop versions around, but the cheapest 'real' 120 cameras are East European or Chinese twin-lens reflexes and folding cameras. All these take excellent pictures. In fact there is no doubt that these are the cheapest cameras to give startlingly sharp pictures. Most of the other twin-lens reflexes are considerably more expensive. They guarantee superb quality, but don't give you much more versatility — except with the Mamiyaflex. On this camera, you can change the lenses.

There are a few 'press' type cameras with separate viewfinders, but certainly the main interest in this format is concentrated on single lens reflexes. One or two of the East European cameras come out about the middle of the price-range for 35 mm SLRs, but most 120

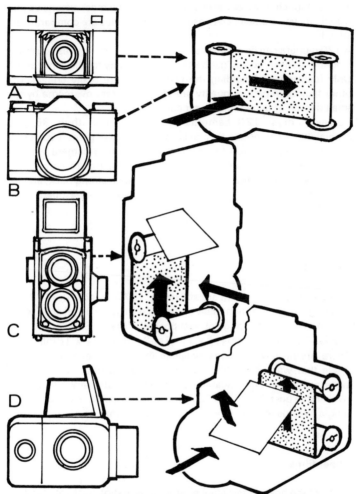

Roll-film camera (120 and 220). A. Simple folding camera — may have coupled rangefinder. B. Horizontal shape single-lens reflex. C. Twin-lens reflex. D. Square shape single-lens reflex. Roll film is loaded on one spool. The paper leader is pulled across the film plane on to an empty spool. The path depends on the position of guide rollers. Once the back is closed, the film is pulled across by winding the take-up spool. After exposure, the film and its paper tail is wound on to the take-up spool. The original film spool is then used to take up the next roll.

SLRs are much more expensive. The price of the most expensive one would buy you a small car. Lenses and accessories are comparatively priced.

A 120 camera can be almost as versatile as 35 mm. It gives you much bigger negatives, so you get better picture quality for the same effort. Only focusing, and holding the camera still are really crucial. The other factors in picture quality are to some extent overcome by the small degree of enlargement you need.

However, most 120 cameras are bigger than their 35 mm equivalents – and so are their accessories. They're great if you don't have to carry them too far, or if you just want a camera without accessories to take really top quality pictures. But to carry them around, with even a few accessories, you need a strong back; and for a system camera with a few accessories, you need a deep, deep pocket.

Other rollfilms

Two other sizes of rollfilm are still made, 127 and 828. The 127 size usually gives pictures nominally either 6×4 cm ($2\frac{1}{4} \times 1\frac{5}{8}$ in) or 4×4 ($1\frac{5}{8} \times 1\frac{5}{8}$ in). This was the original 'vest pocket' (VP) size. Smaller still, 828 allows pictures 4×3 cm ($1\frac{5}{8} \times 1\frac{1}{8}$ in) or 3×3 cm ($1\frac{1}{8} \times 1\frac{1}{8}$ in).

There are no new cameras available for these sizes now. Most of those that were made were of the simple snapshot variety. There were never any sophisticated 828 cameras, but a few 127 models rivalled the best. In fact the 35 mm SLR, now aristocrat of the camera jungle, was developed directly from a 127 format camera.

Sheet films

Much of the best professional photography is shot on sheet (cut) film. For each shot the photographer puts in a separate sheet of film. The smallest commonly used size is 9×12 cm (about $3\frac{1}{2} \times 4\frac{3}{4}$ in), and probably the most common in Britain and the USA is 5×4 in – just slightly larger.

The main reason for using sheet film is that it gives even bigger negatives or transparencies than roll film. So it produces potentially sharper pictures – for posters, magazines and so on.

Sheet films are used in 'technical' or 'view' cameras. Little more than a lens and shutter connected by bellows to a film holder with a ground glass screen for viewing and focusing, these cameras let you adjust the position and angle of the film and lens over an enormous range. We just haven't got the space to tell you about them here, but they could be of interest.

Until recently, there weren't too many amateurs interested in sheet film cameras. They were getting away from plates, and wanted things smaller and smaller. However, the skill and patience needed to produce really sharp 20 × 16 prints from 35 mm has chased many back to larger formats. 120 rollfilm is ideal for most, but the cost! So, if you're looking for perfection, and find that a 120 SLR and the lens you want are beyond reach, have a look at sheet film cameras: not cheap, but lenses are interchangeable between makes without too much fiddling, so you have a great selection of secondhand gear to choose from. Don't forget, though, you'll need a 5 × 4 enlarger: they don't come cheap and they need a lot of houseroom. Also, the price of film is such that you have to think about *every* shot before you press the button.

Tinies

After the largest size you're ever likely to think about – the smallest – and its relatives.

Long before 110, lots of respectable camera manufacturers were producing 16 mm still cameras. Known variously as ultra-miniature or sub-miniature, each of these tiny cameras had its own type of film cartridge. This was their downfall.

You can get film at a few dealers only, it's expensive, and so is its processing. However, the ranges of emulsion are extensive, and you can reload most of the cassettes with 16 mm movie film – either double- or single-perforated depending on the format. Picture sizes range from 10 × 14 to 12 × 17 mm.

But, what about the tiniest? That's the Minox (at least, its the smallest format you're ever likely to meet). It uses unperforated 9.5 mm film. Picture size is 11 × 8 mm, and cartridges hold enough for 50 exposures. It's been around for a long time, and is still with us.

All these cameras can be thought of more or less as sophisticated substitutes for 110 cameras. Handled with care, they can produce

excellent pictures. They're smaller and lighter than most of the 110 pocket cameras, and over the years have mimicked almost all the 35 mm developments. However, now they must be thought of as cameras for the avid enthusiast only. You can get so much better quality from 35 mm, and 110 film is so much more convenient to buy and to have processed. Of course, as I said at the beginning – if you've got one, and you're happy with it, there's no point in changing for change's sake.

Half-frame

One last format needs mentioning – half-frame 35 mm. Instead of 20, 24 or 36 pictures, you get 40, 48 or 72 on a roll, and they're just half the size – 18 × 24 mm (3/4 × 1 in). Its quite a good compromise size. Projected slides and prints are good enough quality for most people. Unfortunately, it suffers from a few problems.

As the pictures are upright on the film, the cameras can be only 20 mm or so narrower than a full-frame 35 mm camera; the upright pictures don't match the horizontal camera shape; and many people have enough problems finishing a 20-exposure film, and would find a 72-exposure load enough for several years.

So, worthy as it is, half-frame has never been really popular. Now there is only one make of half-frame cameras available in any quantity.

Choosing one of them

So, which size do you need?

If you are going to concentrate on making big enlargements, you need a big film, and really ought to consider a rollfilm camera.

You can get quite simple models, but most rollfilm cameras have 'old-fashioned' controls you need to set. If you don't understand these, you won't get much of the picture quality you're looking for.

If you're after versatility, the more sophisticated of these cameras can offer you an enormous range of ancillary equipment. They are, however, relatively big and heavy and, even more daunting, they are very expensive. Remember, there's never any point in buying a sophisticated camera if you can't expect to afford the accessories it's made to use.

74

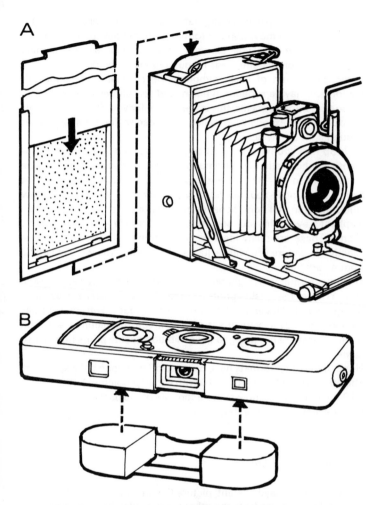

A. Sheet-film (cut-film) cameras. Single sheets of film are loaded in special light-tight holders. The cameras tend to have more facilities than do roll film cameras, often allowing the lens to move around to compensate for difficult viewpoints. Modern studio examples have lens and film panels mounted independently on a single rail. B. Ultra-miniature cameras are like sophisticated 110 cameras. They are commonly smaller and lighter but each takes its own type of film cartridge. For ordinary photography, a pocket camera is more convenient.

With a little care, you can get great picture quality from 35 mm film. This is by far the most popular format with 'serious' photographers. It's so popular that you can get most of your system camera accessories from independent manufacturers. This can save you an immense amount of cash, although the original camera maker's equipment may be superior in finish, and sometimes in operation.

If you take transparencies, this is the format for you. Bigger projectors are clumsy and expensive. Smaller ones need to 'fry' the slides to get enough light on the screen.

With 35 mm you have an ideal compromise, and you can go to immense sophistication in automatic operation, dual projection, tape control and so on — if you want to. Also, 35 mm lenses are the most highly developed. You can have wide apertures for relatively slow colour films in dull conditions, monstrous telephotos, to enlarge an elephant's eye to fill your screen from half a mile — and high quality zooms. These are really ideal for transparencies. You can compose exactly the picture you want — just as you could if you were enlarging from a negative.

The other format you might think of is 110 — the cameras are tiny and light. You get reasonable prints from them, and transparencies come out quite well. However, they are so small that — with present day technology — even your great-aunt will see the pictures are a bit grainy. So you're not going to get exhibition quality prints from a 110 camera.

None of the other formats have much to offer anyone but a specialist. The other small ones are like 110 with added problems; 126, 127 and 828 are really just simple camera formats of the past; anything larger needs sheet films these days.

Instant-picture systems

We've not discussed 'instant' picture film at all yet. That's because it is so different in use from the other types of film. You get the picture straight out of the camera. So enlargement and transparency projection are not immediately relevant.

Polaroid 'film' is a combination of negative and positive material. After exposure, the processing chemicals are spread onto the negative part as the material comes out of the camera. There are two sorts. The original type you pull out with a paper tab, and the more recent type pushes itself out.

Instant-picture cameras. There are several different instant-picture cameras. The material is processed automatically when it comes out of the camera. Colour prints take between 1 and 6 minutes to develop fully. A few cameras take black-and-white only, others colour only, but most allow the choice.

With the sort you pull out, you have to wait (15 seconds for black-and-white and one minute for colour film), and then peel the negative from the print. While you are waiting the negative is processed, and the print material exposed chemically and processed. So you end up with a print and a handful of waste paper. You also get a self-adhesive mounting card for each, and a saturated fixing sponge supplied with the film. You stick the print on the card and wipe it over with the fixer. If you want more prints, you have to send the original print off to be copied – best through suitable dealers.

There is a black-and-white version of this film that gives you a normal negative as well as your print. So it's easy to get good quality prints and enlargements.

The more recent variety of material is still a negative and positive pack. However, the negative is retained below the final print, so you have nothing to pull apart or throw away. After you have taken the picture, rollers push the sheet out of the front of the camera. It is at first a pale off-white, but – before your very eyes – the picture slowly appears. It reaches full colour and density in five or six minutes.

Kodak instant picture film works on a reversal system. The chemistry is different, but the effect is the same. After the material comes out of the camera, the coloured picture slowly appears. In fact it comes out on the *back* of the material. But that doesn't affect anything.

One thing is obvious about cameras that produce prints directly, they must be at least as big as the print. You choose the camera that takes the size and shape you want.

The simplest camera takes only black-and-white, and most are more-or-less snapshot instruments. They feature yes/no exposure controls, electronic shutters, and simple picture density controls.

The most sophisticated feature comparatively wide aperture lenses with full manual or automatic exposure control. Many of them fold, but even so are somewhat bulky.

You can fit instant picture adapters to view cameras, and to some of the most sophisticated 120 roll film SLRs. Otherwise there is no way of using the material with specialized lenses or accessories.

So, instant picture film is fine for taking instant snapshots. The range of cameras lets you get really good image quality, but the accessories are severely limited and the cameras considerably more bulky than other snapshot cameras.

The materials are not cheap. In many parts of the world instant prints work out considerably more expensive than comparable conventional prints. A particular temptation, as well, is to take pictures for others.

Variations
on a
Theme

The basic elements of any camera are the same – lens, shutter, film-holder and so on, as we have discussed. Their size is more or less determined by the film, but still there are variations.

In fact, it is an ancillary that really determines how a camera looks – the viewfinder. When photographic equipment was developed from the camera obscura, the photographer composed his picture on the ground glass screen, then put his sensitive material in its place. He needed exposures of several seconds, or even minutes. So there was no point in trying to picture anything that moved. Thus, all his subjects stayed where he had composed them.

View cameras

The modern development of this is the view camera. Such cameras consist of a lens panel and a film panel connected by bellows. A shutter is built into the lens, and a ground-glass screen in to the film panel. To set up the camera, you open the shutter and look at the ground glass screen. There you see the image formed by the lens – upside down. You focus by moving either the lens panel or the film panel (or both).

The lens panel can be moved forward, backward, up, down, or side to side, and both panels can usually be tilted or swung to almost any angle.

This allows accurate framing, manipulation of parallel lines, adjustment of the plane of sharp focus and so on. Such control, and the large-format film commonly employed, is needed to produce the brilliantly sharp pictures demanded by advertising and other commercial photography. It is beyond the needs of almost all other photographers.

View cameras commonly take sheet (cut) film: 9×12 cm, 5×4 in, and 10×8 in are 'popular' sizes. Adapters let you use 120 film or Polaroid material instead. For a few years a 35 mm model was available.

Once, the cost of this type of camera restricted its use considerably. Now, however, purely on an equipment cost basis, small view cameras can rival expensive rollfilm cameras. Equivalent accessory lenses are often cheaper. Before you rush out and buy one, though, think of the cost of film. With processing charges, each shot comes out not so far short of a roll of 120 or 35 mm film. Also, you will need considerable patience and practice to master a view camera. They

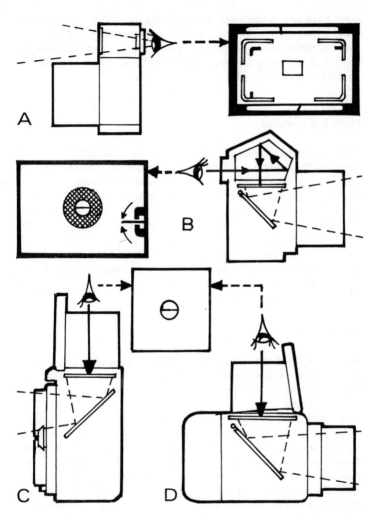

A. Separate optical finder. The picture area may be the whole view, or within a bright line. There are often extra marks for closer subjects. B. Single lens reflex. The viewfinder image is reflected by a mirror onto the viewing screen. Commonly, a pentaprism inverts this to give right-way round eye-level viewing. C. Twin-lens reflex. The mirror and screen produce an image through a separate lens that focuses with the main one. Waist level viewing produces an image reversed left-to-right. D. Some single lens reflexes allow waist level viewing.

don't have any modern conveniences like rangefinders or exposure meters, and the movements can baffle experts. Add that to the inevitable delay between composing your picture and releasing the shutter. Now, don't you think you might be better off with a more convenient camera? One with a viewfinder for a start.

Technical cameras

More portable examples of view cameras are often called technical cameras. They take 9 × 12 cm or 4 × 5 in cut film, and can often be fitted with a 120 rollfilm adapter. The lens panel slides along the folding baseboard, and clicks into positions for infinity focus of the range of lenses available. Rack and pinion focusing is fitted. The cameras usually have a viewfinder and may have a rangefinder. They offer a restricted range of movements.

Such a camera could well be your introduction to large-format photography. However, it is too heavy and film is too expensive for it to be your introduction to photography in general.

Viewfinders

Basically a viewfinder is something that shows you what you're going to get in your picture. Most show you the scene all the time, but SLR viewfinders don't. They black out just for the exposure. We'll come to them a bit later.

The simplest viewfinders consist of a frame, and some form of sight to show you where to look from. The others employ lenses, some by themselves, others with mirrors, ground glass screens and so forth.

Frame viewfinders. Frame finders are still incorporated in to the focusing screen hoods of some modern reflex cameras. In their basic form, they consist of a metal frame the same size as the film mounted directly on top of the lens, and a small peepsight at the back of the camera. On a camera with movements or interchangeable lenses, the frame finder is accurate as long as it remains in the same plane as the lens – and follows the movements. However, such a finder is large and cumbersome. Making the frame smaller and closer to the sight helps, but reduces the ease with which you can frame the scene.

Optical viewfinders. You can get the same sort of view with what is – in effect – a reversed telescope. The optical viewfinder is a feature of

most cameras today. Somewhere at the front there is a rectangular lens. At the back there's another lens – the eyepiece. Look through that and you'll see a reduced-size picture of the scene. On the simpler ones, this is what you'll get on the film if you press the button.

The main problem is that you may not be able to see the corners, especially if you wear glasses. To make them visible, the manufacturers would have to fit very large eyepiece lenses, and consequently large front viewfinder lenses as well. If you have viewing problems because you wear glasses, you can get your optician to supply a suitable conversion lens for the viewfinder. But then you have to put your glasses somewhere while you are taking pictures.

Suspended frames. A better way round the 'corner' problem is to get a camera with a suspended frame viewfinder. Basically, it works just like the ordinary optical finder, but shows you more of the scene – yes, more than you'll get on the film. Within the view, you see a bright frame, a sort of disembodied rectangle just floating there. This shows you just what you'll get on your film. Such viewfinders are often called *Albada finders*, after E. L. W. van Albada, who designed the first one. His design reflected the image of the frame from the carefully curved back surface of the front lens. Today, there are several optical methods of projecting the frame, but there's nothing to choose between them in use.

A suspended frame is nice for action photography. You can see a little of what's going on round the edges. So you're ready to press the button just as everything falls into place in the frame.

Viewfinder cameras

Most cameras have an optical finder built in, often with a suspended frame. They are a terrible problem for photographic writers – we can't think of a decent name. So you'll see them called viewfinder, non-reflex, straight through optical viewfinder, etc. Anyway, if you buy any but the most sophisticated camera, this is the sort you'll get.

Virtually all cartridge-loaders, all compact, and even one or two roll film cameras have this type of viewfinder. Its main advantages are that it shows you a clear bright picture whatever you do with the camera controls; it never blacks out; and you can alter its optics to suit your eyesight without fear of affecting camera operation.

Most 110 cameras are of this type, and a few have range-finders (see p. 84). They vary in price according to their specification. The

five-symbol sort – probably the most useful pocket camera – works out at around the price of a reasonable transistor radio.

Around the same price are 35 mm cameras without rangefinders, although some Russian models cost considerably less. Most 35 mm cameras have comparatively wide-aperture lenses. So they need pretty accurate focusing. Unless you're attracted by the cheapest available, it's worth getting one with a coupled rangefinder. That's really more use than a built-in exposure meter. Lighting doesn't vary much from minute to minute, but your subject may move about a great deal.

Nowadays, the only 120 cameras with straight optical viewfinders (and no rangefinder) are the real cheapies – costing not much more than a pack of cigarettes. You can't really expect them to take sharp pictures, but such a camera could save the day if you forget or lose your own.

There are two inherent disadvantages of an optical viewfinder. It can't display the focus of your lens; and it can suffer from parallax problems.

Parallax

Parallax is the scientific word for the effect of viewpoint. Hold one finger close to your face. Look at the finger and close first one eye, then the other. The two views of your finger in relation to the background are strikingly different. This is just because your two eyes aren't looking from exactly the same place.

The effect reduces considerably with distance; but it is still seen by your eyes – that's one of the ways you measure distance. Some cameras too measure distance with parallax; that's how rangefinders work.

However, when you have a viewfinder displaced from the lens, you have introduced parallax problems. The viewfinder sees a picture just slightly different from the one you get on the film. This doesn't matter at all at normal picture-taking distances. After all, what's a difference of a few centimetres if you're taking a picture of a house? When you get close, however, you can have problems. Even half-an-inch out in a picture of a single flower, and you've cut off one side.

There are two ways that camera manufacturers compensate for parallax. The most expensive cameras have their suspended frames connected to the focus mechanism. The frame moves ever so slightly

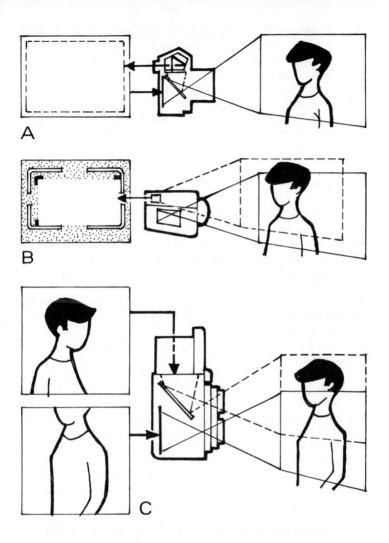

A. With a single-lens reflex, the viewfinder image represents the view of the main lens. Though in most cameras there is a built-in safety margin, so you get a bit more on the film. B. With a separate viewfinder, close subjects are not quite central. Frame within the 'parallax' marks to be sure of getting your subject central. C. With a twin-lens reflex, the problem is often greater because the two lenses are quite far apart.

in the viewfinder. Thus it always frames the subject accurately. A far more common method is to have marks in the viewfinder frame. When you're close to your subject you just line up your subject inside these marks instead of using the whole frame. It's best to take note of the marks for subjects less than about 2 m (6 ft) away, but follow the camera instructions if you've got them.

Parallax also introduces problems with twin-lens reflexes, but not with single lens reflexes. We'll discuss reflex cameras on the next few pages.

Rangefinders

You need to focus the lens on most cameras. You can use a distance scale or focus symbols, but this is not too convenient. It means that you have to estimate your subject distance, and set the focus before you raise the camera to the viewing position. If you're not too good at deciding on distance, you can get a separate rangefinder, but you still have to set your lens.

A built-in coupled rangefinder is a great advantage. You just sight the subject, and operate the lens control ring until you're in focus. So, how do you know?

What you see in a rangefinder is either two superimposed images or a single split image. Either way, when you're in focus, the images coincide or line up. On older cameras, there was a separate rangefinder eyepiece. Today, most coupled rangefinders are displayed in the viewfinder. They are more often the coincident-image type. When you look through the eyepiece, you see a pale-coloured spot in the middle of the scene. This shows a shadowy image of out-of-focus parts of the subject. To set the lens focus, just line up the coloured patch with your most important subject, and turn the focus control until the images coalesce. Now, that part of the subject will be sharp. How much more will also be sharp depends on the depth of field of your lens at that aperture and focus setting (see p 144).

A coupled rangefinder provides the most positive focusing, thus ensuring the fastest operation. It does have limitations, though: it gets beyond its range with really long focus lenses (more than about three times the focal length of the standard lens); and it just doesn't work with most close-up accessories fitted.

You can buy a camera taking 110, 135 or 120 film with a coupled rangefinder. Some 35 mm and most 120 size cameras let you change your lens, or fit other accessories. Interchangeable-lens rangefinder

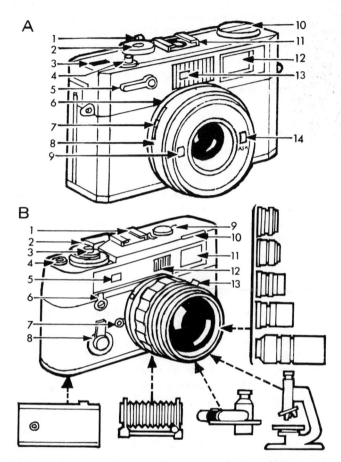

35 mm cameras tend to be more versatile than 110 or 126 cameras. A. Compact camera: 1, Film winder. 2, Shutter speed dial. 3, Frame counter. 4, Shutter release. 5, Self timer. 6, Lens aperture ring. 7, Coupler for flash exposures. 8, Focusing ring. 9, Meter window. 10, Rewind knob. 11, Accessory shoe with flash contact. 12, Viewfinder. 13, Rangefinder. 14, Film speed indicator. B. System cameras can take a range of lenses, motor drive, close-up, copying and other attachments. 1, Accessory shoe. 2, Film transport. 3, Shutter release. 4, Film counter. 5, Rangefinder window. 6, Rewind release lever. 7, Lens mount release. 8, Self timer. 9, Film speed setting. 10, Meter display window. 11, Viewfinder. 12, Viewfinder frame illuminator. 13, Viewfinder frame selector.

cameras are nearly always fitted with focal plane shutters, although a few had behind-the-lens diaphragm shutters. If you take a pride in your photography, but don't expect to take close-ups or fit really long telephoto lenses, you are probably best off with this type of camera. However, there is today no middle-priced 35 mm rangefinder camera with interchangeable lenses.

Fixed lens cameras

Little 35 mm rangefinder cameras are often called 'compacts'. These have all the facilities most photographers need – with the exception of interchangeable lenses. These start at about the price of a cheap record player – about fifty percent up on our five-symbol pocket camera – and go up to three or four times that price. There's little to choose between them, so you'll just have to make up your mind on styling and price.

'System' rangefinder cameras

As we said in the last chapter, 35 mm examples are either amazingly cheap or incredibly expensive. They offer exactly the facilities most photographers need. They're smaller, lighter and quieter than equivalent SLRs. If you don't fancy the cheap ones, and don't want to pay the earth, you're stuck with the used camera market, and prices there are rocketing as more and more become 'collectors items'.

The main 120 (and 220) rangefinder cameras are the so-called *press cameras*. These are quite large and comparatively heavy. They feature external hand-grips for steady shooting, and let you choose from a small range of lenses. They can give you both focal plane and diaphragm shutters (in the same camera). Several let you choose your picture size (on rollfilm), and may let you fit a plate, sheet film, or Polaroid adapter.

These cameras are really simplified versions of technical cameras. But they don't have the movements or the extreme close-up ability. They are handy for studio work, and for set-up work outdoors. You get nice large negatives (or transparencies), and image quality is usually superb. However, they can't be considered highly portable, and their limited range of lenses doesn't commend them to some enthusiasts. If you want simplicity in a 120 camera, the TLR is probably best; if you want versatility, at least consider an SLR.

Folding cameras

Just a word about 'folders'. The only one you can get new is Chinese. It takes 6×6 cm ($2\frac{1}{4} \times 2\frac{1}{4}$ in) pictures and has quite a fair specification – and a reasonable price. However, there still are lots of folding rollfilm cameras about. The better quality ones still take superb pictures. They have excellent lenses, a good range of shutter speeds, and often a coupled rangefinder.

If you travel with a fixed-lens camera, and like the idea of big negatives or transparencies, think about a folding camera. They're quite light. Don't expect them to be rain-proof, however, and do try out an old camera before you take any important pictures with it. In particular, make sure you can see through the viewfinder. If you can't, see if you can pick up a Kontur finder to fit to the accessory shoe (if there's no shoe, you can always glue one on). You look through the finder with one eye, and this 'projects' a frame onto the scene you see with the other eye. After a bit of practice, its easy to use.

Lens changing

There is a basic problem in lens changing on a camera with a separate viewfinder. The main effect of a different lens is to change your picture size from a fixed camera position (see p. 159). So, once you've changed your lens, your ordinary viewfinder is wrong. On the most sophisticated 35 mm rangefinder cameras, this is simply catered for. The viewfinder bright frame is changed to show your picture area. The frame may be selected automatically as you mount the lens. Naturally, the number of frames is limited so the system can work only with a few accessory lenses. The range varies from model to model.

If you want to use a lens outside that range – or if your camera doesn't have the facility at all – you must fit an accessory finder. Such finders go on top of your camera. Some suit just one focal length lens. Others can be adjusted to a number of (or all) focal lengths between standard limits.

The disadvantage with such finders is that they are disconnected from the camera mechanism. They can't have a rangefinder display (or any other information for that matter). Also, they tend to be a long way from the lens, so introducing parallax problems. However, some have built-in parallax correction.

Reflecting viewfinders

It is only comparatively recently (with the introduction of cartridge-loading cameras) that Newtonian optical viewfinders have become common on simple models. Before that, all but the most sophisticated cameras had reflecting viewfinders. These had a tiny lens which projected light onto a mirror and up to a screen or second, viewing, lens. You looked down onto this, and saw a minute reversed image. On box cameras, there were two finders, one for horizontal pictures and one for vertical. On folding cameras, you rotated the finder to the position you needed.

With these horrid little things, its not surprising that Aunt Agatha and Uncle Arnold came out with a list that belied their tee-total life, or that little Tabitha didn't have a head. In fact, anyone who tries to use a tiny reflecting finder today will be amazed that his or her parents got the subject in any of their pictures.

Reflex viewing

However, two developments were soon available to the enthusiast — the *brilliant finder*, and the *reflex finder*. These both worked like the little horrors we've just described, but they were much bigger.

The brilliant finder used a large viewing lens — often nearly as big as the film frame. The image was still reversed, and it didn't show you the way your main lens was focused; but you really could see what was where in the picture. For the first time, the owner of a simple snapshot camera could compose his pictures with an accurate knowledge of what he would get in.

The twin-lens reflex

For the enthusiast, the Rolleiflex introduced the twin lens reflex (TLR) concept in 1928. The viewfinder lens is exactly the same focal length as the main lens, and focuses an image on a screen at the camera top (via a mirror of course). Both lenses are mounted on a common focusing panel. So, as you focus the camera, so you focus the viewfinder image.

This means that you can see the focus on the screen. This focus matches (more or less) what you'll get at full aperture of the lens. As

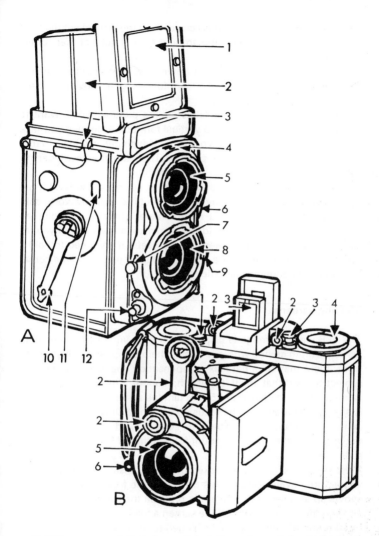

Roll film cameras. A. Twin lens reflex: 1, Frame (sports) viewfinder. 2, Viewing hood. 3, Viewing hood release. 4, Aperture and shutter speed display. 5, Viewing lens. 6, Focusing knob. 7, Flash synchronisation switch. 8, Main lens. 9, Exposure control knob. 10, Winding crank. 11, Frame counter. 12, Shutter release. B. Folding 6 × 4.5 (16 on) camera. 1, Opening button. 2, Rangefinder. 3, Shutter release. 4, Wind on key. 5, Lens and shutter. 6, Shutter cocking lever.

we'll see later (see p. 144) as you close down the lens (to get the right exposure) you also increase the amount of your subject that comes out sharp.

The picture is reversed as you look down on it. That's not too much of a problem, although it does make following a moving subject somewhat of an art.

However, unless the camera takes square pictures, you'll want to change between horizontal and vertical formats. Assuming you take horizontal pictures looking down on your viewfinder, you have to turn *sideways* to see vertical format pictures. Then, too, the viewfinder image is upside-down.

Also, as you hold the camera at waist level, you get a low-level viewpoint in your pictures. You may like that, but it's certainly worth considering before you choose a new camera. There is, though, one minor advantage. You can hold the camera well away from you, as long as you can see the screen. This is useful if you need to hold it above your head to see over a crowd, or push it just round the corner of a wall in a dangerous situation.

Viewing screens

The TLR viewing image is displayed on a ground glass screen. This screen is often etched with grid lines to help composition. Also, at the front, there may be a parallax compensation line. Don't frame your subject beyond that line if it's less than about 2 m (6 ft) away. If the camera can be loaded with 35 mm film (as some of them can), there is a rectangle drawn on the focusing screen to show what you'll get on that film. There may also be other sizes marked, such as 4 × 4 cm — the largest picture you can mount for a standard 5 × 5 cm (2 × 2 in) slide projector.

Most viewing screens are backed by a condenser lens, to make the image more evenly bright. This can be of the fresnel type. If it is, it shows up as a series of concentric rings on the screen.

To keep the ambient light off the screen a folding rectangular hood is fitted round it. Generally, a lens hinged to the top of the hood can be sprung out to stand parallel to the screen. Put your eye to this, and you see an enlarged image of the centre of the screen. Now you can focus much more critically. By moving your eye, you may be able to see most the screen. Beware, however, of trying to focus too close to the edge. The magnifier is a simple lens, and gives you a distorted (and not very sharp) picture if you look through it at an angle.

Parallax compensation

A number of TLRs have parallax compensation mechanisms. As you focus, the screen image is altered to show just the field of view of the main lens. Either the viewing lens is tilted down slightly more the closer you set the focus, or a blind or pointer moves in from the front edge of the screen. This stops you from making framing errors for close subjects.

TLR cameras

There have been 35 mm and 5 × 4 in twin lens reflexes but almost all the famous ones have used rollfilm. In fact, for our purposes, we can consider them to be restricted to 120 (and 220) cameras, taking 6 × 6 cm ($2\frac{1}{4}$ in square) pictures. A number of them, however, can also take 35 mm film, either directly or with an adapter. You get the usual number (12, 20, 24 or 36) 24 × 36 mm (1 × $1\frac{1}{2}$ in) pictures.

The 6 × 6 TLR is typified by the original Rolleiflex. The two lenses (for viewing and picture taking) are mounted on a single panel. You focus by moving a knob at the side. The main lens is mounted in a diaphragm shutter.

The square negative shape lets you choose whether you want to make horizontal or vertical prints. The lens has quite a wide angle of view, and the large negative size gives you considerable scope in enlarging.

Most other TLR's follow the same pattern. Special wide-angle and telephoto versions have been made; but otherwise you're limited to the standard lens. Though, you can fit converters or close-up lenses (see page 269).

One TLR, however, features interchangeable lenses. That is the Mamiya. You can take off the viewing and focusing lenses, and replace them with a wide-angle or long-focus pair. For each focal length you have to buy two connected lenses, one of which is fitted with a shutter and diaphragm. However, these lens pairs are very reasonably priced. If you want to use a relatively large-format camera, and your budget is limited, you can consider it seriously. In fact, this is one of the best cameras you can start with if you have a penchant for the technical side of photography. The negative size gives you plenty of scope for getting first class prints as soon as possible. It's not as portable as 35 mm cameras, of course, but that's not always a disadvantage.

Alternatively, the other TLRs give you high quality results, if you just want to stick to one lens. However, most of them are considerably more expensive than 35 mm compacts. They are also much larger and heavier, and some people find them hard to view and focus.

Chinese and East European TLRs are almost staggeringly cheap to buy. The Chinese cameras, with quite reasonable lenses and shutters, cost about the same as a five-symbol pocket camera. The Russian Lubitel camera can be bought for half this. However, it is not a true TLR. It has a brilliant viewfinder (with lens instead of focusing screen). There is a little ground glass focusing spot in the centre of the viewing lens. Apart from this, it works like any other TLR.

Eye-level viewing

There are two ways of using a TLR for eye-level viewing: a frame finder may be built in to the hood, or you can fit an accessory reflecting finder. The frame finder works just like any other frame finder. In some cases, though, you can look through a second eyepiece to see part of the focusing screen reflected in a mirror. This lets you check the focus, but you see the image upside-down.

If you can remove the focusing hood and replace it, you can fit an eye-level viewfinder to suit your particular camera. These may use mirrors instead of the prism commonly found on SLRs, but the effect is much the same.

The single-lens reflex

The TLR solves a number of problems, but contributes some of its own: the viewing lens is not normally fitted with a diaphragm. So you can't see how much of your subject is sharp at your chosen aperture; the size of the two lenses tends to increase parallax problems; any close-up, or special accessories, have to be fitted to both lenses – adding cost and complication – if you're to see their effect, and interchanging lenses is complicated. You need to change both, and, because the shutter is in the lens, you have to have a secondary shutter in the camera body. This seals off the film while you're changing lenses.

The viewing problems are solved with the single-lens reflex (SLR) design; and the lens changing complication by fitting a focal plane

shutter. We'll discuss that a bit more under the various sizes of SLR. The SLR is rather like the two halves of the TLR combined. The same (single) lens forms the image on the viewing screen and on the film. The reflex mirror (which reflects the image on to the focusing screen) hinges up out of the way for taking pictures.

So your viewfinder image is formed by the lens that will take your picture. You see exactly what you'll get in the picture, whatever lens you fit, and through any close-up or other accessory you care to mount. There is no parallax problem, and you see the actual focus of your picture. As you stop down the lens, you see how the amount of the subject that's sharp increases. But, the image gets darker at the same time.

Viewing with the SLR

Until World War II, SLRs were viewed at waist (or chest) level, just like you view a TLR. They had to have very deep focusing hoods, because the screen got dimmer as the lens was stopped down. This was reasonable for larger formats, but made 120 and (even more) 35 mm, cameras a nuisance. It was difficult to focus the image on tiny viewing screens, and like the TLR, turning the camera on its side presented signal difficulties. In fact, rangefinder cameras were so much easier to use, the SLR really didn't get a look in in the smaller formats. The enthusiast who wanted reflex viewing for his specialized work could always fit a reflex housing to his rangefinder camera anyway.

However, the big breakthrough came from East Germany. Shortly after World War II, the *pentaprism* appeared. First as an accessory for the Exakta, then built in to the Contax S and D.

The pentaprism (so named because it has five operational faces) is a solid glass prism. It turns the screen image right-way round and upright at eye-level. There is hardly an SLR on the market that cannot be fitted with a pentaprism. In fact, almost all 35 mm SLRs have them fitted permanently.

So with a pentaprism fitted, you view and focus at eye level, just as you do with a separate optical viewfinder. SLR viewfinders usually give you a much bigger image, and the designers try to give spectacle wearers a chance to see at least most of the scene.

Pentaprisms are great for most normal work, and useful with really long lenses which are difficult to aim at waist level. However, as a

spectacle wearer, I find it much easier to compose pictures on a waist (chest) level screen, even on a 35 mm SLR. So I would never settle for a camera with a fixed prism.

Focusing aids

Like those on TLRs, SLR viewing screens are ground glass, with a fresnel condenser backing. This is good for focusing, but not good enough for many people. So most screens have a built-in rangefinder device. Basically, these come in two forms – split-image and micro-prism. They work on the same principle: that prisms refract (bend) out of focus rays. The focusing aid is normally moulded in a small circle in the middle of the screen.

Split-image prisms – as their name implies, break up the image. In fact they divide it along a fixed line, displacing one half relative to the other. When the image is in focus, the two halves line up exactly. This great where you've got a straight line to displace. Unfortunately, when there are no straight lines – if you are photographing a bush or a fur coat, for example – it is difficult to see the displacement.

Microprisms make the whole area appear to shimmer when it is out of focus. The whole thing then appears sharp and steady when you focus. This works well on texture subjects, and also on hard-line subjects. In fact, one highly expensive camera has 'micro-microprisms' all over its screen (instead of the usual random 'ground' effect) to give more precise focusing. However, not everyone finds focusing with a microprism spot particularly easy. I don't like them because I find them irritating when I don't want the centre of the frame sharply focused. They shimmer away, distracting me from picture-taking.

Because there are folk who like microprisms, and folk who like split-image prisms, most camera manufacturers now give you both. They surround a split-image centre with a microprism collar. That's fine if you want to choose between one or the other at will – not so good if you find one or the other irritates you. Anyway, you must make up your own mind. The choice of focusing aid is purely one of personal preference. Try them all out before you commit yourself.

There's not that much to choose between different camera brands. So there's no point in putting up with a focusing aid you don't like just because its in the make of camera you fancy. Unless you're forced into it (by your collection of accessories, for example) choose another make that has the focusing aid you like. Of course, if you choose a camera with interchangeable screens, you've no problem.

Mechanical refinements

The SLR is in no way a new camera design. However, the modern SLR is a very refined version. When you press the shutter release on a focal-plane shutter SLR, the lens stops down to its pre-set aperture; the mirror flips out of the way; the shutter exposes the film; then the mirror drops back to the viewing position and the lens opens to its maximum aperture again.

On a diaphragm shutter camera, the number of steps is greater. As the lens stops down, the diaphragm shutter closes to exclude all light. Then a capping shutter (just in front of the film) moves out of the way as the mirror does. After that, the shutter opens and closes to open again for viewing after the mirror *and* capping shutter are back in place.

With a modern example, the only thing that stands out when using an SLR is that the viewfinder image focuses with the lens focus ring (and even that can happen on an eye-level TLR). Eye-level viewing, always at full aperture, is constantly bright, and the mirror flipping up and down is little more than a blink at high shutter speeds. We've discussed the pentaprism viewfinder, but what's it like without the other refinements?

Before the instant-return mirror, there were several types of mirror control. The most irritating flipped up as you pressed the button – and stayed there until you wound on. Your viewfinder image just blacked out. On other designs, you moved the mirror out of the way manually. On the simplest you had a separate lever; on others, physical pressure on the shutter release did it for you. That sounds handy, but, boy, did you need a strong finger.

Now, you have fully automatic diaphragm operation, you view at full aperture, and the lens stops down to the chosen aperture just for the exposure. Just before such lenses came out, you could get ones that stopped down by themselves, and stayed there till you had recocked them. With an instant-return mirror, the picture just went dark until then. Beware when shopping for very used equipment. A lot of these 'semi-automatic' lenses were labelled "automatic". Look for the tell-tale cocking lever if you're not sure.

Of course, many lenses didn't (and lots still don't) have any connection between their diaphragm and the camera. The aperture is just what's set on the aperture ring. That's exactly what happens on separate viewfinder and TLR lenses. It doesn't affect the viewing image. On an SLR, however, they're not so convenient. You have to have

the aperture ring at a suitable setting immediately before you release the shutter. If that's far below maximum aperture, you'll need the lens wide open for composing and focusing. So you end up twisting the ring back and forward between viewing and picture taking.

To make this operation much easier, most manual diaphragm SLR lenses have preset controls. When you've decided on your aperture, you set a stop there. This may be done with a second ring, or by pressing the normal aperture ring against a spring. However it works, once you've set the aperture stop the aperture ring is free to move between there and full aperture. So you view wide open, then turn the ring to the stop just before releasing the shutter.

Do you need the refinements?

Long ago people took superb photographs. So its obvious that the modern refinements are not essential. But they do make things easier. However, don't avoid superb used cameras just because they're short on a few convenience features. And that's not confined to the mechanical features we're talking of here. We'll come back to it again, later, when we discuss metering, lenses, and other areas where 'it's all happening'.

For a time, after experience with several other types, I used an SLR without an instant-return mirror. It seemed a bit strange at first, but I soon got used to it. It had a diaphragm shutter just behind the lens, so I was restricted to the manufacturer's own lenses, and a range of about 28 to 200 mm. However, few people want more than that. This sort of camera can be bought now for a fraction of the cost of a new 35 mm SLR, and the ten year old example I used took first class pictures.

Most enthusiasts have one or two manual diaphragm lenses. They're fine if you're used to them, but need a certain amount of application. I've taken innumerable over-exposed shots because I forgot to stop down as I concentrated on getting just the right composition, or the right instant. Still, you can get two or three preset telephotos for the price of one automatic lens. So don't rule them out. Manual lenses without a preset ring, however, are really too much of nuisance to make for comfortable photography.

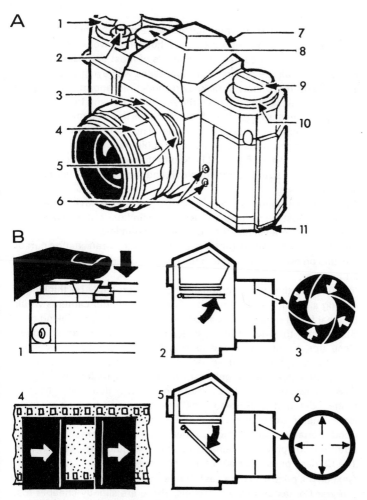

35 mm single-lens reflex. The most popular type of sophisticated camera. A. Features: 1, Frame counter. 2, Shutter release. 3, Aperture ring. 4, Focus ring. 5, Automatic diaphragm control. 6, Flash contacts. 7, Viewfinder eyepiece. 8, Shutter speed control. 9, Rewind knob. 10, Film reminder. 11, Back release. B. Operation: 1, Depress shutter button and 2, Mirror rises, 3, Diaphragm closes down: then 4, Shutter exposes film. 5, Mirror drops down and 6, Diaphragm opens.

35 mm SLR cameras

For the layman, the 35 mm SLR is *the* camera. Names like Nikon, Minolta, Canon, and Pentax are almost household words. It is also the number one type of camera in the minds of most enthusiasts. Why? Well, it's got all the mechanical advantages we've just enumerated; and for any reasonably well known model, an enormous range of accessories available both from the manufacturer and from independent firms. Lenses range from 6 mm fisheyes to 2000 mm and more. Close-up equipment extends to include all normal microscopy, yet for the price of a few films anyone can get equipment to let him take life-size close ups on a 35 mm SLR. Add to that the superb compromise between film size (picture quality) and portability. There's your answer.

To make lens-changing easy, most 35 mm SLRs have focal plane shutters. Most have fixed eye-level viewfinders, but a few let you change the eye-level finder for different viewfinders.

There are one or two current fixed-lens SLRs. You can change part of the lens on one model and fit a focal tele and wide-angle converters on another.

If you're starting to get enthusiastic, you'll probably be thinking of getting a 35 mm SLR. Although 35 mm rangefinder cameras would be ideal for all normal work, there are two reasons for thinking of an SLR. Firstly, they have the capability in reserve if you want to do real close ups, or fit specialized lenses (fisheyes, perspective control, monster telephotos and so on). Secondly, there just aren't any interchangeable-lens rangefinder cameras in the middle price range. SLR cameras come a bit more expensive than the cheapest rangefinder models, Russian and Chinese cameras working out at the lower end of the compact 35 mm price range – about the same as a good portable radio. The cheaper Russian cameras don't have automatic diaphragm mechanisms or a rangefinder spot of any kind. The Chinese ones have both these conveniences.

Next on the price list come East German cameras, developed from the pre-war Contax and Exakta models. These are slightly cheaper than moderately-priced Japanese cameras of equivalent specification. Either offers the sort of quality that most photographers need.

Virtually all, except the cheapest East German model, have built-in exposure metering. In fact, if you don't want a meter in your 35 mm SLR, you're stuck with the cheapest, or the most expensive. What you can have at a relatively low price only in Japanese SLR cameras is

automatic exposure – you set the shutter speed, the box does the rest. We'll tell you much more about it later (see p. 149), but it's well worth considering.

Most medium-priced SLRs come from the Far East, though you'll be able to buy some of them with German, American, British or Australian brand names. They all have built-in exposure meters, and many have automatic exposure (but all with manual override). All the famous Japanese makers have at least one medium-priced camera and most of the lesser known companies concentrate on this range. It's more or less the price range you expect for an automatic washing machine – about fifty per cent more than equivalent cameras in the moderate price bracket.

The chances are, you'll consider one or more of these medium-priced cameras. So what do you get for the extra money? You get better quality control, so you're less likely to get a poor camera. You get longer life; most of these cameras are designed to give trouble-free service to the professional. It's unlikely that anyone else will even loosen them up, let alone wear them out. You get slightly better optics, but any respectable camera is likely to be better than most people need. Finally, you get a fully up-to-date camera.

Although, as we said earlier, people took magnificent pictures on really old cameras, sometimes new developments are worth paying for. Current designs give you smaller, lighter lenses, with technical performance improvements. Shutters are becoming quieter and more versatile. Cameras are getting smaller and easier to handle.

One manufacturer has introduced a radically new combined split-image and microprism rangefinder. No doubt, you'll find a number of other tiny improvements. Such changes tend to appear a few years later in the more moderately priced makes. However, unless you want or need them, there's no point in paying for them. We'll tell you a little more about them later on in the book, so that you can make up your mind whether they're important for you.

Of course, you can pay an enormous amount for a more advanced 35 mm SLR, either from the famous Japanese manufacturers we've just mentioned, or from German and Swiss manufacturers. These cameras are made to the highest photographic standards. Intended to last the professional for a lifetime, they are excellent if you want to spend the money. Over and above this, they do let you use more accessories – special viewfinders, motor drives, add-on automatic exposure systems, radio controls, and so on. If you need to use any of these, or think you might, you'll have to have a top-price camera.

120 SLR cameras

This is perhaps the most varied group of cameras. The most expensive are the glamour boys of the photographic scene. They're roughly twice the price of the most expensive 35 mm SLRs. They use between-lens shutters for ease of flash photography, and can be coupled to an enormous range of special accessories. Even so, the spread of their lenses can't match 35 mm SLRs. At the other end of the scale come East European cameras. They have focal plane shutters, and cost about the same as medium-priced 35 mm SLRs. In between these come a whole range of Japanese cameras.

Basically, 120 SLRs come in two shapes. More or less cubic models, developed for waist-level viewing, and elongated cameras like enlarged 35 mm SLRs for eye-level work. However, you can get eye-level prisms for the boxy cameras, and waist-level hoods for the elongated jobs.

The boxy cameras mostly have one major advantage. You load the film in separate magazines. So you need only one camera body. You put a magazine of suitable film on one end, and a lens on the other. If you want a different film, or a different lens, you can change either. So you don't have to buy (or carry) a second body with this type of camera system.

The other shape should appeal to you if you're looking for a big format camera to supplement or replace your 35 mm SLR. They operate the same way. However, the range of accessories for this type of camera doesn't approach that for the most expensive cubic ones. Most 120 SLRs can take 220 film to give double the number of pictures and the more sophisticated ones can also use 70 mm wide perforated film. This allows even greater loads.

When 120 SLRs first appeared, they all took square pictures 6 × 6 cm ($2\frac{1}{4} \times 2\frac{1}{4}$) or oblong ones 6 × 9 ($2\frac{1}{4} \times 3\frac{1}{4}$ in). The 6 × 9 cameras were never widely popular. However, there are now two other formats in use as well – 6 × 7 ($2\frac{1}{4} \times 2\frac{1}{2}$) and 6 × 4.5 cm ($2\frac{1}{4} \times 1\frac{5}{8}$ in). The oblong formats have considerable advantage in film saving when you make oblong pictures. The 6 × 7 size needs considerably less enlarging than a 6 × 6 negative to produce (say) a 10 × 8 print. A 6 × 4.5 cm negative needs only a little more than 6 × 6. The oblong formats do, however, mean that you have to choose between horizontal and vertical shape when you take the picture. They also make 'waist level' reflex viewing a particular problem for vertical format pictures, as we discussed under TLRs.

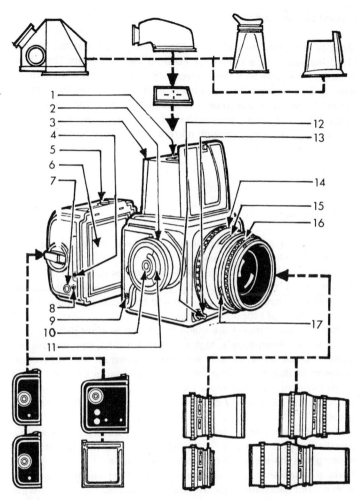

120 SLR. The most sophisticated hand cameras can have accessories custom-made for virtually any job. Viewfinders, lenses, and film magazines interchange for highly versatile normal photography. 1, Screen magnifier. 2, Film wind knob and exposure meter. 3, Viewfinder hood. 4, Film plane indicator. 5, Magazine latch. 6, Magazine sheath. 7, Film counter. 8, 9, Film transport symbols. 10, Film speed setting. 11, Exposure meter scale. 12, Cable release socket. 13, Shutter release. 14, Focus ring. 15, Depth of field indicator. 16, Shutter speed ring. 17, Aperture setting lever.

Instant picture film

Most of the cameras with interchangeable film magazines can be fitted instead with a holder for Polaroid instant picture film. Also, Polaroid make one SLR themselves – the SX-70. This is an unusual folding SLR design. As the print is made directly on the camera material, the image has to be reversed by reflection from a mirror on to the film. So the film goes at the bottom of the camera. The viewfinder image is formed through mirrors. The camera has a fixed lens and automatic exposure.

Special cameras

If you have a special photographic problem, there's probably a camera specially made to tackle it.

Panoramic cameras make ultra-wide pictures by rotating the lens so that it scans the film, recording the image sequentially. These cameras are used both for scenery and for those enormously long group portraits of schools and clubs.

Multiple image cameras are made to take up to eight pictures on a single frame. Alternatively, high speed motor drive cameras are virtually a cross between still and movie cameras. The difference, however, is that the shutter mechanism retains its separate speed control system, which a movie shutter doesn't have – it rotates continuously, the exposure being governed mainly by the film transport speed.

Underwater cameras are designed to be totally waterproof (down to a specified depth). You can fit almost any camera into a watertight housing, but there are one or two specially made.

There are snap-shot type cameras – ideal for most situations, where a diver cannot take time to operate sophisticated controls. Also, there is one interchangeable lens camera – the Nikonos, or Calypso-Nikkor. This is a 35 mm camera with a rigid metal body. Assembled correctly, it can be used to considerable depth without modification. It has a small range of lenses, some of which are suitable for photography in air. In fact, it is an ideal camera for use in rugged conditions; almost indestructable, and of course, impervious to sand, mud or water. However, it is expensive for the facilities it gives if you compare it to a conventional 35 mm camera.

Load up with a fast film when you want to take pictures indoors without using flash.
400 ASA films are widely available and even faster films are now on sale. These
make photography possible in poor light, indoors and out.

The same subject at two different exposures, one for the highlights and one for the shadows. In contrasty scenes like this 'correct' exposure depends on the effect you prefer, not on what your light meter says.

Direct light from behind the subject creates wonderful highlights in hair and flimsy materials, but the exposure must be carefully judged.

Top during a long exposure – about 1 second in this instance – moving lights become fantastic coloured streaks.

Above lightning photographed on daylight film: the shutter has to be left open until a flash has occurred.

Unlike the catherine wheel on the opposite page these fireworks were taken with the camera hand-held, at a shutter speed of 1/30 second. Always be prepared to 'have a go' at subjects such as this – you may be pleasantly surprised when you see the results.

Top Kodak Ektachrome infra-red film, available in 35mm cassettes only, produces pictures with curiously distorted colours.

Above shoot against the light to get silhouette effects – and it helps if your subject is dark to start with.

Candles emit a dim light that is redder in colour than it may look to the unpractised eye. Even with fast daylight film the photographer had to use a wide lens aperture – if you scrutinize the picture you will see how carefully he had to focus.

Top a long, long, long focus lens is needed to bring the moon this close! In fact it was a 600mm telephoto with a 2× converter.

Above if daylight is available resist any temptation to use flash in situations like this. Objects such as bottles and metal surfaces throw back reflections that can be very difficult to control.

Films
and
Exposures

The sort of film you use decides the pictures you get. Basically, you can choose negative films or reversal films. As the name implies you get negatives from the former. Those parts of the film that received the most light come out darkest, and vice versa. Negatives are only intermediaries. To see a normal reproduction of the scene, you have to have prints made (or make them yourself) from them. Reversal films are processed to make transparencies. They are called 'reversal' because during processing, the natural negative effect is reversed. So reversal films produce positive images (that match the tones of the original scene).

Film characteristics

You *can* process reversal films as negatives, or negative films as transparencies. However, films intended for one purpose or the other are specifically designed for that purpose.

Negative films have lower contrast than reversal films. This lets you get more highlight and shadow detail on the negative – although you may not get the detail on the print. It also lets you be less precise with your exposure, but more of that shortly. The lower contrast means that reversal-processed negative film tends to produce rather weak-looking transparencies. Especially, they can be disappointing when projected. To overcome inherent deficiencies in the colour dyes and make printing easier, most colour negative films have a built-in brown or orange mask. If you reversal process masked colour negative film you're going to get funny brown-orange transparencies.

Reversal films generally give you punchy, high-contrast transparencies. In fact, on sunny days, you might be happier with slightly less contrast. You can process such films to high contrast negatives, but they may be a problem to print. The lack of masking means that prints from negative-processed colour reversal film can never match those from correctly exposed genuine colour negative film.

Film speeds

Before we discuss the various types in detail, we'll have a look at a universal property of all films. Whatever your film is designed to produce, it needs to be exposed to a particular amount of light. The 'exposure' is determined by the brightness of the image formed by your lens, and the length of time (shutter speed) you let the image

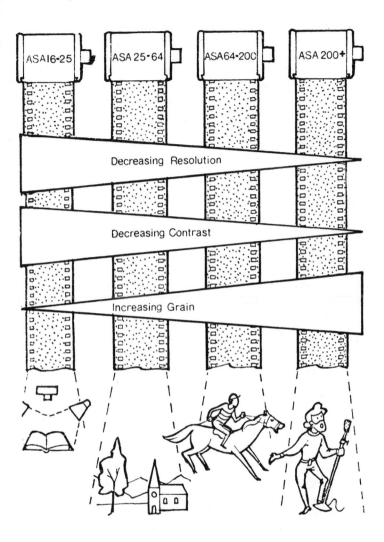

Film speed determines the exposure necessary. It also dictates the film's characteristics. Slow films (below ASA 25) produce the sharpest and most detailed images. Moderately fast films (ASA 64–200) are fine for most work, and higher speed ones necessary in low light. Because they give greater colour saturation, slower films (ASA 25–64) are popular for colour slides.

reach the film. We'll go into detail about that shortly.

The exposure needed differs from one type of film to another. So each is labelled with a number to represent the exposure it needs. This figure is usually either on the ASA scale or on the DIN scale. It is called the film speed. Scientific film speeds are based on sensitometric testing, but the figure you read off the film box is what the manufacturers call the 'recommended meter setting'. This means that if you follow the exposures needed for a film of a particular speed, you'll get the results the film manufacturer intended. This rather tortuous approach avoids any arguments about the correct sensitometric basis for measuring film speeds.

The ASA scale works on a simple arithmetic system. If one film needs exactly half the exposure of another, it has an ASA index exactly twice that of the other. For example, a 200 ASA film needs *half* the exposure needed by a 100 ASA film, and *twice* that needed by a 400 ASA film.

DIN speeds are enumerated on a logarithmic scale. If one film needs exactly half the exposure of another, it has a DIN speed three higher. So a 200 ASA film is rated at 24 DIN; 100 at 21 DIN, and 400 at 27 DIN. Each ASA speed has a DIN equivalent.

ASA AND DIN FILM SPEEDS

ASA	DIN	ASA	DIN	ASA	DIN	ASA	DIN
6	9	25	15	100	21	400	27
8	10	32	16	125	22	500	28
10	11	40	17	160	23	640	29
12	12	50	18	200	24	800	30
16	13	64	19	250	25	1000	31
20	14	80	20	320	26	1250	32

The speed of a film depends on the way it is made, and the way it is processed. So, if you want to be able to trust the meter setting on the film box, follow the manufacturers' recommended processing – or go to a processor who does that. If you're more adventurous, you can experiment with different processing techniques to alter your film speeds as you want – as long as its possible.

Emulsion characteristics

All conventional photographic materials depend on the action of light on silver halide grains in the emulsion. The visible unevenness

(graininess – see p. 58) produced by clumping of the exposed grains tends to increase with film speed, i.e. the faster the film (or the faster the speed you process it for) the more the grain.

Also, in general, the faster the film, the lower its contrast. However, this doesn't apply between film types; and, what's more, the manufacturers now have enormous control over the contrast of their materials. So, the trend may even be reversed in colour materials.

Colour negative films

Today, most colour negative films need about the same amount of exposure. They are rated at 80 or 100 ASA (20 or 21 DIN). This is just right for taking pictures on sunny days with a non-adjustable pocket camera. Its not so good for taking pictures in low lighting, whatever your camera.

Even with this comparatively moderate speed, colour negative films are quite grainy. The blobs are easily visible (though not obtrusive) on an enprint made from a 110 negative. From 35 mm negatives you can make prints up to about 10 × 12 in before you find the grain irritating. With modern films, you can produce grain-free enlargements virtually any size from 120 negatives (and of course cut films).

The main difference between the various manufacturers' films come in colour relationships, brightness and contrast. You should find one that produces prints *you* like, and stick to it. However, there is one point. Films intended for professional photographers are made to reproduce skin tones as accurately as possible. Amateur type films are made to reproduce general scenes as well and as brightly as possible. I stick to the professional type films because I use colour negative mostly for people pictures, and because I prefer its slightly lower contrast.

Faster (400 ASA–27 DIN) films are available. They increase your low-light photography potential, but are more grainy.

Exposure is not too critical for colour negatives, partly because of their relatively low contrast, and partly because negatives are only intermediaries. You can compensate for dark or light negatives when processing. If you must err, though, err on the side of over exposure. Under-exposed colour negatives tend to produce rather muddy prints. You'll get reasonable pictures from about $1\frac{1}{2}$ stops under exposed to about $2\frac{1}{2}$ stops over exposed.

Black-and-white negative films

There are far more black-and-white negative films than those in all the other categories put together. That's because you can choose from an enormous range of film speeds.

Ultra-slow films (2–10 ASA, 4–8 DIN) are intended for microfilming. You can use them for ordinary photography if you want virtually grain-free enlargements of enormous size. However, they are often very high contrast, and so slow that they can cause exposure problems. An exposure of 1/60 second at *f*4 on a really bright day doesn't give you much to play with.

Slow films (12–50 ASA, 12–18 DIN) are the ones you really want if you're going to produce giant enlargements from normal pictures. You can't get this sort of film for a 110 pocket camera, but you can for several other 16 mm cameras. So, if you *must* have a pocketable camera and want reasonably big prints – over 5 × 7 in – you'll have to look for one of them.

By the time you get up to 35 mm, you can expect to make 16 × 20 in prints if your slow films are properly processed. Of course, you can produce much larger ones for looking at from far away. Slow films are available for 120 cameras, but aren't really likely to be needed by ordinary photographers. Medium-speed films now have such fine grain that you're not likely to notice the difference from a big negative.

Medium speed films (64–200 ASA, 19–24 DIN) take in most of the famous names. Any one from a well-known manufacturer gives you an almost ideal combination of fine grain and acceptable speed for most conditions. Unless you have something special in mind, select your black-and-white material from this range (for a 110 camera, you have no choice at the moment). The 110 cameras are good for 5 × 7 in enlargements or a bit bigger; 35 mm for 10 × 12, and 120 for 16 × 20 or more, if the films are processed properly. Of course, you can go much larger if you don't mind a bit of grain.

Fast films (250–600 ASA, 25–29 DIN) are ideal for low-light situations – you can use higher shutter speeds or smaller apertures than with slower films. However, many photographers use nothing else for almost all their black-and-white work. With careful processing, you can expect respectable 10 × 8 in prints from 35 mm and 15 × 12 prints from 120. Anything larger, and the grain tends to become obtrusive. However, it has been fashionable to produce pictures with an obvious sharply-focused grain, so this need not stop you.

118

Ultra-fast films (800–4000 ASA, 30–37 DIN) are just that. They sacrifice virtually all image quality to getting a picture come what may. However large your negative, you can't expect to get grain-free prints from such films; but if you want to take pictures out of doors by street lighting, or in a night-club, you haven't much choice. Of course, you may make a feature of the grain.

These categories are arbitrary. You can move any film from one to the next above or below by modifying the processing should you wish. You then get more or less the characteristics of the new category.

Exposure isn't that critical with black-and-white negatives. However, the recommended meter setting tends to give you the *minimum* necessary exposure. You can get prints from negatives up to about two stops under exposed and four stops over exposed.

Colour reversal films

For many years, 'colour' meant slides. Now, like black-and-white photography, they're confined to enthusiastic photographers. Reversal films are the only ones in which processing types affect you. There are two ways they can be made: the colour formers may be included in the film or they may be added during processing.

Substantive films, with integral colour formers lend themselves to home processing. Basically, you first process (to a b and w negative) the latent image produced in the camera. You then expose *all* the unexposed silver halides (this is done chemically in some processes). You develop that in a colour developer, which produces suitable colours wherever the second exposure had effect. Bleach out the silver, and you've got a picture in the tones and colours of your original scene. A signal advantage of this type of film is that by modifying the processing you can alter its speed (and colour), provided you can mix chemicals reasonably accurately.

Non-substantive films are much more complicated. They need three different-coloured, accurately-timed reversal exposures, coupled to three separate colour developments. This type of film, typified by Kodachrome, can be processed only in the most sophisticated laboratories. In fact, in most countries, it is processed only by its manufacturer. This type of processing, however, does appear to produce a sharper image with less grain than seen in equivalent-speed substantive films.

Colour reversal films are available in three speed groups.

Slow films (12–40 ASA, 12–17 DIN) produce the finest grain transparencies. You can project such transparencies on lecture-hall screens without the grain becoming obtrusive.

Medium speed films (50–100 ASA, 18–21 DIN) make life easier in dull conditions. The latest versions of these films match the image quality of the slow speed films of only a few years ago. You're unlikely to see the grain in normal domestic viewing. However, some people find that they don't like the contrast or colour saturation of these films as much.

Fast film (125–500 ASA, 22–28 DIN) let you make the most of dull lighting. Also, you need this sort of speed if you're going to photograph through really long focus lenses. Otherwise, your apertures will be too large, or your shutter speeds too long for sharp pictures. I use a 400 ASA (27 DIN) film for general photography, because I like its colour, and don't find the grain often obtrudes (even when it's processed to give me 800 ASA, 30 DIN).

Exposure is most critical with colour reversal films. First, they yield a high-contrast projection image, so a small change in exposure alters the density a lot. Secondly, and even more important, your camera film is processed to produce the final picture. So there is no way you can change the density (as you could when printing). If you've got a reasonably bright projector, err on the under-exposure side if anything. This produces stronger colours. For good transparencies, you want to be between one stop under-exposed and half a stop over-exposed.

Black-and-white reversal films

Much the smallest category. There are only one or two such films around. They are slow-to-medium in speed, and produce startlingly good black-and-white transparencies. They've not got much more exposure latitude than colour transparency materials.

Light sources

Just before we get down to the real business of exposure, a word about the colour of lighting. It doesn't make much difference with black and white films, but it does affect colour films. If you use amateur type colour negative films, the manufacturers tell you not to

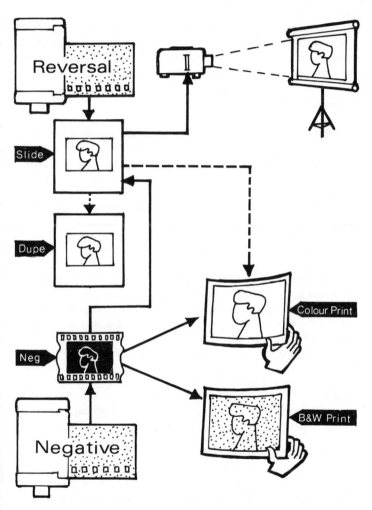

Colour films are commonly available to give either as reversal (slide) or negative emulsions. Choose the one that produces what you want. You can, though, make prints from slides or slides from negatives.

worry, but you may get better prints if you follow the recommendations.

Colour reversal films and professional colour negative films must be exposed to a suitably coloured light source. Basically, daylight, blue flash bulbs and electronic flash are bluish. Tungsten light (including photofloods) is yellowish. We are not going into details; but either you must use a suitably balanced film, or fit a colour correction filter to your lens. The film makers recommend filters, but if you want more details, look at the *Focalguide to Filters*.

Exposure controls

As we've said, a film of a particular speed needs a particular exposure. The light falling on your subject varies with the weather and the time of day. The simplest cameras work only in bright sun. On others you control the amount of the light that you let through to the film.

You control it in two ways; by restricting the time that the shutter is open, and by restricting the brightness.

You control the time by selecting a suitable shutter speed. Today's cameras have speeds on the scale: 1, 1/2, 1/4, 1/8, 1/15, 1/30, 1/60, 1/125, 1/250, 1/500, 1/1000, 1/2000 of a second.

Some cameras give you the choice of all of these and more, others just a few of them. However, the most important thing about the scale is that each successive step lets the light through for exactly half the time of the previous one. So here's a way of halving, doubling, or quartering etc. the light that reaches the film.

At a given brilliance, a film of one speed (e.g. 100 ASA,21 DIN) needs twice the exposure time of one double the speed (200 ASA,24 DIN). So if the first film needed 1/60 second, the other needs only 1/125 second.

You control the brilliance (intensity) of the light reaching the film by altering the size of the lens aperture. The light-passing ability is calibrated in *f*-numbers. Today's lenses are marked on the scale: 1, 1.4, 2.8, 4, 5.6, 8, 11, 16, 22, 32, 45.

Some lenses start near *f*1; others much further down the scale and must stop at *f*16 or *f*22. The starting point – or maximum aperture – is often an intermediate figure, such as *f*1.2, 3.5, 4.5, etc. Apart from these maxima, the most important thing about this scale is that each successive step represents a reduction to exactly half the light transmission of the previous stop. So here's another way of halving,

doubling, quartering etc. the light that reaches the film.

At a given shutter speed a film of a particular speed (e.g. 100 ASA, 21 DIN) needs one *f*-stop more brilliance than one double the speed (200 ASA, 24 DIN). So if the first film needed *f*8, the other needs *f*11.

Combining shutter speed and aperture

So, now you have all the factors together – film speed, shutter speed and lens aperture; and they all work on a doubling/halving scale. So they are easy to relate.

The film speed determines the exposure, as you'll soon see. However, once you've decided on the exposure, you can choose from a number of shutter speed and aperture combinations. Just remember that if you move one stop up one scale, you must move one stop down the other to compensate, and vice versa.

For example, suppose you decide 1/125 at *f*8 will give you the correct exposure. You get just the same exposure with any of 1/1000 at *f*2.8; 1/500 at *f*4, 1/250 at *f*5.6, 1/125 at *f*8, 1/60 at *f*11, 1/30 at *f*16 or 1/15 at *f*22. Of course, if your camera lets you, you can extend further in either direction.

Which combination you choose depends on pictorial considerations. We'll come to those in the next chapter.

Exposures

All you have to think of now is the light falling on your subject. In bright sun, you need an exposure of 'one over the ASA film speed at *f*16'. For example, a 125 ASA (22 DIN) film needs 1/125 second at *f*16. Keeping the shutter speed the same, if it's just a bit cloudy, you need *f*11; cloudy bright *f*8, cloudy dull *f*5.6, really dim *f*2.8. Only if its really bright *and* you're surrounded by light coloured reflectors (such as snow, light sand or whitewashed walls) do you ever need less than the bright sun *f*16 exposure.

Simple cameras are set to give about 1/60 second at *f*11 or so. For 64–125 ASA negative film, this is fine in bright sun, or in weak hazy sun. If it gets much duller, you'll get very dull pictures. It is also fine for 64 ASA transparency film in weak hazy sun, but not in bright sun or if it is cloudy.

The first improvement is to fit a two-speed shutter. This gives about

1/40–1/50 and 1/80–1/100 with the same lens. So you get about the right exposure in bright sun or weak hazy sun, and you can use negative or transparency film in either.

Next comes the five-symbol camera – the one I think suits the pocket format best. This has the same two speed shutter, but a lens of about *f*5.6 maximum aperture. The five weather symbols represent: really bright, 1/80 at *f*16; bright sun, 1/80 at *f*11; weak hazy sun, 1/80 at *f*8; cloudy bright, 1/80 at *f*5.6; and cloudy dull, 1/40 and *f*5.6.

Some models have an extra high shutter speed set automatically when you put in a 400 ASA film. This reduces the risk of taking shaky pictures.

More sophisticated manual exposure cameras have the conventional shutter speeds and lens aperture we've just described. Follow the rule above, or the instructions packed with the film, and you'll do as well as you would with weather symbols.

In fact, a number of cameras are calibrated to do that for you. You set a dial for the film speed, that sets the *shutter* speed. Then you just follow its weather symbols to set the aperture. There are other more complicated programmed shutters, but they all follow this sort of procedure. They're fine to start with, and no disadvantage if you know what *actual* speeds and apertures you are setting.

However, whatever system you set your weather information with, it's not always the best way to choose exposures. It's easy to tell when the sun is shining; it's not so easy, though, to decide between, say, cloudy bright and cloudy dull. When its really dull, there is no way you can estimate the light. There's always less than you imagine, so you just have to measure it. If you hope to achieve consistently good results, especially with reversal film, you ought to measure the light whenever you take pictures.

Exposure meters

You measure the light with an exposure meter. The first exposure meters were just holders for light-darkened paper. You held them in the light, and measured the time it took for a fresh piece of light-sensitive paper to darken until it matched a standard. From this, you calculated your exposure. Today, light meters use photoelectric effects.

Selenium meters – long favourites, use the generating effect of selenium. It produces electric current proportional to the light falling

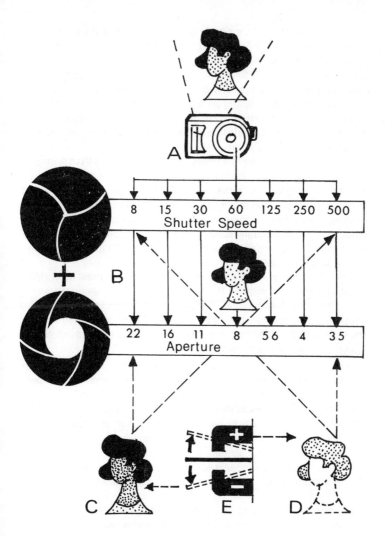

A. The exposure you need depends on the subject, lighting and film speed. B. You choose from a range of combinations. Each shutter speed having one suitable aperture. C. A faster speed or smaller aperture (without compensation) produces under-exposure. D. A slower speed or wider aperture produces over-exposure. E. Some interval meters show you the degree of over − (+) or under-exposure (−) in the viewfinder read-out.

on it. Measure this with a simple galvanometer, and you have an accurate measure of the light. With normal handling, a selenium meter never needs any attention.

Cadmium sulphide (CdS) meters – a more recent development, use the photo-conductive property of a CdS cell. Its resistance changes in proportion to the light falling on it. So, you measure the current from a small battery attenuated through the CdS cell – again with a galvanometer. The batteries must be changed when it loses power; or, preferably, at regular intervals.

CdS meters are sensitive to a wider range of light levels than selenium meters, letting you use them in lower light. However, they have two irritating features. They 'remember' bright light for some time. So, in very low light, you may have to wait several minutes to get a correct reading, and even in ordinary conditions they are quite slow to react. Also, they are not equally sensitive to all the visible spectrum. They react more strongly to the red end, so tending to give inflated readings in tungsten lighting.

Silicon and gallium arsenic, phosphorus meters – the most recently introduced, employ the generating effect of a silicon or gallium arsenic, phosphorus cell (photodiode). It produces a minute current accurately proportional to the light falling on it. Because the current is so small, it must be amplified before the measurement can be displayed. So for these, too, you need a battery.

Silicon meters are very sensitive to low light levels and have a suitable spectral response. They react very quickly, and have virtually no 'memory'. With these advantages, they are quickly replacing CdS cells in most new camera models with built-in meters.

Whatever means you use to measure the light, you must convert your light level reading to an exposure setting. Hand-held exposure meters incorporate a calculator for this purpose. You set the film speed (ASA or DIN as required) to line up the calculator. Then, the needle may indicate shutter speed/aperture combinations directly, or it may indicate a figure. Set this figure on the calculator to show the recommended exposures. As any one of a whole range of combinations gives the same exposure, your meter will recommend a range.

What to measure

You can measure either the light falling on your subject (incident light) or that reflected from it.

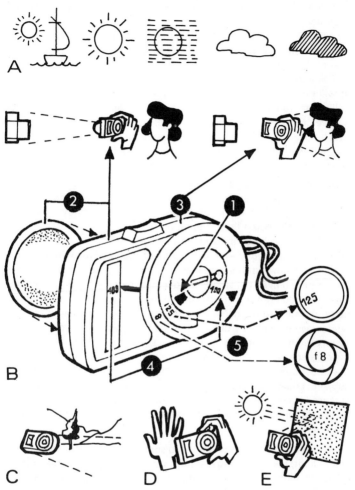

A. Typical weather symbols: for extra bright conditions with light sur-
roundings; bright sun; weak hazy sun; cloudy bright; and cloudy dull.
B. Greater sophistication, and higher proportion of success in un-
usual conditions comes with a light meter. 1, Set film speed. 2, Fit
diffuser for incident light readings, or 3, measure light reflected from
subject. 4, Read off scale or transfer reading to calculator. 5, Set
camera controls. C. Tilt meter down to avoid bright sky. D. Read off a
substitute for abnormal subjects. E. Grey card is most precise
substitute.

Incident light readings are really the best. You measure the light by pointing your meter toward your camera position from the subject position. For this you must have a meter fitted with a diffusing dome or cone. Set such a reading on your camera, and you can expect to get the most accurate representation of your subject's tones. The only consideration is to make quite sure that you're measuring the light as it will be when you release the shutter. If you measure the sunlight falling on your subject, you won't get any detail in your shadows. Conversely if your meter was shaded, any sunlit parts of the picture will be over-exposed. If you can't get to your subject, you can make a substitute reading from the camera position if the lighting is identical. Just point the meter *away* from the subject.

Reflected light readings are more often used. You point your meter at the subject and measure the light reflected from it. That's easy, but there's one point to think about: the meter doesn't know what your subject is. Reflected light meters are calibrated on the assumption that they are to measure from an average scene.

If you took a correctly exposed picture of such a scene with your lens so out-of-focus that the light was jumbled evenly across the film, you would get an even palish grey all over (in colour or black-and-white). The reflected light meter reading always give you a result that mixes up (integrates) to the same tone — whether you're measuring from a whitewashed wall, or a dirty coal cellar. So, if you want your pictures to represent the tones of your subject, you must measure from an average scene.

The most commonly encountered difficult scene is when your main subject is back-lit; or standing against a very light background. If the subject is only small, a general reading leads to its severe under-exposure. Fine if you want a silhouette; useless if you're trying for a portrait.

There are three possible solutions to such a problem: measure the incident light; take a reading just from your main subject; or take a substitute reading. To take a reading just from your subject, go up close enough so that nothing else affects your meter. (If it measures through your lens that's easy; otherwise, you'll have to make a few tests to see just what it does cover.) Alternatively you can use a spot meter, which we'll come to soon.

Substitute readings are made from suitably toned objects. The ideal one is an 18 per cent grey card made especially for the job. Most convenient, though, use the palm of your hand. If your palms are particularly dark, you may have to modify your reading a little, but its

easy to test that. Choose an ordinary scene with reasonably evenly distributed light and dark tones, light more or less behind you, and take a meter reading. Then take one from your hand with the light the same. If the readings are about the same, you can set the exposure read from your hand whenever you need a substitute. If they are different, just remember that you'll *always* need half a stop (or whatever the difference is) more or less than your hand reading.

High contrast subjects

The only problem then is — what happens to the shadows? If you follow the sunlit exposure reading, the shadow parts of your pictures on sunny days will just be dark — with no detail. The best compromise you can make is to measure from the darkest shaded part and brightest highlight area in which you need detail to come out. Calculate the necessary exposure for each, and use the average of the two.

That may be good, but may give you exactly what you don't want — a picture without detail in either shadow or highlight. It all depends on the difference in brightness, and the contrast range of your film. As a general guide, you are unlikely to get accurate representation of colours in both highlights and shadows if the brightness range exceeds about 16:1. That is, if there is more than four stops difference between your highlight and shadow readings. If you have a modern camera with a high contrast lens, this range is further reduced. (Flare within older lenses can effectively halve the contrast range without any other noticeable effect.)

Still, you can take an average of your readings and then bias your exposure towards the more important parts of the subject. Remember, though, that with colour reversal film, your exposure determines the overall density.

Spot meters

Spot meters are meters with lenses that reduce their measuring angle to a degree or so. They let you measure small areas of the subject without having to move too far. They are only useful if you want to make special highlight and shade readings. However you take such readings, you need considerable experience to understand them. You

can't just point your spot meter at 'the most important part of your subject' and expect to get perfect exposure. You'll only get even reasonable exposure if you choose a more or less neutral tone – say a palish face.

For most pictures, you'll get the exposure you want by taking a general reflected light reading. Do point your meter to avoid especially bright areas (such as the sky), though; they might otherwise influence the meter unduly.

When you have a reading, set your camera controls: of course both the shutter speed and lens aperture affect the picture.

Built-in meters

It's a nuisance to carry round a separate exposure meter. So most reasonably sophisticated cameras have a meter built in.

The simplest built-in meters are just that. A meter somewhere in the camera. You point it at your subject, operate the calculator controls (usually on the top plate) and set the reading on your lens and shutter controls. To make things easier, many of these meters have a single follow-pointer system. They have just two controls – often concentric discs. One disc is coupled to the follow pointer. You turn that until the pointer matches the meter needle. Then you set the other disc so that the ASA and DIN speed of your film is against the film speed index. Where the two discs overlap, you can read off all the recommended shutter speed and aperture combinations. You set any one of these on the camera.

Exposure values

Because there are so many combinations that give the same exposure, camera manufacturers used the exposure value scale for a time. Instead of a whole range of apertures and shutter speeds for each film speed and lighting levels, the meter simply gives you one figure – the exposure value. You set this figure on an exposure value scale on the camera and the shutter speed and aperture controls are then locked together. So, as you vary one, the other changes to keep the exposure the same. You could measure exposure values with some separate meters, but they were more common on built-in meters. This was quite a simple system, but was superseded by coupling the camera controls to the meter read-out.

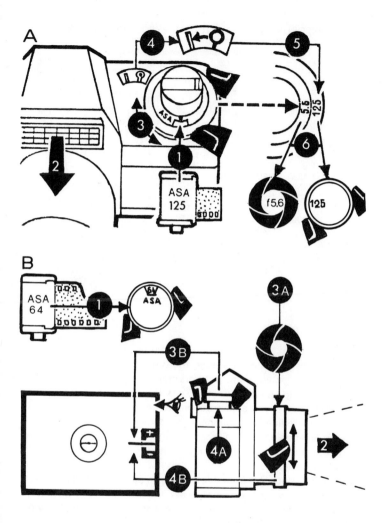

Built-in meters. A. A camera may just have a meter built in to make it simpler to carry. 1, Set film speed. 2, Point meter to subject. 3, Turn control dial to 4, align pointers. 5, Read off exposure. 6, Set on camera controls. B. Many meters are coupled directly to the camera controls — and in single-lens reflexes often read through the camera lens. 1, Set film speed. 2, Focus on subject. 3A, Select lens aperture and 3B, align needle with the shutter speed selection *or:* 4A, select shutter speed and 4B, align needle with aperture selection.

EXPOSURE EQUIVALENTS OF EXPOSURE VALUES

Exposure Value	Shutter Speed (Seconds) at Aperture							
	f1.4	f2	f2.8	f4	f5.6	f8	f11	f16
−1	4	8	$\frac{1}{4}$m	$\frac{1}{2}$m	1 m	2 m	4 m	8 m
0	2	4	8	$\frac{1}{2}$m	$\frac{1}{2}$m	1 m	2 m	4 m
1	1	2	4	8	$\frac{1}{4}$m	$\frac{1}{2}$m	1 m	2 m
2	1/2	1	2	4	8	$\frac{1}{4}$m	$\frac{1}{2}$m	1 m
3	1/4	1/2	1	2	4	8	$\frac{1}{4}$m	$\frac{1}{2}$m
4	1/8	1/4	1/2	1	2	4	8	$\frac{1}{4}$m
5	1/15	1/8	1/4	1/2	1	2	4	8
6	1/30	1/15	1/8	1/4	1/2	1	2	4
7	1/60	1/30	1/15	1/8	1/4	1/2	1	2
8	1/125	1/60	1/30	1/15	1/8	1/4	1/2	1
9	1/250	1/125	1/60	1/30	1/15	1/8	1/4	1/2
10	1/500	1/250	1/125	1/60	1/30	1/15	1/8	1/4
11	1/1000	1/500	1/250	1/125	1/60	1/30	1/15	1/8
12	1/2000	1/1000	1/500	1/250	1/125	1/60	1/30	1/15
13		1/2000	1/1000	1/500	1/250	1/125	1/60	1/30
14			1/2000	1/1000	1/500	1/250	1/125	1/60
15				1/2000	1/1000	1/500	1/250	1/125
16					1/2000	1/1000	1/500	1/250
17						1/2000	1/1000	1/500
18							1/2000	1/1000
19								1/2000

Coupled meters

When you've got an uncoupled built-in meter, you've got two sets of similar scales. One on the meter, the other actually on the camera controls. So, logically, manufacturers started coupling them together. Instead of using an independent disc or lever to align your pointer to the meter needle, you adjust the camera controls. Once the needle and pointer are lined up, your camera's set for the metered exposure (as long as you've set the film speed right). This is undoubtedly the most convenient way of following the meter reading on a manually controlled camera.

The main development from this stage is an automatic exposure control. Instead of telling you what to set, the built-in meter does it for you. Very convenient. It's such a complex subject, though, that we'll give it a chapter on its own.

Through-the-lens meters

With selenium cells, you need about a couple of square centimetres (half a square inch) of light-receiving material. CdS meters and the new silicon ones can be much smaller. On most rangefinder cameras,

the meter cell is mounted on the front of the camera. This is fine if you can't change the lens or use extension devices. But most SLRs do have these facilities, which can reduce the advantages of a built-in meter of that type.

The problem for a camera with interchangeable lenses is that the meter cell is designed to measure light over a particular angle (usually a little less than that of the standard lens). When you fit a very wide angle lens, it may ignore the most important parts of your subject. When you fit a very long focus lens, you may photograph something lit quite differently from the overall scene. So in either case, your meter may mislead you. As extension tubes or bellows make extra exposure necessary, you have to calculate the increase if you have an outside meter.

The solution to both these problems is to measure the light inside the camera. This you do with a through the lens meter. Introduced first by Topcon in 1964, these are available now on almost any 35 mm SLR produced in reasonably large numbers. Some makers, however, still give you the option of buying a camera without a meter. Meterless cameras with interchangeable viewing heads may have meter prisms added. Otherwise, you can't convert a meterless camera to through-the-lens metering. Through-the-lens metering prisms are available as viewfinder accessories for 120 SLRs; and at least one TLR (but that meters through the viewing lens).

There are three common meter cell positions: beside the viewfinder eyepiece or at the front of pentaprism, reading from the viewing screen; behind the viewing screen, reading through a beamsplitter; and behind the reflex mirror, reading through a semi-reflecting area. There is little to choose between them. However, those that read from the screen always give correct readings with polarising filters, while the other types don't necessarily. They do, though allow the manufacturer to provide interchangeable viewfinders without affecting the metering.

Two other systems have been introduced recently. One reads from the film plane immediately before exposure; and the other measures light reflected from the shutter before exposure or the film during exposure. Obviously, both these systems measure the light after the mirror has flipped out of the way. They are coupled to automatically timed shutters. Such meters use silicon because they must react instantly. As these meters don't work till you release the shutter, they are supplemented by more conventional cells to give an exposure read-out or to allow manual exposure control.

Wherever their cells are placed, through-the-lens meters measure the light from your subject through whatever lens or accessory you have mounted, thus virtually eliminating the need to compensate your readings for your accessories.

Spot or average?

One problem, though, is how much of the scene to meter. Some systems measure the overall light level; some just measure a small central spot; others are somewhere in between and one or two give you a choice. So, which is best?

Theoretically, 'spot' meters give you the most information. You can measure your exposure from just the area of your subject that you choose. As we've seen, however, you need to understand all the factors before you can expect to get good exposures every time with a spot meter. To get better than good exposures, you need experience as well.

Average meters, on the other hand, are unduly influenced by bright lights on the edge of your picture. So, you have to point your camera to make sure that you meter from a representative part of the scene. To reduce this problem, most manufacturers introduce a degree of 'weighting' to the meter. In fact, it is easier to produce a meter that gives slight prominence to the centre of the viewfinder field, than one that takes an entirely even view. However, centre-weighted meters are more biased than that. Usually about 60 per cent of the reading comes from about 10 per cent of the screen (in the middle). With this type of measurement, you must be sure that the centre of your picture is representative of the scene.

One point to note is that the weighting may vary with different lenses. This is a result of the construction of the meter, but it may be useful. Commonly, the effect is that the longer the focal length of the lens you fit, the more of the scene the meter reads. As this differs from model to model, you must get the information about your camera from the manufacturer or dealer.

There are other weighting systems. One manufacturer restricts the meter reading to the lower half of the horizontal picture – fine when you're taking horizontal shots, but possibly misleading when you turn the camera on end and meter from part of the sky. If you're not sure which metering system you want, choose a weighted average one – they all work well for most pictures. If you camera also gives you the

Through the lens meters vary in their sensitivity pattern. A. Some read from the entire screen area. B. Spot meters let you select a small part of the subject to read from. C. Meters may read just part of the scene, for example the bottom. D. Most read all over the scene, with extra attention to the centre. One which can measure light reflected from the shutter blind shows clearly the pattern of sensitivity.

choice of a spot setting, that's a bonus. But don't buy a camera confined to spot-metering unless you know that's what you want.

Full-aperture metering

When they were first introduced, internal meters measured the light through the stopped-down lens. So, you just had to set the film and shutter speeds, then adjust the lens diaphragm until the light falling on the meter cell matched the meter's requirements. This system produces accurate results from simple mechanics. It is still used on a number of cameras. The introduction of silicon meter cells has allowed it to be used on automatic SLRs. More of that later.

However, semi-coupled meters, like that on the now-discontinued Exakta cameras, let you meter at full aperture. Because you transferred the lens aperture reading manually to the lens, you could just alter an aperture ring on the meter controls, without moving the lens diaphragm. As long as the meter was 'programmed' with the lens' full aperture, you did not have to suffer screen darkening while metering.

Soon, though, systems of fully coupled full aperture metering were introduced. The lens' automatic diaphragm preset ring was coupled to the camera meter. You just operated the ring to centre the meter needle without actually stopping down the lens. However, you still had to set the camera to the lens' maximum aperture whenever you changed it. The Minolta SR-T meter in 1966 simplified that. It just counted the number of stops below full aperture that you set. Simple and effective with any lens that had the coupling prong.

Today, virtually every SLR maker can offer you full-aperture metering. The coupling systems vary from make to make. One uses electric connections to supply the diaphragm setting and maximum aperture information. Most of the others rely on automatic mechanical links to connect the lens to the meter. These indicate the maximum aperture, and the aperture ring setting.

There are still a few models that require you to set the maximum aperture manually. In fact, on the most famous 35 mm SLR of all, you have to turn the lens diaphragm ring back and forward to set the meter after you mount a lens. These systems are not quite so convenient if you change lenses often. I've spoiled several pictures by forgetting to reset the aperture on changing lenses. However, if you're fairly methodical, don't rule out cameras just because you have to set the maximum aperture.

So, do you need full aperture metering anyway? It's a convenience; I like it, but it's nowhere near universally regarded as a blessing. Stop-down metering is just as accurate (some say more so). It's not often that the screen darkening is much of a nuisance and — most important if you're economy minded — the couplings are less complicated. When we get to lens changing, we'll see that the popular 42 mm diameter screw thread mount (Praktica mount) has great economic advantages. However, a full aperture metering system demands special connections. There are at least four different couplings for 42 mm screw-mount cameras. To retain full aperture metering (or in some cases metering at all) you must have exactly the right coupling. The interchangeability aspect doesn't apply with bayonet mount lenses; each make is virtually unique. However, full aperture metering lenses may be an extra expense.

Of course, you can usually meter stop-down with uncoupled lenses. However, there's not much point in having a full aperture system that works only with your standard lens, because you use economy lenses for the rest of your work. I feel that if you decide on a 42 mm screw camera because of the plethora of independent lenses available, you shouldn't bother with full aperture metering. However, if you buy a bayonet mount camera, you're much more likely to be restricted to full aperture metering lenses anyway, so get a full-aperture model. In fact, in 35 mm SLRs, stop down metering is becoming limited to screw mount cameras.

Viewfinder displays

One feature of through-the-lens meters, shared by many other built-in meters, is that their information is displayed in the viewfinder. This means that you can compose, focus and meter without moving your camera from your eye. However, it does lead to rather excessive exposure adjustment. With hand held meters, it's normal to measure the light level, set your exposure, and put your meter away. You only get it out again if the light changes, or if you move to a radically new shooting angle. This normally produces excellent results. With a viewfinder display, you're tempted to centre the needle every time which is seldom necessary and can distract you from the real business of picture taking — composing your picture and managing your subjects if they are living.

While on the subject of displays, there are two distinct meter display

systems — centre needle and follow pointer. With the centre needle system, you set the needle to a static mark — usually with one stop over and under-exposure marks either side. With the follow-pointer system, the meter needle follows its own course irrespective of what you do with the controls. These all operate on a follower. You manipulate speed and aperture until the pointer matches the needle. The introduction of LED displays — first associated with automatic-exposure control has produced more informative viewfinder displays. Instead of just showing you when the exposure is right, the display tells you what shutter-speed or aperture you should set.

Creative
Control

We've seen that you have to set the correct combination of shutter speed and aperture to get properly exposed pictures. Now we come to the question of how to choose the combination. This is the second most important influence on your picture. The first, of course, is the picture you see through the viewfinder the instant you press the button.

Movement

Go out on a dark cloudless night; point your camera toward the sky; open the shutter, and leave it there for half-an-hour or more. When you develop the film, you'll see stars. Not as little points, but as lines. If you left the camera there for long enough, you'll see the lines are curving. You have demonstrated that the world goes round!

You have also found out what happens when your subject 'moves' while you're taking a picture. It gets spread out into a line or blur. The extent of spreading depends *only* on how far the image moves on the film while the shutter stays open. In your star picture, in fact the stars didn't move; the camera did — with the Earth. It doesn't matter whether it's the camera or the subject that moves, the effect is the same.

Most often, you won't want your pictures blurred through movement. Despite that, movement blur spoils more pictures than anything else. It's impossible to hold a camera dead still, and most subjects move as well. So, for sharp pictures, you are restricted to fairly short exposures — i.e. fairly fast shutter speeds. We'll go into exactly which speeds in the next few pages.

There's one point to bear in mind: when you change your lens, you change your image size – and thus the relative effect of any camera or subject movement. Basically, for sharp pictures, the longer the focal length (for a particular film size), the faster the shutter speed you need. There's a bit more information on that in the chapter on interchangeable lenses. The figures in this chapter are for your standard lens.

Shutter speeds

The first consideration in choosing a shutter speed is to avoid camera shake. You must have seen badly shaken pictures, taken by inexperienced photographers. Double, blurry images of the whole

scene. However, camera shake on a lesser scale affects everybody's pictures sometimes. It manifests itself just as a thickening of fine lines, and a softening of edges. Not noticeable until you want a really big enlargement. Then, disappointment.

The popularly quoted minimum shutter speed is 1/30 second. If you hold the camera really steadily, in a comfortable relaxed position, you can get quite acceptable pictures at 1/30. If you lean on a firm support, you are less likely to get visible blur. Whenever possible, though, select a higher speed. Remember, even the simplest pocket camera gives you about 1/60 second, and they are notorious for producing shaken pictures.

Outdoors, I always try to set 1/125 second or shorter, even with a standard lens. If its windy, especially, you need higher speeds. In a gale, you may even get some blur at 1/500 second. Often, though, you find you just can't manage such speeds because the light and lens aperture prevent you. If so, try to take several pictures, in the hope that at least some come out sharp. Always have a go; if it comes out, you're in luck; if it doesn't, you're no worse off than if you hadn't tried.

Subject movement is more predictable. The faster it moves, the higher the speed you need. Assuming you are going to give the same degree of enlargement to your picture, the nearer a subject moving at a particular speed, the faster the shutter speed you need to picture it sharp. (If you blow it up to be the same size, its distance makes absolutely no difference to the shutter speed you need.) Take care with

SUGGESTED SHUTTER SPEEDS TO 'FREEZE' SUBJECTS MOVING ACROSS THE LINE OF A STATIONARY CAMERA FITTED WITH A STANDARD LENS

Distance		Shutter speed for subjects moving at a speed of:						
m	ft	4 2.5	8 5	15 10	30 20	60 40	250 150	1000 kph 600 mph
0.5	1.5	1/2000						
1	3	1/1000	1/2000					
2	6	1/500	1/1000	1/2000				
4	12	1/250	1/500	1/1000	1/2000			
8	25	1/125	1/250	1/500	1/1000	1/2000		
15	50	1/60	1/125	1/250	1/500	1/1000		
30	100	1/30	1/60	1/125	1/250	1/500	1/2000	
60	200	1/15	1/30	1/60	1/125	1/250	1/1000	
125	400	1/8	1/15	1/30	1/60	1/125	1/500	1/2000
250	750	1/4	1/8	1/15	1/30	1/60	1/250	1/1000
500	1500	1/2	1/4	1/8	1/15	1/30	1/125	1/500
1 km	1/2 mi	1	1/2	1/4	1/8	1/15	1/60	1/250
2 km	1 mi	2	1	1/2	1/4	1/8	1/30	1/125

subject speed. For example, a horse moving forward at 20 mph may have legs moving at 50 mph or more. Choose the 20 mph shutter speed and your horse will be sharp – with blurred legs.

If the subject is moving toward you, you don't need so short a shutter speed. In fact, you can use more than double the exposure time – say 1/125 instead of 1/250 or possibly 1/500. For diagonal movement, you can double the time. Remember, these are only guides. Always set the fastest speed you can with a moving subject. You never know, you might decide to enlarge it much more than usual.

All this assumes you want a sharp picture. You don't always. If you want a pin sharp picture of a racing car, go into the paddock, it's easier that way. If you're taking pictures on the track, you want them to look as if the cars are moving. So, choose a shutter speed that will give just a little blur or a considerably lower speed and pan.

Panning

It's the movement of the subject *relative* to the camera that makes the blur. If you swing your camera with a moving subject, it stays in the same relative position. Swing so that a racing car stays in the same position in your viewfinder before, during and just after you release the shutter. Even at 1/60 second on a simple camera you can get a sharp picture – of the car. It takes a lot of practice, and if you can choose your shutter speed, try 1/125 or 1/250 second for moving cars. Keep practising the swing, without releasing your shutter, or without a film in your camera. After a time, you'll find that you get sharp pictures most times.

The background, however, will be all blurred. At the right speed you can smear hoards of spectators and advertising banners into an unidentifiable blur. Not only does this remove an otherwise impossible background, it provides a strong indication of speed. Think of ski-jumping pictures. Have you ever seen one without the diagonal blur behind the jumper? Would it be in any way impressive if someone took one?

Depth of field

In theory, when a lens is focused on a particular distance, all objects at that distance are rendered perfectly sharp within the capability of

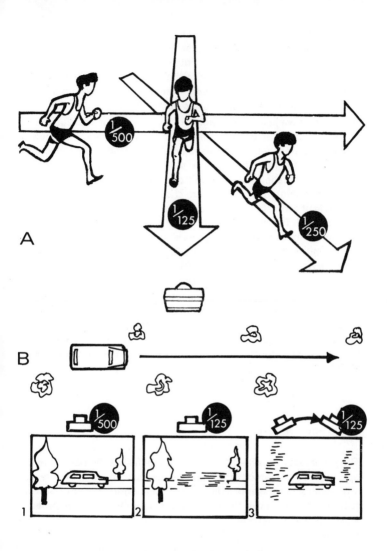

At long (slow) shutter speeds, moving subjects come out blurred. The faster they move, the faster speed you need to 'freeze' the movement. A. The speed depends on the direction of the movement in relation to the camera. B. If you swing the camera with the subject, then it comes out sharp, and the shutter speed determines just how blurred the background is.

the lens. (In fact, the image is formed of minute discs, so small that our eyes assume them to be points). Nothing else is even as sharp as that. Instead of our theoretical points, the rest of the image is formed of tiny discs even in theory. The further the subject lies in front of or behind the plane of focus, the larger the discs. However, up to a certain size, we still see these discs as points.

The size that we just see as a point, rather than a blur, is called the circle of confusion. It varies with viewing distance, so is difficult to define accurately. As, too, we usually talk of the circle of confusion on the film, its effect also depends on the degree of enlargement, or size of projected image. So, we won't put a figure on it here, we'll just accept that camera manufacturers choose a sensible figure.

The circle of confusion is important because it leads to quantifying the depth of field. That is the amount of the subject in front of and behind the point of focus that we accept as sharp in the picture. For example with a normal 50 mm lens set to f8, and focused on 4 m (14 ft) everything from just over 3 m (10 ft) to just under 10 m (30 ft) comes out sharp in a normal-sized enlargement.

We have to note the focused distance, because it is a very important factor in determining depth of field. In fact, the further away you focus, the greater your depth of field (all other things being equal).

Conversely, in close-ups, you have very little depth. That is why focusing is so important in close-ups – why reflex focusing is so useful.

Focus and aperture

The other fact that influences your depth of field is the size of the lens aperture. It's not directly the f-number because for each focal length, any f-number represents a different sized aperture. For any particular focal length, however, depth of field is determined by f-number (at any particular focus distance). Simply, the larger your aperture (smaller f-number), the less your depth of field. For example, a 50 mm lens focused on 3 m (10 ft) produces a sharp picture of everything from about 2 m (6 ft) to about 8 m (25 ft) at f16. At f2, however, the range is restricted to about 10 cm (4 in) or so either side of the 3 m mark. In fact, the depth of field is always more beyond the focus point than it is in front of it. However, the closer you get, the less the difference between the front and back depth.

Depth of field and focal length

Each f stop represents a bigger aperture on a longer focus lens. So, the longer the focal length, the smaller the depth at any given f-number (and focus distance). This is so even if you enlarge the *subject* to the same size on your print. For example, when a 400 mm lens at $f8$ is focused on 9 m (30 ft), depth of field extends only from about 8.75 m to 9.5 m. A 50 mm lens at the same settings has depth of field extending from just under 5 m (6 ft) to infinity. A 28 mm lens can match the 50 mm focus at an aperture of just under $f2$.

This has two effects. First, small-format cameras have greater inherent depth of field for the same lens angle. Their effective depth of field is, in fact, extended slightly further because the extra enlargement enlarges even the sharpest points to a slight blur. So you need slightly greater lack of sharpness to distinguish from apparently perfect sharpness. Secondly, on any particular format, you can enhance your depth of field by choosing a wider angle lens, then enlarging later. This is exactly the same as using a smaller format camera, within the limitations of the system.

Conversely, of course, you should choose the longest focal length available if you want to increase differential focus. Note here, particularly, that focus doesn't just disappear suddenly at the edge of the depth of field. It fades gradually away. So for effective differential focus, you need a little space between the in-focus and out-of-focus parts of your subject.

Depth-of-field scale

If you have an SLR you can estimate your depth of field visually. Just press the lens stop-down control with an automatic diaphragm, or set a manual lens to the selected aperture. The focusing screen darkens, and the out-of-focus parts sharpen up. It's difficult to be accurate with the limits, but it gives you an idea.

However, the most important ready to hand aid is the depth of field scale engraved on virtually any camera lens. The scale usually consists of a series of parallel lines marked or colour coded with lens apertures. There are two lines for each aperture, one either side of the central focusing index. To find the limits of sharpness, you just read the figures against these lines on the focus scale. This applies wherever you're focused.

Depth of field in practice

There are times when small depth of field is a great advantage. You can suppress a nasty disturbing background, or form an artistic blurry frame from some rather boring leaves near the camera. No serious photographer can resist the lure of differential focus to bring out a suitable point. However, mostly it's a problem more often than it's a boon.

One point is not to waste too much of your depth of field. For example, if you focus on infinity, more than half your depth is beyond infinity. And it can't do you any good there! What you want is the point of optimum focus.

Suppose you want to focus a distant hillside and the cows 20 ft (5.5 m) away. Look at your focus scale and your depth of field scale. On a 50 mm lens, you'll find you can set one f8 mark to infinity, and the other one indicates about 18 ft (4.5 m). You're actually focused on about 30 ft (10 m). Consult your depth of field scale whenever you have such a problem.

Simple cameras have no focus control or depth of field scale but they obey the same optical rules. The lens is set so that you get everything from about 1 m (4 ft) to infinity reasonably sharp. This is easy with a bright-sun type of camera – it has only a tiny aperture. However, if you have a series of apertures (as on the five-symbol cameras) you have a little more problem. As you select settings for more dull conditions, so you reduce the amount of really sharp image. Set for a dull day, you should keep at least 2 m (7 ft) from your subject, and nothing over 30 ft or so will stand great enlargement.

Hyperfocal distance

There is one term that crops up from time to time – hyperfocal distance. This is the *closest* sharp point at any particular f-number when a lens is focused on infinity. Its value is calculated from an arbitrary circle of confusion, the focal length of the lens and the f-number. Once you have a hyperfocal distance for each aperture, it is also easy to work out a depth of field table.

Knowing the hyperfocal distance also has a practical value. You can set the focus to the hyperfocal distance with the knowledge that your depth of field then extends just to infinity and that the closest point of focus is half the hyperfocal distance. For example, if the hyperfocal

distance for a 135 mm lens at f22 is calculated at 20 m (65 ft), depth of field stretches from 10 m (32 ft) to infinity when the lens is focused at 20 m.

Choice of exposure combination

So now you have both sides of the dilemma. Do you want to 'freeze' movement, or have great depth of field. Unless you want to sacrifice one for effect, you just have to compromise.

On a bright day with a 25 ASA (15 DIN) film, you might set 1/125 at f8 (the film manufacturers' suggestion) as a good compromise figure. If there's a bit more movement than you think that can manage, 1/250 at f5.6 is better. For greater depth of field, 1/60 f11 is an easy choice. Go beyond that small range with a standard lens, and you're beginning to make life difficult. With a much longer focus lens, even these variations may go beyond the limits of convenience. Of course, once the weather deteriorates, you are restricted even more – you just have to decide between depth of field and movement. As often as not, you have to accept limited depth of field just to avoid camera shake.

The simple solution is to load a faster film, if you can. However, in colour you're somewhat restricted; and anyway the faster the film, the lower your image quality. For general purpose colour work, a film between 64 and 160 ASA is probably best. For black and white, you can load 400 ASA film and expect to get good results. Even so, most people prefer the pictures taken on 125 ASA films.

In really low light, of course, you just load up the fastest film available. Then, it's a choice of pictures or no pictures, and image quality just has to go by the board.

Cameras

How the control available affects your choice of equipment depends on what you want to do. If, like many people, you take all your outdoor pictures on quite bright days, you don't need a great range of shutter speeds and apertures. For snapshots, a couple of speeds and four or five apertures are quite adequate. Automatic exposure is probably an advantage to you – see the next chapter. If what you want is *sharp* pictures you can enlarge to a good size, you need a little more

sophistication. Shutter speeds up to 1/250 and 1/500 are essential. However, as long as it's a good one, a relatively small aperture (f4 or f5.6) lens is fine. Larger aperture lenses tend to be less good (quality for quality), and they are much bigger and heavier to carry round.

If you think you might want to take pictures in dull conditions, you do need a wider aperture. You also need it to make viewing and focusing easy on an SLR. For most people, an aperture of around f2 is fine. Larger apertures (f1–f1.4) let you make the most of really low light levels, or use really fast speeds on relatively dull days; however, they do introduce problems of their own. None can match the image quality (measured scientifically) of the best f2–f3.5 lenses, especially in close-ups; though few photographers will be worried about the quality differences on normal pictures. More important, the wider aperture lenses cost more, weigh more, and are easier to damage. So, if you're buying a top quality camera, think first of a lens around f2. Naturally, this sort of camera has an extended range of shutter speeds. The ones you will find most interesting for the occasional special shot are the really slow ones (1/2 second and longer).

Wide apertures and long shutter speeds let you take available light pictures indoors. However, with the simplification of flash equipment, this is somewhat of a specialist preserve. For most pictures, just fitting a flashgun gives you all the light you need in a house, even with the simplest camera. In public buildings, though, you may find that versatile camera controls are more useful than flash.

So, before you choose a camera, think carefully about what you need it for. Buy one that does everything you think you'll need, but don't just buy 'the best'. There's no point in carrying round a great sophisticated monster with a lens like the end of a bottle if it's always set to 1/125 at f8 and focused on the middle distance. On the other hand, you're not going to get good motor racing pictures on a dull day with a fixed focus pocket camera (see also p. 202).

Automatic
Exposure

The logical extension of an exposure meter coupled to the shutter speed and aperture controls is one that sets them. That makes an automatic exposure camera. As long as the film speed is set right, you get the metered exposure every time. Automatic exposure systems are available for all the popular camera types; from pocket cameras with tiny fixed focus lenses up to 120 SLRs. Basically, there are three types: those that set the lens aperture; those that set the shutter speed, and those that set both. The most sophisticated cameras give you the choice of which they set.

Shutter-speed-priority systems

The first automatic camera had only one shutter speed and took film of only one speed. When you pointed it at your subject, the exposure meter set the lens aperture control to a suitable size. Some simple automatic cameras still work like that. They give you accurate exposures over a range of lighting conditions, limited by the usually small maximum aperture of the lens. As you know the shutter speed, you can predict just how moving subjects will come out.

A simple elaboration of the basic auto-aperture system resembles the programmed shutter (see p. 124). When you set the film speed, that just sets the shutter speed. Then the meter sets the lens aperture according to the light reflected from your subject. Your exposures are just as accurate or inaccurate, and limited in just the same way as the basic system. You do, however, have a choice of film speeds.

This also lets you make a contribution to the exposure. You *can* compensate for unusual subjects by changing the film speed. For example, if you subject is against a bright background, you can set the camera for a slower film, so getting a longer shutter speed to compensate for the small aperture set by the meter. (The meter sets too small an aperture because it measures the whole area, not just your subject.)

More sophisticated shutter-priority systems let you set any shutter speed. The meter then sets the aperture to suit that and the film speed. This type of automation is common on compact 35 mm cameras. Sometimes the aperture is indicated on a scale, often in the viewfinder. Then you *know* what exposure combination your camera is setting. If you don't like the combination, you change the shutter speed, and the camera alters the aperture to suit.

That gives you the creative control you need. However, often there's

no direct way of compensation for unusual subjects. You just have to alter the film speed until you get the exposure you think you want (if you can).

Shutter-speed-priority systems usually work by setting a stop. The meter has a more or less conventional needle to indicate exposure. When you press the shutter release the needle is trapped where it is, and forms the stop. The diaphragm mechanism closes down that far and no farther. With a lever (virtually the reverse of the aperture setting teller for full aperture metering), the stop can be transmitted to the diaphragm mechanism of interchangeable lenses. There are several interchangeable lens cameras with this type of exposure automation.

Aperture priority systems

Slightly more recently, electronic shutter-timing mechanisms have become common. It's a simple matter to couple an exposure meter to such a shutter. So, many modern automatic cameras work on aperture priority.

This is the system chosen for the simplest automatic pocket cameras. They have a fixed aperture lens. The meter adjusts the shutter speed to suit the lighting conditions and one particular film speed. This gives you more exposure range than you get with the fixed-shutter or two-symbol versions. Unfortunately, in all but the brightest conditions, you get a fairly slow speed. There is a warning light for really slow speeds (longer than 1/30 second), but even so, camera shake is a considerable problem. In fact, this type of camera offers little advantage over the five-symbol manual type.

A much better automatic proposition is the five-symbol electronic pocket camera. Just like the manual version, you choose the weather symbol. However, that sets an aperture over the meter window as well as the lens. So the shutter gives the metered speed automatically. What's more, you don't *have* to follow the weather symbols. You can set 'cloudy bright' on a sunny day and get a short shutter speed to freeze movement. Or set the aperture for really bright conditions irrespective of the lighting. You'll get a long shutter speed if its dull, but retain the maximum depth of field (which is more or less equivalent to close focusing on a fixed-focus camera).

The other main group of aperture-priority automatic cameras are among the most sophisticated of all. This is the system favoured by

most of the recently developed automatic SLR cameras (110, 35 mm and even one 120 model). It has signal advantages for interchangeable-lens cameras. You get an automatically-determined exposure through any lens or other optical system (more of that later).

Combination systems

Although there have been many recent developments in automatic shutter-speed control, it has been around for a long time. Mostly, however, it was combined with automatic aperture determination, as it still is in a number of 35 mm compacts and some fairly sophisticated pocket cameras. The meter measures the light, and then 'chooses' a combination of shutter speed and aperture. The combination depends on what the camera designer thought you would find best.

Usually, you get a reasonably fast shutter speed until the light gets so low that the lens is getting toward maximum aperture. Then the shutter speed lengthens. This is the best compromise, and probably follows more or less what you would set on a manual camera for ordinary pictures. However, it doesn't give you *any* choice of creative control. If the camera feels that 1/250 at *f* 11 is what you want, that's what you'll get. You can't change things to freeze movement or increase depth of field.

That is so much of a disadvantage that such cameras must be regarded as sophisticated snapshot machines and nothing else. Don't look down on them for that purpose, though. They are great for people who don't want to do *anything* with their camera except point and shoot. The better examples produce superb quality pictures. In fact, they probably produce a higher proportion of correctly-exposed sharp pictures than any other type of camera. But if you want some control you need some settings.

Biasing the exposure

A few automatic cameras have exposure modification systems. You set a dial to (for example) +1 or −1 to get one stop more or one stop less exposure than the meter measures. This lets you compensate for special conditions. Give more exposure if you want details in the dark parts of an average subject; less for details in the bright parts. How much, you'll just have to learn by experience.

If you haven't got an exposure override control, you can usually alter the film speed setting (if there is one). This is not possible on cartridge-loading cameras. The cartridge has physical keys to set the speed.

If you can alter the speed, you halve the ASA speed setting (reduce the DIN setting by 3) to give one stop more exposure, and double it to give one stop less. For example, suppose you have a backlit subject that needs two stops more exposure than the overall meter reading suggests. You have 100 ASA (21 DIN) film in your camera. You must set the meter scale to 25 ASA (15 DIN) to achieve the exposure you need. If you change the film speed setting, do put it back again straight away, though. Otherwise you will get horrible results with normal subjects.

Manual override

There's no reason why an automatic exposure camera shouldn't have manual controls as well. Especially if the lens apertures and shutter speeds are already indicated. The override may be mechanical or electrical. It makes no difference to operation. You just set the exposure *you* want irrespective of the automatic system.

If you want an automatic camera, but are worried about the odd occasion when you don't want the automatic exposure, get one with manual override. Preferably one which lets you use its meter with manual operation. Then you can meter the scene, and modify the exposure exactly as you want; just as you can with any other built-in meter.

Automatic SLRs

For many years, there have been automatic 35 mm SLRs. However, only recently have the most prominent manufacturers entered this field. Such cameras now form a significant proportion of the 35 mm SLR market, and there are some roll-film models, so we will look at them in a little detail.

Virtually all the current models allow manual override, with match-needle metering. In the automatic mode, they let you bias the exposure by a fixed factor, or have an auto-exposure hold. With this, you take your reading from a suitable area, and retain it for as long as you like. So you can expose for just what you want. There are, however, three more or less distinct metering systems.

Shutter-priority cameras are the exact equivalent of other shutter priority cameras. Their lenses have an extra mark on the aperture scale to indicate the automatic position. Set the ring to that mark and you get the metered aperture automatically. Alternatively, you can set any other aperture manually. A display in the viewfinder indicates the aperture the system is to set, and sometimes the manually-chosen aperture. The first examples had separate meter cells, but now this type of camera has a through-the-lens meter measuring at full aperture. The main problem is that automatic exposure is restricted to correctly coupled lenses. With others you get stop-down exposure metering, with manual shutter *and* aperture settings.

Some of the most sophisticated and expensive 'system' cameras can be fitted with automatic aperture controls. These attach to the lens, and have a servo motor to drive the regular diaphragm ring. They have external power supplies, and are really designed for remote operation. They are not the answer if you just want an automatic SLR. If you do, buy one of the cameras with built-in automatics.

Aperture-priority camera – full-aperture metering was customary on top range SLRs when the first electronically-timed shutters were introduced. These cameras meter through the full lens aperture, and calculate the shutter speed equivalent to the aperture set on a coupled lens. The speed is displayed by a needle against a scale in the viewfinder. The meter has a memory circuit so that it retains the reading after you release the shutter (so raising the mirror and cutting off the light to the meter). When the shutter dial is set for automatic exposure, that is the speed you get. If you turn the shutter dial to indicate a speed, this is indicated by a second pointer on the same scale. Most of these SLRs let you select any speed from the normal range, with extension up to four or eight seconds. The simpler versions, though, have no manual shutter speeds (except one for flash). However, you alter the shutter-speed by altering the lens aperture, thus losing very little in versatility.

If you fit a non-coupled lens, the camera can still measure through it and set an automatic shutter speed. However, readings must be made at the shooting aperture. With conventional CdS meter cells, this means that you must close down your lens *before* releasing the shutter (even if it has an automatic diaphragm). Be careful, though, if you fit a full aperture metering lens from a different camera system. It is possible that such a lens could give you incorrect readings (either at full aperture or stopped down) and thus incorrect exposures.

With coupled lenses these are as convenient as the shutter priority

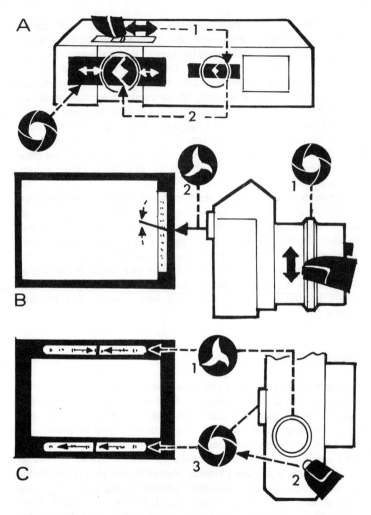

Automatic exposure lets you concentrate on composing the picture. Systems vary though, and some cameras give you no choice. A. Some pocket cameras let you choose the aperture (1) by setting weather symbols, the meter then sets the shutter speed, (2). B. A similar system (with *f* numbers, of course) is found on much more sophisticated cameras, but gives much greater manual over-ride. C. Alternatively, on others, you set the shutter speed (1) and the camera sets the aperture (3) when you press the shutter release (2).

types, and they are more convenient with non-coupled optics. However, there's not that much difference, so the choice must depend more on other (incidental) features of these automatic SLRs.

Aperture-priority cameras – stop down metering through-the-lens with auto exposure control has become possible because of the fast response of silicon photo-cells. These cameras work quite simply. When you press the shutter release, the mirror rises and the lens stops down to the preselected aperture. *Then* a cell in the film plane measures the light level. This sets the shutter speed, the cell moves out of the way and the shutter opens and closes. Like all the other aperture-priority cameras, the shutter speed is not confined to fixed points on the conventional scale.

These cameras are made to take the popular 42 mm screw (Praktica) mount lenses. Because they meter stopped-down they need no special connectors. They work with manual diaphragm lenses, as well as with conventional single-pin automatic diaphragm examples. Undoubtedly they provide the best low-cost automatic SLRs. You can buy lenses to suit them from a multitude of makers. Because they have no full aperture metering system, there's no danger that they might be set incorrectly by fitting lenses with alien aperture connections.

Dual-mode automation

The development of micro-electronics has offered camera makers a whole new range of sophistication. The first result is the widespread use of LED displays (in place of needles). The information is shown either by lights against a scale, or as a direct digital read-out.

The main effect of electronics, has been to enable manufacturers to offer you cameras with the choice of shutter-speed priority or aperture-priority exposure control. Basically, you simply switch the camera to hold one shutter speed if you are photographing a moving subject; or to hold one aperture if depth of field is of major importance. The camera then varies the other factor – and displays the result.

This is a useful feature, which makes auto-exposure even easier to use, but it does take a little more thought in choosing the original setting. Undoubtedly, this is a facility that is well worth considering. Combined with dual-mode automation are other electronic options – auto-flash, programming, and, so forth. These are less

essential, but their advantages are probably the major influences between camera brands.

Which system?

We can rule out those automatic cameras that give you no control, except in a snapshot or notebook role. That includes virtually all the combined aperture and shutter controlled cameras. Of the others, there really is little to choose between aperture priority and shutter priority. If there is a display in the viewfinder, you can just alter one until the other is at the value you want. If the feature you control is also displayed in the viewfinder, that makes things even simpler.

Shooting

The best way to use an automatic camera is to choose a suitable aperture or shutter speed for the film and conditions, and let the camera get on with it.

For example, with a shutter-priority camera loaded with 125 ASA (22 DIN) film, you might choose 1/250 second on a bright sunny day. Then the aperture will hover around the f11 mark, changing as your subject changes, or the lighting varies. With an aperture-priority camera loaded with 500 ASA film, you might choose f2.8 indoors in room lighting. The shutter speed may then fluctuate around 1/30 second or so.

Under such extreme conditions, watch the shutter speed with great care. It may drop so low that camera shake or subject movement spoils your pictures. To help, a lot of cameras have a viewfinder light to indicate exposures of longer than about 1/30 second.

If you know that conditions will 'fool' the meter, bias your exposure to suit. If there are extra bright unimportant parts, make the camera give more exposure; if dull ones, less.

Problems

So, is automatic exposure so fantastic?

Yes, it is under normal conditions. It lets you concentrate on the important aspects of picture-taking. However, all automatic exposure

systems depend on reflected light readings, and we know they can be a nuisance. If you can predict the effects of special lighting conditions, you can compensate by introducing an exposure factor or by altering the film speed set. However, this is not a substitute for an incident light reading or a grey card reading. Nor can it necessarily match an average of the highlight and shade readings.

Undoubtedly, there are cases where you might improve over the automatic reading. However, they are few and far between. If they worry you, get a camera with *full* manual override. Then you can set whatever exposure you like whenever you don't trust the automatics. *Reliability* can cause concern. Automatic cameras are more complicated than manual ones. So they are more likely to go wrong. However, if you have your camera checked regularly, it should be absolutely reliable. One point, though, automatic cameras depend on a battery. If that goes flat, the automatics won't work. Even if you have manual override, the electronically timed shutter can't work without a battery. If you're lucky, your shutter changes to one fixed speed — often around 1/90 second when the battery dies. If you're not so lucky, it doesn't work at all.

Automatic meters are supposed to stop working immediately there is too little battery power. Unfortunately, some at least may give irregular exposures for some time before the battery finally fails. If you don't trust your battery, replace it as soon as possible, and keep an eye or ear out for irregular exposure. Naturally, if you're taking unrepeatable shots, you're better with your fixed (battery-less) speed if there is any chance of irregular exposures. Still, if you can't repeat them, go on shooting. If they don't come out, you are no worse off than you would have been if you hadn't taken them in the first place.

Interchangeable Lenses

Most cameras have a fixed lens. The manufacturers choose the one they think best suits their prospective customers. This is fine for general picture-taking, but many people prefer to be able to change their lens. They pay a considerable premium on the camera price for that privilege.

Why change your lens anyway?

The normal lens on any camera takes a fixed section of the view. The camera designer has decided how much you're going to get into your picture. He chooses the angle of view he thinks suits you best. When you buy the camera, you have a little choice between models, but then your lens angle is fixed. If you want more in your picture, you have to go further back, and if you want things to come out bigger, you have to go closer. Moving around to get just the picture you want is an extremely important part of photography, but sooner or later there comes a time when you can't get near enough – or far enough away. If you just want a bigger picture of something you can't get to, you can have part of your negative enlarged, or part of your transparency blown up – as long as the picture quality is good enough to warrant it. If, however, you want more in, you're stuck. Maybe you can take two pictures and stick them together, but its not too easy.

The easy answer is to change the angle of view of your camera lens. There are accessories that do this for a fixed lens (see p. 230). They're quite useful if you've no alternative, but have two problems. They don't often produce very sharp pictures, and they don't make an enormous difference to the angle of view. If you're going to need to change your angle, really you need an interchangeable lens camera. Don't rush out and buy one without thinking, though. Most people get on quite well enough with just one lens – fitted to the camera. If you do want the extra versatility, note that there are two fairly different interchangeable lens cameras in the smaller formats – rangefinder models, and single-lens reflexes. There is also one twin-lens reflex.

We have already discussed the relative advantages of the different types. However, to recap, rangefinder cameras (and the TLR) are fine for the comparatively moderate range of lens angles that satisfy almost all photography. SLRs really come into their own with extra long-focus or extra wide-angle optics, and with close ups.

Undoubtedly the aristocrat of interchangeable-lens formats is the 35 mm SLR. The range of lenses available lets you choose your image

size from one quarter of that produced by the standard lens (covering nearly 120°) to about 40 times the size (covering just over 1°). So, its natural that we pay most attention to that format. However, don't rule out 120 cameras just because their lens line doesn't look so impressive.

The standard lens

As we've said, the standard lens is normally chosen to give an angle of view more or less approximating to that covered by the human eye. This is normally about 45–55°. There has long been controversy as to the most suitable angle for a normal lens. As this has been between those who consider best an angle of about 65–70° and those who feel that 30–35° is right, the choice of a lens somewhere in the middle is logical. Nevertheless, some feel that it is a compromise that falls between two stools, and does little else.

Anyway, rightly or wrongly, 45–55° it remains. This is the angle you get when you fit a lens whose focal length roughly equals the diagonal of the film plane. So the standard lens is often defined as one that does just that. Remember, though, that is just a convenient definition, no more.

You will probably find that you can take most of the pictures you want with your standard lens. If you make your own enlargements, this becomes even more the case. On fine-grain film, you can enlarge the centre section, and get a result just the same as you would with a long-focus lens. The comparatively short focus 75 or 80 mm lens fitted to most TLRs is particularly suited to that. It takes in a usefully wide view, yet the good sized negatives let you choose quite small sections to enlarge, if you want to.

It is not really possible, though, to mimic the effects of a wide angle lens. You can approach it by taking two or more pictures from the same viewpoint, and pasting together the prints. That works quite well unless you have a straight-line subject. Then the lines appear bent where you join them. However, a wide-angle lens is not essential for most photography. In fact its effects – tiny rendering of even quite close parts, coupled with too much foreground, and sometimes funny perspective, make it a difficult lens to use well. Certainly not ideal for easy snapshots. Of course, if you enlarge up a section equivalent to the normal lens' view, you'll get a normal lens type picture.

So, before you buy an interchangeable-lens camera, think carefully

about whether you need one. Fixed-lens cameras are generally less costly (for the same quality), lighter and often easier to operate. Without any special printing work, the standard lens tends to produce pictures with pleasing perspective. Most of your subject comes out big enough to see, and people look quite natural, as long as you don't go much nearer than full-length portraits.

Focal length and angle of view

The focal length of a lens determines just how close it focuses a distant subject. At the same time, this determines the size of the image it forms. The closer the image is to the lens, the smaller its size in relation to the subject. The size of the image of any particular object is always the same for the same focal length lens — regardless of film size. What's more it is directly proportional to the focal length. A 100 mm lens produces an image twice the size of that produced by a 50 mm lens; and a 25 mm example produces one half the size. The film format simply determines how much of the subject appears in the image.

For example, an 80 mm lens is more or less standard for the 6 × 6 format. On such a camera, you get a full length portrait from round about 2 m (7 ft) away. Put the same lens on a 35 mm camera, and at the same distance you get a waist up picture (with the camera vertical) or a head-and-shoulders (horizontally) of exactly the same proportions but reduced in area. Conversely, an 80 mm is an extremely wide angle lens on a 5 × 4 camera. You get bags of space all round your man at 2 m.

It is of course the image size which is the final arbiter of enlargement quality. For example, a 500 mm lens doesn't sound as impressive on a 6 × 7 camera with a 90 mm standard lens as it does on a 35 mm camera with a 50 mm standard. But the image proportions are exactly the same. There must be a 36 × 24 mm section of your 6 × 7 cm negative that is identical with your 35 mm negative. In fact, it may not be quite so sharp because the designer of the larger lens has to provide good resolution over a wide area and may settle for less than the best resolution in the centre. However, it is extremely unlikely that anyone would spot the difference.

That changing the format can't alter the image size is quite obvious when you think about it. Take a large format transparency. Cut out a tiny piece and mount it in a 110 slide mount. Obviously, you have not

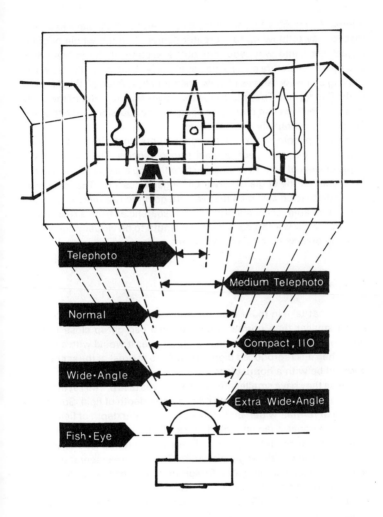

Interchangeable lenses alter the field of view. Wide angle lenses let you get more in, and long focus lenses (telephotos) get a bigger picture — without moving.

altered the image size, you have just converted a little piece to a form that is easy to blow up to a greater degree than the whole original. In just the same way, you 'cut out' a section of the image when you take your picture on a particular film size. That is what determines the angle of view. Angles of view are normally quoted on the diagonal of the film format. That's because that gives the diameter of the circle in which the lens can produce a sharp image. Outside that circle, the image falls off rapidly in most cases.

Like most people, you probably make prints from almost all of your negative area, or project original transparencies. Then you get the angle of view of whatever lens you fitted. If you enlarge but part of the area, you get the angle of view of a longer focus lens. The remainder of our discussion assumes that you are going to use more or less the whole film area, and view prints or transparencies from a reasonable distance. Now we can consider focal length to be virtually equivalent to angle of view on a particular format.

Wide angle lenses

Lenses that take in more than the normal angle reproduce most of a scene smaller than normal. However, you can go up close to your foreground subject, that comes out as large as it would with a normal lens. Then it is reproduced bigger relative to the rest of the scene than it would be with a normal lens.

Because they have smaller effective apertures (see p. 145) at the same f-number, shorter focus lenses have greater depth of field. So, *on any particular format*, wider angle lenses give greater depth of field at the same f-number than standard ones. This aids you in portraying objects at widely differing sizes. These two features lead to what is generally called wide-angle distortion. That is, an exaggeration of the apparent distance between foreground and background – or a 'steepening of perspective'.

In fact, this effect is due solely to your close picture taking position. It has nothing to do with the optics. You can demonstrate that by taking two pictures of the same subject from the same position. One through a wide angle lens, the other through a standard lens. Now, enlarge from each negative to produce an identically-sized print of exactly the same amount of your subject from each negative. They both will have exactly the same perspective.

To see a picture with its original perspective, you must view it from a

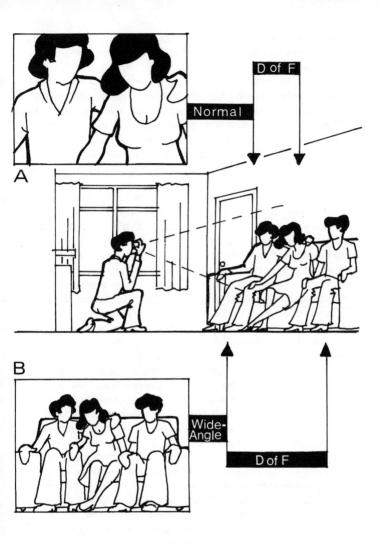

A. Normal lenses may not include your whole subject. B. Wide angle lenses are useful in confined spaces, especially indoors. Not only do they increase the field of view, they also give greater depth of field at the same f-number. Beware, though, because they encourage a close viewpoint, they can 'introduce' distortion. Look carefully to see that the closest parts of your subject are not over large.

distance proportional to the picture-taking distance. This can be estimated simply by multiplying the focal length of the camera lens by the degree of enlargement.

For example, imagine a 10 × 8 in print made from a 35 mm (1½ × 1 in) negative taken with a 50 mm (2 in) lens. Enlargement is roughtly eight times. So you would expect to look at the print from about 16 in (400 mm). Take a picture with an ultra-wide 15 mm lens, and you could expect to view the 10 × 8 print from about 5 in (120 mm). As that is an unlikely viewing distance, the wide angle picture will look distorted if it was taken with any part of the subject particularly close to the camera.

Another effect associated with wide angle lenses is the convergence of vertical parallels, such as the sides of buildings. The convergence is caused whenever the camera is tilted, just as it is when you look upward; so if your tilt is upward to take in all of a building, or reduce your foreground, you get convergence. You are more likely to do this with a wide angle lens. Further, the steeper perspective effect of 'incorrect' viewing distance exaggerates it. It is a convention of western art that verticals remain parallel – though horizontal lines converge in the normal 'perspective' manner. So it is better to try and avoid converging verticals in most cases, and to be especially careful with wide angles.

Wide-angle lenses, though, do introduce some inevitable optical distortion. Three-dimensional parts of the subject toward the edges of the picture are broadened. Spherical objects spread out to egg shapes pointing away from the centre. This distortion is an inevitable consequence of the optics of reproducing a wide angle scene on a flat film. Without it, the lens would be unable to reproduce straight lines' as straight. Just look through an SLR with a wide angle lens, and scan a scene (pan). Move quite slowly, and see just how the image changes from the centre to the edges as you do. It appears to surge around you. Try the same thing with a standard lens; there's not much effect: with a long focus one, none.

You may want to use the wide angle lens to give you violent perspective distortion. This is a fashionable way of adding 'impact' to a picture. On the other hand you may just want a lens that gets more in – indoors or out. If this is the case, remember – especially out of doors – how much smaller things will look. A really wide lens may get all that mountain range in, but if it makes it look like a row of molehills, you need not have bothered. Bear this in mind, however, and you will find a reasonably wide angle lens (65°–75°) is one of your most useful accessories.

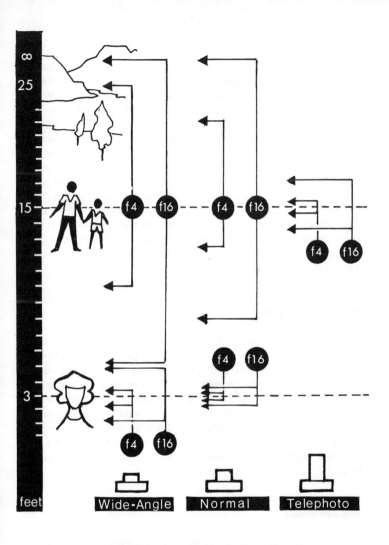

Depth of field is the amount of the subject that comes out sharp in a picture. It increases with smaller lens apertures, greater focus distance and shorter focal length. So, focusing is much more critical at wide apertures, close up or when shooting through long focus (telephoto) lenses.

167

Moderately wide angle lenses

For 35 mm cameras, anything shorter than about 45 mm is regarded as wide angle. The most popular one is 35 mm, with an angle of about 63°. I don't think it's really worth having one if you use a standard lens round about 50 mm; the difference is not really great enough. If it's 55–60 mm, though, a 35 is often useful. It is also an almost ideal 'wide standard' if you find a 50 mm lens too narrow. You can get very wide aperture 35 mm lenses for this purpose. They are particularly useful indoors, where you are cramped by 50 or 55 mm optics. Equivalent lenses on 6 × 6 and 6 × 7 are 60 or 65 mm. Although the 65 doesn't cover so wide a field, it matches the feel of a 35 on 35.

I find the best general purpose 35 mm format wide angle a 28 mm (76°). This is a really useful complement to a standard lens. It gives you a broad view without being too difficult, yet lets you take quite spectacular distorted images if you want. It's equivalent on 6 × 6 or 6 × 7 is about 45 or 55 mm.

Really wide angles

The wider lenses are more often used for effect than just to get things in. If you have a 35 mm lens already, the logical choice is a 24 mm (84°), which is still normal enough to be thought of as a wide 28 mm. Wider still are the spectacular 13 to 21 mm lenses. They provide straight-line reproduction over angles of 120°–92°. You get so much in, they make 24 mm shots look like the product of a long focus lens. Pictures taken with these lenses exhibit wide angle characteristics, almost whatever the subject. They are undoubtedly attractive tools for the creative specialist, but can hardly be considered 'every day' lenses.

Fisheye lenses

To get the widest possible angle, lens designers forego rectilinear reproduction. They allow (even encourage) straight lines to become curved. The results are the so-called fisheye lenses.

One sort has an angular coverage of about 180° on the diagonal. These produce pictures like those taken with a conventional wide angle lens. However, towards the edges straight lines come out as

curves – bowing out in the middle like a barrel. In fact this form of distortion is called barrel distortion. Lenses of this type have a focal length of around 17 mm for 35 mm cameras and 40 mm for 6 × 6 cameras.

The classic fisheye lens, however, produces its whole image entirely within the film frame. So you get a circular picture covering 180° or even 220°. It was these lenses that contributed the name, because their bulging front elements (needed to see literally behind some of them) resembled a fish's eye, no less. This type of lens has a valid scientific application. However, its main use is undoubtedly in producing unusual images. When the lenses were first introduced, the circular distorted pictures had great impact. Now, they tend to be rather ordinary.

In fact, neither type of fisheye is an especially worthwhile buy. They are not cheap, and once the novelty wears off, you probably won't find much use for one. I would certainly spend my money on a really wide straight-line lens instead. That can do most of the jokey things nearly as well, and it has other uses.

If you want to try out a fisheye – hire one. Alternatively, buy a fisheye converter for your other lenses. They are about a quarter the price of the cheapest real fisheye lenses. They don't produce anything like the image quality of the best, but they satisfy most 'creative' needs. What's more, changing them from lens to lens gives you a choice of both types of fisheye image.

Long-focus lenses

Long-focus lenses magnify the image. As a converse to wide angle lenses, they introduce distant viewpoints, so 'compressing' perspective; and have less depth of field at the same f-number as a standard lens.

Basically, their purpose is to give you a bigger picture at any distance from your subject. There are two reasons why you might want this facility. First, you may be unable to approach your subject for any one of a number of reasons. Secondly, you may prefer the perspective from a more distant viewpoint. You may, for example, want to climb a hill so that you can picture a tall building from a viewpoint level with its midline.

More likely, you may want to take a head or head and shoulders portrait. If you do that with a standard lens, you have to stand about 1 m

(3 ft) from your subject. That produces a rather distorted view – too big a nose, too small ears. Double your focal length, and you can double your shooting distance for the same image size. You can get the same size picture but a more attractive shape. Of course, you can get virtually the same result from enlarging the middle bit of your negative. That's not so easy with transparencies, though, or if you have your prints made by a normal photofinisher.

Moderate focal lengths

To 'improve' the perspective of your pictures, and to sharpen up the composition, a lens with an angle of view of about 25–30° is ideal. You get that with about double the standard focal length. Say 45 mm for a 110 camera, 85–100 mm with a 35 mm camera and 135–150 mm with a 6 × 6 or 6 × 7 cm camera. Lenses in this range are available for virtually any interchangeable-lens instrument. (Yes, even 110 – long focus at the flick of a switch.)

If you concentrate on portraits, this is the angle for you. You can get nice wide apertures for indoor work. In fact, you may find that you can dispense with your standard lens altogether when you have, say an 85 mm, for your 35 mm camera. That and a 35 mm cover most shots; if you have both, you don't often need anything in between.

However, if you regularly photograph through your standard lens, you are best advised to go for a slightly longer focal length next. Say between 20° and 15° – 120 to 150 mm on 35 mm, 200–250 in on 6 × 6 or 6 × 7. You can still take portraits, though you may need a little more light, and you have probably the most useful angle for photographing distant scenery.

With a lens in this range, you can picture a distant castle or hillside just as you saw it. Your lens covers just about the angle of view that your eyes can concentrate on in the distance. You don't have to take any special care using such a lens; most have reasonably wide apertures, and are convenient to carry about. With a little stalking practice, you should be able to get some great nature shots with one as well.

These are the longest focal length lenses that you can handle conveniently without reflex viewing, a separate viewfinder and coupled rangefinder work really well with them. For narrower angles, however, they begin to be less suitable.

A. Long focus lenses let you get good-sized images of relatively distant subjects. B. They also give you restricted depth of field so that you can isolate the main subject against an out-of-focus background. C. As well as magnifying the image, a long focus lens magnifies any movement. Support the lens to avoid camera shake whenever possible. A bag full of beans or polystyrene granules is a useful aid.

171

Intermediate focal lengths

Get a longer focus lens, and you start to hit the problems. My next grouping holds lenses from 12° to 6° (200–400 mm on 35 mm, 250–500 mm on 6 × 6 or 6 × 7). Its a fairly arbitrary group of those lenses you might hope to use without support. None of them are really suited to non-reflex use. They require precise sighting and accurate focusing – the two main advantages of a reflex screen.

As the angle of view narrows, so the image size increases – naturally. However, you don't just magnify your image – you magnify any movement as well. That is subject movement *and* camera movement. So, if you can just expect to hand-hold your camera at 1/30 second with the standard (50 mm) lens, you need 1/125 at least for a lens with four times the image size (200 mm).

Further, the longer the focal length, the less is your depth of field. So, you need to close down your aperture somewhat to be sure of sharp focus, even of distant subjects. If you could use a wide aperture, you are not too likely to find it on a long-focus lens anyway. To maintain the *f*-number, the physical aperture must increase in proportion to the focal length. Thus, for an aperture of *f*2, you need (in theory) a 25 mm (1 in) front glass on a 50 mm lens. For the same *f*-number, you need a 200 mm (8 in) front glass on a 400 mm lens. Such a lens would be incredibly difficult to make, and extremely big and heavy.

So you are going to find it difficult to set a fast enough shutter speed to avoid camera shake, let alone subject movement. I have a lovely picture of some nice peaceful big game. Shooting through a well-supported 400 mm lens on a 35 mm camera, I was forced to use 1/60 second (at maximum aperture) by dull conditions. Everything is nice and sharp except for one zebra's head. It moved – just from one grass clump to another – and its face is just a smear – no detail at all.

You need a lens from this group to photograph animals, wild or in cages, for sports, and so on. In fact, anywhere where you want to *select* part of a relatively distant scene. The shallow depth of field means that your subject is likely to appear pretty separated from its surroundings anyway.

Although we talked of hand holding, you are much better advised to use a solid support of some kind. That way, you will make use of the fine optical properties of most long focus lenses. Preferably, use a sturdy tripod; failing that, lean on some convenient part of the countryside – a wall, car, table, or whatever is handy. Always use the fastest sensible shutter speed.

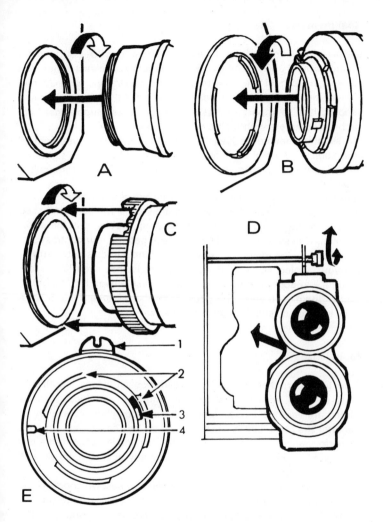

Lenses interchange with many different systems. A. Screw threads are simple and reliable. B. Bayonets are quick to change, but more subject to wear. C. Breach-lock systems give the best of both worlds, with easy accurate couplings. They may, though be awkward to use with large lenses. D. A simple spring wire holds lens pairs on a twin-lens reflex. E. Lens couplings for a full-aperture metering SLR: 1, Meter coupling prong. 2, Bayonet lugs. 3, Automatic diaphragm lever. 4, Bayonet lock.

Real monsters

Lenses with an angle of view of less than about 5° (500–2000 mm for 35 mm, 600–1000 for 6 × 6 or 6 × 7) are really specialist optics. You can just hand hold the smallest 500 mm mirror lens for a 35 mm camera, but you will never reveal the true optical qualities without a support. It is so important that a number of these super-lenses are supplied complete with their own rigid tripod.

The slightest movement doesn't just lead to blur; it takes you right off your subject. Most of the longer examples are fitted with sights, so that you can line up on your subject before trying to find it through the viewfinder.

These are the lenses that a professional nature photographer may use in a hide. They picture things at such a distance you can hardly see them with the naked eye. One of the main problems is the air in between. Unless it is absolutely clear, you get soft low contrast pictures because the image is degraded by all the particles between you and your subject. One particular curiosity is that such lenses are dreadfully affected by shooting through glass – even if it is right in front of them. You just don't get a clean sharp image if you point a really long focus lens through the window.

Zoom lenses

Zoom lenses are those on which you can choose the focal length (and angle of view) without affecting the *f*-number and focus. Closely related are *varifocal* lenses, on which the focus changes slightly as you alter the focal length. These should be less costly, performance for performance, and provide very little less convenience to the still photographer. However, there are hardly any available, so we will stick to describing zooms.

Until recently, zoom lens quality had been dubious. No zooms could match the resolution and lack of distortion of even quite modest prime (single focal length) lenses. However, that is no longer so. The best zooms still don't quite match the best prime lenses, but you would be hard pushed to tell the difference in a print or a projected transparency. So, a good zoom lens can deliver the goods. However, they are virtually limited to 35 mm (and appearing in 110). Also, they are unusable on cameras with a separate viewfinder. Coupled zoom finders are unknown in still cameras.

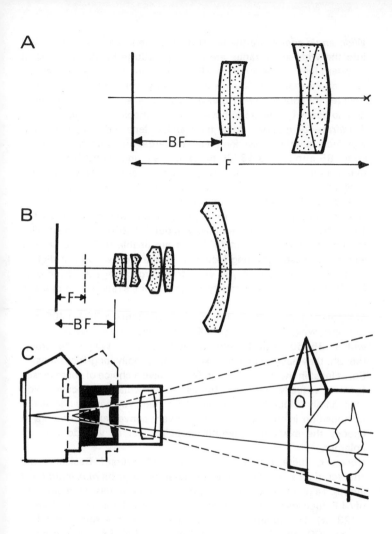

Lens construction affects physical dimensions as well as optical performance. A. Telephoto designs produce lenses much shorter than their focal length: F – focal length. BF Back focus. B. Inverted telephoto designs move wide angle lenses further from the film plane. So that there is room for SLR mirrors or other mechanisms. C. Tele-extenders convert lenses into telephotos. They magnify the image two or three times, but reduce the f-number by the same factor.

Wide-angle zooms are the latest development. Lenses that go well into the wide-angle range are a real substitute for the established standard lens. For example, a 28–45 mm lens covers almost all the wide angle shots that you are likely to take, while at the 45 mm end, doubles for your 50 mm. However, such lenses are difficult to make, and so costly if they are to have even reasonable performance.

Moderate-focus zooms cover the standard lens and go up to portrait type focal lengths. If you don't want the larger minimum aperture of a prime 85 mm lens, a 43–86 mm zoom is a good substitute. In fact that was the range of the first still camera zoom – the Voigtlander Zoomar. That lens, however, was not renowned for its image quality, and could not match a modern zoom.

Long-focus zooms are the most plentiful, and the most successful. There are numerous lenses giving about 80–200 mm, most with maximum apertures about $f4$. These are usable both as a portrait lens and a reasonably long-focus one. There are also several slightly longer-focus versions, if you want to enlarge things a bit more. A 50–300 mm lens should satisfy almost anyone's range of normal and long-focus needs.

Monster zooms are there, too. How do you fancy a 360–1200 mm $f11$ optic weighing 6-1/2 kg (14 lb). Or perhaps you would be content with a 135–600 mm $f6.7$ lens at two thirds of the weight. Naturally, though, they have to be used like any other really long-focus lens.

So, at least in the long-focus range, you have a choice of zoom lenses to cover virtually any need. Zooms are particularly attractive if you take mainly colour transparencies. With them, you have to decide the composition in the camera. So, it is very convenient to be able to choose the exact focal length, cropping just as you do with an enlarger.

However, there are disadvantages – of course! Basically, the characteristics of a zoom lens are determined by its *maximum* focal length. Take a typical 80–200 mm optic. It has a maximum aperture of $f4.5$, focuses down to 1.8 m (6 ft), is 160 mm long and weighs 650 g (23 oz). The dimensions are quite similar to the same manufacturers' 200 mm $f4.5$ prime lens. However, their 85 mm lens has a maximum aperture of $f1.7$ minimum focus 1 m (3.3 ft) is about 70 mm long and weighs 460 g (1 lb). So, the zoom lens makes a poor substitute for *just* the 85. On the other hand, if you use its whole range, you do get a signal advantage from the zoom.

Properly used, a zoom substitutes for several prime lenses, so it's cost and weight are difficult to compare.

Top marbled white butterflies mating, seen through a 55mm macro lens (see page 285).

Above an automatic focusing camera of the type which sends out an infra-red beam is invaluable for flash pictures taken in total or almost total darkness.

When skilfully handled a wide-angle lens can be used to create an impression of
deep spaciousness.

Compare this picture, taken with a long focus lens, to the one on the opposite page. Here, any sense of depth is lacking; the image is jostling and claustrophobic.

A zoom lens enables the photographer to frame his shot in different ways without moving from the spot. These pictures were taken with a 35-70mm lens at 35mm (*top*), 50mm (*centre*) and 70mm (*above*).

A wide-angle lens can be used deliberately to make the human form look grossly distorted.

Through-the-lens metering is often unreliable when objects are photographed against very light or very dark backgrounds. For good results the subject *only* should be metered. The tonal range of the main subjects on this and the opposite page are the same, although the backgrounds are very different.

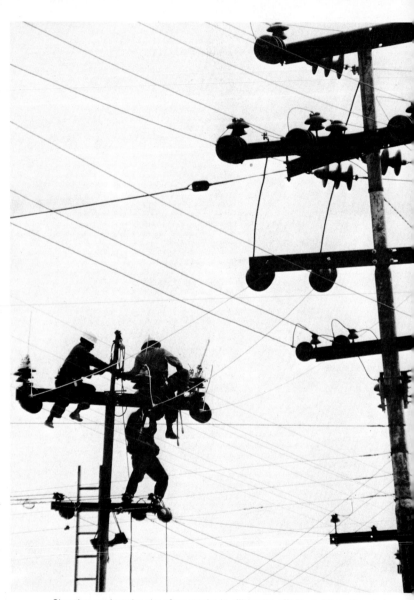

Shooting against the sky often results in silhouette effects, but here the photographer has been careful to preserve detail in the subject.

Special lenses

Many lenses are made for specific purposes. If you need one, you'll have to have a camera that can mount one.

Macro lenses are discussed on page 285. You can get them for virtually any SLR, so they shouldn't affect the brand you select.

Perspective-control lenses are mounted so that you can move the lens relative to your camera. Just like the 'rising front' fitted to a technical camera. The movement lets you select your picture area without swivelling the camera.

Their main use is in picturing buildings with their walls vertical. They come out that way only if you keep the camera back exactly parallel with the face of the building (i.e. vertical). However, with a normal lens this often means you can't get all the building in. If you shift your lens upward, though, you then get the top in without tilting your camera. I find such a lens especially useful for horizontal shots, when you just can't get the top in without making the sides of buildings converge.

Some shifting lenses also let you tilt them. That tilts the plane of sharp focus in the same direction. Very useful for close-up shots when you just can't get everything in focus. Also, it helps you get both foreground and background sharp.

Variable-field-curvature is available on one 24 mm lens. Instead of just the normal flat field, you can choose between convex and concave 'planes' of sharp focus. That is especially valuable when you are taking close ups of roughly spherical subjects – such as flowers.

Soft-focus lenses allow you to introduce a degree of unsharpness to your pictures without their seeming blurred. Such lenses used to be very popular with portrait photographers. They were grossly over-used, and have gone out of fashion. However, there is one soft-focus lens available for a 35 mm SLR.

All these special lenses produce more or less unpredictable results. Once you understand one, you might be able to use it on a view-finder camera. However, they really are confined to screen-viewing cameras. That is, sheet-film models and SLRs.

Lens mounts

One of the major factors influencing your choice of lenses is just what fits your camera. Each camera manufacturer specifies his own lens

mount. Which one you choose should be a prime consideration when you choose a camera.

Bayonet mounts are generally unique to individual cameras. There is little to choose between most of them for efficiency. However, one or two tend to be less convenient – one famous one even requires you to turn the lens *counter*-clockwise to mount it, and clockwise to detach it. Some mounts may begin to wear after a time, so become less positive. Lower-priced ones might not be that firm to start with. This makes little difference in fact, but spoils the feel of your camera.

Undoubtedly the best bayonets are those that use a breech-lock system. You push the lens straight in and turn a ring on the lens or camera to hold it in place. It couples directly with all the camera body levers and so on. This is an excellent system from the mechanical point of view. However, turning the ring is not as easy as turning the whole lens, especially when mounting a large lens. To overcome this, Canon fit a spring-loaded ring. You just offer up the lens, and the ring turns far enough to hold it. You then give it a final tighten.

Screw mounts are currently restricted to two basic types. The 39 mm Leica screw thread on some Russian rangefinder cameras, and the 42 mm Praktica mount favoured by many SLR makers. Also, one SLR manufacturer has an alternative (44 mm) screwthread cut inside their bayonet mount.

Mechanically, screw mounts are superior to bayonets. Any slight wear or manufacturing variations are taken up by the lens turning just slightly further. The extra strength and security are particularly useful for big heavy lenses. However, lens changing is not as quick and easy as it is with a bayonet. So there is slightly more chance of dropping a lens in the process.

The big advantage of the two main screw mounts is the enormous range of new and used lenses on which you can draw. Undoubtedly, you can build up a fine collection of 42 mm screw lenses and lens mount accessories at lower cost than you can build up a collection of lenses for any other SLR mount. What's more, the automatic diaphragm mechanism (if fitted) is universal. Beware though, some older lenses go back slightly farther into the camera, and can foul the mirror operation, or even prevent you from operating the shutter. Also, some diaphragm operating pins are too long to let the lenses be mounted directly on other cameras. If you get a screw mount lens stuck on the camera, first focus it as close as possible. That moves the lens forward. If it doesn't work, select the smallest aperture, and point the camera toward the ground so that the diaphragm pin can fall

down away from the camera. You should then be able to uncrew the lens. If you can't your camera needs specialist attention.

The only other problem with compatibility is in full aperture metering systems. The connections are different on every make. So you have to meter at the taking aperture through alien lenses. It is possible that some lenses may interfere with other meter links to prevent you using the meter even for stop-down readings.

If you want low cost at the expense of slight inconvenience, I suggest you invest in a stop-down metering screw mount camera. Whatever automatic lens you fit, the procedure is the same. With manual or preset lenses, you are exactly in the same position as you would be with a full-aperture metering camera. The inconvenience of the metering is considerably reduced in the lastest *automatic* stop-down metering screw mount cameras.

If you want full-aperture metering, and intend to change your lens reasonably often, then get a bayonet mount camera. As you are restricted to a particular lens system, it might as well be a convenient one to operate. Most bayonet mounts can be fitted with 42 mm screw mount adapters, so you can still use low cost manual lenses with such cameras.

Which bayonet you choose depends entirely on which one you find convenient, or – more important – which manufacturer offers the special accessories you expect to need.

Independent lenses

You are not restricted to your camera manufacturer's own lens range. A few manufacturers supply a range of adapters to let you fit lenses in rival mounts (as well as the 42 mm screw). However, such mount adapters rarely give you any lens-to-camera couplings.

There are quite a lot of independent lens makers. They may offer a camera as a token, but their main business is supplying lenses to the owners of well-known cameras. The best of their lenses are sometimes as good as top brand camera manufacturers' products. In some cases they come from the same factory. Almost all the well-known independent lenses are good, and if you buy a reputable brand, you are likely to be pleased with it. There are not too many independent lenses available for 120 cameras, mostly they are for 35 mm SLRs. The 120 lenses you can get, however, are excellent.

Few of the independent makers can offer a range of lenses quite as good throughout as the top camera manufacturers. In particular, some at least are less robust. Just like lower-priced cameras, they are fine for all but the most hard-working professional. If you expect to expose thousands of rolls of film a year, you should seriously consider getting lenses from a leading camera manufacturer.

Independent lenses may be in fixed mounts to suit a popular camera. Alternatively they may be in a separate interchangeable mount. Fixed mount lenses work out a little cheaper for equivalent optics. Also, the best lines are often restricted to fixed-mount lenses. If you have settled on a camera brand and have no intention of changing, go for fixed-mount independent lenses.

If, however, you feel that one day you might change to another brand of camera, or a different lens mount from the same manufacturer, choose interchangeable mount lenses if you can get the ones you want. When you change your camera, you can just get new mounts for your lenses.

If you have one of the less popular cameras (and there is no reason to presume that that means lower quality) you are probably limited to interchangeable-mount lenses from the independent makers if you want something your camera manufacturer doesn't offer.

Teleconverters

We've talked about afocal units. The alternative way of altering the focal length of an interchangeable lens is to fit a teleconverter. That is a negative lens than fits between the lens and the camera. It doubles or trebles the focal length without altering the focus distance.

However, because the physical aperture remains the same size, the converter does alter the f-number. In fact, a two times converter doubles it, and a three times converter trebles it. For example, a two times converter changes an $f1.4$ 50 mm lens to an $f2.8$ 100 mm optic, or a three times converter changes an $f4$ 200 mm lens to an $f12$ 600 mm. It changes *all* the marked apertures the same way.

That may not be too much of a problem. If you start with a reasonably wide aperture you'll have a combination with quite a respectable aperture. Teleconverters provide a relatively low-cost and easily-portable way of providing longer focal length lenses.

So, why do you want whole lenses then?

The problem with converters is that they magnify any faults in the

prime lens, and few of them are really as good as the best lenses. So, you can't expect quite such good image quality. However, the latest six and seven element types are very good. I know the owner of a new 6 × 6 SLR who uses one. He says the results are if anything better than enlarging a straight negative to the same image size (using perhaps the most renowned enlarging lens of all).

Certainly, it's worth having a 2× converter for the occasional use. If, however, you expect to use a particular focal length lens fairly often, get a long focus lens for that.

Lens construction

A simple magnifying glass doesn't give much of an image. So photographic lenses are made up of a number of different lenses.

Normally-constructed lenses focus so that the distance from somewhere in the middle to the film plane is their focal length. That's nice and simple, but introduces physical problems. For example, the elements of a normal 1000 mm lens need to be 1 m (over 3 ft) from the film. Inconvenient. On the other hand a normally constructed 20 mm lens just wouldn't leave room for a reflex mirror to go up and down. (Early very wide lenses used a separate viewfinder even on SLRs.)

Telephoto construction produces a lens considerably shorter than its focal length. That is convenient, but, of course, costs more. However, almost all currently available long-focus lenses are in fact telephotos.

Inverted telephoto (retrofocus) design produces a lens longer (from the film plane) than its focal length. It is employed in all wide-angle lenses for reflex cameras and in many standard lenses.

The only practical effect of such construction is that when you reverse the lenses (as you may for close ups) you also affect their effective distance from the film plane. Reverse a telephoto lens, and you effectively move it nearer. Reverse a retrofocus lens and you move it optically further away. That makes a simple reversing ring quite an effective close up accessory.

Mirror lenses use some reflecting surfaces in place of glass lenses. This produces shorter and lighter long-focus optics. However, they are much fatter. Also, they can't be fitted with a conventional diaphragm. You alter the exposure with neutral density filters. That doesn't affect the depth of field, nor does it reduce the strange rings

you get in out of focus highlights. The light weight is convenient, and makes hand-holding possible (though not easy). However, conventional lenses give you greater control of the image.

Choice of lenses

Whether you prefer wide-angle or long focus lenses is entirely personal. All I can suggest is that you probably need both in a comprehensive outfit.

Once you have settled on a standard lens (perhaps 35, 50 or 85 mm for a 35 mm camera), think carefully about what more you need. Doubling the focal length is probably the most useful and economic progression. For example, starting from a 50 mm, you might get a 100 and 200. However, you might prefer to go for a 150 if you don't use the 100 much, and then get a 2× converter for your 50 mm lens. For really long shots a 400 or 500 is probably the most convenient. Use that with a converter if you want to try a monster. Such a combination usually works well.

Choice of wide angles is even more personal. Try not to get them too close together, though. For example, you might add a 20 and 28 to a 50. By the way, teleconverters don't work too well with wide angles. A 28 with a 2× converter is no substitute for a real standard lens.

The aperture you choose depends on what you need the lens for. However, bear in mind that the wider the aperture, the greater the cost and weight. What's more, in many cases performance is lower *throughout* the aperture range.

An aperture of about f2 is fine for a standard lens unless you plan to do some low-light work. You might consider a similar aperture for your wide angle and short telephoto lenses though. Especially if they take the place of your standard. If you don't use it in low light, what about a 'macro' focusing lens for your standard? An aperture of f3.5 or f4 was considered pretty adequate not so long ago – and it still is for larger formats.

Apart from low light work, the main reason for choosing a relatively wide aperture is to let you use high shutter speeds, especially if you shoot through a converter. It does make SLR viewing and focusing much easier, too.

The
Question
of
Quality

We have discussed the features of cameras. What we haven't contemplated is their quality.

Cameras come at all prices. Their features tend to limit them to some extent to price groups. However, the main influence on their price is the manufacturers' estimate of their quality and value. Basically, if you buy a top-brand camera, you pay more than if you buy a lesser name machine of the same general specification.

The very top cameras of any particular type offer you extra facilities. For example, the top-line 35 mm SLRs all have interchangeable viewing heads. They can be fitted out for automatic exposure control, remote control, and radio control. They all give you extended low-light metering sensitivity, motor drives, bulk film backs, and a host of other accessories. If you need these facilities, you must choose the camera that gives you the combination you need.

However, next in line come a series of cameras (mostly from the 'top line' makers) that offer 'normal' specification. You can match their facilities on cameras little more than half the price from the same country. Take in international currency and pricing vagaries, and the range is even more disparate. So, how do you decide on 'quality' and do you need it.

Camera tests

All the photographic magazines run camera tests. These vary from vaguely result-minded appraisals, to serials which describe virtually every nut and bolt. There are three things you can learn from such tests: what facilities the camera has; whether it handles well; and how *one example* performed.

The facilities are facts; the most useful part of the tests. The handling is an opinion. Read lots of tests by the same reviewer if you want to know if he likes what you like. The performance report is practically a pure fairy tale.

Performance

Basically, performance is rated by examining test pictures. There may be pictures of a particular scene, or of carefully composed charts. Scenes are representative of what you want the camera for. Unfortunately, any scene varies from day to day – the lighting changes, the atmosphere changes, and things move.

For example, one magazine uses a view of a moored ship taken across a river. There is 100 m or so of atmosphere between them and the ship. That affects picture contrast. Perhaps, even, the boat moves somewhat with the motion of the water. Still, those pictures give you an idea of how *one* example of a lens performed. They are certainly more useful than a lot of resolution, contrast and modulation-transfer-function figures.

Such figures are calculated from carefully shot pictures of specially drawn test charts. The charts let you measure the smallest differences that a lens can just picture sharply on the film. Often you can do that for a range of different contrasts. The resolution is usually quoted in line pairs per millimetre. A good figure approaches 100 on the commonly-used calculations.

Most lenses have higher resolution in the centre than they do at the edges. So, don't just take the centre figure.

Contrast is a measure of the smallest difference in tone that a lens just distinguishes in the image. The *modulation transfer function* is a complex measure that touches on both contrast and resolution.

So, where's the fairy story? Firstly, the review measures just *one* sample. So the results have no real statistical significance. One reviewer I know tested a well-known camera (taken from a dealer's shelf) and found that it had such a superb lens he bought it. Another reviewer tested an example of the same lens a few years ago, and didn't even get acceptably sharp pictures.

Secondly, measuring resolution, contrast and so on from a picture of a test chart tells you one thing — how good that lens is at taking pictures of a particular test chart from a particular distance.

So, you get a set of figures that help the reviewer to say something. To help you interpret them, most magazines rate them — excellent, good, indifferent, dreadful — and so on.

However, different lens angles (for any one format) tend to be more or less easy to produce. So the standards vary from one lens type to another. So, maybe an 'acceptable' telephoto lens would let you produce 16×20 in prints, perhaps an 'acceptable' wide angle would limit you to 15×12 in.

What can you get out of them?

Despite these aspersions, camera test figures or impressions are useful. If you have a series of tests (from over the years) made by one

magazine, you can get some impression of the relative performance of various makes. Any make that does consistently better than average is likely to *be* better than average.

So, if you really want 'the best' measured performance, a lot of research will give you a fair chance of finding it. Apart from summing up camera tests over the years, you may be able to get industrial information. For example, the Japanese Camera Institute publishes occasional comparison lists of the performance of Japanese cameras. (Incidentally, I don't suppose that one knowledgeable person in ten would guess which make came out top in most of the categories on the last figures I saw.)

Lens developments

In the past fifteen years, lens design has become computerized. First, that gave the richest manufacturers an advantage. Now, practically all of them use computers. This means that lens designs are almost equally good from all the serious manufacturers.

A measure of the theoretical advance can be gauged from the fact that a lens described in 1964 as 'one of the best in the world' was described ten years later as a 'moderately priced lens of moderate performance'. The manufacturer has now introduced a new set of designs, which are described as 'nearly equal to the best respected names'. I think this says more about reviewers than about lenses. Once a camera is established (by its price?) as not quite among the best, it rarely gets the praise that may be its due.

Multiple coating

The most heralded 'improvement' to lenses has been multiple coating. From the advertisements, and from some reviewers' comments, you would think that you just can't take pictures without it. However, people have been taking photographs for the previous 130 or so years without it. In fact, for the first 100 years, lenses were not coated at all.

Multiple coating does reduce (but not eliminate) the obvious flare you induce by taking pictures with a bright light in your picture area. It lets you take acceptable pictures without a lens hood in some conditions of off-axis lighting – but, it does not obviate the need for a lens hood.

You can take perfectly good pictures without multiple coating. However, it is useful in extreme conditions – with a bright light shining into the lens, for example. Also, because less light is reflected, more reaches the film. The difference is hardly material in normal lenses of up to six or seven elements. However, in zooms, ultra-wide angles, and other lenses with multitudinous elements, the effect is striking. In fact, multiple coating is essential in some of the long-range zooms used in movies and television. It has been applied to some elements of these lenses for the past fifteen years or so.

Contrast

The main thing that multiple coating does in most pictures is reduce overall flare. That flare is something you can't see – it simply reduces the contrast in your picture. Such flare is present in all images, especially from high contrast subjects. By reducing it, the coating increases image contrast. As contrast is intimately connected with performance testing, that can give a lens a greater measured performance rating.

Unfortunately, most pictures that most of us take have too high a contrast anyway. By reducing the contrast, overall flare can improve sunlit pictures; so much so, that it can increase shadow detail to a marked extent.

The main counter to excessive contrast is to choose a low contrast emulsion. That is not too easy; films each have a number of interrelated characteristics. So you may have to accept increased grain, or a slightly different colour balance if you want low contrast.

The other counter is to use low-contrast lighting. If you can, fill the shadows of any side-lit subject. You can do this with near subjects – such as portraits. It is not possible with distant shots. Two methods are available: reflect some of your main light (with a white sheet or similar article); or add extra light.

Fill-in flash is the most popular solution, but needs considerable experience. There is more about it in the *Focalguide to Lighting*.

Close focusing

Not long ago most lenses focused down to somewhere around 10× their focal length. More recently, many standard and wide angle op-

tics have gone closer, to about 5× or so. With shorter focus lenses, the limit is determined by picture quality. With longer ones by physical limits on focus travel. In fact, specially mounted small aperture standard and long focus lenses allowing much closer focus are commonly available as 'macro' lenses.

Technology from zoom lenses has led to a new generation of close focusing or 'macro' lenses. The first were zooms which made use of their already movable elements. Now you can get the same effect with long-focus lenses. These types are both excellent for close ups. Similar technology – floating elements – applied to the most exclusive wide angle lenses has revolutionized their close-focus performance.

Mechanical developments

While quite small defects in your lens can spoil your pictures, the shutter and diaphragm need be nowhere near so carefully constructed.

A mechanical shutter that gives you speeds within ten per cent of the marked figures throughout the range is doing well – *as long as they are consistent*. You will never notice the deviations. However, some modern top-range cameras now have electronically-controlled shutter speeds. These are more accurate and consistent. Sophisticated versions have not been around long enough to tell if they are as reliable as spring-timed shutters. These often last for upwards of 50 years.

Diaphragm errors are easier to eradicate, and need no special developments. In fact, modern manufacturing techniques have tended to reduce the number of diaphragm leaves and thus the accuracy with which they form a *circular* aperture. This has happened even on the most expensive lenses. The shape of the aperture has little effect on picture quality, except at tiny settings.

Do you really need the latest?

The way most cameras are advertized, you would think that all their features were absolutely essential for taking almost any pictures at all. That is obviously not the case. Otherwise no other cameras would work.

If you accept its inconveniences, you can take perfectly good pictures on any reasonably well made camera later than about 1870. You may have trouble with materials for earlier ones. If you want to shoot a modern roll or cassette film, you are confined to cameras made in this century. However, a 1926 Leica or a 1929 Rolleiflex will still give you *excellent* pictures. For all normal scenes in colour or black and white, you won't be able to tell the difference between them and their modern equivalents.

However, in adverse lighting, the performance of coated lenses is undoubtedly superior; and lenses made with colour in mind are truly neutral in tone. Some older lenses introduce their own pale colours into pictures. Also, the performance at wide apertures is considerably improved by multiple-element (more than 5) designs that coatings made popular. For example, the Zeiss Planar design was overshadowed for 40 years by four-element triplet derivatives (Tessar, Skopar etc.) until coatings became available.

Mechanically, though, there is nothing to choose between early Leicas, Contaxes, Rolleiflexes and so on and their modern equivalents. Only in SLR designs have the developments – automatic diaphragm, instant return mirror, pentaprism, through the lens metering (see pp. 79, 89, 117) and so on really made life easier. If you want an SLR you certainly want a modern style one, just for convenience.

Built-in meters and automatic exposure are also important conveniences of more modern cameras. They too, are well worth considering. But even these facilities don't actually affect the picture *quality* possible.

Do you need the best?

So, it's nice to have the modern simplifications, but they are nowhere near essential for picture-taking. What about top-cost options?

Basically, within any category, you get what you pay for. However, virtually any camera can take reasonable pictures. Most slightly sophisticated ones take excellent pictures.

With increasing cost, you pay for three things: the latest optical standards; mechanical durability; and quality control.

Optical standards certainly are improving. Lower-cost manufacturers produce lenses at least the equal to the top-quality optics of but a few years ago. Top quality lenses are amazing. However, the im-

provements are discernible only through scientific measurement, or in extreme conditions. For example, if you want an 85 mm lens to use at *f*1.2 you have to buy the best to be sure of really sharp pictures when you expose at full aperture. Nevertheless, if you just want a lens to use at about *f*5.6 to *f*11, you will never tell the difference between the best and any other reasonably well constructed lens.

Naturally, if you just have little prints made from your negatives, virtually any lens will do. Neither that nor projecting slides on a domestic size screen stretches the capabilities of most cameras. In fact, few projector lenses can match even average good camera lenses. On top of that, most slides are somewhat bowed, so no normal lens can focus them sharply right across a screen. The only real test of optical quality is making really large prints. Only if you do that do you need anything approaching the highest quality lenses.

If you do opt for optimum quality, the choice is wide. A few makes are known for having slightly lower than average contrast. I would certainly choose one of these. I think they take *nicer* pictures.

Mechanical durability is a problem. The best and most famous cameras are made to last a professional for years. In fact, the only professional likely to wear one out is a 'walkie' beach or street photographer. Treated reasonably well (i.e. *not* put away for months on end without use), such a camera will last several generations of amateur photographers. For example, one manufacturer boasts of having made one million exposures in a single camera.

So, for all but the most dedicated, top professional cameras are 'over-engineered'. If you take 100 or so rolls of film a year, almost any medium-priced camera will outlast you. If, like most of us, you take even fewer pictures, you are unlikely to wear out any camera.

You might, however, break one of the cheapest. Some have rather soft gears that don't withstand rough handling. Also, you might suffer a mechanical breakdown. If the thought of that worries you, choose a well-known branded make. You will then have slightly less chance of a breakdown. Don't pressume, though, that any make can guarantee perfect operation. Every make can suffer. But it is usually easier to get better known makes repaired.

Certainly, for most people, moderately-priced cameras are quite durable enough. Within any particular category, there is little to choose between makes. In fact, you find that in some places one make is lauded, in others, the same make totally disregarded by virtually any 'serious' commentator.

Quality control is much more nebulous. You can get an appalling

camera from virtually any maker. However, the more you pay for a particular type of camera, the less likely you are to get a 'lemon'.

When you buy a new camera, test it. Any camera should give you sharp, properly-exposed pictures. If you operate yours *correctly* and still get blurred pictures, or badly-exposed ones, go straight back to the dealer. Be prepared to be told that it is your fault. If you are sure it isn't and the dealer won't accept that, buy a film, have the dealer load, expose it there and then, and process it. That should sort out the problem. In most countries, the retailer is responsible for replacing any defective goods he sells. It is up to him to approach the manufacturer or distributor for restitution. However, you often find it is quicker and more pleasant to deal directly with the distributor over guarantee claims.

The real quality-control effect is that lower-cost manufacturers accept wider tolerances of performance. Nevertheless, for all ordinary purposes, the standards of even moderately priced equipment are more than adequate.

Camera quality and picture quality

There is one little point to think about. On the whole, people with top quality cameras *do* take better pictures. That is to some extent because they know that they have a superb optical instrument. So, if their pictures don't come up to scratch, they can't blame it. They must take all the responsibility themselves. That way, they concentrate more on the important parts of picture-taking to the benefit of their photography. Once you accept that your camera (whether expensive, famous, or not) *can* take really good pictures within its limitations, you too can concentrate on making pictures.

Nationality

Cameras are made in many countries. Most of the famous 'precision' cameras come from Japan or Europe (East or West); East European cameras tend to be less attractively finished than the others. West European ones are mainly more 'hand-crafted' than Japanese products. In general, West European cameras have the best quality control, and East European ones the worst. The difference is more than compensated by the prices.

There is another nationality consideration. Many companies set up overseas factories. On the whole, such factories are not *quite* as good as their parent ones, but they do allow famous names to maintain realistic prices.

Which camera?

If you've ploughed through this lot, I hope it has been useful. Still, you have got to decide what is right for you. To sum up, here is a short resume of the main considerations:

Film size – determines what you can do with your pictures: 110 is fine for pocket prints or small screens; 35 mm is an excellent compromize for the slide photographer; it also lets you make excellent prints for decorating your walls; 120 is almost essential if you intend to make really large exhibition prints; it is great for portraits and scenes, but the cameras and accessories are big and expensive.

Basic camera features – determine when you can take pictures. The simplest restrict you to bright sun. Greater ranges of shutter speeds and lens apertures let you extend the lighting: with five-symbol cameras to any reasonably bright daylight, with more complex models to any type of light you can see by, and with the most sophisticated even to darkness.

Coincidentally, these advances also let you control whether various parts of the picture are sharp or not.

Accessories that you can fit determine the range of pictures you can tackle: flash lets you take indoor pictures easily; interchangeable lenses let you choose your picture angle; various accessories let you take pictures of tiny subjects; and so on.

Camera type determines the ease with which you can take pictures: rangefinders make focusing easier; reflex viewing makes it simpler still, and single-lens-reflexes are ideal for interchanging all manner of accessories.

Modern developments determine the convenience of your camera: a built-in meter saves you carrying a separate one; automatic exposure saves you having to set the controls; motor drives save you winding on; automatic diaphragms, instant return mirrors and full-aperture metering make recent SLR viewing as straightforward as possible; and the latest optical designs and electronic shutters give you amazing picture quality at all settings.

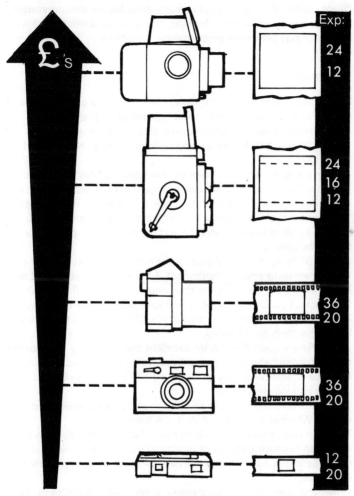

Exp:

24
12

24
16
12

36
20

36
20

12
20

Five basic camera types. Cost relates directly to versatility. Roll film single lens reflex represents the ultimate sophistication in a hand camera. Twin-lens reflex is much more restricted, but offers high quality results at reasonable cost. 35 mm single-lens reflex gives all the picture quality most of us need, with extraordinary versatility. 35 mm compact has far fewer accessories, but offers the same picture quality. For simple everyday photography, five symbol pocket camera is easy to use, and produces acceptable pocket-sized prints or small scale enlargements.

Quality determines what your camera looks like. It also determines whether it will last virtually for ever, and whether it will maintain its picture quality under the most adverse conditions.

'Best buys'

From there it's up to you. Basically, I feel that there are five types of camera that should appeal to most types of photographer:

Five-symbol pocket cameras are fine 'notebooks'. Good for snapshots, great for learning composition and so on. Not so good for big prints.

35 mm compacts are the choice for most people. They take excellent pictures. Automatic exposure and a rangefinder are desirable, but not essential. You need some control over the exposure if you want to tackle unusual shots. If you want to take pictures in any sort of light, but don't plan to buy any extra lenses or special close-up accessories, this is the type for you.

35 mm SLRs are the first choice for the enthusiast. They can be fitted with an amazing array of equipment. For low-cost choose a 42 mm screw-mount with stop-down metering – automatic if you want it. Otherwise, I prefer a bayonet mount with full-aperture metering. All 35 mm SLRs are reasonably well made. Choose on the features you like, rather than on the name.

120 TLRs are good if you want excellent picture quality. Choose the one with interchangeable lenses if you want other lenses. Because of the ease of achieving high quality, a 120 TLR is an excellent camera to start making prints from.

120 SLRs give the ultimate combination of picture quality and versatility. Whether 6 × 7, 6 × 6 or 6 × 4.5 cm.

They can draw on a considerable range of accessories. Virtually all of them can produce pictures of quality as good as or better than the most fastidious could demand. They are proportionately costly and expensive.

When you have chosen your camera, concentrate on taking the best pictures you can with it. Don't just point it and press the button. *Look* carefully at the picture in the viewfinder before every shot. That way, you can take excellent pictures with the simplest equipment.

Camera accessories

Who Needs Accessories ?

When you buy a camera you may think you are fully equipped to take pictures, but the camera is only the beginning. There are accessories.

If you are a beginner and you are wise, you will have bought a relatively simple camera. That is the best choice because the number of additional items you can be persuaded to attach to it or use in conjunction with it, is limited. You are in the fortunate position of being able to learn how to use your camera without too many distractions.

For those who buy a more 'advanced' or sophisticated camera, escape is not so easy. Even if they buy it unseen in a box, they will soon be made aware either by friends or press advertisements or, eventually, by the instruction book, that they can fit wide-angle and long-focus lenses to it. They will learn that special close-up equipment is available and will almost certainly feel that a selection of filters is indispensable.

Then there is flash. It could cost nearly as much as the camera—and there are accessories for flashguns, too.

A tripod may not immediately spring to mind (although it soon will) but what about an easily portable camera clamp, baby tripod, pistol grip, or rifle grip for the long lens?

Can you really call yourself a photographer without a separate exposure meter, even though your camera is fully automated? Perhaps you should give a passing thought to a gadget for copying your slides and surely a look-around-the-corner angle finder is not a luxury?

If you travel you must have a case, holdall or bag in which to carry all your equipment. If you go abroad, you also want a special bag to protect your films from airport security X-rays.

There is an almost limitless supply of extras for all occasions. Do you really need all or any of them?

All-in-one cameras

There are a lot of very simple cameras that are designed to do the entire job. Most of the cartridge-loading cameras fall into this category. They make very good work of taking pictures in reasonable lighting conditions—which is all most camera users want. They are rarely designed to take any extra equipment beyond perhaps a flash unit and occasionally a filter and/or close-up lens.

Slightly more advanced models may even have those extras built in and cannot usefully be fitted with anything else.

Advancing a little further and also moving into the field of cameras that use 35 mm or larger film, there are fixed-lens cameras for which a rather greater variety of accessories is available. Still not a vast amount, however, because the lens cannot be removed from these cameras, and quite a lot of accessories are designed to fit behind the lens.

The ultimate of course, is the interchangeable-lens camera. These are now nearly all single-lens-reflex cameras—the type that use the camera lens to project the image on to the viewfinder screen, instead of having a separate little optical system above the lens. There are still one or two interchangeable-lens 35 mm cameras that are not SLRs but, in general, the relatively low-priced 35 mm camera is a fixed-lens type. If you want a camera that can take a wide selection of different lenses, you have to have a moderately expensive SLR. The interchangeable-lens non-reflex camera can be fitted with only a limited range of alternative lenses.

It is the SLR and mainly the 35 mm SLR that attracts the major efforts of the accessory manufacturers.

System cameras

Interchangeable-lens cameras are often called system cameras because the ability to remove the lens and replace it by another optical system means that the camera can be used for almost any type of photography. It can be used in conjunction with extension tubes or bellows to allow the lens to focus closer than its built-in mechanism allows. It can even dispense with the lens and be fitted to a microscope to provide greatly magnified images. It can also be used on giant telescopes.

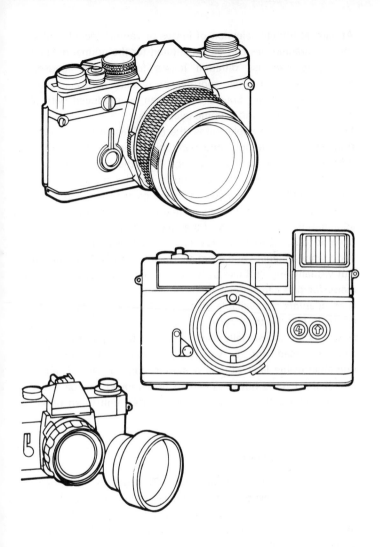

The single-lens reflex is easily recognized by the characteristic hump formed by the pentaprism. These cameras invariably have interchangeable lenses. Most cameras with viewfinders independent of the lens have just one lens that cannot be changed. A few SLRs have lenses with a fixed rear component and interchangeable front components.

An almost infinite selection of lenses of various focal lengths and other characteristics can be substituted for the normal or standard lens. You can use different lenses for portraits, landscapes, architecture, long-range sporting or wildlife subjects, cramped interiors and so on. Special effects can be produced with ultra-wide-angle lenses and extreme telephotos.

For most of these applications, the reflex design is essential. The non-reflex just cannot cope with the focusing and viewfinding difficulties of too radical a change from the normal or standard lens. The reflex design allows you to see the image projected by whatever optical system you fit to the camera, whereas the non-reflex has to have a different viewfinder for each lens or a means of adjusting the angle of view of the built-in finder.

It could be said that the true system camera is that for which a wide range of lenses and other accessories is specifically designed. But virtually any SLR can be a system camera because accessories made for one camera can often be adapted to fit another. Many such adapters are available off the shelf; others can be specifically made. In fact the term 'system camera' has no real meaning, but it serves as an occasionally useful label for the type of camera that can be used for a variety of photographic tasks. Any interchangeable-lens SLR is a system camera. No camera from which the lens is not designed to be removed can be a system camera; although it may be one specialized unit in an otherwise integrated system.

The need for accessories

Are your accessories really necessary? This may sound flippant but it is a serious question. Manufacturers will produce anything they think the public can be persuaded to buy. If you think that is an overstatement, remember the camera with a built-in radio—first offered in the 1960s.

Over the years manufacturers have done such a good job on filters that many a beginner has bought a camera and immediately asked the salesman 'What filters do I need?' Filters probably provide the outstanding example of unnecessary accessories. Of course, they have very real uses and no photographer concerned with the truest

possible rendering of colours in garments, threads, textiles, etc. would be without his personal collection. But filters are sold in unbelievable quantities every year and it is a safe bet that a very large proportion of them are rarely, if ever, used.

Let us go to the other extreme and think of an accessory that is rarely used but should, in fact, be used much more. There are one or two candidates: lens hood (more for protection than its intended use) and, for the same reason, lens cap; tripod and its associated cable certainly. Beyond that it is very difficult to think of anything—except the shutter release finger, the most useful accessory of all. A lot of the time spent in amassing accessories could more usefully be spent in taking pictures.

Perhaps that is too cynical a viewpoint. Many accessories have a definite use and are invaluable for their particular purpose. If your photography involves a lot of extreme close-ups a set of extension tubes, or even a bellows unit is essential. Conversely, if you habitually find it necessary to shoot at relatively long range, you must have a lens of longer than normal focal length. In either case, and certainly in the first, you need a tripod and, preferably, a cable release. If you have a tripod, then you really should have a quick-release shoe—and so on.

How to choose accessories

When you buy an interchangeable-lens camera, you virtually commit yourself to buying accessories for it. There is nothing wrong with this, provided you first encounter the need for the accessory and then go looking for it, rather than vice-versa.

The need generally arises only when you habitually take pictures that call for a particular accessory. If you only occasionally take a close-up photograph it might make more sense to buy an inexpensive supplementary lens and improvise a camera stand, rather than invest what could be a really large sum of money in bellows, focusing slide, tripod, copy stand, macro lens, etc. For the occasional long shot, a tele-extender might make more sense than a telephoto lens or, with care, you can even manage with selective enlargement of part of the negative. A power winder makes little sense for everyday photography but is very useful for remote control work.

A clear pattern emerges. For everyday photography, in the fields, perhaps, of portraiture (even glamour) landscapes and scenics in general, shots of friends and relatives, their children and pets, general human activities at work and play and the hundred and one other subjects that make up most of the photographs taken every day, accessories are rarely necessary. Sometimes, admittedly, you might prefer a lens of other than the standard focal length. You are unlikely to need much more. For the specialist, exactly the opposite may apply. He often needs a particular accessory or range of accessories to enable him to do his job efficiently.

The system camera is designed to cater for specialist needs as well as everyday photography. The specialist item may be no more than a single extension tube. Or it might be a whole range of sophisticated equipment allowing the camera to focus, zoom, pan, tilt, assess its own exposure and take the picture from an almost endlessly remote location. Between these limits there are items for nearly every eventuality, and some that seek to create a use where none may have previously existed.

So once you have established a need for an accessory how do you go about buying it? The camera manufacturer will tell you that only his own products are suitable for his camera. That is rarely true and many camera manufacturers, particularly those using the popular 42 mm screw thread, actually rely on independent manufacturers to produce accessories that they themselves do not supply. The same independent manufacturers supply camera manufacturers with accessories that are then sold under the camera name.

You do have to be careful with some items. Despite attempts at standardization, there are still a lot of different methods of attaching lenses to cameras. Items that attach to the camera lens mount, therefore, tend to be unique to a particular camera. Independent manufacturers offer suitable products and they are often as efficient as the genuine article. Sometimes, however, they do not couple with all the automatic workings of that particular camera. If your camera has complicated electronic gadgetry, it might be as well to make careful enquiries before buying a lens-mount-attaching accessory of another make.

This applies specifically to lenses, of course. It is rarely an insuperable problem with such items as bellows and extension

tubes. Despite the many so-called automatic bellows units available, few use anything more automatic than a double cable release or similar external coupling. Even fewer maintain full-aperture metering or any of the other sophisticated functions of some camera-attached lenses. In the circumstances in which bellows and tubes are used, such refinements are rarely of any particular value. The independent manufacturer's product, often a great deal less expensive, is generally perfectly satisfactory.

That is not however, a recommendation to buy the cheapest item available. In most cases, you get what you pay for and some accessories are very easy to make—badly. Lenses, bellows, tripods, filters and slide copiers are among the products that are available in relatively inexpensive versions. But by saving money you could easily be wasting it. A tripod with spindly legs or locks that need to be fastened with a wrench is likely to give worse results than if you supported the camera on a pile of books. If you cannot examine the product before you buy it, stick to the well-known names and be prepared to pay more than at the lower end of the market. If you have a real need for the product it must do its job well. If it does, the extra money is well spent.

Choose your accessories with as much care as you put in to choosing your camera. Most people recognize that there are vital differences between one camera and another: vital to them, that is, whether because they have small or large hands, or poor eyesight or because they have a particular need or preference. The same applies to many accessories. It is how they measure up in use that counts.

What You Can Do with Filters

The number of different lenses that you can attach to your camera can cause some confusion. As they are rather expensive, however, lenses are not often bought on the spur of the moment. Economic considerations impose a certain amount of thought. On the other hand, there is an extraordinary range of lens attachments on the market and many of them are moderately inexpensive. It is easy to be persuaded that they are essential.

What are filters for?

If you want the complete answer to that question, read the *Focalguide to Filters*, which points out the genuine uses of filters for those who have a real need for them. Here, we are confined to basics and to showing that the possession of a fine collection of filters should not become an obsession.

Most camera filters are coloured—dyed in the mass glass. Some expensive types consist of gelatin in a glass sandwich. The colour of the filter modifies the colour of the light reflected from the various parts of the subject before it passes through the camera lens to the film. With a yellow filter, for example, the effect is rather as if you were looking at the subject through a sheet of yellow glass, or as if you had put a yellow wash over a colour painting of your subject.

In a colour picture the yellows, reds and mixtures thereof, might not be very affected, but the blues, some green and other colours containing blue, are darkened and rendered very impure. That is not a desirable effect with most colour pictures but it has its uses in black and white.

Black-and-white film is panchromatic, i.e. it reacts to light of all colours. It does not reproduce the colours but it darkens according to the brilliance of the light. So a yellow filter, by its different effect

on different colours, changes the relative brilliances and hence the tonal rendering of the subject. A brilliantly blue sky reproduces darker through a yellow filter than if the filter had not been used, while no noticeable change takes place in other parts of the subject not containing blue.

All coloured filters work on the principle of selectively absorbing light of certain colours. The effect is most pronounced with colours furthest apart in the spectrum. As the spectrum of white light runs through red, orange, yellow, green, blue and violet, it is readily seen that yellow has some effect on blue, while red and orange have a greater effect, and vice-versa.

Filters for black-and-white

So the main function of coloured filters for black-and-white photography is to alter the effect on the film of coloured subjects, thus 'falsifying' the tonal rendering. That can be necessary for various reasons but more often than not in order to separate subjects or parts of a subject that are similar in brilliance but different in colour.

White clouds in a blue sky are a common example. Black-and-white films are a little over-sensitive to blue, seeing it as rather lighter than the eye sees it. Thus, clouds that are clearly visible to the eye sometimes appear much less well defined in a black-and-white photograph. Put on a yellow filter and the blue is held back somewhat and rendered darker in the final image. You can go further and exaggerate the effect by using a deeper yellow or orange or red filter.

Nevertheless, a filter is not necessary every time clouds and a blue sky appear in your picture. Modern films are quite capable of rendering cloudscapes satisfactorily without a filter. If you do not find that so, the probability is that you are overexposing, allowing the blue sky so much exposure that it 'catches up' with the white cloud.

In any case, you should not use a filter for such scenes without first studying the rest of the subject carefully. Blue clothing, flowers, paintwork, etc. will also be darkened, while yellow, orange and some red objects may be rendered in too light a tone. If you

use an orange or red filter for a really dramatic sky, some brickwork may go virtually white.

Therefore restrain your enthusiasm for filters and use them only when absolutely necessary. Flowers can sometimes benefit from the filter treatment when the tonal brilliance of the bloom is almost the same as that of the surrounding foliage. Lettering on coloured backgrounds may stand out well to the eye but need filtration to render it satisfactorily in black and white. Specialist tasks like photographing postmarks across coloured stamps or envelopes, faded and/or discoloured documents, tissue sections in microscopy, etc. often demand carefully controlled filtration to increase contrast, but day-to-day photography rarely needs it.

Filters, however good their quality, are just flat pieces of material. Used in front of the lens, as they normally are, they must affect image quality. The degradation may be minimal but it can take the edge off the performance of the lens. There is no point in that unless the filter is being used for a real purpose.

Filters for colour photography

There is even less reason to use filters in colour photography than in black-and-white unless you are after special effects. Their function is the same but in this case they affect the colour, as well as the brilliance, of the various tones of the subject. Consequently, filters for colour photography are very much paler in colour. The relatively strong filters used for black-and-white are usable only for effect. The weakest yellow filter, for example, would put a noticeable yellow tinge or cast over the whole scene.

Colour film, however, is sensitive to the actual colour characteristics of the light used for photography. It needs what is generally called white light which approximates to daylight in the middle hours of a sunny day with some cloud in the sky. In early morning and late afternoon, or when the sky is heavily overcast or exceptionally clear, the colour of daylight departs from the ideal and the colours in your picture can be distorted.

Often that is no disadvantage. If you are shooting a sunset you generally want it to look like a sunset, with a preponderance of yellow or red in the scene. You would expect some neutral, and

even flesh tones, to be tinged with the sunset effect. In dull conditions you may well wish the picture to show the dullness. At other times you may want to use a filter to offset these conditions. A bluish filter compensates for the yellow effect of sunset (or sunrise sometimes) and is often called a 'morning and evening' filter. It does not produce a morning or evening effect; it kills it. You use it on the rare occasions when you are shooting at these times of the day and wish to make it look as if you were shooting at midday. Similarly, you can use an amber or straw-coloured filter to warm up the tones of a scene in dull weather or in an excess of blue light.

The 'warming up' filter can, in fact, have many genuine uses. The palest is often called a 'skylight' filter and that gives a clue to its most valid use. Strong sunlight in a cloudless sky can cause too powerful contrasts for some colour pictures, notably outdoor portraits. In such conditions you could take your subject into the shadow of a building. That gives lower contrast but by cutting out the direct sunlight it leaves all the light to come from a blue sky. You may not notice it, but the film does, and your picture has a distinct cool-colour effect. A skylight filter can make a noticeable improvement. Some photographers regularly use a slightly stronger salmon filter on dull days to relieve the rather strong blue-green that sometimes appears in these conditions.

Ultraviolet filters

Some colour workers make much ado about the use of a UV filter—ultra-violet absorbing. Ultra-violet is a 'colour' beyond the visible end of the spectrum. It cannot be seen but both black-and-white and colour film are sensitive to it. It is most noticeable in colour as it causes a blue colour cast similar to that from sunless skylighting.

Ultra-violet radiation (we should not call it light, because it is invisible) is generally present only in very clear air. Being a very shortwave radiation it is easily absorbed by the tiny solid particles in the normal atmosphere and, as all lenses absorb a certain amount of ultra-violet, very little gets through to the film. In sunlight after heavy rainfall, high up in mountain areas or near

large stretches of water, however, the air is cleaner and ultra-violet radiation can be troublesome.

Again, don't rush to the filter. A bluish tinge to mountain scenery is not at all unexpected. When it is too strong a UV filter can be helpful but you may well find that your camera lens absorbs quite enough of the UV to make a satisfying, only slightly blue picture. If you use a skylight or darker salmon filter that also absorbs UV, you do not need a separate UV filter as well. Colourless, the UV filter has no effect on visible colours but it restrains the over-blue effect of the ultra-violet, sometimes effectively reducing blueness in complexions and other lighter colours in colour photography. It generally has little effect on the distant blue haze in landscapes, however. That is more likely to be caused by the scattering of visible blue light by the atmosphere and is more effectively treated by haze-cutting orange or red filters in black-and-white, or amber filters for colour.

Polarizing screens

The usefulness of a single polarizing filter or screen is somewhat overplayed. Polarizing material is made from a special type of material that acts like a slotted filter, transmitting only those light waves that vibrate in the direction of the slots. Light polarized in one plane can thus pass fully through the filter only when the slots are correctly oriented.

The theory is fine. Some light—notably that reflected from glass and some other shiny surfaces—is plane polarized, but only when the light falls on it (is incident upon it) at a certain angle. Shoot from that angle (the angle of incidence is equal to the angle of reflection) with a polarizing filter rotated so that the slots are at right angles to the plane of polarization and no reflections can get through. Ordinary (random) light from the scene passes relatively unhindered but the reflections are stopped.

Shoot from any angle other than this perfect angle and the polarizer has less and less effect until, when you reach the normal (at right angles to the reflecting surface) it has no effect at all. There, you can eliminate no reflection, which makes the polarizer hopeless for square-on photographs of shop windows, paintings

under glass, etc. It is not even a lot of use to photograph oil paintings at the seemingly correct angle because reflections from the uneven surface come off at all angles.

Again, polarizing screens have legitimate uses, but mainly in pairs. One polarizer can be used to polarize all light passing through it, and another to control the amount reaching the film. We come to that shortly. You can use large sheets of the material to polarize the light from one lamp and light only part of the subject with it, and so selectively control subject lighting. With more sophisticated equipment in photomicrography you can set up specialist treatments of stress and structural photography that can also be turned into interesting abstract patterns—but that goes beyond the scope of this book.

A marginally justifiable use for the polarizing screen is that involving landscape or other photography that includes significant areas of blue sky. On a cloudless day you may often notice that part of the sky looks a much deeper blue than the rest. When you photograph into that blue colour, however, it tends to come out far less dramatically than you expected. That is because films are more sensitive to blue than the human eye. The polarizing filter can help because that very blue skylight is to some extent polarized by reflection from tiny moisture droplets in the atmosphere. A suitably oriented polarizing screen can cut out some of that polarized light and thus restore the deep blue that you see.

The particular advantage with colour films is that there is no effect on any part of in the scene.

Polarizing screens, like UV filters, can be used with black-and-white or colour film. The effects are similar but tend to be more dramatic in colour.

Neutral density filters

Neutral density only means density without colour. So neutral density filters can be used with both black-and-white and colour films. Their function is simply to reduce the amount of light reaching the film.

This is the filter that perhaps has the greatest justification for its existence and yet is the least often used. It has various applications

Random light (*top left*) radiates in all directions and passes almost unimpeded through a polarizing screen no matter how it is oriented. Perfectly plane-polarized light (*middle*) cannot pass through the screen oriented as immediately below but passes freely when the screen is rotated through 90 degrees. The more practical strongly polarized light (*right*) is strongly impeded by the polarizer in the first position but passes relatively freely when the screen is rotated through 90 degrees.

that are mostly related to its function as a substitute aperture control. You may remember that a mirror lens generally has no iris diaphragm because the central part of the lens is used for reflection. You cannot control light transmission by the normal aperture control so you use neutral density filters. Sold in 2X, 4X, etc. designations, they reduce the light transmission of the lens by one stop, two stops, etc. and demand a corresponding increase in exposure time.

The increase in exposure time can also be useful with ordinary lenses. It has been used to eliminate moving traffic from daylit scenes. Really heavy filtration can bring about so long an exposure that moving objects do not even register on the film. More usefully, an ND filter allows you to adapt a very fast film to bright sunlight shooting. Normally, you would be confined in those circumstances to working at small apertures, perhaps with much more depth of field than you want. By reducing the light transmission, you can shoot at wider apertures and regain the required depth of field control.

Special constructions

Filters were originally introduced for corrective purposes. Early films left a lot to be desired in accurate colour rendering. It did not take long, however, for photographers to realize their creative value, particularly in colour photography, where various effects can be obtained by juggling with colours and image quality. Heavy filtration can render images in monotone or close to it. Couple that with image modification techniques and the possibilities begin to show. As always, there is a danger of overdoing it, but interesting and valid effects can be created.

There are some filters and filter systems that are designed with such creative work in mind. One type is a special construction containing a fixed-position colour filter bonded to a polarizer, and a rotatable polarizing screen. As one polarizer is rotated relative to the other, light transmission is changed to vary the density of the filter. Thus it appears to become of a lighter or darker hue, by merely reducing the amount of light reaching the filter. It is necessary, however, to increase the exposure time or use a wider

aperture to obtain a correctly exposed film. These filters are for black-and-white photography only and are available in six colours at a price a great deal higher than that of ordinary filters.

A variation primarily for colour photography may have a little more validity. This, too, works by polarization but it seems to use narrow cut filters of the complementary colours to leave only two of the three primary colours to pass through the construction.

The relative content of these two colours can be varied to give an overall subject illumination between, for example, red and blue. At the same time, the polarizers can work on reflections, and the interesting part is that the reflections are coloured at one extreme or the other of the colour range according to their plane of polarization. Turn the polarizer or the camera and the colour of the reflections is reversed. Various odd effects can be obtained but trial and error seems to be the recommended method of obtaining either effect or exposure.

A less dramatic but perhaps more often usable effect is obtained from partial filters. These, too, are rotating types allowing the filter to affect only part of the scene but they include neutral density to give shaded colours that are peculiarly attractive. The colour effect is not drastic and the filters are available in relatively subdued colours.

Double polarizers are another effect filter that can have valid uses, but more commonly in movie work than in still. A double polarizer, allowing one to be rotated in relation to the other has the effect of absorbing light in a smoothly controllable fashion. They are therefore useful to introduce fade-out and fade-in effects with movie cameras. They can be used for still photography in a similar manner to neutral density filters, with the advantage that only one is needed for a range of densities.

Most of these effects are obtained by combinations of filters and it is surprising that it took so long to come up with a system that made it possible to combine orthodox filters and many others in a single unit. This has now been done by using the existing lens filter thread merely to attach an auxiliary filter holder that can accommodate two filters or screens and allow them to be moved independently.

The filter holder can be attached to any lens with a 49, 52, 55 or

58 mm thread. The special filters designed to go with it compare very favourably in price with normal filters, many of them being much cheaper, and the range at one's disposal is truly extensive. The effects that can be created are so numerous that there is no space to describe or even indicate all of them here.

Naturally, the normal range of filters for black-and-white and colour photography are available, together with starburst, multiple image, diffusion, fog effect and polarizing attachments and many others. There are mask attachments for combination printing, frame masks and an extraordinary 'linear shutter' allowing you to produce elongated, misshappen pictures over two or three film frames.

The filter holder has two slots in which filters can be rotated and moved up and down. The filter holder itself also rotates on its mount so that virtually any filter and screen combination can be created.

Choosing filters

When you first buy your camera, there is no need to quiz the shop assistant on the necessary filters. None is necessary but he may very well try to to sell you at least a UV filter 'to protect your lens'. It might do that, but a dirty filter has more effect on image quality than a dirty lens.

As you begin to take photographs, the need for one or two filters may emerge. A haze or skylight filter certainly has occasional uses. If you do much landscape photography in black-and-white you may well want to have a yellow filter handy on occasions to emphasize a cloud effect. Architecture, more often the steel and concrete type, can sometimes be made more dramatic by overdarkening the sky with an orange or even red filter.

The reddish colour of tungsten lighting could make lips a little pale and a weak green filter might improve matters. But it might also emphasize skin blemishes. Make-up is a better solution.

If you go on to specialize, filters are a help in some cases and almost essential in others. Really careful colour correction can be necessary in catalogue work. Often, you can reproduce a particular limited range of colours almost perfectly, but have to sacrifice

A proprietary filter system depending on an attachment for the lens (*bottom*) into which filters, screens and masks can be slotted. Two filters, screens, etc can be used simultaneously.

others. Sometimes you might falsify colours deliberately, as in some medical work where the actual colours are unimportant but the clear rendering of some features is essential.

When you reach that stage, you need a very clear understanding of all principles involved and a collection of filters specially designed for this type of work. You need to study something like the *Focalguide to Filters,* with its more specialized information.

Buying the filter or filters of your choice involves a judgment of quality and a knowledge of the fitting required. What quality should you look for? You may have a very expensive lens capable of superb definition and high contrast, coated to reduce flare caused by internal reflections, and 'colour-corrected' to perfection. It is just as well to reduce the harmful effect of the filter as much as possible.

That rules out buying filters from the used bargain box—at least without the most minute inspection. Preferably get the best possible quality. That may mean the most expensive—excluding the generally overpriced camera manufacturer's brand—but there is little point in pennypinching here.

Should your filter be multicoated? If you believe implicitly in the multicoating of your lens then you will not want two more reflecting surfaces. On the other hand, what is the effect of two different multicoating techniques? There are no clear-cut answers, possibly because it is not easy to prove them. A good quality filter, coated or not, should have only a marginal effect on the quality of your image. It should not show up too often but flare and extra fall-off could become evident when shooting into the light, or at large apertures. The filter is flat and is generally right out at the front edge of the lens, so there may be a case for a lens hood. Conceivably that could be a better answer than multicoating.

Most filters are supplied in circular form with a male-threaded rim to screw into the front of your lens. That is the filter thread, sometimes marked on the lens rim, usually quoted in the camera instruction book, and measurable on modern lenses with reasonable care.

There have been many threads over the years but modern lenses tend to use a reasonably wide-spaced standard range; the most popular sizes in which are, in millimetres, 49, 52, 55, 58 and 62.

That is the internal diameter of the thread on the lens. There were intermediate sizes, however, and if you have any difficulty in determining your thread size, take the camera to a dealer and get it confirmed.

Lenses for non-reflex cameras are frequently smaller and 40.5 mm has been a popular size. Some of them, and some older lenses, have no filter thread. For those a push-on or clamp-on fitting may be needed. Again, take the camera to a dealer and try whatever fittings he offers before paying any money.

Other Attachments for Lenses

The filter thread of a lens accommodates not only filters but a variety of other attachments that can be screwed into this useful thread. One of the most notable is the close-up or supplementary lens, but that is dealt with in a separate chapter on close-up equipment.

Effects lenses and screens

One of the earliest of the 'special effect' attachments for lenses was a so-called soft-focus lens. It was fashionable at one time, particularly in formal portaiture and movie work, to subdue the occasional cruel sharpness of the camera lens. It was thought unkind to emphasize lines, creases or other skin blemishes. It is possible of course, to slightly defocus the lens so that tiny lines and marks are not resolved but the result is simply an out-of-focus picture.

The habit arose, therefore, of putting something in front of the lens to effect a slight scattering of the light rays before the lens could do its cruel work. This effectively obscured fine detail, particularly the sharp edges between masses of different tone, by spreading the lighter tone into the darker. Small marks disappeared and shadow edges were softened, but the picture was still essentially sharp. The effect came to be known as soft-focus and the attachment as a soft-focus lens.

A soft-focus lens can be created in various ways, the simplest being to engrave concentric lines in a disc of glass placed in front of the lens. If the central area of such a disc is left clear, the degree of softening can be controlled by the lens diaphragm. A wide aperture uses most of the softening rings. A very small aperture might use none of them.

A similar effect can be obtained merely be spreading a thin layer of

petroleum jelly over a UV filter or other clear glass disc. At the other extreme there were camera lenses specially made for soft-focus effects. A common practice was to insert a perforated screen in the lens, again with a 'hole' in the middle so that the effect could be controlled by the aperture setting.

The soft-focus lens is not now so popular, most photographers seeming to prefer low-contrast lighting or deliberately-induced flare, but other types of effect attachment developed from it. Probably the most popular, and therefore the most over-used, is the starburst type. A pattern of lines engraved at right angles on the disc instead of concentrically has little effect as a softener but causes small highlights to take on the long streaks of stylistic stars. A square grid gives four points. Put in an extra line to cut the squares into triangles and you get six points. A later development for colour work contains a very large number of lines that use diffraction effects to produce coloured patterns in small highlight areas. Starburst effects can add appeal to some subjects, particularly night shots in wet weather, disco-type lighting and so on. Over-use can soon nullify the effect, however.

Rather more elaborate is the multi-image lens—a faceted lens ground with various faces at different angles instead of one smooth curve. The result is a number of different images of the subject blending one into another. There are many types of multi-image lens, with the images varying in number and pattern. The effect can be striking in movie work for mood creation, continuity breaks, publicity shots, etc. but the applications in still camera work are limited.

The simpler attachments of this type are not too expensive but the faceted types cost rather more than they are really worth, especially in the larger sizes. Consider how many pictures you are likely to make with this type of lens. It is worth taking a long, cool look at its real value to you before rushing off to buy an effect lens. You can't put too many starburst or multiple images all over your pictures, as special effects soon become monotonous.

Auxiliary lenses

There are some more ambitious front-of-lens attachments about

which you should be even more cautious. We have already remarked that auxiliary lenses for wide-angle and telephoto effects that fit to the front of the lens are of doubtful value. Nevertheless, there are still a few on sale and they tend to be very expensive for what they offer. They range from very wide-angle types to wide-angle plus close-up, and wide-angle plus telephoto zooms. They often claim edge-to-edge sharpness, which is virtually impossible except at very small apertures and with absolutely first-class prime lenses. If you are tempted to buy one of these attachments, try to get it on a trial basis first. Except with the extreme wide-angle types, which do not claim optical perfection, the change in angle of view is generally so limited that it is hardly worth while.

Most of these auxiliary lenses are suitable only for reflex or other screen-focusing cameras, because they do not include separate viewfinders or focusing scales. This is the very type of camera that does not need them, however, because the much more efficient, behind-the-lens tele-extender can offer a greater magnification, and often at a lower cost.

There is no behind-the-lens wide-angle attachment but, again, some of these attachments are offered at a price that would buy a reasonable wide-angle lens of far greater versatility—and even more so on the used equipment market.

There is one exception to these strictures about front of lens attachments—the monocular. A genuine photographic monocular, and there are one or two, can give surprisingly good results. It attaches to the filter thread of the camera lens and multiplies its focal length by the power of the monocular. An 8×30 monocular therefore, converts your 50 mm lens to a 400 mm.

As always, there is a drawback. The front glass is only 30 mm in diameter so the maximum possible aperture is $f13$. In practice, light losses are likely to make it $f16$ or even smaller. Additionally, you can use the monocular for its normal distance-viewing purposes.

Round-the-corner pictures

One front-of-lens attachment that has had a lasting appeal is the mirror box arrangement that allows you to shoot at right angles to your line of sight when looking normally through the camera

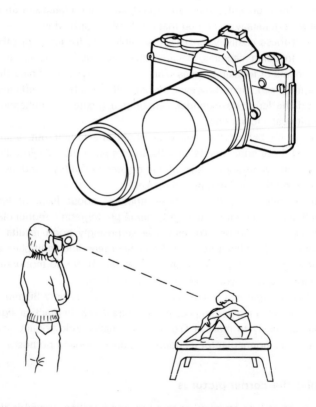

A right-angle attachment fits to the front of the camera lens. The tube houses an angled mirror allowing the lens to shoot through the hole in the side. The front of the tube is made to look like a lens.

eyepiece. It consists of a tube made to look like a lens but with a large opening in one side to throw the image onto a mirror and thence to the camera lens.

It has great appeal for the photographer who is wary of his subject's reaction to being photographed, or for the chronically shy. He can appear to be shooting in a different direction and hope that his subject does not notice the strange hole backed by a mirror in the side of his lens. It has some limited use also for unobserved shooting by allowing just the attachment to protrude past a wall or for periscope-type shooting in crowds.

The disadvantages are important but not crippling Naturally, the attachment is suitable only for screen-focusing cameras, which generally means 35 mm reflexes. You must be able to frame the subject, and the direct-vision viewfinder cannot cope with that. Equally obvious is that your shots are made via a mirror and are laterally reversed. You may find it difficult to keep a moving subject in view. When printing or projecting your results, you have to remember to reverse the film to turn the image back the right way round.

The angle of view is comparatively narrow so that for normal work only lenses of 100 mm focal length and over can be used for a full-frame image.

This attachment is moderately expensive and, again, do not be carried away by the apparent, rather than real, advantages. If you are completely unable to shoot strangers face to face, *and* you expect to do a lot of that type of work, then this gadget might help you. It is one of those things, however, that often turns out to be a good idea at the time, but subsequently languishes in a cupboard unused.

The case for lens hoods

Apart from filters, screens, lenses, etc. the filter thread of a camera lens can accommodate such obvious items as lens hoods and lens caps and a few less obvious adapter rings.

There are still those who are adamant that a lens hood (sunshade) is essential for all photography. The theory is that some light from outside the picture area passes through the front glass and,

because it cannot be bent back (refracted) sufficiently to form an image, bounces about inside the lens, taking advantage of all reflective surfaces therein to reach the film eventually as non-image-forming light or flare. So it does, but in most modern lenses, anti-reflection coating and internal baffling reduces the effect to a minimum. Whether it is desirable to reduce it even further is debatable. Super-efficient flare treatment can cause a lens to produce almost unmanageably contrasty images. This is fine for process lenses used in the graphic arts but it can sometimes be too much of a good thing in general photography.

The flare inherent in every lens can be regarded as a valid function. It does no more harm than to reduce contrast. Its total elimination would, in fact, reduce the speed of the lens—or film, whichever way you look at it. It would reduce shadow detail, and that is where true speed lies.

Apart from the effect of the anti-reflection coating, many lenses are protected from flare to some extent by being deeply recessed in their barrels. Not much light reaches them from outside the picture area. There are still many lenses, however, particularly wide-angle types, with large front elements protected by no more than a narrow bezel or rim. These can be subject to flare in certain cirumstances and it is worth trying the effect of a lens hood on them. The snag is that the wider the angle, the smaller and less efficient the lens hood becomes. A fisheye lens obviously cannot have a lens hood.

There is no lens hood that allows only image-forming light to reach the lens in all circumstances. To do that it would need to be tailored to every lens and to every focused distance, not to mention the format. Various types of 'professional' hood are available but it is doubtful whether they are any more efficient in most circum-stances than the normal tubular type.

A lens hood must at least be designed for the focal length of the lens. A 25 mm long hood on a lens with a 2 angle of view would be pointless. A 75 mm long hood on a lens with a 90 angle would certainly stop non-image-forming light but would produce a rather small circular image.

It is a matter of personal conviction and the shooting conditions, whether or not you use a lens hood. With bright lights just outside

the picture area and a lens you know to be subject to flare, a lens hood is evidently desirable, and you should always use a lens hood with such a lens. In normal conditions, especially with modern lenses, its value is questionable.

Despite that, a lens hood is a wise investment. A camera lens, particularly a large or long lens, is vulnerable to knocks and bangs as the camera is carried around. Its front surface also has an extraordinary magnetic effect on fingers. A lens hood provides very good protection against such mishaps and makes a lot more sense than a UV filter.

The case for caps

A lens cap is a wholly protective device, normally for the lens, occasionally for the meter circuit to avoid drain on batteries. It is wise always to attach a cap to a lens when it is not in use, even if it is stored in its case or a plastic bag. We might as well include the rear lens cap here too. That often serves to project pins and levers in the back of the lens as well as its function of keeping out dust and moisture. It should always be firmly attached when the lens is off the camera.

There are different opinions about front lens caps. On non-reflex cameras they are a nuisance at best and a disaster at worst. It is so easy to forget to remove the cap when you shoot unless you invariably use it and its removal becomes a habit. No such problem arises with reflex cameras and the habitual use of a cap makes sense. The trouble is that, after removing it for a prolonged shooting spell, you may forget where you put it. Then there is the question of the type of lens cap—screw, bayonet, push on, edge-catch, etc. The screw-type is the most secure but is fiddly. The genuine bayonet-type is rare and can also be awkward to use. Push-on types and some of those with push-in edge catches can easily be knocked off. The easiest, but most undesirable, answer is to forget about it. If you do decide to do without a lens cap, think of a hood, because lenses do need protection in use and while carrying them about.

Adapter rings

There are three main types of adapter ring for lens filter threads—coupling, reversing and stepping.

A coupling ring allows two lenses to be joined together by their filter threads. It has two male threads. The purpose of this is to allow a standard focal length camera lens to be used as a powerful supplementary lens when placed in front of a telephoto lens on the camera. This subject is dealt with more fully in the chapter on close-up equipment.

A reversing ring allows a lens to be mounted in reverse on the camera or on an accessory such as bellows or extension tubes. It has a male filter thread and a male lens thread or bayonet to suit the particular camera system. In practice, very close-range photography can often be carried out in this way without either tubes or bellows. Many lenses are deeply recessed in their barrels and are therefore well forward of the infinity position when reversed directly on the camera. They then have only one focused distance, however, except in some later lenses with internal focusing. On normal-focusing lenses operating the focusing ring can draw the lens into its mount to provide a degree of hooding.

A stepping ring converts the lens filter thread from one size to another. With lenses of two different sizes, you can buy a stepping ring to allow one size of filter to be used on both lenses. The adapter may be a step-up or step-down ring. A 58-62 mm adapter is a step-up type, allowing a 62 mm filter to be used on a lens with a 58 mm filter thread. It has a 58 mm male thread and a 62 mm female and is sometimes listed as M58-F62 to avoid all doubt.

Step-down rings allow smaller filters to be used on larger lenses which, with very large lenses can effect quite a saving in price. Naturally, they are liable to affect the maximum aperture of the lens and you have to conduct a few experiments to determine the extent of the effect. Step-down rings are usually quoted in the form 62-58, etc.

Matte box effects

If your camera has multi-exposure facilities (i.e. you can easily make more than one exposure on the same frame) you can create a

variety of special effects with a matte box and a selection of masks. Even without multiple exposures, you can make circular, oval or vignetted pictures directly in the camera.

The matte box is, in effect, a rectangular (usually square) lens hood and can double for that purpose without its attachments. The attachments consist of a mask holder and masks to fit. The masks can be split screen types, allowing you to put a different subject (or the same subject) into each half of the picture, various shapes for insets, banners or flashes, grids, jigsaws, etc. They need some care in use—the focused distance should be the same for each shot to avoid gaps or overlap—and their applications depend a lot on the ingenuity of the operator if the results are not to appear hackneyed. There are various commercial opportunities in wedding, portrait, family group and similar work.

Rear-of-lens attachments

Accessories to fit between the lens and the camera body are, not surprisingly, for interchangeable-lens cameras, but not necessarily only for screen focusing types.

Perhaps the most frequently encountered accessories of this kind are extension tubes and bellows, which are dealt with in the chapter on close-up equipment. The next most popular is the tele-extender or tele-converter.

The principle of the tele-converter is very old indeed. Astronomers used the idea to enlarge telescope images more than a century ago and it was subsequently adapted to cameras to provide the special telephoto construction.

A tele-converter is a negative (diverging) lens, unlike the positive (converging) lens on the camera. It works by lessening the convergence of the camera lens so that its image is focused further back. That in itself results in a larger image so the film receives only part of the image produced by the camera lens but on a larger scale. The converter is of such a length that the image is focused correctly on the film for the distance indicated by the focusing scale. That, incidentally, makes the converter usable on non-reflex cameras and makes it possible to couple it with a rangefinder. Most versions provide a doubling of focal length but 1.4X, 3X, 2 and 3X, and 2-3X zoom types are also available.

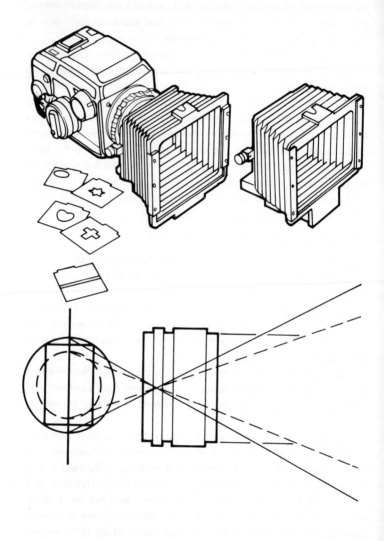

A matte box, also known as an effects box, available in 6×6 cm and 35 mm sizes. A wide variety of screens is supplied enabling various vignette, split screen, superimposition and similar effects to be obtained. Alone the box acts as a lens hood.
The effect of too long a lens hood (*bottom*) is shown by the broken line.

A good, modern tele-converter is a useful accessory for those who occasionally need a lens of longer focal length than the maximum they have available, and that must include almost everyone. They are said to work best with telephoto lenses but there is little convincing evidence on that point. The outstanding advantage of a tele-converter is that it needs little storage space but can instantly convert, a modest 135 mm lens to 270 mm or 405 mm.

The price for that convenience is a loss of illumination at the film plane, owing to the increased light path. The loss is equal to the square of the increase in focal length. With a 2X converter, you have a fourfold loss, resulting in the illumination at the film plane falling to one-quarter of its intensity without the converter. All the *f*-numbers on your lens should thus be doubled to restore their accuracy. A 50 mm lens with apertures from *f*2 to *f*16 becomes a 100 mm lens with apertures from *f*4 to *f*32. A 3X converter reduces illumination to one-ninth, so that *f*2 becomes *f*6. Tele-converters are available at various prices and it is fairly safe to say that the cheaper they are, the less likely they are to perform well. On the other hand, some are extremely expensive and there can be a reasonable doubt whether they are really worth that much more than middle of the range types. Certainly some of the earliest kinds were very poor. Now there are not many with fewer than four elements in their construction and a lot with six or more, with a consquent increase in picture quality. There are undoubtedly some that are well worth the cost for occasional use. If you intend to do a lot of work at the extended focal length, however, a not-too-expensive prime lens will almost certainly serve you better.

The only other rear-of-lens attachments, apart from close-up equipment, are lens-mount adapters. There is at present a tentative movement toward a certain amount of standardization in methods of attaching the lens to the camera but it is doubtful whether it can go very far. The Praktica M42 screw gained a lot of followers but is shortly to be deserted by its originators. Asahi have already left it and have managed to license their bayonet to a few other manufacturers but it is unlikely that the famous names will change their established designs in the cause of standardization. As electronic control is extended such a move should be possible and would be of undoubted consumer benefit but would not serve the

manufacturers' interests. Consequently, except with the many cameras still using the M42 mount, lens attachment methods tend to be unique to each marque. If you change your camera there is the virtual certainty that your lenses will not fit your new model.

Accessory manufacturers do their best to overcome this problem by supplying adapters that can be attached to the rear of your lens and to the new camera. Some independent lens manufacturers supply their lenses in a common mount to which a variety of adapters can be fitted, so that when you change your camera, you change only the adapter and not the whole lens. That can cope with most changes while the adapter that attaches to a complete lens sometimes runs into problems of camera body depth, and lens mount diameter. If one body is considerably deeper than the other, it is unlikely that another lens could be adapted to it except for close-up work. Either method can come unstuck in the matters of auto-diaphragm, full-aperture metering and other more sophisticated lens-to-camera connections. However, most of the better-known interchangeable-mount lenses have mounts which couple with all the functions on popular cameras.

When you think about changing your camera, therefore, or even when you buy your first interchangeable-lens type, and certainly before buying a used model, give some thought to the lens-mounting method. Check the independent lenses to see whether they offer fully compatible types. Make sure that the used camera in particular does not have a unique lens-mounting system no longer in use. Lenses may be very difficult to come by. None of this is very important if you are going to stick with the camera you buy (except for the out-of-date used model) but it can affect its resale value and might make it necessary for you to sell lenses you would rather not part with.

Adapters are available from stock for most popular conversions and even for a few discontinued models. In other cases, it is possible to have adapters made on a one-off basis but they are naturally more expensive. In a few cases the conversion is impossible. Before you order an adapter, make sure you know exactly what it will and will not do. Specify clearly what you want and put the onus on the supplier to tell you whether his product comes up to your specification or not.

Working out the Exposure

As soon as you acquire a camera with more than one or two shutter speeds and lens apertures, you run into exposure problems. The film needs a certain amount of light to produce an image, but you must decide on the camera settings that give just that amount of light—no more, no less.

It is not the function of this book to provide the answers, merely to point the way to where they may be found. There are, of course, a lot of automatic-exposure cameras around now. With most photographic subjects they work extremely well to give you a more or less factual representation of the subject. But this is not always what you want. You may wish to show a backlit subject as a silhouette or as if there were more frontal lighting; you may want to increase or decrease contrast. That is when you feel the need for assistance and information.

Books, charts and tables

Books are photographic accessories, just as lenses and filters are, and a lot of books have been written on the subject of exposure. This is not surprising because correct exposure is vital to the production of technically good pictures. Imaginative or creative photography may use exposure tricks but many photographers have to produce clear, crisp pictures showing every detail of the subject.

Understanding the exposure problem is a great help in solving it, so we can confidently recommend you to read as much as possible about the subject. It *can* be learned, certainly on the technical level, from books, and technical knowledge is at least useful, even if you only want to use exposure as a tool to produce imaginative

and individual results. Technically, exposure is a straightforward matter that can be simplified into charts and tables. Given the film sensitivity, the lighting conditions and standard processing, it is a fairly simple matter to calculate a combination of lens aperture and shutter speed that will give correct exposure.

Many tables have been produced on those principles. The simplest is that provided in the instruction leaflet packed with most films. If the film has a sensitivity of 80ASA, for example, you might get something like this:

Bright or Hazy Sun on Light Sand or Snow	Bright or Hazy Sun (Distinct Shadows)	Weak Hazy Sun (Soft Shadows)	Cloudy Bright (No Shadows)	Cloudy Dull or Open Shade†
f/16 1/125 s	f/11* 1/125 s	f/8 1/125 s	f/5.6 1/125 s	f/4 1/125 s

In weak hazy sunshine, you set your shutter speed to 1/125 second and your lens aperture to f8—or to any equivalent settings, such as 1/250 second and f5.6 or 1/60 second and f11.

For most subjects you need no more information. After all, no more is supplied to the automatic-exposure camera, which is calibrated to give exposures of that nature when its meter reads light levels corresponding to those in the table.

There are much more elaborate charts available, such as those working on a system of points allotted for geographical position, time of day, nature of subject, film sensitivity, etc. The points are all totted up and the total looked up on a table that indicates shutter speed and/or aperture to be set. The tables are ingenious and they work. They must, because the problem is usually capable of purely mechanical solution. Such tables are, unfortunately, not practical. They help you to understand the principles involved but are a little too cumbersome in the field.

The 'bright or hazy' sun column in the film manufacturer's leaflet is the standard exposure and that works roughly on the principle of using the shutter speed numerically nearest to the film speed figure and an aperture of f16, i.e. for 80ASA, 1/60 second at f16 or its equivalents. The other columns follow at one stop intervals.

Exposure meter practice

Most photographers, at least in the hobby field, rely totally on the

exposure meter built into their cameras. For a few years, in fact, the hand-held separate meter almost fell into disuse as the advantages of the built-in, and particularly the through-the-lens, types were extolled beyond all reason. Of course, built-in meters are an advantage and TTL meters have the slight additional advantage of measuring only the picture area or perhaps even only a part of it, but that is generally all they can do. They take an average, reflected-light reading of what they see and should come up with an answer close to that given by the film manufacturer's leaflet.

Only a few can be used to measure the light reflected from a particular small area of the subject. They cannot easily assess subject or lighting contrast, and are clumsy to take to or around the subject. They are not suitable for incident-light reading and they are rarely of any value to assess negative density or assist with enlarger exposures. The good separate meter can do all these things and more.

Even the most sceptical of us will rarely buy a small format camera without a built-in TTL meter, having become so conditioned to its use. Indeed, we do not often have the choice because there are comparatively few cameras of this type without them. The meter undoubtedly has its uses in day-to-day photography but it does have a tendency to mesmerise you into making constant minor alterations to exposure that can have no possible effect on the result. With a hand-held meter you are much more likely to assess the lighting conditions once and then make your own individual adjustments according to the nature of the subject and the type of result you want.

Types of exposure meter

After briefly almost succumbing to the onslaught of built-in versions, hand-held exposure meters are now available in various forms. There are two important divisions—large-area reading and spot—and three less important—selenium, cadmium sulphide (CdS) and silicon.

Most hand-held meters read an area within about a 30 arc, but there are a few genuine spot meters reading only about a 1 or smaller arc. We shall come to those later.

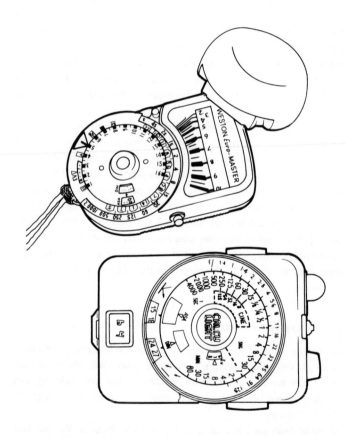

The traditional exposure meter (*top*) uses no battery and gives readings by needle and scale. The latest version is all-electronic with digital readout.

The other division is concerned with the type of light-sensitive material used. An exposure meter works on the principle that certain materials respond electrically to light, either generating a current or changing resistance according to the amount of light they receive. The response can be translated by a sensitive meter and needle or by an electronic circuit to indicate the 'light value' and/or recommended exposures for a pre-set film sensitivity.

Selenium was the first material to come into popular use. Its advantages are its close correlation with the colour sensitivity of panchromatic films and the fact that it generates a current large enough to drive a meter movement. Its disadvantage, compared with later materials, is that it needs to be of a relatively large area to attain usable sensitivity.

Cadmium sulphide came next and looked as if it would totally supersede selenium. It had the advantage of a considerably better size/sensitivity ratio, allowing it to be located behind a camera lens and so provide TTL metering. Selenium cells could be built into cameras but not in the light path. CdS has the disadvantages, however, that it is oversensitive to red light, compared with panchromatic film. Also it needs a battery, is rather sluggish in reaction, and needs time to recover from exposure to bright light.

The oversensitivity to red can be counteracted by including a blue filter in the system but full correction brings the CdS sensitivity down close to that of selenium. The battery is unavoidable because CdS changes its electrical resistance on exposure to light. That changing resistance has to be used to modulate the current supplied by a battery. All in all, it is doubtful whether CdS would ever have been brought into use but for the need to introduce TTL metering.

The next material to be used and the current front runner, was a silicon derivative commonly known as silicon blue—again from the filter fitted to correct its oversensitivity to red. Like selenium, this material generates a current on exposure to light. Unlike both selenium and CdS, however, it reacts very quickly—so quickly that it can be switched by the camera shutter release and activate an electronic circuit before the shutter opens. Although it generates a current, however, silicon blue still needs a battery, because the current is so small that it has to be amplified.

Other materials are used but silicon and selenium are, perhaps, more likely to survive than CdS—at least in hand-held meters. The sluggish reaction of CdS and its need for battery power give it no very great advantage over selenium.

Choosing a meter

The number and variety of hand-held meters is expanding rapidly as demand re-establishes itself and as new designs take advantage of the fast-reacting silicon sensors.

The basic selenium meter is still very much alive—notably as the Weston Euromaster, latest of a long line of renowned meters from the Sangamo Weston factory. Still using a needle and a scale, this is the type of meter that can be used to convey the information needed by practitioners of zone systems of exposure. The selenium meter may not be able to read moonlight but as no meter reading can give you much more than a guess at such low light levels, that is hardly a drawback. The Weston will, after all, give a perfectly reliable reading at 3 m or more from a shaded 100-watt lamp and has the great advantage of not needing a battery.

Most CdS meters give greater sensitivity than the selenium types. They can be made to give quite extreme sensitivity but their sluggish reaction to low light levels makes this a doubtful advantage. They are gradually being replaced by silicon types and, if your need is not urgent, it might be as well to wait until these more efficient versions begin to come down in price.

One great advantage of the silicon meter is its versatility. Its fast reaction enables it to be produced as the core of an exposure meter system. With suitable adapters, it can be used as a flashmeter, colour temperature meter, spot meter, enlarger meter and so on.

The type of reading given by various meters might influence your choice. The traditional meter uses a needle swinging across a scale, which may give you no more than a single exposure recommendation and leave you to work out alternatives for yourself. Sometimes a calculator dial is used, showing all the alternatives at a glance and, as with the Weston, giving alternative index marks for shadow and highlight readings and other information.

The vulnerability of the less-well-made meter movements brought about the introduction of light-emitting diodes (LEDs) as signal lamps in place of the swinging needle. Later developments brought full electronic circuits to give digital readouts. These can also be combined with calculator dials as in one of the latest designs claiming a range of two million to one on a single scale. With this model, you press a button to obtain a two-digit readout instantly convertible to exposure readings on a large calculator dial. Let go of the button and the readout fades. Press it again and a memory circuit recalls the reading. So that the reading can be retained in the memory almost indefinitely, there is no on-off switch. Power consumption, from four 1.5 volt batteries is extremely low.

The choice, therefore, is really between a relatively inexpensive meter for use in conjunction with the camera only, and a much more versatile and expensive type for use in various other circumstances as well. There is very little sense in buying an expensive meter for camera use only on the grounds that it can read the proverbial black cat in a coal cellar. When exposures reach the level of one second or more, the reaction of the film emulsion can become unpredictable without precise information from the film manufacturer. That information is available but the electronic wizards have not yet got round to programming it into their meter circuits.

Spot meters

Some manufacturers claim 'spot' reading for their TTL meters by confining the meter's angle of acceptance to a small part of the picture area. This can be a useful facility only if the photographer fully understands the principles involved, otherwise such a meter can give very unsatisfactory results.

The genuine spot meter is a separate instrument with an angle of acceptance no greater than one degree of arc or less. It allows you to measure the intensity of light in what will be a very small part of your picture area unless you are using a giant long-focus lens. It can be used in the normal exposure meter mode—to measure the light reflected by a mid-tone—but is more often used for shadow

or highlight readings, to check the brightness range of the subject. Most photographers take straightforward reflected-light readings of the whole subject area and obtain perfectly exposed results most of the time. They know enough to adjust the reading when it is not likely to provide the result they want. But many photographers specialize in subjects that are commonly of the type that could mislead a meter. Others use a metering system that depends on careful measurements of the brilliance of various parts of the subject.

Colour films have a limited ability to handle great contrasts in lighting. They can reproduce the differences in tone adequately but colour fidelity must suffer at one end of the range or the other. A spot meter can give an indication of the limits, so that the photographer can adjust the lighting or use fill-in from flash or reflectors. Low-lit interiors, as in churches, often have important inaccessible detail. A spot meter can measure the illumination of a small part of a stained glass window and so tell the knowledgeable photographer how it is likely to reproduce with exposures at various levels.

Spot meters are expensive instruments and their uses are highly specialized. The average photographer has no use for them. He can cope perfectly well with an ordinary meter and a good under-standing of the basics. Those who take exposure very seriously and intend to pursue to the full one of the 'zone' systems can hardly do without a spot meter—if only to avoid buying an extremely expensive densitometer to read negative densities.

A soft-focus attachment has the effect of diffusing hard edges, and this can be flattering with some subjects. It also spreads light into areas of shadow, rendering them less severe.

There are various kinds of star filter. These examples illustrate the use of 4-rayed and 8-rayed types.

A motor drive or a winder is a useful accessory in action photography. The winder can be set to take around 2 frames per second or simply to advance the film after an exposure; motor drives are faster, taking up to about 5 frames per second, or even more.

Many kinds of prism attachment are available. They can transform an ordinary or familiar scene into something much more exciting.

Park Avenue, New York. Here the subject is repeated in a circular pattern; the Statue of Liberty on the opposite page is horizontally divided.

Top two transparencies mounted together and rephotographed in a slide copier make a splendid image of Concorde.

Above a graduated tobacco filter has been used here to good effect.

Page 255 a polarizing filter can deepen the blue of the sky – by how much depends on the intensity of the sun and its angle (see pages 221-2).

Modern filter systems permit two or more lens attachments to be used simultaneously. Here a yellow filter and a soft-focus attachment have been combined for a romantic portrait.

Aids to Viewing and Focusing

Most cameras have an eyepiece. There are, of course, direct focusing screen types for use in studios and for technical work and a few reflexes that are not generally used at eye level but the mass market camera is a hand-held, eye-level type of various designs.

The eyepiece of a non-reflex camera cannot usefully be added to or modified in any way, except as may occasionally be provided by a built-in mechanism. In some such cameras, for example, the field of view through the eyepiece alters as you change lenses. More commonly, however, when you change the lens, you also change the viewfinder.

Viewfinder for non-reflexes

The additional viewfinder clips into the accessory shoe on the camera top plate and you use the rangefinder, where fitted, in the normal viewfinder. Auxiliary finders come in various forms. They may be single types for one focal length only, or in a small turret form, tiny lenses rotating on a disc to give the appropriate field of view for the lens in use. A third type looks rather like a single viewfinder but has a zoom-type adjustment allowing it to cover several focal lengths.

Attachable viewfinders have taken many forms over the years but few of them are still available as separate items, except on the used market. They can be useful with those older cameras that have rather unsatisfactory viewfinding systems.

Brightline finders were very popular. They used the old Albada system which had a partially silvered curved glass at the front and a frame printed on the the rear glass. The effect as you looked through the eyepiece was of a frame apparently suspended in the same plane as the image of the subject. Brightlines were simply updated Albadas giving a brighter, larger image and frame. The

advantages of the system were the clear delineation of the frame (the edges of the ordinary viewfinder frame are not always so clear) and the fact that the frame was within the viewing area. Parts of the subject just outside the picture area could be seen.

A similar type also used the suspended frame idea but in a vastly different way. The large eyepiece was a lens focused on a frame etched into a black glass at the front, effectively putting the frame out at some distance from the eye. The black glass obscured all except the frame so the other eye was kept open to view the scene. It takes a little getting used to but has all the advantages of the brightline finder, together with a life-size image and two-eyed viewing. Naturally, there is no loss of illumination and you can watch moving objects come into shot from a long way out.

These finders were essentially for single focal lengths. They incorporated parallax marks to compensate for their distance from the lens in close-range work; or, occasionally, a primitive form of parallax adjustment that allowed the viewfinder to be tilted downward.

There were also various types of metal frame finders, consisting of an eyepiece aperture spaced at a fixed distance behind an open frame according to the focal length of the lens. This was a common type of 'sports finder' on screen focusing cameras that could also be hand-held but a few stouter models were made to fit into an accessory shoe. They are not noted for accuracy but are better than nothing if you have an old camera with only the tiny reflex finder fitted to most early models.

Brightline and turret finders are still available for 35 mm interchangeable-lens non-reflexes but the other types are rare. There may be some available with specialized equipment but they are not on general sale.

Most current viewing aids are for screen focusing or reflex cameras. In these cameras, you see the image projected on a screen by the camera lens and it is an easy matter to modify the eyepiece to suit the view of the image to particular conditions.

Eyesight correction lenses

You view the image on the screen of an SLR camera through a

The turret viewfinder (*top left*) is still occasionally supplied for non-reflex interchangeable-lens cameras. Individual viewfinders for each lens are otherwise necessary (*top right*) and are sometimes required for very wide-angle lenses on SLRs. The Kontur finder (*bottom left*) had to be used with both eyes open. The open frame finder is popular for action photography.

fixed-focus eyepiece, because your eye is too close to the image to be able to focus it unaided. The focal length of the eyepiece is such that it works as a sort of supplementary lens to allow the eye to focus at the screen distance. It works adequately for most people, despite variations in eyesight, provided those with significantly defective eyesight wear their spectacles to view.

If you find that your viewfinder image is fuzzy, ask somebody else to look at it first, preferably somebody who is familiar with the type of camera. Don't judge by the clarity of any exposure indicators, shutter speed figures, etc. that may appear in, or beside, the field of view because they could effectively be at a different distance. When you are satisfied that you cannot get a sharp image (wearing distance glasses, where applicable, *not* reading glasses even for the longsighted) you might have to resort to having the eyepiece changed.

With some cameras, this is a simple matter as the manufacturer supplies auxiliary lenses to fit over the existing eyepiece: -2, -3, -4, -5, 0, $+0.5$, $+1$, $+2$, $+3$. The difficulty is in deciding which you want and there is no really satisfactory alternative to trial and error, which is after all, how spectacle lenses are prescribed. You may know your spectacle prescription but you also need to know how the manufacturer quotes his auxiliary lenses. Most of them quote the corrected dioptric power, not the actual power of the lens they supply.

Where the manufacturer does not supply corrective lenses try your optician who should be able to have your eyepiece lens changed by cutting and grinding the lens to your specifications. It might be difficult to find an optician who both understands and is willing to carry out the task, but most people will be able to adjust to the standard eyepieces. It is not generally advisable for spectacle wearers to have their eyepiece lenses changed to allow them to use the camera without their spectacles. With very short-sighted people advancing in age and so having lost their short-range accommodation, it might seem a good idea because they can then use the viewfinder and see the aperture and shutter speed figures on the camera without spectacles. But then they have to put the spectacles back on to view the subject. Better to learn to set the camera controls by touch—as everybody should do, in any case.

Long-sighted people or older people who need spectacles only for reading, must not be deluded into thinking that they should use their reading or close-range spectacles for viewfinding. The eyepiece is adjusted for near normal sight. Although the image is actually close to the eye, the eyepiece lens acts just like a supplementary lens to induce the eye to see the image as if it were much further away. One meter or so is a popular distance, well beyond the range of reading spectacles.

The only case in which there would be a clear-cut argument in favour of a corrected eyepiece is that of eyesight that needs spectacles other than distance spectacles to see objects at about 1–2 m, where most screen images are placed. Some are placed much further out but then normal distance spectacles should give perfectly clear vision or at least the best vision that is possible for that type of eyesight.

The temptation to have an eyepiece adjusted often arises from the damage that eyepiece frames can do to spectacle lenses. Considering the number of people who wear spectacles, camera manufacturers are strangely insensitive to their needs. There are few, if any, cameras that allow a clear view of the whole field to *all* spectacle wearers and many of them have hard-rimmed eyepieces. Rubber eyecups are certainly available but they are designed for the naked eye, as they more or less have to be, considering the size and variety of modern spectacle lenses. The only satisfactory answer is to modify the eyepiece yourself with a foam or rubber surround.

Magnifiers

The viewfinder eyepiece may be quite suitable for general photography but there can be occasions when you need a closer view for fine detail. There is an apparently simple answer to that, but it has one very large snag for most cameras.

Focusing magnifiers are provided by both camera and independent manufacturers. They clip on to the viewfinder eyepiece and provide a magnified (2.5X up to 7X or so) view of the central portion of the viewfinder image. Most of them are well made and easy to use. They generally incorporate an eyesight correction capability

(useful in this case) and are hinged at the top so that they can be rapidly flipped out of the way to allow a view of the whole field after focusing.

Unfortunately, it might not be the centre of the field that you want to magnify. Even if it is, that is the one area in most reflexes on which you cannot focus except by that iniquitous rangefinder spot. So, if you have the now almost universal split-image rangefinder spot surrounded by a microprism collar, the magnifier is virtually useless—and the greater its magnification the more useless it becomes. These magnifiers can, in fact, be used satisfactorily only with plain, fine-ground screens. To provide a brighter, more evenly illuminated image, even some modern screens are not as fine-ground as they might be. The texture of the screen can often break up the finest detail and in those circumstances, too, the magnifier is of little value.

Magnifiers are also available for ordinary screen focusing cameras, of course. In that case, however, they do not need to be attached to the camera. Almost any magnifier will do and you can use it anywhere on the screen.

Angle finders

A more useful eyepiece accessory is the angle finder. There are many occasions in copying, photomicrography, low-level shooting, etc. when it may be inconvenient or even impossible to get an eye to the eyepiece. The angle finder is an L-shaped construction with a mirror box in the angle. Attached to the camera eyepiece, it can be rotated through 360° to allow viewing from a variety of angles.

The mirror necessarily causes the image to be laterally reversed, which can be awkward to those not accustomed to it. Angle finders are commonly used in relatively static set-ups, however, where the wrong-way-round image does not often raise problems. Some models do provide a double-reflected image to correct the lateral reversal but they cost more, and even the standard type is quite expensive. Most models incorporate an eyesight correction control that allows the finder to be used without spectacles by all except the very shortsighted.

The right-angle finder (*top left*) allows viewing from almost any angle. The soft rubber eyecup (*top right*) sometimes accommodates a correction lens holder. Screen-image magnifiers (*bottom*) may show part or all of the image. The hinge allows the magnifier to be swung out when not required.

There is little standardization in eyepiece construction, so angle finders and, indeed, most other eyepiece attachments, have to be tailored to individual camera models. Some slot into grooves; others require a clamping ring to be removed and replaced; some have even had bayonet attachments. Angle finders are therefore generally available only as equipment for specific cameras. There are one or two independent makes but only for the most popular camera models.

Interchangeable finders and screens

There are a few single-lens-reflex cameras that allow the whole viewfinder assembly of eyepiece, pentaprism and viewing and focusing screen to be removed from the camera and changed for other types. Others allow only the screen to be changed.

The removable pentaprism can have various purposes. It has been used for example, to permit a TTL metering system to be incorporated in a camera that previously did not have one. It can allow automatic exposure facilities to be brought into use or add a low-light-reading capability. The principal use, however, has been to allow a different type of viewfinder to be fitted.

The simplest alternative finder is a reversion to the original 35 mm SLR—direct viewing of the screen instead of eye-level viewing via the pentaprism. A magnifier is generally incorporated. Many people prefer this view in relatively static set-ups and there are occasions, as in low-level photography, when it is preferable. It is very difficult to get any eye to the normal eyepiece of a camera placed on the ground, and an angle finder may not be the complete answer. As with the angle finder, direct waist-level viewing gives you a laterally reversed image.

Another popular type is a sports finder or speed finder, as one maker calls it. That one has a swivelling eyepiece on a more orthodox pentaprism allowing both eye-level and alternative-angle viewing—downward for low-level or upward to clear the heads in a crowd and various other alternatives. It is useful in photo-micrography and copying and many other applications because, apart from the choice of angles, it gives a full view of the screen with the eye up to 2.5 inches behind the eyepiece. This is

Interchangeable viewfinders for SLRs take various forms. With some, the eyepiece can be angled. The waist or chest level type is favoured by many for low-level work. Interchangeable screens are also available in many forms for specialized work.

especially useful if you use the camera in an underwater housing. Alternative finders are available only for specific cameras and there are no universal or independent brands. They usually also allow the viewing screen to be changed and, in this case, independently manufactured alternatives are available.

The popular standard screen at present is a fine-ground type with a central split-image rangefinder spot surrounded by a microprism rangefinder collar. Not everybody finds that ideal, particularly for specialized work. About a dozen alternative screens are made. The effectiveness of a rangefinder, for example, depends on the focal length of the lens and the angles of the prisms forming the rangefinder. Special types are made for longer-focus lenses. Screens without rangefinder spots are made for those who prefer them and for critical work such as extreme close-ups. Even more critical focusing can be carried out on a plain screen with central crossed lines giving a form of parallax focusing with an aerial image. Lined screens or graticules are useful for measuring and lining-up purposes.

Again, these screens are made for specific cameras but it is possible to have the screen in almost any camera changed. It could be expensive but, if you are going to specialize, and feel happy with your camera except for its screen, it must be cheaper than buying a new cameera.

Checking the focus

Not strictly a viewing aid, but in the same field, perhaps, is a focusing check screen. You might sometimes have a doubt about the mirror or screen line up in your camera. With a non-reflex, you might want to check the focus of a supplementary lens or some other piece of equipment.

All that is needed is a piece of very fine-ground glass small enough to be pressed against the film runners in the back of the camera, ground surface toward the lens. With the camera rigidly supported you can then check the focus against the screen image or measure the distance to the subject after focusing accurately on the check screen. A small magnifier could be helpful because the small size of the image tends to sharpen it. Always carry out the test with the

lens set to full aperture, not only for the best illumination but to reduce depth of field as far as possible. Keep the back of the camera shaded, too, to increase contrast.

There is little point in checking the focusing scale engraved on the lens except to confirm that it is drastically adrift and the lens needs attention. It is necessarily compressed and imprecise and you cannot set it accurately.

A commercial version of the focusing check screen is available, with useful hints on its applications.

What You Need for Close-ups

Close-up is an indefinite term in photography. When lenses commonly focused no closer than about 1.5 m while attached to the camera, close-up photography could be any shot taken from less than that distance. For some fixed-lens cameras it might still apply. Generally, however, the standard lens of a 35 mm SLR can focus to 60 cm or less and, although that might be considered close range, it is not generally regarded as close-up photography.

Perhaps there is no better definition than that the term close-up means photography carried out at closer range than the normal focusing mechanism of the camera allows. We have already raised one objection to that and it is also true that many technical and other bellows-focusing cameras can focus close enough even for life-size (1:1) reproduction. It is adequate for most purposes, however, and makes the point that close-up photography generally calls for special accessories. These accessories rely on two methods of enabling the camera to be used closer to the subject.

To focus closer, a camera lens has to be moved further away from the image plane, where the film is located. When the image-lens distance is equivalent to the focal length (actually fractionally more) the focused distance is out at infinity—far, far away. As the lens-to-image distance is increased, the focused distance becomes nearer. Cameras using rigid lenses (no bellows) have a limited amount of movement built into the lens—limited because the closer you get the greater the necessary movement of the lens becomes. To get to 1:1 reproduction, you have to move the lens forward by a distance equivalent to its focal length, while getting down to one meter or so involves only a few millimeters of movement.

The first approach to allowing a lens to focus closer is simple. If

you put another converging lens (all camera lenses are necessarily converging) in front of the camera lens you produce a combination of shorter focal length than the camera lens alone. That combined lens is then effectively further forward for a given focused distance than it should be, because its minimum (infinity) extension is the focal length of the camera lens alone. So you can focus closer. Such an additional lens is known as a supplementary or close-up lens.

The second approach is to increase the lens-to-image distance by placing extension rings or tubes or a bellows construction between the lens and the camera body.

Supplementary lenses

The basic principle of a supplementary or close-up lens is relatively easy to understand. When a lens is separated from the image plane by a distance equal to its focal length, it is focused on a very distant subject from which the rays of light reaching the lens are virtually parallel. That is why we said the distance is actually fractionally greater than the focal length: the rays from the subject must diverge, however fractionally. Similarly, when the lens focuses an object one focal length in front of it, the rays emerging from the back of the lens are parallel.

So, if you set a camera lens to its infinity focusing position and place another lens in front of it, the combination will focus an object at a distance from the supplementary lens equivalent to its focal length. The supplementary lens sends parallel rays to the camera lens, which accepts them as coming from infinity and bends them to form an image. The point of all this is that there is no mystique about a supplementary lens. Any lens can be used, always providing that it is a converging (positive) and not diverging (negative) lens. You can even use another camera lens as an extremely strong supplementary. There is no question of compatibility or of one maker's supplementary lenses not being usable on another maker's cameras.

The only occasion when some difficulty can arise is when the supplementary lens maker does not tell you the actual focal length of his lenses and you want to use them on a fixed-lens camera

with no focusing screen. You cannot see the image so you have to measure the focused distance. If the lenses were designed for a particular camera and the maker tells you only that they are numbers 1, 2 and 3 and they focus at certain stated distances from the focal plane of his camera, you will have some difficulty.

There is another possibility, too, also concerning non-reflex cameras but this time only the simpler type with fixed-focus lenses. The focus at which such lenses are fixed is rarely stated, but it is certainly not infinity. So you cannot rely on a supplementary lens focusing at its own focal length. You have to use the camera maker's supplementary lenses, if he supplies them, or make rather a lot of experiments.

None of these problems arises with screen-focusing cameras. You see the effect of the supplementary lens on the screen and you focus in the normal way.

Supplementary lenses are generally single glass types of relatively low power, expressed in the optician's term of dioptres. A few manufacturers sensibly quote focal lengths. When they do not, you have to convert the dioptre strength into focal length by dividing the dioptre number into one metre. A 2-dioptre lens has a focal length of 500 mm and focuses an object at that distance in front of it when attached to a camera lens focused at infinity. The only value of the dioptre number in photography is in calculations. Dioptre numbers can be added together to indicate combined strength, whereas the calculation of the combined focal length provided by two lenses is more complex. It is easier to convert the focal lengths to dioptre strengths by dividing them into 1 metre; then add together these figures, and convert them back to focal lengths by again dividing them into 1 metre. For example, a 50 mm lens is 20 dioptres (1000/50) and a 100 mm lens is 10 dioptres (1000/100). Added together they form a 30 dioptre combination which has a focal length of 33 mm (1000/30). Lenses up to about 4 dioptres are relatively inexpensive. Those of greater power need to be of better quality and can become much more expensive. Some are of more than one-glass construction.

Should you buy close-up lenses, or are they inferior substitutes for more sophisticated close-up equipment? If you have a fixed-lens camera you have no alternative. With an interchangeable-lens

camera, you do have the alternative of increasing the lens extension, and some will unhesitatingly condemn the supplementary lens in favour of extension tubes and bellows.

As with so many photographic matters, the true facts are not so clear cut. The theory is plain. A supplementary lens is optically imperfect, of course, but you are not using it alone. Any one element from your 14-element camera lens could be said to be imperfect, too. Theory is not enough. In practice, supplementary lenses can give excellent results. The argument that extra extension avoids the use of an optically imperfect product is untenable. Few camera lenses are designed to operate at very short subject distances.

Supplementary lenses have other significant advantages. They are normally supplied in the same form as filters, to screw or bayonet into the front of the lens in no time at all. They have no effect on light transmission and the screen image remains bright and easy to focus. Even with a viewfinder camera, it is not difficult to improvise a focusing jig.

At very close range, you are working with extremely limited depth of field and often beyond the flat-field capability of a wide-aperture camera lens. So you work at small apertures and make no use of the outer areas of the supplementary lens, which might indeed cause poor image quality. Certainly the average supplementary lens does not offer very great magnification, unless you use it on a longer focus lens, and higher power types have to be expensive to be good. At moderate reproduction ratios, it is a completely acceptable close-up device on any type of camera.

To buy a supplementary lens, decide on the approximate reproduction ratio or magnification that you want. We use the term magnification in this sense although, more often than not, we actually mean reduction. Reproduction ratio is expressed in the form 1:2, meaning that one unit of linear measurement on the film represents two units of the subject. In this case, an object 4 cm long would be reproduced as 2 cm long on the film (half life size). Life size is 1:1, twice life size is 2:1 and so on.

Magnification is expressed as a single figure. Life size is 1 ($M=1$), half life size is 0.5 and twice life size is 2.

The magnification provided by supplementary lenses is pro-

portional to dioptre strength or focal length of both supplementary and camera lens, when the camera lens is set to infinity. A one-dioptre lens gives a 0.05 (one-twentieth life size) magnification with a 50 mm lens or 0.2 with a 200 mm lens. A 4-dioptre gives a 0.2 magnification with a 50 mm lens or 0.4 with a 100 mm, and so on.

Having decided on the magnification you want and the dioptre strength that entails, check the filter attachment of your camera. Most are now screw-fitting in a standard series, commonly running from 49 mm to 58 mm. Order up your lens quoting the dioptre number and the filter thread.

If you have any difficulty in identifying your filter fitting, take your camera to a dealer to make sure that you get a lens that fits. It simply has to attach securely to the camera lens. It does not matter how it is fixed. Some cameras use push-on fittings, others use a sprung ring and a clamp screw.

There is an exception to the dictum that supplementary lenses cannot provide very great magnification. They can if they are of sufficiently good quality. There are a few 10-dioptre types about that can just about make it but that is the limit—unless you use a camera lens. To use this method effectively, however, you need a telephoto lens and a standard lens in your collection—a usual practice. Various combinations can be used but a 135 mm lens on the camera and a 50 mm lens on the front is probably most practicable. Attachment is simple in most cases because manufacturers provide coupling rings to join the two filter threads together. The 50 mm is thus reversed on the 135 mm. This combination is effectively a 20-dioptre supplementary on the 135 mm camera lens and it gives a magnification of 2.7 on the film.

The magnification provided by a supplementary lens on any given camera lens is derived from a quite complicated formula but you can take a short cut by simply dividing the focal length of the supplementary into the focal length of the camera lens. A 50 mm lens on a 200 mm set to infinity gives a magnification of 4.

Special types of close-up lens are also available. Their advantages compared with the normal types are debatable, particularly in view of their considerably higher price. There is a variable type, for example, that changes its focal length rather like a zoom lens, and

allows a greater range of focused distances than is available with an ordinary supplementary lens and the camera lens focusing mechanism.

Another type is part close-up lens and part clear glass, enabling you to focus very close and very distant objects at the same time. The idea is to give the illusion of great depth of field. The illusion is generally obvious because, naturally, the two focused planes have to be in different parts of the picture and the dividing line can rarely be realistically concealed. The area between the two focused planes (or part of it at least) is inevitably out of focus and that is even more difficult to cope with.

Extension tubes

Supplementary lenses can give very good results at moderate reproduction ratios. A 4-dioptre lens, for example, on a 50 mm camera lens set to infinity, can give a ratio of only about 1:5. Even a 10-dioptre lens in such circumstances can only reach 1:2. You can increase these ratios proportionately by using longer-focus camera lenses but it *is* generally preferable when working at reproduction ratio greater than about 1:5 to use the alternative method. Increased dioptre strength brings the risk of inferior quality except at unrealistic cost.

Extension tubes need not be expensive. Some camera manufacturers' types are offered at exceptionally high prices that cannot really be justified, so it pays to shop around among the independent brands. If you have a complicated camera linkage, however, some of these independent brands may not operate satisfactorily in all the automatic functions. In most cases that is not important because the set-up is often relatively static and you are not unduly rushed. You may prefer full performance, however, when using a single short tube simply to enable you to focus a little closer with a long-focus lens.

Generally speaking, extension tubes are suitable only for single-lens reflexes or other screen focusing cameras. On such cameras, their length, construction, etc. is relatively unimportant. You can improvise with cardboard or plastic tubes if you blacken the inside. The screen shows the effect precisely. Naturally, you lose any

auto-diaphragm or other special links but it is no great hardship to use the diaphragm manually or operate the meter in the stopped-down mode.

When tubes are used on interchangeable-lens cameras without focusing screen facilities, their exact length and effect on focused distance must be known. Such information is rarely available these days. When these cameras were more popular, various focusing aids were available, from a simple screen box that temporarily replaced the camera body to a full reflex attachment still provided for the Leica.

Extension tubes are normally supplied in a set of three different lengths adding up to about 50 mm. They can be used singly or in any combination to give reproduction ratios up to about 1:1 with a 50 mm lens. Doubling the lens extension gives 1:1 ratio: if you use the 50 mm set on a 100 mm lens, you get only a 1:2 ratio. Theoretically, there is no limit to the number or length of tubes you can put on the camera but the greater the length the lower the illumination at the film plane and the greater the difficulty in focusing. You can, of course, use a powerful lamp for focusing purposes only, or even for the actual photography if your subject will stand it—but it is more likely that at great magnifications you would use electronic flash. You should not use too much tube extension together with an automatic diaphragm facility. That can impose quite a strain on the mechanism. If you must use a lot of tubes, make them the manual type and operate the diaphragm manually—but preferably use a bellows.

Extension bellows

The disadvantage of extension tubes is that each tube allows only a very narrow range of focused distances, using the focusing mechanism of the lens. To change the reproduction ratio significantly you have to remove the lens and change the tube length. A more flexible arrangement is to use an extension bellows. The basic bellows unit consists of a front and a rear standard attached to a rail or rails and joined by a concertina-like construction of light-proofed material. The front standard carries a lens mount and can be moved along the rails either manually or by

a rack and pinion drive. The rear standard carries a camera mount and is often fixed to the rails but is movable in some models. Locking knobs are provided to hold the bellows at any required extension.

The thickness of the standards imposes a minimum extension, generally in the region of 20-30 mm for 35 mm cameras. Maximum extension depends on the length of the bellows and varies with design and price. It is not often greater than 200 mm. There is an obvious conflict here between rigidity and size.

A notable point with bellows is that none of them provides all the trouble-free links with camera controls that can be made available on well-constructed tubes. The bellows makes a direct link impossible so various indirect methods have been devised. Most so-called auto-bellows in fact use double cable releases, one to operate the camera shutter and the other the lens diaphragm.

The disadvantage is not always as great as it might seem. A bellows set-up is customarily static and you normally have plenty of time to take meter readings, adjust the lighting, set the camera controls and so on. In fact, it can be said with considerable justification that some manufacturers waste both time and money struggling to provide semi-automatic facilities. The product becomes very expensive, while it should be possible to make a sturdy, uncomplicated bellows at a reasonable price.

All bellows units are provided with a tripod socket in the rear standard and they should have one in the front standard, too, for the occasions when you want to use them with heavy lenses. The camera mount on the rear standard should also allow the camera to be turned to give vertical or horizontal views, preferably with click stops in those positions.

When you decide to buy a bellows unit, you will find that some are shockingly expensive. Some camera manufacturers and independents appear to think there is no demand for a straightforward gimmick-free bellows, being, presumably, deterred by the low profit margin.

There are some simple independent products but they tend to be rather flimsy. Probably the only really stout unit at a reasonable price is the small bellows in the Praktica range of accessories but that has the M42 thread system.

You must examine the bellows unit of your choice before buying, if at all possible. You might need it for a long time and it is essential that it is of absolutely rigid construction. The standards must not be capable of even fractional movement in any direction once locked. The stouter the rail or rails the better. Don't deride one-rail units. They can come up to standard if properly made. Rack-and-pinion drive is useful but by no means essential. Extension, magnification, exposure-adjustment and similar markings are totally unnecessary and are even misleading on some models. You must know how to handle all these factors yourself when practising close-range photography. Similarly, automatic-diaphragm and other such mechanisms are of no great value. Exposure metering for close-ups is best carried out with a separate meter if you are not using flash, together with careful calculation of the effect of the extension, the nature of the subject and the lighting.

Bellows extras

Focusing is often difficult at very close range, especially if you want a specific image size known to be provided by a certain bellows extension. The easiest method of focusing then is to set the required extension and move the whole outfit back and forth (or, if more practical, move the subject) until correct focus is achieved.

With the camera on a tripod, that may be less simple. It can be made relatively easy, however, by mounting the bellows on a focusing rail or slide. This holds the bellows rigidly on an additional sliding support, again operated by push-pull or rack-and-pinion drive. Some bellows units incorporate such a slide, or merely a small block (at a price) or have one available as an optional extra. Independent manufacturers' items are also available and can take most other bellows units because the method of attachment is by tripod screw. Again, look for stout construction and positive locks.

It is common practice to reverse the camera lens on a bellows unit because it often gives better results that way. The snag with some M42 screw lenses is that they have no auto/manual switch. When

you turn the lens round, you have no means of stopping it down manually except by holding the depth of field button, if any. That could cause significant camera shake. To solve that problem there is a 'reverse pin depresser' that screws on to the rear of the lens and presses the pin into the stopped down position. The other end has a 49 mm female thread to take lens hood or filters.

The same trouble can arise even with the lens the right way round, but some bellows incorporate a pin depresser in the lens mount. Where they do not, or even where they do, a so-called Z-ring can be used. This has a cable-release-operated pin depresser similar to that in extension tubes so that, with a double cable release, a sort of automatic-iris facility is maintained. Naturally, you can also use the Z-ring with the lens reversed.

Reversing the lens

Reversing the lens on the bellows is often accomplished by removing the front standard, turning it round and replacing it, and then clipping the bellows over the front of the lens. On bellows where that is not possible, the lens has to be reversed by means of a reversing ring, which screws into the lens filter thread and has a male thread or bayonet attachment to fit the bellows lens mount.

Copying equipment

Some close-up equipment is specifically designed for copying flat originals and is therefore operated in the vertical mode. It is easier to lay the original flat than to pin it to a vertical surface. The simplest equipment of this type is a stand consisting of four legs, sometimes telescopic, fitted to a ring to which the camera is fastened by its filter thread and through which it photographs the subject.

This type of stand originated with non-reflex cameras and the length of the legs was designed to fix the focused distance for specific lenses and extension tubes. The ends of the legs also indicated the area covered. It is a more versatile instrument than it appears at first sight because its light weight allows it to be carried and used in any location, and not only in the vertical mode.

A double cable release and special intermediate ring allow auto-iris operation to be maintained when a lens is reversed or is separated from the camera body by non-automatic accessories.

A typical bellows unit incorporating movement of both standards and a focusing slide to allow camera, bellows and lens to be moved as a unit. On many bellows, the lens can be reversed by removing the front standard and replacing it the other way round.

The true copy stand is a much more substantial piece of equipment. It is designed on the same principle as a vertical enlarger and, indeed, many enlargers can easily be converted to copying stands. The basic arrangement is a stout baseboard with a vertical column at the centre of the back edge. Riding up and down the column is a lockable arm to which the camera, bellows unit, focusing slide, etc. are fastened by the tripod screw. For greater security a camera cradle is used with some models. Alternatively a bracket may attach to the arm and provide a means of attaching the camera by its lens filter thread. Either arrangement generally aims to centre the lens over the baseboard.

Lighting set-ups are available to fit most copy stands. They normally take the form of lampholders and reflectors on flexible, swan-neck arms with fittings for standard ES lamps. Two lamps may attach to the stand column or four may be provided to clip near the corners of the baseboard.

Copying stands can be expensive and they occupy rather a lot of space. Many enlargers may, however, be converted to copying stands merely by removing the lamphouse and attaching a repro arm or copying attachment. This is a very simple bracket (that can cost an incredibly high price) with tripod screw fitting to take camera, bellows unit, etc. Lighting equipment may also be available to attach to the bracket. If you are thinking of buying an enlarger and also expect to need a copying stand, this is a point worth considering. Prices of the attachments and lighting units vary considerably.

Slide duplicating

Colour reversal, slide or transparency film—call it what you will—has one big disadvantage. The final picture appears on the film you put in the camera. There is no negative from which you can make further copies. You can make prints, of course, or have them made, but that is not quite the same thing. If you want more than one slide of the same subject you have to shoot it the required number of times or copy the original. The first alternative is obviously impractical in most cases so various types of slide duplicator or copier have become available.

A copying stand is often no more than an enlarger with the head removed and a camera holder attached in its place. Lighting units are available to clamp to the edge of the baseboard.

Copying a slide is simply another form of normal copying and it can be carried out with ordinary close-up equipment. The illumination has to come from behind the slide and must be perfectly even, but that is not difficult to arrange. You could simply fasten the slide over a suitably sized opening in a large black-painted board. Put a piece of white translucent plastic material or opal glass, behind it, and shoot it with your camera set up on a tripod in front with a long sync lead to a small flashgun behind the board. It can be done but it does need a great deal of care in lining up. If you are prepared to spend money, there are easier ways.

If you can afford to, you can buy an elaborate piece of equipment designed to do the job perfectly with just about every control possible. On the lines of a copy stand but a great deal more sophisticated, this type of copier has a substantial base of some depth that houses an adjustable flash unit on rails, a focusing lamp and a lot of wiring. Indicator switches and a meter face you on the top, while behind them, in the horizontal plane, is the copying area proper. This consists of an aperture through which the slide is illuminated, a diffuser plate, filter drawer and interchangeable slide holder. An attachment allows a separate, low-power flashgun to bounce light off a mirror to control contrast by fogging. Rising behind the aperture is a twin-rail assembly carrying a bellows unit to take any type of camera and lens.

Most of us have to manage with less than that and, indeed, would need to be consuming film at a vast rate to pay for it. Fortunately, simpler equipment is available. Perhaps the simplest for those who already possess extension bellows is the slide copier attachment designed for that bellows.

Bellows-attaching duplicators are of more or less standard design, the construction varying somewhat with price. They attach to the front of the bellows rail and consist of a small bellows with lens clamping ring on the front standard. There is no rail: the bellows is simply pulled out and attached to the front of the camera lens (on the main bellows).

The rear standard of the copier bellows has an aperture or film gate, a slot into which slides or film strips can be inserted and a diffuser screen through which the illumination is directed. Electronic flash is the most popular light source. Daylight can be

A slide copier can be a self-contained item attaching directly to the camera body. It has its own lens working at a fixed small aperture. Alternatively, the camera's own lens and bellows can be used in conjunction with a slide-holder and auxiliary bellows.

used but is naturally less reliable in both intensity and colour quality. Some duplicators of this type allow a limited amount of movement of the slide so that selective enlargements can be made. They should preferably be used with lenses designed for close-range work because they rarely allow the lens to be reversed.

For those who have no bellows or whose bellows unit does not have a slide copier attachment, there are various types of rigid copier. A popular model has its own specially-designed zoom copying lens working at f16. Mounted in front of it is a unit containing the normal diffusing screen and film holder plus a filter compartment. The film or slide can be moved into a variety of positions to allow selective enlargements from any part down to one-quarter of the original image area—even off-centre parts. That model is relatively expensive but it does have the advantage of a lens computed for the job, whereas the bellows-attaching copier requires you to use your own lens, which will quite likely not be up to the job. A modified version has a fixed-focal-length lens allowing same-size copies only at a significant reduction in price. Both versions attach directly to the camera via a T-mount adaptor.

Even greater enlargements can be made with this type of duplicator by fitting a tele-extender on the back, allowing the zoom version, for example, to give 4X enlargements. Even at f16, however, you need a lot of light for framing. With the zoom out and a tele-extender added, you are effectively at f64 and framing can be difficult. You can fold the diffuser down to admit more light and it can also help to hold a magnifying glass or old condenser lens over the slide holder if you have such an item handy. Remember to replace the diffuser before shooting.

At the lower end of the price scale is another rigid version without lens or built-in extension. It attaches to the filter thread of your lens on your own bellows or tubes. Reproduction ratio varies with the lens and extension, while quality depends entirely on the close-up performance of your lens.

The choice of a slide-copying arrangement therefore depends on various matters. For most users, we can rule out the top model designed for mass production. That undoubtedly is the most versatile and will give absolutely first-class copies if properly used. It does depend, of course, on the quality of your own lens and it

would be foolish to use it with any lens other than one that has been tested and proved to give the required quality at close range.

The same proviso applies to the other copiers without built-in lenses. If your lens cannot give sharp-all-over results right-way-round, it is useless to buy a copier without its own lens, unless it allows the lens to be reversed and your lens can perform adequately in that position. Don't assume that your very expensive camera lens must give good close-up performance. Some of the most complex are the poorest in this area, whereas a quite inexpensive lens of simple construction may be perfect for the job. Try your enlarger lens. That is designed to work at close range and you should have no difficulty in having an adapter made to allow it to be fixed to your camera or bellows for close-range work. In some cases, stock adaptors are readily available.

In deciding whether you really need a slide copier, remember that they can do various other jobs as well. You can improve an existing transparency by copying it through a filter, or you can try various effects with filters or screens, or by combining two transparencies. They are also useful for making negatives from transparencies (and vice-versa with suitable films). This is the only simple way of getting good black-and-white prints from transparencies.

Microscope adapters

Even the most elaborate close-up equipment is not always enough. There is a practical limit to how far you can extend the camera lens from the film plane before running into illumination difficulties. For really massive enlargements of tiny detail, you need special lenses and what better than the lenses designed for that purpose—microscope objectives.

Many camera manufacturers include microscope adapters in their equipment range. They are all of broadly similar construction, allowing the microscope and camera to be rigidly joined together. The construction generally includes an inner tube that attaches to the microscope drawtube with a removable light shield tube that is used when you photograph without the microscope eyepiece. An outer tube is clamped to the inner tube and attached to the camera

lens mount in the normal way. An additional clamp is provided where the microscope has non-focusing stages. A screen focusing or reflex camera is, of course, essential.

Most modern microscopes are suitable for photomicrography although the less expensive versions may not have very good eyepieces. In that case, either photograph without the eyepiece at rather lower magnification or change the eyepiece for one more suitable for photography.

The magnification given by a microscope adapter depends on the camera extension (film plane to eyepiece plane) provided by the adapter. It is the visual magnification × camera extension (cm) ÷ 25. Thus, if the adapter gives a 12.5 cm extension, magnification on the film is half the visual magnification of the microscope.

Rigidity of the assembled unit is of the utmost importance in a microscope adapter. Once the various units are fitted together and clamped, they must be incapable of independent movement.

Macro lenses

The difficulty of computing a camera lens to provide satisfactory image quality both at normal shooting distances and at extremely close range inevitably means that many lenses are not really suitable for close-up photography. Just as inevitably this led to the introduction of so-called macro lenses.

A macro lens, as the term is now generally used, is a lens designed to give sharp, flat-field images at close range and also to work well as a normal camera lens. Consequently it has a continuous focusing range much longer than normal. This kind of performance is virtually impossible with large aperture lenses and macro lenses generally have modest maximum apertures of about f3.5 or f4. The extra focusing travel allows it to focus from infinity down to about 1:2 reproduction ratio (half life size). Most models also have an extension tube to allow 1:1 reproduction.

Thus, the macro lens, usually of standard or twice the standard focal length, is a lens that can be used both for all general photography out to infinity, and for images up to about half life size simply by turning the focusing ring. It is a useful facility but it is a little expensive and, if you get one in place of your standard

lens, it will leave you with a modest maximum aperture. It is also rather bulkier than the standard lens.

The macro tag has spread to other lenses and there are many long-focus and zoom lenses that have a similar capability—but only by operating a separate control to bring the macro mode into operation. These lenses work normally with the macro control inoperative and give images up to about one-third life size in the macro mode. It is a useful facility, particularly with short zooms, which may not otherwise focus very close. There is a 39–80 mm zoom, for example, that focuses no closer than 2 m in normal operation but can get down to 25 cm from the film plane in the macro mode.

In this context, of course, the term 'macro' is a total misnomer. Macro, if it is to mean anything at all in photography, must mean more than life size on the film. None of the popular, so-called macro lenses can do that unaided. Most of these macro-focusing camera lenses require reversing when used at magnifications much greater than 1.

There are one or two genuine macro lenses produced for camera systems but they are generally based on microscope objectives. They are very small, have no focusing mechanisms and are used in conjunction with bellows units and copy stands. They are generally designed to work at 4 or 5X magnification and greater, and are extremely expensive.

Bellows lenses

A number of the longer-focus macro-focusing designs are available in short-mount versions with no focusing mechanism. These go on bellows units to provide a continuous focusing range from infinity down to a reproduction ratio of greater than life size. On the few bellows that give the automatic diaphragm operation, these lenses are excellent for outdoor work, providing a versatile and light, though bulky, outfit.

A few manufacturers offer these lenses with a separate focusing mount, so that you can use them as normal 'Macro' lenses as well. The focusing mount itself acts as a variable length extension

tube—providing a compromise between tubes and bellows. Some similar focusing tubes are also available without a matching short-mount lens.

Making the Most of Flash

Flashbulbs are still available but, except in the smallest sizes for some cartridge-loading and instant-picture cameras, they have fallen out of popular use. Even where they are still used, they are generally in cubes or other special constructions.

A flashbulb is a filled glass bulb that burns out with one use. Most types are fired from batteries but there are one or two that are fired by a trip mechanism in the camera which produces a piezo-electric spark. Magicubes do not use electrical firing at all. The camera trips a spring-loaded arm in the cube which strikes a blob of firing paste and thus ignites the bulb.

Bulbs are sold singly or in various proprietary packs that attach to specific cameras and fire each bulb in sequence. The first of these was the flash cube, containing four small bulbs, each with its own reflector. You can use this type of flash in a suitable holder with any flash-synchronized camera. Its main use, though, is as a directly-mounted light source on cameras with a suitable socket. On most cameras the cube rotates with the film advance to bring a fresh bulb into position. On the simplest, though, and if you use a separate flashcube holder, you have to rotate the cube manually. The Magicube looks like a flashcube but requires an entirely different socket, and cannot be used on a separate holder. It can, however, be used with an extender which moves the cube flash further from the lens axis, thus reducing the chance of producing red-eyed portraits. Other types may carry more bulbs in a vertical arrangement that remains fixed but fires each bulb in turn. Each of these units needs its own attachment and firing method built in to the camera.

Of the single bulbs, the AG3 type is the most popular—a small bulb fitting into a flashgun consisting of a case containing a battery, capacitor and resistor, with a reflector, often a folding type attached. The bulb flashgun can be extremely small and light and

yet take bulbs giving a remarkably powerful light—much more powerful than a lot of small electronic flash units. There are now comparatively few of them on the market.

The flashbulb, in whatever form, still makes a lot of sense for the occasional user and very powerful types are still available. Nevertheless, they are rarely used these days. The appeal of an electronic flash tube that fires over and over again and so eliminates the need to carry a supply of bulbs has proved irresistible. Further development to provide automatic exposure control and links with the camera's exposure meter have made flashbulbs look old-fashioned.

Electronic flash principles

Electronic flash is provided by an electrical discharge across a gap between two wires (electrodes) in a gas-filled tube. The gas content is adjusted to provide a light close to the colour quality of daylight. The firing circuit is much more complicated than that of a bulb flashgun and, for equivalent power, a great deal more expensive. There are many small and inexpensive electronic flash units but they are generally very low-powered.

The tube can vary in size from tiny to huge with consequent variations in power, circuitry, size of components and price. There is, literally, something for everybody, from the tiny unit smaller than a cigarette pack to studio consoles with power units that have to move about on wheels. The working life of the tube is measured in seconds but, as the duration of each flash is in the region of 1/1000 second or less, the average user rarely wears out a tube.

The great advantages of flash, for professionals at least, are its predictability, ease of handling and lack of heat on the subject. Many studios are geared to more or less standard flash set-ups that can be modified at will to suit particular applications. The large lamp units take a variety of forms to give flood or spot lighting and can be fitted with accessories to shade, concentrate or otherwise modify the effect. Modelling lamps of relatively low power are generally built in to allow the effect to be gauged before the flash units are brought into operation.

Similar advantages are available to the amateur or hobby photographer on a smaller scale. His units do not have as many accessories but they have far greater portability and manoeuvrability. They are convenient in use and, again, do not require him to overheat his subject under the glare of powerful incandescent lamps. The smaller units, too, like small-format cameras, tend to make greater use of electronics to provide automatic-exposure facilities.

Automatic exposure is provided by high-speed electronic switching. A sensor in the flash unit body measures the light reflected from the subject and cuts off the power to the tube when sufficient light has been emitted to give correct exposure. At very close range that can lead to exposures shorter than 1/50,000 second and a consequent increase in the number of flashes per tube or set of batteries.

For complete portability, battery power is essential, but most units can also be operated from the home power supply via a small transformer/rectifier package. These are quite inexpensive but are generally designed for use on specific units. They plug directly into a power supply with a lead to the flash unit that also cuts off the manual switch. Batteries can be awkward because the average number of flashes per set of batteries is in the region of 50 or so, with a marked increase in recycling time (the time needed to recharge the capacitors) after about 20 or so flashes. Batteries with greater capacity are available but at a significant increase in cost. Rechargeable batteries are also costly, and when they are built in to a flash gun, they can be very limiting. Once you have used up the charge you have to do without the flash, usually for several hours, while you recharge it.

Choosing an electronic flash unit

There is a wide variety of electronic flash units available and your choice, as always, should depend on the amount of use to which you expect to put the unit and the type of work you intend doing. The more ambitious you are, or the more you prefer automation to calculation, the more you have to pay.

The cheapest units are small and low-powered to the point of uselessness. Nevertheless, if your only intended use is in very

close-range shots or as fill-in daylight, even one of these units can have its use.

You judge the power of the unit from its guide number. Practically all units short of the large studio types are given a guide number rather than a figure denoting electrical output, which can be rather misleading. The guide number is arrived at by multiplying together the f-number and distance (in feet or meters—two different guide numbers) that give correct exposure for a film of given sensitivity (or speed). The operation of the inverse square law in relation to light sources ensures that any such pair of figures will give the same product.

Thus, a unit with a guide number of 18 (meters) will give correct exposure if the lens is set to f8 and the unit is placed a little over two meters from the subject (or f4 and 4.5 m, etc.) The really inexpensive units have guide numbers from about 6 or 8 to 24 for 100ASA film. A unit that has a guide number that seems a bit high for its price should be viewed with some suspicion.

On some flash units the guide number is indicated by a table printed on the case or by an exposure dial. The table quotes the actual guide numbers for a few popular film speeds. The dial indicates the guide numbers indirectly. You set the dial to the film speed required and in so doing cause an aperture scale to move against a distance scale. Read off any pair of aperture and distance and multiply them together. That is the guide number for the film speed set. A certain amount of rounding off is usually involved.

Such a dial allows you to check the guide number for any film speed on the scale. Without it, you have to do a little bit of calculation. The guide numbers advance like aperture numbers. Twice the light means a guide number multiplied by the square root of two. Ten times the light means a guide number multiplied by the square root of 10. So, if you have a guide number for 25ASA and you want to know what it should be for 250ASA, you simply multiply by the square root of 10 or 3.16.

In that case, the light is not 10X more powerful, it is 10X more effective, because of the increase in film speed. If you were comparing two flashguns, however, one with a guide number of 20 and the other with a guide number of 63, you would know that the latter was not 3 times more powerful but 3.16×3.16, or 10X.

The 'amateur' type electronic flash unit contrasted with a studio type spot with barn doors and filter slot and a sophisticated heavy-duty, high-power type for mobile use.

But you must make sure you are comparing like with like. The guide numbers must relate to the same film speed and must be on the same basis—feet or meters.

For reasonable power, you need a guide number of about 30 upward. At 30 you have power roughly equivalent to that of the smallest flashbulb. At that level, however, the price is no longer low and can be very high indeed. When you are judging power, do not pay too much attention to the often-quoted advantage of being able to stop down to increase depth of field. For that you need quite significantly higher power to increase the shooting distance, because the biggest drawback to flash work (and any other form of artificial illumination) is that its power falls off drastically with distance.

You may be told, for example, that a guide number of 44 allows you to shoot from 4 m at f11. So it does, but the small stop gives you limited extra depth of field. With a 50 mm lens, depth of field at those settings stretches from about 2 to 7.5 m. With your main subject correctly lit, however, the object at 2 m would be 4X overexposed and that at 7.5 m nearly 4X underexposed. The small stop gives you extra depth of field but, with one flash unit, you cannot light it adequately.

Extra power is always useful but its value is in allowing you to shoot at reasonable distances (for full-length figures, perhaps) or to use films of moderate speed. You can always reduce the power at close range by using diffusers, filters or an automatic-exposure model but you cannot increase it. You need reasonable power, too, if the unit has accessories such as wide-angle attachments and filters, which can decrease its effective power dramatically.

Apart from power, you have to consider whether you need an automatic-exposure model. Soon, you may not have the choice. Most of the medium-to-high power units are of this type. Those of very low or very high power are often manually-controlled only.

The automatic versions are useful, particularly for those who find any kind of mathematical calculation difficult. You simply set a lens aperture and a switch on the unit in sympathy and shoot, regardless. Provided you are no further from, or nearer to, the subject than the power of the unit can cope with (the limits are shown on the unit) you get adequately exposed pictures. Many

models have the disadvantages that they can be used automatically only when the flash unit is on or very close to the camera and for direct flash. If you bounce the flash off a wall, ceiling, etc. the sensor also points to the reflecting surface when it should be pointing at the subject.

Some units have a swivelling head, so that the sensor stays pointing at the subject no matter what the head fires at. You pay more for that. You pay still more for a remote sensor that can stay on the camera while the flash is used on a bracket or at a greater distance from the camera.

All automatic models can be switched to manual operation. Then you set the lens aperture according to the guide number and the distance. If you acquire an electronic flash unit without an instruction book, and you wish to know the guide number, simply multiply together any indicated pair of distance and aperture figures at the required film speed. Naturally, the guide number varies with film speed.

Finally, consider the power source. It must be an advantage to have a unit that can be operated from the domestic electricity supply as well as from the internal batteries. There must be some occasions when you want to use it indoors for close-up work, copying, etc. Adapters for this purpose are not expensive but they must be designed for the specific flash unit. Not all units have this capability.

Conversely, it is a definite disadvantage to have a unit with built-in rechargeable batteries. There are not too many of them about now, but there used to be a lot and their great diasadvantage was that when the battery needed recharging, the flash unit was out of commission for about 14 hours. If you forgot to recharge it after use, you could find it flat after two or three shots when you next needed it.

A few of the larger units available may still use the old lead-acid type of battery—like a miniature car battery. Avoid them unless you have a particular affinity for this type of battery because they need a lot of looking after. They are certainly not for the occasional user. Rechargeable nickel cadmium (nicad) batteries are popular but you must have at least two sets and they are quite expensive. They look just like the ordinary dry cell (AA is the usual size) but they

give only 1.2 volts as against the normal 1.5. That can be a little low for some units. For most people, the alkaline battery is probably the best in the long run. They give a great many more flashes than the normal dry cell and have a far longer shelf life. They are a lot more expensive, too, but probably still the better value in the long run for flash guns.

The choice really boils down to power and price. If you intend to use flash regularly—and it has a lot of valid uses in close-up, copying, slide duplication, etc. even if you don't like it for normal work—get the highest power you can reasonably afford. Avoid the gimmicks unless you have a need for them. You don't need a swivelling head on a manual unit. You can probably buy a small ball and socket for less, or a flash bracket with swivelling facilities built in. Apart from that, you are likely to need two or more units if you begin to take flash work seriously. If you can afford it, go for the more professional types that allow for the attachment of extra heads and have switches to enable you to reduce the power. If cash is not readily available, buy a single unit with the idea in mind of buying others of the same type at a later date.

Flash accessories

There has been a tendency for some years now to produce a basic manufactured item and then to offer a variety of accessories to uprate it in performance, comfort, handling qualities, etc. The way is then wide open to independent manufacturers to design extras for your product. You can now buy filters, variable angle lenses, bounce reflectors, remote sensors, slave units, special battery packs, adapters of various kinds and so on. Some of these are specific branded items for particular units and you will learn all about them if you choose that type of unit, but there are a lot of accessories that have more genuine uses, some of which may be regarded as essential.

When you buy a flash unit you generally have just the basic caseful of works and tube with a contact in the foot and a cable so short that it may not even reach the socket on your camera. You can use it only on or very close to the camera. That is hardly the ideal place for any light source so you are compelled almost immediately to

invest in accessories to enable you to operate the flash off the camera.

Off-camera flash accessories

The first essential for off-the-camera flash is an extension cord or lead. The synchronizing cord from the flash unit to the camera is generally very short—perhaps about 15 cm. You can buy extension cords with male and female connectors up to almost any length. The flash can then be operated at a distance from the camera governed only by the length of the cord or cords. If you become too ambitious you will eventually reach the point where the voltage drop over the cord will leave you with insufficient power to fire the tube but you are hardly likely to go that far. There are easier ways to fire a gun at a distance, as we shall indicate later. Generally, you require a cord of moderate length, up to 3 or 5 meters perhaps, to enable you to direct the light on to the subject at an angle. That gives better modelling and may throw the shadows out of the picture area. Spring-coiled leads; get tangled far less easily but cost more and are heavier.

Having taken care of the electrical connection, you then have to support the flash. If you want to move it only a short distance off camera to avoid the direct frontal effect and the possible infamous red-eye syndrome, you can use a flash bracket or bar. These come in a variety of forms. The simplest is a straight bar with a few holes in it, to accommodate a tripod screw, and with an accessory shoe fixed at one end. You attach the bar to the baseplate of the camera and slip the flash unit into the shoe. More elaborate types may be bent at one end to form a handle or at both ends to form two handgrips, with an accessory shoe atop one of them. The grips might have a cable release incorporated. The accessory shoe may be on a swivel or tilt mounting.

Flash bracket and hand grip are sometimes available separately, so that you can use the same handgrip with brackets designed for different cameras. A further development is an adjustable extension piece in the handgrip to raise the flash unit between 30 and 50 cm above the camera. A similar product attaches to the camera tripod socket and raises the flash a fixed 38 cm.

When you want the flash further away from the camera than any bracket can allow, you can improvise simply by standing it on a table, shelf, etc. or by persuading a friend to hold it for you. Greater security is obtained by using a tripod, camera clamp or similar camera support to hold the flash unit. As these items are generally equipped only with a tripod screw, you need another little accessory; an accessory shoe mounted on a block with a tripod bush.

Making multiple flash easier

A single flash unit tends to provide highly directional light leading to harsh shadows. When you take the flash off the camera to improve modelling, you may find part of the subject distractingly under-illuminated. You can solve that problem reasonably well by using reflectors and/or bounced flash techniques, but full lighting, especially on the background, can be obtained only by using more than one flash source. The additional sources can be extra heads that plug into the power pack of the main unit, but the average user is likely to use complete units in each location. The problem then is to fire each unit in synchronism. There are two ways of doing that—with and without extension cords.

Most cameras have both accessory shoe terminals and cord sockets and sometimes both can be used together. Then two units can be fired in synchronism. In other cases, or where more than two units are used, the cords have somehow to be connected together. Multi-way sockets are freely available. You push them into the flash socket on the camera and push the flash unit cords into the two or three other sockets thus provided.

Unfortunately, the straightforward adaptors of this kind are not foolproof, particularly when the flash units used on them are not identical.

They could have different polarities or different firing voltages, resulting in erratic firing or firing of one unit when the other is connected. It is not impossible for damage to be caused to both flash unit and shutter contacts. A more sophisticated adapter is available incorporating a safety circuit to take care of such incompatibilities.

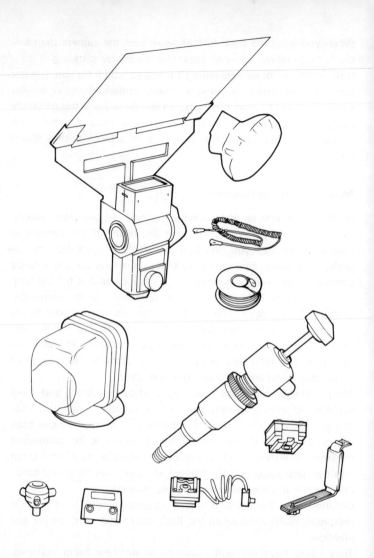

There are innumerable flash accessories including (from top down) large card attachment to diffuse the light, inflatable diffuser, exterior lead for off-camera work, both coiled and wound on a reel, slave unit, external synchroniser, tripod mounting accessory shoe, multi-socket, hot shoe adapter and flash tripod.

Whatever kind of adapter you use, you may have a considerable problem with trailing leads, particularly if you want to use a full lighting set-up with three or four units. If you shoot from 3 m or so with a flash on the camera, another to one side for modelling and another on the background, you could need to be very nimble to avoid pulling the whole set-up down about your ears. This is inevitable sooner or later.

There is an easy and not too expensive way out of this difficulty. The problem is to fire the remote flashes without cords leading back to the camera. That is a simple matter indeed for modern electronic techniques. All you need is a light-operated switch— one that will close instantaneously with any sudden increase in light level. Such switches have been in use for years and have been adapted to photography in the form of slave units. It is possible to find quite inexpensive ones.

A very efficient type is also the least expensive. It consists of a light sensor and three or four other tiny components embedded in transparent casting resin with a flash socket incorporated and a suction cup attached. It measures about $2.5 \times 1.5 \times 1.5$ cm. You plug the flash unit sync cord into it and stick it on the side of the flash unit. You can then place this slave-controlled unit in the required position and it will fire instantaneously when the sensor receives light from the flash attached to the camera. Of course, you can use as many slaves as you like. Generally you should place them so that their sensors face the master flash but these types and most others too, are now so sensitive that they will fire, at least in a small room, when the sensor faces one wall and the master flash faces the wall oposite. They also work at extraordinary distances (12–15 m is not uncommon), even in daylight. Naturally this depends on the power of the activating flash, which should not normally have a guide number less than about 30 (metres) for 100ASA film. Smaller units will operate the slave but at much reduced distances. The most convenient place for the master flash is on your camera; or on a flash bar. In most cases you can treat this as the fill-in flash in your set up, adjusting it and the other units so that the lighting ratio is right. However, if you do not want any light from the camera direction, face your flash to one side, so that all it does is fire the slave units.

Attachments for diffused lighting

Multiple flash and, to some extent, off-camera flash in general, are for the studio or a reasonably static set-up. If you are moving around with the camera and have to use your flash on or close to it, an indirect technique may avoid the harsh, flat lighting characteristic of such work.

Indirect lighting implies the use of a reflecting surface off which you bounce the light on to the subject. It thus becomes more diffuse and covers a larger area. The intensity on the subject is, of course, reduced, so the technique is usable only with units of reasonable power.

It is not really necessary to buy reflectors for this. Most rooms have white ceilings that are fine for this purpose. They need to be white or neutral-coloured when you work with colour. With that proviso you can bounce your flash off any surface within range but it is undoubtedly convenient, especially when working outdoors, to carry your reflector with you.

These, too, come in many forms. Folding types are readily available. Generally white, they can also have silver or gold-coloured surfaces for particular purposes. The gold colour is said to give a suitable 'warming up' effect to shots taken on dull days. A rigid type about one metre square comes with a lightweight tripod.

The brolly flash is a similar idea used in a rather different way. The flat reflector is used with direct flash to throw light into shadow areas. Or it can be used with bounced flash with relatively small subjects. The brolly flash is used as a light source in itself. A common type incorporates a tripod mounting for a more or less conventional umbrella with white or silvered inner surface. The flash is mounted pointing into the opened brolly and away from the subject so that the light is bounced but to some extent directed back to the subject. The result is a cross between diffuse and directional lighting. Other forms are more elaborate with heavy tripod stands and, perhaps, modelling lights.

All these reflector units are portable and easily moved around even when erected but for true manoeuvrability a simpler device has to be used. Such a device is incorporated into some 'system' flash units with swivelling heads. The reflector takes the form of a

standard grey card with a white surface on the other side. It clips into a support attached to the flash unit so that the head can be tilted up to fire at the white surface which is angled to direct a reasonably diffused light on to the subject.

An ingenious device known as an air diffuser consists of a plastic bag construction that fits over the average smaller flashgun and inflates to provide a bulbous diffuse light source.

A minor accessory that can be useful if you have no other means of angling your flash is a ball-and-socket mount with foot to fit an accessory shoe and a shoe at the top on a rather longer stalk than usual. The flash unit can then be tilted in any required direction.

Miscellaneous accessories

Most of the accessories we have mentioned so far involve the use of extension cords. As we have said these are freely available in various lengths. You are likely to need more than one unless you work exclusively with slave units. You could buy only one long cord, say 5 m or more, in the belief that it will serve all your needs, particularly if it is the coiled type that stetches to its full length only when necessary. But the probability is that you will do a lot of work with the flash unit much closer to the camera, say on a bracket. You then have a lot of cord to dispose of when you need only a few centimetres. It is advisable, in fact, always to have a very short cord, just enough for flash bracket work, with the other or others tailored to your expected requirements.

Look at the cord carefully before you buy it, especially if it is a long one. It should be reasonably stout with solidly moulded fittings because it will have to stand up to rough usage when trailing around the floor. It is a lucky man who never catches his foot in a trailing flash lead. That is largely why slave units are preferable.

Some flash units have separate plug-in cords to be used only when required. So universal has the foot contact become that some units are even supplied without a cord. You will need one and it will cost extra. Watch out for these proprietary types. They often use special plugs and sockets and when you buy one you must be sure that you get the right one. Do not rely on the salesman even if you quote the name. The standard camera flash

socket is a 3 mm coaxial and adaptors are available for some of the non-standard types.

An accessory not so commonly needed now is the foot contact (hot shoe type) to cord adapter. This fits into the hot shoe of cameras so equipped and provides a socket for cord-only type flash units. There are now few cameras without both types of contact, however. The opposite arrangement is also now uncommon—the foot contact flash unit with no cable. If you have one, and a camera with no hot shoe, an adapter with cord attached fits onto the flash unit foot and then into the accessory shoe. The cord can then be plugged in to the camera socket.

Another comparatively rare accessory is the external flash synchronizer. All modern cameras have synchronized shutters but if you should use an older camera without this facility, you can buy a synchronizer that screws into the cable release socket. It has a socket for the flash lead and a plunger that operates both the shutter release and a flash switch. Careful adjustment is necessary for each camera and spot-on synchronization at higher speeds can be difficult.

Flash exposure meters

So far we have not dealt to any extent with studio equipment. This is partly because most readers are likely to be interested in the less expensive equipment and also because studio set-ups tend to come complete from one manufacturer. Detailed information is readily available in technical literature and publicity material.

Had this book been written a few years ago, it is likely that this section would not have appeared either. Exposure meters for flash work have been available for many years but they used to be cumbersome, not completely reliable and very expensive. Progress in electronic technology is now so rapid, however, that a practical flashmeter can be obtained for a lot less than some continuous light meters—and prices are still falling.

A flashmeter is basically a very simple instrument in terms of the job it has to do. It has only to measure the light falling on it and indicate a lens aperture for correct exposure. The problem arises, of course, in finding electronic components to react fast enough to

Flash meters are activated simultaneously with the flash and give a reading of the aperture required for correct exposure. The traditional type use a needle and scale. The all-electronic versions give a digital readout to be translated on scaled dials.

measure the flash and translate it into a reading. The reaction time has to be no slower than 1/1000 second and, now that we have the incredibly short duration of some automatic units, it should be much, much faster. That is now relatively easily accomplished and flash meters are well within the reach of many hobby photographers.

The most inexpensive models are naturally less versatile than those that still cost rather more, but they may soon be forced off the market by a steady fall in price of the most advanced models. An average-priced unit may not react faster than about 1/5000 second. It measures only the flash, cannot accumulate flashes and needs to be switched from high to low range according to sensitivity. It may use a moving needle giving occasionally indistinct readings on a compressed scale, and so on.

Already, however, at a price below that of, for example, almost all 35 mm SLR cameras, a flash meter is available with an extra-ordinary specification. It measures both ambient light and flash and can be used in incident or reflected light modes. It holds the reading and adds further flashes to it if required. Normally, it is auto ranging, i.e. it switches itself to a less sensitive range as necessary. An attenuator is nevertheless provided for 'super-high' illumination. The readout is a two-figure LED display used in conjunction with a large, easily read calculator dial. The reading is turned off after 60 seconds but can be recalled by pressing a memory button. A cord from the meter to the flash unit allows manual firing. Reaction time is such that no normal electronic flash is too fast for measurement.

Light from a single source, even if it is a window, can sometimes be too harsh and contrasty to make a flattering portrait. A very small flash unit mounted on the camera (or built into it) can be used to 'fill in' the shadows, and has the added advantage of giving sparkle to the eyes.

For spooky effects like this you need a camera which can make double exposures. The figure was photographed against a perfectly dark background and given an exposure of several seconds so that his outline would become blurred by movement. Then a garden scene was photographed by electronic flash at night (without the 'ghost' of course). Careful selection of subject and control of lighting is the key to success with complicated techniques such as this.

Page 307 top when a very wide-angle lens is fitted the angular spread of a flash unit may be insufficient to cover the entire image area evenly.

Page 307 bottom direct flash on the camera matches daylight in colour but may cause hard shadows and unwanted highlights.

Top a standard 50mm lens fitted in reverse (with an adaptor) was used for this shot of an orange pip, which is twice life size at the film plane.

Bottom at close focusing distances depth of field is always shallow.

Page 308 taken with a 105mm macro lens on a 35mm single-lens reflex camera. The photographer chose to use maximum aperture, otherwise the iris diaphragm would have distorted the shape of the sun.

A fragment of cullet (waste glass, obtainable from glass blowers) photographed with a standard lens on an 18mm extension tube. The glass was lit by a slide projector with coloured transparent sweet papers over the lens.

Copying equipment can be used to make transparencies from prints or other transparencies. By this means trick effects such as this, normally carried out on to printing paper, can be presented as slides.

The top photograph was taken on daylight transparency film, the lower one on film balanced for artificial lighting (see pages 354-5).

Lighting Equipment

Continuous artificial light sources (incandescent lamps, as opposed to flash) are less popular than they were a few years ago. Many studios have turned over entirely to the sophisticated but compact electronic flash systems now available. They offer so many advantages in intensity for size, colour temperature, ease of movement, lack of trailing cables, particularly where slave units are used, reliability, lack of heat, and choice of materials. More spontaneity is often called for in some studio work now and flash undoubtedly helps in that direction, too.

Nevertheless, there is still a lot of lighting equipment about and many people are using it for still photography. The hobby photographer, in particular, does not find it easy to use multiple flash set-ups. For him, the necessary equipment with modelling lights and flash meter is prohibitively expensive, whereas photolamps and reflectors can cost relatively little.

Tungsten lighting is widely used for black-and-white work, probably rather less for colour negative and very little for colour slides. There are few colour slide materials suitable for tungsten lighting and those that are available are designed for studio lamps and not the overrun photofloods that used to be so popular with amateurs.

Tungsten lamps

The ordinary tungsten lamp, as used in the household, is quite suitable for black-and-white photography and there is even a case for using 150 or 200 watt versions to avoid the harsh, overlit effect of photofloods used too closely. They are quite powerful enough with modern fast films and wide-aperture lenses.

The type of lighting you use, however, does rather depend on your kind of work. If you aim at pin-sharp full or three-quarter length

portraits, room interiors, close-ups of small items, etc. you might need to shoot at small apertures. That can be enough to make more powerful lighting preferable and if, in addition, you prefer not to use the slightly coarser fast films, then you certainly need to consider photofloods.

Photofloods are available in two basic forms. The pearl type (not to be confused with photopearls) looks much like an ordinary domestic lamp and is used in a reflector bowl or dish. The reflector photoflood is similar in appearance to the so-called domestic spotlights and window-display lights. It has a built-in reflector that gives a good forward throw of light without external assistance.

There are two popular sizes: Nos 1 and 2. They consume 275 and 500 watts respectively but give considerably more light than would normally be expected from such ratings—perhaps in the region of 650 and 1250 watts. That is achieved by overrunning, i.e. by making the filament burn at a much higher temperature than in an ordinary lamp and so give more light. You have to pay for that with a shorter life—about 3 hours for the No 1 and 6 hours for the No 2.

Both bayonet and screw fittings are available for the pearl types but reflector floods are supplied only with screw fitting.

Photofloods are not really suitable for colour photography. They give a rather bluer light (colour temperature 3400 K) than available tungsten light films are designed for. They are therefore declining in popularity in favour of the photopearl type with a colour temperature of 3200 K. Theoretically, photofloods should work well enough with colour negative film, but the results may not come out too well with machine printing. There are special long-exposure colour negative films which *are* designed for tungsten. Also, in some countries colour movie film in 35 mm cassettes is available. This, too, is usually balanced for tungsten lighting.

Photopearls are not so heavily overrun as photofloods. They consume 500 watts to give the equivalent of about 800–900 watts. They cost a lot more than photofloods but have a life of 100 hours. A very large 1000 watt version and a 500 watt type with internal reflector are also available. Photopearls, sometimes called 100 hour photofloods, are supplied in screw fitting only.

The non-reflector lamps, photopearl and photoflood, are com-

monly used in reflectors of various shapes to give the quality of light required. The popular form of reflector for a No 1 photoflood was, for some years, a spun aluminium type about 6 in deep to the lampholder and about 7 in in diameter at the front. It is still supplied and gives a hard, directional light. Other designs are now freely available and, at the other extreme is a 21 in diameter very shallow dish with white surface and a baffle plate suspended in the centre in front of the lamp. Virtually all light is provided indirectly by the reflector to give a soft, diffused effect.

Tungsten halogen lamps

Ordinary tungsten lamps have a glass envelope filled at relatively low pressure with an inert gas. The tungsten filament gradually burns away and deposits form on the glass envelope, causing blackening and an alleged lowering of colour temperature. (It is more likely to be due to the loss of luminous efficiency in the decaying filament.) Tungsten-halogen lamps incorporate a halogen in the gas filling that reacts in a complicated manner with the incandescent tungsten to prolong its life, prevent envelope blackening, enable higher pressures and temperatures to be used and, above all, to increase luminous efficiency for a given wattage.

Generally speaking, therefore, tungsten halogen lamps give a brighter, whiter light and have a longer life than overrun studio lamps. They are relatively expensive because the higher temperature and gas pressure require a quartz or special glass envelope that is easily damaged by finger marks. As this type of lamp develops, however, double envelopes with glass protecting the quartz inner envelope are becoming more common. Tungsten halogen lamps are gradually replacing the ordinary tungsten lamps in studio lighting units, which can be made more compact as a result.

Various studio lighting heads are designed for tungsten halogen lamps from 650 up to 5000 watts and more. A common 650 watt type gives more light than a 500 watt photoflood and has a life of 75 hours. The 5000 watt type gives about 8 times as much light and has a life of 400 hours. Connections are usually bi-post, or double-ended for tubular types.

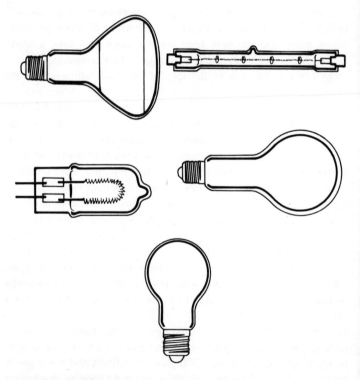

Common incandescent lamp forms in their relative sizes. *Top*: Reflector Photoflood and 1000 watt tungsten halogen. *Centre*: 1000 watt tungsten halogen and Photopearl. *Bottom*: No 1 Photoflood.

Reflectors for amateur lighting stands. *Top*: Soft lighting 21 and 17 in types with baffle. *Centre*: 7, 9 and 11 in reflectors for contrastier lighting. *Bottom*: Middle of the road 13 in type without baffle.

Lamp units for tungsten halogen lamps generally need careful fusing. With the wrong fuse, they can cause heavy arcing when the filament finally burns out. The heat generated can shatter the envelope with dangerous force. Similar results can occur from overvolting, undue vibration (by moving the lamp when it is switched on) or overheating. Most good quality units are supplied with wire guards and more than adequate ventilation, sometimes by fan. Nevertheless, every possible precaution against shattering should be taken and fuses should never be improvised or replaced by ones with higher ratings.

Lamp housings and stands

Most photographic lamps are designed to be used in lamp heads or housings carried on stands. The heads can take the form of simple reflectors as used for photofloods or more elaborate housings designed basically for two purposes—to give either a broad beam of light or a concentrated patch. The generalized descriptions are flood and spot respectively.

The housings vary from small easily portable units weighing a mere kilogram or so to, for example, a 68 x 43 cm housing for three 1500 watt tungsten halogen lamps weighing in at 10 kilos.

Both flood and spot types are supplied with various accessories. The most common accessory is a set of barn doors—opaque flaps fixed to two or all four sides of the housing (most tungsten halogen type housings are now rectangular). The barn doors can be swung toward the front of the unit to control the amount of light that is allowed to spill on to various parts of the subject. Barn doors for spotlights (generally with a circular lens) can be in rotating form.

The simplest reflectors can be on clamps or small stands with clamps incorporated. Little serious work can be done with these however because they rely on the availability of surfaces or edges for standing or clamping at the right height and in the right position.

More versatile stands with small folding tripod bases are available at reasonable prices. A popular type is made from lightweight metal tubing in two sections extending to 1.8 m (6 ft) with a base

Studio type halogen lamps range from the single-tube 500 watt flood to the three-lamp, three reflector type designed to take 1500 watt lamps. The spotlight has a 6 in fresnel lens and takes a 1000 watt lamp.

spread of about 78 cm or 30 in. This, and larger sizes in the same range, is basically a domestic type with its own system of attachments such as a lampholder unit to take a range of reflectors and a brolly flash set-up. Similar, but sturdier, units are supplied for studio or location use with lightweight reflectors and photopearl or photoflood lamps.

The heavier lighting units need sturdier supports and a degree of standardization. These supports generally take the form of heavy three or four leg wheel bases designed to accept 35 mm diameter tubing as the main stem. Tubular inserts with a variety of fittings give the required extension and a rapid lamphouse attachment.

The standard international fitting is now a $\frac{5}{8}$ in spigot on the stand taking a tubular fitting with clamp wheel on the lamp housing. The British Standard type still widely used has the clamp tube on the stand and the spigot on the lamp housing. Adapters to convert from one standard to the other are available.

Lighting stands are generally designed to take a range of accessories. Several types of attachment to the vertical column are provided in the form of swinging sleeves and arms, and clamps for tubes fixed at an angle. Leg brackets allow low level lamps to be fitted to the horizontal, rectangular-section legs. Boom arms are a popular fitment, of course, allowing lamps to be manoeuvred at various distances and height without moving the stand.

In some cases, relatively fixed lighting positions can be catered for by wall or ceiling mountings. A ceiling mounting may take a lamp house directly or, more usually, jointed arms with extension and 360° turning capability. Similar movements are possible with wall-mounted units but, naturally, with only a 180° turn. The maximum turning radius may extend to 1.5 or 2 m.

Choosing your lighting equipment

In the domestic situation, you are confined to occasionally setting up your lighting in a room generally used for other purposes. You cannot go for too sophisticated a set-up, particularly if your storage capacity is also limited. You have to use one of the lightweight pack-away systems or perhaps even resort to small stand or clamp units.

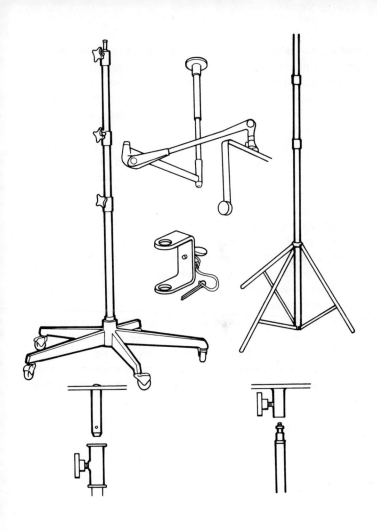

Studio stands can be the relatively heavy wheeled type or the lightweight folding type popular on location. They may be fitted with the British 5/8 in spigot (*bottom, left*) or the International 5/8 in fitting (*right*). The leg bracket (*centre*) allows lamps to be mounted on a stand leg or other 2 × 1 in rectangular tube. *Top*: a versatile ceiling mounting.

Folding stands are more versatile but they need a fair amount of room. If you buy those with a limited base spread, you have to be very careful with the height and balance of your lighting head. Using a boom arm can be hazardous. All this is the fault of the location rather than the product. It has to be designed with space considerations in mind.

Many such designs are available from suppliers to both amateur and professional markets. Location stands need to be rugged but easily portable and most manufacturers of professional equipment supply them at quite reasonable prices.

Lightweight stands may yet prove to be more versatile as tungsten halogen lighting units improve. They are becoming smaller, more powerful and better balanced. They are expensive, inevitably, but the life of some of the later units is way beyond that of normal photographic lamps. There is, for example, a 1500 watt, 2000 hour unit available with standard fitting at the cost of about eight or nine photopearl lamps.

If your are taking indoor work with full lighting set-ups seriously—and have the necessary storage space—take a look at a lighting specialist's catalogue before you decide on your equipment. A lot of their stuff is very expensive but a surprising amount is available at prices that compare very well with those ruling on the 'amateur' market.

Supporting the Camera

When you take a photograph, you allow the light reflected from the subject to pass through the camera lens on to the film. When the subject is moving, the image on the film moves, too, so you have to select a fast shutter speed to 'stop' the movement and get a sharp picture. Everybody understands that: if the subject moves, the image moves. Not everybody seems to appreciate that the image on the film also moves if the camera moves. Or, if they do, they believe it can't happen to them.

We all know the person who can get perfectly sharp pictures at 1/8 second or even slower and never uses a tripod. He is rather like the one who never gets grain on 20×16 in blow-ups from a quarter of a 35 mm negative. Even in carefully controlled conditions it is virtually impossible to hold a camera *absolutely* steady for 1/8 second. Not many people can hand-hold with perfect confidence at 1/30 second, and it is even possible to suffer camera shake at 1/1000 second, especially with a focal plane shutter.

So there is a case to be made out for a tripod as the least used but most essential photographic accessory. Lenses, films and chemistry are now at such a stage of development that most images produced by photographers are less sharp, in absolute terms, than they could be. Fortunately, even the best human eyesight is far from perfect and the lack of absolute sharpness may not be detectable at the normal 25 cm or greater viewing distance. So we can happily shoot at shutter speeds of 1/125 second and faster with reasonable certainty of sharp results. With care, we can manage 1/60 second. Slower than that and *some* loss of sharpness is inevitable.

All that assumes a well-balanced camera and lens assembly of no more than moderate focal length (say 135 mm, or perhaps up to a compact 200 mm on a 35 mm camera). As the angle of view becomes narrower, it takes only a fractional movement of the camera to displace the image considerably.

For the sharpest pictures, and sometimes for any real sharpness at all, the camera should be on some form of rigid support whenever a shutter speed slower than 1/30 second is used or the lens focal length is more than about four times the standard focal length. In many cases, even stricter limits could apply.

Tripods

The best all-round camera support is a tripod—but it could also be the worst. To be efficient a tripod must have a reasonable weight and bulk, and thereby becomes rather inconvenient and conspicuous in use. Those disadvantages alone are enough to make the sight of a photographer carrying a tripod one of the rarities of our time. There is, additionally, a certain lack of elegance in a tripod: it spoils the Cartier-Bresson image, or that of the modern photojournalist.

If you can overcome these ego-trip barriers, you could use a tripod often. A well-designed tripod can ease your task considerably in many circumstances. Any kind of architectural photography benefits from careful lining up of the subject and critical sharpness. Both are easier to attain with the camera independently mounted.

A great deal of sports photography can be, and is, carried out from a tripod. You often concentrate on one particular area of the track or field and, once the camera is lined up, you have little need to use the viewfinder again. You know your lens angle and you can watch the shot coming up. There is the telling, probably apocryphal, story of the cricket specialist who never watched the game. His reflexes were trained to press the cable release instantaneously with the shouted appeals.

Many portraits, figure studies, etc. would be better shot from a tripod. You can communicate much better with your model face to face than through the camera body or the top of your head. With a suitably long cable release you can even sit facing your subject with the camera shooting over your shoulder.

A tripod must be chosen with care. The fact that it extends to 2 m or more is not much use to you unless you intend to carry a step-ladder as well. The popular rising centre column has limited uses unless it is about 75 mm thick. Multi-joints allowing the whole assembly to collapse into a jacket pocket can be less than

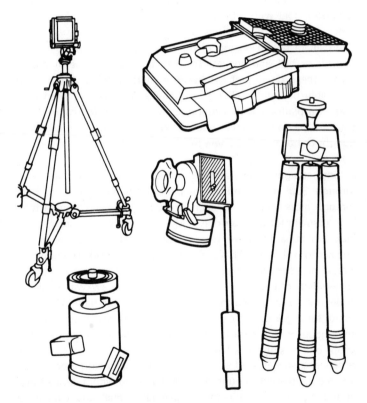

Tripods vary from heavy studio versions on wheels to collapsing portable types in many sizes and strengths. The camera can be attached to a pan-tilt head with long operating handle or a simpler ball-and-socket mounting. For rapid camera attachment to either, mating clip and shoe (*top right*) can be attached to camera and tripod respectively.

advantageous if the joints form also multiple centres of vibration. The efficient tripod has a modest height, 150 cm being about the practical limit for a portable, as oposed to a transportable, model. It may have a centre column extending some 50 cm further, but that should be used only in dire necessity. Strong, lightweight metals are available now, but the legs must be of sufficient cross section to offer fair resistance to bending at the bottom joint under hand pressure. The locks must be absolutely secure in all positions, resisting all attempts to press the assembly down from the top. Reversible feet with rubber plugs on one side and spikes on the other, or similar constructions, are a useful feature.

The camera holder on top of the tripod takes two basic forms—pan/tilt or ball and socket. The pan/tilt seems to be in greater favour these days, perhaps because there have been too many unreliable ball-and-socket constructions. The pan/tilt head consists of a platform with a tripod screw to secure the camera. The platform may be hinged at one end to allow the camera to be held upright or horizontally. There must be a positive stop and lock for both positions.

A long, straight handle allows the head to be turned completely through 360° in the horizontal plane or tilted forward or back through more than 90° in each direction. The handle has a twist lock (usually for the pan only). Most models have a separate tilt lock which is ideal for movie work. Single-locking types are quicker for still work. That is the basic pan/tilt head. The points to watch for, apart from ease of operation and positive locks, are the accessibility of the tripod screw (it is sometimes awkwardly placed under the platform) and the size of the platform. A large platform is useful for larger format cameras, but 35 mm cameras are small and any undue front to back length of the platform can foul protruding knobs or levers on some lenses.

A ball-and-socket head is in several parts. A ball with tripod screw attached is passed through a substantial tube with a cupped hole at the top. A camera platform, generally small and circular, is fastened over the protruding tripod screw. The ball can then tilt to a limited extent in all directions, while a cut in the edge of the cup allows it to tilt the tripod screw into a horizontal position at that point only. The ball is pressed upward in the tube by a cylinder

with a cupped top and a screw socket in the bottom to attach it to the tripod. A locking screw passing through the side of the tube forces the cylinder upward relative to the tube so that the ball is gripped by the two cup faces and so locked in any required position.

That is the basic ball and socket. It is a simple and versatile assembly that some prefer to the pan/tilt head because of its greater range of movements. Its disadvantage is that each movement disturbs the horizontal alignment of the camera. More important is that the lock is a rather brutal arrangement that can lead to rapid wear if poor quality metal is used.

You can mount a ball and socket on a pan/tilt head to get the best of both worlds but it is a clumsy arrangement. There are commercial models combining the two types, however, and much more sophisticated mountings for effortless movement of the camera in almost any direction. Gearing can be incorporated, for example, with or without levels and scales, to allow minute and measurable alterations in camera position. These more advanced heads are of greater interest to movie camera users, who need the smoothest possible movement, but they have their applications in specialist still camera work.

The sturdiness of a tripod is naturally the most important factor. If it is to be used in a studio, weight need not be too much of a problem and it can even be put on wheels to aid manoeuvrability. But the portable tripod must not be too heavy, so it has to rely on its construction to provide rigidity. Unfortunately, aids to rigidity often militate against versatility.

Bracing the legs together undoubtedly adds strength, but it also prohibits unequal leg angles to cope with difficult ground and the wide spreading of the legs for low level work. The bracing struts can be made telescopic, but that adds to the weight and cost. If the legs can be locked absolutely positively at the top, you may manage without bracing, but that is only an advantage if the legs can be really widely splayed.

Tripod accessories

Apart from the alternative heads that can be attached to tripods (ball-and-socket and pan/tilt are generally interchangeable), there

are various accessories connected with their use. Among these, perhaps the most useful is the quick release shoe. Attaching a camera to a tripod can be an awkward business that takes, at best, several seconds and is hard on the fingers. There is a temptation to overtighten the screw which sometimes damages the camera. An easy way out is to attach a shoe to the tripod head and a complementary clip to the camera, bellows, long lens, etc. The shoe stays on the tripod permanently, while the clip can be transferred to the appropriate piece of equipment as required. You can have two or three clips if you like (they are sold separately) and leave them permanently attached to equipment that is always used on a tripod.

There are various commercial designs. In one of the most popular, you simply slide the clip over the shoe until it locks. There is an additional safety lock to prevent accidental operation of the removal lever, which you simply press in to slide the assembly off the shoe. It is virtually an instantaneous operation.

You use a tripod to hold the camera steady so there is little sense in operating the shutter release with your finger in the normal way. A cable release is essential, but not, perhaps, if your camera is fitted with a self-timer, because that is a perfectly satisfactory way of releasing the shutter for static subjects.

The basic design of a cable release is a springy metal cable in a flexible sheath. A rod with button top at one end exerts damped pressure on a rod or pin at the other end. A separate spring returns the push rod, pulling the operating pin with it, as pressure is released. The end of the sheath has a fitting to allow it to screw into or attach to the shutter release button. The standard design is a small tapered thread. Adapters are available to convert the standard design to fit cameras using other designs.

The springiness of the cable is designed to allow it to be operated in a curved position and also to absorb any hand movement so that it is not transmitted to the camera. A cable release should, in fact, always be operated slackly. It should never be pulled taut because that negates its function as a 'shock absorber'.

Cable releases are available in various lengths and qualities. The popular type is relatively flimsy with a thin woven cover. Stronger types with heavier plastic covering and strong metal fitments are

Camera release machanisms range from the ultrasonic remote release with sender and receiver to the simple cable release with locking screw. 'Remote' control can also be achieved by long air release with rubber bulb or by a self-timer. For cameras without a self-timer, an accessory can be screwed into the camera release.

More easily portable alternatives to the tripod are a monopod (*left*), camera clamp (*centre*) or mini-tripod. Each is available in simple or relatively sophisitcated form.

worth looking for if you want a release longer than about 15 cm. Locking types are also available, allowing you to lock the shutter open for long time exposures. The lock may be a disc around the plunger operating on a push and twist principle or a simple pinch screw. The screw is generally safer. The disc type tends to be easily unlocked by accident.

An alternative to a cable release is an air release. The operating pin is moved by air pressure supplied by a small hand bulb. An advantage is that the air tube can be longer than a cable—6 metres or more. It has to be looked after carefully however. The slightest leak makes the release inoperative, and it might be difficult to find the leak in a hurry.

A more expensive method of operation is by ultrasonic radiation. A two-part unit consists of sender and receiver. The receiver plugs into the camera's shutter release socket, either directly or connecting to it via a cable. It works from a dry cell, the signal from the sender operating a solenoid in the receiver up to a distance of about 12 metres. The delay is about 0.2 second and current consumption is relatively high at 400 mA. Unlike radio-wave-operated controls, the ultrasonic unit does not need a licence in the United Kingdom.

Increasingly more cameras are being equipped with electromagnetic shutter release buttons. These models can often be released by any sort of switch, and so a range of remote radio or infra-red controllers and interval timers are available.

The self-timer or delayed action shutter release can be used for shake-free shooting but not all cameras are so equipped. Provided there is a cable release socket, that need not be an insuperable problem. You can buy a small spring-operated timer to screw into the socket. A popular model gives variable delays up to 20 seconds.

A tripod bar can be useful for cameras that have their tripod sockets at one end of the camera. That can lead to a very unbalanced tripod. The bar has a screw fitting for the camera bush and provides a further bush or socket nearer the camera centre. This type of attachment has been made for specific cameras and, in some cases, more elaborate camera cradles have been made available for the same purpose.

If you want to put a flash unit on a tripod, a useful little gadget is

an accessory shoe fastened to a tripod bush. Simply screw the unit on to your tripod head and the flash unit slips into the shoe.

There is even a tripod hanger that screws on to the tripod screw and provides a ring to enable you to hang the tripod on a convenient hook.

A poor relation of cable and air releases is the soft-touch button. It screws into the shutter release button and provides a larger and sometimes pressure-absorbent surface. It can help with cameras that have rather inaccessible release buttons and is particularly useful for the gloved or over-large-fingered cameraman.

Other camera supports

A tripod is the most versatile, but not the only, camera support. There are others, varying from the humble bean bag to the sophisticated copy stand. Copy stands and other close-up equipment are dealt with in a separate chapter.

The bean bag has been around for a very long time. Whether you buy one or make your own rather depends on your DIY ability and how much you care about the looks of your equipment. The idea is to provide a floppy but reasonably firm bag that can mould itself into various shapes to fit over a car window frame, chair back, wall, tree branch, etc. Then you push your camera or long lens into its yielding surface and have surprisingly firm support. It does not lend itself easily to precise framing but is perfectly serviceable and far better than an unsupported shot.

You can buy the bag ready filled or empty. The filling can be dried peas, lentils, plastic granules or any similar substance. The commercial product is made from tough fabric with a zip closure, so that it can be emptied, washed and refilled.

A step up the scale is a camera clamp. The popular variety is similar to the woodworkers G-cramp but has a small ball and socket head and, usually, a detachable spike or screw to enable it to be fixed to a fence post, tree trunk, etc. Screw-in legs are sometimes supplied to convert the clamp to a mini-tripod for very small cameras. Others tend to overbalance it all too easily.

True mini-tripods come in various forms. We refer here to genuinely small tripods extending to a maximum of about 30 cm

and designed for the purpose. There are many of the full-sized variety that collapse to a small size, but in their case collapse is often the operative word.

The mini or table tripod is designed to be carried everywhere and to be used on walls, car roofs and other supports taking the place of the normal tripod elevation. They are often so designed that they can be used, with their legs folded in, as hand grips or as chestpods, with the legs pressing against the chest and the camera tilted on the ball and socket to level it.

Full-size tripods are a little clumsy in use. The three legs are not easy to manage and one always seems to trap the unwary foot. There is such a thing, however, as a unipod, or monopod, with only one leg topped by a tripod screw. Elaborate versions are produced with ball-and-socket head, cable release and other excesses, but all that seems rather to defeat the object. The unipod is a simple, easily-operated camera support that can be tilted in any direction. If you need the full range of movements, you need a tripod.

If you really need a camera support (as you do with most long-focus lenses) but find it too clumsy for your type of work—sport, perhaps, or birds in flight, involving your continual movement from point to point—a rifle grip may solve your problems. A well-designed rifle grip can give a surprisingly steady hold and is relatively easy to carry in ready-to-shoot form.

Designs vary. A simple, popular type consists of a sturdy rod, with shaped shoulder rest and strap at one end and a pistol type butt at the other with trigger-operated cable release. A camera or long-lens platform with tripod screw is attached to the rod. The platform is adjustable for position on the rod and the rod itself can be extended to allow for arm-length variations.

More sophisticated designs support both camera and lens barrel and are often tailored to specific cameras and lenses.

Pistol grips also follow the gun analogy but are not nearly so steady in use. They are designed more or less like the butt of a pistol but with tripod screw or quick attachment on top and a trigger- or button-operated cable release. Their applications are limited but some photographers find them easy to use when resting a long lens on a bean bag, wall, fence, etc. or in the crook

of the arm. They demand such two-point support, being rather ineffective used in any other way. They are more likely to cause camera shake than prevent it.

Cases and Containers

As you collect extra bits of camera equipment—lenses, filters, flashguns, etc.—the problem of how to carry them about arises. There are various solutions.

Camera cases

Most cameras are supplied in or with a so-called ever-ready case. This name goes back a long way but today the name is rarely applicable. In its many forms, the ever-ready case has one feature that is common to all. The part that covers the lens is hinged or press-studded or eyeletted in such a way that it can be dropped down to hang below the camera or, in some, removed altogether. Just a quick flip and the camera is fully operational.

That was the original idea. It was never very successful even before 35 mm cameras became bumpy and often bulky objects. Now that so many photographers habitually carry around a camera with considerable lumps of glass and metal on the front, 'ever-ready' is a very misleading description. The front flap is substantial, often unyielding and a real nuisance, particularly when the camera is turned for vertical-format pictures. You may be able to remove that part of the case, but the best solution is probably to leave it at home.

Perhaps half an ever-ready case is better than none. At least it protects the body from knocks that might spoil its professional black paint. To set off against that doubtful advantage, it is clumsy, invariably badly designed and hinders rather than helps rapid operation. It is odd, too, that so many manufacturers, after making a sales point of the material covering the camera body, and even the shape of the body, then put it in a smooth plastic case of indeterminate shape that is difficult to grip.

As camera design becomes more complicated, the case has to be

pierced with holes to allow the fingers to get at the controls. It has to be cut down to allow those sophisticated edge controls to be used. It must be taken off, of course, to attach a power winder or, usually, a flash bracket. In other words, it is a useless dust trap.

It is generally wisest to put the case away carefully when you first buy the camera and preserve it against the time when you want to sell the camera or trade it in. It might add a little to the used value of the camera.

Cases for lenses

Most lenses are supplied in tubular cases with flip tops. Some have one flat side so that they don't roll about. Quality varies, of course, but many of them are little better than paper-covered cardboard boxes lined with dust-collecting pseudo felt.

If you carry your camera about with just one extra lens and no other equipment, the lens case on a strap could be useful. In that event, check your case carefully and consider buying a better one if it looks flimsy. If you carry various pieces of equipment in a holdall or gadget bag, the lens case is superfluous. It adds weight, increases the size of the holdall you have to carry and offers little extra protection. It also makes lens changing a considerable chore. There is not much point in having the cleanest lenses possible if you never manage to fit them on the camera in time to take the picture.

The habit of using a lens case and dispensing with front and rear caps is indefensible. A case inevitably accumulates a lot of dust and debris and, in its confines all that finds its way on to and into the lens. If added protection is needed inside your holdall, a plastic bag, frequently renewed, is a better choice. But always keep the caps on.

Soft cases and pouches

Some manufacturers offer soft ever-ready cases that are a lot easier to use than the hard variety, but they still have that often massive, always tiresome, front flap. For smaller cameras, however, there are soft pouches that are very serviceable. These cameras, such as

modern compacts and the half-frames that have now almost disappeared, are often much more conveniently carried in a soft pouch on a wrist strap. The pouch is quickly zipped apart and then falls right off the camera and hangs on the strap. Alternatively, a soft pouch is usually flexible enough to be stuffed in the pocket.

Soft pouches or bags that can be completely closed, sometimes on a drawstring are very useful for lenses. They are longer lasting and more efficient than plastic bags and not so dust-attracting as the conventional case.

Holdalls and gadget bags

Once you accumulate more than a camera body and two lenses—and feel the need to carry it all with you—some sort of container becomes obligatory. The options are many.

For several years, a gadget bag was more or less standard in design and many of the traditional type are still in use. This is a box-like case with shoulder strap, generally compartmented inside and with external pockets for small items. The top is zipped or press-studded into place and opens up to allow easy access to the interior with the bag on the shoulder. Later, more ambitious designs, resemble toolboxes with innumerable movable compartment divisions, drop-down sides and even lift-out trays. They remind you of the chest-type deep freezer and some of them are large enough to make the analogy particularly apposite. You sometimes have to unload everything to recover the small item that has found its way to the bottom.

A small well-designed gadget bag can be useful if you discipline yourself to carry just a few essential items. It should be reasonably versatile, however, so that you can vary your equipment for the job in hand. That could mean that you are better off without internal compartments. One day you might want to carry the camera body and two lenses, plus an exposure meter and a filter or two. Another day, you might need extension tubes, a tele-extender and a flashgun.

Cases with variable compartments and external pockets of reasonable capacity are the most versatile. External straps capable of holding a tripod or long lens could be an advantage, although

such items are generally more conveniently carried on a shoulder strap.

One problem with a gadget bag, particularly the plushy expensive looking type, is that it advertises its contents. It is obviously a photographic item and could be a temptation for thieves. It can also become very heavy, even with only a few items packed into it. It is not easy to carry on the shoulder, which tends to sag a little and obliges you to ease the weight frequently. With all these problems it is time to think of something else.

If you are excessively thief-conscious and not concerned with self-advertisement, you can use an old holdall or shopping bag that nobody would think contained anything of value. But then the difficulty is that all your equipment needs added protection against bumping around inside the bag. There are innumerable grips and bags on the market now, designed for various purposes and it is worth searching about in travel goods departments for something that can be adapted to your purpose. Strong canvas bags are available in many sizes, often compartmented and with outside pockets. Among the grips offered on the photographic market, there is one with a built-in changing bag. In sports goods stores you might find the shaped, air-cushioned, waterproof bag that floats.

Grips are practicable only for a relatively limited amount of equipment. If you habitually carry a wide range of items with you, the grip becomes difficult to manage and to stow safely. You must think of something much more robust because you are then more concerned with protection than portability. The metal case must then commend itself. There are many types but they are all designed on the one basic principle. The variations are in size, and durability.

The basic design is that of a rigid attaché-type case; a rectangular box with a relatively shallow hinged lid with strong hinges and locks. Most are made from lightweight metal with reinforced edges and corners. The best are strong enough to survive underneath a pile of luggage. The worst give way visibly under finger pressure.

Almost always the inside is filled with a plastic foam block, either custom-made with cut-out shapes for particular outfits or, more usually, for you to cut as required. Spare blocks of foam are readily

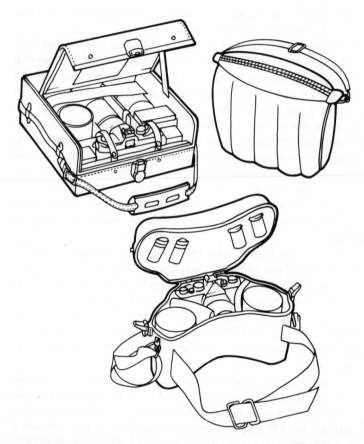

Fitted cases of many designs are popular with those who like to carry a lot of equipment. The shaped case is designed to be strapped around the waist. The pouch is inflatable and provides cushioning against knocks. It also floats.

available. The lid is similarly filled with foam plastic for protection.

Generally, these so-called custom cases are made for transportability rather than portability. As with so many items, however, they became fashionable rather than utilitarian and smaller versions were made to be toted on the shoulder like a gadget bag. They are not ideal for the purpose, being necessarily rigid and not a good shape for this method of carrying. They can bump about painfully on the hip and are, in fact, better carried in the hand.

Each type, the holdall and the custom case, has its followers and there is no point in arguing the merits and demerits. It is a matter of personal choice. Some like the convenience of easily extracting items from a bag sitting more or less on the hip. Others are happy to place a custom case on the ground and open the lid to take the required item from its shaped receptacle.

The larger type of custom case, however, has no equal if you have to carry a lot of equipment. You need a rigid container because the weight of the equipment inside it can be considerable. Most other types of container would tend to pull the items together as they were lifted and carried. The custom case keeps each object virtually immovable but still shock-protected in its foam bed. It is not intended to be carried very far. It is loaded into the transport and possibly spends most of its time there. If you shoot everything from the car door you have no problem, but if you venture far afield another, smaller holdall would be a wise investment. You can carry just the items you need for that exercise, leaving the rest securely locked up in the car.

Cases for small items

Almost everything photographic is either supplied in some sort of case, or a case can be bought for it. About the only exception is a flashgun which is apparently not thought to need added protection.

For the travelling-light brigade, there is even a small case to fit on your carrying strap, designed to carry just one film in its carton. That could make sense on some trips when you have a clear idea of how many shots you are going to take.

If you expect to use more than one film, you can take along the

jumbo version in the form of a film dispenser that holds up to four 35 mm films in cassettes. It clips on to a belt or camera strap. Incidentally, the box in which most processors return your slides takes four 35 mm cassettes snugly. The transparent ones even let you see what is inside.

Now that battery-powered shutters are commonly used, it is a wise precaution always to carry a spare battery. Many camera manufacturers are now including small, strap-attaching cases for that very purpose in their lists of accessories.

Filters are rather vulnerable in a gadget bag. If yours does not afford them adequate protection, there are two alternatives. You can buy a filter purse in the form of a flat, zipped wallet with padded pockets. A popular model has pockets made from transparent plastic sheet on a white padded base. It takes up to four filters and you can easily identify their colour through the pockets.

Alternatively you can screw all your filters together and put caps on back and front to make a sealed stack. It may may be less convenient but it offers first-class protection.

Choosing and using cases

You don't often get a choice of case. When you buy your equipment the case comes with it, sometimes at an incredible extra cost. It does not seem to be such common practice now but in the early days of price-cutting, some dealers tried to compete by advertising very low prices for the equipment and putting an astronomical cost on the obligatory case. It still happens occasionally, so watch out for it.

Sometimes a camera manufacturer offers a choice of soft or hard case. Generally, the soft case is the better choice. Hard cases are very unwieldy, particularly when they allow for bulky lenses. Of course, they look more impressive, especially when trimmed with metal edges and stuck-on badges, but they are not very practical.

Few cases are now made from leather. There was a time when the stiffness of your new case did not matter as it would soon wear in and become reasonably soft and pliable. When the modern hard case becomes soft and pliable, it generally means that the

cardboard interior has broken up. The paper-like covering on the outside soon follows.

You must consider carefully whether you want to use cases for camera and lenses. Once you put the camera in a case, you tend to become careless in handling it. You *think* it is fully protected, but the only real protection you have is against casual knocks and bumps. Some cases are so badly designed that they scratch the equipment every time they are opened. Never put a camera in an ever-ready case without a cap over the lens. That press stud on the back of the lid could have been specifically designed to whip back on to the lens as you unfasten it and drop the lid down.

Modern cases are not very fond of moisture, either. If you use an uncased camera in the wet, you wipe it afterwards. If you use it in a case, you tend not to, but the inside of the case is almost certainly wet and may well begin to rot. It certainly does not offer the ideal protection for the camera once damp sets in.

Much the same kind of argument applies to lens cases. They are a useful storage container if you do not intend to use the lens for some time. Then you can cap back and front and store the lens away in its case. Even then, however, you should first put it in a plastic bag. But then there is little need for the case, which offers virtually no protection against either damp or dust.

It is virtually impossible to keep your equipment in shining, as-new condition. If you want to keep it in a reasonable state but have it always ready for use, just take care of it. Carry the camera on a short strap, preferably across the body, rather than slung over one shoulder. Use back and front caps on lenses and a body cap on the camera if you put it away with no lens attached. Place the equipment carefully into your holdall; do not drop it in. Plastic bags or soft pouches can give added protection if you feel it necessary.

When choosing a holdall or case, think carefully about your requirements. A large case soon becomes a problem as it tempts you to pack in everything you own, and then add something more to prevent the equipment rattling about. You then find you can barely lift it, let alone carry it around.

If you really have to carry a lot of equipment—and that can only be when you are travelling and might take a variety of different types

of shots—you probably need a rigid custom case. But it should be your base camp and should be supplemented by another, smaller holdall to take on actual shooting trips. Unless, again, you never have to stray from your transport. That can happen on some occasions—but it is doubtful if you would need all that equipment in the first place.

Custom cases are expensive, so it is best to examine them before you buy. Pay particular attention to locks, hinges and corners, especially if the case may have to travel as luggage. It is not a good idea to buy a small custom case with the intention of carrying it over any distance. It either puts one hand out of action or, if carried on the shoulder, can be awkward, or even painful.

Choosing and Handling Films

The variety of films available can be quite confusing, especially for the users of the 35 mm format and larger. Cartridge-loaded films in the 126 and 110 sizes are more difficult to find. There is only one black-and-white film generally available, and that of medium speed.

These cameras are really intended for colour print work, and there the later 110 versions are reasonably well catered for by the leading manufacturers and various chain stores. Films of 80–100 and 400ASA are readily available.

The ASA figure is a direct indication of comparative fim sensitivity. The 400ASA film is four times as sensitive to light as the 100ASA film and can therefore be used at much lower light levels or at greater distances with a given flash unit.

Those using 126 film have to be satisfied with 100ASA film as their fastest colour negative or colour print version. There is a reasonable choice among the leading makers.

Neither type of camera is particularly well suited to colour slide production and that is reflected in the availability of only one, rather slow (64ASA), film being generally available.

Black-and-white films

All major manufacturers produce a wide range of black-and-white films but not all sell internationally. For many years, the standard general purpose film has been the 125ASA version typified by Kodak Plus-X and Ilford FP4. It gives good contrast, virtually grain-free results at any reasonable degree of enlargement and plenty of tolerance toward less than ideal exposure. As emulsion chemistry improves, however, the faster Tri-X and HP5, at 400ASA, are becoming more popular. They give better contrast and finer grain than was previously expected of fast film and have

wide tolerance. Above all, they can be push-processed quite satisfactorily to give the effect of greater film speed in suitable conditions. It is the effectiveness of push-processing, in fact, that has eclipsed the few films faster than 400ASA, that have been produced at various times. Those that remain are generally used only in really extreme conditions.

Slower films are still produced, such as Kodak Panatomic-X at 32ASA, Ilford Pan F at 50ASA, and the revived Adox in some markets, at 20 and 40ASA. Slow films are useful when you are striving for the utmost in fine detail at great enlargements or when shooting at large apertures in bright light. Their exposure tolerance is not great, however, and they have to be handled very carefully. Their extra-fine-grain capability is destroyed by the slightest overexposure or overdevelopment.

There are many special types of black-and-white film. Agfa-Gevaert, for instance, have a 35 mm reversal or slide film that gives black-and-white slides directly in the camera or by copying positive images. So-called positive film, on the other hand, is not designed for camera use. With a very slow emulsion (about 6–10ASA) similar to that used on bromide paper, it is primarily intended to be printed on from a negative. Various versions are available with panchromatic or orthochromatic sensitization.

Other print films are generally provided in the form of sheets. 'Line' and 'lith' are common designations. Both are high contrast films, again with varying types of sensitization, and are designed to produce solid black and clear film images. They are particularly suitable for copying line illustrations and, for the greatest contrast, are processed in special developers. They are used in many 'derivation' techniques, such as solarization and posterization. Processed in bromide paper developers, they can give a reasonable half-tone image at a single step, or a 'line' image with repeated reprintings through positive and negative.

There is also an infra-red sensitive film, usable with various densities of red filter on light source or camera lens, to record images by red light or infra-red radiation only. Such a film can be useful for shooting in unlighted areas without attracting too much attention, or for images of striking contrast of landscape, architecture, etc.

A spectacular night-time shot of the bazaar building in the Tivoli, Copenhagen. Most cameras can cope with this sort of picture, even hand-held, provided that a fast film is used.

Top a poppy photographed without filter (*left*), and with a red filter (*right*) to darken the foliage while leaving the red petals pale.

Above an ultra-wide angle lens (20mm in this case) can be useful in candid photography, because subjects at the edge of the frame will not realize that they are being photographed.

A tripod may not be the most exciting accessory to buy, but it is certainly one of the most useful. Neither of the pictures on this page would have succeeded without a good solid support for the camera.

Top lightning caught by time exposure, for which you need a tripod or similar support, and preferably a cable release.

Above a steel rule is a useful accessory when you need to record the size of objects for scientific reasons.

The same scene photographed on ordinary panchromatic film (top) and on infra-red sensitive film (*above*). Infra-red film has technical uses but is often used by amateurs seeking special effects such as this.

Two lights permit a variety of approaches to portraiture. Both can be directed on to the subject, or one of them can be used to illuminate the background independently. *Left* the photographer has become someone else's subject at a portrait session organized by a photographic club. *Right* two lights of different power ratings or placed at different distances from the subject provide good but not flat illumination for portraits.

Page 350 out of doors, direct sun can cast hard shadows that may spoil a portrait. This face is lit by indirect sunlight bounced up from the highly reflective surface of a path in Sicily.

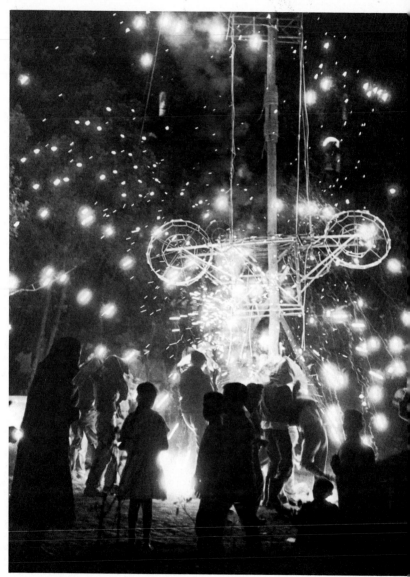

Fireworks can make spectacular pictures even when the camera is hand-held: the flying sparks light up the smoke from previous bursts, and figures in the foreground will mostly appear as silhouettes.

Choosing black-and-white film

The type of film you choose depends entirely on the type of work you do—and your personal preference for a particular type of image. Each manufacturer's film has slightly different characteristics that may appeal to one photographer and not to another. There is no best film and no bad film among the well-known brands.

It is pointless to be influenced by another person's choice unless he happens to do exactly the same sort of work as you. Press photographers are likely to favour 400ASA film for most of their work because it can be used in almost any lighting conditions. Professional photographers in general may use almost any film. Like amateurs, they often have a variety of interests. Those primarily engaged in studio work on still life objects may use flash a lot and therefore could choose a slow film. Medium speed film is likely to be the choice of those doing a variety of work but rarely shooting fast-moving subjects at low light levels. Which brand they use can depend on a variety of things, most of which are personal to the user.

Your choice should be similarly decided. A few years ago the advice would unhesitatingly have been that you should choose a 125ASA film because it can cope with almost any subject you are likely to attempt. Faster films were purely for low light levels and gave rather inferior results. This is no longer the case, so you can consider a 400ASA film as your first choice if you like to have that little extra sensitivity in hand.

You must remember, however, that a 400ASA film is rather over-sensitive for sunny lighting conditions. It might need an exposure in the region of 1/500 second at f16 or f11, leaving f8 as the maximum aperture you could use on most cameras. That could give you a lot more depth of field than you want. There are ways round the problem. You can use coloured or neutral density filters or you can adjust your processing. If you find yourself doing that very often, you are using the wrong film.

Colour print films

Films designed for the production of colour prints are commonly called colour print film or colour negative film—the latter because

they produce a negative image from which prints can be made.

There is a reasonable choice of colour negative film in most markets, again with varying sensitivity. Generally, the choice is between 80, 100 and 400ASA. Most people looking for quality images may still tend to go for the 80 or 100ASA versions. Fast films are relatively new in the field and are no doubt still developing. At present the quality of the image they produce is good but they might have been improved still further before release but for the advent of 110 cameras. The popular versions of these cameras are somewhat limited in their applications with 100ASA film. The faster film gives them much greater versatility.

As with black-and-white film, personal preference plays a large part in the choice of colour print film. Your type of work does not have so much influence because the 400ASA film is definitely for those who do a lot of low-light work, dull weather shooting, etc. It seems to revel in those conditions but has not a lot to commend it for general work.

Personal preference, on the other hand, plays a greater part than with black-and-white film because colour rendering is inevitably slightly different with each brand.

Colour slide film

Films designed for the production of colour slides are commonly called colour reversal or colour slide film—the latter because they produce positive colour images directly on the film used in the camera. The colour reversal name comes from the type of processing. The original image produced on the film is negative in the normal way but it is reversed to a positive by a slightly more complicated processing method.

The choice is a little wider than with colour negative film because there are two types—daylight and artificial light. Colour negative film can be used in either type of lighting, because it is subsequently used to produce prints. Filters can be used to adjust the colour of the printing light. That is not possible with a colour slide, which is produced as the film is processed. So different versions are supplied to allow for the difference in colour quality between daylight (bluish) and artificial light (yellowish).

There are fewer artificial light films than there used to be. At one time, all major manufacturers offered a film designed for the amateur's most popular form of lighting—at that time the overrun photoflood of 3400 K. With the turnover to flash and most of the demand for artificial light film coming from professionals, the emphasis shifted to films for studio type lighting at 3200 K. These are photopearls, the more powerful studio-type tungsten lamps and most photographic tungsten-halogen lamps.

The biggest choice is in daylight films. Ideally, they are intended for use in good sunlight with a reasonable amount of light cloud to reflect the light and subdue excess blue from the sky itself. Such light has a colour temperature of about 5500–6000 K. Electronic flashguns are made to produce a light of similar quality and daylight film can therefore be used with electronic flash, too. It can be used with flashbulbs provided they have a blue coating, as most of the smaller types do.

The range of sensitivities in daylight films is generally from 25, to 400ASA with 50, 64, 100 and 200 popular choices in between. Again, the choice depends largely on personal preference. Kodak's 25ASA Kodachrome has probably survived because of the popularity of the type of image it produces—virtually grainless and capable of extreme enlargement to show the finest detail. It also has a warm colour rendering that its adherents find pleasing. Naturally, not everybody agrees with them, some people preferring what they consider the more natural rendering of the so-called professional films.

Special colour films

Apart from the colour print and colour slide films designed for ordinary camera use, there are two main specialist films.

Kodak's Infra-red Aero Ektachrome was, as its name implies, developed for aerial survey work of a specialized kind. It has been taken up by some general photographers because of the extraordinary effects it can provide. It is deliberately designed to produce false colours, such as magenta foliage and, in the right hands, it can be used to good creative effect—but not too often.

Slide duplicating film is rather more mundane. Colour slide film

generally gives strong contrasts and is difficult to copy on to another, equally contrasty film. Slide duplicating film has a softer contrast characteristic designed specifically for the task. It is generally supplied only in bulk lengths of 30 m or 100 ft.

How to buy your film

You do not have a lot of choice in the packings of colour film you can buy. Naturally, cartridge-camera users buy theirs in the cartridge, perhaps with a choice of 12 or 20 exposures in colour negative.

Roll and sheet film users are similarly circumscribed. Users of 35 mm film, however, have the option of 12-, 20-, 24- or 36-exposure/loaded cassettes in both colour negative and colour slide film and one or two brands in lengths of 5, 10, 15 and 30 m for loading into their own cassettes.

Bulk supplies are much more common in black-and-white (35 mm only), most brands being available in lengths of 5, 17 and 30 m.

Where you buy your film is important. Black-and-white films have a long life (several years) and you are unlikely to run into trouble with any normal film outlet. Nevertheless, if possible, it is just as well to buy from a supplier you know has a reasonable turnover of stock—and that is not always a photographic dealer.

Much more care is needed with colour film. Ideally, it should be refrigerated but most films survive with ordinary cool storage for a reasonable period. If you see a stack of films in a flimsy rack over a radiator or in direct sunlight, avoid that dealer. Look at the expiry date on the packet. If it is around six months or less ahead, that shop has a poor turnover and you would be wise to find another supplier.

When you have bought your colour film, store it sensibly or, preferably, use it and get it processed quickly. Sensible storage does not always mean refrigeration. That calls for a few hours thawing out before you open the packet and could do more harm than good. Store the film in the coolest, driest place you can find.

Film accessories

There are various accessories connected with the handling of film,

the most obvious being spare cassettes and a loader for those who decide to buy their film in bulk lengths.

You can re-use the cassettes you buy full of film, or you can buy other people's used cassettes or new, usually plastic, reloadable cassettes. You can even buy the fixing tape to attach the end of the film to the cassette spool. Designed for the job, it does not ooze adhesive and is a better proposition than ordinary adhesive tape. Masking tape is generally satisfactory.

You can load cassettes by hand with practice but you would be well advised to buy a bulk film loader. There are several types of similar design. The basic arrangement is a light-tight chamber to hold up to 30 m or 100 ft of film. It has a slot leading to the cassette chamber that is opened only when the cassette chamber is closed. In the cassette chamber is a drive mechanism connected to an external handle and a frame counter. Once the film chamber is loaded you can operate in daylight to load cassettes with any length of film up to 36 frames.

Having loaded your cassette, you can even buy reload labels to stick on them to identify the film. They can then be put in cassette containers to protect them from dust and damp. When you load them into the camera, you can use yet another identifier—a pocket that attaches to the back of the camera and is intended to take the top of a film carton. If you have bulk-loaded, you have to make your own label.

If you find it difficult to dismantle the cassette to attach the film end, that too is catered for. There is a tong-like arrangement designed to lever off the end that generally breaks a fingernail. Don't try it on the crimped-end-types which are virtually unopenable without destruction. You have to handle film very carefully when loading cassettes. If your fingers get on the emulsion side, they can leave indelible marks, especially if they are moist or greasy. That eventuality has been provided for too, with the offer of special film-handling gloves.

Finally, you must put the bulk roll of film into the loader in complete darkness. If you have no darkroom, that is a job for a changing bag. This is a useful piece of equipment at any time. It usually takes the form of a large zipped bag with elasticated holes through which you push your arms to complete a light-tight seal.

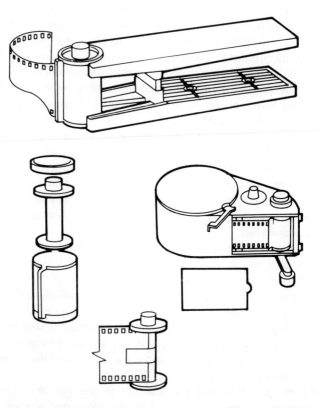

A bulk film loader (*centre*) can save a lot of expenditure on film. The standard cassette (*left*) is easily taken apart for the attachment of the film end to the internal spool. For even easier opening, a special tool is available.

You put all the necessary bits and pieces inside, do up the zip and operate by touch alone, just as if you were in a darkroom but in a rather more confined space.

There is a lot to be said for carrying a changing bag in your case or holdall. Camera troubles are not all that unusual and it is very galling not to be able to open the camera without spoiling the shots you have already taken. There is, as we have already mentioned, a gadget bag that incorporates a changing bag.

Bits and Pieces

There are innumerable odd items available to the photographer that defy classification. They appear in press advertisements, mail order catalogues and shop windows and, in many cases, are designed to catch the passing trade or the impulse buyer. They are often very attractively packed.

We have already dealt with a few of these in the form of adapters, camera clamps, mini tripods, cable releases, etc. while there are others for darkroom and film processing use that are outside the scope of this book. Here, we gather together the few oddments that do not fall naturally into precise chapters.

Carrying straps

Few cameras are easily carried in the hand and the normal mode of transport is to suspend the camera about the person by means of a strap. Ever-ready cases are invariably fitted with straps but not everybody likes these cases, so a strap fixed to the camera itself is necessary.

Most cameras have lugs near the top corners to take strap fixings. Some straps can attach directly to the small holes in these lugs but the majority use triangular or D-shaped rings to which the strap is clipped, or through which it is passed to double back on itself for fastening with an eyelet and stud arrangement.

Almost without exception, the straps supplied with cameras or on ever-ready cases, are no more than 15 mm wide, often only 10 mm or so. This is a villainous construction. It can dig painfully into your neck or shoulder and make even a relatively lightweight camera an intolerable burden after an hour or two. Shoulder pads that slide up and down the strap also tend to do that, and never seem to stay where they are needed to relieve the pressure.

Perhaps the popularity of electric guitars had something to do with

it, because there is now available a wide range of camera straps in widths up to 5 cm (2 in). They are generally of woven material with a belt buckle type of adjustment and strong clips to fit D-rings. To the conventional these straps may look a little extreme and reluctance to attach one to a Leica is readily understandable. But they are a lot more sensible than the orthodox strap and for a heavy camera they are virtually essential.

The narrower straps are, of course, quite suitable for smaller items, including some cameras. Some of these might even be carried on a fashionable snake chain if you wish. One exposure meter at least, was supplied with such a fitment, although the traditional long lanyard of the Weston meters is more sensible. You often need to hold the meter at arm's length and it is convenient to have it still attached to you to prevent dropping it.

Carrying straps are important and should be looked after. We all tend to take them for granted until a vital rivet pops or a nick develops into a rupture and the camera falls to the ground. Inspect your straps regularly for signs of wear and replace them if there is the slightest risk of impending failure. And when you do that, look at the range now available—not necessarily just from photographic dealers.

Wrist straps can be useful for some lightweight cameras that do not fit easily into the pocket and yet are too small to justify a full carrying strap. These can be in the form of a loop rotating on a tripod screw attachment. Make sure that the loop strap can rotate quite freely with the screw stationary or you may find yourself carrying just the tripod screw.

Cleaning items

Cameras and lenses attract dust and fingerprints, and this is unavoidable. Manufacturers have not been slow to provide for the camera-proud. If there is a rule about camera and lens cleaning, it should be 'Don't do it'. Cleanliness is advisable, but ill-advised cleaning can do more harm than good.

Optical glass is not as soft as some would have you think. Now that all lenses are coated, their surfaces stand up reasonably well to somewhat careless treatment. Nevertheless, constant polishing of

the lens surface with a handkerchief or, worse, a lens cleaning tissue, can soon take the edge off its performance, so stick to the gentler methods.

Blower brushes are probably the most useful item. These are soft, stubby brushes on a hollow stem with a small ball attached. Squeezing the ball provides a puff of air to dislodge loose dust. The brush head is generally removable, uncovering a nozzle to concentrate the air jet into corners and crevices. The brush itself should be used gently and only when really necessary to flick dirt out of lens rims, etc.

Photographic lens tissues are made from acid-free material, so that when you rub the tissue all over the lens surface you do not deposit any destructive acid on it. This is a good idea for spectacle wearers, most of whom scrub assiduously at their lenses every day. It is a little pointless for camera users because the tissue should never be used to wipe the lens under finger pressure. It should be folded into a brush shape and used *like* a brush. But in that case, why not use a brush?

The only time you might justify using a lens tissue to wipe your lens is when you have a finger mark on it. That can, indeed, damage the coating and even the glass underneath it. Then you can risk damping the tissue or, preferably, a many-times washed handkerchief, and rubbing the finger mark off as gently as possible. Never use a polishing cloth at all. You can't keep them clean, no matter how much anti-static treatment they may have. Similarly, there can be hardly any occasion when you need to use lens cleaning fluid, finger marks again being a just possible exception. If your lens is so dirty that you feel a need to give it a bath, it is time it was professionally cleaned.

It does no harm to inspect the inside of your camera now and again and to blow out any dust that might have accumulated. You might even use the brush gently on the mirror and the underside of the screen. Don't touch the mirror with anything else.

Batteries and chargers

Never try to economize on batteries by buying cheaper alternatives. Cameras and flash units are quite expensive and are easily

damaged beyond economical repair by leaking batteries. Batteries, generally speaking, are leak-resistant, not leak-proof.

There are several types of battery in regular use in photographic equipment. Those used in cameras for auto-exposure or ordinary TTL meters are generally relatively small button or multiple types of silver or mercury oxide construction. They are expendable and have to be renewed at the end of their life. The camera handbook specifies the type to be used and you should never depart from that. Sometimes only the Japanese reference number is quoted but your dealer can give you the better known Berec, Mallory, Ucar, etc. designation.

In other equipment—flash units, motor drives, etc.—the penlight cell (HP7, Mn1500, etc.) is the most popular. This, like some other dry cells is readily available in the carbon-zinc traditional form or as a manganese alkaline type, both expendable. A rechargeable nickel cadmium type can be used as an alternative.

Carbon-zinc batteries are relatively inexpensive and are generally most suitable for low-current usage. In photographic use, they tend to take high currents so the alkaline types are a better proposition. Their much longer life more than out-weighs the higher cost. Nickel cadmium batteries are much more expensive than even the alkaline types and their life per charge is nearer the carbon-zinc—but you don't throw them away. They can be recharged in about 14 hours at a trickle rate of about 45 mA. Faster charging types are also available.

Battery chargers for nicad batteries are not inexpensive but they do enable you to keep your batteries for a long time and to charge them overnight. The initial outlay can be quite heavy for the charger and, preferably, two sets of batteries.

Choosing batteries

Your choice is generally between nicads and manganese alkaline types—especially for flash use. Carbon-zinc types give only about 50 flashes at best in the average flash gun and even then need rather long recycling times after the first 20 or 30. Their shelf life is not good. Alkaline batteries should give at least four or five times the number of flashes and they can sit unused for very long periods

without significant deterioration. The more than occasional user need not worry too much about the condition of his spare set. They will not die while he uses the set in the flash unit.

The same cannot be said for the carbon-zinc type, more likely to be the choice of the occasional user. As they have so short a life in use, and a doubtful shelf life, he should always have a spare set available but preferably should buy them just before the shooting session.

Nickel-cadmium batteries also have the disadvantage of a short life in use plus the necessity for keeping them in good condition. It is not advisable to leave them discharged for long periods. They should, therefore, be the choice only of the regular user who is prepared to carry two sets, with one set constantly on charge.

If you do most of your flash work at home or where mains electricity is available, you can get away with one set by buying the quicker charging type. An hour or so on charge can then put you back in business. In those circumstances, however, you would be better operating with a mains adaptor if possible.

Battery care

All batteries need to be looked after carefully. Camera and flash gun contacts are not very robust and a high resistance to electrical current can be built up by a completely invisible film of corrosion or finger marks. Always, before you decide that batteries are dead—and particularly after a period out of use—remove the batteries and thoroughly clean both battery terminals and the equipment contacts. That will often restore the equipment to full working order.

If you know that you are not going to use the equipment within the next week or two, remove the batteries. Virtually no battery is leakproof and you only have to experience once the havoc a leaking battery can wreak to learn a valuable but costly lesson. Similarly, when you change batteries, *always* change the complete set. Putting a fresh battery in with others that are more or less discharged can burst the case with sufficient force or pressure to break equipment contacts.

Photographing people

How To Take Successful Pictures of People

You will be more likely to take successful pictures of people if you stop and think before you press the shutter. That is much better than simply aiming the camera in the direction of whoever you want to photograph and clicking away in hopeful anticipation that each picture will be a winner. It probably won't. Shooting pictures in a haphazard manner simply leads to disappointing results which over a period can only be discouraging.

A far better approach is to look carefully in the viewfinder each time you frame up on a picture and to ask yourself the following questions:

1. Is the subject interesting?
2. Is the picture arrangement simple?
3. Is the background free of clutter?
4. Does the lighting enhance the picture?

If you can truthfully answer "yes" to each of these questions, you have a successful picture lined up in the viewfinder and should snap it up without delay. It is worth considering some of these points in greater detail since they form the basis of good pictures.

Interesting subjects

There is no doubt that some groups of people create greater general interest than others simply because they are more appealing to our emotive instincts. Such subjects can be considered to have good picture potential. Just as some groups of people are more appealing than others, by the same token some situations lend themselves more to photography than others and offer plenty of scope to the photographer.

People in emotional situations also create interesting subjects. The humour of a fleeting incident as the camera catches a joke, the

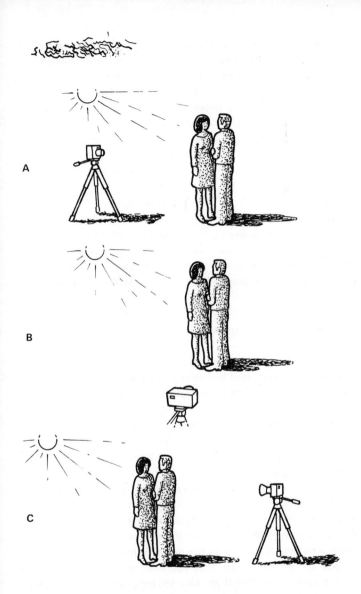

Sunlight from different angles. A. Front lighting (light behind camera shining onto subject). B. Side lighting (light shining onto side of camera and subject). C. Back lighting (light shining towards camera).

sadness of a mother on her daughter's wedding day or the anger of youngsters involved in a fight — each of these emotions helps to add interest and impact to the situation. It is often easier to achieve successful pictures of people if you select subjects and situations that have built-in picture potential.

Subjects with good picture potential	Situations with good picture potential
Babies	Children's parties
Small children	Weddings
Attractive girls	School sports
Famous personalities	Carnivals and fairs
Weather-beaten characters	Markets and outdoor shows

Of course, no list is exhaustive, and you are sure to be able to add to this one. It is a good idea to think of your own favourite list of good subjects.

Simple picture arrangments

Successful pictures of people show the subject clearly and simply and are not complicated by irrelevant details. It is therefore a false economy to look at a scene through the camera viewfinder and pack as much detail as possible into the picture area. Such a photograph will contain so much information that it will probably look an untidy jumble with lots of separate happenings competing for attention. A less cluttered view, making a concise statement, will create a far greater impression.

It is often more difficult to create a simple picture arrangement when you are photographing people than it is when you are photographing static subjects like buildings and monuments. The simple reason for this is that you do not have all the time in the world to frame up and shoot when the subject is on the move. Some situations happen so quickly and are so bizzare that you need to work rapidly to snap them up while they last. If you take too long getting your camera up to eye level, or setting the knobs and dials, you will have missed the opportunity to record the incident. The scene will have changed by the time you are ready to press the button.

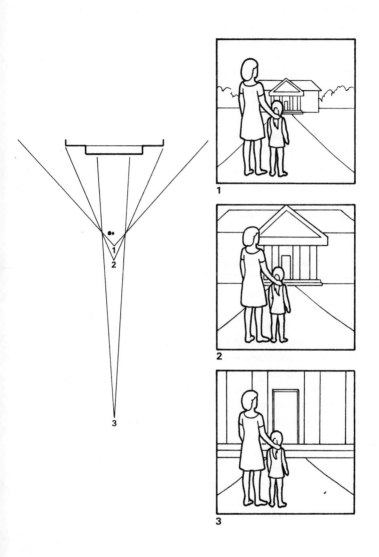

Picture perspective with different lenses. 1. Wide-angle lens at 1m. 2. Standard lens at 2m. 3. Long focal-length lens at 4m.

However, not all pictures of people have to be taken at high speed, more often than not you do have time to take a critical and selective look in the viewfinder before pressing the button. On closer inspection of a particular scene you may decide that the arrangement looks fussy. Frequently a much better view can be obtained simply be standing in a slightly different place to take the picture. It is suprising what a difference a few feet can make.

An effective way of ensuring a simple arrangement is to have the people in the scene filling most of the picture area. To achieve this you can either move in close to take the picture or you can stand at a distance and capture a more intimate view using a long-focus lens. However, as most people take pictures on cameras fitted with standard lenses, you will probably be more interested in finding out how to get the shooting distance right with an ordinary camera.

Get the shooting distance right

When you look at the distance scale on your camera in relation to the person you are photographing, you will discover just how close you need to be to the subject to create a picture that has lots of detail and impact. Generally, it is only by getting in close with your camera that you manage to convey the purpose of a particular picture. For example, perhaps your children and some of their friends are playing "shops" down at the end of the garden and you've been watching the theatricals from the kitchen window. The camera is handy so you take a picture unobtrusively from the back door. When you see the result you can just about distinguish whose children were down the garden that afternoon. You were much too far away to record the detail of the shopping counter and the financial transactions that were taking place, or to capture the intense concentration on the faces of the actors.

Whatever your reason for taking a photograph, the best way to make a clear statment of the occasion is to fill most of the viewfinder frame with a bold close image. The childrens' shop would have made a great picture had the shooting distance been about 2–2.5m (in the region of 8 feet), assuming of course that you were using a normal camera fitted with a standard lens.

The reason why so much emphasis is put on close shooting throughout this book is because most amateur photographers operate at a polite shooting distance when they are photographing people and consequently include far too much superfluous detail in their pictures. If your photographs have suffered from this complaint in the past you can easily help yourself to get the shooting distance right by developing the art of looking at people in the same way that the camera "sees" them.

Learn to develop a photographic eye

If you want to teach yourself to look at people in much the same way as a camera lens sees them, all you need is time to spare when there are a few people around. You don't actually need a camera. For the experiment find a comfortable park bench or somewhere else where you can sit and relax and watch people moving about. Then you should be all set. Make a rectangular frame with your thumbs and both forefingers before closing one eye. Hold your hands up to your open eye and study the people in the scene before you in your "viewfinder frame". There will be little difference between the picture you are seeing in the frame created by your hands and that which you would see in the camera viewfinder from a similar position (provided the camera were fitted with a standard lens).

In all probability you will find it difficult to concentrate on one particular detail in the scene before you without drawing your thumbs and forefingers together to reduce the field of view. By doing so you will cut out background distractions so that there is a single focal point in the scene that fills most of the remaining area of your viewfinder.

The only way you would be able to create the same uncluttered arrangement in the camera viewfinder is by narrowing the field of view of the camera lens. You could achieve this in two ways. You could either change the camera lens to one of longer focal length which would allow you to maintain the distant viewpoint and perhaps frame up on the scene undetected. Alternatively, there's an easier solution for camera owners who are not geared up with in-

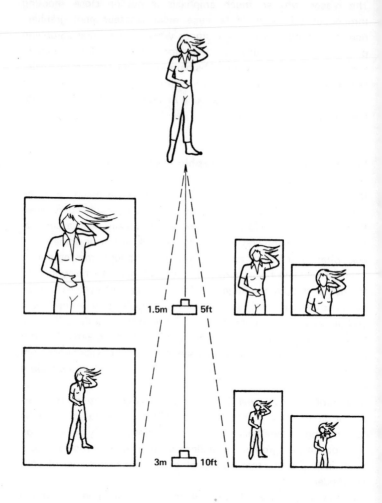

Filling the picture area. The diagram illustrates the size of image that will be formed by a standard camera lens at different camera-to-subject distances on a square format camera (120, 126 etc) as well as on a rectangular one (35mm, 110 etc.)

terchangable lenses, which would be to move in closer to the subject and so present the lens with a more detailed, narrower view. However, there are limits as to how close you can take successful pictures of people. There are two reasons for this, the first is to do with picture sharpness and the second with distortion.

Picture sharpness close up

Every camera, from the simplest Instamatic to the majestic Hasselblad, has a minimum lens-to-subject distance at which it gives sharp pictures. If the subject is closer than this minimum distance the image will be out of focus and therefore unsharp in the photograph.

The image in the viewfinder of a simple, fixed-focus camera always looks crisp and sharp however close the subject. The best way to avoid getting carried away and moving in too close to the subject is to look up from the viewfinder and to have a quick glance in front of you before taking the picture to see if the shooting distance looks about right. Of course this visual check is only necessary when you are practically within arm's reach of your subject. The minimum camera-to-subject distance is between 90 and 140cm (3–4½ feet) for most cameras of this type. The sharpness problem usually only crops up when you are photographing very small subjects like babies, where you can easily be tempted to get in rather too close just to see the little face clearly in the viewfinder.

If you use a reflex camera or one with a rangefinder, you have a reliable, visual reminder when you are too near to the subject because you will be unable to focus on the scene. When this happens the only way of creating a sharp image in the viewfinder (or superimposing the rangefinder images) is to move back a bit and frame up once again on the subject.

Distortion

The second reason for not wanting to take the camera too close to people is that your pictures can be spoilt by the unreality of distor-

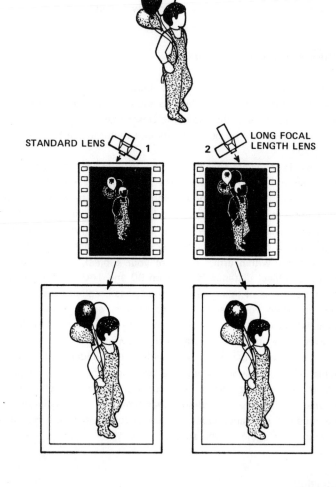

Creating bold images. 1. By enlarging part of the negative area or 2. by filling the frame with a close view to provide a negative that can be enlarged to a greater magnification.

tion. The effect is often called 'wide-angle' distortion, because it is most obvious when you use a wide-angle lens, and so go in very close to your subject.

It's not only the camera lens that sees close objects with a somewhat distorted perspective, the eye does exactly the same thing. You can easily prove this by moving a finger closer and closer to your eye. When you experiment, keep one eye closed and start with your arm stretched out. Move your finger gradually towards the open eye. You will blot out progressively more of the background while your finger appears to get larger and larger as it gets closer to the lens of your eye. You will probably be quite surprised to see a "normal" finger when you take it away from your eye.

Any onlooker might laugh at the scene, but the experiment shows how different things look from a different viewpoint. The trouble is that we are simply not adjusted to seeing things at such close quarters. That is why we find it difficult to accept the distorted, rather exaggerated perspective in pictures taken from too close.

We avoid the discomfort of distortion in real life situations by chatting to our friends at a comfortable conversation distance of around 1.7m (5 or 6 feet). During closer, more intimate conversations we study small areas like the eyes or the lips rather than the entire face. The conversation distance of 1.7m is also the most satisfactory shooting distance for capturing well proportioned pictures of adult faces.

The most frequent reason for distortion spoiling pictures of people is because a hand or a leg moves too close to the camera lens. Perhaps you are taking pictures of the girl friend sitting on the beach, in a side-on view she looks stunning and slim and your pictures will flatter her but if you shoot with her legs coming towards the camera you will convey the opposite effect. Her feet and ankles will appear disproportionately large to the rest of her body. It's easy not to notice this as you are busy focusing the camera. In fact, unless you have a reflex camera, the extent of the effect will not show up in the viewfinder. The easiest way to avoid distortion is to remember to arrange your pictures so that arms and legs and heads that appear in close-up all lie at about the same distance from the camera lens. The effects of distortion are sometimes used to add impact to pictures. How and why this is done is explained on page 451.

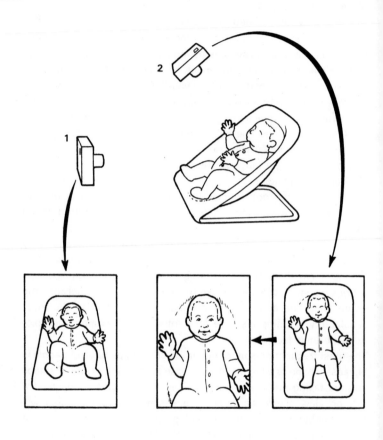

Image distortion in close-up pictures can be minimised by careful choice of camera angle. 1. Unnatural effects obtained when limbs project towards the camera. 2. Well-proportioned image obtained with the camera parallel to the plane of the subject and by enlarging part of the negative.

Picture composition can often be improved by enlarging part of the image area. In this selective enlargement the background distractions that were recorded on the negative no longer spoil the image.

Choice of background

A good background for pictures of people is a simple one that enhances the subject. It should compliment the people and not compete with them in terms of texture, colour or contrast. Unsuitable backgrounds contain ugly or obtrusive details which draw attention away from the focal point of the picture — the person you have photographed. There are several techniques you can use to create suitable backgrounds for pictures of people out of the most ordinary settings.

Your choice depends to a certain extent on the type of camera you use, on whether it has focusing facilities as well as an adjustable lens and on whether it can accept other lenses.

The easiest way of getting rid of a problem background is to view the subject from a relatively low angle. This will mean bending down slightly to take the picture and pointing the camera upwards so that you isolate at least part of the subject against the sky. Such a viewpoint gives a much cleaner picture arrangement than the conventional eye level shot taken at standing height. A low shooting angle can be used with any camera for most outdoor pictures of people. The obvious exceptions are when you are shooting in a really built-up area or in a crowded situation like a market place.

Another simple solution to the problem of cluttered backgrounds is to move in close with your camera so that the people you are photographing fill most of the picture area. There will be little room left for background distractions to appear in the picture. In addition, the shot will benefit from the added impact afforded by the close view. This is another technique that can be used with any camera.

If your camera has an adjustable, wide aperture lens it is relatively easy to separate the subject from an obtrusive background by controlling the relative sharpness of the image areas so that the subject stands out in perfectly sharp focus against a blurred background. You can not, of course, camouflage all background distractions, particularly when you are shooting on colour film. The out-of-focus image of a bright red pillar box, for example, will appear in your pictures as an even more garish red blob and no amount of focusing control will reduce the intensity of the colour. In this case, you just have to choose a different viewpoint.

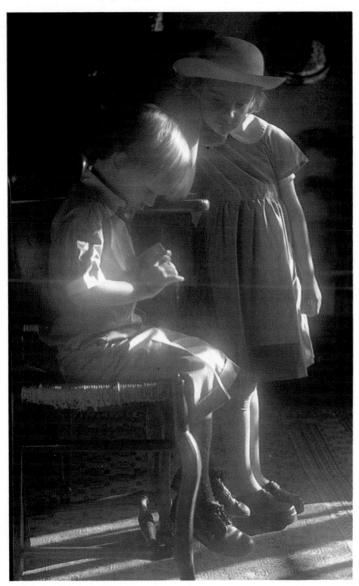

Shafts of sunlight slanting into a room can often be exploited to good effect, particularly with children.

It can be very difficult to focus on energetic children at play. Pre-focusing the camera (see page 440) is one solution; this photographer has found another.

Page 387 whether a human subject is really close or further away, focus on the eyes. This is one 'rule' that is almost always worth observing.

387

Strong directional backlighting is useless where fidelity of colour and tone are required, but marvellous for bold and dramatic compositions.

Page 388 partially or totally diffused lighting is ideal for pictures of people. Take care with white or pale coloured clothing against a bright background – you would need to give more exposure than a TTL meter indicates.

A romantic portrait. By focusing on the rainy window instead of the girl's face the photographer has enhanced the dreamy quality of the picture.

Differential focusing – the subject stands out sharply against an out-of-focus foreground and background. The use of a medium telephoto lens and a wide aperture help to create this effect.

Photographing people out-and-about. *Top* snow, like sand, reflects a lot of light, and accurate exposure can be difficult to assess (see pages 126-9).

Above a successful candid shot of a reveller at London's annual Notting Hill carnival, taken with a zoom lens.

Controlling picture sharpness

When you are photographing people with an adjustable, focusing camera you instinctively focus the lens on the most important part of the subject. This will be a prominent figure in a group of people, a baby's head in a Christening shot or a child's eyes in a close portrait. Having done this you can vary the degree of sharpness in each picture by adjusting the aperture setting. By selecting a large lens aperture (for example, f3.5 or f2.8) much of the picture will be out of focus and only the region around the point on which the camera was focused will appear sharp in the picture.

Conversely, with a small lens aperture for example, f11 or f16, some of the subject in front of the focusing point and most of it behind will come out in sharp focus. The actual amount of control you have over picture sharpness depends upon several factors. The greatest differential comes if you use a long focal length lens at its maximum aperture from close to your main subject. The further your subject is from the background, the more blurred will become the background. Being able to control the zone of sharpness is a great advantage when you are photographing people because it allows you to create artistic pictures in the most unlikely situations. You can tone down the distraction of fussy background or foreground details simply by moving in close to the subject and shooting with a large lens aperture.

Suppose you are taking pictures at a school fete. There are lots of people around and you've got the camera focused on a small boy sitting nearby on the grass with an ice cream in one hand and a goldfish in a jam jar in the other. The situation has all the makings of a super picture if it were not for the background which is a jumble of arms and legs and handbags. It's an impossible situation to photograph well on a simple camera but with an adjustable model all you need to do is to set the aperture to its widest opening to throw the background out-of-focus. By doing so the emphasis of the picture is concentrated on the boy and his winnings. You can easily create just the right effect simply by setting the camera lens to f2.8 and adjusting the shutter speed by an equivalent amount to maintain a well balanced exposure.

If you want to make certain of over-all pin sharp pictures you have to

increase the zone of sharpness to cover the entire picture area. For this to happen you'll need to set the camera lens to a small aperture and to keep the subject at a reasonable distance from the camera. The technical term used to describe the distance in the subject which can be imaged in sharp focus by the lens is depth-of-field. There's more about this on pages 144-147.

Records help progress

If you are just starting to concentrate on photographing people, quite a good approach is to record relevant details of exposure and shooting conditions as you shoot each frame on a film. Then, when your film has been processed, you can compare the facts and figures you have recorded with the resulting pictures. For example:

AUGUST SHOOTING BLACK-AND-WHITE FILM(ASA/BS 125)

Frame number	Subject	Weather conditions	Exposure	Camera-to-subject distance
1	Old man	Bright sun	1/250f11	4.5m 15 feet
2	Man with pipe	Cloudy dull	1/125f5.6	1.5m 5 feet
3	Children on swing	Cloudy bright	1/125f8	1.75m 6 feet
4	Child laughing	Bright sun	1/250f11	1.75m 6 feet

When you first glance through your pictures you will doubtless be pleased with quite a few of them. They will probably be the ones that showed people in natural situations, the children with grubby knees and faces; a girl friend with the wind in her hair smiling happily; or mum, duster in hand, sporting her weekday pinnie.

The best shots will be those which are correctly exposed – although if you've really caught a winning expression, or the emotion of the moment, you'll not notice if the picture is a fraction too light or a shade too dark as your attention will be held by the impact of the image. If you are not satisfied with any of the shots you will find that

your notes will provide clues as to what went wrong. Having established the faults, the task of correcting them shouldn't be too difficult.

A summary of the comments on the previous shots might read as follows:

COMMENTS SHEET

FRAME NUMBER	SUBJECT	COMMENTS	NEXT TIME REMEMBER TO:
1	Old man	Too much background in picture, figure much too small	Move in closer with camera – 2.5m is a good shooting distance for a full-length figure
2	Old man with pipe	Closer view has much more impact – would have been perfect had more of the picture been in focus	Select a camera angle that images the pipe and the hand holding it at roughly the same distance from the camera to avoid distortion
3	Children on swing	Picture surround is sharp but the child and the swing are very blurred	Shoot at 1/500 sec. to freeze rapidly moving subjects at a distance of 3m
4	Child laughing	Natural picture with impact – lighting rather contrasty	Manoeuvre things so that the subject is back-lit. Adjust camera exposure by 2 stops*

* That means giving an exposure of 1/250 second @ f5.6 in a similar situation.

Before you take your next roll of film have another look at your previous efforts. Chances are that you will see additional good and bad points which you will either want to emulate or improve upon

the second time round. And when you have completed another film keep up the good work of analysing your results, for the more you look at pictures, other people's besides your own, the better you will become at taking them.

Composition

When you start exploring photography a bit more deeply you are bound to come across the topic of photo composition. It's the subject of several complete books, a favorite for magazine articles and is usually of great concern to the judges of photographic competitions. Composition is a theoretical explanation of why good pictures are good. The explanations came into being because artists and photographers studied successful pictures and tried to identify all the separate design elements that gave the pictures their appeal. Things such as colour, shape, line, tone and form were considered in relation to the unity of the picture and their effect on the balance and impact of the result.

Picture composition is a subject that is worth reading up when you are starting to take creative pictures. You will find it useful to apply a few of the rules to your own picture taking situations before you begin to develop a style of your own. However, after a while, you will discover that really eye-catching pictures have something more than just good composition, they have that extra bit of creative flare that makes them come to life and make a clear statement in the strongest possible way.

Among the elements that contribute to a well composed picture are:
. Simplicity of subject arrangement and the shapes and forms within the picture.
. Contrasts such as those between colours, light and shade, textures or the size of objects. Chosen correctly, they can add interest and vitality to the subject of the picture.
. Patterns which, when repeated, help to create unity.
. Balance so that the distribution of colours, tones and shapes creates an even, artistically pleasing effect.
. A strong focal point, which gives the picture a prime centre of interest.

Perspective, which can be suggested by the size of different objects or by receding lines.

To get an idea of how these elements of composition can be related to your own pictures of people, have a look at some of your successful shots to see if the subject is:

1. Positioned in a commanding part of the picture area
2. The focal point inside a natural frame
3. The most colourful or the brightest element in the picture
4. The area of the picture in sharpest focus

If you have said "yes" to a couple of these points you are probably already looking at people in a critical way and selecting the best camera angle and lighting to create a feeling of reality and unity in your pictures. If not, you may be able to pick up some tips if the ideas are explained more fully.

Subject position

When you are looking in the camera viewfinder there are usually one hundred and one different positions in which you could place the subject. Some are obviously better than others and it has been established from successful photographs that you are more likely to be pleased with the result when the main point of interest lies slightly off centre, in fact along lines that divide the picture into approximate thirds. You've only got to think of something like a passport photograph where everything is dead centre, symmetrical and boring to realise the importance of subject placement.

Natural frames

Foreground frames to pictures of people help to create an illusion of depth by making the viewer look into the picture towards the subject. The frame can be anything that's conveniently nearer to the camera than the people you are photographing — doorways, flowers, windows, trees, fences, bridges or arches. The illusion of depth is heightened if the frame is darker than the subject.

When you are photographing people in crowded situations you can

Examples of subject placement to show how the compositional strength of a picture is heightened by positioning the most important area of the image along lines that divide the picture into approximate thirds.

often obscure unwanted, fussy details by carefully choosing a foreground frame to block out offending clutter. The frame doesn't have to completely surround the subject, nor does it have to be symmetrical. A suitable frame should blend with the mood of the subject.

If the frame is closer to the camera than the minimum camera-to-subject distance for sharp pictures, it will appear unsharp in the photograph. This is usually quite acceptable provided it doesn't dominate the picture.

Colour

Colour is an important element in picture composition because the mixing and positioning of different areas of colour within a photograph can affect the success of the result. Reds, yellows and oranges are definitely eye-catching colours whereas browns and purples merge well with the surroundings. The impact created by bright colours is much greater when they are confined to the small area of a photograph. Consequently, if bright splashes of colour appear on the edge of the picture area, as a blur in the background or as an indistinct shape in the foreground, they will probably attract as much if not more attention than the people in the picture.

Another aspect of colour which applies particularly when you are photographing people is that of clothing colour clashes. When you are out taking candid shots you don't usually get the opportunity to arrange things to perfection but, when you are photographing the children or formal happenings, it pays to be a bit more careful. The bride and groom will not be too happy to compete for attention with two clashing red dresses standing next to each other in the group pictures. If you are directing operations it's a simple matter to arrange the ladies so that they are well apart, preferably on opposite sides of the wedding couple.

You often hear people talk of colours as warm or cold. Warm colours are red, yellow, orange and brown; and cool ones are blue, green and mauve. In general it's advantageous to picture composition to keep the cooler colours in the background and the warmer ones in the foreground since, by doing so, you can emphasise the feeling of

The diagrams show how picture perspective can be increased simply by selecting an angled view of a scene and by having the family inspecting the view rather than the camera.

depth in the picture. Cool colours compliment a subject whereas warm colours and strong contrasts create an impression of activity and interest.

For the final word on colour it is worth remembering that some of the very best colour photographs are almost colourless. So when you are taking pictures of pink-faced babies or rosy-cheeked children the high key approach can be very effective. High-key pictures are those in which the subject is softly lit and the image is one of lightness and delicacy created with the help of white or lightly-coloured clothing and a white background.

Photographing Babies

Babies are undoubtedly the most photographable and the most photographed subjects around. From the moment of birth, camera shutters start clicking to provide pictures for the parents and the grandparents as well as the aunts and uncles. Once an infant loses that tiny-baby-look and begins to take an interest in the outside world it will have universal camera appeal. Pictures of babies crop up in many places: they are used extensively by the media to symbolize just about everything that is pure, clean and honest; they are prominent among the prints in photographic displays; they adorn the windows of nearly every photographic studio and, quite naturally, they are to be found in practically every home in the country.

A new baby?

The prospect of a new baby in the family is frequently the cause of a renewed interest in photography. If you are the expectant parent as well as the photographer don't rush out and buy a new camera if you already have one. You don't need an up-to-date, black-finished model for taking pictures during the first few months. Why? Because you are going to be far too preoccupied with other things when baby actually arrives on the scene to bother about the technicalities of a new camera. Your days will be fully taken up with four hourly feeding, extra washing and catching up on sleep. In between the baby routine you'll be entertaining friends and relatives who are bound to want to call to see the latest addition.

Once life with the new baby settles down to a regular, unflustered pattern you will have time to learn the ins and outs of a new camera and to experiment with it. Meanwhile, stick to the camera you know so that you can take pictures easily without spending too much energy or time on it; you'll have no surplus of either for a few weeks. Since tiny babies are relatively static subjects, even the sedate,

reliable Box Brownie could, if dusted, be used for taking pictures during the first couple of months. They do, however produce rather small pictures, because you must stay well back.

If you are having your first baby you have probably read all the pre-natal literature that is available and also browsed through a number of baby magazines. You might well imagine that a brand new baby has a chubby smiling face and a clear smooth skin. Pictures without captions can be misleading because newly born babies are seldom chubby and are unable to smile. Advertisers frequently use "established" babies to promote their merchandise because new born babies are not particularly photogenic at close range. On top of that, they are rather small as well as a bit floppy and are therefore not the easiest of subjects to photograph attractively. Fortunately your pictures of baby don't have to have universal appeal, they simply need to tell a very precious story which will bring back happy memories in years to come. Every baby is a different little person and to see your own baby grow and develop is one of the great fascinations of life. As no two children are alike it is impossible to say when you will be able to expect a particular stage of development to be reached. For this reason you should keep your camera handy so that you can frame up quickly when baby discovers a new trick and looks extra appealing and savour the memory in a photograph.

Making a baby book

There is a pretty good chance that you will be presented with a baby book the moment your friends hear about the new arrival. Besides containing pages on which you can enter the relevant weights and measurements, there will be lots of space for you to fill with pictures. During the baby's first few months try and keep the album as up-to-date as possible. If you stick in the pictures and caption them as you go along you will be able to remember the sequence of events that the shots cover. To add variety to the pictures in your album include a few enlargements of your best shots and trim those that contain untidy and irrelevant details. Trimming pictures has the added ad-

vantage of introducing a selection of unusual formats to the somewhat regimented enprints that feature in so many baby books and photographic albums. A combination of square, horizontal and vertical formats of varying dimensions will certainly enhance the overall impact of the pictures in your baby book.

At the beginning

There is no better place to start a story than at the beginning: the birth. As the proud new father you may be able to take a few shots shortly after the birth. This might be frowned on in some hospitals but it is amazing how unobtrusive you can be if you have determination. A little pocket-sized camera is really an asset on such an occasion as it can be kept tucked away out of sight right up until the moment you want to take a photograph. Even though you will need to use a flash bulb to light up the scene, the whole job should only take a second or two.

Visiting hours are not the best times for photography as the wards are bustling with activity and commotion. It is far better, if the hospital permits photography, for mum to keep a camera in the bedside locker so that it is handy during the day when things are a bit more relaxed. You will probably have already been told that anything left in a locker is there at your own risk so this is not the place to leave a camera that you really value.

Besides taking pictures of your own baby you may chum up with another mum who will be delighted to be presented with a shot of her and her offspring. Some hospitals keep the babies in cribs that are made of clear plastic so that baby can be easily seen and photographed from lots of different angles. You will want to get in close with the camera as there will not be very much of the baby on view as it is enveloped in wraps and blankets. Have the camera at the ready when baby is weighed. If you miss the first weighing session, ask the nurse when the next one is due so that you can be ready to snap up a picture at an opportune moment.

One of the rewards of having a baby is being spoilt with cards and flowers. The cards, of course, can be reserved along with other mementos but, sadly, the flowers soon fade, particularly in a hot

hospital atmosphere. If you are inundated with beautiful blooms you will certainly want to take a picture of the display before you leave.

Probably you will do most of your photography towards the end of your stay in hospital. Even if you only manage a few informal shots of scenes in the ward the results will be well worth the effort; you cannot decide to do it later.

During a home confinement there will be a hundred and one things to think about besides photography. If you think you might like to take a few pictures it is wise to buy the film and load it into the camera well in advance of the event. Keep the photographic gear in the bedroom so that you are not rushing around looking for things at the last moment.

In the first few weeks photography will have to fit in with the baby routine. Frequently a good time to take pictures is after the 10 a.m. or 6 p.m. feed for even a new-born baby usually follows these feeds with an alert spell. As baby gets older, so the waking spells become longer and the photographic situation becomes more flexible.

PHOTOGRAPHIC POSSIBILITIES WITH A NEW BABY

Event		Possible photographs
Bath time	1.	Medium distance shot of mother holding baby in the baby bath
	2.	Close-up of soaping operations
	3.	Medium shot of baby swaddled in towels
	4.	Close up of a clean dressed baby snug in mother's arms
Morning play	1.	Long shot of the pram in the garden (perhaps taken from an upstairs window)
	2.	Medium shot of mother looking at baby
	3.	Close up of baby lying in pram
Lunch	1.	Medium shot of mother preparing the bottle
	2.	Close up of baby drinking from bottle
	3.	Medium shot of 'bringing up wind'.

The first baby is quite an experience for everyone involved. All the things you will be doing will be new and different, so you will probably want to take quite a few pictures to tell the story. The chronicle will be more interesting if it contains a variety of pictures, long shots as well as close ups, single shots of fleeting moments as well as picture series containing two or three shots to describe an event in detail.

If you are about to photograph a friend's baby and are not used to handling such a small bundle you may not have developed the firm holding technique that assures baby that all is well. When you are uncertain what to do, leave the lifting and shifting to the parents as any uncertain approaches may upset the peace.

Problems and solutions

An average baby is about 50cm (about 20 inches) from top to toe at birth which makes it a pretty small subject for photography. In fact, if you have never studied a tiny baby through a camera viewfinder you may not have realised just how close you need to be to get a detailed view. For example, even if you go as close as you can with fixed-focus camera, the image of a fully stretched baby from top to toe is unlikely to fill the viewfinder area completely. Using the standard lens on a focusing camera you may do slightly better, the focusing will allow you to move in closer so that baby will just about fill the picture area. Even then, you are unlikely to be able to produce a full-frame picture of baby's face.

Since you are dealing with such a small subject in the early weeks of photography, your first baby pictures will show quite a bit of the surrounding scene. Because of this you will want to be careful to select camera angles that present the most attractive and straightforward view. That is not too difficult with such an immobile subject, as there will be plenty of time for you to look carefully at the picture in the viewfinder and move around a bit with the camera before actually taking the picture. When you do have to contort yourself to get a good view of the baby, in the bath or the bassinet for example, it might be possible to move things into an open space on the floor while you take a few photographs.

In fact, the floor is usually a pretty safe place for a young baby. It is the favourite position for shooting the more formal, Christening-type pictures where both baby and the clothes can be arranged attractively without harm coming to the infant. To make the presentation as simple as possible spread a white blanket or shawl over the carpet, particularly if it is a patterned one, and lay the baby down on it. The white surroundings will not only help to create a neat unpretentious picture, they will also reflect light onto the subject and so give you a softer, more attractive portrait. Try shooting from a high angle so that the camera is looking down onto baby. Taken from this angle the picture will contain all baby and blanket and no background clutter and will therefore have a single centre of interest — the child.

As we have said, babies cannot hold themselves in a pose, they need to be supported. Make sure that the support does not clutter or confuse the picture. A good idea for shooting mother-and-baby pictures is to have the baby wrapped in a shawl so that his back and head can be supported by out-spread hands underneath the shawl. The drape of the shawl will hide the angular distraction that might otherwise spoil the softness of the photograph. The best time to shoot is when mum moves her head near to baby so that their two heads are almost touching. If the scene looks stiff and posed try shooting again later when baby is due for a few cuddles and kisses.

Lighting

Photographs of the baby during the first few weeks will, in all probability, mostly be taken indoors where it is warm in the winter and relatively cool during a long hot summer. This will mean using either flash or a fast film and available light. The brief light from electronic flash or flashbulbs does not harm a baby's eyes.

If you have a simple camera or one with only a few adjustments on it you will certainly need to use flash for indoor pictures. Follow the advice given on page 467. With such a very small subject you need to take particular care to resist the temptation of getting in too close with the camera and flash, otherwise your pictures will be over-exposed (pale and lacking in detail). Of course, with a suitably small

lens aperture, or a "computer" flash this is no problem.

When you are shooting by available light you will be able to take full advantage of the diffused nature of window lighting.

For picture taking outdoors you want the lighting to be soft and diffused, which it will be in the shady spots in which you position the pram for the baby's afternoon nap. If the shade is being provided by a nearby tree like a birch or an oak, it will probably be dappled as the sun will filter through the large open network of branches. This type of shade lighting is not quite so suitable for photography as the dense, even shade that is provided by solid objects and thick foliage.

Three to six months

At about three months photography becomes much more rewarding, and in some ways easier too. Your subject is no longer immobile and tiny; he has become alert and animated as well as stronger and longer. Although you will not be chasing around after him you will certainly need to have your wits about you when you move in close with your camera. A bigger baby will fill a bit more of the picture area and leave less vacant space to be filled with the surrounding scene. If you continue shooting with a camera-to-subject of around 1.5m (5 feet) your shots will gradually begin to feature the baby more prominently and his antics and expressions will create the focal point in your pictures.

Now is the time to bring out noisy and diversion-creating toys to attract baby's attention and turn on the smiles. Be ready to take pictures the moment you shake the rattle or crinkle the cellophane to attract his attention. A young baby is unable to sustain enthusiasm for very long and if you have to fumble with the camera you may miss the chance to shoot a good picture.

At this early stage it helps if both mum and dad are involved with the picture taking, one "working" the camera and the other the baby. Once the baby has decided he wants to play and be the centre of interest, his attention and his gaze will focus on the toy that is being used to amuse him. If the diversion is taking place in the direction of the camera, the picture will show the baby looking into the camera

lens. If you press the button on cue you should manage to capture a picture of an excited expression and animated arms and legs.

Picture taking opportunities

Between three and six months many of your pictures will probably show the baby lying down or sitting supported by cushions as he will still be unable to sit by himself at this age. Brightly coloured cushions create a busy background and draw attention away from the subject. If you have control over the picture taking situation choose props that are white or plain pastel colours so that the baby forms the focal point of the picture.

The modern little bouncing chairs are great for picture taking as they are easy to position for photography without any fuss or bother. Provided the baby is used to sitting in the chair he will be quite content to perform for the camera in a choice spot. The position should be well-lit from the photographic point of view, a shady place in the garden is ideal. A fairly high viewpoint generally gives the most satisfactory results at close camera-to-subject distances. (See diagram on page 382.)

At about this age another good photographic angle is achieved by laying the baby on his tummy and shooting with the camera level with his eyes as he pushes himself up on his arms to get a better view of the world. Different backgrounds, shooting distances and camera angles will produce different pictorial effects. For example, with the camera just above ground level, nearby objects such as table and chair legs will appear large and menacing. This effect is emphasised in a side-on view as more of the background detail appears in the photograph. A simpler, softer picture arrangement can be created by taking a front view of baby's head and arms. If you can focus the camera on baby's eyes and take the picture using the widest possible aperture, the background detail including baby's feet, will be blurred and out of focus in the photograph.

For a more formal, studio effect, try laying baby down in the centre of a large bed. It should be possible, by carefully selecting your camera angle, to take pictures with baby surrounded by the bed cover but without including any background furniture at all. If you

shoot against a plain bed cover or a white or pastel coloured sheet the picture will have all the simplicity of a studio portrait. It is best to have two people on the job just in case the baby tries to roll off the bed.

Taking photographs from low down is a problem if your camera has only an eye-level viewfinder. For some, you can get a right-angle attachment to enable you to look down into the eyepiece. If you intend to concentrate on baby photography, though, a camera with a "waist-level" viewfinder — with or without an eye-level alternative is a better proposition.

Besides photographing every-day events to keep the baby album up-to-date, you will want to record some of the humorous happenings that occur. Possibilities for picture series include:

Event		Possible photographs
Feeding time	1.	Medium distance shot of baby in baby chair (choose a picture-taking spot with a simple uncluttered background)
	2.	Long shot of mother presenting the cereal bowl.
	3.	Close-up of baby's face as he takes his first gulp.
Visiting grandparents	1.	Long shot of baby with grandparents.
	2.	Close-up of baby inspecting grandma's present.
	3.	Medium distance shot of grandma and grandchild.
Baby friends	1.	Long shot of friends arriving with all their paraphernalia.
	2.	Medium shot of the babies surrounded by their toys.
	3.	Low angle close-up of babies playing together.
Out walking	1.	Long shot of mum or dad pushing the pram (A side-on view is usually best).
	2.	Close-up of baby sitting in state.

If you have a baby bouncer hanging in a doorway you'll be able to capture some lively expressions as baby jogs about. To add variety to your baby story take a few unusual shots, perhaps, if you have some close-up equipment, a close-up of baby's hand or foot; a shot

of the washing line full of baby clothes; a picture of the baby's collection of toys or teddy bears.

Six months to a year

Once the baby has gained a bit of muscle power and confidence there will be no stopping him. Within an amazingly short space of time he will learn to sit up and then to crawl and probably before his first birthday he will be careering about in a baby walker, chasing phantom figures around the house and out into the garden. He will be wearing his first proper pair of shoes and gradually losing his baby looks.

Photography can have its ups and downs during this period as teething can cause quite a few off days which no one in the family will want to remember. However, if you escape these traumas you will find that practically every day something new and exciting happens; cupboards and drawers will be pulled open and the contents examined, the telephone will attract a great deal of attention and no stone will be left unturned in the garden. Your belongings will mysteriously appear and disappear as they are discovered, examined and discarded; for baby's life is full of new and fascinating things and the latest discovery is always more attractive and fascinating than the previous one.

Keep on the look-out for humorous situations as the child becomes more adventurous. If you miss an incident the first time round, the chances are it will happen again as most babies take a delight in showing off their latest feats.

Many youngsters spend as much, if not more time playing with household objects as they do with their own toys. A couple of cotton reels, an empty carton, a ring of keys and a purse form a good collection to keep a baby occupied for quite a while. Once you have provided the bait all you need to do is to watch and wait. When the situation warrants a picture, get in close with your camera so that the baby fills most of the area inside the viewfinder frame and shoot quickly because the baby's actions and expressions are beginning to change more rapidly now.

As you are likely to have your hands full with everyday affairs, keep

your camera handy and set, more-or-less ready for quick shots — focused on $2\frac{1}{2}$m (8 feet) and with a suitable aperture and shutter speed for conditions at the time.

If you are able to take close up pictures you may fancy celebrating the arrival of your baby's first tooth with a photograph to mark the occasion. This is one of those shots that are easier to take with two people on the job, one with the camera and the other coaxing a wide smile at just the right moment. It will need to be quite a chuckle for you to get a good view of the emerging incisor. As the first tooth is usually in the bottom jaw you will get a better view if you shoot from a fairly high camera angle. An alert young baby will quite naturally want to investigate the shiny black object that is so tantalizingly placed in front of him. You will need to be prepared to move the camera quickly out of reach if you want to avoid collecting sticky finger marks on the lens.

It is quite a good plan, if friends arrive with their children for an afternoon in the garden, for you to keep your camera on view. The obvious advantage of this is that it is immediately available for picture taking whenever you might want to snap up a situation. In addition, your activities are less likely to attract attention once everyone has become used to seeing the camera around. You can not expect a picture situation to remain "just so" as you dash indoors in search of the camera; for competent crawlers will simply stop what they are doing and follow you indoors to join in the fun.

As picture-taking opportunities increase you can afford to be more discriminating about those you choose to photograph. You will be able to be a bit more fussy as to the suitability of the lighting and the background. You can afford to wait for really impact-creating situations before getting trigger-happy with your camera. Once you are able to become more critical of the photographic potential of a situation, the record shots that you have been taking for the baby album will begin to have more universal appeal. Who knows, they might even start to win you a few prizes in competitions.

The first birthday

The big event at the end of the baby's first year is the first birthday party. And, although this is not usually such an energetic affair as those of later years, it is nevertheless an important landmark which

will probably be celebrated with the Grandparents and a few young friends and their mums.

At the start of the party you will want to photograph the presents and the babies seated on the floor, eyeing each other as well as the new toys. Then there will be the birthday tea. It is worthwhile taking a quick picture of the laden table before the guests arrive — things will probably be a bit chaotic and disorderly with so many small mouths to feed and the attractive display of goodies will suffer in the turmoil.

Detailed studies of the birthday child gazing at the candle on the cake and close ups of the other youngsters' faces as they get covered in food while sampling the delights of wobbly jellies and cold ice cream will have far more impact than more distant shots. Besides, a table surrounded by an assortment of high and low chairs and their occupants is not a very easy subject for photography from an overall viewpoint. For suggestions of lighting and camera angles to use at birthday parties, see pages 455-456.

An effective way of recording the passing years is to plan to take a picture of the baby in the same spot on each birthday. You will need to choose a suitable position, either in the house or in the garden which will be just as good for a picture of a baby as it would be for a shot of a fully grown teenager. You may decide to take a sequence of pictures with the child posed near a garden seat or a favorite piece of furniture so that in later years the seat or the bookcase or the hall stand can be lent on rather than stood beside. Furniture or fireplaces are ideal for gauging the annual increase in height.

The pleasure that a picture record of this sort will give you in later years makes the effort of creating it seem quite insignificant.

Other people's babies

Many photographers find it easier to take formal portrait-type pictures of other people's babies than they do of their own, particularly once the crawling stage is reached and the infant becomes more independent. The main reason for this is that the parents are usually on the scene to lend a helping hand. They will be only too happy to coax a few chuckles and cute expressions out of their off-spring to

provide the photographer with an abundance of camera potential. The situation usually calls for close-up studies for which diffused lighting is ideal. A high-speed fllm is preferable for outdoor photography so that fast shutter speeds can be used to capture the spontenaity of the moment.

Photographing Young People

Once the first few hesitant steps have been accomplished you will have no end of fun watching your baby's antics. If you had the time and the film to spare you could spend hours taking pictures of his activities as he learns to do all sorts of photogenic things. Incidents like climbing on his bike, pushing his wheelbarrow down the garden or sitting himself down in his own fireside chair all spring to mind. Each acvitity is accomplished with great deliberation and an enormous amount of concentration, so much so that the brief click of your camera shutter will pass unnoticed.

A toddler's moods and expressions change from one minute to the next as he becomes delighted, exasperated or just plain bored with whatever he's doing. You'll have plenty of opportunities for photographing humorous situations as he studies his picture book upside down, or chases a fleeing bird with a crust of bread. You will be able to capture scenes of provocation as he stands on tiptoe to reach up high for tempting objects on shelves and table tops. And when he's bored and fed up, that's the time to catch him sitting motionless, wistful and wide-eyed oblivious of the dribble as he debates what to do next.

Planning

Few so-called candid shots of toddlers are complete chance. Of course you cannot force a smile or a cute expression, neither can you make a toddler perform against his will, but you can assist the situation. You can put the toys, the paddling pool or the baby swing out in the garden in a shaded spot and then be in ready with your camera, watching and waiting for things to happen.

Another solution is to put the child into something like an attractive basket or a large washing up bowl and to take as many close up pictures as possible before he realises how to escape. Whenever you

set up a situation though, have a helper close by, just out of view of the camera, to prevent the baby tipping backwards and hurting himself.

When your toddler is fully mobile you will need to summon all your powers of patience to cope with some of the exasperating things that are bound to hinder your photographic efforts. There will be times when you are all focused and framed-up on a terrific picture just waiting for a slightly better expression or for the child to look up for a fraction of a second, then suddenly, without warning, before you have a chance to press the shutter, he's rushed off and left you looking sheepishly at the camera. Alternatively, perhaps you are all ready to shoot a close up and the child will lunge forward to give you an affectionate hug just as you hear the shutter in motion. In spite of the feelings of exasperation and frustration you are bound to have from time to time as you attempt to photograph your offspring you will find that the pre-school years are the best for photography. You will see more humorous happenings and cute expressions as the infant acquires new skills and plays inventive games with young friends during this stage of his development than at any other.

Shoot from a low angle

When your toddler is resting on his haunches contemplating his next adventure you might fancy taking some shots with the camera actually on the ground. However, when the camera is right down low you need to be careful that the lens has an unobstructed view of the scene. Nearby stones and tufts of grass will appear as featureless blobs in a photograph and not as the attractive foreground frame that they appeared to be in the viewfinder. To reduce the amount of foreground in such a picture all you need to do is to point the camera upwards slightly. This shooting position is particularly effective when you can isolate the subject against a background of sky.

Parents get into the habit of stooping down and bending to talk and play with their young children, so it is quite natural for them to take pictures at a low level. However, if you are not used to youngsters it's worth reminding yourself before you start using your camera just how small even the toughest little toddler actually is. Bend down

beside him and study the scene from his level – it is quite frightening to see the size of things from down there.

Pictures outdoors

Outdoor activities are much easier to photograph successfully than most of those that take place indoors. There, the restrictions imposed by crowded conditions and the limitations of simple flash lighting make creative, natural results difficult to achieve. Outside, you can concentrate on picture-making. As young children seldom stay still for more than a moment, most of your outdoor pictures will be taken while the child is in motion. Perhaps he will be running, jumping, skipping or simply fidgeting about contemplating what to do next. Different photographic techniques are required to record successful pictures of, for example, children running flat out to those used to capture shots of them when they are merely ambling along killing time.

For photographic purposes, childrens' actions can be divided into those that take place fairly close to the camera and those that take place some distance away. The difference between the two is the relative effect they have on image sharpness. The direction of movement, whether it is away from or towards the camera or across the field of view, and its speed also affects the sharpness of the image. It is possible to heighten the effects of movement by blurring the image or to strengthen the impact of an achievement simply by selecting an appropriate camera technique.

Movement

Artistically blurred pictures are great for conveying a child's vitality and have terrific impact when seen enlarged in photographic displays. However, shots of your children, particularly those that are taken with a simple camera which are destined for the family album and are therefore unlikely to be enlarged beyond the enprint stage, are better for being clear and sharp.

PHOTOGRAPHIC POSSIBILITIES WITH YOUR TODDLERS PLAYING OUTDOORS

Event	Possible photographs
In the sandpit.	1. Long shot of the child sitting in the sand surrounded by buckets and spades.
	2. Close-up of the serious business of turning out a sandcastle.
	3. Close-up of the child's laughing face.
	4. Medium shot of the afternoon's work.
Action on the roundabouts.	1. Medium shot of the child being helped onto the see-saw.
	2. Close-up of the child sitting in state.
	3. Low-angle shot looking upwards as the see-saw rises to its highest point.
Helping in the garden.	1. Medium shot of toddler and father digging in the vegetable garden.
	2. Close-up of the youngster inspecting a worm.
	3. Close-up of the fence with an inquisitive robin looking at the scene.
	4. Medium shot of the workers returning with their produce.
Cowboys and Indians with older brothers and sisters.	1. Medium shot of the actors dressed up in their war paint and plumage.
	2. Close-up of an Indian in hiding.
	3. Medium shot of a Cowboy giving chase on his bicycle.
	4. Medium shot of the parties negotiating a peace plan.

To make certain of capturing a reasonably sharp image of a moving subject with a simple camera it is advisable to:

1. Take pictures in bright sunshine

2. Choose a shooting angle that images the child moving towards or away from the camera

3. Take the picture when the movement is sedate rather than hectic

4. Keep the subject a fair distance from the camera.

Actions taking place near the camera, especially when the child is rushing around and moving across the picture, are most likely to cause blur. A slightly blurred image of an active child can be quite effective particularly if the camera angle has been selected to include foreground objects in sharp focus. A low angle is ideal if you want to include such things as a tricycle or a scooter in the foreground with the child in the middle distance against a background of clear sky.

If you want to record sharp pictures of the ever-changing, rapid movements of children at play, out on the sports field or simply letting off steam in the back garden, you will need a fast shutter to freeze the action the split second it is recorded by the camera. The diagram gives you an idea of the approximate shutter speeds required to freeze the movement of a youngster on a bicycle. More detailed information on coping with subject movement is given in the sporting section of the chapter "Photographing People Out-and-About", pages 435-440.

Toddlers playing will provide you with some great opportunities for taking interesting picture series. The sort of occasions for which the descriptive treatment is suitable are shown on page 418. In all these examples it is the action that makes the picture interesting, and, because the toddlers are occupied, both their pose and expressions are relaxed and natural, the fact that the hair is untidy, the face a bit dirty and the clothes rather crumpled adds a touch of reality to the situation.

Pictures indoors

The most convenient way of documenting indoor happenings for the family album is by taking flash-on-camera pictures of the

Freezing movement. Approximate shutter speeds required to freeze movement at different camera positions: AB movement coming towards the camera; AC at 45°; AD at right angles, across the field of view. Position B is the idea spot for shooting movement on a simple camera.

daily routine. Young children seem to delight in helping with the household chores, brushing up, dusting, washing. Whatever mother's doing, it is likely her youngsters will be close by lending a helping hand. When they use the wrong equipment for the job or struggle with adult-sized implements you ought to be able to get some very amusing pictures, provided the camera is handy and loaded with film.

Picture possibilities at Christmas and other festivities are legion. So many new and exciting things happen. While Santa Claus remains a real and trusted friend you will want to photograph the scribbled note as it is sent up the chimney, and the bulging stocking hanging at the end of the bed. On Christmas day you will be taking pictures as the presents are being opened. Then there are the gifts being handed down from the Christmas tree, as well as photographs of the children playing with their new toys and the serving of the Christmas lunch. These are only a few of the happenings you will want to photograph during the festive season. You will probably need to lay on extra supplies to ensure that you do not run out of film or flash while the shops are shut.

If you are interested in creative photography you will want to experiment with more versatile forms of lighting than flash-on-camera.

Photography at the play group

A play group is the ideal place for taking candid shots of young children together. If your child attends a local group, the organisers may allow you to visit one morning to photograph the children and their various activities. This is not something that you can do in a hurry as it will take a little while for the children to get used to you and return to more serious things like painting and listening to songs and stories. You will need to take plenty of film and be prepared to mooch around and watch and wait for photographs to happen.

Bigger and bigger

As children get bigger they become more sociable and their play

becomes more adventurous and boisterous. There will be plenty of opportunities for good photography around the home as well as when you go out at weekends and on holiday. The sort of situations that create good picture possibilities are:

Pictures in the garden	Pictures indoors
Playing with the garden hose	Dressing up
Splashing about in the paddling pool	Playing with mother's make-up
Building houses	Practising carpentry
Playing shops	Painting
Building a snowman and snowball fights	Playing with model railways

As the years pass you will find that the school and weekend activities youngsters engage in such as music, dancing, horse riding and sports begin to occupy them more and more. All too soon childhood happenings will be just a memory and dates and discotheques will be the order of the day.

Other people's children

If you like being with young children and have a great deal of patience you will probably find the challenge of photographing your friends' children an extremely satisfying and rewarding outlet for your photographic talents.

Discovering the likes and dislikes of different children is one of the fascinating aspects of child photography. Each child you meet is a different little individual with his own characteristic mannerisms. Some children are chatty and friendly with cheerful grins and infectious laughs; whereas others are shy and reserved with wistful eyes and thoughtful expressions. Fortunately, most children make no bones about their feelings and you can get to know them quite quickly.

Once you are on friendly terms with a toddler it's a relatively simple

matter to photograph him at play, particularly when he is outside pottering about with his toys in the garden. If you have mastered the basic photographic techniques of exposure and lighting and are able to compose a pleasing picture, you are bound to be successful.

Informal portraits

You can, of course, pay special attention to portraying a child's particular characteristics in your pictures. This really comes within the realms of portraiture because you will need to concentrate on photographing facial details to capture fleeting expressions and typical mannerisms. To do this you have to get closer to your subject than you do to photograph the usual informal pictures of play situations. Close to, the region of accurate image sharpness must be carefully chosen and accurately positioned if you are to obtain really successful results. Consequently, it is essential that you use a camera that has fully adjustable focusing for your portrait photography.

The conventional area of sharp focus in child portraits is the eyes. They are the most expressive feature and are usually quite large in proportion to the rest of the face. In fact to be strictly accurate, as you will want your focusing to be, it is the boundary line between the coloured iris and the contrasting white surround that is generally selected.

It's not easy to focus accurately and at the same time to capture the child in a natural attitude with an unaffected, spontaneous expression. You will soon discover this when you try photographing a toddler's face for the first time. Even when a child is sitting down his legs and arms are usually darting all over the place and each animated facial expression coincides with a toss or turn of the head. If you watch the child's face and then reach for the camera and start focusing when a typical expression appears you'll despair of ever capturing natural portraits.

The next time you are taking pictures of a friend's toddler try carrying on a normal chatty conversation as you are using your camera. Then, at the same time, carefully watch the image in the viewfinder rather than the child's face. While you are talking, constantly adjust the

camera focusing so that the eyes are sharp all the time. You will see the child's expression change as the conversation progresses and when a particularly happy smile beams through the viewfinder you can fire the shutter with confidence, knowing that the image will be sharp.

Children who have grown up with a camera around the house will probably never suffer from camera nerves and will be totally untroubled about being photographed. However, not all children are quite so blasé and you will doubtless come across some who find it difficult to behave naturally in front of strangers. Without reassurance they are unable to ignore something as persistently intrusive as a camera, particularly one held so close to them by someone of whom they are not quite sure.

Fortunately such children are in the minority. They can usually be photographed successfully if you are prepared to spend quite a bit of time paving the way for your photographic efforts. A reserved, pre-school child will probably feel more secure if mum or dady were to stick around and will gradually become less self-conscious as you chatter away. Ask questions about this and that, the name of a friend or a favourite doll, the make of a toy car or what they had for lunch or tea yesterday. Bend, sit, kneel or even lie down so that you can converse at the child's level, rather than at an awe-inspiring adult height.

If possible arrange to take the pictures in the child's home rather than your own because children are usually more relaxed in familiar surroundings. It's often a good idea to be discreet about your camera gear and for neither the parents nor you to mention photography until you have got to know the child. If there is any fussing or special clothes the youngster will immediately be on guard and your chances of fun and good picture taking will diminish rapidly with every action.

Lighting for informal portraits

When you start taking informal portraits you will be much more successful if you use your camera outside rather than indoors in the sitting room or the child's bedroom. That's because you will be able

to select an area that is well lit for photography and manoeuvre the action into that area. If you stay indoors you will have to grapple with furniture and flash. These are unnecessary complications when you want to concentrate on mastering new focusing techniques.

The most satisfactory lighting for child portraiture is soft, totally diffused daylight. That is the sort of lighting you get on a cloudy day or when it's sunny but hazy. On a bright sunny day the lighting will be soft in areas that are shaded from the direct sunlight. Soft lighting accentuates facial details and texture and gives a natural effect which is just what you want in an informal portrait.

When you are taking portraits outdoors on an overcast day, or when you are shooting them in open shade, you will get slightly better results with colour films if you use a skylight filter over the camera lens. The filter absorbs ultra-violet radiation which, although invisible to the human eye, registers as blue on the film. There is often quite a lot of ultra-violet about in the shaded lighting that is best for informal portraits. So, unfiltered colour pictures tend to have a slight blue tinge. The skylight filter, which is slightly pinkish, has a beneficial warming effect when used with both colour print and colour slide films. It has no effect on exposure.

A portrait session

A good approach to an afternoon's photography outing is to take a packet of crisps or a tube of chocolate beans along to help break the ice when you first arrive on the scene. Then you can really start to get to know the child while having a cup of coffee and a friendly chat with the parents. Children like to take part in adult conversations, they frequently butt in with an impatient nudge or an "excuse me" and then forget what it was they wanted to say or jumble up their words in the rush to get them all said while they have your attention. Once you've been accepted as a friend you'll probably be invited to take a closer look at their toys and possessions. This is a good time to begin to think about broaching the subject of photography. Your actual approach will obviously depend on the situation, but quite a good introduction is to offer to photograph a favourite toy. Intelligent three or four-year-olds will be most impressed if you explain about

lighting and camera angles and will be very willing to assist. When you have established a working relationship with a child you are well on the way to creating the right situations to take some good portrait pictures.

The secret of success is not to rush things. When you are photographing the tractor or the teddy bear, encourage the child to look at the image in the viewfinder — sharing the experience is part of the game. At this stage if the camera is on a tripod your efforts will seem doubly impressive. When children discover that taking pictures of toys is fun they will probably demand to have their own picture taken in order to prolong the game. You will want to remove the camera from the tripod so explain that you will need to follow their every movement with the camera in order to take pictures that both of you will like. You cannot over stress the point that is is a joint effort, even a three-year-old will understand enough to want to be involved in the picture-taking. It's most important for any future relationship that you do not forget to give them their own picture of their favourite toy as promised. Of course if someone in the family has a camera that produces instant pictures this would be an ideal opportunity for using it.

Another good game is to pretend that being photographed is all a big secret and that mummy and daddy want to surprise grandma and grandpa with a very special present. Children like surprises and having secrets and will probably be only too happy to help you.

There are two traps that you can unwittingly set for yourself, both of which can make the going rather hard. The first is to specifically ask whether or not John or Jane actually want to have their picture taken. The straight answer will almost certainly be "no". Toddlers are very honest and rarely want to do things they don't fully understand. The second trap that you want to avoid is to issue seemingly irrelevant requests like "say cheese" or "watch the birdie". Such comments can easily break the tempo of the photography game for the logical reply to them is "why?" and then you'll be stuck for an adequate answer.

When you have finished taking pictures, continue playing and chatting for a while. If you break off suddenly the child will think that the whole effort was a try on for the camera and will feel less inclined to co-operate in the future.

Children and their pets

Children of all ages love to play with animals and the addition of a new kitten or small puppy to the family will provide you with endless hours of amusement and many good studies for photography. Young animals are easiest to photograph when they are weary from rushing around and ready for some gentle play. To create successful pictures you will need to move in close with your camera as both puppies and kittens are quite small subjects compared to a three or four-year-old.

The early school years

Once the serious business of learning the three R's begins and the children settle in at primary school, your record photography for the album will be confined mainly to weekends and school holidays. You will want to use your camera on family outings to places like the zoo and the seaside and to capture the fund of summer picnics and country rambles. There will be plenty of opportunities for you to take pictures of school activities during open days, at the Christmas carol concert or nativity play and at the summer sports or swimming gala. Whatever the occasion, you will want to capture close ups of the children being themselves and medium shots of their activities. If you set your camera to a fast shutter speed you will find it easy to record happy faces and the wild gestures of boisterous children having fun. You will need to anticipate actions and expressions to take successful pictures of moving subjects on a simple camera. (Details of how to do this are given on page 417).

When you are taking more formal portrait shots you will find that many of the tips given on pages 425-6 still apply although you will need to be prepared for a more adult line of chatter as you pave the way for each picture. Don't be surprised if you get asked some pretty searching questions about what you are doing and your equipment. If you can supply interesting and informative answers to these, you may well be sowing the seeds for a future interest in photography.

Photographing 8-to-12 year-olds

Once at school, children soon get into the routine of things. As they begin to widen their circle of friends and start to follow new pastimes they will spend progressively less and less time around the home. When there are no extra lessons to attend, their leisure hours will probably be occupied with clubs or group activities, bicycles, plastic modelling or hobbies that take them out-and-about discovering things. If you can keep up with their ever-changing fads and fancies you should still be able to find opportunities for using your camera to record pictures for the family album.

Many children go through an athletic spell around this age as they learn to master the skills of different sports at school. You will probably find your own kids only too willing to pose in front of your camera dressed-up in uniform colours when they win a coveted place in a school team. But it is out on the sports fields that the real action takes place and that's where the best pictures are to be had. For tips on how to photograph action see pages 441-445.

Young teenagers

It is not unusual for teenage children, even those from the most photographically-orientated families, to become gawky and diffident in front of a camera as they grapple with the problems of puberty. Many young teenagers are only too hapy to loose themselves in a loud dreamworld of pop music and discotheques to escape from the realities of growing up. It may be diplomatic to forget about taking close-up portrait pictures and to be more discreet about photography for a while. There will be ample opportunity for family pictures, to keep the album up-to-date, when you are all together away on holiday or enjoying a rest in the garden in the cool of a hot summer's evening.

It is often in their early teens that youngsters begin to want to stand behind the camera instead of in front. Perhaps they will be requiring pictorial records for projects or learning about the hobby at the youth club or school camera club or even studying the subject for school

examinations — whatever the reason for their interest, your experience and encouragement will be of great value.

Photographing girls

There has never been a better time for photographing girls. With our modern attractive fashions and natural-looking make up, there are great opportunities for really good photography. There are three different methods of approach. Either you can take candid pictures when you are out-and-about with your camera, alternatively you can photograph girl-friends in picturesque settings outdoors, directing operations when necessary, or you can go in for the more formal indoor sessions for which you need to direct the model and control the lighting.

The candid approach

If you are keen on the candid approach then it is worth going some place where you know there will be plenty of people and action as well as lots of attractive girls. Why not start looking for talent at local sporting events; not only will you probably be able to spot some good camera material, you will also find photography easy as your subjects will be fully occupied watching the sport.

There is no doubt that some girls enjoy being photographed and others don't, and those who are totally unaccustomed to cameras and photographers frequently stiffen up awkwardly at the mere thought of having their picture taken. That is where the candid approach scores because if you see a super-looking subject who obviously enjoys life and having fun, you needn't give her a chance to freeze up if you are unobtrusive about your shooting. That is easy to do if you keep your distance and rely on your equipment to provide you with a forceful close-up of the girl. If you do not have a telephoto lens, distant shooting will give you an over-all view of the scene and you will have to enlarge a small part of the negative to get the same close-up as you would with a long lens. When the degree of

enlargement is going to be considerable, your results will be more satisfactory if you:

1. Shoot the picture on a slow or medium-speed film so that the image grain in the enlargement does not adversely affect picture sharpness

2. Use a fast shutter speed so that the negative is completely free from camera shake and the image well defined

3. Are especially careful with camera focusing. Make sure that the negative you use to make the enlargement is pin sharp. You can check for sharpness by inspecting the negative with a magnifying glass. (If you check image sharpness take care not to touch the image area of the negative with your fingers because creasy marks will show up on the print)

The girl-friend or boy-friend

Your enthusiasm about photography is bound to rub off on any regular friend. You can reinforce that if you get into the habit of using him or her as a model in some of your pictures. Because you know each other well your model has probably got into the habit of relaxing in front of the camera and adopting easy-looking positions when you are about to shoot. If you are using your friend in scenic shots to add interest to the view, have the friend looking at the scene and not straight at the camera. Experiment with different lighting effects, try taking silhouettes at sunrise and sunset (see page 453 for details on photographing silhouettes) and soft-lit head-and-shoulder shots against natural backgrounds such as bracken, wild flowers, tree trunks or the sky.

While you are shooting, try to keep a look-out for small details that may spoil the effect of the result like underwear straps showing on the shoulders or a badly turned collar or polo neck. When you feel the urge to throw in a few words of direction, try to be constructive and precise about what you say. Continue chatting about this and that inbetween asking for a shoulder to be turned towards the camera or a chin to be raised a little.

If you get too serious about the whole business you will find it difficult to create spontaneous, happy pictures. An effective techni-

que is to invent some action for your partner to do. A toss or turn of the head, a twist towards the camera or a request to remove a wisp of hair from the face will divert attention away from the camera lens. Then, if you take the shot the moment the action ends, you should catch a relaxed and natural pose.

If you find it difficult to explain the effect you are trying to create or the attitude you want your friend to adopt, a quick demonstration usually does the trick. And, if this doesn't work, don't labour the point, try a different idea or move on to another location because as soon as either of you begins to get fed up with things the situation and consequently your pictures will lose their spontaneity.

As you are working you may have vague impressions at the back of your mind of the glamorous studies of beautiful girls and their debonair escorts in way out fashions that you've seen in Vogue and other such glossy magazines. There is no reason why you should not be able to create pictures just as attractive, particularly if you choose photogenic settings to work in. The sort of places that inspire enthusiasm and creative efforts are:

The landscaped gardens of palatial houses
Grand old buildings with attractive courtyards and balconies
Glass-houses full of exotic plants and palms
Apple orchards in the spring
The woods in autumn
Botanic gardens in the summer ... etc.

Wherever you choose to take your friend and your camera you need to work the setting itself into your pictures so that there is harmony between the model and the surroundings. You can do this by shooting through close-up foliage and close to nearby masonry so that your model becomes part of the scene. The foreground and background will give extra dimensions to the picture. The relative importance of these elements can be subdued by the use of selective focusing so that the attention of the picture is centred on the sharpest area which should be your model. To be successful with selective focusing you need to focus the camera lens carefully and to shoot with a fairly wide lens aperture (f5.6 or f4 for example).

Even with a simple camera you can still soften the effects of the surroundings by using one of two special techniques. The first is to

Image softeners. 1. Tracing paper with a hole in the centre attached to the camera with a rubber band. 2. Glass, smeared with petroleum jelly, held in position in front of the lens with two rubber bands.

cover the lens with tracing paper with a hole in the middle so that the person appears in sharp focus when lined up in the centre of the picture. The area surrounding the subject will be blurred by the diffusion of the light through the tracing paper.

The second technique is to smear petroleum jelly onto a small piece of glass which is a bit larger in size than the area of the camera lens. You will want a clear patch in the centre of the glass which has no trace of the jelly on it. Fix the glass onto the camera as shown in the diagram. The amount of diffusion from the jelly depends on how thickly it is coated onto the glass.

Both these techniques obscure the detail surrounding the subject and direct attention to the centre of interest — the person you are photographing. You can obviously use tracing paper or petroleum

BRIDAL PORTRAIT TECHNIQUES

Emphasis on	Technique
A slim line	1. Take a side-on view.
	2. Have her standing rather than seated, a seated curled-up position only really flatters slender girls
	3. Ask her to take a deep breath before you shoot, this has the effect of improving both line and posture.
	4. Compose the picture with a vertical format in mind.
The legs	High-heeled shoes or boots have a more slimming effect on the legs than flat shoes or sandals.
The eyes	1. Focus the camera on the eyes.
	2. The careful use of make-up helps to make the eyes look larger and more appealing.
	3. Take head-and-shoulder close-ups.

jelly with an adjustable camera to achieve equally effective results.

Apart from camera techniques, the other way of creating a flattering image of your girl-friend in particular is to emphasise her attractive features and to play down any prominent ones she may have. This latter topic is covered fully in the chapter on Wedding Photography. There are several ways of emphasising a girl's best features, these are shown in the table on page 433.

Many of these techniques are equally applicable to photographs of your boy-friend. Naturally you tend to pick out different characteristics in a male portrait. Slimness is not so important, but do avoid emphasis on bad points. A side view, for example, may show up a paunch, or a close view exaggerate a long nose and chin.

Photographing People Out-and-About

So far we have concentrated mainly on family pictures, particularly of babies and young children, because these are the kind of pictures that most mums and dads want to take. However, as the children grow up their development slows down dramtically, they go through awkward, sometimes spotty, phases, become restless and camera shy and far more interested in their own teenage world than in your hobby of photography. It is at this stage that you may decide to expand your photographic interests in other directions. There are various ways you can do this.

Lots of photographers find a new stimulus through joining a local camera club where they are able to share their experiences with people who have similar interests. Most camera clubs and photographic societies offer a seasonal programme of lectures and discussions covering a wide range of topics. In some clubs there is a strong emphasis on human interest pictures. Others are renowned for the excellence of their pictorial and landscape photography. Some have their own darkrooms where you can learn the art of developing, printing and enlarging your own pictures, usually under the guidance of more experienced members. Once you have been to a few meetings and got into the swing of things, a camera club will certainly help to further your photographic skills.

Another outlet for your talents would be to specialise in portrait photography which you would enjoy if you like the more formal approach to things such as arranging lighting and posing models. If you are interested in branching out in this direction you should read the *Focalguide to Portraits* which contains lots of helpful information on the subject.

On the other hand, you may decide to expand your hobby in the direction of pictures with a general human interest. To do this you need to go out-and-about with your camera, involving yourself in the sort of situations where you will meet people and see things happening. To begin with you will probably have more fun if you

limit your horizons to a single activity, perhaps to following a sport with which you or a member of your family has connections; to attending local events, or to supporting your child's scouting activities. Whatever activity you choose to follow and to photograph you will find that once you become an accepted supporter your photographic pursuits will be considered part of the scene. People will become interested in your pictures and, since one thing generally leads to another, you will probably carve a niche for yourself as photographer-in-chief.

As you discover more about the people and the ins and outs of your new interest, you will probably begin to concentrate less on your camera and more on the people you are photographing. Your pictures will certainly become more life-like as you look at people and their activities with a knowledgeable eye rather than as an outsider. You will be able to anticipate expressions and actions when you know what is hapening and position yourself correctly to capture the best view at just the right moment. Being able to appreciate just such subtleties is a great help when you are following a sporting activity.

Photographing sporting activities

There are several ways you can photograph sportsmen in action to heighten the effects of effort and speed. The method you choose depends on the sport involved as well as on the versatility of your camera.

Effect	Setting
Action frozen, picture completely sharp	Fast shutter speed and small lens aperture
A blurred image against a sharp background	Slow shutter speed – action near camera
A sharp image against a "moving" background	Panning slow shutter speed with moving camera
A partially sharp image against a sharp background	Medium shutter speed and small lens aperature

Partial blurring of the image is often achieved accidentally when parts of the sportsman's body such as the legs of a sprinter or the arms of a javelin thrower, are moving faster than the action-stopping speed of the camera shutter.

Photographing movement with a simple camera

If your camera shutter functions at a languid pace, you can still get satisfactory results provided you adjust your photographic technique to cater for the limitations of your equipment.

A very effective solution with continuous action sports such as motor racing, cycling or running, is to emphasise the speed of the action rather than to freeze it. To do this, you want to record the subject as a fairly sharp image against a blurred and streaky background. This will happen if you follow or "pan" the subject as the action takes place, keeping the figure in the centre of the viewfinder all the time. As you move the camera, press the shutter release and continue following the motion without interrupting the smooth panning action. The degree of background blur depends on the speed of the panning. Naturally, that is greatest with fast-moving subjects.

Beware though, if you magnify the image — either through a long-focus (tele) lens, or by subsequent enlargement, you will enlarge the blur just as much. For example, with the 2x tele lens fitted to some pocket cameras, you'll have as much blur from 3m (10 feet) away as you get from $1\frac{1}{2}$m (5 feet) when you photograph with the normal lens.

If you have a practical knowledge of the sport you are photographing you may be able to snap a picture when the action is at a peak. Then the movement halts for a fraction of a second before it starts again in the opposite direction. The pole vaulter at the top of the bar, or a horse rider at the highest point of a jump are examples of such moments when the effects of an action are at a climax. These moments usually coincide with the sportsman adopting his most graceful stance which is another reason why this is a good time to take pictures. During this brief interlude, the relatively slow shutter speed of the simplest cameras can cope quite adequately with the situation.

To create successful pictures, your timing needs to be perfect. The usual cause of disappointing results is that the picture has been taken too late. The secret is to fire the shutter a fraction before the action reaches its peak. This allows just enough time for your reflexes to get to work so that the opening of the camera shutter coincides with the moment of suspended action. If you wait until you see the action reach its peak (when, for example, the diver has reached the top of his spring) then the static moment will be past by the time the camera shutter is ready to record it. The moving figure will photograph as a blurred image if the camera has a relatively slow shutter speed. Even if you can use a high speed and freeze the action, you are likely to get an out-of-balance picture; or even lose part of your subject outside the frame. Once you have taken a few pictures you will soon get the hang of things and discover how to judge the timing to perfection.

Another effective way of recording sporting activities on a simple camera is to shoot from a position where the effects of movement are at a minimum. This occurs when the action is coming straight towards you or going directly away from you. In addition, the effects of movement are less apparent the further they are from the camera. So, if you are photographing a sedate sport you should be able to take sharp pictures of happenings as close as 3m (10 feet) from the camera provided the direction is favourable. However, if the movement is energetic, you will need to consider the camera-to-subject distance as well as the direction of the movement. You should be able to record a sharp image of sportsmen competing 7.5m (about 25 feet) from the camera.

A simple yet effective way of implying motion is by carefully positioning the subject within the picture area. By placing the moving figure along the picture diagonal, so that the subject is tilted in the picture, the impression of motion is much greater than it would be if the figure were upright. Certain actions are obviously more suited to tilting than others but frequently the background determines whether or not tilting the camera will give a successful picture. If nearby trees and buildings are going to feature in the photograph it is almost certain that the tilted view will prove unsatisfactory and look more like a photographer's error than an intentional creative impression.

Shutter speeds and movement

If you have a shutter speed of 1/250, or better still 1/500th second, you should be able to freeze the action in a considerable number of sporting activities. But, to make the most of an event and to create exciting pictures of the effort and skills that are the trademark of a good sportsman, you will find that you will get the best results by shooting on high-speed films. For most people, that means sticking to black-and-white. If, however, there is a specialist laboratory near you – or you process your own – you can use some colour reversal films at high speeds. The increased sensitivity of these films provides you with a far greater choice of shutter speed and lens aperture set-

SHUTTER SPEEDS FOR FREEZING MOVEMENT

Subject	Approx. speed MPH	Camera-to-subject distance	Direction in relation to camera		
			Right 45° angles	Towards or away from	
Slow walking	$2\frac{1}{2}$	4.5m 15ft	1/250	1/125	1/60
		7.5m 25ft	1/125	1/60	1/30
		15.0m 50ft	1/60	1/30	1/15
Fast walking	5	4.5m 15ft	1/500	1/250	1/125
		7.5m 25ft	1/250	1/125	1/60
		15.0m 50ft	1/125	1/60	1/30
Slow running	10	4.5m 15ft	1/1000	1/500	1/250
		7.5m 25ft	1/500	1/250	1/125
		15.0m 50ft	1/250	1/125	1/60
Running sports (sprinting etc)	20	4.5m 15ft	1/2000	1/1000	1/500
		7.5m 25ft	1/1000	1/500	1/250
		15.0m 50ft	1/500	1/250	1/125

Note: If you have a telephoto lens which has a focal length about twice that of your standard camera lens, you will need to use the next faster shutter speed to achieve a similar effect. Conversely, with a wide-angle lens which is about half the normal focal length, you need to use the next slower shutter speed to that given in the table. Shutter speeds in excess of 1/1000th second are rare.

tings when you are photographing summer sports. In winter, particularly on dull muddy afternoons, you will need the speed and exposure flexibility of such materials to muster a reasonable shutter speed in the poor lighting conditions.

The table gives a rough idea of the sort of shutter speeds that will be sufficient to freeze actions taking place in various directions in relation to the camera and at different speeds. You might find it helpful to remind yourself of the relevant figures from time-to-time. A good place to keep notes on this or any other exposure information is on a card taped inside the top of your gadget bag or light meter cover so that it's handy when you are out-and-about with your camera taking pictures.

If you intend to shoot a particular action, try to have the camera ready focused on the point where the action peak will occur. So you are all ready to fire the shutter when the action reaches the most dramatic point. To be able to pre-focus the camera accurately, the sport needs to be repetitive like show jumping or gymnastics. When there is no action rehearsal you can use the technique of zone focusing to relieve you of the chore of focusing the camera as the action happens. See page 146.

When you freeze movement with a fast shutter speed the action that you record needs to have quite a bit of impact if the picture is going to look really convincing. You need to choose your viewpoint with care and expose your picture at exactly the right moment to make a really successful shot. This applies particularly if you are shooting on black-and-white film, since the monochromatic image requires additional vitality if it is going to attract attention, especially when seen alongside colour photographs.

If you are using colour print film and your selection of shutter speeds is limited by the film and the low level of the lighting, it is best to forget all about fast shutter speeds and make a point of creating artistic impressions of the sporting scene. You can either use the panning technique described on page 437 in which case the background will be blurred but the competitors fairly sharp, or create the opposite effect of blurred figures against a sharp background. To do this you simply keep the camera stationary so that the background appears sharp and blur the movement by selecting a shutter speed in the region of 1/15 second. You will need to ex-

periment to achieve the most creative effects. It is advisable to use your camera on a tripod or rest it on a firm support, while you are making such long exposures. Otherwise, you may shake the camera and blur the background unintentionally.

Look for pictures

It is much easier to take successful pictures of sports that you are involved in. If you know the participants and a bit about the rules of the game, you should be able to find good shooting positions to record different stages of the event. Besides the obvious positions at the start and at the finishing line, for example, you will soon find out where exciting incidents may happen. You can be ready, focused and waiting for good picture taking situations to happen.

When you are photographing a local event which is attended by families, friends and a few keen supporters, you will probably be able to get fairly close to the action. By doing so, you feel the tension and excitement of the competition. With all the ferment of the occasion and either luck or a fast film you should not find it too difficult to capture action-packed pictures.

On the other hand, at most big sporting events like Wimbledon, the Olympic Games or a Formula 1 grand prix, you will find it almost impossible to take intimate shots of the competitors from the public seats unless you are lucky enough to be right at the front of a stand. And, even when you are relatively close to the game, you will probably only be able to fill the viewfinder frame with the action if you have a camera fitted with a long focal length lens so that the image size is increased. If you are a follower of sports on television you may have noticed how press photographers are often stationed perilously near to the action: behind the goal, along the touchline or even in specially constructed stands at some events. Vantage points like these are yours for the afternoon at the school sports or local matches and from them you should have plenty of opportunity for exciting photography. When you are looking for good shooting positions you will need to keep an eye on the sun – you won't want it shining straight into the camera lens.

Professional sports photographers make the most of the picture

taking opportunities by never trying to economise on film. They take lots of pictures of entire action sequences on motor-driven cameras capable of recording images at the rate of up to 8 or 9 a second. Do not imagine though, that pressing the button on a motor driven camera will give you the ultimate picture every time. Virtually all the best pictures are taken by accurate selection of the ideal moment of exposure. Even without elaborate equipment, you should still aim to be liberal in your use of film as you will stand a better chance of selecting winning pictures if you have more to choose from.

Professionals, though, don't always get special ringside seats. Some of the published pictures of really big events are taken for ordinary spectator sports.

If you are interested in the choice of equipment that is available for sports photography, there is much more information about the subject in the Focalguide to Action Photography.

Generally, the spectators are every bit as photogenic as the sportsmen. Most people will be far too preoccupied with the competition to worry about you and your camera. There are usually good pictures to be had when the climax occurs and cheers of encouragement bellow forth from the most refined-looking spectators, whilst others watch in breathless silence, bodies tense and fists clenched in excitement.

The spectators are one of the attractions at big sporting events, particularly those which have gained a reputation at society gatherings. Fashions are paraded in style and you can really have a ball with a candid camera. Sporting occasions are often patronised by the famous. So keep a good look out for a chance of photographing them. If it is the famous you really want to record, then you should choose suitable events for the crowd rather than the action.

When crowds of people are gathered together you can usually get some appealing pictures of small children peeping past skirts and trouser legs in the general direction of the excitement. If you bend down to shoot you will record the surroundings just as the child sees them. If you want to make a feature of the smallness of the child in contrast to the adults in the background, then the adults should also appear in sharp focus in the photograph. That will mean shooting with the camera lens stopped down to $f8$ or better still to $f11$.

If you really want to make the most of picture possibilities at any

sporting event you should always stay until the end. Making a mad dash for the car half an hour before the close of the competition will doubtless save having to sit in the traffic jams but your premature exit might well lose you the best pictures of the afternoon.

Photographing local events

Sporting activities are not the only events that are full of action and excitement. You will have just as many opportunities for photographing interesting people at most large outdoor gatherings where the participants are enthusiasts of one sort or another. Veteran or vintage vehicle meetings, agricultural shows, street festivals, funfairs, markets, and a host of other displays and activities abound everywhere. Keep an eye on your local paper, or public notice boards to be in touch.

When you are planning an outing with photography in mind, it's worth taking a couple of extra rolls of film so that you can make the most of picture taking opportunities. If one is a high speed film so much the better because then your photography won't come to a halt the moment the sun goes in.

Whatever the event you will want to be on the lookout for interesting people and weather-beaten characters, fashionable figures as well as colourfully dressed hippies. If the day is one of hazy sunshine you will have plenty of opportunity for using your camera. Any shadows there are will be just barely discernible and will not hinder your photography. Hazy sunshine creates the ideal shooting conditions for taking outdoor portraits so make the most of the situation by taking a few informal close ups to add variety to your picture record. On the other hand if it is bright and sunny you will need to be on the lookout for pictures of people in shaded situations and in areas where the sun is producing side lighting so that the effects of the strong directional light will not spoil your pictures.

At many local events, good pictures are often to be found behind the scenes where the animals are being groomed for the occasion, or the vehicles spruced up for the parade by their doting owners; where nervous competitors pace out their torments, or the Carnival Queen and her entourage undergo last minute titivations as they mount

their flowery chariot for the parade. It is behind the scenes that you will see wide eyed children fascinated with all that is going on and winning competitors proudly adding the latest rosette to the collection on display.

Don't make the mistake of taking only a single picture of each situation you come across. People are constantly changing their expressions and stance and you may not always be lucky and get a natural effect with the first shot. Once you have taken a picture, your camera will be all set up to capture the scene. So you can easily and very quickly wind on, frame up and shoot again if the person you are photographing seems to become more animated or relaxed after the first shot. It is often a good plan to keep looking at the image through the viewfinder as you wind on so that you can be really quick off the mark to take the second picture. Then, even if your subject is aware of the camera, your swift action will not be anticipated and therefore probably help to capture a spontaneous pose.

When you see people engrossed in a particularly interesting activity, you can usually only make a really descriptive account of the event by taking several pictures from different shooting distances and camera angles. If the action is intricate or complicated a single picture will probably contain insufficient detail to make a clear statement. For example, suppose two people are looking under the bonnet of a veteran car. A low angle shot will show their faces in rapt concentration and a second close up will be needed to do justice to the gleaming engine. Similarly, a front view of the bric-a-brac on a stall at an antique market with the dealer in the background could be accompanied by another side-on close-up of a customer paying for a purchase.

Occasionally you see craftsmen giving demonstrations at local events. To fully document their actions, you may need several pictures. A series of shots forms an interesting and more comprehensive account than a single picture would.

Try using your camera in a photojournalistic way to tell complete stories when you are out-and-about taking pictures at special gatherings. You will find the approach an interesting change from creating the more usual staccato picture record. This pictorial method of reporting events is frequently featured in the Sunday colour supplements. The subjects are usually more colourful and

emotive than those you will probably come across on the local scene. Even so, the photographic techniques are excellent and you could pick up quite a few ideas by studying the picture sequences in detail.

Another place where you frequently find comprehensive and descriptive picture series is in exhibitions displayed for a purpose. For example, those intended to portray the activities of public utilities such as power or water supply companies; and at police, nursing and the forces recruitment centres.

Off-beat pictures

When you are taking pictures at exciting and emotive places like pop festivals, the conventional approach to photographing people does not always produce pictures that fully convey the mood of the occasion. There are however several off-beat photographic ploys you can use which in themselves creat unusual pictures that help to heighten the impact of the image. These include:

1 Using a slow shutter speed to blur the action of dancers and other fast movements like fingers strumming guitar strings or feet tapping.

2 Photographing silhouetted figures against the orange sky, if there's a good sunset. Details on how to photograph sunsets are given on page 453.

3 Emphasising the emotional impact of the situation, if you do your own developing and printing, by increasing the graininess of your prints. To do this you can, for example, make a big enlargement from a small area of the negative, use a high-speed film, or print on a high contrast paper.

4 Selecting a picture format which emphasises the mood of the scene. For example, if a couple are lying stretched out on the grass enjoying the music, by creating a slim horizontally-shaped picture you will add to the feeling of lazy contemplation; conversely, by fitting upright figures inside a narrow vertical format you will accentuate the impression of strength and dignity. If you frame the picture in the viewfinder with the final cropping in mind

you can easily mask the print or transparency to the required format later.

5 Taking pictures at dusk, if you are shooting on colour film, when spot and flood lights illuminate the performers. The artificial lighting will make the colours in your picture appear more red than usual but the contrast between the shadowy figures and the colourful highlights can be most impressive. Exposures at dusk, even with a meter, are unpredictable as the light level will probably be insufficient to give you an accurate reading. If you give a relatively short exposure, the shadows will remain dark and the colours will stand out, whereas with a longer exposure there will be more detail in the shadows but the brightest colours will tend to be overexposed and therefore a bit pale. The shorter exposure gives a more dramatic and effective result.

Photographing club teams and groups of people

You may be asked to make a special photograph of a group of people, the school football team for example, the contestants in the annual golf tournament or simply the locals outside the pub. Obviously you will want to have a pretty clear idea of how you are going to tackle the task before arriving to take the pictures.

It is worth enquiring beforehand if there is a standard line up for photography which is part of the team or club tradition. Often such groups want an updated version of that, rather than some imaginately posed pictures. You will obviously need last year's photograph to guide you if there is a traditional way of doing things. As well as the grouping of the team, the place you take the picture in is often fixed. If it is, you well advised to study the lighting there beforehand. Then you can confidently recommend the most suitable time to do the job. The day of the photograph may be sunny or cloudy so it is best to choose a time when you know for certain that, if it is sunny, the group will be side-lit. If you get your timing right your pictures will not be spoilt by the sun shining into the camera lens or straight into the eyes of the people in the group.

Once you have arranged the group according to your picture guide you will want to make sure that everyone is looking in the same

direction when you press the shutter. That hackneyed expression "say cheese" sometimes works. Better, a well-timed joke usually does the trick and paves the way for a couple of extra pictures. Those extra shots are always worth taking because it is easier to select one really good photograph if you have several to choose from.

If you are able to create your own natural groupings you will want people to appear at different heights in the picture rather than strung out in a line. The easiest way to arrange this is to find some steps or even a robust park bench so that people can cluster around at different levels.

Quite a pleasing arrangement with six or seven people is to form a triangular pattern with two or three people sitting on the ground, two people behind, perhaps sitting on the bench and one person standing at the back to add height to the picture.

Another approach is to find a physical prop for people to gather round, so that there is a natural centre for the grouping. Such a prop could be the goal post or a table with a sun umbrella above, an open sports car or the umpire's chair. You will find that once there is something handy for people to lean on they nearly always settle down and become more relaxed. That is a great help for the photographer. You may need to reposition one or two people to add height to the grouping.

The more light hearted and humourous you make the occasion the better will be your pictures but, however relaxed the atmosphere, the sure way of creating unflattering and awkwardly posed pictures is to keep people hanging about for too long.

Amateur dramatics

Amateur dramtic societies all want photographs. Approach, or join one, and you will have plenty of opportunity to photograph different aspects of stage life. Your pictures will be in great demand for the society will be only too pleased to have records of their productions. Individual members will want personal copies for their portfolios; and the local press will probably be delighted to publish your pic-

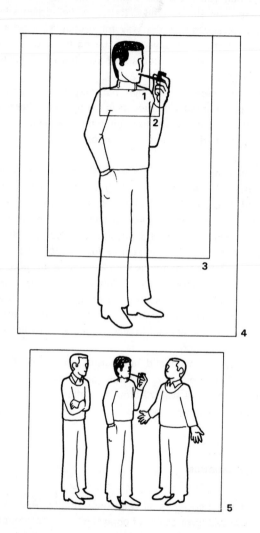

Pictures of people are usually categorised according to the amount of the subject that is included in the negative area i.e. 1. Full head. 2. Head and shoulders. 3. Three-quarter length. 4. Full length. 5. Group.

tures, although they tend to prefer prints that show the entire cast rather than those showing individual performers.

You should have no difficulty photographing actors, either on or off stage, because they are generally the sort of outward-going characters who will act just as well in front of your camera as they will in front of a live audience. Do not forget to picture the sets and costumes as well, though.

Lighting and film

Your pictures will be more interesting and dramatic if you are able to shoot by available light rather than by flash. To do this you need to have a camera with a lens that has a maximum aperture in the region of $f1.4$. Even with such a fast lens you will need to use a really high-speed film to record natural actions and expressions in the relatively low lighting levels that you will come across in many small theatres and community halls.

When you are exposing colour films to theatre lighting your pictures will not necessarily be of the correct colour balance. Colour inaccuracies, which tend to appear more pronounced in facial close ups than in scene-setting shots featuring several actors, are generally acceptable when the lighting is dramatically coloured.

Colour balance defects tend to be less pronounced in pictures taken on colour negative films as the printing process automatically attempts to normalise colours. In doing so, however, the process lessens the effectiveness of pictures taken in dramatically coloured lighting. Pictures taken on colour transparency film, on the other hand, present colours as they actually are provided the type of stage lighting and the colour balance of the film are compatible. When they are incompatible you can use filters over the camera lens to rectify the situation.

To make certain of successful results you really need to experiment with your film and selection of filters. See the *Focalguide to Filters* for more details.

If you are presented with the opportunity it's worth testing the lighting level on the stage in advance of the session to ascertain if available light photography will be possible so that you can stock up

with high-speed film for the occasion, you will probably need to use flash to record scenes on the slower colour films.

Colour is particularly suitable for photographing young children giving dancing displays, as the costumes are usually very bright and cheerful and, when many have been made by the kids' mums, your colourful record will be greatly appreciated. It is preferable to shoot on a colour negative film on such an occasion to ensure that the prints will be of a high standard.

When you are recording outdoor performances you do not have the restrictions imposed on you by the low level of indoor lighting.

Picture taking opportunities

The conventional time for photographing most stage performances is during a dress rehearsal, when you can move around the stage looking for ideal viewpoints. You usually cannot take photographs at the actual performance. If you did, you would have to shoot from the audience or the wings and the picture possibilities from such distances would be very limited.

You will probably enjoy the picture taking session much more if you read through the play you are to photograph and find out a bit more about the production beforehand. Being familiar with the script has the added advantage of enabling you to anticipate suitable shooting positions and camera angles as well as to time your shooting according to the importance of a particular scene in the play.

It is often impractical for you to be on the stage to photograph ballet, particularly when young children are rehearsing their annual show and prancing about in all directions. But in a small theatre you are usually quite close to the stage positioned in a side box or the circle and from such a high vantage point it would not be too difficult for you to shoot a few general pictures of the performers spanning the stage in attractively patterned groupings.

In the summer, outdoor productions are great fun to photograph and during a performance the audience can be almost as entertaining as the actors themselves. Small children fidget about, bored and uncomfortable on the corporation seating. Pensioner's heads sink

slowly chestwards as their slumbers deepen. They are oblivious of the regimented school children dutifully following the performance under teacher's ever watchful eye. However, it is difficult to record such candid scenes without attracting attention and annoyed comments from people nearby. Matters are improved if you have a long focal-length lens and manage to time your shooting to coincide with the noise of passing aircraft or the sound of applause.

The dramatic effects of distortion

One of the easiest ways of creating dramatic pictures is by photographing people in very high contrast lighting such as that found in night clubs or during the tense moments of a theatrical performance when extremes of lighting are used to heighten the drama. However, a different rather gimmicky approach is sometimes used by advertising photographers to hammer home a particular message. The eye-catching, dramatic appeal of the picture is sometimes created by the use of excessive distortion, a hand, a nose or a foot might appear disproportionately large to the rest of the body.

Distorted pictures can be very effective when they appear larger than life on an advertising hoarding with an appropriate caption like "Your country needs you". The odd distorted image can be quite amusing in a family slide show. Beach settings lend themselves to this type of creative photography as people tend to adopt more relaxed attitudes as they sunbathe and play games. It is easy to creep up on a sleeping model and take close-up pictures from odd angles to emphasise a particular part of the body. Although parts of the body will be at different distances from the camera, you will want them all to appear in sharp focus in the photograph. To achieve this you will want to shoot with a small lens aperture (f16 or f22 for example).

Excessive distortion is created by:

1. The use of a wide-angle lens rather than the standard camera lens
2. Moving in too close to the subject
3. Shooting from an angle that exaggerates the perspective

1. Camera too close to subject, resulting picture spoilt by distortion. 2. A shooting distance of about 1.5m gives a distortion-free image but a less intimate view. 3. A long focal-length lens enables you to fill the frame and have an image free from distortion.

Distorted images are generally not as successful when they are confined to a small enprint since the exaggerated perspective of the close view does not have the same degree of impact without the enlargement.

Photographing silhouettes

Silhouette photographs are fun to take and usually very effective. To be successful, the dark figure must stand out against a brightly-lit background. There are various techniques for creating silhouettes with artificial lighting indoors in a photographic studio. Fortunately, however, similar effects can also be produced outdoors in available light.

The ideal time for creating silhouetted images outdoors is at dusk when background illumination, provided by the setting sun or bright lights, is sufficiently intense to enable the photographer to focus the camera accurately on the foreground figure and shoot with a relatively short exposure. A slightly under-exposed negative or transparency will produce the best silhouette as the under-exposure will ensure that the figure is really black. The background illumination will be extremely striking and for this reason available-light silhouettes are excellent subjects for colour photography.

It's usual to associate silhouettes with figures in profile. Such a side-on view is generally most effective with close shots. When the camera is some distance from the figures in the scene, front or back views can be equally successful.

Party Pictures

Birthday celebrations, particularly in the form of parties for small children, office parties and dinner dances as well as formal banquets and balls provide a wealth of material for the photographer. There will be numerous opportunities for capturing humorous situations as well as more serious formal moments.

Childrens' parties

The method of approach depends very much on the age of the children and on the location of the party. Tiny tots at a party are much easier to photograph than their elder brothers and sisters; parties outside are easier to cope with than indoor ones; undoubtedly the easiest event of all to photograph is a party that takes place outside on a warm hazy summer's day. Unfortunately for the photographer, most children's parties seem to take place indoors in rooms that were designed for normal living rather than for a group of children in festive spirit. There is seldom enough space for party games, onlookers or really good photography; but if you pitch in with the idea of catching just a good series of record shots for the family album, you should be well pleased with your results.

There will probably be little opportunity, while the party is in full swing, for mum to pause long enough to think about using the camera at her own children's party. On this occasion photography is usually the métier of fathers and keen helpers.

Be prepared

Try to use the minimum of photographic equipment so that you can keep a tight hold on it while it is in use, or hide it in an unobtrusive corner if you are required for other things. Have a spare roll of film at the

ready just in case you get trigger happy during the opening stages of the party and run out half way through. If the party is indoors you will need to have plenty of flash in reserve as well.

Most children's parties consist of an eating session and a playing session. Of the two, the eating is often the funnier and more rewarding from the photographic point of view. Fortunately for the photographer the children are usually reasonably still, and usually seated at a table. So, you will have time to frame up and focus on several good-looking pictures without fear of the subject disappearing from view. For a while they are unlikely to bother about you or your camera as they succumb to the lure of sausage rolls, crisps, jellies and birthday cake. This is the time you should be ready with your camera just waiting to make the most of picture-taking situations as they crop up.

Camera angles

If you want a picture of all the guests enjoying the feast it is best to shoot from a fairly high camera angle. If possible, stand on a chair or a stool so that you are looking down on the table to take the photograph. It's quite a good idea to line this shot up before the party begins. View the table from several different high shooting positions so that when the time comes you will know exactly where to put the stool for the best possible results. The advanced planning will save you having to interrupt the feast at an inopportune moment and spoil the tempo of the occasion. Hungry and excited youngsters will probably not take kindly to an over-enthusiastic photographer rearranging them and the furniture for a photograph.

With a high camera angle you will be able to record, in detail, the table setting with all its colourful dishes and party trappings. In addition, such a shooting position provides greater opportunity than would a normal camera angle to include all the guests in the scene. Take your over-all shots as soon as the meal begins. Quite shortly, the table will look a total shambles and all the plates will be bare.

Whenever you are shooting indoors from a high camera angle, you will be tilting the camera downwards and vertical lines appearing in the outer edges of the scene will converge toward the bottom of the

photograph. The convergence of these lines tends to be accentuated by the dead straight edges of the print or transparency frame. The distraction will be less if vertical lines in the centre of the picture are truly vertical. It is always best to try and arrange a high angle picture so that things such as fireplaces, picture frames and door frames are well to the centre of the scene.

Indoors you may find that the most satisfactory camera position is from a high angle looking into the dining room through the doorway. This is frequently the only possible camera position when lots of children are crowded into a small room for the birthday tea.

When the fun and games begin you will want to shoot from a fairly low angle so that the camera is on the same level as the party guests.

Family celebrations

Parties and dances are ideal events for photography as people will be too busy enjoying themselves, gossiping with old friends and sampling the good food and drink to worry about the camera. With special parties like silver wedding anniversaries and those to celebrate a teenager's coming of age, you will want to take pictures of the speeches and toasts as well as the cake cutting and shots of the guests enjoying themselves.

When elderly folk are celebrating it is worth making the effort to take a special family group of all their children and the grandchildren together, particularly if the family is scattered and seldom gathers in full strength. If you want to achieve the most pleasing result you will have to:

1. Take the picture in diffused lighting
2. Move in close to take the picture so that the group fills most of the image area
3. Arrange the family artistically so that their heads are not all on the same level
4. Have the older members of the family sitting down with others sitting in front and the men standing behind
5. Catch everyone's attention as you are about to shoot so that they will all be pictured looking toward you

When travelling, take pictures of local people as well as your own family. *Top* a boatman on Lake Titicaca. *Above* Pisaq market, near Cuzco (Peru).

Street theatre in Red China. The light was not good, so the photographer had to use a wide aperture and a fairly slow shutter speed. The resultant blurring adds interest to the picture.

Top Moscow circus. The orange colour cast is a consequence of using daylight film in artificial lighting.

Bottom Shum Chun, Red China. Bustling everyday street activities make excellent subjects for photography and are seldom hard to find.

Running figures (like running water) can be photographed with a fast shutter speed, freezing them in mid-stride, or a slow one, conveying a helter-skelter sense of movement.

Christmas is an excellent time to photograph children (of all ages). When absorbed in the festivities they are too excited to bother about you and your boring old camera.

Situations such as this provide many opportunities for taking fascinating pictures, but you must put safety before photography. The drivers of the lorry and the combine harvester shown here have to concentrate on maintaining the correct distance between them and could not be expected to look out for photographers. Nor would they be pleased about having to swerve if someone did stand in front of them.

Page 462 disco lighting, like stage lighting, is not easy to measure accurately, although it can provide spectacular pictures. Take a number of pictures at different exposures to be sure of getting one or two really good ones, and resist the temptation to use flash, which would swamp the coloured light and destroy the atmosphere.

While the hired photographer is preparing things for the formal series of wedding pictures after the ceremony there may be plenty of good informal shots to be taken.

Page 465 most children will be happy to pose if they have some artistic creation to show off, such as this sculpture in the sand.

Top children and animals often have an air of spontaneity even in situations rigged up for the camera.

Above the framing of this picture is unorthodox, but highly effective; you need fast reactions to get the best out of freely moving subjects.

Page 467 when framing a subject look at the edges and into the corners of the picture as well as at the middle. This photograph would have been far less effective if the top of the window had been chopped off – a mistake that is infuriatingly easy to make.

Two pictures of men at work. Craftsmen plying their trade make fascinating subjects for photography; the main difficulty is gaining access to their places of work.

Top the warm evening sunlight imparts a romantic glow which is in keeping with the subject.

Above the fairytale atmosphere of this picture is enhanced by the use of a soft-focus attachment.

In old cities where the streets (or waterways) are narrow a wide-angle lens will prove to be an enormous asset, whether your interest is in the architecture or the life of the community.

Page 471 in the great open spaces a telephoto lens can be used to good effect to portray your subject against a simple but impressive background.

A new school uniform may provide the occasion for semi-formal portraits of your children. This schoolboy was clearly reluctant to co-operate, but his rebellious expression adds interest to the picture.

Office parties

The most usual time to think about work and photography is when there is a celebration or a party in the offing. But, unfortunately, all too frequently when there is no staff photographer to do the honours such thoughts usually happen on the day of the party just when the presentations or the speeches are being made. This is generally far too late to organise films and flash and camera gear so the event passes unrecorded. In fact, it's at just such parties, particularly when a member

SUMMARY OF FILMS AND LIGHTING FOR PARTY PICTURES

Location	Lighting	Suitable films	Picture possibilities
Indoors	Flash-on-camera*	Colour print film (so that you can easily have copies made for party friends).	Record shots
	Available light	High-speed films – colour slide or black-and white	Creative pictures.
Outdoors	Available light	Colour print film or any colour slide film**	Record shots and creative pictures.

*If you have electronic flash and are able to bounce the light from the ceiling as well as operate the camera you may be able to take a couple of soft-lit shots of the party table. Once the serious eating starts there will probably be too much activity for you to indulge in such creations. (For details on bounced flash see pages 183–188.)
**If the party is taking place in a large garden children will probably rush around and get very excited. To capture sharp images of moving subjects you will need to shoot on high-speed film.

of the staff is retiring or leaving the company, that a camera really comes into its own for creating a pictorial account of the event as well as a lasting souvenir of familiar friendly faces, the tributes and the merrymaking.

Picture possibilities

When a member of staff is retiring or leaving the company you will want to include everybody that's at the party in at least one of your pictures. This is not a difficult task because the principal guest usually makes a point of chatting to everyone present. If you wait until three or four people are in conversation and photograph mainly groups you should soon have a good collection of pictures of the complete assembly.

You should be able to snap a few unposed shots but, if space is limited, you may well have to ask people to move around a bit so that you can get a better view. You will find your pictures much easier to compose if the people in them are standing rather than sitting down. In the sitting position you have the untidy complication of people's legs, tables, chair legs and handbags cluttering up the bottom half of the photograph.

The presentations and speeches usually assume a slightly formal tone so you will want to be prepared to photograph the ceremony with sufficient film in your camera to record:

1. The boss giving his speech
2. The handing over of the gift
3. The thank-you speech
4. Cutting the cake (if there is one)

When you are sorting through the pictures to show to your colleagues, you will want to number the prints so that they are easily identifiable. Then, if you wait to send for the reprints until everyone has had a chance to ask for copies, you will be able to place one large order and possibly benefit from a reduction in price as a result of the quantity printing.

If you are taking photographs at a conventional office party, you will want to picture your friends having fun, gossiping and dancing together and enjoying the food and drink.

Formal occasions

Photography is often easier at formal occasions such as banquets and celebration dinner dances than it is at less formal gatherings. That's because there is usually a set programme of toasts and speeches through which the photographer will be guided by the Master of Ceremonies. Speeches are generally made by the guests on the main table which makes the task of picture taking a relatively simple one as most shots can be taken from a single camera position.

Camera angles and lighting

Occasionally, at some really formal dinners, the principal guests are seated at a higher table than everyone else. When this happens you will want to take pictures from a similar elevation. A low shooting angle, which tends to be unflattering particularly with elderly people, is even more detrimental in the harsh lighting of direct flash.

Lighting indoors

The most practical general lighting for indoor photography at parties or on more formal occasions is flash-on-camera. It enables you to take pictures easily and wander freely among the guests looking for good photographic possibilities. Generally parties are not the time to go in for the more subtle forms of lighting. They need extension cables and other delicate photographic paraphernalia which will be very vulnerable to damage by the party guests. At some daytime parties, particularly those in large, well-lit modern offices it may be possible to shoot by available light.

Flash-on-camera is a rather harsh form of lighting. However, there are several ways you can minimise the derogatory effects of the direct illumination. The most obvious is to take full advantage of the flexibility of movement that it affords by choosing imaginative camera angles for some of your pictures.

In addition the following points are particularly relevant.

When you are taking pictures through a doorway, make sure that the flash is actually pointing into the room and not straight at the doorframe or an adjacent wall. If the flash fails to light the scene in the room the resulting photographs will be under-exposed and the party guests will picture as dark shadowy flgures against an even darker background. "Computer" electronic flash is particularly prone to this problem. The sensor cuts off the flash as soon as enough light is reflected from the subject. If you let even a little of the flash spill onto a close-by wall, you will reduce the light falling on your main subject.

Large glass windows, which are a feature of so many modern offices, reflect light like any other shiny surface such as oak panelling, wine glasses, silver tankards and trophies and even people wearing spectacles. Such surfaces are all capable of reflecting the light straight back into the camera lens if the camera and the flash are pointing directly at them. To avoid spoiling your pictures by unnecessary blotches of reflected light, try to make a point of framing up on shots from such a position that the camera and the flash are at a slight angle to the offending surface. Then, in all probability, any reflected flash light will be reflected away from the camera.

Formal dinners usually take place in large halls where the tables are arranged well away from the room walls. This is ideal for flash-on-camera photography because it means that your pictures should be free from the harsh shadows which so often spoil flash-on-camera shots of groups of people in small rooms.

Avoid including people in your pictures who are sitting or standing at different distances from the camera. The fall-off in light from the flash increases dramatically at increased distances, so someone who is twice as far from the flash as the principal subject for whom the flash exposure was calculated, will only receive one quarter of the exposure and therefore be hard to recognise in the shadowy depths of your photograph.

Lighting outdoors

At most outdoor parties the table is set in a shady spot which is ideal for the photographer. The soft lighting in the shade is perfect for

recording close faces and expressions – these will abound as the food is enjoyed and the party begins to swing.

When the subjects are in the shade, it is best to take pictures with the camera looking into the shade; rather than out towards the sunshine. This positioning is important if your camera has a built-in light meter. The meter will give a reading for the average brightness of the scene. This reading will be high if the sunny background is included in the scene and the children in the shade will be under-exposed in the resulting photograph.

When you are taking pictures outdoors in various lighting conditions, and you are using a camera that is not automatic, you will need to remember to adjust the exposure to suit the different levels of lighting in open shade, full sun, side light, etc., in order to get consistently well-exposed pictures.

Choice of film

A colour print film must be the first choice for recording party pictures as quite a few people will want to have copies of your photographs. If you are taking pictures at a formal gathering or an office presentation you may be asked to submit prints to the local newspaper or staff magazine. Black-and-white enlargements, rather than colour prints, are generally required for reproduction.

It is possible to have black-and-white prints made from colour negatives but, before you decide to shoot in colour and have the odd monochromatic enlargement made from the appropriate colour negatives, it is worth phoning the photographic establishments in your area to make sure that someone is in a position to provide such a service.

Making your own top quality, black-and-white prints from colour negatives calls for working in total darkness because to get first class results you need to use special printing paper that is fully colour sensitive (panchromatic). The usual monochrome printing paper (such as bromide) is not colour sensitive. It does not give accurately toned prints from colour negatives. When you are using bromide paper you can, of course, work in subdued safelighting which greatly simplifies matters.

Using an exposure meter. To make an accurate exposure assessment you can either take a reading close to the subject (A) or substitute the back of your hand for the subject and take a reading from that. (B).

Special equipment

Although you can get satisfactory results photographing parties on any camera, if you intend to enlarge your negatives to provide prints of a suitable size for reproduction, you will be wanting the additional picture sharpness afforded by the better quality lenses of a more sophisticated, adjustable camera.

A great asset when you are shooting under cramped conditions is a camera fitted with a wide-angle lens. The additional covering power of short focal length lenses enables you to record a far greater subject area than you could with a standard camera lens.

Photographing Weddings

When your friends know about your photographic talents it won't be that long before you get an opportunity to prove your abilities at a wedding. At first you might be asked to take some extra pictures, a few informal shots of the guests arriving at the church and enjoying the reception. As one thing usually leads to another, you may eventually be requested to completely cover a wedding ceremony.

However willing you are to accept such responsibilities, you are not being fair to yourself or to your friends if you are only used to using a simple camera. Wedding photography requires a camera that is equipped with controls for both shutter speed and lens aperture. That is because weddings happen without regard to good photographic conditions and, having committed yourself to taking photographs, you need to be able to cope with the task whatever the weather.

Another important aspect to consider is that the sequence of events that you can anticipate at a wedding depends upon the religious following of the families involved. The ensuing details relate to Anglican Christian weddings. However, the photographic requirements of the bride and groom may not follow the same pattern if the religious service is conducted differently. If you do happen to be asked to take photographs at a wedding for friends whose religion is different from your own, you will want to find out what will be expected of you well before the day.

Informal wedding pictures

If you have established that you are taking fill-in pictures and not the formal photographs you can sit back and relax. Apart from your usual camera gear you will need an extra roll or two of film and to be able to cater for a few more flash pictures than usual. A quick trip to the local supplier, then you should be all ready for the day.

Which film?

The sort of pictures you will be taking, people enjoying a special occasion, will get shown around. The wedding couple will want to see them, the parents will want to show them to their particular side of the family, the bride will want to show them to her friends – they will certainly go on tour. So you need to use a print film rather than one that gives transparencies. And, of course, you will want to shoot in colour to do justice to the occasion.

Colour transparency films are not really suitable for wedding photography when extra pictures are certainly going to be required. Slides are more cumbersome to show around than colour prints and need to be seen projected in a darkened room to be really effective. Although it is possible to have colour prints made from colour slides the results are often disappointing. Picture contrast increases on reproduction. A wedding, with all its black-and-white clothing, is a high contrast subject and a print made from a high contrast transparency is extra harsh and lacking in detail. If you stick to a colour negative film you'll be far more satisfied with the results and any additional prints you have made will be just as good as the original ones.

What sort of lighting?

The outdoor pictures you will be taking will require the same sort of exposure treatment as any other outdoor pictures of people. If it is sunny you will want to avoid taking pictures when people are looking into the sun and make full use of any open shade you can discover.

For pictures at an indoor reception you will need to use flash. Before the event make sure that you have enough flashes to take a couple of films. There is nothing worse than running short just as things start to become less formal and the guests get to know each other. You can now get fast (400 ASA) print films. These allow you to take pictures without flash in brightly-lit churches or receptions . However, they are decidedly granier than normal (100 ASA) films. So, use them only when you need them.

Picture taking ideas

As the bride or groom will probably be a family friend, you will be able to chat about possible pictures before the wedding day. The couple may already have an idea of the range of shots the professional photographer will take. There's no point in duplicating these pictures.

When you are talking to them, stress that you will be taking mainly off-beat, informal shots to convey the feeling of the event. A wedding is an emotional occasion, there will be solemn moments as well as a little sadness, but many happy times too. These are the sort of situations that create great opportunities for candid pictures.

The following list of picture possibilities may give the bride a few ideas and, having read it, she will probably make suggestions and request additional pictures. Write down her comments so that you'll have a descriptive photo shopping list to mull over before the day. "Fill-in" picture suggestions:

. the bride at home having a dress rehearsal with the bridesmaids
. the couple at the altar*
. special family friends
. elderly relations
. disabled guests
. young friends and relations
. the wedding presents on display

If you are asked to take photographs at the bride's home before the wedding day there are several situations that make good pictures. Have a look round before you start shooting and discover possible settings for your pictures. Perhaps there is a mirror in one of the bedrooms which would make an attractive setting for a shot of the bride arranging her veil, or a well lit French window which might be used as a frame to a full length picture. Alternatively, the garden might be a good setting for photography, particularly if it contains attractive flowers and trees.

If you intend to concentrate your efforts on a few head-and-shoulder portraits you should aim to take the sort of pictures that the bride

*Photography is not allowed in some churches so you will need to check beforehand.

herself is going to like. That means taking pictures that are well-lit and carefully posed to give an attractive profile.

Let's consider the lighting first

Without a doubt you will get the most pleasing results by taking the pictures outside in the garden in diffused lighting. The soft even lighting on an overcast or hazy day will enable you to capture all the intricate detail of the dress and veil and will emphasise the softness and colour in the bride's face.

You will get a similar effect by shooting in a shaded part of the garden on a sunny day. The ideal spot is where the background is fairly uniform in colour so that the whole emphasis of the picture is focused on the bride.

Sometimes, you just can't get away from the sun. In that case you need fill-in flash to give you reasonably well-lit pictures. Be careful, though, that you use the flash just as a fill. Fully flash-lit outdoor wedding pictures really look artificial. If you have to take the pictures indoors you can either arrange the bride near a well lit window and shoot by available light or, alternatively, you could use flash.

When you have selected a suitably lit location for the pictures you will need to give the bride a few directions before you start shooting. Although she might be a little nervous she will want to do all she can to help you to make a good job of the photographs.

She will feel much more relaxed if she can do something other than stand and look at the camera. Give her an attractive flower to hold or find something that she can lean her arms on so that she is not all stiff and tense.

While you are chatting about this and that, study the scene in the camera viewfinder from all possible angles, and a few different camera-to-subject distances. Ask her to keep her body still and to simply follow your movements with her head and eyes. You are bound to find that some camera positions give much more pleasing pictures than others.

The annotated diagram on page 480 will help you to find the most flattering position for a portrait picture.

Mirror images. If your camera has a subject-distance setting, the focusing distance for a mirror shot is A plus B (the sum of the distances from the camera to the mirror and the mirror to the subject).

Corrective treatment for problem faces

If the bride has any obvious prominent facial features you can minimise these in the photographs by careful choice of camera angle. For a head-and-shoulder portrait it is usual to have the camera on a level with the subject's eyes. Raising the camera slightly so that you are looking down onto the subject has the effect of narrowing and lengthening features. Conversely, lowering the camera so that you are looking slightly upwards at the subject flattens and broadens facial features.

Use a low camera angle to reduce the effects of a . . .	Use a high camera angle to reduce the effects of a . . .
Long nose	Short nose
Short neck	Long neck
Narrow chin	Prominent jaw
Prominent forehead	Narrow forehead

Full length shots

When you are taking full length shots of the bride alone, or surrounded by the bridesmaids, you will need to arrange the train of the dress artistically to get a pleasing picture. The most flattering photographic angle is to have the bride in semi profile. This emphasises the line of her dress and the slimness of her figure. If she is at a loss as to what to do with her hands and arms a neat solution is for her to clasp her hands gently together below her waist. Group the bridesmaids around the bride so that they are clustered around her rather than strung out in a line. If there are several bridesmaids and pageboys as well, have the smaller children stand in front of the taller ones.

On the wedding day

On the day of the wedding make sure that you don't impede the professional photographer. You will probably use your camera most after the ceremony while the official pictures are being organised.

Keep on the look out for humorous happenings as the youngsters re-discover their legs and lungs. While people chat and watch the bride and groom, try to take a few close-ups of heads and hats and the elderly relations as well as the shots the bride has requested.

Be ready when the bride and groom depart for the reception and the confetti rains down on them. And, if you have any film left after the reception, try to get a final shot of the guests waving farewell to the couple as they depart for their honeymoon, or a shot of the car as they drive away.

Formal wedding pictures

If the only wedding pictures you have ever been involved in were your own, you probably won't remember all that much about how the photographer organised things. Now that you are going to be on the other side of the camera, in command, you will need to find out the general routine before the big day. Have a look through your own or a friend's wedding album to see if you can pick up any ideas from the pictures. Go along to the local church and watch the photographer in action. See how he organises different groupings around the wedding couple, how he cajoles the guests into order and catches their attention just at the right moment as the shutter fires. You cannot help but be impressed by the performance of a good wedding photographer.

If you begin to have second thoughts about taking pictures remember it will be much easier for you to organise people whom you know. You will be able to ask Mr Smith to stand by Mrs Smith and to tell Aunt Jane to move in closer. There will be none of "would the lady in the white hat, yes you madam, face the camera — thank you" which can make the going rather hard.

Be prepared

Make a point of inspecting the scene a few days before the wedding and at about the same time as the ceremony. See the direction of the light and find the best areas for photography. Select spots with

regard to the background. Attractive porches or plain walls feature most frequently in wedding pictures as they provide a relatively neat background for the complicated group pictures.

Take an exposure meter with you (unless your camera has a built-in meter) and take a few readings so that you can plan what camera exposures you will want to use for the different shots. Remember to cater for both bright sun and cloudy conditions.

The final check

1. Have you enough film? (You will probably take about 40 pictures)
2. Is your camera working properly?
3. Have you enough flash? (See that any batteries are fully charged)
4. Are you sure of the route from the church to the reception?

Don't leave this check until the last minute just in case you have to call in outside help.

Have a standby supply of fast black-and-white film for taking outdoor pictures if the weather is really bad.

Use a tripod

Many wedding photographers like to put the camera on a tripod, particularly when they are taking the group pictures. Apart from looking impressive, a tripod creates a focal point for the guests to cluster round. It also leaves the photographer free to move about and to organise things while the picture remains set up in the viewfinder.

Heavy, steady tripods are just the thing for wedding photography. Another asset if you do have a tripod is a cable release. This is a gadget that enables you to fire the shutter without touching the camera so that once the picture is correctly framed in the viewfinder and is in sharp focus you can concentrate on the subject rather than on the camera.

Features of a bridal portrait. 1. Picture balance created by leaving space for the eyes to look into. 2. Camera focused on the eyes. 3. Head in semi-profile. 4. Sholders at an angle to the camera. 5. Background out-of-focus. 6. 35mm format — camera held vertically. 7. Veil attractively arranged.

Pictures at the church before the ceremony

1. Groom, best man and ushers.
If they arrive together you may get a chance to take a group picture.
2. The guests.
If you photograph them while they are walking towards the church you will need to use a shutter speed of 1/250 second to freeze the movement. At a country church there may be an attractive entrance gate which would make an ideal frame for these shots.
3. The bridesmaids.
Group them together with the smaller youngsters at the front. The attractive dresses and colourful bouquets will create a very pleasing picture.
4. The bride and her father.
Try to get a full length shot as they enter the church. The bride is likely to have her veil covering her face — do not ask her to raise it.

During the ceremony

When the guests are inside the church you will want to get out your flash gear ready for the next shot and to change the film in your camera before you enter the church if there are only a few shots left. There is nothing more off putting to a photographer than to have to change the film at an inappropriate moment.
If you have a tripod it is a good idea to leave it tucked out of sight in the entrance lobby. You can pick it up on your way out of the church after the ceremony.

Pictures after the ceremony

1. Signing the register
As soon as the religious ceremony is over the couple will sign the register in the vestry. The parson will probably be quite used to photographers recording this scene and will probably know exactly where you should put the camera. Most vestries are so small that

Portly brides. A frontal view has the effect of broadening even the slimmest of figures (A). A side-on view shows off the dress to advange. A dark background emphasises the fuller figure whereas a light one produces a much slimmer effect (B). A portly groom is a different matter! (C).

there is little room for photographic artistry. A straightforward flash-on-camera shot will record the scene.

2. Walking down the aisle

You need to gather up your things faily speedily and make your way to the church entrance so that you are framed up and ready to shoot as the couple walk down the aisle together. The flash-to-subject distance will be greater in this shot than in the previous one so you will need to adjust your lens setting aperture accordingly. (Or make sure you are within the "automatic" flash range.)

3. The group pictures

This is where that tripod will come in handy. Most of the guests will want copies of these pictures so you will want to make quite sure of your focusing. Use a small lens aperture for the large groups to ensure maximum sharpness over the entire picture area ($f8$ or $f11$). Try to capture everyone's attention just as you are ready to shoot. A witty remark can work wonders.

4. Leaving the Church

Once the formalities are over people will be chatting and congratulating the happy couple. Your last shots before the reception should show the couple by the wedding car with perhaps a flash-on-camera shot of them sitting inside it.

5. At the reception

The one formal flash shot you will need to take is that of the bride and groom cutting the wedding cake. The way in which you do this depends very much on the surroundings. Ideally you should show the couple at the side of the cake rather than behind it with both their hands on the knife as it touches the icing.

There will probably be quite a few other cameras recording the informal shots of the couple chatting to their friends and meeting new relations, of the toasts and the speeches and the couple leaving for their honeymoon. So why not put your camera away, relax and enjoy yourself.

Register-office weddings

The usual time for photography at such an occasion is after the register has been signed and the formalities have been completed.

The wedding line-up. A. Groom and bride. B. Bride alone. C. Bridesmaid(s), best man, bride, bridesmaid(s). D. Groom's parents, bridesmaids(s), best man, groom, bride, bride's parents and bridemaid(s), E. The wedding party.

The groupings of parents and guests around the bride and groom are similar to those at a church wedding. If there are a few people at the registry itself, the wedding couple may want you to take lots of pictures of friends and relations gathered at the reception. If this is the case you will probably be requested to take a few formal groupings as well as a record shot of the bride and groom cutting the cake. As you are moving around taking informal shots of the guests, make a point of including everyone present on at least one picture so that the wedding album will be a complete record of the event.

Presenting your wedding pictures

The final touch, and just as important as the wedding photography, is for you to display your pictures to advantage in an attractive wedding album. It takes time, care and patience to make up a really good album that both you, the wedding couple and their families will be proud of. The time will be taken up making sure that all the pictures sit neatly trimmed and carefully positioned on the pages. Care will be needed to ensure that the white covers and pages of the album remain in an immaculate condition while you work on them. A good place to start looking for wedding albums is on the advertisement pages of a photographic magazine. You can usually find the addresses of several companies offering descriptive brochures of their different photographic mounts and wedding albums.

Photographing People on Holiday

Many camera owners take more pictures on holiday than they do at any other time of the year. This is not surprising since there is usually more time to think about photography when you are not having to cope with the rush and bustle of a working week. As you unwind on holiday and start to enjoy yourself, everything begins to look more cheerful and colourful so it is quite natural for you to want to reach for the camera and record the fun.

Part of the enjoyment of a holiday is seeing and meeting different people, making new friends, chatting to guests in the hotel, or swapping stories with the locals over a drink or two. Everything is so fresh and animated that you should have lots of scope for making successful pictures. And, if you holiday abroad, there will be so many new faces and fascinating scenes to photograph that you will have a hard job to contain your enthusiasm.

Planning before you go

It can be quite interesting, particularly if you are going abroad, to find out in advance a bit about the places you will be visiting on holiday. Have a look for relevant books in the travel section of your local library or bookshop; study the travel agency brochures and any tourist guides that you can acquire before you go away. Some of these publications will undoubtedly be illustrated with maps and photographs. The pictures might give you a few ideas of the sort of conditions you are likely to encounter on holiday. They cannot possibly tell you the whole story, they are simply an appetizer, the rest will be waiting for you on arrival.

Some advanced knowledge is particularly useful if you are about to embark on a touring holiday. There is nothing more annoying than to make a special detour to visit a place that is well known perhaps for its market day, weekly bull fight or monthly auction sales, to find

that you are a couple of days early or a day or two late. Such mishaps could easily be avoided with a bit of forward planning which, if you are equipped with the right books and reliable travel guides, can be done at a leisurely pace long before you set off on your travels.

Holiday films and camera gear

Another aspect of advanced planning concerns films. It is generally more convenient to buy your films before you go on holiday and usually cheaper too if you are going abroad. If you are not particularly photographically orientated, it is wise to take your holiday pictures on films with which you are familiar, rather than to experiment with new ones. You won't want to spend precious time in the photo shop bothering about film speeds and other technicalities when you could be out having fun, or to return home and discover that you had used a new film incorrectly and your holiday pictures were not up to standard.

How much film? It is a difficult question to answer because the amount you need depends on the length of your holiday and on the things you plan to do. If you are a keen sunbather you will probably take less pictures than someone who is out and about exploring places and meeting people. The number of pictures you take also depends on how sharp you are at recognising situations with picture potential. If you are a keen photographer, touring with a camera, you should have enough film to cater for an average of 10 pictures a day (4 x 36 exposure films for a 2-week trip). You can always bring back unexposed films and keep them in a cool place, such as the refrigerator, for another occasion. Of course, if your main purpose is photography, you may want far more film. If that is the case, I am sure you can work out your own needs.

It is a good plan to keep all your photographic gear together while you are away on holiday. Most photographers use a gadget bag for this purpose. Another item which may come in handy and is a useful thing to have with you just in case, is a polythene bag which is large enough to comfortably hold the camera and a spare roll of film. If the

beach is very sandy or the holiday weather rather wet, the bag will come in very useful to protect the camera from grit particles or rain.

Two items of photographic equipment that are particularly useful on holiday are a lens hood and a skylight filter. The lens hood comes in handy when the light is very bright, at the seaside for example, or on snowy mountain slopes. It will shade your camera lens just enough to prevent stray beams of reflected light spoiling your pictures. A skylight filter reduces the slight bluish tinge which can affect photographs of people taken in diffused lighting or when there is an excessive amount of reflected light about as there is at the seaside or in the mountains. Many photographers keep a skylight filter over the camera lens throughout their holidays to protect the lens from sand, dust and dirt. The filter has no effect on exposure.

Wherever or whenever you go on holiday, even if it is only for a long weekend, it is worth being prepared to take a few flash pictures so that you can take some record shots of hotel scenes and the nightlife.

Photographing people in towns and cities

Most of the people who holiday in cities like London, Copenhagen, Paris or Amsterdam usually go there to see the sights. A few visitors are more interested in the cultural attractions than in ancient monuments. However, whatever your reason for holidaying in a busy city, you will certainly find that it is the people, the hustle and bustle of commuters and shoppers, the pageantry of ceremonious occasions as well as the antics of other tourists who make the city alive and interesting. It is the people who live and work in the city who create the personality of the place. You may have noticed while on your travels that even in this country, where cities are relatively near to each other, there is a marked difference in character between one city and the next. If you holiday in cities abroad you will find the distinctions even greater.

Photographing the personality of a city is a challenge to any photographer. By far the most stimulating way of doing it is to

photograph people doing interesting things. Usually there will be lots of people around and much going on so you should have plenty of opportunities during your holiday to do just that.

You should be able to describe some of the happenings and places you visit quite adequately by taking a single photograph, provided you select your shooting position and camera angles carefully. For example, in London's Trafalgar Square a shot of children, preferably yours, feeding the famous pigeons could quite easily show the National Gallery in the background. However, some of the places you will visit on a city tour will be so busy and colourful that you will need to take several pictures to make a really descriptive account of the event.

While you are being shown round a famous building or monument it can be quite an education to watch the antics of fellow photographers as they frame up and decide whether or not to take the plunge and fire the shutter. How easy it is to spot their mistakes and yet we all do the same things from time to time. There's the man dripping with lenses and a very professional looking camera — the group's moved on and he still can't decide which lens to use; and over there is a young lad shooting away with his lens cap on; whoops, someone's fired a flash bulb, to light a room this size, what a waste ... and so it goes on. As you watch you will surely be tempted to record a few of the weird poses of photographers as they lean and twist and bend to get a better view of things.

Famous shopping areas like London's King's Road are always full of activity whatever the time of day or night for the trendy shops, bistros and discotheques are the Mecca of "with it" youngsters. To capture the free and easy mood of such a place you should try and photograph the shops as well as the shoppers and the off-beat characters. Candid shots are easy to take, particularly if you have a telephoto lens, for no one will hear the click of a camera shutter above the traffic noise. Provided you don't make any fuss you should get on fine. If you want to photograph the shops as well as the shoppers you will need to stand at an angle to the glass so that you can see the display inside the window rather than the scene outside reflected in the glass. This is much easier to do in the early evening when the shop lights are on. However, the artificial lighting will give your colour pictures an overall orange glow which, although not the

true colour of the scene, adds to the exciting atmosphere of the place and the people.

Photography in the dim lighting of an evening requires a fully adjustable camera and a steady hand. Exposures at maximum aperture will be in the region of a quarter of a second on a medium-speed colour film.

In southern continental cities you may find photography a bit more difficult as you are unlikely to blend quite so well with the crowd. Young people are used to seeing tourists and cameras but women and elderly folk might hold up a hand across their face or simply wave you away. You can usually avoid detection for all but close ups if you have a long focal length lens (not less than 135mm for a 35mm camera).

There is no better place for studying people than from the comfort of a chair in a pavement café. In hot continental cities you can usually get a ring-side seat to view an ever-changing scene of shoppers and tourists, business men and long-haired students. People of all ages, shapes and sizes will parade past your table and provide you with a wonderful opportunity for candid photography. Many cafés are in refreshingly cool, tree-lined boulevards which create ideal conditions for photography. The canopy of trees will soften the light and passers-by will be unhurried and relaxed as they take in the cool air.

A good way of indicating the pace of a city is to photograph people while they are actually walking along so that they reproduce as a blur in the picture against a sharp background. To look effective, you need to create a really blurred impression, a slightly fuzzy outline is usually misconstrued as a photographer's error. If the movement is taking place at right angles to the camera you will need to leave the shutter open for about an eighth of a second to get a completely abstract effect. If you are sitting at a table in a pavement café you should be able to rest the camera on the table to make sure that it is perfectly steady during such a long exposure. If you have a camera with a waist-level viewfinder, you can frame up the scene accurately. If not, you can estimate more-or-less what you will get in. Do put your camera right on the edge of the table, otherwise the bottom half of your picture will be blurred table top.

An alternative way of emphasising the bustle of city people is to use the panning technique described on page 437 to isolate a solitary

figure against a background of colourful streaks. To be effective you need to choose a person who stands out from the crowd — you can usually spot someone who obviously enjoys dressing up, every city has its share of dandies, young and old, male and female. Having selected a likely subject, all it needs is a bit of smooth panning to create a colourful picture that has considerable impact. Pictures of people walking across the image area are a good example of shots that call for a horizontal format. A narrow horizontal picture accentuates the impression of movement. To create a picture of this shape with a square format camera you will need to bear in mind when framing up on the scene the final masking of the print.

Pavement cafés and open-air restaurants are ideal places for taking informal holiday pictures of the kids as well as candid shots of the waiters and the occupants of nearby tables. At a busy time of day there is usually so much going on that no one will notice an unobtrusive photographer or hear the click of the shutter above the chattering and clatter. At your own table the children will be far too interested in the exciting new dishes that are set before them and in the general surroundings to bother about the camera. You should be able to capture their expressions and gestures at close range as they discover the delights of the food and turn their noses up at the not quite so familiar tastes.

When the action is about 1.5m from the camera, you will be able to include part of the table setting in the picture foreground; water jugs, wine bottles, menu cards or drinking glasses can be used to frame the picture. You may need to move your props further from or nearer to the camera to create a better effect. You will need to use a fairly low camera angle to "see through" the foreground props across the table to your subject. In the photograph the foreground will probably be out-of-focus and should therefore not be too colourful or obtrusive otherwise it will dominate the picture.

Action pictures of waiters carrying bowls of attractive desserts and cheese boards at shoulder height as they wend their way through the tables need a fast shutter speed to freeze the movement. With a telephoto lens you can capture detailed shots of distant activities and facial close-ups of the staff as they attend to 101 jobs. Such shots will not only remind you of your holiday but also feature in your collection of informal portraits.

In many cities, markets are scenes of great activity. Keen photographers will want to sample the camera potential of the early morning meat, vegetable and flower markets where the shop keepers buy their fresh produce for the day. These markets can be particularly colourful in big continental cities where the trading atmosphere is tinged with fragrance and Gauloise and there is a never ending supply of picture possibilities.

To recreate the air of excitement and to capture the gay atmosphere and raucous colours of the flowers and fruits you will need to use a high-speed colour film and to shoot by available light.

You will need to use fast shutter speeds to record in close-up the animated expressions on the faces of the traders when the bidding and bartering is in full swing. In such busy surroundings you will want to make maximum use of foreground frames to simplify pictures and to hide the worst of the background details.

Then, of course, there are the daytime markets which these days seem to have an almost international atmosphere. Whatever city you visit, you are bound to discover another version of the Portobello Road or Petticoat Lane tucked away somewhere in the back streets. Nowhere else in the city will you come across so many colourful and odd characters and so much noise and jostle. You could spend many long hours taking photographs and mooching round the stalls which are usually laden with bargains and bric-a-brac and garish junk. Hopefully, at the end of the day, you will have bagged a good collection of photographs and picked up a few bargains as well to add to the success of the visit.

It's quite fun, while on a touring holiday, to select a particular group of people for pictorial study – continental postmen or policemen usually go down particularly well with the youngsters. If you plan to visit several countries the antics of the traffic police are well worth photographing as their podiums and signalling techniques vary from place-to-place. Picture series like these frequently come in handy at a later date to illustrate the children's school projects when they study the customs of other countries.

Sometimes you can add a lot to a series of photographs with a few shots showing just that people have been there; footprints, litter, ski tracks and so on. Perhaps, too, you can convey the atmosphere of a busy street with a picture of feet, or shopping baskets.

Pictures at night

As dusk falls on any city the atmosphere changes, on come the bright lights as idling crowds throng the streets waiting for the evening's entertainments to begin. During the summer many cities assume an almost festive air as long hot days draw to a close and people relax in the cool of the evening. Students and youngsters gather in their favourite meeting places, the parks are full of wandering couples and at the gates there is a roaring trade in cool drinks and hot dogs. Suddenly, the crowds begin to thin, as people disappear in the direction of the open-air theatre, the river or the concert hall. Then there is a lull before the final homeward rush begins. Dusk, rather than nightfall, is the best time to take available light shots of people and all the goings on. When it is really dark there is insufficient light to record anything but static subjects. By shooting at dusk on a fast colour film, your pictures will show some detail in nearby figures as well as the colour and impact of the bright lights. A film speed of 160 or 200 ASA permits a dusk exposure in the region of 1/30 second at f2.

In low levels of illumination light meters are not one hundred per cent reliable, and readings taken at dusk may result in pictures that are under-exposed or over-exposed. In under-exposed pictures the bright lights will stand out from extra dark and dramatic surroundings. Conversely, in over-exposed pictures the lights will be a bit pale but there will be considerably more detail in the people and the background. If you are really keen to get good results it is advisable to take a couple of shots at different exposures. For example, if the meter reading gives an exposure of 1/60 second at maximum aperture, take one picture at that exposure and another at 1/15 second at maximum aperture. There will be quite a difference in density between the two shots, you will want to choose the one that creates the greatest impact.

When you are taking pictures of people against a colourful background of bright lights, try and compose the scene so that the brightest and most garish colours are not on the outer edges of the picture area. This applies particularly if the background is out-of-focus since point sources of light reproduce as luminous circles, which increase in size as the image becomes progressively out-of-

focus. So what appears in the viewfinder as a distant orange dot will not necessarily be as inconspicuous in the photograph.

And, while on the subject of do's and dont's, remember that lights near to the camera will have more effect on the film in terms of exposure than distant ones. So avoid framing the scene with an attractive old fashioned street lamp in the foreground as it will probably appear as a larger, and far less attractive over-exposed blob in the photograph.

The gay night life in city casinos, clubs and dance halls is there to be enjoyed rather than to be photographed. Strictly speaking you need permission from the management before you can start taking flash pictures and by the time you have sorted that out you will have begun to wish you hadn't bothered. So why not sit back, relax and enjoy yourself, save the film for when you are in smaller, less formal places where everyone takes pictures of the performers and the dancing and joins in the fun.

Photographing country folk

The centre of country life is the village and in this country every village has a charm and a distinctive character of its own. This is frequently reflected by the local people, in their clothes, their speech and in their friendliness to strangers like yourself.

In foreign parts these distinctions are harder to pin point because everything is so excitingly new and different. It is impossible to detect regional variations in speech and vocabulary when you are struggling with a dictionary and phrase book. However, the language of photography is universal, a camera not only means pictures, it also labels you with a tourist tag. This can be a disadvantage when you are trying to be inconspicuous and aiming to snap up candid pictures of villagers and village life.

In very small villages where everybody knows each other and exactly what is going on, you will find it very difficult to chance upon spontaneous happenings as all eyes will be turned in your direction, particularly if the village is remote and visiting tourists are rare. The only people to totally disregard you and your camera will be the young children and elderly folk. Children are the same the world over – if

they are deeply engrossed in conversation, perhaps telling secrets or planning adventures, they will be far too preoccupied to notice an adult and a camera. You will be able to get in close enough to take detailed pictures of the huddled scene. If their activities involve fast actions you will need to use a shutter speed of at least 1/250 second to freeze the movement in a relatively close view.

It is much easier to photograph elderly folk as their actions are usually slow and sedentary and you will have plenty of time to think about such things as backgrounds and camera angles before pressing the button.

Village festivals and shows, which do so much to maintain the continuity of country life, offer the visitor plenty of photographic opportunities as local choirs, dancers and horticulturalists sport their talents.

Another very English institution is the village cricket club. Up and down the country weekend matches are hotly contested by enthusiastic players and their supporters. There is nothing more relaxing on a summer's afternoon than to sit and watch and perhaps to take the occasional photograph as the wickets fall and the excitement rises.

In most villages there is usually a place where people congregate to chat and gossip. In this country it is often near the pub or the general store whereas in continental countries the favoured meeting place is frequently the village bar where you will see colourful characters in heated conversation from early morning onwards. It is in places like these that you will have the best chance of meeting people and taking the odd shot of the locals.

If you are touring around the countryside it is always worth having the camera at the ready to record any particularly photogenic scenes that you might come across; a farmer ploughing a roadside field; a shepherd working the sheep with his dog; a peasant leading a team of oxen pulling a laden cart. The possibilities are many if you have time to stop the car and be sociable. But, if you simply lean out of the window and snap timidly from afar, your photographs will surely lack the impact and conviction of a more intimate picture series.

Do take care, though, to keep out of the way when work is going on. Modern farm machinery is powerful and fast. The driver is usually concentrating on several aspects of his job, and quite likely not to be

looking where he is going. Even if he does see you, he is not going to be pleased at having to stop or swerve.

Beside the seaside

Lots of British families spend their holidays beside the seaside which perhaps is not surprising as we are basically an island people. It is our good fortune to be surrounded by 6,000 miles of coastline which contain such a variety of scenery and pleasures to satisfy the inclinations of every kind of holiday maker.

The wide spectrum of holiday amenities provide the photographer with an equally wide choice of camera material. During the hurleyburley of the high season the photographic possibilities are endless. Later on in the year the emptiness and the bleakness of the popular piers and promenades is heightened by the quality of the light as the storms and mists roll in from the sea and the local people recover from the seasonal onslaught.

On the beach

Children are in their element on the beach for there is no better, or more therapeutic diversion than a bucket and spade and the sand and the sea. Since children are relatively easy to photograph when they are happy and occupied you should have no difficulty in getting in close with your camera and taking lots of good pictures.

If you are buying new play things for your children before you go on holiday, it is worth thinking about the effect these accessories will create in your pictures. Red or orange buckets and spades always look bright and summery, and photograph well against yellow sand. White, green and blue accessories tend to create a distracting element in a photograph as they vie for attention with the child who should be the focal point of the picture.

During the first few days of your holiday you will probably be too busy getting brown to want to investigate all the different things that are going on around you. This is a good opportunity to photograph the children playing on the sand and at the water's edge.

Event		Possible Photographs
Building sandcastles	1.	Medium shot of the beach before work begins.
	2.	Medium close-up of child decorating the facade with shells.
	4.	Longshot to show the finished castle and the workers having a breather.
Learning to swim	1.	Medium shot of child and parent running towards the sea.
	2.	Close-up of child testing the water.
	3.	Close-up of parent helping to keep the child afloat.
	4.	Medium shot of child wrapped up in towels after the adventure.

When the children are splashing about at the edge of the sea or playing ball games on the beach you will need to use fast shutter speeds to freeze the movement. Your choice of shutter speed depends on how far you are from the action and on the direction of movement relative to your camera. The fastest speeds, 1/500 − 1/1000 second will freeze movement at right angles to the camera provided that it is happening at a distance of at least 3m (10 feet). If you do not have an adjustable camera with fast shutter speeds you can still get sharp pictures by keeping at a reasonable distance from the action and by shooting from an angle where the movement is coming towards or away from the camera rather than across the field of view.

Crowded beaches are fascinating places if you are interested in people. Nowhere else will you see such a variety of scenes as people unwind and have fun. If you are not too intent on the serious business of acquiring a suntan you will see endless subjects for photography as you walk along the beach. There will be children everywhere playing energetic games and rushing in and out of the sea, fishing for shrimps in rock pools and scaling the cliffs behind the beach; cosy groups of ladies surveying the scene from the comfort of their deckchairs; elderly folk keeping a watchful eye on their adven-

turous grandchildren and of course the sunbathers who come in all shapes and sizes and provide ideal subjects for the candid camera.

When you spot a really gorgeous-looking girl she would probably be quite flattered if you were to mention that you would like to take a few close-up shots of her. Try to work out beforehand how you would like her to sit or to stand and which way she should face, bearing in mind the lighting and suitability of the background. With a little planning you should be able to tackle the situation with tact and confidence and organise some good pictures. The following tips will give you an idea of the techniques used by glamour photographers to enhance the appeal of their models:

Selecting an appropriate camera angle contributes much to the success of a glamour picture. If you bend down and shoot from a low camera angle you should be able to isolate a figure in a sitting or standing position against the sky. However, this is not always possible to do when the beach is really crowded. If there are people sitting fairly near to your subject the best way of creating a simple picture is to throw the background completely out-of-focus so that the detail of distant deckchairs and sunbathers merges into a mottled array of muted colours. You will only achieve this effect by setting your camera to wide aperture and moving in close to the subject. If your model happens to be lying near some rocks you may be able to clamber up and shoot from a fairly high camera angle. From such a vantage point it should be possible to isolate the girl against a background of sand, even when there are other people sunbathing fairly nearby.

On foreign beaches the sand is usually a little whiter and the bathing beauties more scantily clad. It doesn't matter if you cannot speak the language, all you need to do when you come across a super looking girl is to improvise with a smile and point at your camera. At worst she will wave you away but you may be lucky and get the chance of taking some really glamorous shots.

Conclusion

When you are not composing your own pictures of people in the camera viewfinder or sorting out your slides and prints, the best way

of finding out about the techniques of good picture taking is to study other people's pictures. Get books out of the library by well known photographers like Henri Cartier-Bresson who is about the most famous candid cameraman, Irving Penn, Man Ray and Edward Steichen to name but a few, look at the picture collections in books such as Helmut and Alison Gernsheim's "Concise History of Photography" and "The Family of Man" which presents a unique collection of photographs of people made by photographers in all parts of the world. In addition, look carefully at the pictures in the photographic annuals and the weekly and monthly photographic magazines.

While you are leafing through a book or a magazine your attention may be caught by a particularly effective shot of a person or a group of people. When this happens try and work out how the picture was taken – what made it effective? Where was the camera? Where did the light come from? You can learn a great deal by analysing other people's pictures and, as you become more critical of other people's efforts, so your own pictures of people will improve because you will find yourself applying the same critical eye to scenes that you are looking at in the camera viewfinder. And there is nothing like a few successful pictures to spur you on to greater things.

Photographing places

Preparing your Equipment

Learning to be a photographer involves two separate processes: the first is learning about the equipment and how to get the best out of it. The second part is learning how to take pictures. That means looking through the viewfinder and getting the picture you really want. Of course, no one succeeds every time; I have never met a photographer who could do that; but a good photographer can get acceptable pictures most of the time and very good pictures regularly. You can learn how to operate a camera anywhere, but you can learn to take real pictures only by going to look for them. Learn from the pictures you have taken yourself, and read magazines and books. If you can go out with a more experienced photographer and watch him work, then go, because it is undoubtedly the best way of learning, once you have mastered the basic skills.

In fact that is the way most professionals learn their craft. They start as a photographer's assistant, and spend two years loading and unloading cameras, carrying bags of camera gear, taking exposure meter readings and many other 'chores'. They do everything except take pictures. It is a fairly frustrating life, and it is only when they start as photographers in their own right that they discover just how many tricks, and how many techniques they have learned, just by watching and making sure that they have the right equipment for the assignment, and the right sort and amount of film. If you do not run to an assistant you have to check your own gear, and you have to do it every time. It does not matter how simple or complicated your camera equipment is, make sure it is clean and working before you set out. It can save a wasted trip, or a lot of frustration.

What to take

There are many books on the relative advantages and disadvantages of different types, sizes or brands of camera and their accessories.

Here we should just note that you should aim to have with you everything you may need on that trip: but not to lug bags full of unused equipment around the world. Just as each picture should be your personal decision on the best way to show your subject, so each outfit should be your decision on the best way to be in a position to secure the pictures you want.

For example, if someone offers to take you sailing for your first time, take along a simple cheap camera. You can take quick snaps when you have a moment, and a capsize will not be a disaster. On the other hand, if you are going on a world cruise, take every useful piece of equipment that you own, or can borrow or hire. You might need a 7.5mm fisheye lens just once, but if you took one, you have it.

The fortunate few can build up a stock of different camera outfits to suit their different photographic pursuits. The rest of us, however, have to make do with just one outfit. If that is your case, make sure that each item is there for a good purpose.

Checking the gear

Having presumably made a choice of equipment, always check that it is clean and working before you go out. It is the only way of remembering the lens you took out of the gadget bag to clean and left in the bedroom drawer. Before you go on a long trip, have your equipment looked over by an expert repair service. It costs money, but it also saves pictures.

For everyday outings, use the following checklist.

Simple cameras

1 Check there is no film in camera.
2 Open the camera back and dust out with soft brush.
3 Hold this lens towards light and fire shutter. A quick flash of light indicates that the shutter is working. Sometimes there is a small lever inside the back of a 126 camera which has to be pressed before the shutter will work.

4 Check that the lens is clean. If it is not, clean it carefully. Most simple camera lenses are plastic and scratch easily. Brush the dust away from the lens until *all* of it is removed – if you leave any you will scratch the lens. Then gently breathe on the lens and polish it with a 'Selvyt' cloth. These are sold by most photographic dealers and are the only cloth you should ever use on a lens. The corner of a handkerchief might be all right for a professional who frequently changes his lenses, but if you do not want to do the same, never use a handkerchief.

5 Select and load your film.

Complex cameras

1 Check there is no film in camera. With a 35mm camera turn the rewind knob as though you were rewinding a film, but without pressing the rewind button. If you start to feel pressure on the rewind knob, then there is film in the camera.

2 Assuming there is no film, open the camera back and dust out with a soft brush.

3 Turn the wind-on lever to make the shutter work, look through the back, point the camera towards a window and press the shutter. A quick flash of light will show that the shutter is working. This does not test the accuracy of the shutter, but it does show that it is not jammed.

4 Select and load your film. Keep the end flap of the film box to remind you which film is in the camera.

5 35mm only – check that the film is winding on – some cameras have an indicator, with others you can check by looking at the rewind knob.

6 Check the lens. It should be protected by a clean UV filter. If necessary clean it, first with a lens brush and then with lens cleaning fluid to remove any greasy marks, such as fingerprints. If you have to clean the lens itself, be very careful not to scratch it, and *never* use a silicone coated cleaning cloth. The silicone can affect the coated surface of the lens.

7 If you have other lenses, make sure that they too are clean and protected by their own UV filter.

8 Check that all the lens hoods are in their place in the camera case.

9 If your camera has a built-in meter, check the battery, if you have one. If it is exhausted, replace it.

10 If you are going to take a tripod with you, check that the cable-release is in place.

Planning Pictures and Finding Them

The earliest stages of photography are in many ways the most satisfying. Learning to manipulate the controls is easy and comes quickly, and you can measure the results in terms of sharp and correctly exposed pictures with the depth of field you want. Once you have mastered that you can start on the second phase of your photographic career – applying these basic skills in a wide range of situations to give the pictures you want. Concentrating on what you see through the viewfinder and turning that into the most effective picture becomes totally absorbing. Once you can take the mastery of the controls for granted, the ability to look through a viewfinder becomes critical.

Scan almost any magazine on virtually any topic and you will see a bewildering range of pictures – some good and some not so good. Look more carefully and you will see that all the good ones have one thing in common, there is no doubt what the subject of the picture is intended to be. Focus, exposure and composition all lead your eye to the same point, they all make the subject of the picture stand out.

Every photographer must apply those same standards to his work, not only to the finished results but to the subject before he takes it. Always work out quite clearly what the subject of the picture is to be and why you are taking the picture. 'I am going to take a picture of this street to show the different styles and ages of the buildings and that people have been living, working and shopping in them from time immemorial.' Or 'I want to show that this shopping precinct has been designed and built especially for people who are shopping in the 20th Century and that it serves the people who drive rather than walk to the shops'.

By doing that you have a better idea of what to include in the picture and what to leave out. Both pictures need people in them because you want to show that the buildings are still in use. In the first case

you probably have to include as many different buildings as possible in the shot because you want to show the conglomeration of buildings of different ages. In the second case you may need to show only one shop, but you still need people in the picture and you should include at least part of the car park. Defining the purpose of the picture has told you that, and it is a feature you might otherwise want to hide. If you can stand back a little and show how the precinct is isolated from the places people live – perhaps in the middle of a desert or an industrial estate – then that too reinforces the automobile-dependent nature of the place.

How often have you been shown photographs taken by people away on a trip somewhere. The commentary is always similar, something about – 'the car park is just out of the picture to the left', or 'you can't quite see it from this picture but if you go a short way up the street ...'. The photographs are usually muddled collections of buildings, people, parked cars, possibly a distant glimpse of an ancient cathedral, and best of all, a blurred figure, which you are told is Aunt Henrietta, disappearing in the middle distance. When the photographer shows you his pictures he has a clear idea of what he wants to bring to your attention, but it often does not appear in the picture. If he had devoted just a little of his time to think about his future commentary *before* he took the picture then the picture would relate it's own story.

There is no way of taking a prize-winning picture of the west front of Rheims Cathedral which also shows the hotel you stayed at and is a perfect outdoor portrait of your wife. Good pictures have only one subject and are taken for only one purpose, probably that purpose is just to make a good picture. But whatever the purpose everything done is aimed at making the subject and the purpose of the picture more unambiguous, clearer and easy to understand. If the commentary with a picture is 'I was trying to show ...' that picture is a failure, take pictures which *do* show what you wanted them to and forget the commentary. Good pictures communicate quickly and easily.

That does not, though, restrict you to taking boring record shots. If you can achieve your purpose better with a silhouette, a misty blur or an abstract array of lights, all well and good. The important thing is to decide just what you want the picture to look like; and to frame

that picture in the viewfinder with the camera controls set to give you the right effect on your film.

Before you take a picture, work out clearly what the subject is and you will find that the selection of lens, shutter speed, depth of field, viewpoint and the actual framing within the viewfinder are almost decided for you.

Composing a picture

Consider a particular picture – a view of open rolling countryside. The picture must have one point of interest. If there is nothing for the viewer to rest his eyes on, then he looks frantically round the picture looking for a point of interest, fails to find it and gives up. Always include some point of focus, it might be a church steeple or a farm or a solitary tree, but it gives a focal point to the picture.

Because the picture is of rolling countryside it should have a sense of distance of the countryside rolling away to a distant horizon. To get that feeling of distance in a two-dimensional picture you need to include a nearby object. The difference in size between an overhanging branch, or a gate, and the distant trees and hills allows the viewer to subconsciously make a comparison and he comes up with the right answer – great distances.

As you can see the decision to take a picture of rolling landscape has virtually told you the sort of picture you are looking for. That does not mean that all pictures of landscape are boringly similar, it just means that you have a clear idea of the elements needed for the picture.

The sort of countryside you are in will suggest which lens to use. That may not be very obvious at first, but the pattern becomes clear quite quickly. A compact countryside with a winding river and a narrow valley may suggest a wide-angle lens to include both sides of the valley. With a wide view, perhaps even the widest of lenses will not do justice to the panorama. You can use a short telephoto lens, and select some of the typical features of the view in the narrower angle of view, which will hint at the scenery surrounding the picture without actually showing it. If the features you want to include in your picture are well scattered, say the cottage you want

to include as the focal point of the picture is a long way away, then you may want to use a telephoto lens to 'pull' the cottage into the picture.

When you start looking through the viewfinder, the basic elements of the picture are already decided. The foreground usually needs to be sharp and in focus as well as the horizon. The horizon should run, not across the middle of the picture, but towards the top or bottom of the picture; about one-third from the top or the bottom of the picture is the usual rule of composition. You should not hesitate to break rules, because they are designed for perfect landscapes, and many landscapes photograph best if you do break the rules.

If in doubt, leave it out!

Look in the viewfinder for things which do not need to be there. If you come in closer to the foreground, does the picture lose anything, or does it make the picture simpler?

The fewer objects there are in a picture, the more simply it tells its story. Work at removing unneccessary objects from your pictures. Look through the viewfinder, and check off everything you can see in it. What is the purpose of the picture? Does that purpose need that object in it? Does a view need three trees in the foreground, or can you move closer, and shoot between two of the trees. That way you lose the tops of all the trees and all the sky above them. Instead you have interlacing branches, and the view appears between them; the trees form a dark frame for the view of the countryside in front of you. That dark area helps in another way. The darkness makes the light view behind stand out more, increasing the feeling of depth in the picture, and because there is no light around the edge to distract his attention making the viewer move further into the picture. Over to the left in our imaginary location, there is a piece of rusty farm machinery. Does it add anything to the picture? Not in this case, so take a step to the left and hide it behind a hedge. In this way, the number of objects to distract the viewer are reduced, and the picture gains in impact.

Consider all the items in each picture and at first consciously look at each item and decide if it is useful in the picture. Very soon your eye

A

B

Viewpoint is becoming increasingly important as our world gets more cluttered. A. Sometimes you can select a closer view—perhaps by changing your lens—to avoid problems. B. Walking around your subject can improve the picture beyond recognition.

will become trained into looking at these things and making the decisions without thinking about it. From that point your apprenticeship in photography is at an end and your pictures can expand because you have control over the pictorial content and can start to make your pictures express your personal view of the world.

Composition

Leonardo da Vinci drew a man and from that drawing took all his proportions for works of art and architecture. The Greeks made their columns with slightly curving sides because they look straighter like that. Throughout history man has been looking for, but never found, a simple rule which would allow anyone to draw a perfect picture or design the perfect building. No man without a sense of scale of balance, scale, harmony, tone or colour will ever make a picture as well as a man with great artistic flair. The greatest pictures of each age break the rules which are in vogue. Rules are useful however, they allow most people to make satisfying pictures most of the time. They also form a starting point for the genius.

Rules of composition are a great help but they are made to be broken. If you want to take a picture which does not fit the rules it does not mean that the picture is bad, only that the rules do not suit it.

The rule of thirds is the most common of the compositional dicta. Divide each edge of the picture into thirds. The rules say that the principal point of interest should be placed at a point where these thirds intercept. It is a useful guide particularly in the early stages of composing a picture in the viewfinder, but it can also be restrictive. This is particularly true if you are using a wide-angle lens which places a great deal of emphasis on the foreground. Closely related to this is the 'golden section' so favoured in earlier centuries. The golden section divides each edge not into one-third and two-thirds but in the ratio 618 : 382. Then the ratio of the longer section to the whole edge is exactly the same. Pictures taken applying the golden section have a still, old-master look to them which is good for some pictures and bad for others.

Composition concerns what happens to a viewer's eye when looking

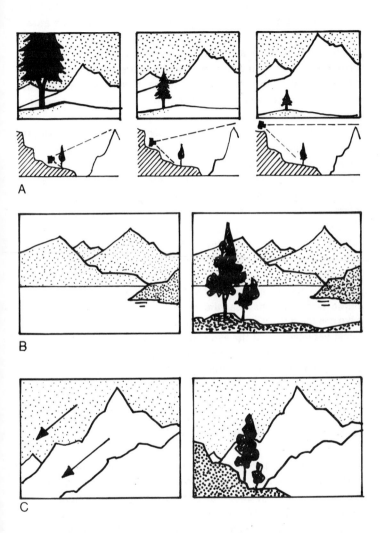

Look carefully at landscapes to be sure of the right view. A. As you move up and away from the foreground, so you increase the domination of the hills behind. B. Try to include enough foreground interest to balance a distant scene. 3 strong diagonals can be irritating unless you include a 'stop'.

at a picture. People do not take the whole of a picture in at once. Their eyes start looking at one point – the point of entry – and move around looking at the various elements of the picture which attract their interest. Eventually they end up at one point – the point of interest – or they slide aimlessly away from the picture and start looking elsewhere. So to make a picture interesting and absorbing, create a point of entry then give a series of clues which direct the eye in the way you want it to move until it arrives at your selected point of interest.

The golden section, by placing the centre of interest obviously nearer to one edge than the other, allows the eye to rest and concentrate on the subject of the picture. If the centre of interest is placed nearer the middle, the viewer's eye starts to judge which edge it is nearer. Distances are compared, and the viewer becomes interested in judging the relative distances instead of looking at the picture itself.

Another rule which is generally useful is that the subject should lead into the picture. A road, hedgerow, wall or river can lead the eye from the edge of the picture towards the centre of interest, this provides a convenient point of entry. This rule can be extended to define what happens near the centre of the picture, and you can have it leading to a single point of interest, or two or three points of interest between which the eye can move in a smooth circular movement. Do the opposite, and have the trees, or river leading out of the picture, and the eye follows the line and is directed smoothly *out* of the picture.

Looking through a viewfinder?

Now it is time to apply the rules when you take your pictures.
First of all, check that there are no visual 'stops' which prevent the eye moving smoothly about the picture. A tree-trunk stretching from top to bottom of the picture, or a power line which stretches across the picture. These are the sort of things which can stop the eye moving in the way it should in a good picture. One of the worst of the visual stops is the horizon. If it is positioned across the middle of the picture, the picture is cut in two. The eye is not sure whether the

Rules can be a good starting-point for attractive pictures; but many of the best shots ignore them. A. The rule of thirds suggests that you put your subject one third of the way across the frame, and points of interest at the intersections of 'third' lines. B. Diagonals running into the picture give you a settled, tranquil effect.

picture is below that horizon line, or above. So it dodges back and forth between the two.

Compose your picture so that, when you look around the viewfinder, nothing gets in the way of the eye seeing the picture, nothing blocks the view, there are no unexplained shadows which wander across the picture, and there is something of interest for the eye to focus on.

To sum up

1 Never position the horizon across the middle of the picture.

2 Never position the main centre of interest at the middle of the picture.

3 Provide some point of entry into the picture.

4 Arrange the picture so that the eye is led towards the centre of interest.

Bear these rules in mind but remember, many more good pictures have been taken which break rules than have been taken by slavishly applying them.

Selecting the lens to use

If your camera will accept interchangeable lenses, then you have to select a lens for each picture. Sometimes the picture will dictate which lens should be used. Sometimes you have to stand up close and still picture all of your subject; then you have no choice but a wide-angle lens. Conversely, it may not be physically possible to get closer to the subject, so to fill the frame with your chosen subject you must shoot through a long-focus (telephoto) lens. In those cases the only problem is whether you have the right lens with you.

However, there is also a wide range of subjects where you must make a choice of lenses. The selection is normally based on the effect you want in the picture. By 'effect' I mean apparent perspective; perspective is conveyed by the difference in size of objects near to the camera, and objects further away, as they appear in the finished photograph. People generally talk of wide-angle lenses giving 'deep perspective' – objects get smaller very quickly as the distance between them and the subject increases; normal lenses

give 'normal perspective' and telephoto lenses give 'compressed perspective' – objects further away from the camera do not become as small as you would expect.

In fact this is not strictly true. What a telephoto lens does is to magnify a small part of the scene until it fills the frame on your camera and a wide-angle lens makes a larger part of the scene smaller, fitting more of the subject into the same frame size. However, if you take a picture on a normal lens and magnify a part of it, then you will see the compressed perspective of a telephoto lens. In fact, at one stage I did not have a telephoto lens and had to do just that whenever my subject was too far away.

In the same way, if you took a series of pictures using a normal lens, and assembled them to cover the same angle of view as a wide-angle lens, you would probably include more foreground objects, and so get deep perspective. So what really controls perspective? Viewpoint controls perspective. If you get very close to a subject you will get the deep perspective associated with wide-angle lenses. When you are using a wide-angle lens you can get closer to the subject and still get all of it in the viewfinder, so you stand closer to the foreground when taking your picture, and get deep perspective. In the same way, stand a long way back from the subject and you get the compressed perspective associated with the telephoto lens.

Wide-angle lens

Obviously, if you cannot stand further back and cannot get the whole subject in the frame using a normal lens, use a wide-angle lens. This also makes the foreground, which appears very large in the picture, the most important element, and separates it clearly from the background, which appears very small.

When composing any picture using a wide-angle lens, pay special attention to the foreground. You must have something to give interest to this area, otherwise the gaping area of foreground will distract the viewer's attention from the remainder of the picture. If this area can be arranged to lead the eye into the picture, so much the better. If you are using a very wide-angle lens, such as a 20mm lens on a 35mm camera, beware of getting your feet in the picture, it is

much easier to do than you would believe. Also watch out for your own shadow, or the shadows of someone standing behind you appearing in the bottom part of the picture, they will form a line which leads interest out of the picture, and leaves the viewer more interested in who the shadow belonged to than the intended subject of the picture.

Telephoto lens

Use a telephoto lens if you cannot get closer to the subject, and want to fill the frame. Use a telephoto lens also when you wish distant objects to appear closer, and form a more important part of the composition. The pictures have a 'huddled' close-together feel, and the telephoto lens is almost irresistable when photographing city streets, when trying to convey the closed-in feeling any city gives. Again quoting for a 35mm camera, I would suggest that a 135mm lens gives almost equal emphasis to the foreground and background. Use a longer focal length lens, and the background begins to be more dominant than the foreground.

Do not forget, if you do not have a telephoto lens, use a normal lens, stand further back from the subject, then mask down the processed picture. This is easy if you make your own prints, but not quite so easy with transparencies.

Finding pictures

The keen amateur does not *have* to take pictures and he can choose his own subjects; so how do you set about finding subjects for your pictures?

Really only three sorts of photograph are ever taken: snaps, perfect pictures, and pictures with a purpose.

Snaps are a record of what your family and friends did, and where they went. They are one of the most enjoyable sorts of picture to look back on; but do not waste time taking them on an expensive fully adjustable camera, buy a cartridge-loading camera and stop worrying about exposure and depth of field.

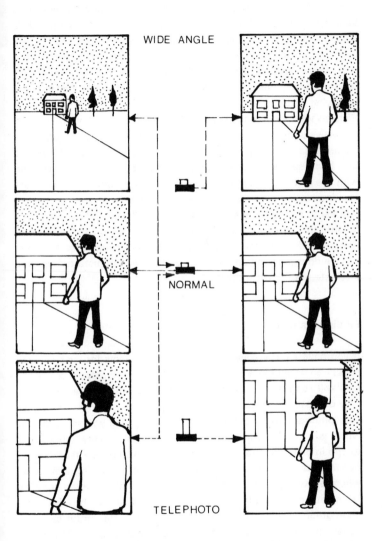

WIDE ANGLE

NORMAL

TELEPHOTO

Interchangeable lenses (or a zoom lens) offer great possibilities when picturing places. When you remain in the same place, increasing focal length enlarges the whole scene at the same rate. If you move to keep your foreground the same size, then the different focal lengths change the relationship.

Perfect pictures are carefully considered compositions where mass balances mass, and light areas balance light areas. The emphasis is placed exactly in the ideal place and figures are introduced where necessary. The exposure is absolutely right, with enough detail in both shadows and highlights. They are the sort of pictures which tend to do very well in camera club competitions, and they are very satisfying and absorbing pictures to take.

Pictures with a purpose are not perfect compositions, but they make a positive statement about their subject, or rather the photographer makes a statement in the picture. This type of picture is absorbing to take because the photographer has to work out what he wants to do with the picture, and what sort of story he wants it to tell. They are also interesting pictures to look at because they have something of interest to say to the viewer. Most pictures taken by keen amateurs fall into this category, and almost all the pictures taken by the commercial and industrial professional. The right subject for a perfect picture does not crop up too often, and this sort of picture keeps you interested in the meantime.

Finding subjects

If you have a pet obsession, then finding subjects for your pictures should be no problem. Pictures of stained glass windows or vintage cars will soon pile up in your collection. But if photography is your only obsession, then you have to find subjects on which to practise your photography. There are two ways of setting yourself subjects, which will develop your picture-taking eye, your ability to develop a theme in pictures, and produce some nice pictures on the way.

Set themes are probably the simplest way of producing a situation where pictures can be found fairly easily, and little forward planning is needed. Simply load your camera with film and photograph — rainy days, reflections, shoppers, the motor car, your house, people at work, trees, concrete, roads, glass. The list is almost endless. By setting a theme, you cut down the number of pictures which you could take, but looking for a specific type of picture makes them easier to find. It narrows down the field of possible pictures.

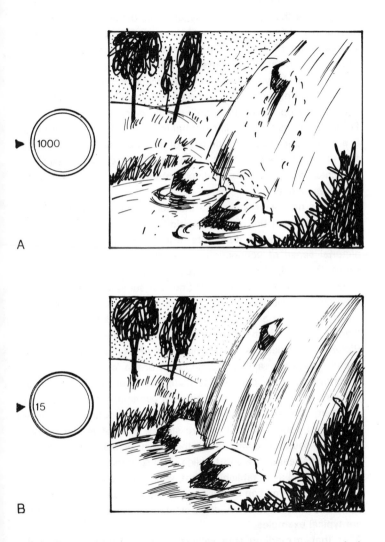

A

B

Shutter speeds are important when you have water in a landscape. A. A short exposure 'freezes' the motion to produce a crumbly effect. B. A long exposure blurs the water into a smear, which is often more attractive.

Once you feel confident in your ability to tackle this sort of assignment, try loading your camera with black-and-white film and shoot one of these themes very quickly, using all the equipment you have in your gadget bag. Try the most outrageous viewpoints and tricks you can think of. Process the film and make a contact print of the negatives. Look at all the contacts. First of all, look for good pictures, and analyze why you like them. Secondly, look through the sheet of pictures looking for logical trains of thought, pictures which follow on and develop the ideas in earlier pictures in the series.

For instance, picture one is a normal lens shot of a tree; picture two is a wide-angle shot from the base of the tree looking upwards; picture three is a telephoto shot of the pattern of tracery formed by the branches; picture four is a telephoto shot of a bird sitting in the branches, and so on.

At first do not deliberately take that sort of series, because, at first, the gap between the pictures would be too large, and the train of thought would be too deliberate. But you will gradually develop a pictorial sense of connection, rather than a deliberately planned series. Once this sort of thing does start to develop as you shoot a series of pictures, then you will find that subjects of all sorts start presenting themselves to you. You are no longer walking, or driving along looking for a beautiful picture, you are looking for a specific *type* of picture which will help to develop your theme.

Picture-story taking is the second sort of exercise which can be useful. These are really a development of the 'connected' pictures which started to happen in the pictures on set themes. Often the pictures are very obvious, but it needs continuing concentration to see them. Some of the rules for planning and shooting a movie can be applied equally to still picture stories. First of all decide on a theme, it could be a visit to another town, or market day, or your local sports team, or a short holiday. Think in movie terms.

First you need an establishing shot, which shows a general view of your subject. If you can find one, a title slide is also useful — the signpost for your holiday town, or a poster advertising a sports meeting are typical examples.

After that, a medium shot selects an area of interest within the general shot. Then a close-up which focuses on a particular detail of the subject. Then a further medium shot allows you to shift the area

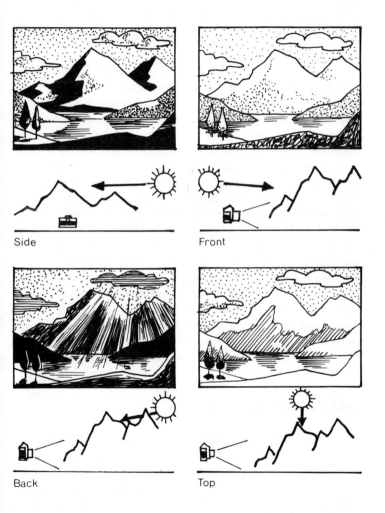

Side

Front

Back

Top

Lighting is as important in landscapes as it is in the studio. You need patience to wait for the right time of day, or even the right day of the year.

of attention, perhaps back to a close-up. Mix in with the shots which are called in movie terms 'cut-aways', shots of signposts, spectators; pictures which are not directly concerned with the main theme, but add interest and variety to the overall story. Put it all together, and there is a picture story. It can be planned out in more detail using a story board technique, but to find out about these read *The Focalguide to Moviemaking*, *The Focalguide to Slides*, or *Visual Scripting* all published by Focal Press.

The advantage of this type of approach is that it encourages you to look for specific pictures, to analyze whether or not the pictures have the elements you need, and consciously decide either not to take the picture, or to simplify it. It makes it easier to form judgments about every element of the picture which appears in the viewfinder. From that point on, all your decisions are about viewpoint, focal length of lens, and exposure. Your aim throughout any photographic session is to make your pictures more and more simple, removing the distracting elements until all that is left is the point of the picture. Include less and less in your pictures and make them say more and more.

A secondary advantage to the picture story, is that it does result in slides which make excellent slide shows. They can be far more interesting to the casual viewer than a collection of pictures which leaps all over the place for its subject matter, and the only linking theme is that you consider them to be your 'best' pictures. Add taped music, and get the tape to change the slides if you like, and you are into audiovisual presentations. This is an entirely different facet of photography, and a very fascinating one in its own right.

Looking at other people's pictures

Look around at the use of photography in television, in the cinema, and most of all, in advertising. The very best photographers earn their bread and butter from taking advertising pictures. So the work of the top men is available for inspection at any time. Always look through colour supplements, magazines and watch the television to find pictures that you like.

Be careful to differentiate between liking a picture and liking the

subject, for example, almost half the population enjoy looking at pictures of attractive girls, whether they are good pictures or not. However, when you find a picture you like, study it carefully to find out why you like it and how it was taken. Look at the focal length of the lens used, the depth of field, and the shutter speed. Is there any movement in the picture; has it been stopped by a high shutter speed or has it been allowed to blur to emphasize the speed? What was the photographer trying to say in his picture? Why has he framed it in the way he has? What do you think was the most important part of the subject from the exposure point of view? Has any artificial lighting, fill-in flash for example, been used? What type of film do you think he used and why?

Once you have decided how the picture was taken, think about the options that were open to the photographer. What would have happened, for example, if a telephoto lens had been used instead of a wide-angle one, and so on. Why was that viewpoint used? What difference would it make if the viewpoint had been moved a few feet to one side or the other? And the final question is – could I have taken the shot better myself?

Picture formats

My camera produces pictures which measure 24 × 36mm. Photographic paper is manufactured in a range of sizes, and very few of those sizes match the shape of my negatives. So, it seems surprising that the shape of a picture is never altered by most people. Whatever comes back from processing, or the shape the paper comes out of the packet, is *not* the shape the picture *has* to be. If you have a subject which would look best on a thin, wide picture, or a tall narrow one, then make it that shape. If you need a triangular print, do not hesitate to cut one.

If you use a negative-positive system and do not make your own prints, then white borders can be a problem when trimming the format. The only way round the problem is to ask for borderless prints from your photodealer, or to trim the white border off first. Then carefully trim the print to exactly the format you want, and if you like white borders, dry-mount the print onto white card, leaving a small

white border round it. If you make your own prints, then you can mask them to any size or shape you want on the baseboard.

Slides can also be masked to give the format you want. Because slides are usually projected, it is even more necessary to frame the picture accurately, and doing so gives a lot of scope for improving the picture. It does mean that the slide must be remounted, and this can be done using any of the commercially available mounts. A word of warning here: although glass mounts do protect slides from finger marks and surface dirt, there is a certain amount of evidence which suggests that in the long term – 15 years or longer – slides which are mounted in glass may not last as long as slides which are open to the air.

Although the mounts can be bought commercially, the masks must be made up to fit the picture. Black paper can be used, but the edge of the paper usually looks 'hairy' when the slide is projected, and some contents of the paper may affect the life of the slide also. You may prefer to use commercial aluminium masks (thick cooking foil may work); cut it up and retape it into the required shape. Once the mask is the right size tape the pieces together then tape the mask to the perforated edge of the transparency before mounting it in the usual way. Remember that masking is one way of effectively producing a 'telephoto' shot, and it is the final stage in the quest to eliminate everything from the picture which does not directly contribute to the effect you want from the picture. In fact, masking slides is yet another way of adding impact and variety to the pictures you project.

The photographer has thrown a snowball into the water to create ripples and add interest to the large area of foreground water.

Anne Frank House, Amsterdam – it was an imaginative idea to leave the curtains in the window; the first reaction of many photographers would have been to draw them back.

Page 539 top the sky can itself be the main area of interest, as in the top picture (which was taken with an orange filter fitted to the lens – see page 217), or it can be a neutral background for elements in the scenery, as in the lower picture.

The camera angle has been deliberately chosen to draw comparisons between old and new styles of architecture – the background, which at a fleeting glance looks like the sky, is in fact the glass front of a recent high-rise block.

Page 541 top Kastrup Airport, Copenhagen. The interiors of modern buildings with large windows often make interesting contrasty photographs.

Page 541 bottom Senate House, Cambridge. The solitary figure leaves us in no doubt as to the academic function of the building.

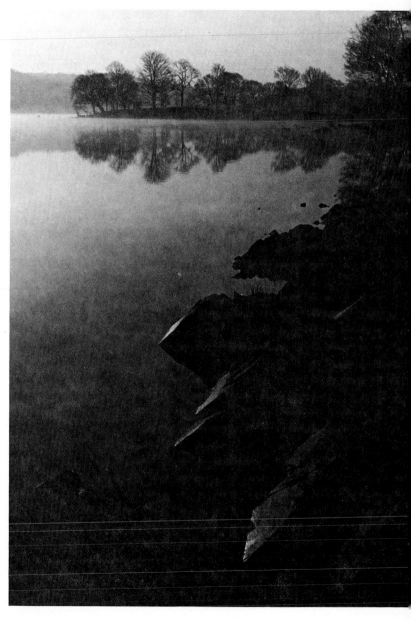

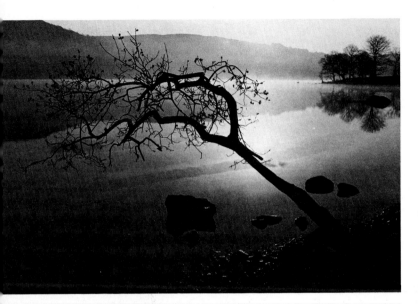

The three pictures reproduced here and on the opposite page were all taken within moments of each other, and they illustrate the value of looking around carefully for alternative ways of portraying the landscape.

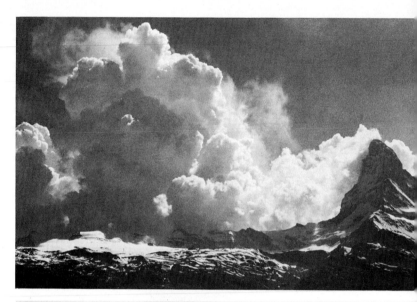

Top the Matterhorn, dominated by a towering cloudscape.

Above for pictures of people together with buildings, ask them to look towards the buildings rather than at the camera.

Landscapes

Landscapes are one of the most popular photographic subjects, for snaps, perfect pictures or for pictures with a purpose. Lots of people try to record a scene, or a view, with whatever sort of camera they possess. And most of them fail miserably, especially when they compare their efforts with those on picture postcards. The superior camera used by the picture postcard photographer is generally held to be the reason for the superiority of his pictures. But we know that an expensive camera does not make good pictures; a good photographer does, and it does not matter what sort of camera he is using. So what is the trick with landscape photography? Let me start by analyzing what landscape pictures are taken to show.

What is in a view?

Landscape pictures are taken to show a particularly beautiful view, they are taken to record a scene which makes you stop and look at it. But lovely views tend to disappear once you start looking at them *critically* through a viewfinder. By that I mean when you objectively search the viewfinder and say 'Does this view produce the same reaction as when I first saw it?'.

When you first look at the scene, you see it in depth, and the way your eyes see the scene is rather complex; the total angle of view is very large – about 170°, but your eye subconsciously selects the part of the picture it wishes to concentrate on, and 'fades out' the rest of the picture, while still being aware that it is there. Also your eyes scan a scene taking in a very wide angle of view and relating the various parts that you see. Normal cameras cannot match that view no matter what lens is fitted.

Your basic problem is to compress the very wide impression of a view which your eye gives you, so that your picture recreates your

vision. First of all, you have an impression of depth, of the view receding from you. That is very important when recording a piece of landscape. You have to feel the land stretching away from you. So you must include something fairly close to the camera, as well as the medium and far distance. So fill the foreground of your picture. Use hedges or fences, trees, rocks or flowers, anything which will produce the contrast in size which conveys the impression of depth. You may want the foreground in or out of focus, it depends exactly what you are taking the picture of. But you almost always need something there.

You also need to compress the landscape into the small viewfinder. So you must decide on a typical feature of the landscape and compose your picture around it. There is a great temptation when you are in Holland to look around for windmills and 'Van Gogh' bridges, because that is supposed to be typical Dutch scenery. But dykes, water and wind and a wide sky are far more typical of that country's scenery. So we are looking for a picture which includes something which is typical.

This sense of depth, and of typicalness have to be combined in your picture, and the rules of composition can help. A picture always works best if it is contained within itself, if the eye is led into the scene by the strong lines in it, and there must be some point or points for the eye to rest on when it has been led into the picture, and preferably some sort of compositional stop which prevents the eyes from wandering out of the picture again. All that is fine, except that the view is there, and you cannot rearrange it. But you can move around to vary what actually appears in the picture and chose the best view.

Depth and perspective

Close by, we see the relationships between the elements of our surroundings because we have two eyes. Our brains correlate the minute differences between the two pictures to calculate distances. You can duplicate the effect photographically with a stereoscopic camera (or attachment).

At landscape distances, in practice, we use other signs to dis-

tinguish depth. These signs are the ones you have to use in a normal photograph, however close your subject. There are three basic contributors: shape, size and contrast.

Shape we discussed a little earlier. Lines of roads, hedgerows, ploughing patterns, etc. leading to the distance give a strong feeling of depth.

Size is closely related. The reason that lines can convey depth is that they appear to converge with distance. That is, things look smaller the further away they are. Familiar objects, such as houses, trees or animals, give an instant clue to their distance. So strong is their effect that you can totally confuse your viewers if you cheat with models of familiar things carefully placed in your landscapes.

The size of texture is also important. Nearby a ploughed field appears as individual clods, in the distance, just as a speckle. That is why ultra-wide angle landscapes often appear so striking from low down, you emphasize the size of the elements of texture — the rough surface of a concrete pavement, or the individual ears in a field of barley.

Contrast is to some extent another facet of the same phenomenon. Once you look too far away to see the texture, the landscape takes on an even tone and colour. The effect, though, is emphasized considerably by the intervening atmosphere. In most of the world, for most of the time, the air is far from clean — so it scatters the light from distant objects.

This results in the phenomenon called aerial perspective. It is simply that with distance, things appear paler — and bluer. Artists have long portrayed the distance as blue, and for good reason: it is blue. To your film, in fact it is even bluer. Films are all sensitive to UV, which comes out blue in colour pictures, and white in black-and-white shots. So that faintest haze tends to become a blue veil.

So, often, you need to reduce the haze effect. You do that by absorbing the UV with a suitable filter. For a stronger effect in colour you can use a polarizing filter, and in monochrome work you can use a yellow orange, or even red filter.

When, though, you want to emphasize distance, especially when the air is clear, you may want to keep the haze. In black-and-white work, you can even emphasize it with a blue filter should you want to. Of course you cannot convey depth by just producing hazy pic-

tures. You need strong high contrast foreground to compare with the misty distance.

Setting up the shot

So you are out in the country and see a lovely shot of a 15th century mill against a backdrop of hills, surrounded by trees, but with a new factory built nearby. First of all walk around to find the best viewpoints, and consider the lens for each shot. With this particular location there is a perfect shot framed between the trees but there is no way you can take the picture without the factory appearing in the background. Admittedly it is a good way away, but as the trees are also well away from the mill you would need a telephoto lens to pull the mill up to a reasonable size in the picture. So abandon that shot and walk around to take the view looking another way, with the hills in the background. Look at the picture keeping an eye on the foreground and any eyesores other than the factory that might appear, like old farm machinery. Look for the most typical and uninterrupted view, hopefully with an attractive cloud-filled sky. Look for low-angle, wide-angle shots looking towards the mill sails.

Remember what you are picturing – the mill in its surrounding countryside. So you need to show that relationship. The mill is built in the middle of fields on a slight artificial incline to lift it into the wind, hence why the trees are so far away and why it is so far from the village and the hills. If you use a wide-angle lens you have to be close in to make the mill appear large in the picture. Again the close viewpoint means that the hills appear much smaller and are not noticeable in the viewfinder. With a telephoto lens you have to move much further away and the mill appears large in the picture, but it also makes the hills appear larger and closer. Maybe a little too close as the mill was originally built well away from the trees. So the best choice after all is the normal lens.

Taking the shot

Now look through the viewfinder and see what there is to see. The hills sweep down from right to left, but a clump of trees low down

on the left stop the eye being carried out of the picture by the sweep of hills. If you bend down the mill stands above the line of hills and looks higher; and it appears in the right-hand side of the frame which avoids splitting the picture in two. In the foreground a field of wheat is appropriate if a little uninteresting, to increase the interest look around for some wild flowers or ask a model to walk down the path.

Now to set the exposure. The sun is bright, but it is very windy. The wind might cause camera shake so you need a fairly high shutter speed. You do not need a lot of depth of field because you are not including the nearest foreground – f8 will leave everything in focus from 5 m (15 ft) to infinity, quite enough for this picture. Now for a meter reading. Make sure to point the meter down a little. With through-the-lens metering point the camera down slightly so that the meter is not fooled by reading too much of the light reflected from the sky – 1/250 second at f8 will give the correct exposure.

Ask the model to walk and watch the progress through the view-finder and when he reaches the right place in the picture, take it. Do not stop and pose the person there. If you want to take another shot just to make sure, ask him to retrace his steps and walk along once more. A walking model is much better than a stiff, posed one. Anyone asked to stand and 'look interested' is made to feel and look awkward so always get the people in your pictures to do something.

A second shot

Briefly, let us consider the second picture. We have a 15th century mill and near to it a well-preserved village, mainly dating from the 16th century. The picture needs to show both the mill and the village it served. There is a problem because the village only appears as the tops of roofs and the church spire above the trees, but they should be clearly visible in the picture. Select a telephoto lens and walk well back from the mill with the village appearing larger in the background. Try to find two clumps of trees to form visual stops to the line of trees and village, keeping that line well up in the picture to avoid cutting the picture in two. A telephoto lens is even more

difficult to hold still in this wind so increase the shutter speed to 1/500 second, opening up to *f*5.6 does not throw anything out of focus. Hang on, *squeeze* the shutter nice and slowly and we have another good shot. Because it is so windy repeat the shot in case the wind has shaken the camera first time.

Bubbling waters

Water can help enormously, it is fascinating and photogenic in itself and mirrors exacting reflections. A fast running stream can provide the key into a picture, spreading away and carrying the eye into the composition. However running water presents its own problems and offers its own rewards. Let us approach the subject logically, starting with the stream running wild down a hillside, and lead from that into the wide, smooth flowing rivers and lakes of the low plains. The fascination of running water is in its vitality, in the splash and swirl and its rapidly winding course. The photographer's problem is how to capture that effect on film. Cameras and film combine to make waves and spray look considerably less significant than they appear to the eye so unless you live near Niagara Falls or Victoria Falls you will have to make an effort to make any mountain stream look more than a rather slow little brook. For a start any stretch of running water looks more rough and broken if you look upstream. That way you see the swirls and eddies, and the white crests of the waves running over and round the rocks. Look the other way, downstream, and all you see is the almost glacial smoothness of the water as it pours down over rock, the wave below is hidden and the scene much less wild.

Be careful when choosing your viewpoint – to make the falls and spray look as big as possible you will need a low viewpoint, looking up at the water as it falls. This does not mean the most comfortable viewpoint, or the safest, so move slowly and carefully, remember that the ground underfoot may be wet and slippery. There is always a temptation to keep your eyes glued to the picture you are trying to take, but in this case, you really have got to keep glancing up as you work your way round to the camera position. Convince yourself that the best picture is not necessarily taken from the most dangerous

position, and always think about the effect of changing the focal length of the lens will have on your viewpoint.

A daring, wet and risky trip across wet rocks could be avoided by putting a telephoto lens on the camera and shooting from safe ground.

Having decided on a nice low viewpoint, there is always a danger of spray drifting over the camera. A UV absorbing filter fitted over the lens will help to protect that, but you should also take care to keep the spray from the camera body. You can do this by taping a plastic bag over the camera, having first cut a hole in it for the lens, and taping the bag to the lens hood once it is in position. If the bag is big enough you will still have room to adjust the controls, and if the bag is stretched tight across the viewfinder it should still be possible to see through it. Once you have taken your pictures and got back to safe ground, take the bag off the camera and thoroughly dry the body with a tissue or soft cloth, and dry the UV filter.

The choice of lens for your pictures of fast running water must depend on the picture, remember that the wide-angle lens will need a lot of foreground interest, and will make the stream recede quite sharply. If you do not immediately know which lens to use, I suggest that you mount the standard lens and try to fill the foreground. Choice of shutter speed can be quite critical with this subject. A very high speed will 'freeze' the water, showing every swirl and ripple clearly with pin-sharp accuracy. If this is the effect you want, then 1/500 or 1/1000 second is not too fast. On the other hand, a slow shutter speed will allow the water to blur, bubbles of foam will become a white shapeless blur, the waves and eddies will move during the exposure, giving the impression of speed and movement. Try for both effects, and see which one will best convey what you want to show about fast moving water. My own preference is for rocks standing sharp and clear against blurred water, and for that I would try to use 1/60 second if my foothold allows me to hold the camera still at that speed, certainly, if you go beyond 1/125 second you will start to dilute the effect.

Slowing down

Come lower down the hills and the pace of the stream slows. It is no

longer so compelling as a photographic subject in its own right, but it starts to become a part of the landscape instead of one of the forces creating it. So the pictures you take in this sort of landscape are going to reflect that change. Show countryside with a stream in it, instead of the stream with a little country either side of it. The water still meanders interestingly, and used carefully it will add to your pictures. Remember the 'rules' of composition. Try to arrange the stream so that it leads into the scene. If possible, try to hide the area where it leaves the picture, behind trees or a small hillock. Trees leaning over the stream start to form useful picture frames, the flow of water has slowed up enough to allow reflections to form in the larger pools, and they can produce yet more interest and effect. Do not be afraid to include animals in your landscape pictures too, streams will always attract them and they can help to add the feeling of depth and life which you are looking for in your pictures.

At about this stage in the life of the stream you can use the reflective properties of water in another way too. You can picture reflections of sunlight as well as scenery. You have to start worrying about false meter readings once you start doing this trick, and to base your exposure of the surrounding countryside, not of the sunlight sparking on the water. This is one of the times that you have to fiddle with an automatic camera.

Still waters

Further down still and the stream has become a river, and forms lakes which reflect the view most obligingly. If the water is completely still then it forms a perfect reflection and you can make the most fascinating pictures using that perfect reflection. Do avoid the water level running across the middle of the picture, cutting it in two. Decide whether you wish to make the reflection or the subject the main part of the picture, and arrange the waterline to fall about two-thirds or one-third of the way up the picture respectively. If you do make the reflection the main part of your subject, try to avoid the real subject leading the eye out of the picture, for example by having a church spire leaving the top of the picture. Always try to keep the picture framed within itself.

If you are photographing reflections in still water, you will find that blue sky becomes a deeper blue once it is reflected, and clouds will stand out more clearly with greater contrast.

This can be a very useful effect, adding more 'weight' of colour to the bottom of the picture, and making composition easier. The effect is probably most noticeable in the classic pictures of mountain lakes, where the dark mountains contrast with snow peaks, and a clear blue sky can be reflected a deep blue, getting deeper toward the bottom of the picture. The fact that it does so is convenient, especially with the problem of filling foregrounds.

Sometimes the water can be too still, lacking life and refusing to look anything like water. A few ripples can help to bring the picture to life, and to make sure you know which way up it is supposed to be. In fact when taking pictures from boats, where foregrounds are always a very real problem, the wake of the boat is often used to fill an otherwise dead area. On lakes, you may be able to make enough of a wash by swishing your hand in the water. The old style technique was to throw a stone into the water, but I have no wish to incite people to fill up every lake, stream and pond in the photographable world with stones and boulders.

Even a good hand swishing session could upset any fishermen in the area, so make waves with caution, or they may spread further than you anticipated. If you do make some ripples, give them time to spread out over the surface, a few ripples close to the camera position and glassy stillness everywhere else looks artificial.

The problem of depth and distance is greatly eased when you have water and reflections, since the water forms the middle distance, and the far distance is taken up by whatever is being reflected. Most of the time, you will find enough interest in the shapes formed by the reflections, to happily fill the bottom part of the picture, but if you want to increase the feeling of space, you can still use trees or reeds to frame the picture. I would not do this as a matter of course, it can make the water look small and enclosed, and fight against the feeling of space and sky that attracted you to the picture in the first place. Rather I would suggest using that confining effect of reeds when you want to make the water look smaller, for example when you are photographing an ornamental lake inside formal gardens or by a stately home.

Fisheyes and the like

There are times, however, when the most assiduous search for a viewpoint, and the cleverest hunt for a piece of typical scenery all fail to bring that view which compresses the wide vista satisfactorily. You *must* record the whole sweep of the view, but once you start looking through the viewfinder, that idea fades rapidly.

A fisheye lens encompasses a 180° field, but it does so in all directions. The view you are aware of is 180° only in the horizontal plane. For example, when you look at a view do you remember seeing your feet at the same time? Your eye and the brain automatically forget that they are there unless you specifically look for them. Use a fisheye lens and you suddenly become aware that every picture contains your feet, and because they are close to the camera they appear very large in the picture. (In fact ultra-wide angle lenses [13 mm – if you can afford it! 15 mm or 17 mm] are very often much more use than fisheyes in getting everything into landscape pictures. The effect though is quite similar.) What you actually see is a wide-angle, but horizontal picture. Some cameras have been produced which reproduce this sort of a field of view by using a moderately wide-angle lens which swings during the exposure to cover a wider angle of view. They take long, narrow pictures and have some limited value, as do fisheye lenses.

Panoramas

There is a way of constructing the sort of panorama picture we are talking about. You need a very firm tripod. Set up the tripod and camera and take a series of pictures across the vista. Look through the viewfinder each time to make sure that the picture includes the features you want to include. Make sure that the camera swings parallel to the horizon level. This is easier if you have a pan-and-tilt head (one which swings both horizontally, pan; and vertically, tilt) otherwise you will have to alter the legs until they are the correct height to leave the camera absolutely horizontal. If the camera does not follow the horizon accurately your finished panorama will fall pathetically out of one end of the picture.

Start with one end of your panorama carefully framed in the view-finder. Wait for a period when the lighting will not change, for example, with clouds passing over the sun, and take your first picture. Note some landmark which marks the end of your picture and move the camera so that about one-third of your first view remains in the second picture. Then take a second picture, move the camera so that one-third of the picture remains, and take a third picture, and go on until you have covered the panorama you want.

Have the film processed and printed, or print it yourself. If you choose to print your own pictures then take great care to get the density of all the prints exactly the same, even slight differences will show up. Commercially made prints produced on an automatic printer should give prints of the same density, but this is the hardest of all tests for any printing apparatus and you may have to learn to live with some differences in density whether the prints are produced by you or by a machine.

Trim the borders off the prints if they have any. Lay the prints out on some photographic mounting board and sort them into order. You will also need a very sharp knife and a steel rule. Lay the centre print down and take the picture which lies next to it. Match the features on the edges of both prints, this will give you an overlap of about one-third of the total print. Once they are exactly matched, lay the steel rule on top of the prints, press down firmly and cut through *both* prints at once. Then take the print which matches the other side of the centre one and repeat the treatment. Carry on working out from the centre print. The outer edges of the outer prints do not need trimming. When all the prints have been trimmed, mount them onto the card taking care to butt the ends exactly together.

Mounting one section at a time is the easiest way of doing this. You may find the latex adhesive is easier to use than dry-mounting materials, although the results are not as permanent. Other techniques can be used, such as making diagonal cuts, or chamfering the edge of one print so that it lies slightly on top of the previous one. All these techniques are designed to make the join less obvious, but carefully aligned butt joints are perfectly satisfactory for normal purposes.

The reason for the massive overlap, in effect you only use the middle third of each picture, is that this minimizes the distortions which

occur at the edge of the picture, use more of the picture, and the features will not match as exactly. If you are happy to have jumps in things like fences, then you can go ahead and use more of each print.

If you find that you want to concentrate on panoramic pictures, you should consider buying a panorama head. This is a little device which goes between the tripod and your camera. It includes a spirit level to ensure accurate horizontality, and allows you to rotate the camera by a fixed angle between shots.

Light, sun and seasons

All landscape photographs are lit by the sun (yes, moonlight is just reflected sunlight). The light though, changes in angle and quality from hour to hour and from week to week.

Classically beautiful landscapes very often benefit from strong sunlight. It produces rich blacks, bright highlights and saturated colours. Every feature stands out in its own right. When the composition is right – and we have already decided what it is going to be – all that matters is the direction of the light, as we soon see.

What about the glowering Welsh mountains, though? A heavy overcast day with a livid overall light may be much more satisfactory. Or perhaps the beauty of a New England valley can best be portrayed with the soft dewy mist of an early spring morning. Whenever you have the possibility of choosing the light for your landscapes take it. The weather contributes immeasurably to landscapes. Clouds liven up the sky – and sometimes an exciting storm can be your main subject. Your foreground need be nothing more than a field of ruffled corn, or a wind-tossed lake.

Even when you want a sunlit landscape, rather than a stormscape, you have to think carefully about the light. The old advice to 'photograph with the sun over your shoulder' is correct more often with landscapes than with most other pictures. However, that is not saying much. Scenes often benefit from strong cross-lighting, especially in black and white, and shooting straight into the sun should also appeal on occasions. As we see in the Exposure chapter, this can require a little extra thought, but it is worthwhile in almost any landscape.

We all know that the sun rises in the east, but how often do we apply that knowledge to our landscape work. When you look at a scene, look at the way the sunlight falls on it. Could you do better if you could control the sun? Would the shot be nicer with different shadows? Or with the light slanting from the other way? It all depends on the scene, the lines of stately poplars edging many French main roads cry out for a low sun to produce long shadows. On the other hand, the brassy heat of a desert may be best portrayed with the sun directly overhead.

With just a little thought, you can predict when the sun will shine from the right place. If possible, return at the optimum time of day. Arrive a little early, and watch the scene as time passes, and the shadows move. That way you can be sure of taking the picture you want.

The sun's rays change in direction through the day, and through the year as well. Outside the equatorial zone the sun is never directly overhead, but you can still choose between a high summer sun and a low winter one. So, if the vegetation is acceptable, you can choose both the direction and the angle of the sun.

In temperate climes, though, the landscape varies dramatically with the seasons. In fact much of the joy of landscape work comes from the selection of seasonal variation. It is well worthwhile to set yourself a project of recording the seasons as reflected in your local landscape. If you are a slide-tape enthusiast, you can take a series from exactly the same viewpoint, then dissolve through it as an effective display of the year's passage.

Sunrises and sunsets

The sun coming up or going down can be an ideal subject for spectacular slides, particularly for the beginning or end of slide shows. You can bind up colourful slides with title pictures to make impressive opening and closing slides. What is needed in the picture apart from the sun? Well, clouds are always a help provided they are sufficiently broken to allow the sun to shine through. Something which has an easily identifiable shape also helps, pine trees or a windmill are good examples. Add water to reflect the colours in the sky and there is a picture which offers almost endless permutations.

In fact the only thing which is not really needed is the sun. Pictures taken just after the sun has set can be especially effective.

One attraction of sunset pictures is that they do not need very exotic locations. I saw one recently taken by a single-handed yachtsman in mid-Atlantic, which was rather ordinary, but a picture taken from the end of a very ordinary harbour wall would have exactly the same qualities.

Exposure

How do you take them? Well one attraction is that they look difficult but are really easy. Even if you do not get the picture you originally wanted, you do end up with a nice slide. Most people worry about the exposure for this sort of picture, but the rules are still the same. Make an exposure reading for the part of the subject you are most interested in recording. If you want to record the ball of the sun then take a reading straight at the setting sun. Everything else in the picture will be underexposed giving strong silhouettes and detail only in the sky. There will be none in the foreground.

If you want detail in the shadows then make a meter reading for the shadows, but with that exposure the sun will be bright and burned out with little or no colour in the sky. For a general sunset exposure, turn round with your back to the sun and take a reading of the scenery illuminated by the sunset. It will give you an exposure halfway between the shadow reading and the reading for the sun itself. That should leave the sky bright but full of colour, but with enough detail in the shadows to please the most technical. If you have time take a series of 1 stop intervals; choose the best when the film has been processed.

When the sun is included in a picture you may see bright coloured dots or rings appear in the viewfinder. These are 'flare spots' caused by internal reflections in the lens or camera body. So far the possibility of such reflections has not been removed from even the most expensive optical systems.

But it has saved some of the most ordinary pictures. The circle type of flare can be used to form a halo round the sun, the nearer to the centre of the picture you bring the sun the more nearly the flare

around it will form a circle. If the flare spots do appear there is little which can be done to remove them. Reframing the shot so that the sun does not appear in the picture and the use of a lens hood designed specifically for that lens will help. If the lens being used is more than 15 years old the flare problems may be much worse. Not only will spots and circles appear, there may also be an overall white or coloured light which makes the picture look washed out, with no depth of colour anywhere. This is called flare light or overall flare and no amount of skill can remove it. If you see it in the viewfinder, just go and look for another picture.

Building your own pictures

Clouds can add interest to the sky in a landscape picture and if there are no clouds, the answer is to put them in at the processing stage. A small stock of negatives, or transparencies with interesting cloud formations and a straight low horizon, are always valuable. The transparency can be cut carefully along the line of the horizon (sea pictures are ideal, because the horizon is straight); remount the two transparencies together. They can be accurately positioned and fastened by a piece of tape across the edges of the two pictures. In this case, mounting between glass is much the best way, since it keeps the two pieces of film in contact and prevents them flapping.

The most usual combination however, is to use a nice flying bird to fill an otherwise empty sky. You do have to remember a little simple logic, though. White objects, seagulls, for example cannot mask out anything behind them. So, you cannot superimpose them on anything other than a plain white area. Transparent gannets or boobies just do not add realism. So, for stock birds, choose darker species or shoot against the light.

You can add anything dark to your transparencies — trees, maybe. All you need is a transparency of a branch silhouetted against a clear ground, bind it in with your landscape slide, and you can have silver birch leaves framing death valley – or the Antarctic wastes.

Of course, if you do your own printing, you have even more scope. Printing from negatives, you can always add darker parts to a print. The classic case is the use of a cloud negative. If your original

negative has a clear white sky, expose your print in the normal way, then change the negative for a stock cloud shot. Mask off the land (or sea) in your picture – roughly with your hand held well above the paper, or accurately with a carefully-cut mask. Then expose the sky to the clouds. Nothing could be simpler – in black-and-white or colour!

If you have a strong blue (or grey in monochrome) sky, then you have to hold it back during the first (main subject) exposure so that the paper remains white for your second (sky) exposure.

Printing from transparencies works in the opposite way. You can burn white clouds into a plain blue sky, but once you have exposed the paper to a white sky transparency the sky is white forever. In that case, you have either to mask off the sky area during the first exposure, or combine the transparencies in the enlarger carrier and make a single exposure.

The most beautiful buildings are the most often photographed. But this awful place, mirrored in water with scum on it, is a superb subject.

Top industrial regions are often as photogenic as the more obvious countryside scenes.

Above water pouring on rocks from a tufa spring, taken at 1/15 second with the camera firmly supported.

Winter landscapes can often look rather murky and skeletal. Here the photographer
has overcome this problem by the bold use of reflections and by including the sun in
his picture.

Taken with a shift lens (see page 575) – this can be deduced from the fact that the vertical lines of the building are parallel while the horizontal lines are not (except where level with the camera position).

Page 565 top a telephoto lens is useful in landscape photography for isolating distant details or patterns.

Page 565 bottom Mount Kilimanjaro – a spectacular geological feature, but it is the tree that really makes the picture.

A good dark frame helps to create an impression of depth – this is an effective compositional device in many situations, but especially in architectural and landscape photography.

Page 566 top Montjwich Palace, Barcelona. For advice on photographing after dark see pages 634-645.

Page 566 bottom the Inca ruins at Macchu Picchu in the Andes. The photographer waited until the sun was slanting in quite low to reveal the contours and textures.

Foreground silhouettes can add atmosphere to otherwise bland sunrise or sunset pictures. Use a through-the -lens meter reading without modification to get a good dense silhouette in situations like this.

Buildings

Far too much has written about 'architectural photography', describing peculiar techniques with specialist cameras, all designed to make proper photographs of buildings. You might think that it was really something special but, in fact, picturing buildings is no different from photographing landscapes, gardens or people. The basic rules are exactly the same: decide what you want to photograph; and photograph just that.

Of course, there is special equipment to help, and tricks of the trade. Like every other subject, the more sophisticated your equipment, the wider the range of pictures that you can take, and the better the quality (sharpness and correct exposure) of the picture should be. But you can make good pictures of buildings on the simplest equipment. I know an excellent collection of architectural photographs, outside and inside, taken with a 1920s box camera bought secondhand for very little money.

What are 'buildings'? They are cathedrals and churches, castles and thatched cottages. They are also office buildings, airline terminals, hotels – and your home. All of them have one thing in common, they are designed and built by people, and intended to be used by people. The best of architectural pictures, in my opinion, are those which show people using the building. It is often difficult to avoid the people anyway, even if you want to. In most cases, it is better to relate the building to people, streets, hills, trees, rubbish tips and so forth – fashionably called its 'environment'.

Leaving buildings in their proper light

Often, on holiday or a business trip, you have no choice but to picture buildings when you are there. Whenever possible, though, a

little patience and planning can make all the difference to your pictures, because different buildings need a different type of light, even different sides of the same building can show up better in different lights.

Three things affect the choice of lighting: what it is made of; which way the building faces; and what else is around it.

Obviously, you cannot actually light the building, but what you can do is to wait until the sun shines from the best direction – or until it is masked by just the right sort of cloud to soften it the way you want it.

'Lighting' always conveys the impression of arranging a series of floods and spots to produce the angles and balance you want on your model in the studio. Outdoors, though, the same principles apply. It is just that time, tide and the sun move with absolute regularity and all you can do is choose is the moment.

What is it made of?

Old buildings are often full of fine detail, delicate carving and ornaments. A strong clear sunlight across the front of the building helps to show up that detail, particularly if the building is grey, brown or dark coloured. But make sure that the shadows are not so deep as to hide part of the detail. Particularly in colour, photography tends to emphasize the blackness of shadows.

If the building material is white, then the contrast between light and shade may be too much for any film. You may lose detail in the blinding white highlights and the shadows. You have to choose a softer day. Cloudy bright is just right, with light cloud covering the sun. That produces positive but more gentle shadows to show the detail, and does not burn out the highlights.

Modern buildings, in particular, make use of very bold shapes and textures. The light and shade from strong sunlight can help to bring out these shapes. You may have to wait for the right time of day to get shadows in the right place. The pattern of shadows and shapes can produce fascinating abstract pictures in their own right. Look for these as well as for more complete 'record' shots.

Cross-lighting on brickwork

However skilled the bricklayer, there are always irregularities in his work. Strong cross-lighting is very unkind and shows up every tiny one. It shows were the bricks do not quite line up and areas where the courses may not be quite straight. Such light can make any piece of brick building look terrible. So, avoid it, except when portraying 'character' in old buildings, or when amassing evidence if you want to sue the builder!

Which way does the building face?

That question is not as silly as it sounds. Of course, all buildings face in all directions — since they enclose a space, but usually one side is 'prepared' for the public to see. The main entrance lobby of an office building or an art gallery, a carefully contrived view over a lake, and so on. The north face of a church, for example, is often less well detailed than the other three and can be less attractive to photograph.

If the side of the building you wish to photograph is always in shade, then 'cloudy bright' conditions will give the shade some directional light; that is the lighting to choose if you want to record some texture.

It is possible to shoot pictures of a north facing building with a clear blue sky, which gives a soft diffuse light all of its own. However, colour pictures shot in skylight appear very blue and cold. So, use a pale salmon filter ('skylight' or stronger) to improve them. You must also remember to go close in to the building to make an exposure meter reading, and point the meter slightly down, otherwise the picture will be underexposed. A deliberate overexposure of about $\frac{1}{2}$ stop may help, particularly when shooting transparencies, with buildings in deep shade.

Clouds

When buildings face the wrong way, perhaps always with one wall shaded, and too often with another brightly illuminated, you have no

choice but to wait for a dull day. Clouds diffuse the sun to provide a soft even light. However, then you may find that your pictures lack impact; even that it is hard to see where one side ends and the next starts.

So, cloudy days are suitable only for subjects with their own clear shape, pattern and tones. Colour pictures are often more successful than black-and-white in such conditions.

What else is around it?

Most buildings have other buildings around them, as well as trees, large towers, pylons carrying power cables, street lighting and much else. All of them can throw a shadow across the face of the building. If you are lucky the shadow will only be there at certain times of the day. Things to the east cast a shadow in the mornings, those to the west in the afternoon. Objects to the south of the building can cause trouble for most of the day.

With luck, there is a gap in the surrounding buildings which allows a shaft of light to fall clear across the face in the early morning or late evening. It is a matter of scouting around and seeing how the land (and building) lies. If you are in a hurry and really cannot come back tomorrow, it may be possible to wait for a cloud to cross the sun and grab your picture in the brief period of shaded light. Otherwise, cloudy weather is again really the best answer. If all your days pass in a blaze of sunshine, you have to decide where the shadow gets in the way least, and take your picture then.

Constructive shadows

Shadows hide detail. That can be a great boon. Often the building you want to portray is surrounded by ugliness. If you are lucky, there will be a time when the surrounding horrors are shaded, and just your prime target sunlit. It may be that the shadows of buildings do the hiding, or clouds restrict the sun to a natural spotlight. Alternatively, if the buildings face in different directions, you just have to wait for the right sun angle.

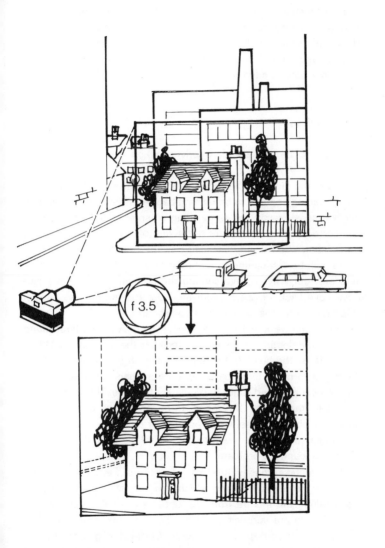

In towns, attractive buildings are often surrounded by unattractive ones. You can do much to improve your urban pictures choosing a long-focus lens to select just the portion you want; and by using a wide aperture to throw the surroundings out of focus.

Because buildings are so often arranged in streets, you are often faced with strong contrast between sunlit and shaded examples. Look on the shaded buildings as a solid mass of darkness to use to compositional advantage, leading the eye into a building, or providing a natural edge to the scene.

Do not look up!

This used to be the standard advice when taking architectural photographs. If you tilt the camera upward (to get the top of the building in the picture), the top comes out narrower than the base. So the building appears to be leaning back – away from the camera. Your eye sees exactly the same thing when you look up, but your brain corrects for it, so you are not aware of the fact when looking at a building. 'Converging verticals', as the phenomenon is called, though, can be disquieting in a photograph.

There are four ways of overcoming the problem when taking pictures: move back, or use a wider-angle lens; climb up; use special equipment; or tilt the camera and correct later.

Moving further back includes the top of the building without tilting the camera. Selecting a wider-angle lens has the same effect. When you do either, the building becomes smaller in the picture, and the foreground forms a large part. More often than not, this is being used as a car park and is not particularly attractive. That means that your final image can be made from only part of the whole frame – which implies selective printing or duplication; or masking your transparency. If you want to use the whole area, there may be other ways round the problem.

Climb up to take your picture from higher up. Perhaps there is a monument nearby with steps which you can climb. More often it means taking the picture from the upper storey of a building opposite. People are surprisingly kind when you ask permission, but take care when you open the window. Some sliding windows will not stay open on their own, and come crashing down when you let go of them. It is rarely satisfactory to take the picture through a closed window – reflections in the glass will ruin the picture. However, if you can turn all the lights off in the room and if there is

only one window, it can make an interesting picture in its own right. Beware, though, of even trying with a really long-focus lens. Any lens longer than about 135 mm on a 35 mm camera will produce an appalling image through glass.

Special equipment can be expensive. The ideal machine for specialized architectural photography is a 'field camera' taking 5 × 4 in or 5 × 7 in sheet film. These cameras have *movements* which allow the lens and film to be pivoted and tilted independently of each other and give the skilled photographer considerable control of image position, depth of field and so on. But they are expensive, heavy, bulky, need a tripod – and the cost of film is fearsome.

However, the movement most used when photographing buildings is *rising front.* This allows the lens to move up and down in front of the film. The effect is to raise the camera's 'view' without tilting the camera itself. That way you get the top in without convergence. You can buy a moderately wide-angle 'shift' lens for virtually any 35 mm SLR. Such a lens offers a limited rising front facility. Using this accessory, it is possible to hold the camera horizontal and raise the lens until the foreground disappears and the top of the building is in frame.

A shift lens is surprisingly useful if you concentrate on photography in towns. I find it an especial advantage when taking horizontal-format shots, with walls all around. Unfortunately, it is also a very expensive type of lens. The reason is that the lens has to produce good definition over a much greater area than is normally asked of a 35 mm format objective. Most are either 28 mm or 35 mm focal length. The 28 mm is probably more useful, and most of the recent ones allow automatic-diaphragm operation.

One point, however, to bear in mind – shifting the lens can have a strange effect on through-the-lens exposure meters. So, always take a meter reading with the lens in its central position. Even with an automatic-exposure camera, set the controls manually if you can. If you cannot, see the Exposure chapter on ways of influencing mis-metering automatics.

Correction of convergence is possible if you do your own printing. You simply tilt the enlarging easel to compensate for the original camera tilt. When the original is projected onto the baseboard the bottom of the building is larger. Lift that end of the baseboard until

the sides of the building become parallel. You have to stop down the enlarger lens enough to give enough depth of focus to make the whole print sharp. It is a technique more fully described in the *Focalguide to Enlarging*.

You never get something for nothing. So tilting the baseboard has two effects. Firstly, it means that the exposure varies across your printing paper. So you must dodge (shade) the bottom of the building a little if it is not to be overexposed.

Also, the building becomes unavoidably elongated by the process. It does also with a rising front. In practice, this has no effect on normal pictures, but does make it impossible for you to measure proportions exactly from such a photograph.

Do look up!

The alternative to all this is, of course, to go in very close to the building, put a wide-angle lens on your camera, point the camera well up into the air, and make the distortion deliberate. The pictures you can make like this are very exciting – particularly with the bold shapes of modern buildings.

Using the foreground

Everybody knows the funny picture of Aunt Edith with a tree growing out of her head, which demonstrates the importance of looking at the background when taking a picture. When photographing buildings, the foreground is even more important. If it has not been considered it can wreck an otherwise good picture. Used properly it can turn an ordinary picture into an excellent one. If you are using a wide-angle lens, the area in front of your picture becomes very important. The relative size of objects in it is much larger.

Before taking your picture, have a look round. Are there paths leading up to the building? Or flower-beds? Or ornamental paving? Or a pavement artist? Or a stall selling souvenirs or vegetables? Paths are particularly useful because they lead the eye into the pic-

A shift lens, or rising format camera is a boon for townscapes. A. High buildings often extend beyond your picture area (1). If you tilt your camera (2), the sides then appear to converge toward the top. By raising the lens on the camera (3), you raise the picture area without tilting your camera. B. Cross shift is good for making two-shot panoramas of buildings, with horizontal lines remaining straight and parallel.

ture. If there is a patio with a particular pattern in it, then select your viewpoint to show that pattern to the best effect.

Flower-beds can be very useful for example to hide parked cars between you and the building. The more red the flowers or plants in the foreground the greater the feeling of space and depth in your picture. Desperate photographers have been known to go and buy a pot plant which they prop or have held up in front of the camera to hide a particularly bad foreground.

Do not be afraid to bend your knees as you look for the best view-point. A low angle can hide most monstrosities, or a high angle can turn a jumble into a pleasing pattern. If you can get about half a metre (2 ft) above the heads of people walking about you, they can give depth to your picture as well. For both techniques, if your camera allows 'waist-level' viewing, you are at a considerable advantage. In fact, despite the modern emphasis on eye-level cameras, a waist-level type viewfinder is usually better for everything except photojournalistic and action photography.

Using people in the foreground does require patience and practice – you have to look very carefully into the viewfinder until the pattern formed by people is pleasing. In particular the nearer people should all be walking into the picture, not walking out of it, and the distribution of people from foreground to background should be well balanced, for example, not a large crowd on the left hand side of the picture and no one on the right. It is worth developing the knack of using people in your picture – it is a good topic for the 'set themes' mentioned on page 530.

If you have to go in close to a foreground subject, there are available 'half close-up lenses' which will keep the foreground sharp as well as the main subject.

Selecting a lens

When photographing buildings, there is often little or no choice of the lens you will use. The size of the building and the space available means that only one lens will fill the bill. However, if you have a choice – consider the effect of each lens.

A *wide-angle* picture with the verticals correct will emphasize the foreground to relate the building perhaps to an ornamental garden or the activity going on in front of it. It can isolate the house or make the area around it appear more spacious. It is particularly useful when photographing your own house or those of your friends. It flatters the size of the garden considerably.

A *normal lens* shot is probably the most useful for buildings. It does not produce distortions, either in the shape of the building, or in its perspective. The relationship between foreground and background remains normal, and the problem of filling the foreground is minimized.

A *telephoto lens* is chosen for one of three reasons: you have to stand too far away; to 'compress' perspective, making a building or row of buildings seem less deep than it really is; or to pick out details on the building.

Details are particularly important in churches which have interesting statuary or carvings on the face of them. The angle of lighting is very important if these are to be successful. The statues are often hidden, placed in niches, and the depth of shadow will govern the amount of detail which can be seen. Side-lighting about 45° to the face of the building is usually best for this type of picture.

More ways than one

By now you will have realized that photographing a building offers a whole range of possibilities. Each building calls for a different technique – or does it? Why not try out as many as possible on one building. For a start choose a familiar local building, and try to take twenty quite different shots. Show it in its surroundings – balanced with a strong foreground, hidden by its neighbours – show details, shapes, reflections and so on.

How many really good pictures can you take – pictures that raise a reaction from your audience? Can you take *good* pictures that local people do not recognize? This is not a pointless exercise. It allows you to begin seeing buildings from a photographer's view. When you travel, you will know just how to treat each new one.

Buildings in a landscape

This chapter has, so far, dealt with buildings which have other buildings near them. But equally, buildings can be part of a landscape, indeed the landscape may be part of the building. Many buildings have their surrounding countryside designed for them. 'Stately' homes, country clubs, schlosses and chateaux have parks and gardens designed as part of the house, put there especially to be seen from that viewpoint. The views of the house from the park and garden are designed to show the house at its best. Suburbs and the best private gardens are designed on similar lines, and that fact should contribute to the picture you take.

Remember this when you are looking closely into the viewfinder, eliminate all irrelevant detail – but the surrounding countryside may not be irrelevant. For example paths and driveways can make an excellent 'lead-in' when composing your picture. Ornamental gardens of the building, as well as making excellent picture subjects in their own right. Scale and distance will suggest which lens to use. For example, the long straight drives or 'rides' which are a feature of country houses often demand quite a long telephoto lens to 'compress' the distance to the house. Use a normal lens and the house becomes tiny in the distance.

Ornamental gardens often look best from a distant viewpoint, through a normal lens. The gardens have been laid out to give a careful symmetry and balance, which the normal lens captures with the least distortion of proportions.

Suburban gardens usually benefit from the wide-angle treatment. Plenty of foreground plants, if you are lucky a path which winds up to the house rather than being straight, and an overhanging branch can lift the routine to exotic heights. The half close-up lens can be a boon in very small gardens, and serves to increase the feeling of space dramatically.

Looking through

Views through doorways, windows and archways are always splendid for pictures. Frame them carefully so that there is a striking point

A

B

C

D

Buildings are not always best in isolation. A. A single artisan's cottage tells only part of the story. It is the serried ranks that portray industrial society. B. Step back a little from a village church, and you include its surroundings. C. Classically designed squares and terraces benefit from a distant view and wide-angle lens. D. The splendour of a country house can be enhanced by its rural isolation.

of interest in the view – a tree or statue, lake or gateway are typical. Make your exposure reading with care. Normally, expose for the outside view only. If you do not have spot metering, go up to the opening and make your meter reading directly from the outside. It is possible to expose for the shadow detail of the archway or window by making your reading close-up to this area, but the results are usually disappointing the eye is distracted by the white area in the middle where the view has 'burnt out'.

A compromise is possible by taking an exposure reading for the view and overexposing deliberately by $\frac{1}{2}$ stop for transparency material or 1 stop for negative materials. The transparency will more easily cope with the great differences in light levels. If you have your prints made by a photofinisher using fully automatic equipment, then be prepared for disappointments. If you do your own printing then detail can be retained by 'dodging' and 'burning-in' the print.

Another way of showing shadow detail is to use flash to illuminate the dark areas. If you are photographing a view through glass, be careful to position yourself off-centre to the window – looking at the view from an angle – otherwise the flash will reflect from the glass, back into the camera lens.

Using flash will produce complications, because the flash must give the same exposure that you need for the outside view. If you have a 'computer' flash that can be a help.

Make your exposure meter reading for the view. Start from the aperture you need for the view (at a suitable flash-sync speed, of course). If you can set your computer flash to that aperture, well and good – if you want the arch fully exposed. If you want shadowy details, then set the flash for a larger lens aperture (1 or 2 stops).

If you are outside the right range with the film in your camera, you have to use manual flash. Then work out the correct flash-to-subject distance for your aperture from the calculator on your flash. If it is possible to move to that distance without wrecking the view you want, do it. If that is not possible, a single layer of white handkerchief placed over the flash-head will reduce the light by about half, reducing the required distance to a quarter.

Remember, if you are using electronic flash and a camera fitted with a focal-plane shutter, you must use the shutter speed specified for

A

B

C

Many pictures cry out for framing, and ready-made foregrounds are often to hand. A. Foreground pillars can give a great feeling of height and spaciousness. B. Allow the top to arch in, and you have a much more closed in, confined feeling. C. Trees and shrubs are the classic rural framing agents.

flash in the camera instruction book. Set this shutter speed before you take an exposure reading from the view.

In many buildings the flashes, even of electronic flash, can be distracting and offensive to other people visiting the building – for a start it can destroy the concentration of those seriously studying. Particularly in churches the flashes of enthusiastic photographers can upset those worshipping. Flash is a useful tool for the photographer, but it must be used with consideration for others.

The use of flashguns is not allowed, or is restricted in many public buildings. This is not purely because of the distraction but also for safety reasons. If expendable flash-bulbs are used, and then thrown away, not only do they cause litter, but when they are still hot, they are a fire risk.

Buildings after dark

Highspeed films have made the photography of floodlit buildings very easy. Using 400 ASA film in Paris last year, I only found one building which needed a shutter speed of less than 1/60 second with a normal lens of f1.8. The pictures of Sacré Coeur, Paris, were shot on 200 ASA film, and the floodlighting is not very bright. The best exposure reading I could get was 1/15 second at f1.8. However, with a tight neck-strap and a convenient lamp-post to steady the camera, the hand-held exposure produced no problems. All the night-time material is considered later – once it gets dark, the subject becomes less of a determining feature in photography.

Churches and cathedrals

Ecclesiastical buildings are perhaps the most awkward of all to photograph. They tend to be long, narrow and high. Although many were built originally in open countryside, they have tended to act as centres for growth and development so many of the world's great churches are hemmed in virtually on all sides by buildings. If you are lucky, part of the building will face on to a large square and usually it is the most impressive front, as it is with, say, Notre Dame in Paris,

France, or St. Peter's in Rome, Italy. That does allow you at least to stand well back and picture the front. With other examples, such as the enormous and intricately decorated cathedral in Florence, Italy, there is no real opportunity of picturing the building as a whole structure. Wide-angle shots from close below the walls tend to make churches look strange and dumpy rather than spectacularly high and impressive.

Added to the awkward shape and confined space, are the problems of people milling about. In fact, when you are just visiting a place you are probably well advised to buy pictures (slides or postcards) of famous churches and concentrate your attention on picturing details. Look for the individualistic features of the design, like the intricate tracery of flying buttresses on the upper parts of Seville cathedral, Spain, which you can see from the top of the Geralda Tower; or the array of strange and curious gargoyles that you can find on virtually any Gothic church. This is often where your longest telephoto lens comes in.

Whether you are picking out the whole of a deeply sculptured west face or picturing a single cupid, the quality and direction of the light is particularly important. Harsh cross-lighting with its strong relief is not often suitable. A softer more diffuse day showing up shadow detail is usually better. Temples in the Far East have much in common with the older European churches. They are very intricately built with a wealth of external detail. The most striking difference, though, is in their colour. While the West's great churches are ideal subjects for a black-and-white photographer, their Eastern equivalents cry out for the most brilliant colour film.

In really hot countries most of the buildings, including religious ones, have comparatively plain outer walls, whether the white lime-washed ones of a Mexican mission or the sandy pink of an Iranian mosque. These buildings can look very impressive if you can stand well back and picture them complete. If you cannot, then you must concentrate on detail and gorgeous detail is certainly the characteristic of most mosques with their tiled doorways and tiled or gilded domes.

Some of the most decorative features of Western churches are their stained glass windows and they are something which does not show at all in a normal photograph. To see the glory of the glass the

church must be lit from inside. Of course, no church has lights whose brilliance can compare to the sun. The answer is to wait for dusk. As the light fades, set up your camera on a tripod and focus it carefully on the church wall. Take a meter reading from the window and wait; keep taking meter readings of the dimly lit exterior. When the light level drops so that the two readings match then take your pictures. You may find it worth waiting even longer until the walls are underexposed by about 1 stop. That will give you a picture in which the windows glow.

Indoors

Go inside the church and your problems are magnified. Not only do you have the enormous height, but of course you cannot step back; so if you want a picture of the columns vertically, you need an extremely wide-angle lens. With a normal lens, you can pick out details, statues, tombs, and so on, and you can picture the ceiling. That is quite simple — set your camera for the floor-to-ceiling distance; set the exposure and the self-timer. Now lay your camera on the floor, lens pointing towards the ceiling. Release the self-timer mechanism and stand well back. In due time the camera will take the picture.

Unfortunately, space is not the only problem. There is often very little light and what there is tends to be highly patchy. To use a reasonably small aperture which you need to get the depth of field, your exposures are likely to run into several seconds or even minutes. If you are allowed to, use a tripod. If not, the inside of most churches provides plenty of things to rest the camera on, so that longish exposures are no problem. Brightly lit windows, though, very often are. An exposure to give you detail inside totally burns out the sky visible through the window, usually producing a rather soft flary edge. The only practical solution is to compose your pictures so that they exclude bright windows. Picturing the windows themselves is a problem only of access not of exposure. Perhaps surprisingly a meter reading taken directly from a stained glass window usually results in about the right exposure. If for some reason, perhaps you cannot get close enough, you cannot take a meter reading,

then try setting the normal exposure level that you would use outdoors. Try that and try opening up by 1 stop from that, depending on the colour of the glass and its cleanliness. One or the other will probably give you satisfactory pictures.

Apart from the windows, the interiors of many of the older churches of northern Europe and North America, like their exteriors are especially suited to black-and-white work. Again, more southerly churches, temples and mosques tend to use more colour inside and so need colour photography.

In religious buildings more than in any other please be careful not to upset the other people there. Always ask permission to take photographs if you can and do keep as quiet as possible. The noise of shutters can be pretty deafening and the use of motor drives or power winders is inexcusable.

Houses and smaller buildings

Much of the world's domestic architecture is very uninspired – row upon row of little boxes.

It is sometimes very difficult to make it look interesting in an attractive photograph. If you can, stand well back, use a telephoto lens and shoot through the space between other buildings. On the other hand the cramped conditions and the row of cars parked at the kerbside often confine you to the use of a wide-angle lens.

The best approach is to try and show one distinctive feature of the building or its surrounding. It may be the plastic gnomes in the garden or the marvellous decorations of the front; or it may be a more attractive and normal feature. To emphasize the gnomes you can take a shot from low down by the one sitting on a toadstool fishing in the pool using a wide-angle lens, so the little chap appears to command the whole garden with the house as a diminutive backdrop. On the other hand, to picture the colour scheme, you need a highly selective shot, probably taken with a telephoto lens to exclude the distracting colours of the neighbouring garden.

Another approach is to try and think of something to say about the building – may be that it is a cosy warm home or an extremely busy gas station. To make the place look warm and cosy, take a shot at

dusk with the warm lights shining in the windows. To make the gas station look busy, not only should it be full of customers, but you need some entering and some leaving. How about a $\frac{1}{4}$ second exposure so that the moving ones are blurred. It all adds up to the message of the book – the secret of good photography is knowing what sort of picture you want to take and then taking it.

People and buildings

Most buildings were designed for people, so most building pictures look better with people in them. In fact, it is almost impossible to exclude them, but do not have them too close to the camera, otherwise you have a picture of people with a building in the background. When people are some distance away, it does not really matter whether they are facing the camera or not, nor is it too important if some of them are walking out of the scene. Once you have chosen your viewpoint, watch the scene through the viewfinder until the groups of people make a nice arrangement – then take the picture. Of course, when you include your friends or family or a model you have employed in the scene, then you probably want to picture them rather larger. If you use them carefully as a frame you can still retain the building as your main subject. Once the people become the most important part of the picture, then you are no longer picturing the place.

Of course, there are times when you really do not want any people in the picture. Sometimes you can avoid them by choosing a higher viewpoint and shooting over their heads. Sometimes you can choose your time with care – there are seldom many people in a shopping precinct at 4 am on a Sunday morning, and provided you are well away from the equator, there is plenty of light at that time on a summer morning. You can also eliminate people by giving an extremely long exposure, preferably half an hour or more, to eliminate the few who stop for a minute or so. Set up your camera firmly mounted on a tripod and reduce the light coming through the lens to a minimum. Indoors you may be able to do that just by stopping down. Outside, though, you will need a dense neutral-density filter.

Townscapes

Most people live in groups. Photographing collections of dwellings, whether they form a hamlet or a city, involves more than just photographing a lot of individual houses. To make things simpler we will consider the whole problem under the heading 'Townscapes' because the principles are the same however large or small the community.

The basic idea is to take pictures to show the town as it is, to record the ancient and the modern, the domestic and the industrial, the administrative and the recreational, the static and the mobile, and to show how they all blend together to form a single unit. When starting from scratch, a serial approach gives you the best chance of arriving at the right pictures. Imagine that your photographs are going to illustrate a storyboard or form a slide-tape show, even if you never take a slide in your life. That helps you to develop a logical train of thought through the series of pictures. It gives an immediate clue to the sort of answers you want to the question – why am I taking this picture?

It is helpful if you start off with a caption picture if you can, a road-sign, townsign, the name over a public building such as the railway station, or the destination board of a bus maybe. Then try to get an overall view of the town. For that you need a high viewpoint, such as the top of a church tower or a hotel balcony. In mountainous regions, you can often drive up above a town and, with a telephoto lens, picture it nestling in the foothills below. Curiously this technique tends to be more flattering with modern towns. They almost always look better from above, while older towns are often more attractive from street level.

Buildings

Buildings contribute to a townscape by their individual features and by their relationships to each other and to the streets and squares of

the town. From place to place in the world the buildings are different and so are their relationships. The skyscrapers of central New York are totally different from the large villas of suburban New Delhi, but pictures of the two types of building alone would do less than justice to the difference between the two areas. To show busy commercial New York needs pictures of the bustling canyons between the skyscrapers, and the placidity of the tranquil parts of New Delhi is indicated just as much by the wide tree-lined streets.

People, though, are the most important part of any town. Empty streets almost lose their meaning and the buildings become mere shells. So, for example, when you are photographing a hotel, do not just take a distant shot of the building with the correct verticals and possibly a few attractive trees around it. Try also a low wide-angle shot of a taxi in the foreground with someone getting out of it and the building tapering away into the distance. Include a few shots of luggage and porters and guests. Again, when you get inside a pin-sharp picture of large areas of beautiful carpet with geometrically placed chairs and tables may be exactly what the architect would like to see, but the same space filled with bustling holidaymakers gives a far more natural picture of the hotel.

All the problems we talked about in the last chapter return with a vengeance when you start taking pictures of townscapes. While you can often wait for an individual building to be lit in the optimum way, that is far less easy with a townscape. As the sun moves round to illuminate one building, it throws the one opposite into the shade; so when the sun is shining you often have a considerable problem with contrast. Luckily, though, in hot countries the problem is often reduced by the buildings themselves. I remember taking a transparency of a busy shopping street in Southern Portugal. It looked quite impossible – one side was lit by strong slanting sunlight; the other was in deep shadow. With no opportunity to return I decided to try anyway. I based my exposure on the sunlit buildings because to have overexposed them would have resulted in a total valueless piece of film. The result to my surprise was a quite acceptable – though not particularly exciting – transparency with plenty of detail in the not amazingly dark shadows. In fact, the predominantly white-fronted sunlit buildings had illuminated the shaded side quite well.

Picture shape is important. A. A horizontal picture (often called 'landscape')
gives an open feeling. B. A vertical shot, complementing the feeling of an
urban canyon can enhance the height and domination of the buildings.

591

Famous landmarks

Virtually every large town or city has its landmark — a famous building, or several famous buildings, which indicate the town as well as any nameplate could do. Of course, you need to include these in your townscapes. In fact they often make a good starting point. Before you set foot anywhere near the place you can look at other people's pictures of them. Work out what to you are the most important characteristics and try to decide how you can relate the landmark to the town. With waterside landmarks, such as the Opera House in Sydney, Australia, or the National Theatre in London, England, you may well get your best view from a boat. If you are very lucky the weather may be calm enough for you to have a reflection as well in your shot. A waterside view allows you to show the monument with the rest of the town clustered behind it. Once again, the stacked-up perspective from a telephoto lens is ideal.

When your famous building is surrounded by land and by the other buildings of the town, once again your best choice is usually a distant view in which the silhouette is instantly recognizable. Often, if you can get high enough up a wide angle view is ideal. It can show the town spreading out in all directions from its famous heart.

Some of the world's best known landmarks are bridges. They call for extra thought. Do you want to show them leading into town or leading out? Should they be impressive monuments or busy highways? What about their massive towers? Should they rise to indefinite height out of the top of your picture or should their whole majesty be included? The questions are mine, the decisions are yours.

Streets and squares

We have talked of the relationship between buildings and their streets, but do not overlook the fact that the thoroughfares themselves are an important part of the townscape. Sometimes their construction is particularly individual. For example, there are the yellow brick streets of Sophia, Bulgaria, or the cobbles found in the older parts of many European towns. On the other hand there is

Strong lines in your subject provide a great feeling of depth.

the rough beaten red earth that forms the main street of many a small African township. Then there is the underlying geography. What is more immediately memorable of San Francisco than its amazingly steep streets, with of course their world famous cable cars. Although it is the canals that make Venice, Italy, so famous, most tourists carry back with them an even stronger memory of the narrow paved courts and alleys with their humped bridges over the tiny canals. Of course, when in Venice you should picture its watery highways with the gondolas, waterbuses, watertaxis and boats of every description. But do take a few shots of the worn paving as well.

Roadsurfaces tend to have a much greater prominence in wide-angle shots; that is because such lenses include a lot of foreground and because they have immense depth of field so the foreground is likely to be sharp. In fact it is tempting and often worthwhile to take a number of townscapes with a wide-angle lens from very close to the ground. That way, you picture an impressive stretch of cobbles or flags leading up to the buildings. The technique is particularly impressive from the bottom of a flight of steps.

Activity on the streets

Almost everywhere in the world as well as being arteries of communication, streets are centres of commerce. In the comparatively well regulated West, most of such commerce takes place in preappointed places. Streets or squares are set aside for market stalls, and they provide endless possibilities for the creative photographer. No one, though, is going to stop and pose for you. In fact in some places photographers are beginning to be regarded as a nuisance, so you must be ready to take pictures very quickly. Take a meter reading underneath the awnings of the stalls and set your camera controls to give you a reasonable aperture and adjust the lens to give you a reasonable zone of sharp focus. For example, with a standard lens set on 3 m (10 ft) and an aperture of f8, your pictures will be sharp from about 2 m (7 ft) to about 6 m (20 ft).

More often, though, you are likely to use a wide-angle lens which should give you an even deeper zone of sharp focus. With a 24 or

28 mm lens on a 35 mm camera, you can compose your pictures so that you show both the stallkeeper and his wares, and with luck a customer in the process of transacting a deal. In the West we are accustomed to going to large modern shops for much of the shopping, but the market is a much more important centre for trade in countries of the Middle and Far East. The bazaar in Istanbul is typical of the sort of trading centre you can expect. It consists of mile after mile of covered arcade bordered by lock-up shop units. Trade is divided between the streets and the shops themselves. From the photographer's point of view, this arrangement suffers from considerable crowding and lack of light. The most you can normally hope to do is to record impressions on a high speed film through a wide-angle lens.

Industry

In some countries little open-fronted shops face directly onto normal open air streets. Many of them just supply the normal necessities of life, and are not especially interesting to the photographer. However, if you look in the right places you can find rows of shops full of craftsmen: silversmiths, woodcarvers, embroiderers, carpetmakers or whatever. The open fronts of these shops mean that however dingy their interior enough light normally falls on the workers for you to take very good photographs, if they do not mind you doing so. The craftsmen usually work at low tables or on the ground, so you can stand over them to take your pictures. For this sort of picture the standard lens is usually the best.

While few travellers go out of their way to visit the local steel mills, it is quite common to go on tours of more craft-orientated light industries, especially in developing countries. Examples that spring immediately to mind are potteries, vineyards, carpet works, and diamond cutters. Most of these activities take place, at least partly, in well lit small workshops. Load your camera with high speed film; mount the standard lens and you are well equipped in most cases. You should be able to use exposures of around 1/30 second at f4; that provides you with adequate depth of field and with a little judicious leaning a reasonable chance of getting sharp hand-held

pictures. Do not worry too much about movement in the pictures. Most workers remain remarkably still, confining their actions to the job in hand. For example, you should be able to take an adequately sharp picture of a potter, but the pot spinning on the wheel will be blurred. In fact, that blur really improves the picture concentrating your attention immediately on what is happening.

Usually it does need concentration – small workshops are not set up to please the photographer and you will find it extremely difficult to achieve a satisfactory background.

At least indoors your necessarily wide aperture means that most of the background will be somewhat out of focus. Out of door activities often pose the same background problem, but without the saving grace of it being out of focus. However, that does not mean that you should avoid them. No pictorial collection of a marine town is complete without the dockside activity. Such activity can vary from fishermen mending nets to shipwrights cutting up steel plates. Many such shots call for the use of a telephoto lens which allows you to stand well back and out of people's way and out of danger.

Traffic and transport

Mobility is essential to the modern city and while the motor car has become virtually universal, some of its results are an essential part of any townscape. The great highways snaking through the houses, rising on stilts above the smaller ones and swooping through tunnels divide our cities into segments. Their intersections provide dramatic sculptures and even the lines of brightly coloured cars glinting in the evening sun as they shuffle homewards, nose to tail, can form an exciting picture. The classic way to portray them is from above, standing on a bridge and through a long telephoto lens. That way the individual vehicles become crowded resembling a single multi-coloured snake.

The environmentally-concerned point to the great social benefits of using public transport and certainly public transport is of much greater advantage to the photographer, whether on the surface, overhead or even underground. Trains are large and impressive. They and their lines are a striking feature of most modern towns. And the number of people they carry can be equally impressive. We

have all seen pictures of station staff cramming people into trains on the Tokyo subway, or of the mass of people clinging to the outside of Bombay's commuter trains, but you do not have to go that far afield to take impressive pictures of the mass of commuters cramming into trains or pouring out of the station. In fact you do not even need the trains, just choose somewhere where the pedestrians are funnelled into a narrow passage – London Bridge is a particularly good example. Every morning thousands flock across the bridge as the commuter trains from the south-east empty their loads south of the river.

When you go to more exotic parts of the world, the means of transport can be ancient, quaint or exotic. Ireland still has a few of its jaunting cars, tricycle taxis and even rickshaws are widespread in parts of the Far East, San Francisco has its cable cars and Bulgaria still some bullock-carts. Unfortunately, these and most other exotic means of transport tend these days to be intermingled with modern traffic, pedestrians and a jumble of roadsigns. To get even satisfactory pictures, you have to go in close, fill the frame with main subject. Sometimes the juxtaposition of ancient and modern can make a nice picture. For example, the intermingled camels and Cadillacs of the oil-rich states of the Middle East.

It is not just pictures of transport which are spoiled by cars. Many old and interesting cities are wrecked by the tin-litter of the rows and rows of parked cars. In the commercial centres they belong to commuters to salesmen and to shoppers or theatre goers, so you may be able to find a quiet day. In Christian countries Sunday mornings are often very quiet, except of course in tourist and entertainment areas. One solution is to go early in the morning – very early – or out of season if that is possible. If you cannot avoid the cars, the least you can do is to minimize their impact on your pictures. Firstly, try and shoot from comparatively high up. Stand on the roof of your car if you are using one. Secondly, choose times when the cars in the particular area that you are photographing are comparatively dull coloured. It is possible to ignore a row of dark-coloured cars where red and yellow ones would be totally unacceptable. Sometimes you can take this a stage further by choosing a time when shadows fall across the cars but not across your main townscape.

Details can add to your picture story. Often, much local colour comes from the small things in life. A. Doors are an interesting source of pictures, common throughout the world, yet subtly differing. B. The patterns created by builders can be revealing, or just attractive. C. Small detail is worth looking at. D. Reflections and abstractions are another source of pictures. E. Markets and prices tell you a lot later.

If the traffic is constantly moving, you can remove it from your pictures with a long time exposure, in the same way as you can remove people.

People in townscapes

We have talked about people going about their business, and really that is the best way to photograph them. In a market – buying, selling, looking, practising their craft and so on. If you want to include friends, family or a model in your picture, then try to make them look as if they are part of it – not just standing there waiting for you to press the button. Focusing them where you want them to stand, and then get them to walk into shot. If you want them to be doing something, use the same technique and when they reach the appointed place wait for them to start examining the old cameras on the stall or looking at a menu or whatever it is. That way, the whole picture will seem much more natural, at least partly because your subject does not know the exact instant that the picture is going to be taken.

Most people are happy to be photographed; in crowded streets just take your pictures, but if you want to portray a particular person, do ask them first; be especially careful if there is any chance that you will want to publish the picture. Throughout the Western world the law is quite clear that if you use someone's image for commercial gain, they can expect you to compensate them adequately. This is not normally a problem if the people are simply part of a crowd especially in Western Europe. However, close shots of individuals may get you into trouble, especially in the USA. If you go to countries where the people have radically different beliefs, you may find that some or all of the people do not like being photographed. If you suspect that this might be the case, ask somebody who knows first: your travel representative, a colleague who lives in that country or at the hotel to make sure you are not going to get into trouble. In less well developed countries children, and sometimes adults, demand money if you take their picture. It is worth finding out what the going rate is before they ask.

Keeping out of trouble

During World War II my father was photographing a quiet rural scene in Southern England when he was approached by a policeman on a bicycle who said 'You can't photograph there, Sir, it's secret' to which my father answered 'What's secret' to receive the reply 'Can't tell you that, Sir, can I, because it's secret? But if you take a picture of that perfectly innocent-seeming agricultural scene, I'll have to confiscate your camera'. My father never found out what it was that he was supposed not to have been photographing, but it does illustrate the dangers you may fall into. Of course, you should never photograph military installations anywhere in the world, but in politically sensitive countries the list of forbidden subjects is considerably greater. It is unwise to picture soldiers or even police in many parts of the world and even the smallest civil aerodrome is often regarded as being of military importance. The 'Authorities' are often far less polite than a British policeman. The unfortunate conclusion is that if you are unsure of the regime you should confine your townscapes to unashamedly tourist shots, or at least before you get arrested to find out at your hotel or the tourist office just what the local restrictions are.

The sum of the parts

So, to capture a town photographically you need to photograph the buildings, modern as well as historic, its institutions and its transport system, its people going about their daily lives, even the messages sprayed on the walls tell you something about the people who put them there. If you start with a plan you should end up with a logical series of pictures. Perhaps not enough to make comprehensive slide-tape presentation the first time, but certainly something considerably more than a series of totally disconnected snapshots, and together they should be considerably more than the sum of the parts.

Certain views have become very familiar as photography has continued to proliferate. Look for alternative ways to approach the more common subjects – using a coloured filter is one idea.

Paris in the spring – three images of a great city. The photographer kept his camera with him as night began to fall, and took the trouble to set it up on a tripod for the shots on the opposite page. It may seem a bit of a chore at the time, but you will not regret it later.

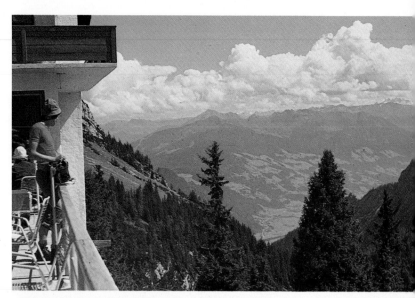

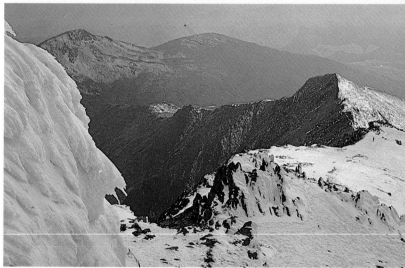

Top including foreground objects or people in spacious vistas helps to create an impression of depth and scale.

Above good composition – the viewer's attention is drawn right into the picture and held there.

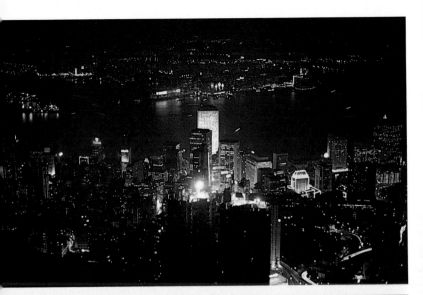

Top Hong Kong at night – a mass of coloured points of light. You can take pictures like this with a hand-held camera; you need not necessarily give as much exposure as a meter indicates.

Above night-time landscapes can be particularly successful if there is some daylight left in the sky.

Colour pictures do not always need to be saturated with brilliant hues.
Page 607 strong lines in your subject can create a feeling of depth.

Many photographers might have been tempted to go in close to photograph the chickens – but without the entire door the picture composition would have been rather ordinary.

This is a double exposure, although it may not look like one. Photographing a white object (such as pampas grass) against a dark background will burn out subject highlights on the film, so that the second exposure can make little or no impression except where the dark background has left the emulsion unaffected.

Top this landscape contains a very narrow range of colours, but the effect is striking – the picture resembles an oil painting.

Above the Grand Canyon, seen from the air.

Top an unusual colour composition. The brownish tinge is from light reflected by dead bracken on a hillside beyond the top edge of the frame.

Above many landscape photographers prefer to work shortly after dawn or before dusk, when the sun is low enough to cast dramatic shadows.

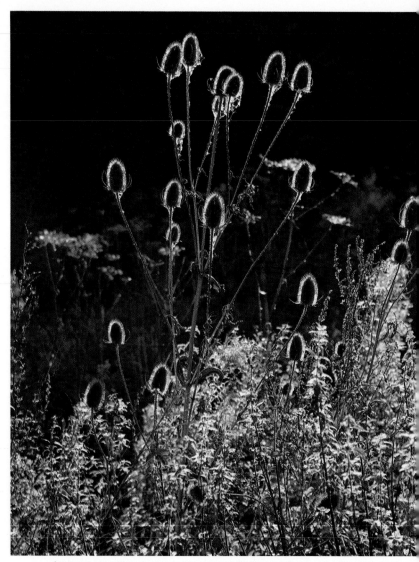

A person surveying the original scene would discern plenty of detail in this dark background. In order to make the teazels stand out as they do in this picture, the photographer has to lose that detail by making sure the background is underexposed.

Top Ektachrome 400 underexposed by one stop and given extended development to compensate: one result of this procedure is exaggerated contrast.

Above during an exposure of about 10 seconds the water has swirled around the rock and left a curiously amorphous image on the film.

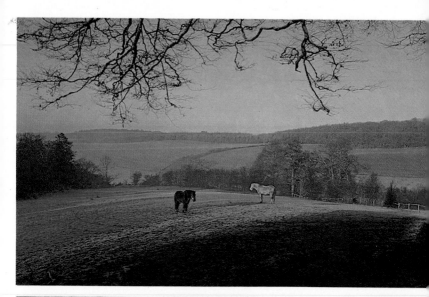

Top the sun will melt the frost in no time: landscape photographers who rise early can often find conditions that others will miss.

Above you cannot afford to hurry with photographs of wild plants, because if they merge into the background they may look utterly insignificant. Take time to plan the shot and set it up.

Photographing an interior by available light. A fairly long exposure may be required
(the musicians have all moved) and the camera must be firmly supported, if not by a
tripod then on a shelf, ledge or pew etc.

Detail of a temple in Bankok, showing the flamboyant ornamentation.

Coasts and Beaches, Mountains and Snow

Most of us go to the most interesting places only on vacation. At least, few of us regard the place where we live or the place where we work as being as interesting as the place we go on holiday. There are basically four separate types of popular holiday place: the seashore with its beaches and promise of swimming and boating; the countryside, with its vegetation and wildlife, often of course with some water close at hand; the mountains with their promise of climbing, walking or of winter sport; and towns and villages where the people and their activities are probably the most important part. There is a fifth kind of holiday which actually takes place on or around the means of transport: seaborne – it is a cruise; landborne – it is a tour. We have looked at the photography of towns, villages and their inhabitants and the countryside, so here we look at the other two major areas; different in many respects, but tied together with their much greater dependence on the weather and by their high proportion of tourism.

Coasts and beaches

The classic holiday beach consists of lots of golden sand, thronging but not too crowded, with happy holidaymakers, the hot sun beating down and the blue sea lapping gently on the shore. It may be idyllic for the sun worshipper, but photographically it can be a disaster. Cameras left in the open sun get extremely hot (if they are not stolen first) which does the film no good; the slightest wind and there is sand blown around. Once that gets inside you are in danger of damaging the delicate mechanism. With the salt-laden air and maybe some spray, you are introducing the possibilities of accelerated corrosion to your valuable equipment.

The next problem is that there is usually rather a lot of light around – often enough to fool a normal reflected light meter and if the sand is at all dark, glaring overhead sun is less than flattering to most people. Light sand reflects up a lot of light, filling the shadows and thus portraits can be quite satisfactory.

As well as being photographically unpleasant, bright sun makes your subjects screw up their eyes unless they are wearing sunglasses – so once again, on the beach, you do not want to be taking pictures with the sun over your shoulder. Turn your subjects round with their backs to the sun – then they can look more natural. There is quite enough light reflected up from the sand and down from the blue sky for you to take a picture even with the simplest camera. If you are using a sophisticated camera, follow an incident light reading or a substitute reading. With a simple camera, set the exposure for cloudy bright.

Simple snapshots

So what are the answers? The first is that if you are going on the beach to sunbathe, swim and play with a beach ball, leave your sophisticated camera behind. It is much safer in the hotel safe. Take a simple 126 or 110 camera with you, and load it with colour negative film. It should take excellent pictures in those conditions and you really do not need to worry about losing it. The important thing to remember, though, is that all the usual aspects of photography – composing the right picture, getting the lighting right, concentrating on your subject and so on – are just as important with a simple camera as they are with any other.

Full-scale photography

When your main aim is to take pictures, of course, then you want all your equipment and you do have to take special steps to protect it. Most of them are commonsense; keep all your accessories in individual polythene bags tightly tied with a rubber band. That way

they stay clean and dry even if you drop the bag in the sand, or possibly even the sea.

Take special care of your camera. One way is to cover it with cling film. Set the lens aperture and shutter speed to suit the conditions and use a suitable focus setting for zone focus. With all that light around, you can be quite sure of extensive depth of field. Now you can cover it up with the cling film, leaving the lens poking out through a hole. The film is quite flexible enough to allow you to press the shutter release through it. So (unless you have a power winder, in which case you can cover the camera completely) you need only expose the wind lever to the elements. Of course, in calm weather you do not even have to worry about covering your camera at all – just take special care when you change a lens or load a film. At either of those times, the camera is open and even a slight gust of wind could blow sand into it.

Exposures

Now you have your camera protected, what about taking pictures? We have already mentioned that exposure meters are not necessarily reliable on the beach – the best way to get the right exposure is to take an incident light reading. If you depend on a through-the-lens meter, though, a substitute reading is an excellent alternative. These are all discussed in the Exposure chapter.

Be especially careful if your camera is automatic. Check the exposure that it sets against the substitute reading or even against the information sheet packed with the film. If in doubt use manual exposure or use the exposure compensation dial to give you the setting you want.

The one thing you do not notice, but the film does, is that the amount of UV is much greater by large stretches of water. This can produce a quite unpleasant veil in your pictures, blue on colour film, so you need to use a UV filter the whole time. As always when you use a filter you need a lens hood – sources of flare abound on the beach. Not only is the sun blazing down from above, it is reflected from every wave and often from glasses, bottles and other items used by the holidaymaker.

Beyond the beach ball

We are here really concerned with photography of places rather than of people, or even holidaymakers. So what special opportunities are there.

The first thing to do is to climb up on the cliffs, if there are any, and look down on the sea. You can often get some almost map-like pictures with the winding coastline stretching into the distance and with perhaps a fishing village or two nestling at the bottom of the cliffs. On a still bright day, the blue-green of the sea makes a magnificient contrast to the beach, even in temperate latitudes.

Tropical waters really are a deeper colour. Near the shore the effect can be one of an almost opaque turquoise and further out to sea a strong almost royal blue. The Red Sea is particularly noted for this strong blue.

Back down again at sea level the water, whatever its colour, tends to be rather insignificant on calm days. In fact your pictures are quite often better if it is rather hazy. Pictures of sailing boats – either moored or under way – look especially good against a hazy background. If there are few boats further out to sea to emphasize the hazinesss, so much the better.

When the weather turns nasty, then the sea becomes much more exciting, with swirling waves and pounding surf it takes on the role of number one subject. The rush and roar and flying of a storm-tossed sea are an impressive sight. Unfortunately, back home in the dry without the sound effects pictures are often disappointing. The spray that appeared to reach the top of the lamp posts appears hardly to wet the promenade rail.

So what are the answers? The first is to thoroughly waterproof your camera. Use it inside a polythene bag fitting tightly round the lens. Make sure the UV filter is tightly screwed on and then go in close. A telephoto shot never approaches the drama of a wide-angle shot which appears to have been taken almost inside the waves. If you are lucky enough to have any sun, shoot directly against it. That will add considerable sparkle to the spray. The choice of shutter speed is very much a personal one. Fine spray is one of the few moving subjects which can be thrilling frozen in mid-air; on the other hand, the swirl imparted by a longer shutter speed can also be an attraction.

While the spray is usually the main subject, do not forget to include some land or part of the boat if you are waterborne – it helps to give some scale. In tropical waters where you have fine coral rock is an ideal ground as it closely resembles, in form but not in colour, spray frozen by a short shutter speed. Wherever you are, do watch the sea carefully for a while before you start taking pictures. That way you can choose a vantage point close to the likely spray points, but not right inside them.

People again!

The coast may well be impressive spread out below you like a map or pounded by high seas. In either case, though, pictures may well give the viewer no clue as to their scale. The best and simplest indicator of size is a person or a group of people. If you are photographing deserted beaches try to arrange for someone to walk across sand – near enough to be more-or-less recognizible – not, though, so close as not to give scale to the main picture. With spray pictures, the choice of position is easy from a photographic point of view – right in it! However, finding people who will happily stand and be soaked with the sea is not so easy. When it is really rough to even attempt to do such a thing could be stupidly dangerous.

Harbours

Near the coast most of the trades are related to the sea; just as with townscapes your coastal pictures need to involve the people who work there. So, a visit to the harbour is a must, not only will that give you pictures of individual activities as we talked about in the last chapter, it will also provide a centre piece to your series of pictures on the whole place.

If it is a fishing harbour you would do well to work out the times the fleet are likely to come in or go out. That depends very much on local conditions. With a deep-water harbour the timing may well depend on the fish market in a nearby big city. Therefore, the fleet may start coming home at 2 or 3 am in the morning so that their catch

can be off-loaded and ready for sale in the market by 6 or 7 am. Alternatively, it may be the custom to sell the fish on the quayside, either in the morning or in the evening. Once you have found that out you have one point of reference. In general the time the boats go out is determined by the time they have to come in. It is very often 10 or 12 hours before.

In difficult waters, the boats may depend more heavily on the tides. They may, for example, be unable to get over a sand bar at low water. In that case the times will vary with the tides, as they will if the fishermen want to make full use of the tide. Perhaps they leave the harbour round about high tide so as to go down to the sea as the tide falls, carrying them with it; and then return as the tide rises again.

All at sea

Just as you can take pictures of the sea from the land, so you can take pictures of the land from the sea. The convenience of photography from boats depends on the weather and on the boat. Working from a cruise liner presents no more problems than working on land. On the other hand, working from a 5 m (16 ft) boat in a force 8 gale is virtually impossible.

Between these extremes the difficulties and risks to your equipment increase. Just as with storms and spray on land, if there is a lot of water around keep your camera dry. In fact working from small boats is an excellent reason for having an underwater camera. The metal-bodied Nikonos is a simple-to-use interchangeable-lens camera with a direct optical viewfinder. Assembled properly it remains watertight for all normal skindiving and is particularly suited to rough water marine photography.

In rough conditions, whether or not your camera is waterproof, the danger times come if you want to change a lens or change the film. While you are doing that the camera is open literally to the elements. So it is well worth loading up with a fresh cassette of film before you go; and selecting one lens which is best suited to all your shots. Most often that is a slightly longer than normal focal length; perhaps 85 or 105 mm for a 35 mm camera.

A

B

C

Pictures of places often benefit from man's activity—harbours are particularly photogenic. A. Sea and masts cry out for back lighting. B. People working add much to a series of marine pictures. C. If you walk out along a harbour wall, you can take pictures as if surrounded by the sea.

Such a lens emphasizes the size of the waves on the sea and also enables you to picture the shore with reasonable detail. In moderately calm conditions you might also consider using a zoom lens to give you greater choice. Do not be tempted, though, to use one when it is really rough. You cannot fully waterproof its control collar while retaining the zoom action, and some designs suck in air (and water) when you move the controls.

While a stormy sea can make excellent pictures, most seascapes depend to a large extent on the land you include in them. That can vary from a detailed close-up of the shore, with all its building and activities to an intricate pattern of receding misty shapes formed by rocks and islands. Once you get away from the shore your eyes become attuned to the vast expanse of the sea. Any disturbance of the gently curving horizon stands out in stark contrast. When you look at a photograph, though, what clearly was another ocean liner or palm topped coral atol has become just a minute pimple in the endless boring blue. Once again, you have to examine the viewfinder image with the greatest of care. Ask yourself whether the fact that the blob is the Queen Elizabeth II, Bikini Atol or Tristan da Cunha is actually going to give your picture any significance.

With a real monster lens, of course, you can magnify virtually anything you can see to become a reasonable picture. Unfortunately because you enlarge the effect of any movement with the enlargement of the image, the lenses you can use at sea are somewhat restricted even on the brightest days. Small boats, of course, bob up and down the whole time, while larger ones often vibrate gently to the throb of their engines. With a normal lens, you are well advised to choose a 1/125 or better still a 1/250, second which means you need a 1/250 or a 1/500 second with an 85 or 105 mm lens on a 35 mm camera; and even at 1/1000 second, you cannot be sure of getting pin-sharp pictures with a lens of focal length longer than about 300 mm.

You can often take pictures as if from the sea without setting foot in a boat. Many coastlines are broken up into spurs and inlets; harbour walls curl round so as to virtually enclose a piece of water; and piers are common at least at the more popular resorts and the sea abounds with spurs of sand and groups of rocks. So in many places you can walk out to sea, turn round on your firm dry footing and pic-

ture the land. Naturally, if you do that in the middle of a storm you may need some explanation for the spray flying round you.

Shooting against the light

Whenever you picture water or just wet objects, it is well worth while trying to capture the sparkle of the sun's reflections. The classic way to do this is to shoot directly towards a comparatively low sun; with the angle just right every piece of water shimmers and sparkles in front of you. You can include the sun itself in your pictures; but it is usually better if it is just outside the picture area or concealed behind a suitable part of the scene, such as the mast of a ship or the trees on a headland.

The effectiveness of such shots depends to a large extent on their exposure. Surprisingly enough it is well worth starting with a direct reading from the scene. Some of my most effective sun-across-the-water shots were taken on a fully automatic camera with no special compensation. The meter, of course, reacts strongly to the bright points of light and to the sun if you have included that in the picture and gives you a very short exposure, so all the normally lit parts of the scene come out dark, which is the way they look anyway because your eyes give the equivalent of an automatic exposure.

Another starting point is to take an incident light reading and then reduce the exposure by two whole stops. Either way, if the scene is really exciting, then take a whole series of shots changing the exposure at half-stop intervals either side of your starting point.

Bright spots of light in the picture are a real test for your equipment. Lenses with the latest anti-reflection coatings and carefully applied anti-flare interiors, seldom produce strong flare spots. However, the slightest trace of dust or dirt on the lens results in the strong overall veiling with flare. This is certainly one situation where you should not have a filter on your lens just as a matter of routine. Filters are flat – they have to be – and however well they are coated, their flat surfaces are liable to produce flare spots. What is more if you keep a UV filter on your lens to protect it, then by definition that filter is liable to accumulate dirt or to collect tiny scratches because you

have to keep cleaning it. Taking the filter off can produce quite a dramatic improvement when you are shooting against the light.

Snow and ice

Photography in winter conditions has much in common with photography by the sea. Conditions tend to be very bright and you can add sparkle by shooting directly into the sun. Once again, you cannot rely on a normal reflected light meter reading; your exposure meter, hand-held or built into the camera, does not know that most of the scene in front of it is pure white snow.

The answer again is to use an incident light reading or to take a substitute reading, from the palm of your hand for example. That really can be effective. I photographed some ski racers in appalling conditions; of course the hillside was covered with snow, but it was also hidden in dense cloud. The skiers appeared out of the white perhaps 30 m (100 ft) away and shot or rolled past. I used the through-the-lens meter to take a reading from my hand and set the camera controls to that. When the film came back from processing I was surprised to discover that the competitors were rather more visible in the transparencies than they had been in real life.

Luckily, most snow pictures are taken in rather more predictable conditions and so you can normally modify a reflected light reading by a standard amount. When the scene consists of little other than snow, two stops extra exposure should be about right. When the snow is a background for people, trees and so forth, then one stop more is about enough. With a fully automatic camera, just set the exposure compensation dial to +2 or +1. If you are not sure which, use the meter to find out. Take a reading from a suitable substitute, such as the palm of your hand, or better still a neutral grey card, and note the exposure. Now point your camera toward the general scene and move the exposure compensation dial until the camera registers the same exposure. While you stay in the same conditions, the automatic exposure system should give you perfectly exposed pictures. In the absence of an exposure compensation dial, with the 35 mm type camera you can instead alter the film speed setting. To give extra exposure set the camera as if you were using a slower

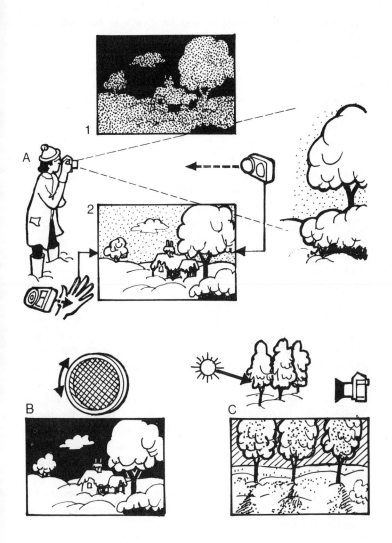

Snow and ice pose their own special problems. A. A direct reading (1) can lead to considerable underexposure, turning the white snow a muddy grey. To achieve the right result (2) take a substitute reading, or measure the incident light. B. The selective darkening from a polarizing filter can often add to snow shots. C. With back lighting, the snow sparkles to add life to the simplest subject.

film. Halve the film speed setting to give you one stop extra exposure or quarter it to give you two stops extra. However, you modify the exposure system, do be sure to put it back to the correct settings as soon as you finish the session. It is much better to think about readjusting it for special conditions each time than it is to have it set incorrectly when you return to normal photography.

Sun and skylight

We all know the snow is white, and unless we look very carefully we see snow as mounds of white stuff; but like any other white object the snow reflects the light that falls on it without changing its colour. Light that reaches directly from the sun is white, maybe tinged with yellow or pink when the sun is low in the sky. Light from the rest of the sky, especially high in the mountains where much snow photography is done, is blue.

You realize just how blue the first time you look at processed transparencies you have taken in the snow. The shadows look quite unnaturally azure. To take more neutral-coloured pictures, you need a suitable filter. The one designed for the purpose is called a skylight filter. It is a very pale salmon UV-absorbing filter and in fact many photographers use such a filter the whole time because it gives them very slightly warmer looking transparencies. In snow, though, while it absorbs UV, thus removing the overall blue veiling, a skylight filter is not really a strong enough colour for many photographers. If you want to reproduce the shadows more nearly a neutral colour then choose a slightly stronger salmon or pale red filter. One which requires an exposure increase of about $\frac{1}{3}$ stop is usually about right.

As virtually all your snow pictures will be taken through at least a UV filter and probably a slightly coloured one, once again you need a good lens hood.

Photography in the cold

Cold conditions affect you and your camera. Whenever you go out to take pictures in the snow make sure that you are dressed to keep

warm. Cold fingers make it almost impossible to take sharp pictures. When working in the snow I wear warm clothes with capacious pockets so that I can avoid carrying a gadget bag if possible and soft leather motor-cycle gauntlets. With these gloves on I can take pictures quite easily with a normal 35 mm camera. I need take them off only when re-loading. When photographing sporting events or animals, you often have to wait around for long periods, so footwear is particularly important. Not only should it give you a good grip in slippery conditions, but it should also be warm enough to keep your toes warm.

In arctic conditions, camera problems fall into two categories. The effects of damp and condensation and the effects of the temperature.

When you take a camera out into the cold, the warm moist air inside it tends to condense onto the film and onto the elements of the lens. Although this does no permanent harm, it does make it impossible to take sharp pictures at the time. In extreme conditions, the condensation may even freeze and remain on the camera until you warm it up again. The answer is to let the camera cool down slowly – leave it, perhaps, in a hallway or by a window while you get ready to go out. Then if you have one, put it in a large pocket in your anorak until it is nearly as cold as the outside. Be especially careful of falling snow. If your camera is still warm, the flakes may melt and run in through the camera controls – then as the camera cools, it may freeze solid.

Used with a little care, though, virtually any camera can be mechanically reliable under most normal cold conditions. If you are intending though to take your camera to the Antarctic or on a high-mountain expedition, then consult the manufacturers or their agents about having it lubricated with special low temperature lubricants.

Protecting the mechanical functions is quite straightforward, but dealing with the electronics is a rather more hit and miss affair. The main problem is that mercury cells, and to a lesser extent silver oxide cells which are now more commonly used, can fail to give enough power in extreme cold conditions. When you are selecting equipment the answer is simple – choose a camera which relies on mechanical control for all its normal picture-taking functions and

carry with you a separate selenium-cell exposure meter. That way, if the camera's internal meter stops working, all you have to do is use your separate meter and set the controls manually. If you use an electronically controlled camera, you should have no problem with fresh batteries down to about −20° C (about −5° F) and when it is colder still you have to take steps to keep the batteries warm. The simple solution is to keep some spares in an inside pocket; and if the camera appears to be faltering, change them.

Coming in from the cold has its hazards too. Your cold camera, just like your cold spectacles if you wear them, is an immediate target for condensation from the warm air indoors. To protect your camera seal it into a polythene bag before you bring it indoors and allow it to warm up for two or three hours before you open the bag. In fact if you are going out again, and you have no reason to adjust the camera, leave it in the bag until you go out again.

Mountains

Mountains are immense slabs of land but surprisingly often people's photographs make them look like molehills. The reason may be that the shots are taken from too far away, or with too wide an angle lens, but more often it is because there is nothing to which you can directly relate the size. Ideally, you should aim to produce a continuous vista running from recognizable foreground up to the top of the mountain or mountain range. If there is dead ground in the intervening valleys, then you need to give your viewer clues as to how much. Choose a position which shows clearly the relative sizes of similar trees on both sides of the valley, for example. If you are shooting from a long distance with a telephoto lens, the aerial perspective produced by atmospheric haze is likely to give good clues to the distance. More often, though, the standard lens is about right for picturing mountains. With a wide-angle you have to stand so close to the bottom of the mountain that the top may taper into insignificance.

The best place to take a picture of a mountain is from a level of about half way up. While the possession of a helicopter is an obvious advantage for this, the way most people do it is by climbing a

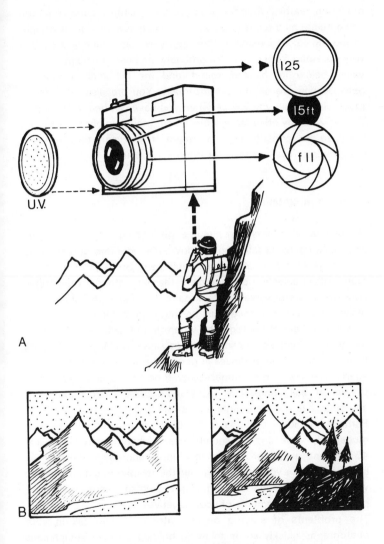

U.V.

A

B

Climbing mountains calls for the simplest photographic equipment. A. A 35 mm 'compact' camera is the first choice. Equip it with a UV absorbing filter, and set it for taking snapshots. All you need to do then is to press the button. B. Mountain shots are particularly enhanced by a suitable foreground.

mountain nearby. When the peak you are scaling is round about the same height as the one you want to photograph, do not go straight to the top – start looking for the right viewpoint when you are half way up. Apart from giving you probably the best viewpoint with the valley below in the foreground, and the hill itself undistorted because you are shooting horizontally. You are also likely to be much closer than you will be when you have climbed to the top.

Just as with any other large subject, your mountain photographs are likely to be considerably improved if you can find suitable foreground or even a frame for the main subject.

Climbing mountains

The dedicated mountaineer has enough problem in getting himself and his companions safely up and down the mountain without being overburdened with photographic equipment. So he probably has a more critical selection of equipment than any other photographer. To a great extent, versatility must take the hind seat; light weight, reliability and convenience must be the major criteria.

This is one field of photography where the rangefinder camera, or the simple direct vision camera reigns supreme. Most pictures are taken at reasonable distances in good light, so sophisticated wide-aperture lenses are quite unnecessary. Precarious positions preclude the use of really long-focus lenses and accessories such as tripods and bulky flashguns are quite impossible to carry.

Perhaps the ideal outfit is a compact rangefinder camera with moderately wide angle standard lens, perhaps between 35 and 45 mm and an 85 or 95 mm medium telephoto. If you work in black-and-white you can do without the telephoto; simply load up with a slow fine grain film and be prepared to enlarge from comparatively small segments of your negatives.

The problems of staying on the mountain and taking your photographs quickly so as to avoid holding up your companions means that you must be able to bring your camera to your eye single-handedly, take a quick shot and put it away. Keep your camera preset on a convenient snapshot setting, say with ultra-slow speed film 125 at *f*8 with the lens focused on 5 m (15 ft). On more

arduous climbs you may even want to tape the controls so that the camera stays at that setting; then you know that every picture will be acceptably focused and properly exposed. Of course, automatic exposure and auto-focus cameras are ideal for mountaineering.

At first sight, pocket 110 cameras seem the obvious choice for most mountaineers. Certainly, with the most recent films their performance is quite adequate. However, while their pocketability is acceptable, very few of them are easily operated with one hand. Their long thin shape makes that extremely difficult. What is more, most of them have facilities only for a wrist strap, and the last thing you want when you are scrambling up mountains is a camera dangling from your wrist. The best way to carry any camera is on a short neck strap, tucked inside your anorak.

The one accessory which makes a camera totally dependent on both hands is an every-ready case, so your camera must go naked. To protect it from knocks, though, and to protect yourself from the sharp corners, you may well be able to use the bottom half of an ever-ready case (with the front top piece removed). The best way to protect the lens is to put a filter on it, and then to use a rubber lens hood to act as a shock absorber. Whatever you do, you must avoid the camera swinging around while you are climbing — not only is it rather bad for it to bang it against rocks, you are also in danger of catching it and the strap on an overhang and getting into a difficult situation.

Pictures after Dark

When the sun goes down, the inhabited parts of the world are lit by man. To our eyes the light appears quite bright because they compensate for its low level. A film, on the other hand, takes a more realistic view. Even with a fast film you have to use a wide aperture lens and a relatively long shutter speed to get acceptable exposures after dark, so you need a camera which can give you at least 1/30 second at f2.8, but that is well within the scope of most sophisticated or moderately sophisticated modern cameras.

Films at night

Most photographers take most of their photographs either by daylight or with electronic flash. These both produce light of around about the same colour and the colour is important when you are taking transparencies. Transparency films record faithfully the colours of the light reflected back to them from your subject and if the light falling on your subject is a different colour, then the picture will be a different colour. In the past, transparency films were produced for a number of different colours of light. Now things are much easier to understand. There are two sorts of transparency film generally available – daylight film or tungsten or artificial light film. Daylight film is the one most of us use, as we have said, most of the time.

If you use a daylight film indoors at night, then you will produce strong orange-coloured pictures; that is because the tungsten lights of most homes is much more orange than daylight. To get natural looking colours with that light you need artificial light film. In fact, artifical light film is balanced for photographic lights which are not quite as orange as domestic lights, but for most purposes it is near enough. If you use artifical light film in daylight not surprisingly you

get blue-looking pictures because the film expects the light to be orange and compensates for it.

Instead of using different films you can use conversion filters. In tungsten light you need a strong blue filter, if you have daylight film in your camera. This filter absorbs so much light that you have to treat the fastest films as if they were only moderately fast, ar d medium-speed films as if they were slow. As tungsten lighting is seldom very bright, this is not a particularly good solution to your problems.

The orange filter which you need to use with artifical light film to take pictures in daylight, on the other hand, absorbs comparatively little light and it is quite practical to keep your camera loaded with artificial light film and use a filter whenever you go out of doors or want to use an electronic flash. However, there is little point in doing that unless you expect to take interior shots.

The colour of most light sources can be quantified as its colour temperature – the higher the colour temperature the bluer the light. Armed with a list of colour temperatures; or, to be even more exact,

APPROXIMATE COLOUR TEMPERATURES OF SOME LIGHT SOURCES

Source	Colour Temperature	Mired Value
Skylight	12000–18000	85–56
Cloudy dull	6250	160
Electronic flash	5500–6500*	182–154
'Photographic' daylight (Daylight film balance)	5500	182
Blue-coated flash bulbs	5500	182
Mean noon sunlight	5400	185
Morning or evening daylight	5000	200
Flashcube or magicube	4950	202
Clear flashbulb	3800–4200	238–263
3400K Photolamps (Type A film balance)	3400	294
Tungsten studio lamps (Type B film balance)	3200	312
Tungsten halogen studio lamps	3200	312
Household lamps 250 watt	3000	333
Household lamps 100 watt	2900	345
Household lamps 40 watt	2650	377

* Most small modern units have a tinted discharge tube to bring them close to 5500K and sometimes lower.

a colour temperature meter you can select exactly the right filter to make subtle changes to the colour of your pictures – this is all described in detail in the *Focalguide to Filters.* Here we will just reiterate that when you take transparencies by tungsten light you need artificial light type film to give you a neutral colour balance.

Long exposures

Some night pictures call for extra-long exposures; and films can react oddly to them. At exposure times longer than 1 second or so, films become less sensitive. So, for example, if your meter suggests 8 second at f11, you actually may need 8 second at f8, or 16 second at f11.

The actual change (called Reciprocity Law Failure) varies from film to film. If you intend to make a lot of long exposures, it is as well to get the information from the film manufacturers. Otherwise, just bracket your exposures by 1 and 2 stops more than the meter suggests (i.e. take 3 in all).

Unfortunately, colour films may produce unusual colours as well. That is why each film is given a recommended exposure range. However, few night pictures of places depend too much on accurate colour, so this should not worry you.

Street lighting

Our roads are illuminated by a whole variety of lighting varying from brilliant tungsten halogen units high overhead, like those in Edinburgh's Royal Mile, to the occasional Victorian gas standard left over from a previous era. Most modern street lighting uses gas discharge or fluorescent tubes. This is very unfortunate for the photographer. The yellow orange of sodium vapour lamps records on most colour films a strong red, even with modern high pressure varieties which are much better to see by. The older type of green-purple mercury vapour lamps come out an even more ghastly colour – a lurid green; and most fluorescent tubes also give a pale greenish light in photographs. So where street lighting is the only

source of illumination you are virtually confined to black-and-white work.

In commercial areas, there is a far greater range of light source. Shops, restaurants, theatres and so forth pour out light from their windows; and buildings are often covered in towering hoardings glowing with light of all colours. In brightly lit shopping areas anywhere in the world, you can take hand-held pictures with 400 ASA film. Base your exposure either on an incident light reading or on a selective reading from, for example, your subject's face. It is usually around 1/60 sec and at f2.8 or f4. That is quite adequate to show people doing things, but with most lenses the depth of field is still limited and you are certainly not going to get a sharp picture from here to infinity.

Picturing lights

When you take pictures of the lights themselves it is a different story. Again with 400 ASA film, even a modest local advertising display is probably bright enough to allow you to use 1/60 second at f5.6 or f8. Really brilliant displays, such as London's Piccadilly Circus or Las Vegas' Golden Mile, let you close down possibly to f11 and still use 1/60 second. That allows you to take sharp pictures of signs a considerable distance apart. Many advertising signs flash, but few of them move, so if you can keep your camera completely steady on a tripod or resting against a solid object, you can safely use much longer shutter speeds and so use small apertures with quite modest displays.

Sometimes the displays themselves are enough to make a photograph. More often you need something in the foreground; brightly lit shop windows and the blur of passing traffic are often successful but can get rather monotonous. Undoubtedly the most exciting foregrounds are those which reflect the light, so despite the discomfort it is often better to take your night shots in the rain, so that the pavements glisten with myriad reflections. Of course, where you can find a river, fountains or perhaps a lake, then you need not wait for the rain.

It is not just advertising signs that provide interesting light pic-

tures – many holiday resorts are decorated with coloured lights for the season and so are the centres of many towns for festivals such as Christmas. A record of illuminations such as these is obviously an important part of your portrait of any place.

Floodlit buildings

When people are proud of their buildings, they shine bright lights at them at night. The effect is particularly impressive from a distance and always an invitation to the photographer. They are a subject which is particularly appealing in black-and-white. One reason for this is that most buildings are floodlit from ground level and in fact the light falls off quite considerably toward the top of the building, so the top is quite often lost in the dark. On a colour transparency, there is little you can do about it. On a print you can correct to some extent, and the fall-off is usually less noticeable in black-and-white than it is in colour.

On the other hand, buildings lit from inside almost always benefit from colour even though the fluorescent tubes in an office block may vary in colour from window to window. Given a reasonably long exposure, that just adds interest to the picture.

In a colour shot, whether the building is lit from inside or from outside, you often want to include a deep blue sky as well. Theoretically, there is a point each evening when the light from the sky balances the artificial light on the building. In practice, that is difficult to determine. If you can, it is much better to make your picture with two separate exposures.

In the early evening, mount your camera on a tripod and line it up with the building; take a meter reading from the sky and give about three stops *less* exposure than that suggests. Re-set the shutter on your camera without winding on the film. If it has a multiple exposure system that is easy; otherwise it may be more of a fiddle and with a cartridge-loading camera it is quite impossible. Do not disturb the camera at all; just wait until the lights on the building are illuminated. Then take a normal, fully exposed picture of the building.

Moving lights

Now we have introduced a tripod and, of course, a cable release which you need to take steady pictures, we can look at some more possibilities for using a static camera at night. Most night scenes consist of a series of points or possibly bars of light against, what is to the film at least, a totally dark background. If these blobs move while the camera shutter is open, they become streaks in the picture, which gives you another way to picture places.

Fun fairs, such as the enormous one which accompanies Munich's October Festival and provides entertaining interludes between the more serious sessions of drinking beer, become at night seas of moving lights. Point your static camera toward any of the bigger entertainments – a ferris wheel, the big dipper, the octopus, or a roundabout and hold the shutter open for a few seconds. Your pictures will be a fantasy of dancing lights.

The next most popular subject for this sort of treatment is a traffic interchange. Approaching cars describe lines of white, or in France yellow, light with their headlights; and retreating ones dimmer but usually still visible red streaks. Direction indicators add their own individual effect to photographs. They produce a line of dashes – white amber or red as you might expect; and the effect of sequential flashers can be even more entertaining.

As it is the lights which are forming the picture, exposure is not too important. With a medium-speed film, try an aperture of around $f11$; with a fast film of around $f22$. Decide on the length of your exposure by the amount of movement you want to get into the picture. Remember that, for example, with motor cars the trail left by one blends into the trail left by the next, and times of around half a minute are very often ideal.

Lightning

Storms during the day can make spectacular pictures; those at night even more so. To picture lighting again you need your camera on a tripod, face it towards the storm. You can soon see where the majority of flashes are. Set the lens to infinity and stop it down to

about *f*8 or *f*11, then open the shutter. Close it again after a single flash or when you feel you have seen enough flashes. Usually objects on the skyline appear as silhouettes, but after a number of flashes or if the moon is out you may get some detail in them, which can very much improve the picture.

One of the best thunderstorm pictures I have seen was taken across Lake Tanganyika some years ago. It was produced by a half hour exposure and showed half a dozen or more forks of lighting apparently striking the hills on the far side of the lake. Each flash had illuminated a different part of the sky so as to give an impression of the storm clouds from which they were coming. The lake in the middle distance was covered with lines of light produced by the lanterns on the little fishing boats dashing for shelter before the storm reached the water.

Moonlight

The light reflected from the moon is a very pale imitation of that directly from the sun. With very long exposures you can take perfectly good pictures by moonlight. However, if you really do give enough exposure for the film, the result is just a rather odd and apparently daylit picture. This can work in colour, but usually the colour is distorted because daylight-type films are not designed to be exposed for half a minute or more.

It is perhaps more intriguing to take pictures which look as if they were taken by moonlight – think for a minute what your impression of a moonlit scene is like – most people imagine it as dim and rather blue. In fact, the light is usually so dull that our eyes cannot distinguish colours at all.

To take a dim blue scene, you need to put a blue filter on your camera and give rather less than the normal exposure. The filter most commonly chosen is the one which you need if you are going to expose daylight film to tungsten room lighting. This filter demands that you increase the exposure by nearly 3 stops to get a normally exposed picture. For a moonlit effect, you probably only need to open up by 1 stop from the metered exposure for your film without the filter on it. Of course, a through-the-lens meter

measures through the filter as well, and so if you have an automatic exposure camera, you must use the exposure compensation system to produce the underexposure you want. Instead of using a filter you can take the pictures on tungsten light film in daylight and underexposed – that has the same effect.

Indoors at night

We discussed just a little about the problems of photographing buildings inside by daylight. At first sight, once the lights are on, things would appear to be much easier, but that is not always the case. Lights in the home are placed so that people can see what they are doing. In museums and galleries they are placed to illuminate the displays. Even when the building itself is the subject on display, the lighting is normally arranged just to pick out details. What all this lighting has in common is that it is extremely uneven. Patches of light where they are needed – dark corners, nooks and crannies elsewhere. While that is quite acceptable to someone standing in the room, it can look very odd in a photograph. However, if you are aware of the problem you can usually work round it. Confine your shots to details, perhaps, or sections of a room where it is quite obvious why the light is patchy.

Despite the patchiness, you usually get the best results with a transparency film by basing your exposures on a meter reading from the light reflected from the brightly lit areas. Of course, if they are unusually light or dark, you must either modify your exposure settings or use a substitute reading. One point to bear in mind: most built-in exposure meters are rather oversensitive to red light, so they tend to overestimate the light level indoors. If in doubt, give $\frac{1}{2}$ stop more exposure than the meter indicates. With an automatic camera, use the exposure compensation dial or adjust the film speed setting.

What about the colour?

As you have seen from the table, no film is balanced exactly for the normal sort of tungsten lighting used indoors. With colour negative

film, as we noticed, it really does not make any difference, and in practice a tungsten-type transparency film gives quite acceptable results. Remember that if you underexpose a transparency film, the colours become more saturated and vice versa; so when the lighting balance is not quite right, if anything err on the generous side. That will tend to make the differences less obvious.

Sports

No series of photographs on a place can be complete without representative pictures of its indoor sports. Most sports take place sometimes indoors, or outdoors after dark. These events are lit by batteries of floodlights from above. Usually the playing surface is quite a light colour and reflects back enough light for you to take reasonable photographs. At important events, the lighting is really quite bright – it has to be to allow colour television cameras to work. Bright lighting is particularly useful at sporting events, because they combine two of the photographers greatest problems: things happening at distance, and movement. Even the professionals, with their press passes to photograph the event, will be using very long-focus lenses at times; and anyone working from the terraces is going to need at least 180 mm on a 35 mm camera. Really wide aperture telephoto lenses are becoming available, but are beyond the reach of most enthusiasts. So, you are likely to be working with the fastest films at around 1/60 second at f2.8 or f3.5. At that shutter speed through a long telephoto lens, you cannot hope to freeze action.

That leaves you two ways to treat the subject. Either select stationary points or pan with the motion so as to deliberately blur the background. In fact some of the most effective pictures are events like gymnastics, for which the photographer has chosen an extremely long shutter speed so as to show an action or a whole sequence of actions as a continuous blur. This is a technique particularly suited to indoor meetings because the competitors are brightly lit and often standing out against the dimly lit background of the audience.

Flash is useful for nearby subjects after dark and indoors. A. Make sure that your flash is connected correctly. B. You can see quite easily with an electronic flash by looking through the back. C. Even in flash pictures, beware of false colours, from a bright coloured reflector. D. The ambient lighting can colour your flash shots, especially if you use a small flash.

Entertainments

Public entertainments vary considerably in their attitude towards photographers. Some, such as circuses and ice shows, may positively welcome you with your camera, while many theatres and night clubs try to enforce a rigid ban on photography. If you intend to photograph such an event, do find out beforehand whether it is allowed and if necessary ask permission from the relevant authorities. Assuming you can go ahead you are once again in the realms of fast films and relatively long-focus lenses. From the front rows, though, an 85 mm or 105 mm lens is probably quite adequate and there are usually plenty of static opportunities for you to take pin sharp pictures with a shutter speed of around 1/60 second.

Flash

To most photographers night photography calls flash instantly to mind. With the small and convenient electronic units now available simple flash is there for everyone. It is great for photographing people or animals, small insects and plants, for close-ups and for copying; but really has very little use in the photography of places. There are two reasons for this both related to fact that the light from a flash diminishes very quickly with subject distance. In fact, as you double the distance from the flash to your subject, so you reduce the lighting to one quarter. Really someone must tell the tourists at Niagara Falls one day. They happily go flashing away with their tiny light sources, hundreds of metres (yards) from the water, and like most other places the falls are far too far away for the flash to have any effect at all.

That is the first reason: places are just too big for most flashes. The second reason is that pictures of places, at least those taken following the advice in this book, have a foreground, a middle ground and a background. If your flash is powerful enough to illuminate the middle, then your foreground will be burnt out by being overlit and your background still unlit. So keep your flashgun to take pictures of people doing things.

Painting with light

There is one rather complicated technique which you can try with a flash or in fact with any other portable light source if you have, say, the interior of a large building to yourself to photograph; it is called painting with light.

The way you do it is to set up your camera on a tripod focused on the darkened interior; set the shutter to 'B' open it and lock your cable release. Now walk round the building pointing your flash to each sector in turn and firing it with its open flash button. With careful planning and execution you can take a very good photograph like this.

Remember that as with any other flash pictures, the lens aperture you need is determined by the flash to subject distance; so, for example, you may choose an aperture which requires a flash to subject distance of 3 m (10 ft). Then make sure that each time you fire your flash it is about $4\frac{1}{2}$ m (15 ft) from the nearest subject. To get an even coverage of light you will have to overlap the flashes very considerably so this should give you about the right exposure level. As you build up the picture, work to a plan which gives you some gradation in lights to provide the modelling you require to reveal the shape of the room. Remember, too, to stand well to one side as you fire the flash otherwise your silhouette will appear many times in your picture.

Part 5

The
darkroom

Introduction

Once you start taking photography seriously, a darkroom becomes a necessity. You are no longer satisfied with the small prints provided by D & P services. You want larger prints; you want to print from only part of the negative or slide; you want better prints – the kind of print that only individual attention can provide. Happily, you can now make them in colour as well as black and white; but most home processing and printing is still in black and white. The basic set-up is much the same in either case but there are a few differences. In this book we discuss both methods.

The difficulty for most people, in this era of the small house or flat, is in finding space in which to locate the darkroom. Many ingenious suggestions have been put forward in photographic magazines and elsewhere for making use of even the smallest spaces – from cupboards to alcoves to attics and even a corner of bedroom or living room. Naturally, if you have a spare room or a large garden shed or a garage or half of a garage that is available for this purpose you are in luck. You can then build a permanent workroom rather than the temporary set-up so often needed in other locations.

Wherever you put your darkroom, you run across the same problems – although they may be more acute in some circumstances. You have to deal with electrical wiring, plumbing, waste disposal and space saving. You have to think hard about the type of equipment to obtain. Is an exposure timer really necessary? What about an exposure meter? What size dishes should you buy? In what quantities do you buy paper and chemicals? Should you buy film in bulk? How do you store materials? Do you need temperature and voltage control? Is a running water supply necessary? How do you weatherproof and heat an outside darkroom? How do you make temporary blackouts for windows?

This section attempts to answer all these questions and many more.

It tends to generalize because it is impossible to give specific recommendations for all kinds of windows, all shapes of room, all varieties of garage and shed, and so on. Nevertheless, it gives honest advice on the many problems you will meet, based on the practical experience of the author and on the solutions that other people have found to similar problems.

Think it out first!

Setting up a permanent darkroom is not a task to be undertaken lightly or in a hurry. It is advisable to think carefully about the layout, blackout methods, heating, ventilation, electricity and water supply, and other such matters. They involve a lot of work and have a considerable effect on the comfort and, indeed, safety of your working conditions. Nor, in a state of euphoria at finding yourself with room for a permanent set-up, should you decide that every darkroom gadget available thereby becomes a necessity. The more you spend on 'aids to better printing' the less you have available for paper and chemicals—the essentials that provide the practical experience that is the best aid of all.

Most people, at least in the beginning, have to carry out their darkroom activities in a confined space—more often than not the bathroom—that is available only at certain times and in which they have to set up their equipment before starting and clear it away again when they are finished. We shall deal with the problems of this type of darkroom first.

Temporary Locations

The most popular location for the temporary darkroom appears to be the bathroom—probably because it has running water and there really does not seem to be anywhere else that is suitable. The choice is, in fact, rather a strange one. It must be almost impossible for anybody with a family, for example, to monopolize the bathroom for a lengthy period without causing other members of the family inconvenience and possibly arousing resentment—especially when the bathroom also houses the lavatory. If it were not for the fact that the bathroom has running water, it would logically seem to be about the last place in which to carry on spare-time activities.

Yet running water comes very low indeed in the list of necessities for a darkroom—at least for part-timers working in their own homes. So let us consider the problem of water supplies first, as it seems to have such an undue influence on the thinking of so many people about to set up their own darkroom facilities.

Water supplies

Water is, of course, a necessity for photographic processing and, in the final stages, running water is, though not necessary, certainly very convenient. Prints and films can be washed satisfactorily—and perhaps even more efficiently—in several changes of water, but it is a tedious business. Until you reach the final wash stage, however, whether in film processing or in printing, you have absolutely no need for running water at all.

Undoubtedly, it is useful to have a supply of water in the darkroom but it does not have to be on tap. There are innumerable types of liquid container that can be pressed into service, from the one or two litre plastic bottles that soft drinks, washing up liquids, etc. are supplied in, to 12 litre and larger barrels or cubitainers for wine storage and similar uses. Many of the larger containers are fitted

with effective taps and filler holes—or the tap may be removable for filling purposes.

An inexpensive type of container has been available for many years from camping stores. It is a strong polythene bag with stretcher rods and a cutout at one end to form a carrying handle. It holds about six litres and is fitted with an efficient tap of the push-fit type. It can be carried easily from the water supply to the dark-room, where the stretcher rods allow it to be hung on stout hooks. Probably the best type of container for a temporary darkroom that has to be constantly set up and dismantled is, however, a simple wide-mouthed jug or bottle (or more than one) that can be carried without effort and easily poured from without splashing. It is not a good idea to make up solutions in the processing dishes and then carry them to and from the darkroom area. That positively invites spillage. If you return the solutions to storage bottles in the dark-room, use a funnel. Pour any solutions you discard while you are working into a bucket.

Thus, the absence of running water need not affect your decision as to the suitability of any particular location for darkroom work. Finished prints can be stored in a bucket or bowl of water for washing at the end of the printing session.

Working in the bathroom

Having made it clear that the bathroom is not a very sensible choice as a location for a darkroom—and we shall have more to say about that yet—we must, nevertheless, cater for those perverse people who prefer not to take our advice. Naturally, bathrooms vary considerably in size and shape but, these days, they tend to be small. Floor space is often limited and rarely pro-vides enough room to set up a bench or table to hold the enlarger and processing dishes. The most popular method of operation for those who use large dishes (20 × 26 cm upward) is to locate them on a wooden tray-like structure placed on top of the bath. Sometimes the enlarger has to go alongside them on the same structure but that is not at all a good idea. Apart from space saving, the reasoning behind this location seems to be that splashes will run harmlessly down the drain. Nothing could be farther from the

truth! In most bathrooms, it would be far preferable to let the splashes hit the floor, which is likely to be of a type that can be easily mopped up. Trickles of developer and fixer running down the bath, on the other hand, can leave very nasty stains that can turn out to be practically irremovable, while some of the solutions used in colour printing can make an awful mess of metal fitments. It is not a good idea to locate the enlarger over the bath for two reasons. First, it is difficult to make sure it is very rigidly supported, so it might finish up in the bottom of the bath. If that has water in it —as it should have—the resulting fireworks could be spectacular. Secondly, few baths give a comfortable working height for the enlarger baseboard and the result of a prolonged printing session is likely to be severe back pain. You might, of course, sit down to operate the enlarger but you cannot sit all the time and, with space at a premium, there is a fair chance that, at some later stage, you will fall over the chair or stool that you have pushed aside so that you can more easily reach the processing dishes. The sitting posture may not be all that comfortable, either, because baths are not normally constructed with kneeholes.

In finding an alternative location, however, make sure that the support for the enlarger is completely rigid. Apart from any risk of shake or vibration while making the print, there is, again, the possibility that you might knock it over and break or damage electrical connections. Do not balance it on a chair or flimsy table. It is a relatively simple matter to make up a support from four timber pieces of about 25–35 mm square section cut to the required baseboard height and fastened all round, top and bottom, with timber battens so that the baseboard can rest securely on top. You can even cover the sides and back with hardboard, put a door on the front and shelves inside to form a complete storage unit that might take the enlarger too if it is small and dismantlable.

The height of the baseboard is a matter of personal preference but most people find that ordinary table or desk height is too low. A height of about a metre or 3 feet is generally suitable for people of average height. Be careful, however, if the ceiling is low. Some enlargers need a lot of headroom and you may have to locate the baseboard rather lower than you would like so that the enlarger head can reach the top of its column.

Your set-up in the bathroom, therefore, should consist of the enlarger on a rigid base away from the bath and your processing dishes on a flat level surface firmly braced on the top of the bath—assuming that there is not room to put them anywhere else. Run a little water into the bath so that any spilt liquids that do escape will not sit in the bottom of the bath doing their best to destroy the enamel. This water can also serve as a depository for the finished prints until you are ready to wash them at the end of the printing session.

Blacking out

Excluding light from your working area is a problem in any kind of makeshift darkroom. No general rules can be laid down because windows vary in size, shape and availability of flat surfaces to which to fasten blackout material. The two most suitable materials are heavy duty black plastic sheeting and hardboard—that most versatile, thin but tough composition board that is so valuable to any handyman.

The greatest problem is in making a light-tight seal at the edges. Hardboard on a timber frame tailored to the size of the window opening provides a perfect blackout if you can devise a simple, inconspicuous method of attaching it to the window frame. Sometimes, this type of frame can be held quite securely with two or three small timber wedges at the bottom. If you have a generously sized window ledge, one or two timber supports hinged on the centre line of the frame may be similarly wedged at the bottom. If there is woodwork available at the sides, you might drill small holes into which dowel-type pegs can be pushed. The disadvantage of any hardboard frame, however, is that it is bulky and difficult to store inconspicuously.

Plastic sheeting can be used in a similar manner but, as it has the advantage that it can be rolled up when not in use, it is better to fasten it to top and bottom battens only. The side battens can then be force-fitted into position on assembly. With care, the force-fitting can also hold the frame in place. Alternatively, you can attach the sheeting directly to the window frame by means of press-studs

You need only a saw, hammer and nails to make a sturdy enlarger support. The hardboard blackout *(bottom)* is fitted into a recessed window and supported by wedges at the bottom. Extra support is provided by a central strut if necessary. Details of the ventilator are given in the text.

or strips of the Velcro type of tear-off fastening material. It is advisable to make a double thickness at the edges to provide rigidity and combat any tendency to stretch and sag.

Do not forget the door. Most doors allow some light to leak around the edges and underneath. You can use ordinary commercial draughtproofing materials to block such light but that might not be advisable in all bathrooms, which should have reasonable ventilation. The edges may be treated in this way or with strips of felt but it is often easier to treat any leaks at the bottom simply by blocking it off temporarily with an old towel or similar piece of material or by leaning a piece of hardboard against the door.

Letting the air in

Light-trapped ventilation may already be present in the bathroom. If not, you must try to supply it. If you use a rigid blackout for the window, it is not too difficult to incorporate a ventilator into it. Cut a hole, say about 30 cm (12 inches) square in the board in front of an opening window and cover it with larger pieces of board, about 50 cm or 18 inches square on both sides, spaced from the central board with small pieces of timber so as to allow a passage for air but to form an impenetrable barrier for light. The principle is that light cannot be reflected around two rightangles (not by ordinary materials, anyway). Provided the covers are large enough to prevent oblique rays of light entering directly, all light is prevented from passing through the light trap.

Plastic sheeting does not lend itself so easily to the fitting of a ventilator and you may prefer to do without it. Nor are you much better off if your bathroom has no window. Fitting a ventilator to the door may not appeal to the rest of the household but it may well be that sufficient air can enter under the door to prevent the air from becoming too foul inside. If you really cannot fit adequate ventilation, do not spend too long in the darkroom at a stretch. There is no real danger with the normal chemicals but the fumes and the stale air can give you quite a thick head—especially if you smoke. Open the door occasionally, say every 40 minutes or so, and take a break.

Electricity and earthing

One thing you have to have in your darkroom is electricity—and that is one of the biggest arguments against using the bathroom. Bathrooms tend to hold dampness and may have metal fittings that are very efficiently earthed via the water pipes. When you use electrical equipment in the presence of other items that are well earthed, it is advisable, if not imperative, that all your equipment is also earthed. If, by mischance or carelessness, any exposed metal part of your equipment should become 'live' and you should be in contact both with the faulty equipment and with an earthed item, a powerful electric current will find its way to earth through your body. Its passage is accelerated if your hands are damp, if the floor is solid (and even more so if it is also damp) and if your equipment is not fused or has fuses of too high a rating. That could be lethal. Bathrooms are not, or should not be, fitted with earthed electrical sockets and it is likely, therefore, that you will connect your enlarger to the light socket, which may or may not provide an earth. A safer arrangement is to connect the enlarger to the only type of socket that should be allowed in a bathroom—the shaver socket. If of an approved design, that contains an isolating transformer and fuse that should prevent any heavy current passing. The shaver socket will take your enlarger lamp satisfactorily (it is generally rated at about one amp) but do not plug anything else into it.

Under no circumstances should you fit any other type of electrical outlet into your bathroom, nor should you run in a temporary supply from an outside socket. Any switches you fit to enlarger, safelight, etc. should be of the remote, cord-pull type. Preferably, do not use the bathroom at all.

Protecting the floor

The majority of photographers do not have exclusive use of a bathroom or do not want to use it as a darkroom for the reasons already discussed. So, they have to find another location for a temporary darkroom. One of the biggest problems in that case is the protection of walls, floors, carpets, furniture, etc. from the ravages of splashes from the water supply and worse. If you can manage to

block off the corner of a living room, bedroom or hall, you are unfortunate if it is carpeted, because that calls for immediate protective measures. A carpet attacked by frequent splashing with developer and fixer, not to mention bleach, is not a pretty sight.

The simplest form of protection is a large plastic tray—the largest you can obtain or accommodate—from your nearest supplier of garden equipment or pets' products. They are supplied as gravel trays or seed trays and are not very expensive. It need not be a deep tray—just enough to allow a little paddling about in your processing dishes or careless placing of the print tongs without contaminating the working surface or allowing liquids to ooze along to the edges and thence to the floor. If you work on a table against the wall, it might be as well to protect the wall-covering, too, by leaning the ubiquitous piece of hardboard or other surfaced board against it. If you feel at all doubtful about the floor area, cover it entirely with a large sheet of hardboard.

Providing additional blackout

If you use part of a living room or bedroom for your darkroom, temporary blacking-out is difficult and sometimes impossible, or at best impracticable, in daylight. If the room has heavy curtains or not too large windows, however, it is just about possible to put extra curtaining in your chosen corner by suspending it from the ceiling on runners. There are various types of flexible runner that can be curved quite sharply and allow the curtains to run smoothly if you keep the rail lubricated with a silicone polish. Fastening to the ceiling can be tricky. You must screw the supporting brackets into the beams, not into plasterboard or the laths of a plaster ceiling. The curtain or curtains must be backed with light-excluding material and must brush the ceiling and drag on the floor. You are left, of course, with the curtain rail on the ceiling and the curtains on the wall when you clear away—but you cannot have everything. It is possible for such curtaining to exclude daylight if you use really heavy duty material and put a deep pelmet over the curtain rail. In most cases it should be possible to exclude low-level artificial light if you have to use the room when it is occupied. The only alternative is to black out the whole room and that is not

generally practicable unless you have a room for your exclusive use.

Seeking alternative locations

When neither bathroom nor a corner of another room is available, you have to examine the house for nooks and crannies. The tiny areas in which many keen photographers have been able to cram their darkrooms are almost unbelievable. Among the smallest I have heard of are a caravan shower cubicle with a floor area of about 56 × 140 cm and a loo measuring about 1.6 × 1 m.

The older house may well have a cupboard that large or a reasonable amount of spare floor space at the head of the stairs. There is almost certain to be some room under the stairs. A flat may well have an entrance hall with no windows. The main thing to look for is an area that can be easily blacked out. The disadvantage you generally have to accept is that it may be impossible to provide adequate ventilation.

Blacking out part of an area can be dealt with by the suspended curtaining already described but you have to look for a source of electricity. Do not rely on plugging your equipment into a single socket—especially a light socket—via multiple adaptors. That leads to a dangerous profusion of trailing cables. Use a multiple socket extension as described in the section on electrical wiring. Then you can have several sockets available in your makeshift darkroom and only one lead coming in from outside.

Using the available space

In all temporary locations, space-saving is vital—even if your working area is relatively large. You need your equipment to occupy as little space as possible so that it can be rapidly set up and just as rapidly cleared away. You may be perfectly happy to spend a little time getting your equipment ready at the beginning of a printing session but it is quite possible that you will go on printing longer than you intended. You are then rather tired and, if the session did not go too well (it happens to all of us) clearing away becomes an irritating chore. The more compact your set-up and the

more methodical your approach, the quicker you can clear up. One of the most useful items for a temporary darkroom is a tea-trolley or similar arrangement of trays on wheels. Tack hardboard to three sides of the trays to enclose the area between them. You do not need to be too much of a handyman to put an extra tray or shelf in if there is enough room. Then you have a storage area that might enable you to pack the whole darkroom into a mobile cupboard that just has to be wheeled into position when you need it. If you can put doors on it, so much the better. You are commonly advised not to store paper and chemicals together in such an arrangement but in this modern age we have such materials as cling film and baking foil that can offer perfect protection to your sensitized materials.

You might even get your enlarger into such an arrangement because there is at least one enlarger on the market that packs away into a surprisingly small case and others are designed to take apart for storage in their original packing. In the working area, the top tray can accommodate three reasonably-sized processing dishes but it might be a good idea to resurface it if necessary with a plastic laminate and possibly to heighten the edge both to contain any solution spillage and to ensure that the dishes are not pushed over the edge.

Shelving arrangements

Your basic requirements in the darkroom are space for the enlarger, processing dishes, paper, water, developer and fixer storage bottles, measuring flasks, safelights and a bucket or bowl of water in which to deposit the finished prints. You may have more equipment than that, but those are the essentials. Almost inevitably, you need at least one shelf, whether of the type fixed to the wall (permanently or on tracks) or a temporary board supported on whatever happens to be available. That takes the intermittently or seldom used items like paper, bottles of solution and measures. It might even take the safelight and clock or other timing device. Then you need a support for the enlarger and somewhere to put your

A tea trolley makes a useful mobile darkroom bench. With the sides enclosed, it can even provide storage space for all your equipment.
Do not overlook the vertical arrangement *(bottom)* when space is limited.

processing dishes. Both of these items need to be reasonably solid and stable and may take one of the forms already described.

Do not overlook the vertical arrangement. If all you can find is a deep alcove or cupboard, the enlarger can be on a solid top shelf either together with the paper or with the paper immediately below it. The dishes can go on the next shelf down (on no account above the paper) and the bowl, bucket or whatever on the floor, together with storage bottles, flasks etc. It may not be the best way of working—the enlarger may be too high and the dishes too low for comfort—but it is an arrangement that saves a lot of space. Shelving of this type can be removable, too, if it is made from blockboard (not chipboard) supported at sides and back on solid battens permanently fixed to the wall.

A neater arrangement for small shelves is provided by the various commercial shelving systems using perforated metal strips attached to the wall and brackets that slot into the perforations. There are sturdy types that do not need the shelf to be attached to the bracket; so you can easily remove both shelf and brackets for storage.

If you work under the stairs, shelving is very simple. You nail suitably sized planks or pieces of blockboard to the underside of the riser of each tread (or to alternate treads if you want to accommodate larger items).

Totally removable shelving can be provided in many ways. There are such items, for example, as shoe racks, camp kitchens, vegetable racks, etc. made from bendable metal rod. Many of these can be adapted to take planks or lengths of shelving to provide a free-standing bookshelf arrangement suitable for the odd items. Your local supplier of camping equipment (or the mail order catalogue of the bigger suppliers) has a lot of items you might like to consider when setting up a darkroom. You have a space-saving problem common to most campers—and particularly the tenting types, who have no walls to nail things to. They tend to use hanging storage units with pockets and you might well adapt their ideas to your darkroom. Why not store paper boxes or packets, bottles, etc. in hanging pockets?

A little ingenuity goes a long way in setting up a darkroom. Do not be hidebound by common photographic practice as propounded

in the magazines or even in this book. Improvize as much as possible and look for items to suit your location instead of trying to adapt available photographic items to that purpose. Apart from the gardening centre and the camping goods supplier, there are many do-it-yourself stores and hardware shops that stock items you might find useful. Even the home-brewing specialists have siphons, taps, racks, measures, containers and so on that can be adapted to photographic use and might just solve your particular problem. We shall have more to say about such matters because many problems are common to both the temporary and the permanent darkroom.

Permanent Locations

You are fortunate indeed if you have room to set up a permanent darkroom and you must not waste your good fortune by dashing in with chair and table and an improvised blackout. Whether your available location be spare room, attic, garage, shed or whatever, it is unlikely to be so perfectly adapted to photographic use as to need no modification. It is not likely to be easily lightproofed and well ventilated. The electrical outputs, if any, are almost certainly unsuitably located. The floor covering may well need modification, and so on.

Blackout and ventilation

The first thing to consider is the blacking out of windows and doors. If you are choosing between one location and another (such as which end of the garage) you will normally choose the one without windows or with the smaller windows—but not always. It is, after all, much easier to put a ventilator in a window than in a wall. If there is no simple way to ventilate the room, you may well prefer to keep the window. Then again, a larger window in one room might be an easier one to black out than an odd-shaped smaller one.

We have dealt with blackout methods to some extent in the previous chapter and the methods suggested there are quite suitable for the more permanent location. On the other hand if the darkroom is to be used for that purpose only, you can make more permanent arrangements. This does not necessarily mean that you will black the window out permanently. You could remove the glass and replace it with opaque material but that is rather more drastic treatment than most people would wish to tolerate in a room that may one day need to be converted back to normal use.

You can, depending on the money available, fit a commercially-

produced roller blind tailored to the window size. Those made specifically for darkroom use are expensive but efficient and convenient. Other types and do-it-yourself versions may not be fully light proof unless, in the latter case, you are a better-than-average handyman. Similarly, in a permanent set-up, you may be able to justify the expense of a commercially-produced ventilator. Various versions are available for darkroom use.

The larger the room, the less you have to worry about ventilation and—to some extent—blackout. If, for example, you have a room $2\frac{1}{2}$ m (8 feet) or so long and of such construction that the door can be at one end while your light-sensitive materials are always handled at the other end, it will not matter too much if the door is ill-fitting. Small gaps should not admit enough light to worry about, especially if furniture, dark surfaces, etc. can be arranged to absorb most of the light that is admitted.

The extent of your blackout is largely a matter of common sense. If, in the area where you use light-sensitive materials, you can see nothing at all after ten minutes with all the lights out, the area should be safe. It does not matter if, when you turn round, you can see glimmers of light at the other end of the room. If your darkroom activity is confined to making black-and-white prints, your blackout is not particularly critical. For colour printing, or handling films, though, it must be considerably better.

Safelighting

The darkroom should not be dark. You can handle all normal black-and-white printing papers in bright light of the correct colour. Note that we say papers—not films. Despite the fact that black-and-white films cannot produce coloured images, they are, with few exceptions, sensitive to light of all colours. They are panchromatic. The original photographic films were sensitive only to blue light and were unable to produce faithful tonal renderings of all colours. Red was rendered too dark, for example, because it had virtually no effect on the film.

Photographic paper, on the other hand, is generally sensitive to light only in the blue-green area of the spectrum—and not too much green at that. It is quite blind to light at the red end and to

most mixtures of red and green and can therefore safely be exposed to reasonably bright yellowy-brown light. Darkroom lighting takes advantage of this colour blindness.

A safelight is a simple light-box holding a 15, 25 or 40-watt bulb according to size. One side has an opening into which you can place the required safelight filter, available in standard sizes of 5 × 7 inches and 8 × 10 inches. The filter itself is often a sandwich construction of coloured gelatin or acetate, opal glass for diffusion and plain glass. You can light your darkroom almost brilliantly through such a filter with perfect safety but it is advisable, nevertheless to keep the safelight about a metre or so (3-4 feet) from your enlarger and processing dishes. Take careful note of the maximum lamp wattage allowed. If you exceed it, you could produce cracks in the gelatin and destroy its safelight characteristics.

It is not necessary and is, in fact, undesirable to darken the walls and ceiling of a darkroom. They should preferably be white or of a pastel shade because, no matter what colour they are, they cannot reflect light of any colour not contained in the safelighting. If they are strongly coloured or black, however, they can absorb a considerable amount of light and reduce the overall illumination. Ideally, you should be able to move around your darkroom with ease and should not have to fumble with any part of your equipment because of lack of light.

Layout of working areas

It is worth giving a great deal of thought to the layout of a permanent darkroom—especially if space is limited or you intend to crowd in a lot of equipment. Second thoughts can involve virtually tearing the whole room to pieces again. We dealt with space-saving in the previous chapter, so the following comments are aimed more specifically at those not suffering unduly from such limitations.

First, think about the type of work you intend to do. There are two obvious bench space requirements—for the enlarger and for the processing dishes. These are often referred to as the dry bench and the wet bench and never the twain are supposed to meet; but that does imply a degree of gay abandon to which the amateur is not usually prone. Splashing solutions all over his own property

is not likely to appeal to him so much as to, perhaps, a somewhat disgruntled laboratory worker. It can be very inconvenient to cross the room between enlarger and processing dishes for every print, whereas in the lab, of course, somebody else might want to use the enlarger. If you have sufficient space, there is no reason why the enlarger and the dishes should not be on the same bench provided they do not actually jostle shoulders.

Another important space requirement is for cutting paper. Buying paper in small sizes is uneconomic. It is much better to cut larger sizes down as required. You can carry out the cutting on the enlarger baseboard but it is much more convenient to set aside a separate area if you have the room.

Storage space is vital and, as time goes on, you will find that you need much more than you originally considered necessary. If your darkroom is small, you may have a problem but most permanent locations can provide enough room for shelves above and below the workbenches. The floor below the workbench is the most convenient place to store large containers of solutions. At least one reasonably light-tight cupboard is advisable for the storage of papers, films, filters, lenses and other relatively fragile items.

Shelving and cupboards are relatively easy for the experienced handyman to construct, but they can be a nightmare for others. If you are one of those whose shelves invariably fall off the wall under the weight of a paper clip, the hints on hammer and nail woodwork in the next chapter may help you. Alternatively, you may be able to find free-standing units that will serve the same purpose. Discarded small bookshelf units or bedside lockers may even be stood on top of the worksurface if you have sufficient room. Keep the area by the door as clear as possible, especially if the door opens inward. You may want to get bulky equipment or furniture in at some future date and shelving within a foot or so of the door edge can be an annoying obstacle. If your room is rather small, it is worth investigating the possibility of changing the door to outward-opening or of fitting a sliding door—preferably on the outside.

Your paper and negative storage cupboard, filing cabinet, boxes or whatever, should be located as near to the enlarger as possible. Most people seem to keep the paper in its original packets and

extract sheets as required. There are paper safes on the market and it is possible to construct a light-tight drawer under the bench or the enlarger baseboard, but these arrangements are really more suitable for those who use a lot of paper. It is difficult to feel too confident about paper sitting in a drawer or paper safe for several weeks.

If you cut larger paper, you may prefer to cut a few sheets as you go along and store the smaller pieces in a separate box kept for the purpose. The cabinets used for card file indexes are useful in this respect. With the paper inside a reasonably light tight box and the box in a card file drawer, there is little risk of light intruding and the paper is immediately to hand.

If there is any tendency to dampness in your darkroom you must protect paper and negatives—a subject we deal with more fully when considering outside locations. Similarly, do not leave open dishes of solutions lying about. The solutions evaporate and distribute chemical vapour and possibly dust about the room. That cannot be of any benefit to light-sensitive materials or to lenses. If you do leave solutions in dishes for any length of time, fit the dishes with heavy lids made from surfaced blockboard, marine plywood or similar material.

Having decided on the amount of working surface you require—and it may also include space for a dryer/glazer, room to hang films to dry, a small area where you make notes, calculations, etc.—plan the various positions for the equipment carefully. Take some note of the position of the electrical power points, if any, but do not let them influence the layout unduly. You will almost certainly need additional sockets and you will find instructions in the next chapter for providing them. We are assuming that you do not intend to introduce running water and drainage. If you do, you will find some plumbing hints in the next chapter, too.

Siting the enlarger

The enlarger position is important. Unless you have health problems, it is advisable to operate the enlarger standing up. A sitting position can demand too much room and reduces your mobility. The height of the baseboard should then be in the region

of about 80 cm or 32 inches, rather higher than the average table or desk. That is a convenient height for the processing dishes, too. The baseboard height may be governed, however, by the length of the column and the height of the ceiling—again a problem more often met with in outside locations.

If your enlarger has a limited column height bear in mind the possibility that you may want to make enlargements beyond its normal capability. That can be achieved by swinging the enlarger head round the column to project over the back of the baseboard, or by turning the head sideways to project on to a vertical surface. Position your enlarger so that this is possible. If you intend to project on to a wall, place the enlarger at a suitable distance from it and do not put shelves, safelight, etc. on that wall. A suitable arrangement might, in fact, place the processing dishes between the enlarger and the wall.

The enlarger baseboard can sometimes be a cumbersome obstacle to comfortable working. It projects from the smooth working surface. Investigate the possibilities of doing away with it. It is often possible to mount the column directly on the work surface. This should preferably be effected by bolting the column right through the work surface and through a stout metal plate underneath. Or it might be possible to mount the column on the wall. If you do that, you can even increase its height slightly above the baseboard. In all such cases, however, make sure that the column is truly perpendicular to the work surface or, in the case of sloping columns, that the negative carrier is completely parallel with the work surface.

Outside locations

If your darkroom is in an outside garage or shed or even in the roof space, you may have additional problems caused by low or sloping ceilings, penetration of cold and damp and difficulty in providing adequate blackout. You may also have to do a lot more construction work in the way of cladding walls, erecting partitions, installing electricity and so on. On the other hand, you may have more freedom in using the space. Except in the case of roof spaces, which can have very awkward shapes, your working area is likely to

be regular in shape with no protruding chimney breasts, window ledges, etc. It might have plenty of available timber to fasten things to with a simple hammer and nail technique.

If you do use an outside location, assume from the outset that it will be damp and cold—in temperate or worse climates at any rate. In summer it may well become unbearably hot but you have to think more about your materials and equipment than personal comfort. So, when you plan to clad walls and ceiling, remember that you need insulation, particularly against damp, which can affect light-sensitive materials severely and can effectively destroy negatives and slides. In fact, unless you can provide perfect insulation, which is unlikely, it is inadvisable to store negatives and slides in darkrooms. Keep them in filing boxes or other containers in a warm dry place indoors and take them into the darkroom only when you intend to use them.

Apart from insulation, which we deal with in the next chapter, there are various precautions against damp that you can take inside the darkroom. Plastic bags and cling film are useful for wrapping most items. Enlarger lenses are often supplied in plastic cases that are adequate protection for most purposes. When leaving the darkroom always detach the lens from the enlarger and store it in its case.

Impregnated paper of the type used for wrapping tools can be bought in sheets and attached to walls, shelves, etc. close to metal objects or structures such as the enlarger. It offers good protection up to about 30 cm (12 inches) or so from its surface. Silica gel is a useful drying agent to place in cupboards, cabinets, etc. where you keep film or paper.

A particularly useful item in an outside darkroom is an old refrigerator. If you have to replace your fridge do not scrap the old one. Put it in the darkroom. It makes a fine, more or less airtight cupboard for the storage of paper, negatives and even bottles of solution if they are thoroughly sealed against the emission of fumes. If you are in any doubt about that, wrap your paper packets or boxes in cling film.

You might consider putting a serviceable refrigerator in the darkroom for storing colour materials but for the hobby or occasional worker that can be more of a nuisance than an asset. You suddenly

decide to use the darkroom and then remember that your materials are in the fridge and need airing for an hour or two to reach room temperature. If you do not do that, warm air could condense on the cold paper surface and cause all sorts of trouble.

The same thing applies to glass. If you have a cold darkroom, inside or out, watch out for condensation on the enlarger lens when you turn on the heating.

An outside location may be erected on a concrete base, forming a very cold and probably damp floor. There are various ways of treating that. The simplest is to cover the floor with sheets of hardboard. Depending on the dampness of the floor, you can lay the hardboard untreated or paint the underside with a bitumen-based paint or other damproofing solution. A good treatment for the concrete itself, particularly against dusting, is waterglass—the stuff that was once used for preserving eggs. It will seal almost any porous surface.

If you are more ambitious or the floor is very damp, you could duckboard it or even wooden floor it completely, ie, place beams (5 × 7 cm minimum) across the floor at about 30 cm separation and nail 5 or 7 cm slats with small gaps between them or unspaced floorboards across the beams. The beams at least should be of rotproof timber or should be suitably treated before laying. Alternatively, you can try the type of flooring used in caravans and boats, with an insulating undersurface of polystyrene.

Carpeting on the floor can also reduce heat loss and keep the feet warmer but it is better not to carpet the areas that might receive water or solution spillage.

Arrangement of the various working surfaces may be easier in an outside location but it does raise a few problems of its own. Garages and sheds can have sloping roofs. There is no very great problem if the roof is flat with a slight slope for drainage. Just bear in mind that one end is higher than the other. When the roof is V-shaped, however the side walls are often rather low. Depending on your own height and the height of the enlarger column, that may make it necessary, or at least more comfortable, to place your working surface across the V and locate your enlarger in the middle of it. If your door happens to be in the V-wall, as it usually is, you are left with just one obligatory wall for your workbench.

If you have a choice of three walls, place your enlarger as far away as possible from door and windows in case you have any trouble with light-trapping. If there is any difference, choose the wall most suitable for attaching a solid bench and possibly shelves. It is generally preferable to run the bench right along one wall. Again, do not be unduly influenced by the position of electricity supply sockets, if any. The next chapter deals with their location and extension.

Planning the ideal

Ideals are individual and my ideal darkroom may not be yours. They also depend on the kind of work to be carried out in the darkroom and the availability of equipment. Nevertheless, we can try to envisage what we would like to have and perhaps adapt a few of the ideal arrangements to suit our less-than-ideal surroundings.

We shall deal here with the internal layout rather than the construction because it goes without saying that the ideal darkroom has perfect light-trapping, insulation and ventilation. Inside, it measures 250 cm (about 8 feet) square or larger. It has a door, either opening outward or sliding, almost in one corner. The wall opposite the door (call it the end wall) and the one not adjacent to the door (the left hand wall) have benches running their full length with a height of about 80 cm and a depth of about 75 cm. The enlarger is located toward one end of the left-hand bench but with space to allow projection to the end wall. The space allows you to make notes or house negatives or paper temporarily. It may also accommodate the enlarger transformer, meter, etc.

On the other side of the enlarger is a small cabinet with drawers or trays to accommodate your negative and slide store (or part of it) and sufficient paper for your immediate requirements.

A little further down the bench are three processing dishes for black and white work, followed by a small sink let into the work surface with hot and cold water, or cold water and a wall heater. The sink is drained to an outside soakaway or gulley connected to the house drains.

On the wall behind this bench is a shelf running from the sink end

The 'ideal' darkroom described in the text. Safelighting should be on the ceiling or on a wall not too close to the enlarger or processing dishes.

to the enlarger. It accommodates measuring flasks, thermometers, small bottles of solution, print tongs, lens cases, enlarger negative carriers and the various other odds and ends that a darkroom soon accumulates. Above it, near the processing dishes, is an electric clock with a sweep second hand. Below it, behind the enlarger, is the enlarger time switch and/or exposure meter control box connected to the sensor that reads the baseboard illumination.

On the end wall bench, nearest to the enlarger, is the colour paper processor and next to it a partition or screen across the whole width of the bench and at least 75 cm (30 inches) high. On the other side of the partition, a low-power fully shrouded strip light illuminates the working surface sufficiently for you to make notes, read up the instructions, use a small tape recorder or indulge in whatever other activity you find useful and for which you need light.

Moving down the wall toward the door, we have an old refrigerator which stores just about everything else you cannot find a home for, but particularly your boxes of paper. Whether you store suitably sealed chemical solutions or packets in there as well depends on your calculation of the degree of risk. Certainly you do not use it for your current bottles or flagons of developer or fixer. They go under the processing bench, or if small, on the shelves above the dishes.

Next to the refrigerator is a small table and paper trimmer so that you can cut your larger sizes of paper in uncluttered comfort. On the remaining wall, the one with the door in it, there is a space heater that emits no light.

Attached to the ceiling in the centre of the room, or suspended from it, according to height is a 10 × 8 inch safelight with pull cord operation. On either side of it are three-foot fluorescent tubes also operated by pull cords. One of the cords is taken through metal or plastic 'eyes' to a position near the door. The other has a very distinctive grip at the end to distinguish it from the safelight cord or is also taken to another point in the room.

Ample storage space is available under the benches, protected by sliding doors fitted to the front.

Construction, Electrics and Plumbing

Setting up your own darkroom from scratch calls for various skills, ie, woodworking, electrical installation and plumbing. Be not afraid, however. The simple hand saw, hammer and nail, a modicum of determination and a chapter such as this by one who has suffered as you will, can help you much more than you think.

Cladding the walls

An outside location in garage or shed is likely to need wall cladding. Timber constructions are relatively weatherproof in the ordinary sense of the word but they provide very little insulation against cold and damp. They are usually about the easiest to clad because they are often erected on a framework to which sheets of hardboard can easily be pinned.

It may be sufficient to clad such a structure all round including the roof area, but it is preferable to insulate the gap behind the hardboard. There are various ways of doing this—using metal foil, expanded polystyrene in sheets or granules, glass fibre, mineral wool and so on. Any of the materials recommended for insulating roof spaces will do. Rolls of glass fibre are perhaps the easiest to use but wear garden or industrial gloves when you handle this material. It can be very irritating to the hands. Use a thickness of at least 60 mm, preferably more, but do not compress it. It relies for its effect on the air trapped in it.

If it is not practical to pack thick material behind the cladding, metal foil or heavy duty plastic sheeting might be used instead. At worst, you might at least keep the damp out by covering the rear of the cladding with a bitumen-based paint.

Hardboard is the cheapest cladding but more protection is offered by insulating board, which is softer, much thicker and about twice as expensive. Both are supplied in standard 8 × 4 foot panels.

Fastening the cladding to the wall is easy if you have a timber framework. Panel pins or hardboard pins are easily obtainable but for insulating board you need special large-headed nails. It is worth getting a panel-pin pusher for this job—a gadget that enables you to push the pins into the hardboard via a spring-loaded plunger in a thin tube. Hardboard is tough and it is not easy to hammer small pins into it.

If you have no timber framework, as in a concrete garage, you have to build one to fix the cladding to. With some structures, this is quite a problem because you cannot easily drill into concrete and it is at this stage that you might consider a timber floor. We dealt with this in the previous chapter from the insulation viewpoint but it can also help to provide an anchoring for your framework and for a partition if you are allowed only part of the garage.

Your framework should be made from timber at least 25 × 40 mm (1 × 1½ inches) simply constructed with top and bottom rungs, and uprights at 60 cm (2 foot) separation. If you cannot fix it to the wall, you must rely on force-fitting from side to side, top to bottom and/or end to end.

You can, of course, leave your outside location unclad and rely on such heating as you are able to provide but concrete, in particular, is very cold indeed and your heating bill may be enormous. Moreover, you generally need some timber to put in shelves, electricity points, switches, etc.

Even when you finish the wall cladding, you are likely to have a lot of gaps to fill up. Corrugated roofing material, for example, commonly leaves large gaps through which light and air stream unhindered. The garage manufacturers often supply eaves-filling kits as a remedy but if you do not have such a kit you will have to plug the gaps as best you can. The handyman skilled with a jig-saw can cut pieces of timber to a suitable shape. You and I, perhaps, are reduced to stuffing them with glass fibre wool, plastic foam or whatever comes handy.

Making the workbenches

Working surfaces are most suitably fastened to the wall if possible because that helps to keep them upright and avoids the problem

of getting all the legs the same size. Plugging to the wall, however, does imply a degree of permanence and entails boring holes in the wall, which may not always be acceptable.

Walls vary in construction. The traditional brick wall with plaster covering is relatively easy to drill, but you can never be sure what is under the plaster. In surprisingly many houses, the quality of the bricks leaves something to be desired. Breeze blocks (black, cinder-like texture) give no trouble but if the wall is simply a lath and plaster construction, leave it well alone.

Provided your wall is suitable, the rear support for the bench is a wooden batten about 25 × 75 or 100 mm (1 × 3 or 4 inches). Such a relatively thin batten is much easier to fix than the 50 × 50 mm material often recommended. Drill holes about 60 cm (2 feet) apart along the length of the batten to take about a No 10 screw that will project at least 20 mm ($\frac{3}{4}$ inch) into the wall. Of course, if you have just put up a partition, or clad your walls for insulation, you will know exactly where the battens are. Then you can screw your fittings directly to them.

Hold the batten in the desired position on the wall (about 80 cm or 32 inches from the floor). You will need help if it is a long bench and, preferably, a spirit level. Otherwise, measure up from the floor at each end to make sure you get it straight. It is not a bad idea to mark the wall all round the ends of the batten at this stage so that you can return it to the same position later. Hold the batten securely in position and mark the wall clearly through the centres of the screw holes, preferably with a spike. Put the batten aside and, with the correct size masonry drill (for the size of screw you use) drill the wall carefully to a fraction more than the depth required. Make the holes in exactly the right position. If you use an electric drill, push the drill bit hard into the wall before switching it on and set it to the lowest speed. Plug the holes with proprietary wall plugs if they are clean and cylindrical. If the holes tend to be ragged, use the wall-plug substitute—a loose fibrous material that you damp before pushing it into the hole with the tool provided. Do not overmoisten this material. If you do, let it dry out a little before the next step. Take the batten to the wall again and position it carefully. Screw it to the wall securely but do not overtighten the screws. If they feel very loose, you have the wrong wall plug, the

wall has crumbled or your loose filling is too loose. You will have to make another hole and try again.

When you have finished, take hold of the centre of the batten with both hands and pull outwards hard. It should be impossible to move it. If it comes out, bringing large lumps of plaster with it, your screws were not long enough or the wall is a bad one and you had better forget about plugging to it and go for a free-standing unit.

Some people have the confidence to hammer a batten on to the wall with masonry nails — very tough nails specially made for the purpose. It might work if you care to take the risk. A batten properly screwed to the wall will never come off.

We have spent a little time on this part of the construction because it is rather important. The rest of the woodwork is relatively simple and can be readily understood from diagrams. Hammer and nails, with occasional screws are generally all that are necessary. The true handyman will make neat joints and always use screws. Your general rule can be that a screw is unnecessary when a nail will go in. Clumsy joints are mostly out of sight and those that are not can be covered.

Nails have two main problems. First, whatever you nail into must be firmly supported; otherwise the hammer just bounces off; and in the end you split the wood. Secondly, they can be pulled out relatively easily. Knowing these limitations, you can quite easily get round them.

A batten on the wall provides firm support all along the rear of the bench. All you need then are cross pieces from the batten to the front legs and a long, deepish front piece nailed to the front of the legs. The diagram opposite shows the principle. If you use the wood-block method of securing the cross pieces to the rear batten, nail the blocks to the side pieces before securing them to the rear batten — unless you use screws in pre-drilled holes for this job. You should always put screws into pre-drilled holes but in soft-wood (and that is what you should be using) it is often possible to belt them in most of the way with a hammer and use the screw-driver for the last few turns.

The legs need be no sturdier than 50 mm square (2 × 2 inches). There is no harm in putting in more strength but timber is very

The bench support *(top)* depends largely on the strength of the wall fixing and the weight of the top. For extra rigidity, fasten the legs to the floor with angle irons, or increase the depth of the side and front battens.

Shelf brackets can be fastened to timber battens or you can use one of the commercial slotted systems.

expensive. You do not have to use new timber. Study the small ads in your local paper. You may find somebody offering second-hand timber and it is worth going along to see what they have. Take a steel rule with you. If you do buy new, go to a timber yard rather than the handyman's shop on the corner and, if you see materials advertised at a surprisingly low price, have a look at them before you buy. Hardboard and some of the proprietary laminated-surface boards come in various qualities and conditions.

If you can stand the cost, the best surface for your bench is undoubtedly the laminated-surface material sold by almost every timber yard and handyman shop. You can get it in lengths up to 8 feet and in various widths.

If that is too expensive you can use materials such as blockboard or old floorboards and surface it yourself with plastic floorcovering or similar material. Planks or boards can be nailed on. The laminated board is usually heavy enough simply to lay on top but added security is given by screwing through the top (definitely pre-drilled holes) or fixing underneath with small angle irons.

If you have to make a free-standing unit, the front construction is repeated at the back. If it is not rigid enough, put extra horizontal struts part way down the legs. You may wish to do that anyway because the struts can support a useful shelf.

Putting up the shelves

This is now almost a standing joke, but there are many shelf kits available that make the job relatively easy—again if you can stand the cost. Where trouble often occurs is in plugging the required support to the wall. The ostensibly simplest method is to screw shelf brackets directly into the wall. With a good wall that may work but it is easier to plug vertical battens to the wall first and then fasten the brackets to them, especially if you are putting up a bank of several shelves. This is the principle of the slotted metal strips into which brackets are inserted as required. It is easier and the finished job is stronger when the component plugged to the wall has very little depth.

It might appear that a bracket has no depth but the top screw does, in fact, take quite a strain and the wall plugging often cannot

withstand it. A much shorter screw into wood can take a much greater strain that is not directly transmitted to a single screw in the wall. The metal strips of the shelving kits can be so securely fastened to the wall that their shelves can take an incredible weight. Look for the sturdier types, however, that allow the brackets to be screwed to the shelves or the semi-industrial type with U-section brackets.

Putting in the power

One thing you must have in your darkroom is electricity and it is virtually essential that you provide yourself with several separate outlets. Adaptors and trailing cables plugged into one socket are inconvenient, untidy and potentially dangerous.

In this section, we must inevitably deal with United Kingdom type electricity supplies and regulations. The principles may be common to many countries but there are others (notably the United States) using a different voltage and different connectors. Regulations undoubtedly vary from country to country and there are those in which no wiring can be carried out by the householder. In the UK, there are no such regulations but any new installation or modification should be inspected by the appropriate electricity board.

In the UK, the supply voltage is 240, which simply means that your equipment must be designed for use on a 240-volt supply, either direct or through a transformer. Most projectors and some enlargers use low-voltage (about 12-volt) lamps and must be connected through a transformer, which is a device for converting the supply from one voltage to another (generally lower). The transformer is often built into projectors but may be a separate item for enlargers.

How we get electricity

The electricity arrives at your house in two very thick cables—black and red—that are connected via a heavy-duty electricity board fuse to your fusebox or domestic consumer unit. There the supply is split up via smaller fuses which connect thinner cables to your outlets—wall sockets for power supplies and ceiling or other connectors for lights. In the ring main circuit now generally installed,

the power fuses are rated at 30 amps and the lighting fuses at 5 amps.

An amp or ampere is a unit of current flow. Whenever you connect an appliance to an electricity supply, it consumes electricity which flows (for want of a better word) along the cables. The rate of that flow is measured in amps and is governed by the power requirement or consumption of the appliance. The consumption of power is measured in watts. An electric heating appliance, for example, may need to consume 1,000 watts or 1 kW. To do that, it must cause current to flow at a rate calculated by dividing the rated wattage by the supply voltage, ie, in this case, $1,000/240 = 4.17$ amps.

Two such fires would draw 8.32 amps and if they were plugged into a lighting circuit they would considerably overload the fuse, which should burn out. We shall continue to talk of fuses although many modern domestic consumer units are fitted with miniature contact breakers (MCBs) which cut off the supply when over-loaded but can be reset merely by pressing a button—after you have removed the overload.

The prime function of the fuse or MCB is to stop the overload before it heats up the cables along which the electricity is supplied and causes a fire. The cables used for lighting circuits (they are often flexes rather than cables) can carry about six amps safely. The power cable (a true cable with heavy insulation and much less flexible) can carry about 21 amps but in modern installations is connected in an unbroken ring from a fuse in the consumer unit through various outlets and back to the same fuse. Each socket is therefore effectively supplied through two cables and such are the vagaries of electricity that although the same voltage is present in both cables, the current divides between the two. The cables could therefore carry about 42 amps between them without overheating but the fuse is rated at 30 amps for safety. That is ample for most domestic installations. The exceptions are electric cookers, and sometimes other highly-rated items such as immersion heaters. These are connected to separate circuits with their own fuses and suitably-rated flex.

Thus, each ring (and a house may well have two—one upstairs and one down) can carry $30 \times 240 = 7,200$ watts or 7.2 kW. You

must not, however, connect all that load to one socket because the contacts in the socket can carry safely only about 13 amps or 3.2 kW. Consequently, the plug on the appliance (the three flat pin type) also carries a fuse with a maximum rating of 13 amps. The prime function of this fuse, however, is to protect the appliance. The current-carrying leads into the appliance are red and black in the case of cables and brown and black in the case of flexes. Most appliances have flexes, in which the wires are stranded. In cables, the wires (or conductors) are much thicker single strand. The red or brown wire is 'live'; the black or blue is 'neutral'. This means that the live wire has the mains voltage on it in respect to the voltage-less earth. If you connect a lamp between it and a good connection to the earth, the lamp will light. This is called a potential difference; the live wire has a potential difference in respect to earth of 240 volts, whereas the neutral wire is at the same (zero) potential as earth—or very nearly so in practice.

Why earthing is important

We said that the lamp lights if you connect it between the live wire and earth. So do you—almost. The human body is not quite as good a conductor of electricity as a metal wire but it does conduct. If you stand on a concrete floor with a live wire in your hand and somebody throws the switch, a heavy current will flow through your body and will amost certainly kill you. If you were on a wooden floor, you would feel the effect but you might get away with it. You will not normally grasp a live wire but you might well touch a faulty appliance in which the current has been allowed to reach the outer casing.

For that reason, the normal electrical cable has three wires—live, neutral and earth. In cables, the earth wire is unprotected inside the relatively thick outer insulation. In flexes, it has its own additional green-and-yellow striped insulation. These earth wires run from all outlets to the domestic consumer unit, where they are firmly attached to a good earth connection installed by the electricity board. The three-pin plug attached to the appliance carries a third wire to its largest pin to which all non-current-carrying metal parts, and particularly the outer case are connected.

Thus, if current is caused to flow through any of these parts it is immediately channelled to earth. As the earth wire makes a much better conductor than your body, you would probably feel little shock.

The efficiency of the earth wire as a conductor (it has virtually no resistance to the current, unlike most appliances) means that the current flow is huge. That is another electrical law: the lower the resistance to the flow of electricity, the greater the current. In practice, the flow is so great that the fuse is blown and the danger removed.

The 'short-circuit' caused by the fault might be caused by component failure, allowing the heavy current to flow through other components before reaching earth. That current might be enough to damage those components if it were prolonged. So the immediate cutout effected by the blown fuse protects the appliance. Some appliances are more easily damaged than others and, provided their current consumption is not too great, they can be protected by a smaller fuse. Consequently, plug fuses are available in standard ratings of 13 amps and 3 amps. Additionally, many items have fuses built in of a much lower rating—one amp or less.

Extending the supply

Again, we have to say that electricity board regulations require you to have any work you do on your fixed house wiring to be inspected before you start to use it. We must also say that, unless you are sure you understand exactly what you are doing, do not do it. Call in a qualified electrician.

Now we know how electricity comes into the house, we can think about extending it. Take the simplest case first. You are in a room that has a single socket and we want more in a more accessible place. There is one simple, inexpensive, legal and perfectly safe way of doing that. You buy an extension panel from almost any electrical or chain store. This is a single long, neat plastic housing with up to four sockets, a warning light and a fuse. You merely connect a flex of suitable length and a plug on the end of it and you have four more sockets anywhere you want them. You can even fix them to the wall—and you can completely isolate them when

Wiring a 13 amp plug. The brown wire goes to the fuse, the green and yellow to the large flat pin and the blue to the other smaller pin.
Extension panels *(bottom)* are available from electrical shops and stores. All you have to do is fit a length of cable and a plug.

not in use by pulling out the plug. Such a solution does not require any approval because you are not altering any part of the fixed wiring. Do not use one, though fed by an old-style round-pin 5 amp (or, worse, 2 amp) socket, or from any two-pin socket. An old 15 amp (power) socket is suitable.

If that is a convenient way of solving your problem, read no further in this section. There is no sense in doing anything else. Just remember that they are all running off one socket and that your total consumption must not exceed $13 \times 240 = 3.1$ kW or 3,100 watts. You are unlikely to need that much in a darkroom unless you use a powerful electric space heater.

To put in permanent sockets you have to do a lot more work. First you buy the sockets and a length of ring main cable (technically known as 2.5 mm²) sufficient to run from your chosen location to the nearest pick-up point by an inconspicuous route. The pick-up point will be the nearest existing socket or a junction box. The latter is a round, flattish container with a screw off lid which serves to join cables together either in a simple end-to-end joint or to form a junction between an existing cable and an extension. If there is no junction box between your chosen location and the nearest socket, you might consider putting one in, but do not do that if the cable is at all tight. You need a reasonable amount of slack in the cable to make a satisfactory reconnection after you have cut it.

Apart from the sockets and the cable, you also need cable clips to fasten the cable neatly to the wall, door post, floor joists, or whatever—one to about every 50 cm or 18 inches, plus a few for bends. For preference, buy double sockets. They provide twice as many outlets for the same amount of wiring.

They can be switched or unswitched, surface or flush. There is little point in buying the more expensive switched type if the equipment to be attached to it has its own switch. Flush means that you sink the box containing the socket into the wall. Surface means that you fix it to the wall surface. The flush type has a different box, generally metal and smaller than the outer panel. The surface type has a plastic box the same size as the front panel. It is much easier to handle because few walls now have plaster of such a depth that the box can be sunk into it. You usually have to

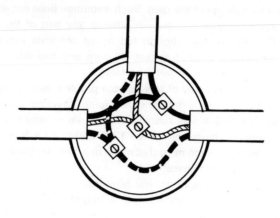

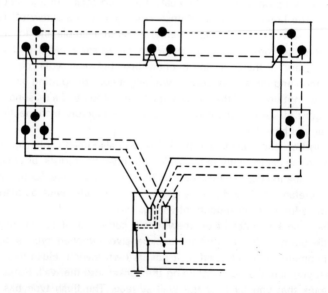

The junction box *(top)* allows the existing wiring to be tapped. All wires of the same colour go to the same terminal.

The principle of the ring main *(bottom)* is that a single cable runs from a fuse in the domestic consumer unit through all the sockets and back to the same fuse.

gouge a hole out of the wall with cold chisel and hammer. Nevertheless, the flush type is neater and more secure once properly fixed.

With all the materials to hand you are ready to start work. Start by fixing the boxes to the wall, then wire the sockets and carry the cable back to the pick-up point. That way you need to switch off the electricity only while you do the actual connecting up. If you go the other way, you have no power to work with and your electric drill, if you have one, is useless.

We dealt with plugging the wall in the section devoted to workbenches and the principle is the same. Once you have the boxes secured take one end of your cable and strip off about 100 mm of the outer insulation. This is best done by laying the cable flat and cutting down the middle—where the earth wire is—with a sharp thin blade. You will find various places in the box where you can knock out a hole for the cable entry. Choose the one most convenient for the way the cable is to run and feed the cable in. Pull it well through to give you room to carry out the wiring comfortably. Take the red cable to the L hole in the back of the socket plate, the black to the N hole and the bare wire to the E. Cut them to suitable lengths to lie reasonably flat behind the socket. Strip about 10 mm or $\frac{1}{4}$ inch off the black and red insulation, insert all three wires in their appropriate holes and tighten the grub screws until the wires are held securely.

Place the socket plate on the box, pulling the excess cable back through the hole in the box as you do so. Do not, though, let the black and red tapes come out of the box uncovered by the outer insulation. Screw the plate on to the box. Run your cable along its allotted route. If you have used a flush box that usually means cutting a channel in the wall plaster down or up as the case may be. Keep the cable taut and flat and secure it to the wall, door frame or whatever with cable clips. Do not run the cable through doorways or window openings. It may become damaged by the door or window, or by people walking through. Such an expedient is not approved by the regulations. From one room to another, you must pass the cable through (or under) the wall.

When you reach the pick-up point, turn off the electricity at the consumer point or pull out the fuse serving that particular circuit.

Return to the pick-up point and unscrew the socket plate from its box. Pull the plate clear of the box. It should bring a short length of cable with it—or two lengths if it is part of a ring main. All you have to do now is to feed your cable into the box (which may entail removing the box if it is a flush type) and connect it in exactly the same way as you did the other socket. You should then have two or three wires at each terminal. Make sure that all wires are securely held by the grub screws. Replace the socket plate and you are finished—apart from switching on again at the consumer unit.

Observing the regulations

There are regulations, of course. The additional wiring we have just described is known as a spur. The regulations say that you must not have more spurs on a ring main than the socket outlets on the ring. That need not concern us too much but the regulations add that not more than two sockets (or one double socket) can be connected to each spur, which is awkward if you intended to connect four. If it were not for this regulation, you could just add two further sockets by wiring another double socket to the one you have just installed. All you need is a short length of cable to connect red to red, black to black and earth (bare wire) to earth.

To keep within the regulations, however, you should run two separate spurs from your original socket or you should extract one set of wires from that socket and take it to a junction box. You then run one set of wires from the new double socket to the junction box and another set to the old socket. You have then, in effect, extended the ring and can run a spur from the new double socket to serve another pair.

An odd point about the regulations is that you can connect your spur circuit to the original socket via a plug instead of wiring it in. It is then a temporary supply and is within the regulations.

Wiring outside locations

If your garage or other outbuilding already has an approved electricity supply you can proceed in the way we have just

described, bearing in mind, perhaps, that the supply may already be a spur and is subject to the regulations regarding the number of sockets.

If the location has no supply, you have to take it from the house. The procedure is broadly the same but you cannot, according to the regulations, connect to the ring main unless the location is attached to the house. If it is a detached structure, your final connection must be made to a separate fuse at the main fuse box or domestic consumer unit. Moreover, you must take the supply into the outbuilding via an isolating switch. The normal switch is in the live wire only: it does not break the neutral wire. An isolating switch breaks both wires and disconnects the outside wiring totally from the main supply.

There is more! If you run the cable underground, it must be at least 50 cm (18 inches) down and enclosed in heavy gauge galvanized steel conduit—or you can use special underground cable. If it runs overground, it must be suspended from a strainer (stranded galvanized wire) at least 3.5 m (12 feet) above the ground and attached to it at intervals of no more than 30 cm (12 inches). You can omit the straining wire if the run is no more than 3 m (10 feet). Alternatively you can run it along a wall provided it is enclosed in heavy gauge galvanized steel conduit but you must not run it along a fence.

Safety is particularly important with outside locations, where the risk of electrical shock is greater. When you run a cable into a building, make sure that the entry is completely watertight. Secure the cable just outside the building so that the entry is in an upward direction. Water cannot then run down the cable to an inside connector.

If you are in any doubt at all—as with any other electrical wiring—do not do it!

Lamps and lighting

Safelights and white lights can be plugged into any available socket (with a 3 amp fuse in the plug) or they can be wired separately. Regulations now demand that lighting circuits also

The double socket has internal connections and therefore needs only three terminals to accept the live, neutral and earth wires.
Pull switches *(right)* are advisable and sometimes obligatory in the presence of water.
Batten lampholders *(left)* are simply screwed to any available surface at any required angle.

carry an earth wire although most houses are probably not so wired and many lighting fittings have no earthing point. So-called batten holders are commonly used in garages and other out-buildings. They are screwed to a suitable wooden base or batten and may have three terminals. The third terminal is, however, a looping-in connection which allows you to run the wiring through to another light fitting.

Lighting wiring becomes complicated by the fact that a separate switch is generally necessary. Switches in power sockets are generally incorporated in the socket but for lighting, the live wire has to be taken from the supply to the switch and thence to the light fitting. As the switch is often remote from the lamp, the wiring arrangements become confusing. They are eased a little if you use pull switches, which are advisable in outside locations anyway. Pull switches can be fitted close to the lamp and the cord taken to a remote point as necessary. Or they can be fitted close to the supply point. Either way, remember that a switch is simply a break in the live (red or brown) wire. Both wires at the switch are therefore live but the neutral (black or blue) wire is sometimes carried through the switch via an insulated terminal.

Earthing and insulation

We have already explained the necessity for earthing. Many electrical appliances have no earth wire however. They are fed via a twin flex only—the brown (live) wire and the blue (neutral) wire. They are commonly described as double-insulated and have no external metal parts that can become connected to the supply. This is brought about largely by plastic construction. Most plastics are efficient electric insulators, ie, they have almost infinite resistance to the flow of electrical current at the domestic supply voltage. Many of them are also extremely tough and durable and can be used in the construction of spindles, cogs and other moving parts that previously had to be made from metal. Where metal still has to be used, therefore, it can be effectively isolated from the electrical conductors by connecting it through plastic components. Such appliances are generally of relatively low power ie, they draw little current. Anything drawing in excess of one amp or so is

likely to be fed by three wires—commonly called twin and earth. In that case it is vital that the earth wire (green and yellow) is connected to the main earth via the large pin of the three-pin plug. This is for your own safety. Unearthed equipment is dangerous!

Water and plumbing

We explained at the beginning of this book that running water is by no means a necessity in a darkroom. If you have a reasonably large, permanent darkroom, however, and particularly if it is isolated from the house, running water is certainly convenient.

To install it you have to know something about plumbing. Modern plumbing is effected by relatively small bore copper tubing that is remarkably easy to use. With any luck you have such a pipe running to the cold water tap in your kitchen, probably of 15 mm tubing. You take your supply from this by cutting the pipe, fitting in a tee-junction and running another pipe out. It is almost as simple as it sounds.

In practice, you first turn off the water at the main stopcock and turn on the tap in case there is still any water under pressure in the pipe. You may have a drain cock that allows you to drain away any remaining water in the pipe rising to the tap. If not some water will escape when you cut the pipe.

Make an absolutely square cut (with a sharp hacksaw blade) in the pipe at about 60 cm (2 feet) from floor level. Take a compression tee-junction (see later) and fit it into the pipe. This entails making a further cut to remove a small piece of the pipe. Tighten the nuts hard. Fit about 15-30 cm (6 to 12 inches) of new pipe into the tee and fit a screw-down stopcock (also see later) to the other end with the arrow on its body pointing in the direction of the water flow. Again, tighten the nuts hard. Turn off the new stopcock, turn on the main stopcock and the household water supply is restored. The rest of the work can be carried out at your convenience. The stopcock is put in here so that you can cut off the darkroom supply when it is not required—especially necessary in the case of an outside darkroom where the pipe may be subjected to freezing temperatures.

If you take the trouble to acquire basic darkroom skills you can expect your pictures to be consistently better than those provided by normal develop-and-print services.

Picture composition may be enhanced by the inclusion of a frame. It is an effective device to do this in the camera if the subject is suitable (see opposite page); otherwise it may help to add a frame to the finished print using an artists' pen.

The use of an enlarging meter can save time and trouble and need not cost a great deal. However, as with through-the-lens meters built into cameras, enlarging meters need to be used with care when an overall high-key (*top*) or predominantly dark effect is sought.

A test strip (see pages 781-4). Reading from the right, the strip was given exposures of 5, 10, 15, 20, 25 and 30 seconds. The finished print corresponds to the third patch from the right – i.e. it was exposed for 15 seconds.

By selective enlargement you can concentrate on a small part of the negative image area – not as good as owning a true macro lens, but an effective substitute for the occasional shot.

Grain (see page 987) tends to be most evident in flat mid-grey areas of black and white prints; a print such as this, which has many such grey tones, would show a lot of grain at high magnifications.

Abstract or semi-abstract photographs are always interesting to produce. *Top* no tricks, just foam on the river, photographed with a standard lens. *Above* pebbles, taken through a 200 mm lens.

Materials and fittings

While we are awaiting your convenience let us consider the materials. The 15 mm tubing is supplied in 3-metre lengths and is easily bent by hand provided you use a bending spring for all but the most gradual bends. It can be joined with compression joints or capillary joints. A compression joint is fitted with nuts that you remove to reveal an olive or compression ring that fits over the tubing. In practice, you need only loosen the nut and push the pipe in through the ring until it reaches a stop. Tighten the nut and the soft copper ring is squeezed between tubing and nut, forming a perfect joint. You need to hold the tube in a wrench and tighten the nut with a spanner. Some say do not tighten it too hard and, if you ever need to undo the joint, it will retighten satisfactorily. Whether that is good advice is open to doubt.

Capillary joints need a blow lamp but they are neater and less expensive. They have an internal ring of solder in a recess around the tube. You push the tube into the joint and direct a blowlamp on to it until solder oozes out all round the joint. Wipe off the excess and you have a neat joint. Preparation has to be more careful for this type of joint. You must clean the end of the tubing thoroughly with steel wool and smear a little flux on to it before making the joint. You must make all joints together because the solder rings all melt when you apply heat to any part of the fitting. When making a joint in a pipe against a wall or other surface, slip a piece of asbestos behind the joint to protect the wall from the blowlamp flame.

Both types of joint are supplied in various shapes and sizes for making junctions or bends or simply for joining one length of pipe to another. They are also available with unequal outlets to allow different sizes of pipe to be joined. You would need such a joint, for example, to take a 15 mm supply from a 25 mm pipe.

There are various types of what we commonly call taps, too. You may not immediately recognize the description 'screw-down stopcock' but it is only another name for the type of valve that is inserted in a pipe to allow the supply to be turned off. It looks much like any other brass tap except that it has no spout. It always has an arrow engraved on its body to indicate the direction of the water

It is a relatively easy matter to fit an outside tap with the compression joints shown right. The text gives full details. If you have to bend the pipe, a bending spring stops it kinking.

flow and should always be inserted with the arrow pointing in the direction of the flow.

Assembly

Now to return to the fitting. You have a short length of pipe and a stopcock fitted to the existing supply. We referred to the supply to the cold tap in the kitchen because that is the easiest to get at and has the greatest flow. You can take your supply from the bathroom if you like but you may have to drain the whole system and you may not find the pipes easy to get at. Wherever you are, with the supply connected, you have to run tubing from the stopcock to the required location. How exactly you do that depends on the barriers in between. You may have to take the cold chisel and hammer to a wall again. Knock it out reasonably gently but there is no need to make a neat, tight-fitting hole. The filling materials now available from hardware stores and do-it-yourself shops are easy to use.

If you are running your supply to another room in the house, take the most direct route available, under the floorboards, if possible. Secure the pipe liberally all the way with pipe clips supplied for the purpose. If you run the pipe outdoors, you can take it along a wall or fence or underground. If it goes underground, it should be at least 80 cm (2½ feet) down to protect it against freezing. Above ground, it should be well lagged for the same purpose. The best protection, however, is to turn off the supply and open the tap at the darkroom end when it is not in use. Better still, fit a draincock at the lowest point of the supply so that you can drain the pipe after turning the water off.

In the darkroom you terminate the pipe in a suitable tap. The type you use is governed by the type of sink unit you fit but if the tap is simply to hang above the sink and run into it, a wallplate elbow of the type used to fit external taps for garden hoses is useful.

If you have to bend the pipe (and that is frequently necessary at the tap end), get hold of a bending spring of the right diameter for the pipe. Grease it slightly and insert it in the pipe to beyond the point of the bend. You can then easily bend the pipe over your knee without kinking it. To make removal of the spring easier, it is best to overbend and then ease back to the curve required. Insert a

screwdriver through the ring at the end of the spring, twist anti-clockwise and pull the spring free.

You can run hot water to your darkroom in the same way, of course, but a better idea, especially outdoors, might be to fit a small electric or gas heater connected into the supply. There are butane gas types that can be run from the same cylinder as a space heater if that is your choice.

Waste disposal and drainage

If you have running water in your darkroom, you need some method of running it out again. The easiest method is simply to fit a flexible hose or piece of polythene tubing to the outlet and run the waste into a suitable container under the bench. There are plenty of 20-litre or 4-5 gallon water carriers available that do the job admirably. You can even seal the tubing through the stopper to avoid fumes or overflow.

Plumbed-in drainage can be awkward. There are regulations about it, especially in newer buildings with single-stack drainage, ie, where all soil and waste runs into one main drainage pipe. If you can easily cut straight through a wall to a nearby existing gully, you should have little trouble because plastic piping and fittings can be used throughout and are quite easy to work with.

Draining an outside location could be effected by means of a soakaway but it means a lot of hard work. You have to dig a pit 1.5 m (5 feet) square and 1.5 m deep, 5 m from the building (and the house). You then fill it to about 30 cm (1 foot) from the top with rubble (broken bricks, stones, etc.) and run an underground soil pipe from the middle of the pit back to a gulley outside the darkroom into which the waste is discharged. Put the topsoil back over the rubble and your soakaway is operational.

All fittings are again plastic and are joined simply by pushing together through O-rings. The underground pipe is immensely strong but is easily cut with a hacksaw or any type of handyman's multi-purpose saw.

Keeping it warm

If your darkroom is inside the house, heating may be already available but you still have to consider its suitability. Any kind of

non-radiant heating is fine but most gas fires and many electric heaters are of the radiant type: they emit light. You may be able to shield your working area from the glow, but it is not easy, particularly when loading films into developing tanks.

The ideal temperature you should aim at is about 21°C (70°F), which avoids in most cases any need for a dishwarmer to keep your developer at the correct temperature. Indoors, that should not be too difficult. Outdoors, it might be expensive if you have not insulated the darkroom carefully. It is best to avoid electrical heating unless you are certain that it will not overload your circuit. If you have, as you should have, a completely separate circuit from the consumer unit to your outside darkroom, you should have no problems with electric heating. Otherwise, when you turn on your 2 kW or more heater while other heavy demands are being made on the current in the house, you might well blow a fuse.

Other forms of heating are bottled gas (butane or propane) and oil (kerosene or paraffin). Either of these is suitable provided the room is reasonably well ventilated and, again, provided the heater does not radiate too much light. Perhaps one of the best types of heater for the darkroom is the butane catalytic type. This is a very safe form of heating that has no flame. It relies on comparatively low-temperature chemical reactions to provide heat. It needs no flue but reasonable ventilation must be provided. The fumes, as with a properly maintained oil heater, are minimal and should give no trouble in the relatively short time you will normally spend in the darkroom. If you have any doubt about the adequacy of your ventilation, take a break every hour or so and open the door wide. If you cannot manage to get the temperature up to 21°C and if you are happy to work in cooler surroundings, a waterbath will keep your developer up to the correct temperature. There are useful thermostatically-controlled immersible heaters supplied for aquaria and also sold by wine-making hobby shops and some photographic stores. One of these in a tray of water larger than your developing dish will keep your developer at the required temperature almost indefinitely. Such a heater can even be used quite satisfactorily for colour work with a processing drum if you divide the solutions up into small bottles and stand them in the tray along with the drum.

Basic Darkroom Equipment

How you equip your darkroom depends on the depth of your pocket and your attitude to the job in hand. The main objective is to make photographic prints. You can get by—and most people do —with the barest of essentials such as an enlarger, safelight, processing dishes, measuring flasks and storage bottles. You can also equip yourself with all the luxuries, such as exposure timers, meters, voltage and temperature control equipment, processing machines, print dryers and glazers, paper safes, colour analysers and so on. In this chapter, we deal with the more or less essential equipment. The accessories and other items that make life easier but do not necessarily improve the standard of work are left for the next chapter.

Enlarger construction

A photographic enlarger used to be a very simple instrument. All it needs is a source of light to illuminate a negative evenly and a lens to project the image of that negative on to a support for the paper on which the print is to be made. In its simplest form, the modern enlarger consists of a column mounted securely on a baseboard. An arm rides up and down the column and supports the enlarger head centrally over the baseboard. The head consists of a light-baffled lamphouse, containing the lamp and, below it, a piece of opal glass as a diffuser. The lamphouse sits on a negative carrier designed to hold the negative flat centrally under the lamp. Below that is the lens, mounted on a small bellows or a helical-thread tube for focusing.

That is all there is to the simplest of enlargers. A cable runs out of the top of the lamphouse for connection to the electricity supply and, when the lamp is switched on, the diffuser spreads the light reasonably evenly over the negative below it and, as the lens is

moved up or down, the image of the negative is focused on the baseboard. Raising or lowering the head on the column allows the size of the projected image to be varied. The principle is exactly the same as that of the slide projector.

A more efficient arrangement is to replace the diffuser with a condenser lens, the function of which is to collect as much light as possible from the lamp and to concentrate it on to the negative area, thus providing brighter illumination and rather more contrast than the simple diffuser is capable of.

The focal length of the enlarger lens is generally similar to that of the standard lens on the camera—50 mm for 35 mm film, 75-80 mm for 6 × 6 cm and so on. The focal length of the lens controls the degree of enlargement possible at a given height of the head on the column. As in close-up photography, to which enlarging is also closely allied, a shorter focal length lens provides a larger image at a given separation between lens and image—but a shorter than standard lens needs careful design and manufacture to ensure even illumination and definition of the projected image. The few 'wide-angle' enlarger lenses available are consequently costly.

The focal length of the condenser lens is related to that of the projection lens. The condenser has to be of sufficient diameter to illuminate the negative evenly, commonly about 65 mm for 35 mm film and about 90 mm for 6 × 6 cm. It should have a focal length that allows an image of the lamp to be focused sharply within the projection lens. As the distance between lamp and projection lens varies, however, with the degree of enlargement, the position of the lamp should be variable too. There often is some provision for this but, as enlarger lamps are now commonly of the opal type, forming a relatively large, diffuse light source, critical focus of the lamp is not necessary.

The compromise focal length generally used for the condenser lens is about half that of the projection lens. It is possible to make such a lens for the 35 mm format from a single glass but for the larger formats such a lens would have to be extremely thick and it is general practice to make two separate lenses that, in combination, provide the focal length required. The lenses are generally of plano-convex construction (one flat side and one curving out-

ward) and, when used in pairs, they are mounted in a metal housing with the convex sides inward.

Negative carriers

The straightforward negative carrier consists of two metal plates with central square or rectangular apertures of the negative size. The negative is sandwiched between these plates in such a way that the image area can be clamped squarely in the aperture. The carrier generally allows negatives to be inserted in strips and is placed into and removed from the enlarger via a slot between lamphouse and focusing unit.

The negative carrier for 35 mm film holds the film flat by pressure on the edges, exerted by the weight of the carrier itself, by pressure on the top plate from the head or by springs in the slot. For larger formats it is preferable that the negative be sandwiched between glass plates or, as the curl is toward the emulsion, at least held flat by a glass plate on top.

Negative carriers vary in design and sophistication. The basic elements are those described but they may consist simply of two separate plates or may be of complex construction, with a thin hinged top plate and a lower part housing a sliding red filter and shutters to vary the framing. In the more sophisticated enlargers, the carrier can be tilted to allow focus to be maintained during perspective corrections when printing from a negative with, for example, converging vertical lines. It may also be possible to turn the head on the column to project sideways to a wall or other support when the column height does not allow the degree of enlargement required. Alternatively, many enlargers allow the head to be swung round on the column to project over the back of the baseboard on to a lower surface or the floor, with suitable weighting of the baseboard.

However the enlarger is constructed, the basic requirements are that its supporting column be rigidly mounted on the baseboard and, if it is a vertical column, that it makes a perfect right angle with the baseboard. (There are some enlargers in which the supporting column slopes forward.) Whatever the type of column, the arm

must support the head in such a way that the negative carrier is in a plane parallel with the baseboard and at right angles to the lens axis. The head must move freely on the column but it must, nevertheless, be possible to lock it positively at the exact height required. The lock may be mechanical, as is common with tubular steel columns, or it may be achieved by a friction drive mechanism, more common on square section columns. The friction-drive types must never be lubricated. They are often much slower in operation than, say, a tubular column with internal counterweight. They rely on the resistance to movement for maintaining a given setting.

Enlargers for colour work

The straightforward black-and-white enlarger contains little more of note but there are few enlargers now that do not take account of the fact that you might want to undertake colour printing. Unfortunately, the terminology applied to enlargers suitable for colour printing is not very precise.

One method of colour printing uses a set of just three—red, green and blue—filters held below the lens. It is called the additive system and calls for three separate exposures, one through each filter in turn. That, though perfectly practicable, is time-consuming and requires great care to ensure that no movement of the image occurs between exposures. The almost universal method of colour printing, however, uses magenta, cyan and yellow filters to subtract green, red and blue light respectively from the 'white' light of the enlarger lamp. This method is accordingly commonly known as the subtractive or white-light method.

The main requirement for colour printing is a set of filters to enable the colour of the light to be adjusted to suit various combinations of negative and paper. These filters are best placed between the lamp and the negative, where they have to be reasonably clean but do not have to be of optical quality, because they play no part in forming the image. If the top of the enlarger head is removable, it is easy enough, though not entirely satisfactory, to drop the required filters in on top of the condensers. From that, it was obviously only

Colour printing needs provision for filters in the enlarger. A simple filter drawer above the negative holder may suffice or filtration may be built into the enlarger and operated by external controls.

a short step to modifying the ordinary enlarger in such a way that you could pull out a light-baffled drawer from that region and insert the filters at the front of the enlarger. Such an instrument is then called a colour enlarger.

The filters used in a filter drawer are commonly sheets of dyed acetate film and are relatively fragile. They are called CP (colour printing) filters. They are easily scratched and affected by heat, moisture, grease, etc. That is why it is not advisable to use them habitually on top of the condensers in an ordinary enlarger without protection from heat-resisting glass. They are supplied in various sizes (75 mm square being normal for 35 mm and 6 × 6 cm enlargers) and are quite expensive in the full set of 17 or more.

You can use high quality gelatin filters (CC filters) below the lens for subtractive printing. However, for that they must be scrupulously clean. Even so, they can degrade the print image somewhat by introducing flare. What is more the process is a little tedious. CP filters are not recommended for this process, but if you need only one or two, they will probably work as well as CC filters.

Rather than a set of filters in a drawer or under a lens, more advanced enlargers incorporate a system of filtration in the lamphouse. Fade-resistant dichroic filter wedges are moved in and out of the light beam to change its colour. They are controlled by dials, sliders or whatever on the front. Some of these designs are relatively simple, others are complex. The dials are calibrated in units similar to those used to define the colour and density of conventional filters. Most are a great deal more expensive than the filter-drawer type.

True colour enlargers with inbuilt filtration often use low-voltage (10-12 volt) halogen lamps, which are not so prone to ageing and alteration of colour value as is an ordinary tungsten lamp. To reduce the mains voltage, the enlarger has to be run from a transformer, which may also contain a voltage stabilizer to maintain constant colour and intensity from the lamp. Reflex illumination is also commonly used to protect negatives from the heat of the lamp. A filter drawer allows conventional filters to be used to augment the inbuilt arrangement. For black-and-white work the filter controls are turned to zero.

Additional features of enlargers

Enlarger manufacturers frequently offer convertible enlargers. The colour enlarger is the black-and-white version with the lamphouse changed. Everything above the condensers of the black-and-white enlarger can be easily removed and replaced by a colour head containing the colour filtration system. It is as well to bear this in mind when buying or replacing an enlarger. The black-and-white enlarger—provided it has a filter drawer—is perfectly satisfactory for colour printing, but the colour head makes life a lot easier. You simply dial infinitely variable filter values in, instead of constantly selecting rather fragile acetate filters and placing them in the filter drawer. If you intend to do a lot of colour printing, you may well find the high initial cost well worth while.

A feature of some enlargers that is not very common these days is an auto focus mechanism. As you raise or lower the head to alter the degree of enlargement, so the lens is automatically moved to maintain correct focus. The facility is generally limited to enlargements up to about 8 or 10x and is by no means essential. It is, however, very useful when you make a series of prints from parts of many negatives and therefore at different degrees of enlargement. Some enlargers have rangefinders instead. You pull out a knob, or make some other adjustment, and the enlarger then projects a line image (instead of the negative) onto the baseboard. Adjusting the focus until this image is exactly continuous, focuses the enlarger. This is a useful but by no means essential feature.

A feature also becoming more commonly available is portability or, in some cases perhaps, transportability. There is one true portable 35 mm enlarger that packs away completely in a stout, small case like a small attaché case while many others can be dismantled and stowed away compactly in the original, reasonably durable packing. This can be a useful facility for those who have to clear the darkroom after each session.

Choosing an enlarger

Choosing your first enlarger is not an easy task. Sensible advice is to choose the most versatile type, ie, one that can handle more than

Portability is useful when space is limited. This enlarger packs away into a suitcase-like container that also serves as the baseboard.

one size of negative and that has a colour head available for sub-sequent upgrading. Ease of dismantling is never a bad feature, provided it does not affect rigidity and smooth, positive operation. In practice, an enlarger with all these features is rather expensive and there are cheaper versions that may suit your requirements perfectly until your financial situation improves. We have already detailed the essentials you should watch out for and there is very little to add. Fortunately, bad enlargers are rare, particularly among those offered by well-established manufacturers and, if your choice has to be governed totally by cost, you should still be able to produce quite satisfactory results.

Enlarger lenses

As important as the enlarger itself is the lens you fit to it. It is not more important because, no matter how good the lens, it cannot produce first class results unless the enlarger holds it, the negative and the lamphouse rigidly in position at all times. The lens is commonly an extra because there are relatively cheap lenses and very expensive ones. Again, the sensible advice is to go for the best you can afford—and again such advice can be modified.

Among the innumerable enlarger lenses on the market, there are a lot of comparatively inexpensive types that can give you all the quality you need when stopped down slightly and used for enlargements up to 8 or 10x. Indeed, in these conditions, even the most expensive lens could not better their performance—and they certainly exceed the capabilities of any camera lens used on an enlarger.

The construction principles for enlarger and camera lenses are entirely different. Theoretically at least, a lens gives its best performance at one object distance only. Certainly it is possible to design a lens that performs better at one fixed distance than the best of camera lenses—and at a fraction of the cost. An enlarging lens, is, in fact, designed to give optimum quality over a limited range of subject distances—the subject being the negative, which it is, in effect, photographing at close range. No ordinary camera lens is so constructed. It is designed to provide sharp images at subject distances from as far away as practicable to a metre or so from the

Darkroom aids. A masking frame is virtually essential to help you position the paper correctly, especially when colour printing.
Focusing magnifiers are not so vital but they can make focusing a lot easier, particularly with dense negatives.

lens. At closer range its performance is often noticeably poorer, as you may find in ultra close-up photography. In fact, you can often use a quite inexpensive enlarger lens on the camera and get a better result than with the camera lens at very close range.

So do not be put off by the fact that your resources are limited. A first-class enlarger lens (by reputation) can cost a great deal of money, but you can get excellent results for far less expenditure. The satisfaction that you can get from making your own prints far outweighs the possible disadvantage that you may run into a slight loss of quality if you push the lens beyond its true capability. If you are thinking of colour, you may paradoxically have less of a problem. Colour printing material is expensive and it is unlikely that you will often make prints of sufficient size to tax the capabilities of even a moderately-priced enlarger and lens.

Of course, enlarger lenses, like camera lenses, come with a variety of specifications. Most have apertures of between $f2.8$ and $f5.6$ for 50 mm and shorter, and between $f4$ and $f5.6$ for longer focus ones. In general, the wider aperture lenses are disproportionately more expensive. If your budget is limited, you will be much better off with a renowned $f4$ or $f4.5$ 50 mm lens than with an unknown $f2.8$, for example. With a reasonably bright enlarger light, you can work quite happily, even in colour at $f4$ or $f5.6$. If you buy an $f2.8$ lens, choose one that has been reliably well reported on.

Another important point is to choose a lens with good aperture click stops. If you work with colour, you will need to select a lens aperture entirely in the dark, so you must be able to count the clicks easily. A few lenses offer illuminated stop numbers to assist with this. The exception to this advice is if you always use an enlarging meter, (see page 741). In that case, with the simpler models, you keep the time constant, and vary the aperture until the meter indicates the correct exposure. Of course, that can be at any point, not just at fixed intervals dictated by the click stops.

There can be one unexpected problem with the lowest-price lenses, though. The aperture may not close down evenly. That is a major difficulty. It means that you cannot safely assume that altering the time and changing aperture to compensate will give you the same print density.

A good print of an average subject has deep shadows, clear white highlights and a long range of grey tones in between.

If you print your own pictures you can crop them in various ways to change emphasis or produce a picture in a different format.

Page 722 top nature provides many good opportunities for black and white photography. The two plants above were taken from a low viewpoint so as to obtain an appropriate background.

Page 722 bottom the young beech leaves are pale in tone and therefore stand out well against a background that is deeply shaded.

Printing papers can be obtained with a variety of surface finishes. Although there are no hard and fast rules, some photographers believe that a matt surface is best suited to subjects such as the portrait above, while photographs containing a wealth of fine detail, such as that of the Mexican temple on the opposite page, look particularly handsome when printed on a high gloss surface.

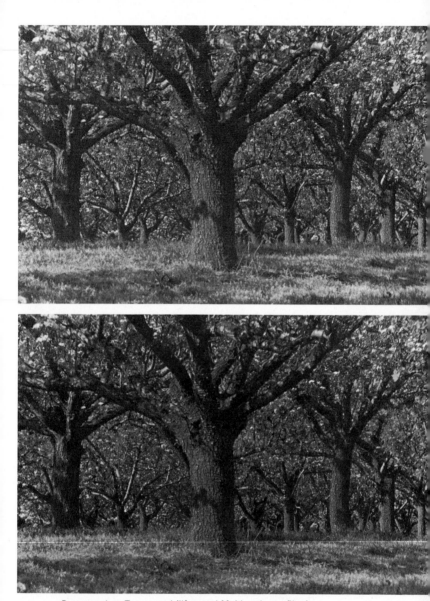

Paper grades: *Top* normal (Ilfospeed Multigrade, no filter).
Above Grade 1 – soft (Ilfospeed Multigrade with filter no. 1).

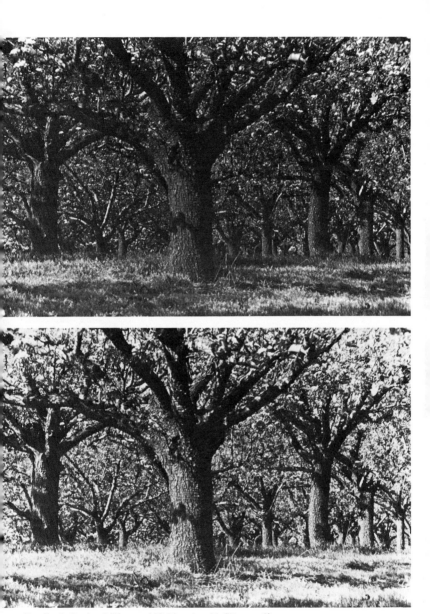

Top Grade 3 – hard (Ilfospeed Multigrade with filter no. 6).
Above Grade 5 – extra hard (Ilfospeed grade 5).

Top vignetting is easily accomplished by cutting an oval-shaped hole in a piece of opaque card and using this to mask the print during exposure.

Above a contact sheet made for a 12-exposure roll of 120 film. The photographer has numbered the prints for ease of reference and punched holes in the sheet in order to file it together with the negatives.

Enlarging easel or masking frame

Ideas about essential accessories for an enlarger vary but it is difficult to manage without some form of masking frame. There are many designs but the basic function is the same. The masking frame (or enlarging easel) allows you to compose your pictures on the baseboard within the area of the paper size, fixes the position of the paper on the baseboard and holds it flat while you expose it. Additionally, it puts a white margin on the paper edges (or a black margin when you print from transparencies). In some cases, the margin is adjustable, while some types allow you to print out to the edges of the paper with no margin.

The orthodox or traditional masking frame consists of a flat metal base plate (usually metal because it needs to be reasonably heavy) with rubber or plastic feet to stop it sliding around on the baseboard. It has an L-shaped frame hinged to it at the top with a thin flexible metal strip attached to the top and left-hand side members by a clip that slides along a scale marked in centimetres and/or inches. The strips overlap so that as they are moved along the scale they enclose a rectangular area in the left hand top corner expanding outward to the maximum available on the baseplate. In use, the paper is held at the edges by the two fixed members and by the movable strips.

Masking frames that allow you to print without borders include one type with an adhesive-coated surface just tacky enough to grip the paper firmly but also to allow it to be easily removed. Another form uses L-shaped magnets with serrated inner edges to grip the paper. The magnets are available separately for use on any ferrous metal surface.

There are two essentials for a masking frame. First, it must provide square corners. That implies a reasonably robust construction of the fixed arms and a positive spring or friction grip of the sliding arms. Any slackness of the grip allows the attitude of the movable arms to vary and thus throw three corners out of square. Secondly, the scale marking must be clear and durable. You can generally use it in white light but it should be clear enough to be seen easily in safelighting. The finish of the surface is important, too. Scantily-painted metal is easily scratched and is then prone to rust. Whether

the surface is black or white is a matter of personal preference. It is sometimes claimed that a white surface reflects the exposing light back into the print and so degrades it. Proof is hard to come by and even the theory is debatable.

A black surface requires you to place a sheet of white paper on it for composition and focus. Again, there is an incredibly hardy adage that says this is necessary in any case and that the paper should be the same thickness as the printing paper. What is the sense in focusing on one surface and then printing on another at a different distance?

Proof in this case is impossible as a simple depth of focus calculation shows. Enlarging is akin to close range photography. In effect, the enlarger lens is photographing the negative at extremely close range—true macro work in fact. In close-range photography, depth of focus (not depth of field) is relatively large. We need not go into details here but at, say 5x enlargement it is in the region of 3 mm at $f4$—regardless of lens focal length or negative size. At greater degrees of enlargement and, of course, at smaller apertures it is greater. So, if you print on anything more than 3 mm thick, you might think about using a substitute focusing surface—although, in fact, at 10x and $f8$, you would have a tolerance in paper position of about 11 mm, or nearly half an inch. This is depth of focus in either direction, but we are not really considering the possibility of the paper being lower than the masking frame.

Masking frames come in various maximum sizes from about 13 × 18 cm (5 × 7 inches) to 40 × 50 cm (16 × 20 inches). Buy the one that accommodates the largest size of print that you make frequently—not the largest you are ever likely to make. For most people that is either 20 × 25 cm (8 × 10 inches) or 20 × 25 cm (10 × 12 inches). Perhaps you will occasionally make larger prints but a large masking frame is a nuisance when you make small prints, whereas you can improvise for the occasional large print.

Exposure timer

When you expose the printing paper, you have to switch the enlarger lamp on, wait for the required time and then switch it off

again. That cannot be described as hard labour and plenty of people cope with it quite happily, but it is a bit of a chore.

A simpler method is to wire a timer into the lamp circuit so that you can set the required time on a dial, press a button to switch on the lamp and the timer switches it off at the appropriate time. An ordinary clockwork mechanism is perfectly satisfactory. Unfortunately, so-called electronic gadgets have become so universally accepted, perhaps even demanded, that the straightforward old clockwork timer is difficult to find. It is worth searching around, however, for the cheapest such instrument you can find. All it has to do is to switch the enlarger lamp on and off for set periods from about five seconds to 60 seconds maximum. It should also have a by-pass switch so that you can switch the lamp on independently of the timer for composition and focus. Anything else is elaboration. The timer does not even have to be accurate. Its alleged five seconds could be six or four or whatever, but that is not important provided it is always the same. There is nothing sacred about the unit of time.

There are more elaborate and considerably more expensive timers that perform the same function rather in the manner of the sledgehammer and the nut. There are those with 0.1 second intervals, believe it or not. Some of these instruments, especially those linked with exposure meters, have their uses, but they are not basic equipment, so we leave them to the next chapter.

Focusing aids

There is only one other enlarger accessory that might be considered basic, and even that is a border line case. It is certainly essential that you focus the image accurately on the baseboard and, if you have any difficulty, you might feel that a focus finder is essential. The function of a focus finder is to brighten and, usually, magnify a selected part of the baseboard image. There are two main types. Both intercept the image forming light rays with a mirror. The simplest then directs those rays an equivalent baseboard distance (just like the SLR camera) to a fine-ground screen. A highly polished mirror and a translucent screen make the image brighter

and easier to focus. This type is small and easy to handle on almost any part of the image.

The second type has a much smaller mirror, with a separate focusing magnifier like a small telescope fixed at a convenient angle above it. A fine-line cross and semi-silvered mirror system allow you to focus the magnifier in the plane of the reflected image. You focus on the grain of the image, the blurb says, but not all of them have magnifiers that powerful. It is advisable to give this type of focus finder a trial before purchase if possible. Not everybody finds them easy to use—especially away from the centre of the image.

Developing tanks

Most of the rest of the equipment in the darkroom is concerned with processing prints and, to a lesser extent, films.

Taking films first, you need a developing tank. That is an absolute necessity for users of 35 mm or roll films (including the smaller cartridge-loaded films). No other form of processing is worth mentioning.

A developing tank is a cylindrical container with a push-on or screw-on lid that is lightproof but allows liquids to be poured in and out. Most types have a cap for the pouring vent so that the tank can be inverted to 'agitate' the developer. This disperses air-bells and prevents premature exhaustion of the solution closest to the film. The tank contains a spiral—a construction of grooves running to a central core so that a length of film (a 36-exposure length of 35 mm film is more than 150 cm or 5 feet in length) can be contained in a small space. The film is loaded into the spiral in total darkness, the spiral is placed in the tank body and the lid secured. All processing can then be carried out in room lighting or daylight.

Developing tanks and spirals are made from plastic or stainless steel. Some stainless steel versions have plastic lids. Each type has its advantages and disadvantages. Modern plastics are not easily shattered or distorted but the materials used in developing tanks may not withstand very hot solutions. Stainless steel bends

relatively easily and a not-too-stoutly constructed spiral can distort beyond remedy if dropped. Naturally there are different qualities and good stainless steel types are virtually indestructible. Steel is a good thermal conductor (ie it conducts heat well). Plastics are quite good thermal insulators. During short developing times, solutions in a plastic tank will probably maintain their temperature accurately enough for black-and-white work even in relatively low ambient temperatures. In a metal tank, the solution temperature could drop a degree or two. On the other hand if you use a water bath to maintain solution temperatures, the metal tank should theoretically work better because it is a more efficient conductor. In practice it seems to make little difference, probably because the water bath serves more to keep the heat in than to transmit it from the outside.

Plastic spirals often have a self-load mechanism starting from the outer edge. You generally load a metal spiral from the central core outward. The plastic type can be easier to handle if it is kept scrupulously clean and dry. Nevertheless, each user swears by his own method and there is very little to choose between them in use or cost.

Tanks are supplied for a single 35 mm film or, in taller versions, to take several spirals, each with its own film. Rollfilm tanks can similarly take more than one film or the single film type may take two 35 mm spirals instead of the single 120 size. Most other sizes of film can be accommodated in special or adjustable spirals. There are types that can be loaded in daylight, those that take two films, back to back, in each spiral, and 120-size spirals that take 220-size film or two 120-size attached end to end.

The tanks can be used for processing both black-and-white and colour films, although some colour processing solutions—bleaches in particular—can attack metals. That is a thought worth bearing in mind; but all good stainless steel tanks are recommended—at least by their manufacturers—for colour processing.

Thermometers and stirring rods

An absolute necessity for processing films is a thermometer. It would be nice to say that the only reliable thermometer is a certified

Developing tanks come in a variety of sizes to take 35 mm or 120 size film and can often be adapted to take other sizes. The film is wound on to a reel that is then inserted into the tank body. Multi-reel types are available. Thermometers are supplied in various types, including those with dials and a 'bent' version for use in a dish.

mercury type—or even any certified type. In practice, the spirit type is easier to read and can be perfectly reliable. The quality of certification, however, is always open to doubt. It is as well to check it for yourself if you can. You do not always find inside what it says on the packet.

There are two basic types of photographic thermometer—the traditional rod one and the dial type. The dial may have its special applications but the rod is generally easier to use in a variety of circumstances. Secured in a plastic, sprung clothes peg, it can be suspended in dish, flask, bottle and other containers. Special 'bent' versions are made for dishes but they can get in the way in a small dish.

It is tempting to use the thermometer as a stirring rod but try to avoid that. It makes an awful mess when it breaks—and mercury is poisonous.

The thermometer is essential for film processing but not quite so necessary for printing. Prints can be developed as far as they will go (to finality) at various temperatures. Consistent results in film processing can be obtained only by reasonably strict control of both time and temperature—the latter certainly to within a degree or so, which is well beyond any guessing capability.

As it is so inexpensive, a stirring rod can also be considered a necessity. You may not even have to buy one. Any rod of plastic or glass will do, but there are versions with paddle ends that agitate the solution more effectively. They are primarily for solutions made up from powders. If you use only concentrated liquids, the stirring rod has little value.

Dishes and containers

If money is hard to come by, this is certainly an area where you can economize. The more or less universal method of processing black-and-white prints in a small darkroom is to use three relatively shallow dishes—for developer, water rinse or stop bath, and fixer. The genuine photographic variety of dish is not terribly expensive but it can cost significantly more than similar trays sold by garden supply stockists as gravel trays.

A photographic developing dish generally has a pouring lip and raised strips on the bottom to make removal of the print easier. It may even have a groove to hold a thermometer. A gravel tray can be virtually identical but without the pouring lip or the thermometer groove. It is frequently more substantial than some of the light-weight developing trays that always seem to be in danger of folding up under the weight of the solution. Photographic dishes are generally white, although different-coloured types are some-times sold in sets to allow you to keep one for fixer and one for developer. Gravel trays tend to be green, brown or grey. The only real snag is that gravel trays are not made to photographic paper sizes and you might have to hunt around to find a suitable shape.

As with a masking frame, buy dishes of a size for comfortable working with your usual size of print. The bigger the dish the more solution it needs and that can be unnecessarily expensive. If you habitually make both large and small prints, you might consider two sets of dishes.

The solutions that go in the dishes have to be stored. Here, too, there are special photographic products and there are beer bottles. It is wise to avoid containers that might allow their contents to be mistaken for beverages but that depends entirely on the conditions of use. Never put a photographic solution into a bottle with a drink label still on it. If you have a temporary darkroom, and there is any chance of bottles getting mixed up, do not use drinks bottles at all.

The variety of containers available is so wide that no specific recommendations can be made. You may be a large user and store your developer and fixer in 20-litre plastic 'jerricans'. You may use concentrated solutions and need nothing larger than a one-litre bottle.

The advantage of containers produced for photographic use is that they are frequently made from durable materials and have efficient stoppers. They can therefore be squeezed to expel air and thus prevent developer from oxidizing. There are special squeeze bottles with extra wide necks for easy pouring. These squash down concertina fashion to reduce the volume of air remaining as solutions are used.

Measuring vessels

To obtain the correct volume of solution for your developing tank or to make up solutions, you need measures. These are in the form of beakers or flasks with scales marked down the side. You can use domestic types but their markings are more likely to be suspect than on those designed for photography. That is a generalization, of course, and you must be wary of the photographic type, too.

Most measuring flasks are plastic and some plastics discolour badly with age. As they discolour the markings become less legible. Buy the clear type if possible but make sure that the scale is not simply printed on. It will inevitably wear off in time. You need two or three sizes according to your working methods. If you regularly measure 50 ml or less, get one measure with no greater capacity than 100 ml. Measuring small quantities in a large beaker can lead to considerable inaccuracy. The 500 ml and one-litre sizes are all that you are likely to need in the larger sizes but you may like to double up on a particular size so that you can keep one for fixer and one for developer. With the better quality materials that is not really necessary provided you wash them thoroughly after use.

If you are at all doubtful about your ability to clean your measuring vessel between solutions, make up your chemicals in the order that you will use them. Naturally, all processes can stand some forward contamination. Few can stand even the merest trace of backward contamination without losing some picture quality.

Miscellaneous accessories

There are many small items that are useful but not vital in the average darkroom. If you are worried about your sartorial appearance, for example, or are just dead clumsy, a laboratory apron is a good investment. Water and chemical resistant, it might just avert a disaster. Colour processing bleach has an interesting effect on fabrics.

Film clips simplify the hanging up of films to dry. They grip the film securely and have hooks or holes for hanging on line or nail, etc. They are sufficiently weighty to stop the film curling up on itself.

More darkroom aids. Film clips allow you to suspend the film safely for drying. Excess moisture can be first wiped off with special squeegee tongs. Ordinary print tongs make paper handling less messy. An exposure timer switches the enlarger lamp off automatically.

Film wipers in the form of chamois or foam covered tongs remove excess moisture from films and allow faster drying. They may prevent drying marks, too, but if they are not treated with care, they can also put marks on to the film. A more elaborate type, known as a print squeegee, is specially designed for removing excess moisture from resin-coated papers.

Print tongs are a necessity for black-and-white printing. It really is not advisable to paddle about in developer and fixer with your fingers. Perhaps a lot of professionals do it; but professional practice is not necessarily synonymous with good practice in any field. You need two pairs, one to be contaminated with fixer only and the other with developer. Get different colours or different types so that you never mix them up. They are made in plastic or stainless steel.

If you habitually use that type of cassette that needs a hammer and vice to remove its end, there is a device for 'effortless opening of 35 mm film cassettes' that does not break the bank.

Look through a mail order catalogue. They have almost endless lists of small items that will make you wonder how you ever managed to do without them. You may go further and wonder why you should not continue to do without them. After all, you never felt the need until now.

We have avoided full descriptions of paper and chemicals so far because they are really basic and need a chapter to themselves. That comes later.

Darkroom Accessories

We have dealt with the basic necessities for the average small darkroom. There are many more items of equipment that are extremely useful but far from essential. Some of them, indeed, could be called rather unnecessary luxuries. On the other hand, once you start getting involved in colour, anything that cuts down the tedium of some of the work involved is welcome.

Exposure timers

We indicated in the previous chapter that a simple clockwork timer was perfectly satisfactory. That is true, but most people are now accustomed to electronic or electrical gadgetry that is sometimes easier to use and often looks more elegant. The exposure timer is a good case in point.

Unfortunately, many manufacturers seem to have gone in for overkill, competing with each other to produce the most sophisticated timer possible. The main requirements for a good, efficient timer for black-and-white work and, indeed, most colour work, is that it should provide timed lamp switching from about five seconds to 60 seconds. Shorter exposures are unnecessary; longer exposures are rarely required and are not critical to a few seconds. For colour work, long exposures can lead to disastrous reciprocity failure effects. In any case, it is not difficult to press the timer button twice or more.

The timer should have a by-pass switch for composition and focus and the ability to repeat a set exposure indefinitely. Anything beyond that is totally unnecessary for an instrument designed only to time the exposure. A very few inexpensive timers confine themselves to this modest specification. Most go far beyond it with refinements that you have to pay for but rarely use, such as the ability to measure 1/10 second intervals. They all claim superb

accuracy, but how often do you refer to previous records for the exposure time you gave to a previous print on a different timer? That is the only time when accuracy is important.

Exposure meters

The accuracy of a timer may be important if you use it in conjunction with a separate exposure meter. The meter tells you what exposure you want and you set the timer accordingly. Most such instruments are, however, calibrated together from test strips. They may even be incorporated in the same instrument.

An enlarger meter may read the light reflected from the enlarger baseboard or it may be placed in the light beam to read either an integrated density or a particular tone. The principle is simple enough and there are a few such meters available for black-and-white work that are not too expensive. Others go a little further and assess the contrast of the image and recommend a suitable paper grade. Yet others are usable for both black-and-white and colour. The simpler meters are not programmed with the exposure time. You keep that constant, and adjust the lens aperture to give the correct light level.

In use, you first produce as perfect a print as possible by test strip or trial and error methods and note the exposure required. You then have to calibrate the meter to give the same exposure for the same conditions. The calibration varies according to design but rarely involves more than turning a knob and noting its setting. You then use the same setting for further prints on that batch of paper processed in the same chemicals for the same length of time and at the same temperature. For convenience, note the setting on the paper box—or in your darkroom notebook.

Automatic exposure

We have had automatic-exposure cameras for a long time, so there should be nothing strange in the concept of an automatic-exposure enlarger. In theory at least, the technique should be easier. Few automatic cameras measure the illumination in the focal plane, but many enlarger meters do. Automatic devices have

a sensor suspended above the baseboard, (out of the beam from the lens) reading a relatively large area, typically 10 × 15 cm or more. There is no great difficulty in transmitting the reading to a timer controlling a switch in the enlarger lamp supply.

Such instruments are available with various degrees of sophistication and at correspondingly varying prices. Among the lowest in price but typical of the genre is a model consisting of a neat box measuring about 15 × 9 × 6 cm (6 × $3\frac{1}{2}$ × $2\frac{1}{2}$ inches) connected to a sensor on a stand about 13 cm high with a large flat foot that allows it to stand at the edge of the masking frame. A coiled lead connects the unit to the electricity supply while the enlarger lamp lead (or transformer lead for a low voltage lamp) is plugged into a socket on the case. There are switches for on/off, function and expose. The three position function switch sets the instrument for automatic working, bypass for composition and focus, and manual to allow the push button expose switch to be used manually. A calibration dial has settings from one to 11 for various paper and process conditions.

To use the meter you make test prints or strips with the dial set arbitrarily to a near-central position to start and to higher or lower positions as the tests indicate. When you have the best possible print, note the setting and use it subsequently for prints on that batch of paper with the same chemistry—regardless of lens, aperture, magnification, type of negative or whatever. To work automatically after calibration, you set the function switch to the auto position and press the expose switch. The enlarger lamp switches on and off automatically and repeats the operation each time the expose switch is pressed.

Naturally, such a system eliminates the need for a separate timer. The most basic model does not, in fact, give any indication of the exposure duration. Other models incorporate a digital readout of the exposure time.

One very important point must be borne in mind when using any type of enlarging meter—and especially the type that reads off the baseboard. The sensor measures all illumination it picks up, including that from the safelight. The paper is not sensitive to safelight illumination but the sensor is and correspondingly gives shorter exposure when the safelight is on than when it is off. That

is taken care of by your original calibration provided you do not change the lens aperture or the degree of enlargement. Once you do that the relationship between image illumination and safelight illumination varies. The result is that a metered exposure of ten seconds at $f4$ may become only 15 seconds or so at $f5.6$ or about 25 at $f8$, giving underexposed prints. So either switch off the safelight when using a meter or shield the baseboard from its direct light.

This type of meter is fully automatic. Others are semi-automatic in that the exposure is determined by adjusting timing knobs before the expose button is pressed. Either type can be of considerable help in printing but, like most automatons, they have their limitations.

For straight prints from good negatives, they can be perfect. If you are straining for the best possible print, they produce your 'starter' efficiently but have to be disconnected or switched to manual for any selective exposure work.

Colour analysers

Most enlarging exposure meters can be used with black-and-white or colour materials but exposure is not the aspect of colour work that gives the most trouble. The composition of the filter pack is the problem that has caused many beginners to give up prematurely. When you have built up a store of experience in colour printing, you wonder what all the fuss was about, because you learn to assess an off-colour print accurately and to correct it by changing the filtration. When you start, this seems to be an insurmountable problem. No matter what you do, success comes slowly, and the pile of discarded pieces of very expensive colour paper grows alarmingly.

Electronics can solve this problem, too, by means of another instrument known as a colour analyser. These vary tremendously in price but there are relatively inexpensive models (in terms of good camera or enlarger prices) that are perfectly adequate for the so-called amateur market. Manufacturers have learned over the years, of course, that the term 'professional' or even a high price tag is an irresistable lure for many hobby photographers with more money

Automatic exposure control can be fitted to enlargers by various means. This instrument is described in the text. The colour analyser *(bottom)* is a simple version with LED indicators. Advanced versions have calibrated setting knobs and a meter dial in place of the LEDs.

than sense. Consequently, they frequently aim their advertising of highly-sophisticated (and correspondingly highly-priced) equipment at this market, when its specification is generally such that only a research laboratory would demand. The practising photographer, professional or amateur, can almost invariably produce equal results with far less sophistication.

To use a colour analyser, you must first produce a perfect colour print by other methods—a statement that will raise many a hollow laugh. That, however, is a fact of colour printing life, so you must do the best you can. There are a few tips in a later chapter and a great deal more information in Jack Coote's *Focalguide to Colour Printing*. You must make this perfect, or reference, print from a suitable negative, ie, perfectly exposed, typical of the type of subject you usually take and with a reasonable range of colours and tones. Sunsets and silhouettes are definitely out, unless all your pictures are like that.

Once you have your 'perfect' exposure, you set the colour analyser controls so that it indicates a zero centre or null setting for each colour, and for exposure. This is in effect the same operation as calibrating your enlarging exposure meter; but it takes account of the colour of your filter pack and negative as well as light intensity. The colour analyser settings form a 'programme' suitable for negatives of similar subjects in similar lighting conditions on the same make of film, printed on the same batch of paper with the same chemistry. To print another, unanalysed negative, you set the analyser controls to the programme figures, then adjust the filtration and lens aperture to balance the image characteristics with those of the reference negative. You then have the filtration and aperture required to produce a print from the new negative, using the same exposure time.

The analyser generally takes the form of a box of complicated electronic gadgetry with a separate probe containing a photomultiplier or other powerful sensor with movable filters that set it to read one primary colour at a time. It has a meter or a simple system of light-emitting diodes (LEDs) that you have to bring to a null position by adjusting programme control knobs when analysing the reference negative, then to the same position by altering filtration and lens aperture when balancing another negative.

It is a remarkably simple procedure but a fresh programme has to be set for each type of subject, as well as for different makes and batches of paper and film, and different chemistry. That is not as difficult as it sounds but it does mean building up quite a library of reference negatives if your subjects are varied.

There are a few short cuts, such as using a grey card included in the subject area of each negative or in the first of a batch. You use that as your reference tone for analysis instead of the flesh tone, green grass, etc. of various separate subjects. Some workers like to use the film rebate as their reference tone. The point is that whatever you use as your reference colour, the instrument tries to reproduce any other tone that it analyses as that colour. If, therefore, you use a flesh tone in a portrait as your original reference and then switch to a grey card area for the next negative, the analyser will try to give the filtration and aperture to reproduce the grey card area as a flesh tone.

As an alternative to reading from a specific tone, you can diffuse the image to form a homogeneous colour and density. This 'integrated' recording is the same as you get with a normal camera exposure meter. It is also the way that commercial colour printers measure colours for printing. It works well for most pictures. It does not work for any unusual subject, such as a close up of a face, or a close up of a coloured door.

Processing drums

The traditional three dishes for processing prints can be replaced by processing drums or machinery. Processing drums appeared some years ago to make colour printing easier for the occasional or small-quantity user. They resemble multiple developing tanks, consisting essentially of a plastic tube (some colour solutions attack metal) with a light-tight cap through which liquids can be poured. The idea is that you put a sheet of exposed colour paper in the tube in darkness and secure the lid. You can then turn on the light. To process the print, you successively pour in and out the various processing solutions (in quite small quantities—as little as 50 ml), agitating the drum continuously and the job is done. There are now

many different brands of chemistry for such processors, using only two or three solutions.

Processing drums are also recommended for black-and-white work for perfectionists who believe in the once-only use of all chemicals. Used thus, they should certainly provide absolute consistency—vital for colour printing, but not quite so essential in black-and-white. Their greatest disadvantages are the need for continual agitation and the limited capacity, often just one 20 × 25 cm print or two smaller ones at a time. After each use they have to be thoroughly washed and dried, which can be a bit of a chore in a darkroom without running water.

A mechanical device can replace continuous hand agitation. These come in various forms, some imparting a two-way action that both turns and tips the drum to provide an end to end as well as a circular movement of the solution. Temperature control can also be built in with space for bottles of water in a water jacket. All these elaborations are a boon to the colour printer; but you can produce perfectly good prints without them.

Stabilization printing

A type of printing that suffered a set-back with the advent of faster-processing resin-coated papers was until then becoming popular and is still widely used. Generally known as stabilization processing, it uses paper with a developing agent, usually hydro-quinone, incorporated in the emulsion. This enables it to develop fully in a few seonds when merely dampened with an activator solution (usually based on caustic soda).

The method is to expose the paper in the normal way by contact or projection and to feed it between rollers that pick up activator from a dish. From these rollers it passes under guides that dunk it in a stabilizer solution and thence to other rollers that squeegee it damp dry. It emerges from the other end of the machine as a fully pro-cessed print that will retain its image for many months. It will eventually fade because the stabilizer is not a permanent fixer. The print can, however, be fixed in the normal solutions at any sub-sequent time.

Stabilization processors are made in various forms—and can even

Many designs of colour processing drum are available. This type provides rotary and end-to-end movement to avoid streaky processing.
Stabilization printing machines *(bottom)* are for the rapid production of black-and-white prints.

be improvised from some of the old wet-process copying machines, which worked in virtually the same way but often with only two sets of rollers. The current machines may have six or more sets of rollers and a feed system that keeps the solution trays topped up and empties them rapidly for replenishment.

The advantages of stabilization processing are speed and space saving. The time you need to produce a print depends on its size. It moves smoothly through the machine, a 20 × 25 cm print passing through in 45 seconds or less. The width of material taken is commonly 35 cm (14 inches) or 50 cm (20 inches) and the length is unlimited, yet the larger machine occupies no more bench space than 91 × 25 × 14 cm (36 × 10 × 5$\frac{1}{2}$ inches).

Stabilization paper is much more expensive than ordinary bromide paper (the standard product) and a little more expensive than the resin-coated papers designed for rapid processing in more-or-less orthodox solutions.

Colour processors

Processing drums are limited in their print handling capacity. Because the chemicals can be toxic, and safelighting virtually nil, dish processing is not recommended for colour materials. So, if you want to process a dozen or so prints together, especially large ones, you have to spend a lot more money for a full-blown machine. Processing machinery of this type, once designed almost exclusively for commercial use, is now coming within the reach of smaller darkroom operators and even the non-professional who takes a lot of colour pictures.

One type follows broadly the same principle as stabilization processors but is essentially a little more complicated. It has to have temperature control because many colour processes work at a relatively high temperature and are much less tolerant of variations than black-and-white processes. As the process time is virtually unalterable in most machines, it must be possible to vary the temperature so that the machine can handle more than one process. The amount of solution fed into the machine is generally much greater, one model taking, for example 2.5 litres each of developer and bleach-fix. A stop bath is interposed in this model

to counteract the travelling time through the rollers (9 cm a minute) between the two essential baths. Finally, the width of material the machine can handle is less than that of most stabilization processors at about 20 cm (8 inches). This particular machine measures 84 × 42 × 21 cm (about 33 × 16 × 8 inches) and weighs 16 kg (35 lb). Above all, it is expensive, costing quite a bit more than most colour enlargers.

Less expensive but still at around the price of an average colour enlarger is a tank-type processing box designed primarily for Ektacolor prints. The paper is suspended in the solutions in double-sided paper holders giving a total capacity of twelve 20 × 25 cm prints or a corresponding number of smaller prints. The machine can process to completion in four minutes at 37°C (100°F). It occupies only about 37 × 27 cm ($14\frac{1}{2}$ × $10\frac{1}{2}$ inches) of bench space.

Yet another approach is supplied by the laminar-flow type of machine that has a capacity of one 28 × 36 cm (11 × 14 inch) sheet at a time (or a corresponding number of smaller sheets) and has to be hand-fed. Nevertheless it is much easier to operate than a processing drum. It is a flat-bed machine in which the solutions flow evenly over a platen on which the exposed print is laid. The solutions pass between the print surface and the platen and do not wash over the back of the print.

The solutions have to be poured into a trough by hand but are pumped out again. Wash water between solutions is also pumped through from an inbuilt tank or can be poured into the trough.

There are models with and without temperature control. The control is not essential, but does make life easier. The machine incorporates a tempering trough to hold 300 ml (11 oz) containers (supplied) and to hold their contents at the correct temperature. It is the contents of these containers that are poured into the machine for each print and circulated by the pump. It is therefore evident that any process can be handled—black-and-white or colour, paper or film—no matter how many solutions are required. All operations are in full lighting after establishing the developer flow and positioning the print.

This is the least expensive of the machines we have described and is claimed to be the most economical of any process including

drums. It does not dump the chemicals after use. They are pumped out into the original containers and can be replenished for subsequent use. The machine measures 56 × 40 × 28 cm (22 × 16 × 11 inches) and weighs about 4.5 kg (10 lb) empty. Its tank capacity is about 13.5 litres (3 gallons) and the filled weight is about 18.5 kg (41 lb). A larger model, to take material up to 40 × 58 cm (16 × 23 inches) is also available at about twice the price.

Paper storage

If you find it tedious to store photographic paper in its original packing and to extract each sheet as required, you can buy a paper safe. These are enclosed trays or drawers with light-trapped slots through which paper is pushed as you turn a knob or similar control. They are rather expensive for the simplicity of their construction and have the disadvantage that you can store only one size and type of paper in each safe. If you use various combinations of sizes, grades, etc., you need a safe for each.

You may find it more satisfactory to construct a light-tight drawer under your bench or enlarger baseboard. Then you can fit dividers to separate the various sizes, etc, that you commonly use and, perhaps, provide labelled covers for both identification and additional protection. Yet more protection can be provided by wiring in a switch that breaks the circuit between the white light and the electrical supply. The light then goes out when the drawer is opened and cannot be switched on again until the drawer is shut. There is no protection against other light entering the darkroom, so you must make sure that drawer is truly light-tight and is shut before you leave the darkroom.

Making proof prints

It is a waste of printing paper to make enlargements from every negative just because you cannot see the reversed image clearly. Contact prints, even from 35 mm negatives, can generally show you whether a larger print is worth the time and expense.

Various types of proof printer are available, the most popular being

the type that allows you to print the complete roll of film in one operation on a 20 × 25 cm (8 × 10 inch) sheet of paper—35 mm film cut into strips of six and 120 film into strips of four. Basically, this type of printer is simply a baseboard to hold the paper, hinged to a clear plastic plate with holders for the negative strips. Negatives and paper are held in close contact, emulsion to emulsion, and illuminated by the enlarger beam or other source for a compromise exposure for the whole film.

It is hardly less convenient in practice to place a suitable sheet of bromide paper on the enlarger baseboard with the head at a sufficient height to enable the beam through the lens to illuminate it evenly. On the paper (emulsion up) you can then lay the negative strips (emulsion down) and press them together with a sheet of plate glass. Switch on the enlarger (with no negative in the carrier) for the required exposure time and then develop the paper in the normal way.

Drying and glazing prints

Now that resin-coated paper is so commonly used, print glazing is becoming less popular. It was always a difficult process with amateur type equipment and many people avoided using glossy paper for that purpose. A good glaze, however, undoubtedly improves the appearance of a glossy-paper print and such a surface is necessary for the best delineation of very fine detail.

A print is glazed by bringing it into contact with a highly polished surface while the emulsion is wet and relatively soft and allowing it to dry there. When it peels off, the high gloss of the glazing surface is reproduced on the print—together with any previously invisible spots of dust or other blemishes that were on the glazing surface. The difficulty with the relatively small flat-bed glazers supplied to the amateur market is in establishing and maintaining perfect contact between the glazing plate (stainless steel, chromed brass, etc.) and in excluding dust. The plates have to be treated with extreme care and washed carefully after each use.

The machines consist essentially of a box enclosing a heating element. Attached to the back edge is a framework for a cloth blanket or apron that clamps over the front edge to tension the

apron and hold the print down. The box generally has a curved surface to assist in this operation. The wet print is pressed into contact with a separate glazing plate that is then placed on the box with the print upward. The heater is switched on and the apron clamped in position. When the print is dry the blanket is lifted and the print drops off the plate with a perfect glaze—if you are lucky. The machine can be used without the glazing plate as a dryer only or without the heat as a cold glazer. The only advantage of using heat for glazing is that it is quicker. There is no difference in the glaze. The machines are supplied in a variety of sizes that are not very closely related to paper sizes. A dryer/glazer is not a very expensive item, nor is it very necessary for most people.

If you use resin-coated paper exclusively, you have no use for a dryer/glazer at all, because these papers must not be subjected to excessive heat. There are thermostatically-controlled models that you might risk using at the recommended temperature, but it *is* a risk. There are special dryers for RC papers but they are unbelievably expensive for the job they do. These materials dry very quickly indeed at room temperature, especially if they are wiped with a clean chamois leather to remove excess moisture or blotted with photographic blotting paper.

If that is not quick enough, you can speed up the process with a hair dryer—but you may overheat the print, or blow dust onto it.

Drying films

If you want to make prints from your films as soon as possible after the film comes out of the tank, you need a drying cabinet or some similar arrangement. Films can take an hour or two to dry naturally, and, until they are dry, the emulsion is very susceptible to damage; and to dust which sticks to it.

The usual drying method is to attach film clips to top and bottom and hang the strip of film somewhere where the cat cannot get at it. It should be in as draught-free a place as possible so that no house dust or debris can be blown on to the tacky emulsion before it is completely dry. Similarly it is unwise to attempt to accelerate the process with a hair dryer or fan heater. Some of these can ruin

A dryer/glazer speeds up the drying process and, when used with a glazing sheet, puts a hard glaze on glossy papers.

Film drying can be accelerated in a drying cabinet. The metal shield over the lamps should leave space at the sides to allow warm air to rise past it.

a film in five seconds flat as they propel tiny dust particles like bullets into the emulsion.

If you must have artificial drying, buy or make a drying cabinet—a tall thin cupboard arrangement with a heater at the bottom. You can use one or two ordinary household light bulbs for the heater. They will create quite enough updraught of warm air to dry films rapidly and with no danger of overheating. Nevertheless, position a curved or V-shaped piece of aluminium or other metal above them to protect the films from direct heat and to divert drops from the hot bulbs. The structure can be quite simply made from wood and hardboard. The essentials are openings at the bottom, below the heater, protected by the finest filter material you can improvise— muslin, nylon mesh, etc. That is to avoid dust being drawn in and carried up to the films by the convected current. At the top you need outlets for the warm air to establish the current from bottom to top. Naturally, you need hooks or whatever to suspend the films from and the door must be close fitting. You might even make the outer skin from sheet plastic rather like a shower curtain provided you keep the lamps well away from it. Make sure the wiring to the lamp bulbs is well protected from any possible water splashes. Earth the lamp holders if possible.

Handling bulk film

Once you have a darkroom, you can use bulk film with confidence. If you have to black out a cupboard or use a changing bag to load cassettes, you may feel that the task is a little too troublesome. In the darkroom, however, you can cut 1.5 m or so from a 5, 17 or 30 m roll of film and load 36 exposures into a cassette with ease. You have to devise some method of measuring the required length but that is not too difficult. The simplest method is to hook a perforation over a nail or similar projection on the bench or door jamb and then carefully pull the required length out to another mark that you can easily locate in the dark.

That is a bit fiddly, however, and you would be better advised to get hold of a bulk film loader. Then, of course, you do not need the darkroom, because only loading the roll of film into its chamber needs to be done in darkness. There are several models of bulk

film loader on the market and they do not cost very much. They are all rather similar in design, consisting of a chamber for the roll of film, light-trapped from a smaller chamber for the cassette connected to a winding handle and a counting mechanism. The cassette chamber is generally arranged so that you cannot open it without closing the light trap between the two chambers.

A short piece of film is left protruding through the light trap and you attach that to the cassette spool, reassemble the cassette and close the chamber. Open the light-tight trap (to allow the film free passage with no risk of scratching) and wind on the required number of exposures (any number you like up to 36). Close the light trap, open the cassette chamber, cut through the film and extract the loaded cassette. It is an easy-to-use relatively inexpensive piece of equipment that can cut your film costs dramatically.

Washing prints

Prints on ordinary bromide paper need to be washed for at least 30 minutes after they come out of the fixer. The fixing process converts unused silver bromide (or other silver halide) to non-light-sensitive compounds that are somewhat unstable but can be washed away in water. Of course, most of them bleach out into the fixer solution, but significant amounts remain. If they are not removed, they will, in time, degenerate and produce stains and other undesirable effects. Single-weight papers are washed clean for all practical purposes after about 20 minutes in running water that is allowed to reach all parts of the print at all times. They should, therefore, be kept separated throughout the washing operation. Double weight prints need 40-60 minutes. Resin-coated papers are effectively washed in five minutes because only the emulsion can absorb solution.

The necessary separation between prints is provided by various designs of print washer. One is a deep open dish with pronounced ribs on the bottom. Water is fed in at force through small jets, so imparting a circulatory motion that keeps prints on the move. Another is box-like with specially-designed separator plates between which the prints are slipped. Inlet and outlet pipes ensure that the water circulates adequately around the prints.

Less expensive and quite efficient is a sink stopper replacement that empties the sink (or bath) when the water rises to a certain level and then allows it to refill with fresh water.

One ingenious method uses a simple syphon tube on a sucker pad to draw away fixer-laden water from the bottom of a dish while fresh water runs in at the top—a system that is quite easy to improvise. This is, in fact, the essential of any washing operation— that the contaminated water should be drawn out and not left to rise to the top of a dish and overflow. Almost any system that takes care of the removal of contaminated water, together with frequent separation of the prints, is quite adequate.

How to buy accessories

It is easy to persuade yourself that every accessory you see is essential. Certainly there are many labour-saving gadgets that are very tempting. It is wise to temper your enthusiasm with a little sensible thought, especially if you are setting up a darkroom for the first time. No matter how bottomless your pocket, there are enough manufacturers of gadgets to find their way down there in double quick time.

We described the essentials in the previous chapter. We have added several inessentials to the list in this chapter. There are plenty more and you could spend a great deal of money equipping your darkroom with just a few of them. It is more sensible, however, to start with the essentials and gain experience with them. Find out which parts of the process you find irksome and cast around for something to make things easier in that direction. Then, as you gain proficiency, look for the items that can actually help you to get better results—and realize how few of them there are. Most accessories are simply alternatives and they are often ridiculously expensive, even when costing comparatively little, for the task they perform.

If your cash is limited, settle for the minimum of equipment and the maximum of materials. You are more likely to get better results from long practice than by fitting your darkroom out with every conceivable luxury.

Print-Making Materials

So far, we have been concerned almost exclusively with equipment. We have had very little to say about the items you will be buying most frequently and on which, in the long run, you will spend most money. These are the actual print-making materials—basically paper and chemicals.

What makes a print

This is not a textbook on photographic printing or enlarging. There is another book in this series—the *Focalguide to Enlarging*—that takes you through the whole process. Here we deal with the basics. A photographic print is produced by passing light through a negative on to a light-sensitive emulsion on a paper, plastic or any other support. For the moment we will refer to paper, even though many so-called photographic papers are now, to all intents and purposes, plastic. The normal printing papers are commonly called 'bromide' papers because silver bromide is a major constituent of their emulsion. You can make a print with the negative in contact with the paper, so producing an image on the paper that is the same size as that on the negative. Or you can project the image on to the paper through a lens—generally to produce enlarged images. Contact prints are now rarely made because most cameras use rather small negatives.

When the light passes through the negative and strikes the paper emulsion it acts the same way as did the light from the subject on the film emulsion. It blackens it selectively in proportion with the light falling on each part. To be accurate, if affects it in such a way that it can subsequently be blackened by treatment with a chemical solution—a developer. Just as the image on the negative is reversed in tone compared with the original subject (because the more the light the blacker the image), so the print image is reversed com-

pared with the negative. It therefore reproduces the tones of the subject.

The paper, by itself, is not enough, just as the film is not enough. The image is invisible until we amplify the effect the light had on the emulsion. That we do with chemicals—a solution containing a developing agent and various other constituents to ensure a clean print with well-graded tonal values.

The developer changes the silver bromide to black metallic silver in the areas where it has been light-struck but has no effect on the areas the light did not reach. In those areas, therefore, the emulsion is still light-sensitive after development. So we need a further chemical solution to destroy the sensitivity of the unused bromide. This is the fixer. It converts the unused silver bromide to substances that are not light-sensitive and the image is then said to be fixed.

The materials with which we are primarily concerned then are paper and chemicals—using the term paper to cover all types of printing material.

Resin-coated papers

The traditional photographic printing material is a high quality paper coated with a light-sensitive emulsion and various other layers to assist adhesion, protect the emulsion from abrasion and so on. The paper base is absorbent. It soaks up the chemicals used in processing much more readily than the emulsion layer and has to be washed thoroughly when processing is complete.

Various types of paper base have been produced to combat the tendency to absorb moisture, including a waterproof-back type much favoured by the armed foces. The latest product, and the only one to be introduced generally, is a sandwich construction with a thin sheet of paper laminated on both sides to a plastic coating. This is commonly known as RC (resin-coated) paper in the Kodak-speaking empire and PE (polyethylene) where Agfa reigns supreme.

The great advantage of such coated paper is that it is almost completely non-absorbent. Only the emulsion, coated on the top plastic layer, needs to be washed. Additionally, it can, with its own special chemistry (shorthand for the processing chemicals and

procedure) be very rapidly processed, sometimes with the assistance of a developing agent incorporated in the emulsion. In the glossy form, it retains a pleasingly high glaze after drying and it dries very flat with only the slightest tendency to curl.

There are those who object to RC paper on the grounds of its lack of tactile appeal, the inferior quality of the image, and possibly the ephemeral nature of the plastic coating. It is certainly strange to the touch, compared with paper, but that is hardly a serious objection. The quality of the image is a highly debatable point that seems to be very near the hair-splitting evasion of the 'will not be convinced' diehard. The possible short life of the plastic coating is a more serious matter. What the truth of that is, we laymen will not know for many a year. What do we know of the lasting ability of photographic paper? Has its discoloration or its ageing effect on image quality been measured scientifically? Has not the plastic coating been subjected to similar premature ageing tests for the same purpose?

For most of us the questions are academic. Our masterpieces are not likely to live for a century or two and, if they do, those that are in colour are more likely to deteriorate because of the inadequacy of the dyes than the short life of the plastic. There are more permanent methods of black-and-white printing for those who need them but they had better hurry up and make their archival prints because their negatives are on a plastic base.

For the average worker, resin-coated paper is a blessing, simply because it considerably reduces the time from enlarger exposure to finished print. It eliminates the necessity for glazing, but is available in other surfaces for those who prefer them. It dries almost perfectly flat in a very short time. Its disadvantages are few, the main one being perhaps that its surface is rather easily damaged when wet.

Paper surfaces, grades and weights

Photographic papers, resin-coated or otherwise, are made with various surface textures and various types of emulsion.

Surface textures are fewer now than they used to be and tend to be confined to glossy, semi-matt and one or two slightly roughened types known, according to the manufacturer's whim, as lustre,

stipple, pearl and so on. These generally have a finely-broken surface of regular or irregular pattern that can work wonders in concealing slight grainy effects but can also obscure fine detail, especially in small prints. They are fine for pictorial work but are not generally favoured for commercial photography that has to be put through another reproduction process. They can be very difficult to rephotograph.

It used to be possible to obtain photographic papers that were off-white or even cream in base colour but they are now becoming rare. More strongly tinted papers—in blue, orange, red, green, etc. as well as metallic gold, silver and steel blue, and fluorescent colours—are available from specialist manufacturers. Various other bases can be obtained, too, such as opal film, washable linen and aluminium. These are particularly useful for display purposes. The opal film looks like any other photographic print when viewed by reflected light but has the luminosity of a transparency when transilluminated. Photo linen can stand up to heavy punishment without effect on the image and can be cleaned to restore its brilliance.

The major manufacturers produce a limited range of papers in the three main types—bromide, resin-coated and stabilization—apart from special products for commercial, scientific and industrial use. The more esoteric products come from specialist manufacturers and are often gathered together by a single agent in each territory. A type of paper that used to be a great deal more popular than it is now, adds silver chloride to the usual silver bromide in the emulsion and is consequently known as chloro-bromide paper. It is sometimes referred to as an exhibition paper because, with suitable development, it can produce a range of image colours from red-brown to pure black that many exhibition workers find more pleasing than the cold black of bromide paper. The paper was available in a wide range of tints and surface textures but many of these have now been rationalized out of existence. Today's giant manufacturers need a correspondingly huge demand to make any line worth continuing.

The orthodox photographic papers are produced in two thicknesses or weights—single-weight and double-weight. Single-weight is to be preferred for most purposes, if only because it costs less, but some find it difficult to handle in the larger sizes. In fact, some

textured surfaces are available only as double-weight paper in the larger sizes. Resin-coated papers are generally available in one weight only—sometimes called medium weight.

Some papers can be supplied in extra light-weight and airmail versions while the specialist materials—opal film, linen, etc.—are generally supplied in one version only.

Emulsion contrast

Depending on how the film is exposed and processed, negatives may vary in character. One worker may prefer rather thin, flat-looking negatives, another may like to be able to see good strong tones on the film. Or the subject of one set of pictures may be evenly illuminated while the lighting on another occasion may have been so directional as to produce high contrast between shadow and highlight areas. Or the processor may simply make a mistake.

Whatever the cause, negatives vary in density and contrast. Nevertheless, most of them can be printed quite satisfactorily, especially by an expert printer, on the same type of 'normal' paper. For the best possible print, however, it might be necessary to print on an emulsion that gives a rather more or less contrasty image. Consequently, photographic papers are produced with different emulsion characteristics, specified as grades.

Grade 0 or 1 (manufacturers' specifications differ both in number and actual emulsion characteristics) is a soft (low contrast) emulsion designed for use with high-contrast negatives. Grade 5 or 6 is an extra hard (high contrast) emulsion designed for use with low-contrast negatives. Between the extremes is a Grade 2 or 3 that is regarded as normal and intermediate grades that are less or more contrasty.

The normal classification is largely a personal matter because each worker naturally tends to regard the paper grade he uses regularly as normal. In most cases it is Grade 2 or 3, depending on make, because that is the paper intended to be used with the normal mid-density, well-graded negative. The other grades may differ in sensitivity, the more contrasty papers needing more exposure, although at least one manufacturer has succeeded in standardizing the sensitivity over all paper grades except the most contrasty.

Some papers are produced with multiple-layer or mixed emulsions that are designed to respond differently to coloured light. They are used with filters that change the colour of the enlarger light slightly and thereby alter the contrast characteristics of the emulsion. The effect is that you have several grades of paper in one box or packet. When you change the filter, you change the paper grade. Although a little more complicated in use than single grade papers, the so-called 'multigrade' papers offer definite advantages to those who master the technique.

Colour papers

Colour papers work just like colour film. They have three separate emulsion layers, each sensitive to a different part of the spectrum of white light, broadly grouped under red, green and blue. The emulsions incorporate dyes that are released on development to combine in their various layers to produce a full range of colours. The dyes are universally called yellow, magenta and cyan, which are mixtures in light terms of red and green, red and blue and blue and green respectively.

It is as yet impossible to produce dyes in films and paper that are absolutely pure and stable. Variations occur and, when colour printing, we have to filter the light from the enlarger lamp (change its colour) to reconcile the differences. The filters used are consequently also yellow, magenta and cyan and are interposed in the light beam between the enlarger lamp and the negative. When the light is sufficiently corrected, the light passing through the various coloured portions of the negative selectively exposes the three layers to reproduce the colours of the original subject. The filtration is critical and, as we mentioned in the previous chapter, it causes beginners a great deal of trouble.

Prints from transparencies

Until comparatively recently, most colour prints were made from colour negatives on basically the same principles as black-and-white

printing. Now, however, there are two forms of colour reversal paper, corresponding roughly to colour reversal film, for printing from colour slides. One is processed in a similar manner to reversal films. A negative monochrome image is first produced, the remaining light-sensitive parts are fogged to produce a positive image and colour-developed to release the dyes. The silver images are bleached out to leave the full-colour positive dye image.

In the other form (Cibachrome) the dyes are already present in the emulsion layers when it is exposed. They are selectively destroyed where they are exposed to light, so producing white or lighter colours and unaffected where the light is weaker, producing black or deeper colours. The main advantage of this method is that it is possible to use more stable dyes. A considerable practical advantage is that, although filtration still needs to be handled with care, there is much greater latitude in the time and temperature of processing.

The final part of this book, beginning on page 801, describes colour printing processes in detail.

Resin-coating was first introduced for colour materials because it reduces the risk of cross contamination between the solutions used. Indeed many processes eschewed the use of paper entirely and used a totally plastic base. Most colour materials are now resin-coated, the notable exception being the Cibachrome dye-destruction process, which has reverted to the plastic base with no paper content.

Developing and developers

All print materials have to be developed to produce a visible image. Developing is basically what chemists call a reduction process and the main constituent of the developer solution is accordingly known as a reducer or developing agent. It reduces the light-sensitive silver bromide or other silver halide in the emulsion to non-light-sensitive metallic silver that appears black.

To produce an image of suitable density, the developer has to act on the emulsion for a given time at a given temperature. In film developing, the time and temperature is critical for optimum results but in paper processing quite wide variations are possible. This is because the paper can be exposed in such a way that it can be developed to finality (as far as it will go). With film, this would

result in loss of middle tones but the paper emulsion has a much more restricted tonal range (the number of distinct separate tones it can squeeze in between white and black).

Ideally, most black-and-white papers are processed for about two minutes at 20°C (68°F) but no detectable difference is likely to arise with considerable variations in both factors—provided the exposure is correct.

Similarly, there is less scope for producing widely-differing types of developer for papers. Film emulsions vary in sensitivity and grain structure. They intend to include slightly larger grains of silver to form the image in faster films. Papers are very much less light-sensitive than films and their emulsions do not have to pay much regard to grain size. The image on the paper is never enlarged; the enlarged grain structure of the negative is always greater than that of the print.

A few developer formulations have been produced but the choice of developer is neither critical nor gives the average photographer much concern. Whereas he might be very reluctant to process a film in any developer other than his own favourite brew, he will generally accept any paper developer at a push. Most of them are based on simple formulae that have stood the test of a great many years. The main choice is between those sold as powders to be mixed with water and those sold in concentrated liquid form to be diluted for use.

Colour papers are different in that they are, with the one exception already mentioned, very dependent on the correct time and temperature of development and they must be processed in their own particular chemistry. The main reason for that is that they have to maintain a balance between the three separate emulsions. Only at a critical level of development can the three emulsions remain in step to produce correct colour. An additional increment of exposure may have a different effect on each of the three layers. There are also considerable differences in emulsion chemistry that make solutions suitable for one type of paper totally unsuitable for another.

This selectivity is offset to some extent by the fact that some manufacturers use chemistry so similar that substitute solutions can be produced by independent companies to process more than one

make of paper, perhaps with slight variations in time and temperature; or with the aid of separate additives.

Fixing solutions

The developed black-and-white print is still sensitive to light, as we have already explained. The unused silver halides have to be made insensitive to light and this we do by immersing the print in a fixing solution, so-called because it preserves the image. The first photographs suffered from the fact that an image could be produced but it could not be made permanent.

The fixer—often called hypo—converts the silver halides into compounds that are no longer light-sensitive and are soluble in water. They can still be harmful to both image and paper base so they have to be washed out.

Fixing solutions are traditional in formulation and there is no need to cast around for the ideal brew. There are two types, one faster acting than the other, but the use of the faster type for paper is rather pointless because papers fix much faster than film—about 30 seconds in ideal conditions and two minutes in general practice. Again, however, there is the choice between powders and concentrated solutions.

Mixing your own solutions

For the regular darkroom worker, there is undoubtedly money to be saved in making up your own black-and-white developer and fixer from raw chemicals. For the irregular worker, it is hardly worth the effort. He is likely to waste more chemicals than he uses. The formulae shown here are suitable for all normal photographic papers.

MQ BROMIDE PAPER DEVELOPER

Metol	1.5
Sodium sulphite anhydrous	25
Hydroquinone	6
Sodium carbonate	30
Potassium bromide	2

Water to make 1000

Dilute 1 + 1 for use

PQ BROMIDE PAPER DEVELOPER

Sodium sulphite anhydrous	50
Hydroquinone	12
Sodium carbonate anhydrous	60
Phenidone	0.5
Potassium bromide	2
Benzotriazole	0.2
Water to make	1000

Dilute 1 + 3 for use

The quantities indicated are proportions. Any unit can be used. Grams per litre is the most convenient. Benzotriazole can be replaced by about 35 ml per litre of IBT Restrainer or similar commercial antifoggant. Phenidone is Ilford's alternative to metol.

When making up the MQ formula, dissolve a pinch of the sodium sulphite first in about three-quarters of the total volume of water at about 45°C (120°F). Add the rest of the chemicals in the order shown, stirring constantly but not too vigorously to avoid beating in air. When all the chemicals are totally dissolved, make up with cold water to the total volume.

The pinch of sulphite is designed to prevent early oxidation of the metol. You must not add too much because metol will not dissolve in a strong sulphite solution. Phenidone presents no such problems and the formula can be made up by mixing the chemicals in the order shown.

Most fixing solutions are acidified to arrest development immediately and contain a hardener to protect the emulsion from subsequent damage. Neither is particularly necessary for prints if you develop to finality and pass the developed print through a water rinse or stop bath before fixing. The function of the stop bath is to reduce or eliminate the alkalinity of the developer remaining in the print and so preserve the life of the fixer.

The straightforward fixing solution consists of about 100-150 g of sodium thiosulphate in a litre of water. You can acidify it if you wish by the addition of 25 g of potassium metabisulphite. Such a

solution, provided its temperature is above 10°C (50°F) fixes a print in a minute or two if it is fresh and the prints are not simply dumped in it in a pile. They must be kept moving and separated.

The hardener is completely unnecessary. It helped a little with hot glazing but is more of a hindrance than a help with any other form of afterwork. This does make it unnecessarily expensive to use proprietary fixers for papers because they are virtually all acidified and contain hardeners.

Buying printing materials

Each worker is confident that the particular brand of printing paper he uses is the best, which is as it should be. The best paper for you is that which gives the results you want. There is nothing to choose in quality between the established brands but there may be characteristics of surface texture, colour, sensitivity and even feel that make you prefer one brand to another. Naturally, price could come into it, too, but there seems to be little competition in that area. You can buy job lots of paper from certain dealers at bargain prices and they are always worth trying.

If you do a lot of experimental printing (to use a polite term for mucking about in the darkroom) or otherwise make a lot of prints that need not be of superlative quality, some of these special offers may well interest you. It is very unlikely that the product will be outright bad and if the dealer is well established, it will probably be worth the price asked. But you must compare the quality of your results with those on fresh paper to make sure that you do not accept inferior quality because you know no better.

Economy in the buying of materials is important to most of us but the economies must be in the right direction. If you find that you are not always printing in standard sizes, choose your paper size carefully. You might be able to settle on a larger size that cuts handily to two sizes that you commonly use. Strangely, cutting larger paper to a convenient number of smaller sizes without waste does not seem to pay very well since the introduction of metric sizes. Quoting from an outdated price list for example, 25 sheets of 20.3 × 25.4 cm (8 × 10 inches) paper cost 1.71 (the currency does not matter for purposes of comparison). This would cut to

100 5 × 4 inch sheets. That size is not available but 100 sheets of 10.5 × 14.8 cm (4.1 × 5.8 inches) cost only 1.89. It hardly seems worth cutting it yourself. The A4 size does cut directly to two A5s or four A6s but is available only in 100-sheet boxes. There are some larger sizes, however, that are available in packets of ten sheets and could prove useful if you have a cutter that can handle them.

Storing the paper

Having bought the paper, you have to store it and you may have to store quite a lot if you have no dealer near at hand whose prices are reasonable. We have already mentioned the value of an old refrigerator for this purpose but it is worth emphasizing that the greatest enemy of printing paper is damp. It does not mind cold at all. In fact, it flourishes on it and deteriorates faster in a warm atmosphere, particularly if it is also humid. Damp can lead to a lot of unpleasant activity in the emulsion, resulting in uneven development, lack of contrast and even damage from papers sticking together. Resin-coated papers are a little less prone to these troubles because at least the paper is protected but they can still give a lot of trouble. If your darkroom is at all damp, wrap all your paper packets and boxes securely in cling film or put them in sealed polythene bags. Always keep them inside their original black envelope, which affords quite a lot of protection.

Silica gel and other drying agents can be used in your paper cupboard but do not rely on them exclusively unless you use the type that indicates when it needs drying out. Do not use a paper safe or even a light-tight drawer where dampness is present. The essence of these is that the paper is unprotected and it is not easy to make a light-tight drawer that is immune from damp.

Buying and storing chemicals

Make up your own chemicals if you do a lot of printing or buy them in the larger quantities that are now easily obtainable. Using commercially-produced concentrated solutions is said to be an expensive way of buying water but there are some highly-

concentrated solutions that make up to considerable quantities. Study the prices and quantities carefully and decide what is best for your purposes.

It is generally more economical to make up your developer from two-powder packs. These, too, are available in very large sizes that work out a great deal cheaper than a 500 ml bottle of semi-concentrate, the price of which is becoming absurd.

Be careful when making up solutions from powders (particularly fixing solutions) and preferably do not do it in the darkroom. If a little powder floats about in the kitchen or bathroom, it will do little or no harm to anybody: in the darkroom it can be a menace. You never know where it is going to settle, but there is a 'law' that says that it will not be somewhere harmless.

Similarly, watch the drips when you pour chemicals. Store them in wide-mouthed containers if possible. They have less tendency to slurp and shoot the contents over the edge of flask or dish. For large containers, you can buy dispensing taps that are a perfect safeguard against this trouble, while even small bottles can be fitted with pouring tubes.

Pour from the opposite side to the label, assuming that you have remembered to label your made-up solutions. An obscured or soaked-off label does not lead to even-tempered working conditions in the darkroom.

Store large containers on the floor unless you have built a stout support to hold a cubitainer, for example, with a tap. Smaller bottles are reasonably safe on the shelf above the processing dishes. It is not generally advisable to store chemicals in the same cupboard as papers but that need not be an absolute law in these days of improved packing and wrapping materials. Sealed packets of powders, for example, should be perfectly safe as should securely stoppered bottles but give the papers the added protection of cling film or bag wrapping if you are in any doubt. As a general rule store chemicals in this way only when there is no other option, such as shortage of space, or when the darkroom is very damp. Although powders should be safe in their plastic bags or sachets, the outer wrappings are often very susceptible to damp that can work its way inward.

Processing Film

When you are ready to start processing and printing your own films, the starting point is the exposed film you have just taken out of the camera. Black-and-white film processing is the simplest of all the tasks confronting you. It is purely a time and temperature process—rather like putting a cake in the oven.

The necessary equipment is a developing tank, a thermometer, two measuring beakers (at least) and two film clips. The materials are the film, the developer, fixer and water.

Loading the tank

You start in the darkroom with the roll or cassette of film and the developing tank. At this stage the white light is still on. Take the lid off the tank and extract the spiral. Lay the parts to hand where you can easily locate them when you put the lights out. Lay the film beside them. Switch out all the lights (*no* safelight) and remove the end of the cassette or break the seal on the rollfilm. Extract the film from the cassette, winding the knob a few turns to tension the film and so loosen it in the cassette, if necessary—or detach the rollfilm from its paper backing.

From now on, be careful to handle the film by its edges only. Load it into the spiral according to the manufacturer's instructions. This is a nerve-wracking job on the first few occasions but try to keep calm about it. Sweaty palms are no help at all. This is where you are glad you made a good job of the blackout but are somewhat frustrated at being so completely visually detached from your arms.

It is not a good idea to use a film with unrepeatable shots on it for your first attempt at loading a developing tank. In fact, this is the ideal time to use a film to take those lens-testing or suchlike shots that you have been meaning to take ever since you bought the

camera. If you make a mess of the loading, you are no worse off than when you started.

When you have managed to get all the film into the spiral, put the spiral in the tank and replace the lid securely. Now you can turn the lights on again.

Preparing the developer

The procedure naturally depends on what type of developer you are using but it generally involves pouring solution from a stock bottle of developer into a measure marked in fluid ounces or millilitres (cubic centimetres for practical purposes). If you use a concentrated solution calling for 50 ml or less to be measured, use a beaker of that capacity or not more than 100 ml. Having measured the required amount, pour it into a larger beaker (500 or 600 ml) and add water from the cold tap to the total quantity recommended for your tank. If the cold tap water is exceptionally cold, you might add slightly warmer water instead.

Suspend the thermometer in the solution. A plastic spring clothes peg is useful for this job if the thermometer makes no provision for it. Check the temperature. In temperate climates and depending on your storage conditions it will more often than not be lower than the 20°C (68°F) generally recommended for black-and-white films. Fill a smallish basin, pan or other receptacle with hot water to make a water jacket. Stand the container of developer in it until the thermometer registers the required temperature. Give the developer an occasional swirl to keep it mixed and speed up the warming.

If you are working in a very cold darkroom (and you should avoid that if possible) it may be necessary to warm the developing tank, especially a metal one, at the same time. You can use the same method, but keep the water below the lid-to-body seal. They are not always completely watertight. Alternatively, just before the next step, you can pour clean water at 21°C (70°F) into the tank and leave it there for one minute before completely draining it out. If you do that, however, you may find that you need to adjust the recommended developing time.

Processing the film

Check the manufacturer's leaflet for the developing time of your film and pour the developer into the tank as quickly and smoothly as possible. At the same time, start the timer or check the time on watch or clock, preferably with a sweep second hand. Immediately start agitation of the developer. That is now usually by inversion of the tank slowly and deliberately but some older models have a twiddle stick down the middle for twisting to and fro. Agitate continuously but gently for 30 seconds and then give two or three slow inversions or twiddles at one-minute intervals.

Between times, prepare your fixer solution, in a different beaker, just as you did your developer. If you have to spend some time getting the temperature right, prepare the fixer before you pour in the developer. On the other hand, do not worry too much about its temperature. Anything from 15-21°C (60-70°F) is suitable.

At the end of the development time, pour the developer out of the tank into its beaker for subsequent return to its stock bottle, or pour it away if it is a one-shot type. Fill the tank with water at 15-21°C (60-70°F), invert it once or twice and pour out. Pour in the fixer and agitate for about 30 seconds. Subsequent agitation is not necessary. At the end of the fixing time (follow the manufacturer's instructions) pour out the fixer and rinse the tank again. You can then look at the film, handling it very carefully by the edges only, to make sure that there is something on it before you bother to wash it.

Temperature variations and reticulation

The rinse water between solutions, the final wash water and the solutions themselves should, ideally, be at the same temperature. Marked differences can cause rapid swelling and shrinking of the emulsion that leads to a crazing effect of tiny cracks known as reticulation. This is generally barely visible on the negative but becomes very apparent on enlargement.

Unfortunately, there is little or no consistency in this effect. It may depend to some extent on the type of water used. It appears, however, that modern films are highly resistant to reticulation.

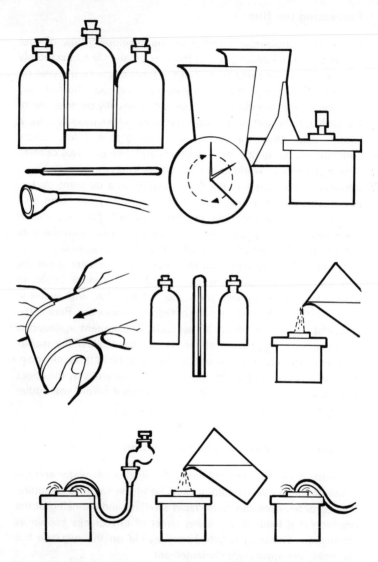

To process films you need storage bottles, measuring flasks, funnel, developing tank, timer, thermometer and wash hose.

The procedure is: Load film into tank; check solution temperatures; pour in developer; pour out and rinse; pour in fixer; pour out and final wash.

They can almost certainly withstand a 6°C or 10°F drop from the normal developer temperature for intermediate rinse and fixer temperature and probably much more. For the final wash, after a hardener-fix, they can certainly withstand a drop to 7°C (45°F). In most cases, therefore, both intermediate rinse and final wash can be directly under the cold tap and the fixer need not be brought up to more than 13°C (55°F). If you are the careful type, however, stick to the same-temperature advice until you have tested the effect of variations yourself.

Washing the film

The average film needs to be washed for about 20 minutes in running water to be as near chemically clean as it is likely to get. The easiest way is to put the tank under the cold tap with the lid off and let the tap run for the required time at a steady flow— neither full force nor a mere trickle.

You will no doubt be advised that the water then simply runs into the top of the tank and straight over the edge, leaving fixer-laden water at the bottom. It is not difficult to disprove such a theory. Nevertheless, it does no harm to run the water through a tube to the bottom of the tank and there are commercial tubes with flexible tap attachments sold for just that purpose. There is also an item known as a turbo washer that mixes air with the water and delivers it to the film with some force, claiming to wash a film completely in five minutes.

Where running water is not available, several changes of still water are just as efficient. Even in running water, the process of washing is really one of diffusion. The unwanted chemicals diffuse out of the emulsion into the surrounding water and are washed away. If you fill and empty the tank at five minute intervals about six or eight times, you will do the job as effectively as most running water operations. In this case, water at a temperature above 13°C (55°F) will probably accelerate the process.

Many claims are made about washing methods, times and temperatures—some of them designed to sell equipment. If you want to test your own procedure, you can buy something for that, too. There are indicator solutions that you can use on a piece of

waste film or paper to show whether you have achieved the required chemical-free state.

Colour film processing

There are two types of colour film—negative and reversal, also known as print and slide. Colour negative film is the easier to handle and, with the improved chemistry of recent years, processing is hardly any different from that for black-and-white film.

The main important difference is in the temperature of the solutions. A popular independent two-bottle system, for example, is used for all Type II colour negative films with a total processing time (excluding the final wash) of about seven minutes, but it has to be used at 38°C (100°F).

The procedure is broadly the same as that we have described for black-and-white films with the exception that, at such high temperatures, pre-heating of tank and film is a necessity. After loading the film into the tank, therefore, you fill the tank with water at 40°C (105°F) for one minute. You then drain the water out completely and pour in the developer at 38°C, agitating for 20 seconds and then four times a minute over $2\frac{3}{4}$ minutes.

Pour out the developer for re-use and give three 15-second rinses in fresh water at 35-40°C, or you can use an acid stop bath for 30 seconds. Next comes a bleach-fix solution at 35-40°C for three minutes followed by a final wash at 30-35°C for five minutes. Your film is then ready to dry for printing.

A few variations in the procedure are possible but the minimum developer temperature is 35°C (95°F), so you need a thermometer that reads rather higher than the average type and it must be reliable, because the developer temperature is critical.

This type of processing, and there are several such products, has brought colour negative processing well within the capabilities of any reasonably careful person. It is not inexpensive but compares well with the least expensive commercial charges and is, of course, a great deal more convenient.

Reversal film processing is a different story. This, too, has been simplified over the years but it is still a tedious job and really only worth while for the dedicated do-it-yourselfer. Apart from the

rather long task of processing, you have to buy slide mounts, cut the film and mount each exposure if you intend to project them. On top of that, of course, the most popular 35 mm colour reversal film cannot be home-processed.

There are four basic steps in reversal film processing, the extra steps being necessary because it is an indirect process. The image is not produced directly by the camera exposure but by a subsequent fogging (by light or chemicals) of the silver halides not affected by the camera exposure. Hence, you first develop the film in a more or less normal manner to produce a negative image. You do not want this image but you have to develop it to render it insensitive to the subsequent fogging step that activates the remaining halides. This second lot of light-struck halides is then colour developed to release dyes in the three emulsion layers in proportion with the colours and densities of the original image (because they are in inverse proportion with those of the negative image).

Finally, a bleach/fix removes the silver image and stabilizes the colours. Rinses or more prolonged washes are required between each step. There is nothing difficult about the process but many find it tedious and barely economical compared with commercial processing prices. However, as processing prices are soaring, you may decide to try it.

Because you have no further chance to manipulate the image (as you do when printing from a negative) processing times and temperatures are extremely critical. Even small variations can alter the density, contrast or colour of your transparencies.

Cutting and filing

Slides are almost universally mounted singly after processing or, in the larger sizes, placed in acetate or similar sleeves that allow them to be viewed without removing them from their protective covering.

Negatives have a further process to undergo before they become viewable so they have to be preserved in a usable state. With most enlargers, it is preferable to handle negatives in strips—four or six 35 mm, three or four 120s. Single 35 mm negatives, in particular, are very tricky to handle.

The most popular 35 mm filing aid is an envelope or bag to take strips of six, generally open at one end. Such bags can be bought loose in hundreds or can be incorporated in wallets, loose-leaf folders and other filing aids. In those cases the bags may be open along one long edge instead of at the end. It is certainly advisable to use something of this sort to preserve your negatives. The one-time practice of rolling up the whole 20 or 36 exposures and cramming them into a film can is definitely not to be recommended. It is not a lot better to keep the whole film (six strips or more) in one envelope. Constant insertion and extraction will eventually lead to scratches and other blemishes. Stick to one strip per envelope if possible.

Most such envelopes are made from translucent acid-free paper that enables you to view the contents with some difficulty. You can also obtain clear acetate versions which, although more expensive, make the contents more readily accessible and can even be printed through for proofing purposes. Whatever you do, do not put your negatives in envelopes or other wrappings not specifically designed for the job. Many ordinary papers contain ingredients that can harm photographic emulsions.

Filing the negatives in such a way that you can easily find them again is a terrible problem for most people. Subjects tend to vary widely on a film and even on a single strip. How do you file a strip containing three shots taken at the zoo—one of a child eating an ice-cream, one of the giant gorilla and one of a passing aircraft? The filing genius knows the answer but really efficient filing means a lot of work and a meticulous mind. If you do not like the one and cannot cultivate the other, probably your best bet is to file in chronological order. You may have a rough idea when you took that particular shot you are searching for.

If being able to find a particular negative years afterwards is important to you, then your shooting must be disciplined with that fact in mind. Waste film rather than carry out two or three different assignments on the same roll. Do not leave film in the camera when a particular job is finished. Resist the temptation to take the odd shot of an unrelated subject unless it is really worthwhile.

However you file them, keep your negatives away from the old enemy—damp—and from excessive heat. Most indoor locations

should be adequate. If you have an outside or loft darkroom, it would be better not to keep your negatives there unless it is well insulated or you have an airtight box, cupboard or what-have-you. A bag or two of silica gel in the cupboard or container will do no harm.

Black and White Printing

Printing is a much more exacting process than developing the film. It is not difficult, of course, to produce a print of sorts, but good printing is a skill and the best photographic printers are people of immense skill born of long experience.

The object of printing, which is now virtually synonymous with enlarging, is to produce the best possible positive image from the negative image on the film. Generally, that means a print that retains as many as possible of the individual tonal values of the negative and shows a clear white and a true black somewhere in the image. The first sign of bad printing is a muddy greyness where there should be black. The most frequent cause is too much exposure and too little development.

If you have already tried making your own enlargements and have come up with prints that lack sparkle, try a simple experiment. Adjust your exposure time until you can leave the print in the developer for at least three minutes without it going too dark. You will probably be surprised at the improvement in your print quality. Over-developing a print (with the correct exposure) rarely causes problems. Underdeveloping is invariably bad practice.

Setting up

We have already described the equipment you need for black-and-white printing. To start work, set out your dishes in the order: developer, rinse, fixer. Whether you work from left to right or right to left depends on your personal preference and perhaps on the layout of your darkroom.

Pour the required quantity of developer into its dish. It is false economy to skimp on the developer. Put enough in the dish to be able to submerge the print without difficulty and to keep it sub-

merged without constant prodding. Pour a generous quantity of water into the second dish to serve as intermediate rinse and finally pour fixer into the third dish, again not skimping on the quantity.

The developer should be at 15°C (60°F) or higher. The rinse and fixer can be at virtually any temperature but preferably not below 13°C (55°F). If your darkroom is cold, you can place the developer dish in a larger dish containing water at about 20°C (68°F). Keep a thermometer in the developer dish and top up the warm water if the temperature falls significantly. Alternatively, there are various types of aquarium thermostatically-controlled heaters that serve to keep the water at the required temperature indefinitely. Dish-warmers can also be obtained. These are a sort of hotplate on which you stand the processing dish. Some models are also thermostatically controlled.

With the dishes in position, place one set of print tongs by the developer dish and one by the rinse. Place a bucket, bowl or other receptacle with clean water to receive the finished prints and store them for the final wash. You are now ready to make the first print.

Making test strips

To produce a successful print, you must know how long to expose the paper to the projected image. Too much exposure and the print is too dark; too little and it is too light.

Place the required strip of negatives in the enlarger negative carrier and adjust it to frame the negative from which you wish to print. Set the enlarger lens to full aperture. Set your masking frame or cut a piece of white paper or card to the size of the paper on which you intend to print. Switch off the white light and switch on the safelight. Raise or lower the enlarger head to give an image roughly the correct size and then focus it accurately. You may need to adjust the size again and refocus. You will not be able to use all the paper or include all the image unless you have cut the paper to the correct size. There are various negative sizes and papers are made in a compromise range based more on stationery sizes than photographic needs. Move the frame or baseboard paper about until you settle on the composition that pleases you. When you are satisfied, switch off the enlarger lamp.

Use a reasonably large piece of paper to make a test strip and place it so that it includes as many tones as possible. Switch on the enlarger lamp and give stepped exposures by moving a black card into the beam. Process the strip and determine by inspection under white light which part received the correct exposure.

The traditional way to proceed now is to make a test strip to find the correct exposure. Take a sheet of the paper on which you intend to print and cut it into strips about 5 cm (2 inches) wide. Keep one of them out and put the others back in the packing for later tests. With your strip of paper clutched to your body or otherwise safely shielded, switch on the enlarger briefly and check the best position for the test strip.

The aim is to place the paper so that it covers as wide a range of tones as possible—not all dark foreground or all light sky. If there are important flesh tones in the picture, be sure to include those. Switch off the enlarger lamp and place the paper in the chosen position. You may be able to do all this by swinging the enlarger's red filter into position. Some people like them, some do not, but they allow you to study the image at greater length and to position the paper accurately. The red light has no effect on the paper, but never focus through it.

Now the idea is to make at least three different exposures on this piece of paper by shielding it for part of the time with a piece of black card or other opaque substance. Stop the enlarger lens down by two or three stops and switch the lamp on. After five seconds move your shield into the beam to obscure about one third of the strip of paper. After a further five seconds, move it forward to cover another two-thirds. After another ten seconds, cover all the paper and switch off the lamp.

You have now given exposures of five, ten and twenty seconds to different parts of your test strip. Naturally, you use the shield in such a way that each differently-exposed section contains as close to the same range of tones as possible. You do not obscure first the sky and then the middle distance.

Take the strip from the baseboard and drop it emulsion side down into the developer. Hold it down with the tongs and gently rock the dish to cover all parts of the paper as quickly as possible. Turn it over and continue to hold it down gently until it will stay down by itself. Rock the dish slightly now and again and leave the strip in the developer for *at least three minutes*. At the end of that time take it out of the developer with the developer tongs and allow surface developer to drain back into the dish.

Drop the strip into the rinse water without allowing the tongs to

enter it. With the fixer tongs, paddle the strip about in the rinse for a few seconds, drain it and place it in the fixer. Push it down and rock the dish to submerge it.

After 30 seconds or so in the fixer, you can turn on the white light and examine the strip. With luck, you have one or two bands that are too dark or too light and one that is nearly right. What you are looking for is a full range of tones, providing the subject had such a range—and it should have for your first test. You do not want pure white where there should be some detail or a muddy grey representing a deep shadow or even the pupil of an eye. On the other hand, you do not want the shadows to be jet black along with some of the slightly less dark tones that should show detail.

If all the bands on the strip are too dark or too light, take another strip and start again, opening up the lens one stop if the strip was too light and closing it one stop if it was too dark. Keep the times the same if possible.

If you find that the 10-second strip was a little too light and the 20-second strip a little too dark, try another strip with about 13 and 17 second exposures. After two tests at most, you should have the correct exposure.

Making the print

All you have to do now is to take a full size piece of paper, position it in the masking frame or in the same place as your baseboard paper (by safelight only, of course), turn on the enlarger lamp for the time ascertained and process the paper.

You need not necessarily develop for three minutes this time. The recommended time for most papers and developers is $1\frac{1}{2}$-2 minutes. You should find that two minutes gives you results indistinguishable from three minutes because the aim is to develop the paper to finality and, with the correct exposure, it will develop to finality in two minutes. If you develop your test strip for only two minutes, you cannot be sure that, although the print looks good, it is really fully developed. If you develop a little longer, any tendency to overexpose shows up because the print goes darker, which it would not do if it were correctly exposed and developed to finality. After an excessive length of time it might start to 'fog' when the

developer finally attacks the unexposed halides but it will not do that in three minutes or probably even four or five, depending on the paper and developer.

The longer development time, even for the actual print, is a useful habit because it ensures that you do not overexpose and drag the print out of the developer before it is fully developed.

Improving the print

We have described the procedure for printing on a normal grade of paper from a perfect negative, ie, a negative that has no extremes of contrast and is neither too thin nor too dense. With practice, you can produce that type of negative on most occasions but you will inevitably have to handle unsatisfactory negatives from time to time.

You might, for example, shoot a subject in low, even lighting conditions that fool your exposure meter. You give a long exposure but it is not quite long enough. The shadow areas are almost clear film with just a trace of the detail that you really wanted to bring out more strongly. Even the medium tones are a little weak and the densest highlights are far from opaque.

That is the classic underexposed negative, lacking in contrast and very difficult to print. If you try to print it on a normal grade of paper, the print comes out flat, grey and uninteresting. You can improve matters by using a harder (more contrasty) grade of paper, say Grade 3 or 4 instead of your normal 2 or 3.

On the other hand, you may err on the side of overexposure in brilliantly sunlit conditions. Then the important highlight areas (as opposed to tiny brilliant spots in which no detail is required) are practically opaque. The medium and shadow tones are also darker than they should be but not in proportion with those clogged highlights. When you try to print that on the normal grade of paper you have to give a very long exposure to bring out the detail in the highlights but then the medium tones and shadows print too dark. A softer, less contrasty grade of paper might help, say Grade 1 or 2.

Even changing to a different paper grade may not solve such problems. In fact, it rarely does produce a first class print from a poor

negative. What you really want is more exposure in the highlights than in the shadows. That you can arrange without too much trouble.

It is self-evident, for example, that if part of the paper is shielded from the image-forming beam during the exposure, no image will print in that area. If you remove the shield part way through the exposure, the image prints less strongly where it was shielded. After all, that was just what you did with your test strip. Thus, you can shield (or shade) any part of the image that a full exposure would cause to print too dark while allowing the rest of the image to form normally. Alternatively, you can shade the major part of the image and allow a small piece to burn in.

The technique is relatively simple. To shade a small portion inside the borders of the image, you cut a small piece of black card, generally in a circular or oval shape and affix it to a wire just thick enough to hold it horizontally. During the exposure you interpose this dodger in the light beam so that no light reaches the area you wish to print lighter. Position the dodger a few inches above the baseboard to avoid a sharp outline and let it tremble slightly throughout the operation so that the wire support does not cast a shadow.

To burn in, take a large piece of card and cut a small hole through which you can direct light on to the area that needs extra exposure while shielding all the rest of the image. Again, keep the card moving slightly to avoid forming a hard edge between the differentially exposed areas.

If the area that has to be shaded is at the edge of the print you can do away with the wire and simply hold the piece of card in the appropriate position, or you can even use your hand.

You can determine the different exposures required from your original test strip or by making further tests for each area. The first-class printer uses these techniques frequently. Photographic paper cannot reproduce all the tones in a good negative and some manipulation is nearly always necessary to produce the best possible print. The difference between you and me and the first class printer is that he simply appears to wash his hands over the print, directing light here and there with casual expertise while we struggle with our bits of card and wire. Practice makes perfect, however,

and maybe you, too, will soon graduate to that state of professionalism.

Drying the print

We have described print fixing and washing adequately in the chapter on print-making materials. After the final wash, however, your print may need further attention.

The first problem comes in drying. Ordinary photographic printing papers tend to curl strongly toward the emulsion side as they dry. Straightening them out is relatively easy when you know how but can lead to unfortunate accidents if you are careless. The easiest method is to hold the print diagonally over the edge of a table. The sharper the edge the better. Grasp the protruding corner firmly and pull downward while holding the face of the print flat with the palm of the hand. Be careful that large prints do not curl inward as they reach the edge. That puts in an irremovable crease. Repeat the operation for each corner and the print should then have a slight reverse curl that will straighten later.

If you find such a method beyond you, try drying prints under pressure. Again, there is a simple method. Get hold of sheets or books of photographic blotting paper (a special pure fluffless kind). Interleave your prints with the blotting paper and weight the pile down with suitable objects—not books: the damp will get through. Heat-drying with a dryer-glazer can be satisfactory, provided you do not use too much heat. The slight curl tends to straighten out as the prints cool.

Resin-coated papers give far less trouble in this respect. They dry very quickly and almost perfectly flat because the paper is coated on both sides with a plastic layer that resists the pull of the drying emulsion.

Glazing the print

For normal purposes, the print is finished when it is dried and suitably flattened. If it is on glossy paper, glazing improves its appearance. Dryer-glazers, as already mentioned, are not too expensive but are not all that efficient either. It is generally said that

You can shade a part of the print during enlarging so that the required portion prints more strongly without overprinting elsewhere. Use your hands or a piece of card to intercept the light beam. If the area requiring shading is within the print borders use a piece of card on thin wire and keep it moving gently during the exposure.

prints glaze better after hardening in a suitable hardener-fixer but the logic of that is a little difficult to follow. It is probably based on the possibility of damage to an unhardened emulsion if too much heat is used.

You do not have to heat glaze or even have a glazing machine. A sheet of spotless plate glass (more likely to be thick float glass now, in fact) gives a far superior glaze once you get it working. The difficulty is that the print may stick to the glass. If it does, there is no way out but to soak it off and try again. It is worth persevering because repeated glazing seems to break in a suitable sheet of glass.

The art of glazing is to affix the glossy surface of the print to the spotlessly clean glass by excluding *all* surface water and air. It is best to float the paper on to the glass under water and then to use a good, free-running roller squeegee relatively gently on blotting paper on the back of the print. Do not squash the emulsion on to the plate with heavy rolling. All you want to do is to make perfect contact all over the print surface. Leave the print to dry in room temperature and it should fall from the glass. If you have to do anything more than pick an edge with a fingernail, you will probably ruin it by attempting to pull it off.

There are various solutions sold to aid glazing—from a 'cold enamel' to a simple detergent. They can help but the greatest aid is clinical cleanliness. Wash the glass thoroughly after every use with soap or detergent to remove all traces of grease. Soak the print thoroughly and preferably glaze it straight from the final wash.

Retouching the print

However careful you are, you may find that specks of dust or minute scratches on the negative have disfigured the print with white or black spots or lines. If you use resin-coated papers you must be extra careful to avoid such blemishes because the plastic coating does not respond well to the removal of black marks.

On ordinary paper, black marks are relatively easily removed (with practice) by knifing, the most suitable instrument being a razor blade, single-sided if you can find one. The idea is to scrape away the offending blackened emulsion. If you work very, very slowly

with the lightest of pressure with a corner of the blade you can remove black marks with hardly any evidence. Some of the gloss is removed from the paper (glossy papers should be retouched before glazing) but that is only evident from an angled viewpoint.

White marks have to be treated with retouching pencils, dyes, etc. Ordinary lead pencil is very effective on some paper surfaces, particularly semi- or dead matt, but the normal procedure is to use retouching dyes or pigments with a good quality fine-pointed brush. The fine point is absolutely essential, so the brush from a child's paintbox will not do.

Take a very little of the dye or pigment and spread it very thinly on a paper, china, plastic etc. surface and allow it to dry. With the brush almost bone dry—a gentle lick is the best moistening method—take up the absolute minimum of colour and make the smallest possible spots with the tip of the brush, which is held almost vertically. Fill in the offending spot as much as possible without overlapping the dots. Allow that to dry—it should be virtually dry already—and start again, gradually building up the coverage and density until it matches the surrounding area. Again, your greatest asset is a feather-light touch and infinite patience.

Printing on other supports

Most printing is aimed at producing a positive image as an end result but there are many other jobs that your enlarger can tackle. You might want to go through an intermediate stage or two before you produce the final print.

We have already mentioned that paper comes in different grades to allow you to increase or lower the contrast of the image. Generally, you use a less contrasty paper with a contrasty negative to obtain a more or less normal result. But you might want high contrast. You might have produced a near silhouette on the negative. To turn it into a complete silhouette, you print it on the hardest paper available.

Sometimes that is not enough. It is better to make another more contrasty negative and print from that. Nothing could be simpler. You can use your enlarger to print on film just as easily as on

paper—or nearly as easily if you are working in 35 mm. As you want a silhouette, you use contrasty film and it is quite easy to obtain sheets of such film, known as line or lith film, in various sizes. Get the blue-sensitive type if you can because that can be used in ordinary safelighting, just like bromide paper. It can be processed perfectly satisfactorily in the same chemicals, too, but you get high contrast quicker if you use the recommended developer.

If your enlarger takes both 35 mm and 6 × 6 cm, it is reasonably easy to print on to the larger format and use the final high-contrast negative for enlarging in the normal way. If you can handle only 35 mm, it might be better to print on to film the same size as your final print so that you can contact-print the final result. We dealt with that when discussing proof printers.

Your first print from the negative on to line film is a transparency (positive image) that has to be printed again to produce a negative. This second printing should give all the contrast you require but you can repeat the process as often as you like.

Apart from high-contrast film, you can print on to ordinary film to produce a well-grade positive transparency of any required size. You can use sheet film in any of the well-known brands or specialized materials such as photo-linen and opal film (see the chapter on print-making materials). You can even buy emulsion to coat on to a variety of supports and another special type for firing on to ceramics. Both are expensive, the latter very expensive and available only to order. It also needs specialized equipment.

There are innumerable experimental processes that you can use in your darkroom, such as the production of poster-like prints, bas-relief images, solarizations and so on. These are beyond the scope of this book but you can find plenty of inspiration in another book in the series—Gunther Spitzing's *Focalguide to Enlarging* as well as many other books devoted to more advanced print-making methods.

Testing the safelight

The one essential for good darkroom work is an efficient safelight. It should give you plenty of light to work by but must be absolutely

safe, ie, it must have no effect at all on your light-sensitive materials. If you are tempted to improvise your own safelight, you must test it. It is even wise to test any commercial product you use, if only for your own peace of mind.

That is not as simple a procedure as it might seem to be. The obvious way is to place a piece of bromide paper on the enlarger baseboard and obscure part of it with a coin or any other small opaque object. After a few minutes, develop the paper and if there is no trace of where the coin stood, your safelight is safe.

That is a rather rough and ready test that tells you little if anything. When you make a print, you do not only expose the paper to the safelight. You also use the light from the enlarger lamp. It is possible for the safelight to have no visible effect by itself but to put just enough light on the paper to overcome the inertia of the emulsion. It then needs only a fractional exposure from the enlarger lamp to produce a tone that the safelight alone would not have produced. The result is a slight veiling of the highlights and a merging of mid-tones that would otherwise be distinct and separate. If the fault is slight, you may not notice it but you will never get prints quite as good as they should be.

The best method of testing, therefore, is to place the coin on the paper as before but then, after a few minutes exposure to the safelight, to remove the coin and give a quick flash of light from the enlarger lamp (with no negative in the carrier) before processing the paper. If there is then no trace of where the coin stood, you can be satisfied with your safelighting.

The flash from the enlarger beam should be just sufficient to provide a visible tone on the paper after development, so you may need to experiment to find that exposure first. After your test, that tone should be unbroken across the paper. If your safelight is affecting the paper, the place where the coin stood will show up lighter because it did not receive the safelight exposure.

Alternatively, after the test exposure, make a print on the paper in the normal way. Again, there should be no trace of where the coin stood.

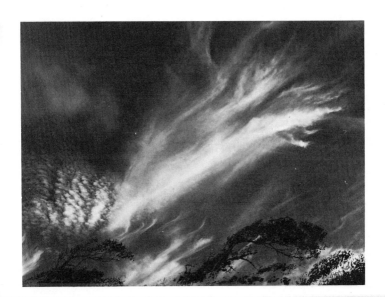

Multiple printing – for the top picture two negatives were printed once each, one with the clouds and one with the trees. For the picture above, the seagull was printed three times with the enlarger head at different heights (once with the negative reversed) on top of the background seascape.

An amusing trick, and not difficult when you know how: the portraits (all from the same sitting) were individually printed, then trimmed and put in the bottles; these were then rephotographed against a black background.

Top the top half of this print was exposed for longer than the bottom half, so that there is detail in both sky and foreground.

Above the photographer considered the foreground in the left hand picture to be too light, so he made a better print by giving extended exposure to this area.

Paterson texture screens – these are placed in the enlarger together with the negative to be printed, and can give a variety of interesting effects. *This page –* drawn cotton. *Opposite page –* steel etch.

Paterson texture screens. *This page* – screen dot. *Opposite page* – grid line.

Top enlarging a tiny part of a negative simulates the effect of a telephoto lens, although grain becomes fairly coarse.

Above a photograph of a single blade of grass, printed three times in different positions to make a delicate pattern.

Colour printing

The Fascination
of Making
Colour Prints

Ever since the earliest days of photography when all colour prints had to be made by assembling three separate images in registered superimposition, colour printing has held a fascination that has captured the imagination of an ever increasing number of photographers. In the last few years colour printing processes have become much easier and this has meant that even the amateur can enjoy the excitement of making his own colour prints with quite modest equipment and facilities.

Not only have the processes and methods become simpler, the time required to make colour prints has been reduced dramatically. Not so long ago, you were lucky if you could get a good result after two evenings of work – the first evening was spent making a set of separation bromide prints or a set of dye-transfer matrices and the next evening you put the necessary three colour images together to see the result. Now, while you may have to spend a part of your first evening getting a balanced result with your particular enlarger and batch of paper, once this has been done you can expect to get several good prints during each session.

I have often wondered just why it is so fascinating to make a colour print, but I suppose any form of photography is miraculous – even the development of a black and white print in a dish – and if this is so, then to produce a colour print is so much more wonderful.

Until you have opened a print drum at the end of a processing sequence and removed your colour print, you can have no idea of the thrill it will give – particularly when you have got it right.

The creative element

Some enthusiastic amateur photographers – the Americans call them hobbyists – take the view that black and white printing allows more opportunity for self-expression than colour printing, but this is

only true so long as perfectly straight prints are made from the original negative or slide. Once you have gained some confidence with a colour printing process it will not be long before you decide to modify your prints to suit your ideas. It is a relatively simple matter to darken skies or lighten shadow areas in order to reveal more detail. It is a bit more difficult to modify local areas of colour, but even this is well within your bounds as your skill and confidence increase. The very least you can do is to choose the degree of enlargement and the composition or cropping of the picture that you prefer – factors which are all decided for you when you order prints through your dealer.

Merits of negative/positive and positive/positive printing

At this point it might be as well to consider the relative merits of working via colour negatives or colour slides. I believe that some people are puzzled by the fact that there are these two ways of getting a colour print. Some amateurs have never used any colour film other than colour negative – simply having graduated from black and white negatives to colour negatives. They know that there is no problem in getting their exposed films processed and printed because the procedure, as far as the chemist or photo dealer is concerned, is exactly the same as it is for black and white films. Some amateurs use the occasional colour transparency film, but they are unlikely to use it when they really want prints. Most 'keen' amateurs have projectors and screens and use them regularly to display the slides they get from reversal colour films. This group, although usually very enthusiastic and well equipped, frequently seem to be under the impression that prints cannot be obtained from transparencies, or if they are then their quality is invariably disappointing. There are several reasons why these impressions have been created, but the fact is that colour prints can be obtained from colour negatives and from colour transparencies.

Photofinisher prints

It is probably true that photofinishers, whose job it is to make the prints ordered by amateurs through chemists and dealers shops, do produce better prints from negatives than from transparencies. The reasons for this are a little complicated.

The two most important factors in the colour negative system are that the camera film has almost as much exposure latitude as a black and white film; and the characteristics of the negative image can be designed for the sole purpose of producing the best possible prints on paper. In other words the colour negative is a means to an end, unlike a transparency which is itself a finished photograph.

A correctly exposed and processed transparency has a much higher contrast than a negative of the same subject. This makes it more difficult to print from and sometimes either highlight or shadow details are lost. In addition, photographic manufacturers have found difficulty in making some colours come out well in colour reversal papers.

Having said all this it remains a fact that there are several reasons why the amateur who intends to start colour printing for the first time, should seriously consider the advantages of working from transparencies rather than negatives.

Advantages of printing from transparencies

The most important advantage that comes with printing from transparencies is that you can easily tell what the original photograph looks like, so you know if it has been properly exposed and if it is correct in colour balance. It is much more difficult to predict the kind of colour print that will result from any given colour negative, because both brightness and colour values are in reverse. Although a disadvantage in one respect, some advantage comes from the fact that the contrast of the colour transparency is relatively high, because then the contrast of the reversal printing paper must necessarily be relatively low. This means that enlarging exposure times are not so critical neither is colour filter adjustment so sensitive.

Integrated printing of colour negatives

If you are wondering why it is that colour negative printing presents problems to amateurs which do not worry the photofinisher, it is because the finisher will be using automatic integrating printers costing £50,000 or more. These machines are capable of looking at a negative photo-electrically and very rapidly assessing the correct printing exposure and colour balance. Working in this automatic way can result in first time balanced prints from some 95% of all negatives.

So you see, you have a choice to make and only you can make it. Much will depend on which of the two types of colour film you normally use, because the best thing is to start printing from some of your favourite negatives or transparencies to see how you get on. Having used both colour negative and colour transparency films at different times I must admit that the wide exposure latitude of colour negative materials always gives me a comfortable feeling because I know that provided my exposures are not more than two stops under or three stops over the optimum, then I shall probably be able to produce satisfactory prints. But when I use transparency films I must try to get within half a stop either side of the optimum exposure if I am to have transparencies from which I can make good colour prints. However, this is a purely personal feeling and I know that if I used an exposure meter regularly, or a camera with built-in exposure control, then I should get a much higher proportion of successful transparencies.

History of colour negative film

Historically, colour negative materials took a good deal longer to achieve general acceptance than did colour transparency films such as Kodachrome. There were a number of reasons for this – not least of which was that the early 35 mm transparency materials were a spin-off from the 16 mm amateur movie systems of the late 1930's. The first colour negative film to be sold to amateurs was launched in 1942 in the U.S. by Eastman Kodak who called it Kodacolor and made it available only in roll film sizes. There followed a period when all the processing and printing of Kodak films was done exclusively in

Kodak laboratories; but following an anti-trust suit, Kodacolor and Kodachrome processing information was released to independent photofinishers in the U.S. and later throughout the world. This extension of processing facilities together with the introduction of 126 Instamatic cartridge loading cameras in 1962 resulted in a tremendous increase in the use of colour negative films by amateurs. It was not long before the volume of colour negative exposures greatly exceeded that of colour transparencies. Professional photographers also favour colour negative films if they are to produce colour prints. Professional laboratories will produce superb handmade prints at a price: and can also make colour transparencies or black-and-white prints from colour negatives when required. Nevertheless, with the continued improvement in the quality of reversal films, it is generally agreed that for sheer excellence of quality and brilliance of reproduction no other form of colour photography surpasses the colour slide.

Masked negatives

But there are ways in which the colour negative offers advantages over the colour transparency when colour prints are the main objective. Greater exposure latitude has already been mentioned but there is another important advantage. None of the dyes used to form colour photographic images is quite as perfect as theoretical requirements demand. In other words a magenta dye should transmit all blue and red light and completely absorb any green light, but in fact there are no magenta dyes that behave so perfectly. Because of such limitations the accuracy of reproduction in colour transparencies suffers to some slight extent as a result. But there are ways of compensating or counteracting this type of deficiency. The solution depends upon the fact that only the printing characteristics matter with a negative, its visual appearance is immaterial. When you saw a processed colour negative for the first time, you almost certainly wondered for a moment why it had an overall orange appearance. It is because yellow and red masking dyes are incorporated in the layers in the form of coloured couplers in order to improve the accuracy of colour reproduction in the finished print. Coloured couplers of this kind cannot be used in transparency films

because the image obtained from the camera exposure must look correct when viewed directly or by projection.

However, in the mid 1970s the Cibachrome research team in Switzerland discovered an entirely new way of obtaining a colour masking effect while maintaining perfect highlights and whites in finished prints. So now that printing materials have improved and processing times are reduced, it may yet prove easier for the inexperienced amateur to obtain satisfactory prints directly from transparencies than to make them from colour negatives.

Since this book is concerned with colour printing it will be assumed from now on that you have either colour negatives or colour transparencies already available. Many transparency materials are processed by the film manufacturer anyhow, so their processing poses no problem. Similarly it is not really necessary for an amateur to process his colour negative films simply because he wants to make his own colour prints. In fact there is much to be said for having your negatives processed by a good photofinisher and perhaps having a set of small prints made at the same time. If you do this, it will make it much easier to decide which negatives are worth printing and how they might be cropped for the best composition.

Developing colour negatives

If you do feel that you would sometimes like to be able to develop your own negatives – in cases of urgency for example – then you will be interested in the possibility of using a chemical kit such as Photocolor II, a two solution chemistry that can be used either for developing films or papers.

Photocolor II

Photocolor II is sold as a two solution chemistry, but strictly speaking there are three solutions involved – a colour developer, a bleach-fix and a developer accelerator to be used when developing prints. The Photocolor outfit will process Kodacolor II, Vericolor II, Fujicolor II and Sakuracolor II films – as well as many others designed to suit

Kodak's C41 process. As·time goes on, other manufacturers may decide to produce films that are compatible with the C41 process in which case it will be possible to process them in Photocolor solutions.

Processing times with Photocolor are quite short – development only requiring 3 minutes at 36°C (97°F) and the whole processing cycle taking about 7 minutes.

Negative and transparency sizes

Some thought should be given to the size of the negatives or slides you will be using as originals from which to make your colour prints. If you have only one camera – and you do not intend to buy another – then the matter has been decided, but if you do have a choice you should consider the following points.

To obtain a 10 in print from a 2¼ in (6 cm × 6 cm) square roll film negative you must make a four times linear enlargement; from a 126 or 135 negative you will need to enlarge about 8 times, but if you use a 110 size camera, your original negatives or slides will have to be enlarged some 15 times to give you an 8 in × 10 in print. Such prints from 110 size originals are likely to need a good deal of spotting because of the blemishes that will result from any dirt or marks on the negative or transparency.

Statistically, there is a very good chance that if you are a keen amateur photographer you will already be using a 35 mm camera, in which case you will have chosen a good compromise between a reasonably sized format and a handy camera.

Differences between black and white and colour printing

It is often said that making colour prints is just as easy as making prints in black and white. This simply is not true. What is true, now that methods have been simplified and materials improved, is that the basic sequence of steps involved in exposing and developing a colour print is very much the same as is used in black and white printing and processing; with one big difference – *filtration of the*

printing light. Many beginners feel that once a correct exposing combination has been found, then provided processing remains constant, they should be able to continue making prints from any subsequent negatives or transparencies merely by changing the duration of the exposure to suit the density of each original. Unfortunately, things are not quite as simple as that.

When a black and white image is printed onto a sheet of bromide paper it is not at all important what kind of printing light is used – provided that the printing paper is sensitive to at least part of it. Correct exposure will be made by judgement and the whole operation is uncomplicated. But a colour negative is a combination of three different images – one of them formed of yellow dye, another of magenta dye, and the third of cyan dye. (Magenta is a bluish-red colour dye discovered in 1859 and called after the battle of that name fought during that year in Northern Italy; and cyan is bluish-green in colour and is so named because of its similarity to the colour of cyanide.) These coloured negative images are each required to modulate a corresponding emulsion layer in the three-layer colour paper on which the final image will be formed. All colour papers carry three superimposed, differently sensitised emulsion layers – one is sensitive to blue light, one to green and the third to red. The yellow image in the colour negative – or the transparency as the case may be – has to modulate or regulate the amount of blue printing light that reaches every part of the picture area of the printing paper. Similarly, the magenta and cyan images in the negative or transparency regulate the green sensitive and red sensitive layers of the paper. Now this all has to be very delicately balanced if the result is not to come out too blue or too yellow, or wrong in some other way.

Variables affecting colour balance

There are a great many variables that must be countered when determining the precise colour of exposing light that is required to yield a correctly balanced colour print. Some of the more obvious factors that can cause changes, are the colour of the light when the photograph was taken, the type of enlarging light, and above all, the characteristics of the particular type of colour paper that is being

used. Any of these can easily cause a significant difference in the colour balance of the final print if their influence is not compensated by suitable modification of the colour of the print exposing light.

It may be a little difficult to realise that two enlargers of apparently similar construction can be using different lamps running at different voltages so that prints made on them using the same filtration might look significantly different when processed. Even a 10 volt change in the power supply to the enlarger can result in a noticeably different print when everything else is equal.

Two ways of colour printing

Compensation for the variables already mentioned and any others can either be made by changing the relative times of three separate red, green and blue light exposures or by modulating the colour of the printing light by means of one or more filters that we call a pack. The pros and cons of these two methods of printing are dealt with in some detail later on, but there are several good reasons why most colour prints are now being made by a single exposure rather than by three successive exposures. The amateur who is just beginning does not want to spend too much on specialised equipment until he has more experience. So he uses a set of colour filters that can be put together to form packs in an almost unlimited range of values so that the requirements of virtually any negative/paper combination can be satisfied. Professional printers and the more advanced amateur hobbyists will invest in an enlarger with a colour head. This incorporates the means of changing the colour of the printing light through a wide range of values without the need to handle any filters at all.

Simplified processing

More than anything else, simplification of processing has encouraged the amateur to take up colour printing. Print processing times are now often less than 10 minutes with only two or three solutions involved. For example, with a three solution chemistry such as Kodak's Ektaprint 2, the time required for the wet stages of proces-

sing a print from a colour negative will be around 8 minutes, while the Cibachrome P-30 process for making prints from transparencies will take you about 12 minutes.

Processing drums

It has already been explained that all colour print materials have to be sensitive to red, green and blue light. For this reason it is impossible to carry out the early stages of print processing by inspection – another way in which making a colour print is different from making one in black and white.

A very low level of carefully chosen safe-lighting can be used with most colour papers, but the kind of light permitted is too little to be of much use.

One can therefore think of developing a colour print in much the same way as developing a panchromatic film. Films are usually developed in a so-called daylight tank after having been loaded into the tank in darkness. This logical idea eventually spread to colour print processing – initially with the Simmard drum – and the technique has grown so rapidly as to have transformed amateur printing. Small volumes of processing solutions will also suffice if the liquids are made to flow over the surface of the print by reason of a rocking or swirling motion. The Agnecolor rocking 'Wedge' and the Paterson 'Orbital' processors are examples of this form of processing.

One-shot chemistry

Because very little solution is necessary when developing the print in a processing drum, it is not too expensive to use each of the processing solutions once only, pouring them away immediately after use. This form of processing, called one-shot or total loss, has the advantage of not involving any kind of replenishment or regeneration. A fresh quantity of each solution is used for every print, thereby ensuring reproducibility of processing conditions.

Of course, just as if you were developing a film in a daylight tank, the time of treatment, the temperature of the developer and the agitation must all be kept constant if you are to achieve the results you expect.

Shortened processing times

Not so long ago, it was quite usual for a colour print to require 45 minutes of wet processing, but now it is possible to get a print in 10 minutes or less. This striking reduction in processing time has contributed greatly to the popularity of colour printing, because too long a wait between exposing a print and seeing the result did become frustrating after the magic of making one's first few prints had begun to wear off.

Ektaflex

Kodak's Ekatflex system of colour print processing can be thought of as an extension of the process normally associated with 'instant' photography. The only 'processing' solution required is an alkaline bath through which a sheet of exposed Ektaflex PCT film is passed before it is combined with a sheet of Ektaflex receptor paper. The processor or 'Printmaker' used for immersing the exposed film in the activator and its subsequent lamination to the receptor paper is more elaborate and more expensive than a processing drum, but the time taken to 'process' an Ektaflex print is much the same as other colour print proceses, although there is no time required for drying.

There are really only two variables involved in processing an Ektaflex print: 1, the activation time and 2, the lamination time (i.e. the time during which the exposed film and the receptor paper remain in contact). A simple table indicates the relevant times at different temperatures.

Room temperature		Activator soak time (seconds)	Lamination time (minutes)
°F	°C		
65	18	20	8 – 15
70	21	20	7 – 12
75	24	20	6 – 10
80	27	20	6 – 10

Finding the right filtration

Estimating, calculating, or even guessing the right filtration for a colour negative undoubtedly remains the most difficult part of colour printing. Opinions are still divided as to the best approach to the problem. Some people think it better to make whatever number of preliminary test strips are necessary before the final exposure is made; and this may mean two, three or even more tests for the inexperienced amateur. Others find that at least one and sometimes two testing stages can be avoided by using some kind of calculator or estimator. One thing is certain, subjective judgement must always play a significant part in the production of any really successful colour print and this kind of judgement can only come from experience, so the more colour prints you make the fewer test strips you will find you need.

Compact. Small 35 mm camera, usually with fixed lens. May have coupled rangefinder and exposure meter.

Component. Part of a compound lens consisting of one element (single lens) or more than one element cemented or otherwise joined together. A lens may therefore be described as 4-element, 3-component when two of the elements are cemented together.

Computer flash. Electronic flash guns which sense the light reflected from the subject, and cut off their output when they have received sufficient light for correct exposure. Most units must be used on or close to the camera for direct lighting only, and the camera lens must be set to a specific aperture (or a small range of apertures) determined by the speed of the film in use.

Condenser. Generally a simple lens used to collect light and concentrate it on a particular area, as in enlarger or projector. Frequently in the form of two plano-convex lenses in a metal housing. A condenser, normally of the fresnel type, is used to ensure even illumination of the viewing screens on SLR cameras.

Contact sheet. A sheet of prints made the same size as the negatives, with the printing paper in direct contact with the negatives. Although too small to be interesting for normal viewing purposes, such prints can be used to assess negatives.

L-shaped masks

Cartridge. Film container with feed and take-up chambers – used in 110 and 126 cameras.

Cassette. Light-trapped film container used with 35 mm cameras.

Cleaning accessories. Camera interior and lens brushes can incorporate a blower bulb; they may be retractable to protect the bristles, or have swivelling heads. Compressed air is also available in cans.

blower brush

retractable brush

swivel-head brush

compressed air can

Click stop. Ball bearing and recess or similar construction used to enable shutter speeds, aperture values, etc. to be set by touch.

Colour negative. Film designed to produce colour image with both tones and colours reversed for subsequent printing to a positive.

Colour reversal. Film designed to produce a normal colour positive image on the film exposed in the camera for subsequent viewing by transmitted light or projection on to a screen.

Box camera. Camera with simple controls, usually just one or two apertures and shutter speeds. Take pictures outdoors in bright sun.

Cadmium sulphide (CdS). Photo-conductive material used in exposure meters as alternative to selenium-based or silicon photocells. Its electrical resistance decreases as the light falling on it increases. CdS meters use current from an external power source.

Camera shake. Movement of camera caused by unsteady hold or support, vibration, etc., leading, particularly at slower shutter speeds, to a blurred image on the film. It is a major cause of unsharp pictures, especially with long focus lenses.

Camera strap. Camera carrying straps are available in a variety of forms: shown below are a wide strap, which obviates the need for the shoulder pad needed with thin straps; wrist strap, and metal neck chain.

Bellows. Device used to provide the additional separation between lens and film required for close-up photography. Consists of extendible bellows and mounting plates at front and rear to fit the lens and camera body respectively. (See also Extension tubes.)

bellows with slide copier

Bounced flash. Flash light illuminating a subject indirectly by reflection off a ceiling or wall or other surface; this diffuses the light and makes it appear more natural.

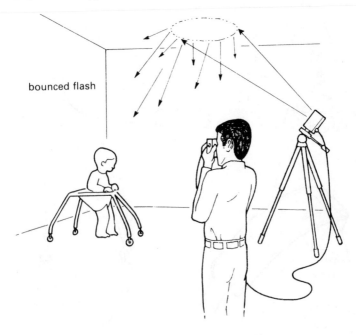

bounced flash

Aberration. Failing in the ability of a lens to produce a true image. There are many forms of aberration and the lens designer can often correct some only by allowing others to remain. Generally, the more expensive the lens, the less its aberrations.

Angle of view. The extent of the view taken in by a lens. For any particular film size, it varies with the focal length of the lens. Usually expressed on the diagonal of the image area.

Aperture. The opening in the lens, usually provided by an adjustable iris diaphragm, through which light passes. See Limiting aperture. Effective aperture, f-number.

Aperture priority. Automatic exposure system in which the lens aperture is set by the photographer, and the camera sets the shutter speed. Can be used in the stop-down mode with any lens that does not interfere with the metering system.

Artificial light. Light from a man-made source, usually restricted to studio, photolamp and domestic lighting. When used to describe film (also known as Type A or Type B) invariably means these types of lighting.

ASA. Film speed rating defined by the American National Standards Institute.

Automatic iris. Lens diaphragm which is controlled by a mechanism in the camera body coupled to the shutter release. The diaphragm closes to any preset value before the shutter opens and returns to the fully open position when the shutter closes.

Balanced. Description applied to colour films to indicate their ability to produce acceptable colour response in various types of lighting. The films normally available are balanced for daylight (5500-6000 K), photolamps (3400 K) or studio lamps (3200 K).

—— Glossary of camera terms ——

or under a colour processing safelight, such as Kodak 10 H filtered 25 watt lamp.

Because you are likely to be dish developing this paper (in your normal black-and-white solutions), even this dim safelight is a considerable help. It is, however, much too dark for any inspection, so you must develop by the recommended time and temperature method. To see slightly better, you may find one of the pulsating 'colour' safelights a useful addition to your darkroom.

As it is panchromatic, the tone reproduction obtainable with Panalure is comparable with that obtained with panchromatic film when photographing a normal portrait or scene. In other words hair, eyes and lips in a portrait picture printed on Panalure will appear as correct relative densities, while clouds in a blue sky will be well recorded instead of disappearing as they would if ordinary bromide paper were to be used.

As an alternative, a variable contrast paper such as Multigrade will often yield a quite good black and white print without the inconvenience of working in almost complete darkness.

dyes used in his colour paper will never fade or change in any way, you can rest assured that unless you place your prints in direct sunlight, you are unlikely to detect any significant change in them for a long time.

This is one feature which is particularly attributable to dye-destruction prints. Such prints, although not eternal, do have a longer life in sunlight than prints produced in a colour development process.

Ektaflex PCT reversal film

The Ektaflex image transfer process can be used to make prints from slides as well as colour negatives, the procedure being the same in both cases, although the image forming 'films' are quite different. Ektaflex reversal film is exposed in just the same way as any other reversal print material, but rather like 'instant' camera films, Ektaflex print materials require no adjustments between different batches, either for speed or colour balance. This is an obvious advantage, because the number of variables is thereby reduced. As with many cut-sheet camera films, Ektaflex reversal film is notched in the right side of the top edge when the emulsion is facing you. This is important because the reversal film must be handled in complete darkness. One notch is used to indicate negative film and two are used for the reversal film.

Black and white prints from colour negatives

Because of the coloured masking densities that are present in all modern colour negatives, it is quite difficult to get any kind of black and white print from such negatives on normal – blue sensitive – bromide paper. Yet there are occasions when it is very useful to be able to make a quick black and white proof of a colour shot, or to be able to make a number of black and white prints when it would be too expensive or take too long to make that number of prints in colour. With these considerations in mind, Kodak produce their Panalure monochrome printing paper – a panchromatic material that is processed in just the same way as any other black and white enlarging paper. However, it must be handled in complete darknes,

metabisulphite and leave for about half a minute until the brown stain disappears.

Finally, wash the whole print for 2 or 3 minutes and re-stabilise, if a stabilising step was included in the processing cycle.

In the case of large or very dense blemishes, bleaching and cleaning can be repeated several times with merely a rinse between treatments.

Mounting colour prints

No matter whether your print is on a resin coated paper base or on a white pigmented acetate base such as is used for Cibachrome, you will not be able to use any of the old simple methods of mounting with water based paste. The reason is simply that there is no way in which the paste can dry out by evaporation through the print. There is no problem if you are using a porous mount through which it can dry. For most purposes, however, it is best to use a double faced adhesive sheet or, if you cannot obtain sheets of material, then narrow double sided adhesive tape can be applied to the back of your print in a criss cross pattern.

Colour prints can be dry-mounted – either in a press or by using a domestic hand iron. Dry mounting tissues now work at lower temperatures than were once required. Even so a test should be made, using a waste print, before any important photograph is mounted. The surface of the print – particularly if it is glossy – should be protected with a sheet of silicon release paper – obtainable from the suppliers of dry mounting tissue. On no account should the temperature be allowed to exceed 90°C. If it does, the resin coating may start to melt.

Permanence of prints on display

In the earlier days of colour printing, the permanence of the dyes used to form an image were greatly suspect. Most of us remember seeing badly faded colour prints in house agents windows, but nowadays colour print materials are all greatly improved in this respect. While no manufacturer would go so far as to claim that the

areas to cover, you don't really need to get them the right colour. If they are *exactly* the right density, for normal viewing your eyes will automatically colour them to match the surroundings. Naturally, neutral coloured spots will not go undiscovered in a minute examination; so colours are needed for perfection as they are for retouching for larger areas.

Removing colours

Now that colour print materials are almost all made on resin coated base, areas cannot easily be removed by knifing because there is a tendency for the polyethylene layer to pick up and permanently spoil the surface of the print. The only way round this difficulty is to remove the blemishes by chemical bleaching, before spotting back to match the surrounding area.

Bleaching procedure

Three stock solutions should be prepared for bleaching out black spots on colour prints:

1 Potassium permanganate 8 gm
 Water to 500 ml

2 Sulphuric acid (conc.) 50 ml
 added to 450 ml of water.

 Always add the acid to the water and stir while doing so.

3 Sodium metabisulphite 10 grams
 Water to 500 ml

For use, mix equal parts of 1 and 2 – say 25 ml of each, and proceed to spot out blemishes. Bleaching may take 2 minutes or so, but when it is complete, cover the areas you have treated with the solution of

971

metabisulphite and leave for about half a minute until the brown stain disappears.

Finally, wash the whole print for 2 or 3 minutes and re-stabilise, if a stabilising step was included in the processing cycle.

In the case of large or very dense blemishes, bleaching and cleaning can be repeated several times with merely a rinse between treatments.

Mounting colour prints

No matter whether your print is on a resin coated paper base or on a white pigmented acetate base such as is used for Cibachrome, you will not be able to use any of the old simple methods of mounting with water based paste. The reason is simply that there is no way in which the paste can dry out by evaporation through the print. There is no problem if you are using a porous mount through which it can dry. For most purposes, however, it is best to use a double faced adhesive sheet or, if you cannot obtain sheets of material, then narrow double sided adhesive tape can be applied to the back of your print in a criss cross pattern.

Colour prints can be dry-mounted – either in a press or by using a domestic hand iron. Dry mounting tissues now work at lower temperatures than were once required. Even so a test should be made, using a waste print, before any important photograph is mounted. The surface of the print – particularly if it is glossy – should be protected with a sheet of silicon release paper – obtainable from the suppliers of dry mounting tissue. On no account should the temperature be allowed to exceed 90°C. If it does, the resin coating may start to melt.

Permanence of prints on display

In the earlier days of colour printing, the permanence of the dyes used to form an image were greatly suspect. Most of us remember seeing badly faded colour prints in house agents windows, but nowadays colour print materials are all greatly improved in this respect. While no manufacturer would go so far as to claim that the

areas to cover, you don't really need to get them the right colour. If they are *exactly* the right density, for normal viewing your eyes will automatically colour them to match the surroundings. Naturally, neutral coloured spots will not go undiscovered in a minute examination; so colours are needed for perfection as they are for retouching for larger areas.

Removing colours

Now that colour print materials are almost all made on resin coated base, areas cannot easily be removed by knifing because there is a tendency for the polyethylene layer to pick up and permanently spoil the surface of the print. The only way round this difficulty is to remove the blemishes by chemical bleaching, before spotting back to match the surrounding area.

Bleaching procedure

Three stock solutions should be prepared for bleaching out black spots on colour prints:

1 Potassium permanganate 8 gm
 Water to 500 ml

2 Sulphuric acid (conc.) 50 ml
 added to 450 ml of water.

 Always add the acid to the water and stir while doing so.

3 Sodium metabisulphite 10 grams
 Water to 500 ml

For use, mix equal parts of 1 and 2 – say 25 ml of each, and proceed to spot out blemishes. Bleaching may take 2 minutes or so, but when it is complete, cover the areas you have treated with the solution of

change the straightforward processed result. Bearing in mind that skilled colour print finishers are rather rare and very highly paid, we should not be too ambitious in our early attempts at correcting prints by hand. Practice alone will lead to the skill required to modify areas of a colour print without obvious evidence.

To start with you will probably limit your efforts to spotting out the blemishes that result from dust or scratches. Lots of patience, a set of three subtractive coloured (cyan, magenta and yellow) dyes or water colours, and a good quality (No. 1 or 2) sable brush are all that you need for this job.

Several photographic companies sell sets of retouching dyes and often the colours have been chosen to match the subtractive dyes formed in their particular colour print material. So whenever possible, use dyes that are offered by whoever makes your colour paper. But if you find these special dyes difficult to obtain or more expensive than you feel is justified for the small amount of use you have for them, then you can try using water colours. Although slightly more opaque than dyes, most water colours are sufficiently transparent not to be noticed on the surface of a finished print – particularly if a little gum is used with the colour. If you buy these colours in pans you will find them more useful than in tubes.

When deciding how much of each colour you need to apply to match a blemish into its surrounding area remember that the image you are working on results from varying proportions of yellow, magenta and cyan dyes and you should therefore be able to obtain an almost perfect match by applying one or more of your three spotting colours in the right amounts and proportions,

I find that spotting with a brush is easier to do when the emulsion surface of the print is slightly damp. This is a little more difficult with Kodak papers because of the opalescent appearance that persists until the print is dry. But whether you work on a moist or dry print, you will find that a stippling technique with a semi-dry brush will give you the greatest control. After picking up the dye or water colour on your brush, remove all surplus on a sheet of blotting paper, leaving the brush just moist enough to transfer controllable amounts of colour to the surface of the print.

For much simpler spotting, you may find that you can get away with using a single dark grey or brown colour. When you have only tiny

sea in a seascape look bluer by giving additional local exposure through a red filter.

Correcting prints from transparencies

The techniques of colour correction during printing are probably easier to learn when printing from transparencies, since then the effects of any local filtration will be much easier to understand and see. But remember that because of the relatively low contrast of reversal print materials, stronger filters will be required to produce a given alteration than you would need when printing from a colour negative.

One important point to remember is that you are *reducing* the light with your dodging. So if you want to change the colour without altering the density, you must give some of the exposure through the filter as an extra, while the rest of the print is covered.

Retouching colour negatives or transparencies

While it is possible for a skilled retoucher to make corrections or alterations directly on a colour negative, it is certainly beyond the ability of most amateurs. In the same way, although colour transparencies can be (and often are) retouched and modified for reproduction purposes, the job is beyond the skill of most of us.
There is one kind of correction that should be made on the negative and that is the blotting out of any pin holes or scratches that would result in totally black blemishes in any print that is made. Since it is much more difficult to remove a black spot from a print than it is to fill in a white spot, small 'minus density' defects on a negative should be neatly covered with an opaque paint of some kind using a No. 1 sable brush. They then make corresponding white areas on the print.

Handwork on prints

Because the size is larger and visual effects are more easily seen, most of us will resort to working directly on our print if we need to

Local density control during printing

When the sky area of a black and white print looks too light and devoid of the clouds that can be seen in the negative, it is a comparatively simple job to make another print and give the sky additional exposure by burning in. When the area to be modified is large and well defined, the extra exposure can be given simply by using the hand to prevent any additional light from reaching the foreground of the picture. More complicated areas can be burned in by means of suitably shaped holes cut in stiff black paper. Of course, whatever is used as the mask, it must be held fairly well away from the paper plane and kept gently moving so as to avoid a hard line of demarcation.

Dodging

Dodging or holding back is the opposite of burning in. It too can be done with the hand or with suitably shaped pieces of black paper attached to the end of wires – devices sometimes known as paddles. Exactly the same methods can be used when colour printing with the white-light or subtractive method. In fact these techniques can be developed still further when colour as well as density needs to be changed.

Modifying density and colour

Instead of simply darkening the sky area of a print by additional local exposure, you can make it a stronger blue by making the extra exposure through a yellow or orange filter. In the same way when printing from a colour negative it is sometimes possible to make the

Modifying and Finishing Colour Prints

Drying prints

You can dry your Ektachrome RC prints with a fan heater or a hair dryer, or you can simply hang them from a line or lay them out on blotting paper or muslin covered racks.
Don't try to glaze them on a flat-bed or a rotary glazer.

this advice is somewhat difficult to follow. One partial solution to this problem is to store the made up solutions in several smaller bottles – which can be plastic – thereby ensuring that some of your working solution remains in sealed containers until you need it. As an alternative, you can top up nearly full bottles with inert solids, such as glass marbles. Also, there are now available concertina bottles. You simply press on the top of the bottle until is squashes down to the level of the liquid. Screw on the stopper and you have expended all the air.

In stoppered bottles, stored at reasonably low temperatures (less than 10°C (50°F) the keeping periods will be at least 2 weeks for the two developers, 3 weeks for the bleach-fix and 8 weeks for the stop bath and stabiliser.

Processing

When using a typical 8 in × 10 in processing drum it is recommended that 70 ml of each solution should be used.

Contamination

As with any other process, care must be taken to avoid contamination of one solution by another. Reversal colour development processes require rather more care because they involve the use of more solutions.

If at any time you find that your prints persistently lack density and have either a blue or cyan cast, then that is the time to carefully check your routine in case you are unwittingly allowing contamination to creep in at some stage of the process.

Opalescence of wet prints

Because it uses the same kind of couplers as all the other Kodak colour papers, a wet Ektachrome print has a pronounced bluish opalescent appearance and its colour cannot be reliably assessed until it has been dried.

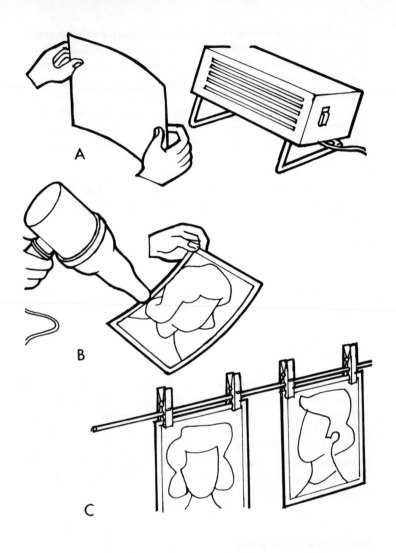

Neither resin coated colour papers nor Cibachrome print material can be dried by glazing. Alternative methods requiring no special equipment are: A – to hold the wet print in the current of air from a domestic fan heater, or B – to use an ordinary hair drier, or C – to hang the wet prints on a line with plastic pegs.

Since Ektaprint R-1000 chemistry was originally intended for use with Eastman Kodak's Ektachrome 2203 paper, the times of treatment required when processing Ektachrome 14 may well be slightly different and up to date information should be sought from the instructions packed with the paper.

Re-exposure of prints

When using Ektachrome 14 with Ektaprint R14 chemistry the print must be re-exposed before colour development can take place, and as a guide, the exposure can be to a 100 watt lamp at a distance of about 45 cm (18 inches) for about 10 seconds.

Mixing instructions

Among the instructions included with Ektaprint R 14 chemistry, there are one or two points worth repeating:

1 At least three mixing vessels should be used to avoid contamination. Use them exclusively for the first developer and stop bath, the colour developer, and the bleach-fix and stabiliser.
2 Always rinse out the concentrate bottles with a little water that is then added to the solution you are making up.
3 Do not divide the concentrates in an attempt to make up smaller quantities of working solution than those specified. (No explanation is given for this advice.)
4 Do not mix air into the solutions when you stir them. Excessive stirring serves no purpose – two minutes should be sufficient.

Keeping qualities

Kodak stress the importance of storing the working solutions for the Ektaprint R 14 process in tightly stoppered *full* bottles. In practice,

Processing procedure

There is one fundamental difference between the procedures to be followed with Ektaprint R 14 and Ektaprint R-1000, in that the European process requires that a print be re-exposed to light before colour development can proceed, while the American R-1000 process requires no re-exposure, because the residual silver halides are chemically fogged by the colour developer itself.

The two sequences are:

Ektaprint R14 (at 30°C)

Stage	Time (mins)
Pre-wet	4
1st developer	3
Wash	4
Reversal exposure	
Colour developer	3½
Wash	2
Bleach-fix	3
Wash	4
Total time	23½

Ektaprint R-1000 (at 38°C)

Stage	Time (mins)
Pre-wet	1
1st developer	2
Stop	½
Wash	1
Wash	1
Colour developer	2
Wash	½
Bleach-fix	3
Wash	½
Wash	½
Wash	½
Stabilizer	½
Rinse	½
Total time	13½

If you were using lower densities in your old filter pack than those indicated on the package of your previous batch of paper, then the differences between the two will be minus in value and they should be subtracted from the filter ratings printed on your new packet. For example, the pack you were using successfully comprised 20 Y and 35 C, and the rating for the batch of paper was 30 Y and 40 C. The difference is 10 Y and 5 C. If the values given for your new batch of paper are 20 Y and 20 C, you should start testing with a pack comprising 10 Y and 15 C.

Different slide films

Transparencies made on different film materials, even though they look correctly balanced, may need some slight compensation before they yield equally good prints. For example, Kodak suggest that a Kodachrome slide will (in general) require 15 C and 05 M less filtration than an Ektachrome original.

Exposure rating

The exposure coefficient given on each packet of Ektachrome 14 is simply a factor (based on 100) which can be used to relate the exposures you found to be correct with one batch of paper with the exposures you will need – with the same or equivalent transparencies – when you come to use the new batch of paper.
To take a simple example, if the exposure time for your reference transparency was 10 seconds on the old batch of paper and it had an exposure rating of 100, then the next batch, supposing it has an exposure rating of 120, will need 12 seconds exposure.

Ektaprint R 14 chemistry

In Europe, Ektaprint R 14 chemistry is supplied in the form of concentrated liquids in a kit to make one litre each of the three working solutions – first developer, colour developer and bleach-fix. In the U.S., the chemistry used for processing Ektachrome 14 paper is known as Ektaprint R-1000 and the one quart kit comprises nine bottles to make five working solutions – first developer, stop-bath, colour developer, bleach-fix and stabiliser.

A heat absorbing glass is also necessary to protect both filters and the slides you will be printing.

Importance of heat absorber

Your slides are usually left in their mounts while you are printing from them so there is always a risk that the film will 'pop' in the same way as it sometimes does in a slide projector. This makes the use of a heat absorbing filter very important. It reduces the risk of popping.

Exposure times

It is quite impossible to predict exactly the exposure you will need when making an enlargement from a slide; however, some kind of guide is better than nothing when you are about to make your very first tests. Supposing you are enlarging a 24 × 36 mm transparency on to an 8 in × 10 in sheet, you will probably be somewhere near right with one or other of your tests if you make an exposure series giving 2, 4, 8 and 16 seconds at *f*8.

Filtration

Kodak recommend a filter pack comprising a 40 M and a 30 C as a starting point when printing on Ektachrome 14 paper. This is quite a different combination from the yellow and magenta filters almost always required for printing from colour negatives. It must be understood that the filter data printed on every packet of Ektachrome 14 paper is merely intended to indicate the amounts by which the particular batch of paper varies from a reference batch chosen by the manufacturer. For example, if good prints were being obtained by using a 20 M and 35 C pack, and the filter rating given on the old package of paper was 10 M and 30 C, then the difference between the two would be 10 M and 5 C, and these filter ratings should be added to the filter ratings given on the new packet of paper. Say these new values are 20 M and 20 C, then the filter pack to try would be 30 M and 25 C.

already removed the print to see what it is like, you can wash it in a dish. In either case, three minutes in running water will be enough. While it is often very tempting to judge the quality of a Cibachrome print immediately after fixing and before washing, you should realise that while it is wet a Cibachrome print looks slightly more red than it will after it has been dried.

Drying prints

To facilitate drying, always remove surface water from both sides of a print with a soft rubber squeegee or a sponge. The print can then be hung up to dry in a clean room or a hot air blower can be used to speed things up.

Ektachrome 14 Paper

This resin coated paper is the fastest of all the currently available direct reversal colour print materials and of course is sensitive to light of all colours. Kodak Pathé, the manufacturer, gives no recommendations for safelighting, but sensibly advise you to work in total darkness.

Storage

As with most other colour materials, it is best to store Ektachrome 14 paper at a low temperature – say at 10°C or less. However, a week or so at room temperature (20° – 25°C) is unlikely to cause any discernible change in the performance of the paper.

U.V. Filters

Ektachrome paper should be protected from any ultra-violet light that might pass through both the transparency and enlarger lens. A Kodak CP2B filter or its equivalent should therefore be permanently housed in the filter drawer.

Control of contrast

Some control over contrast can be obtained by adjusting the time in the black and white developer within, say, plus or minus half a minute at 24°C. Extend development time to obtain slightly higher contrast and reduce it for softer results.

Rinse after development

Although it is not strictly necessary, it is advisable to use a short rinse between development and bleaching. This removes any residual developer and so avoids any unpleasant smell when the strongly acid bleach solution is poured into the drum.

Bleaching

Do not reduce the time allowed for bleaching or let up on the agitation during the bleaching stage. As the bleaching reaction goes to completion you can do no harm by over-bleaching.

Neutralizing bleach solution

The P-30 process requires no special neutralizing step, as did the P-12 process it replaces. It is only necessary to collect all used solutions – developer, bleach and fix – in a common container such as a plastic bucket, before they are discarded.

Fixing

A three minute fixing step follows bleaching and since this reaction also goes to completion, it should not normally introduce any kind of variation in your finished results.

Washing

After fixing, the print must be washed free of chemicals before being dried. The washing can either take place in the tank or, if you have

accurate processing times. When the required time of treatment has elapsed, the drum is again held in a vertical position, this time over a sink, and then, while the next solution is being poured into the filling end, the used liquid will drain out of the bottom end.

This drum does not have a cam action to provide 'wash-wave' agitation, so it needs an absolutely level bench top. The slightest tilt in the rolling surface will send the liquid to one end of the tube making processing uneven.

Recommended volumes

The recommended quantity of solution to be used in the 8 in × 10 in Cibachrome drum is 75 ml and to use any less solution would be to invite streaking or other kinds of unevenness should the rolling surface not be perfectly level. The quantity of solution recommended for use in the 11 in × 14 in drum is 150 ml.

Processing temperature

Unlike the recommendations given for most colour print processes, Ilford assume that if all your solutions and your tank are allowed to assume the ambient temperature of the room in which you are working, say between 68°F and 82°F (20°C to 28°C) – then you will merely need to adjust treatment times appropriately in order to achieve standardised results. The temperature latitude of this process is one of its advantages, especially for the amateur.

The times for each step are given below:

Recommended standard processing 75°F (24°C)

Temperature °F	68 (20°C)	72 (22°C)	75 (24°C)	79 (26°C)	84 (29°C)*
Develop	4	3½	3	2½	2
Rinse (30sec)					
Bleach	4	3½	3	2½	2
Fix	4	3½	3	2½	2
Wash	4	3½	3	2½	2
Process time	16	14	12	10	8

*To ensure even processing at 84°F (29°C), pre-soak the material in water for 30 seconds before starting processing.

Partial re-use of solutions

P-30 working solutions can be partially re-used during any one processing session and this almost doubles their capacity.
At any given temperature, the treatment times for development, bleaching and fixing are equal; another convenient feature. The following table indicates the periods over which both concentrates and the working solutions can be safely stored.

Form	Storage conditions	Useful life
Concentrates	Full bottles	1 year
Working Solutions		
Developer and Bleach	Full bottles	8 weeks
	Partially filled bottles	4 weeks
Fixer	Not critical	6 months

Mixing procedures

As with any other process, it is essential to avoid cross-contamination of either the concentrates or the working solutions and it is strongly recommended that separate containers be used for mixing each of the three active solutions and that the same bottles are used each time to store working solutions.

Processing drums

The processing drum sold in the U.S. is different from the one supplied by Ilford in Europe. The American drum has a removable cap at each end, so that the central tube can be of different lengths and therefore accommodates different sized prints. The two tube sizes offered are for 8 in × 10 in and 11 in × 14 in prints.
Another difference lies in the fact that the drum is always placed in a vertical position for the addition of processing solutions or wash water. While vertical, any liquid that is poured into the tank is retained in a reservoir until the drum is moved to a horizontal position, when the solution comes into contact with the print for the first time. This feature is intended to make it easier to achieve

print material and the variations between different batches of it. A secondary reason for needing filter adjustment is to compensate for the characteristics of your particular enlarging set-up. Thirdly, the filter pack needs to be changed slightly according to the type of transparency film that you are printing. You must not assume that because they seem on visual examination to be matched for colour, that an Agfachrome slide will print correctly using the same filter pack as the one you used successfully when printing Kodachromes. Starting filter packs for the more popular makes of transparency film are printed on every packet of Cibachrome print material. For example, if the pack given for Kodachrome is Y 30 MOO C20, then this simply means that, assuming average enlarging conditions, you should get a quite well-balanced print from a good Kodachrome slide if you use a 30 Y together with a 20 C filter.

In practice you may well find that the suggested starting pack will need some adjustment to give you the best results under your conditions.

Whatever pack you end up by using will probably need to be altered when you change to another packet of print material. The alteration you make will depend simply on the difference between the recommended filters printed on the two packs.

For example:-

Filter found best for old batch	Y50 M00 C35
Filter recommended on old pack	Y30 M00 C25
Difference	Y20 C10
Filter recommended on new pack	Y30 M00 C10
Filter required with new batch	Y50 M00 C20

Cibachrome Process P-30

Process P-30 kits are available in 1, 2 and 5 litre sizes, all of them comprising a developer made up from two liquid concentrates, a bleach made from one powder and two liquids and a single liquid fixer concentrate. The large kits can be divided into one litre batches because the bleach powder is conveniently supplied in separate packets for that purpose.

Reciprocity failure

The meaning of reciprocity failure has been explained on p.920, and as its effects are rather more pronounced with Cibachrome, an attempt should be made to keep exposures as nearly as possible the same duration by adjusting the aperture of the enlarging lens.

Safelight

Although a small amount of weak green safelight illumination can be used, it is probably safer and not much more difficult to work in total darkness while exposing Cibachrome print material and loading it into a processing drum.

RC or polyester base

The emulsions for Cibachrome 'Pearl' surface (44 M) material are coated on a resin coated paper base rather like that of any other colour paper. In the case of the Glossy material (1K), the base is of white pigmented polyester.

All the sheets of any Cibachrome print material are packed so that the emulsion side faces the label on the inner foil packet. This is important because both surfaces of the material are almost equally smooth and cannot easily be distinguished by touch.

If you ever place a sheet of Cibachrome print material in the enlarger easel the wrong way up, you will quickly realise it once exposure starts because it will look white, whereas the emulsion surface of the material is in fact quite dark because of the dyes incorporated.

Starting Filter Pack

The principal reason for using filters when printing from colour slides is to compensate for the characteristic colour balance of the

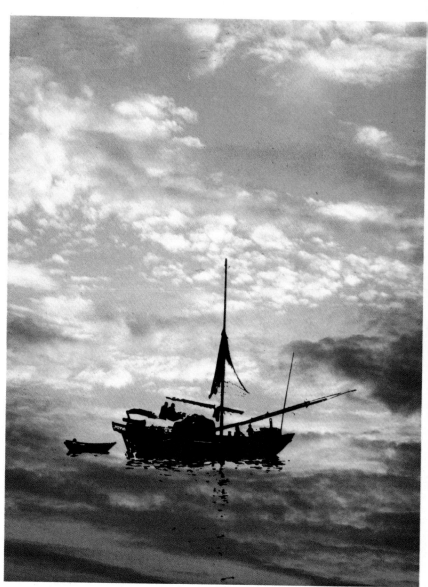

A sandwich consisting of two transparencies printed together. Silhouettes often respond well to this treatment.

Multiple exposure – one transparency printed four times on to a single sheet of Cibachrome paper. The best effects are obtained with an interesting main subject against a perfectly black background.

Top two transparencies printed on to the same sheet of Cibachrome paper – a spectacular effect, but one which requires carefully chosen originals.

Above with careful masking you can print captions of any colour directly on to reversal papers. The oriental lettering in this case is purely ornamental.

With suitable subjects dramatic colour shifts can be introduced into your prints to add interest to routine photographs.

Top Cibachrome paper can be used to make copies (by contact printing) of single-sided colour originals. In this case the original was a hand-toned black and white print.

Another special effect with Cibachrome – the wing of a fly was placed in the negative carrier of the enlarger instead of a transparency, and exposed four times. Colour is manipulated by filtration.

Dodging with reversal papers achieves the effect of burning in with negative papers – here, detail was retained in the duck's feathers by shading this area during exposure. Compare with the straight print in which the highlights are entirely burnt out.

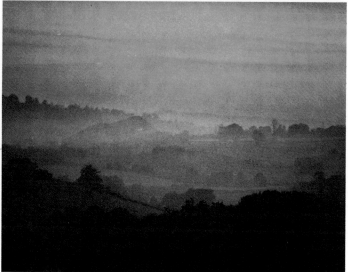

Burning in with reversal papers – in the straight print the landscape is clogged and murky; by giving the central area extended exposure the photographer has created a much more satisfactory print.

A transparency of poppies printed together with a home-made texture screen. The poppy is probably the most photographed flower of all, but this 'trick' treatment is one way to add fresh interest to a familiar subject.

Other reversal print materials

If you think about it, you will realise that by using reversal colour processing, it should be possible to obtain a positive colour image by printing from a colour slide on to a sheet of colour paper of the same kind as you would use for printing from a colour negative.

In practice, if you did this, you would get a very contrasty print. The contrast of a colour transparency is much higher than that of a negative. However the idea would have been right, and in fact, apart from their contrast characteristics direct reversal colour development papers are really quite similar to colour negative papers in their construction.

Direct reversal print processing by colour development inevitably involves more processing steps than a negative-positive printing system. The sequence of operations following exposure of a print starts with development of the three negative latent images in a black and white developer. Then, the residual silver halide in all three emulsion layers is fogged either chemically or by exposure to white light. The print is developed again, this time in a colour developer that reacts with the couplers in the emulsions. These produce the required yellow, magenta and cyan positive image components. Of course, at this stage all three layers of the emulsion are totally blackened by the developed silver; the second development having filled in all the gaps in the original negative images. All the silver is removed in a single bleach-fixing treatment, leaving the required composite colour image.

Ektachrome 14 RC

Kodak Pathé in France have worked on reversal colour print processes for many years, and by general consent, have always produced products superior to the equivalent materials made in the U.S. But now it seems that Ektacolor 14 papers will be available in more countries. The chemistry to go with it is available in 1 litre kits in Europe and is known as Ektaprint 14, while in the U.S. the equivalent chemistry is offered in the 1 U.S. quart size as Ektaprint 1000.

Using either chemistry involves much the same sequence of processing steps, except that there is no need to re-expose a print to light before colour development with Ektaprint 1000, since a chemical fogging agent does the job instead.

Unfortunately, the coloured coupler idea cannot be applied to colour print materials because a print must be capable of displaying colourless whites and highlights. It was therefore accepted for many years that nothing could be done to offset the shortcomings of the cyan and magenta dyes used for colour prints. Then, in the mid 1970s it was announced that the Cibachrome research team in Switzerland had discovered an entirely new way of obtaining a colour masking effect while retaining good highlights and whites.

Initially, the new self-masking Cibachrome II print material was only made available to professional users employing machine processing with a new chemistry known as P-3. But now, the hobbyist can also benefit from the improved material and its associated chemistry – P30.

Non-compatible chemistry

It is not possible in the space available here to explain adequately the mechanism by which the colour masking effects are obtained with Cibachrome II, but the addition of a small amount of thiosulphate (hypo), to the developer is an essential feature of the process, and for that reason alone none of the earlier Cibachrome chemistries (such as P12) can be used with the new 'self-masking' materials.

Outline of silver-dye-bleach process

When a sheet of silver-dye-bleach print material is exposed to the image of a positive colour transparency – either by contact or in an enlarger, three latent images are formed in the three superimposed emulsion layers in just the same way as with any other colour material. Then, these latent images are developed in a black and white developer to form three *negative* silver images within the yellow, magenta and cyan dyed layers.

These silver images are then bleached away together with the dyes immediately adjacent to them. So the dyes are destroyed selectively in all three layers. Since the silver images were negative, the remaining, unchanged dyes in the three layers are positive images which together form the complete colour picture.

Silver-dye-bleach process

Cibachrome is made in Switzerland by the Ilford Group. The Cibachrome process depends on the silver-dye-bleach principle and not on colour development.

Cibachrome has the merit of requiring only four processing steps taking 12 minutes at 24°C. Other advantages claimed for Cibachrome prints are: high colour saturation; excellent sharpness; and great resistance to fading.

The last of these three claims can be made confidently because the azo dyes used in this print material can be chosen – among other properties – for their resistance to fading by light.

In silver-dye-bleach or dye-destruction process, the three subtractive dyes – yellow, magenta and cyan – are present in the three emulsion layers at the time of coating, and that proportion of dye that is not required in each layer to form part of the final colour image is destroyed during processing.

Colour masking

It is fairly well known that the dyes which have to be used to form a photographic image in colour do not fully comply with theoretical requirements. For example, cyan dyes do not transmit (or reflect) all green and all blue light in the way we would like them to, any more than the available magenta dyes pass all red and all blue light as theory requires they should. In all the early processes of colour photography, these deficiencies were accepted and all that could be done was to make the best choice of dyestuffs available.

Then, in 1947, Hanson of Eastman Kodak revealed a method of compensating for the shortcomings of the cyan and magenta dyes used in Kodacolor negative film by an ingenious system of 'coloured coupler' masking.

Exposure and
Processing
Reversal
Colour Print
Materials

enlarger can be used as the exposing source if it is set up so as to enlarge a 24 in × 36 in frame to just over 8 in × 10 in. Assuming that you already know the exposure time required for your reference slide when enlarged to 8 in × 10 in then this same exposure and same filtration should be used to expose your group of slides for proof printing. The resulting proof sheet will enable you to judge what exposure to give each transparency and whether any of them seem to require colour correction and therefore a different filter pack.

Ring around

As with any other colour printing process, the most difficult thing to learn about direct reversal printing is what direction and degree of exposure and filtration changes are necessary to make a correctly balanced print after having made one that is not quite right. The only really satisfactory way in which you will gain confidence in estimating filter and exposure changes it to make a series of ring around prints for yourself. If you do this, you will soon recover the time you spend and regain more than the value of the print material you use by reducing the number of tests you have to make in future.

Sometimes the difference between the reference print and your test result is greater than any difference illustrated by the prints in your ring around. Then, you will have to use your judgement as to any additional change required. In cases like this, don't be afraid to make substantial adjustments – it is better to go a bit too far and then come back a little than to be not quite sure whether the change was really enough.

negatives applies equally well to an enlarger that will be used to print directly from colour slides.

Generally, transparencies can be left in their mounts while they are printed, although if they have been mounted between glass it will be better to remove and remount then in card mounts. This eliminates the four extra surfaces that would almost certainly increase the risks of marks and dust resulting in unnecessary black marks on finished prints. Because the image projected on the base-board of the enlarger is a positive, it is usually quite easy to tell that it is the right way round. To ensure that the image is projected correctly onto the print material, think of your enlarger as a projector and insert each slide accordingly – that is with the emulsion surface away from the enlarging lens.

Reference transparency

Just as it is important to have a reference negative as a yardstick when printing from colour negatives, so it will help you in your early attemps at printing from slides if you choose a well balanced and correctly exposed transparency with which to make your initial tests and subsequent comparisons. When you have arrived at optimum density and colour balance, the exposure conditions generally serve to print other slides of similar density taken on the same brand of film. You will probably find that once you have established the basic filtration it is easier to make colour prints from transparencies than from negatives.

Don't forget to record carefully all the relevant details of the exposure and filtration you used for your best print from your reference slide.

Proof printing

Twenty 2 in × 2 in mounted slides can be proof-printed at one time on a sheet of 8 in × 10 in reversal material. When 36 exposures have been made on the same length of film, 35 of them can be printed (while in their mounts) on a single sheet of 8 in × 10 in print material by using a special contact printing frame made by Ilford. The

The easiest way to expose a contact print from a set of negatives (or slides) is to use the light from your enlarger. This way, you can easily adjust the filtration and the duration of exposure.

borders, then you will have to prepare a glass plate with an opaque central area to protect the latent picture image, while you give a flash exposure to thoroughly fog the borders of the print.

EFFECTS OF CHANGES IN FILTRATION
ON COLOUR REVERSAL PRINTING

Required Change	Add–or remove when possible
Less blue (more yellow)	Add yellow or remove magenta and cyan
Less yellow (more blue)	Add magenta and cyan or remove yellow
Less green (more magenta)	Add magenta or remove cyan and yellow
Less magenta (more green)	Add yellow and cyan or remove magenta
Less red (more cyan)	Add cyan or remove yellow and magenta
Less cyan (more red)	Add yellow and magenta or remove cyan

Colour correction and exposure latitude

Although it is not likely that you will often want to print slides that are a long way off colour balance, you will still need a fairly wide range of colour correction filters because larger changes in filter densities are required to bring about a given change in the colour of a print. This advantageous feature of reversal colour printing results from the relatively lower contrast of the print material required when printing from transparencies rather than negatives.

Put another way, reversal colour print materials have a wider latitude in both exposure and filtration than negative printing papers.

Printing speeds

Although they are on the whole slower than colour negative printing papers, all the currently available direct reversal print materials are quite sensitive enough to allow enlargements to be made using normal equipment.

Enlarging equipment

All that has been said in earlier chapters about the various kinds of enlarger and colour heads that are suitable for printing colour

Whichever process you use, there are two very important differences in technique between printing from colour negatives and printing from transparencies. When you make prints from slides you must remember that: 1, more exposure produces a *lighter* print; and 2, a predominant colour cast is corrected by using filters of a complementary colour.

It should help if you have previously made prints only from colour negatives if you study the following table of differences between negative-positive and direct reversal printing.

EFFECTS OF EXPOSURE ON COLOUR REVERSAL PRINTING

If you:	Result by Direct Reversal Printing	Result by Negative–Positive Printing
Increase exposure	Print will be lighter	Print will be darker
Decrease exposure	Print will be darker	Print will be lighter
Double or halve exposure	Significantly lighter or darker print	Significantly darker or lighter print
Print with margins protected during exposure	Borders will be black	Borders will be white
Print from damaged slides or negatives	Defects will appear black in print	Defects will produce white marks on print
'Dodge' or 'hold back' During exposure	Will darken those areas on print	Will lighten those areas
'Burn' or 'print-in' during exposure	Will lighten required areas	Will darken areas

Black or white borders

It is interesting that borderless colour prints have recently become extremely popular as a result of the marketing policy adopted by photofinishers in many countries. In fact, it is rather difficult to obtain reversal colour prints with white margins. The reason will be obvious when you think about it – for the margins of the print to be white they must be completely exposed, whereas they are normally protected from exposure by the masking frame of the enlarger easel. The margins of a reversal print will therefore be black, and are probably best trimmed off. If you consider it important to obtain white

At one time there was a justifiable belief among photographers that it was much more difficult and usually rather unsatisfactory to make colour prints from transparencies. This belief was not only held by amateurs, but also by photofinishers – whose business it is to make and sell colour prints from both negatives and slides.

One method of getting prints from slides is to make an intermediate colour negative from the original transparency and then to print from the internegative on to colour paper as if it were an original colour negative, but obviously this is a rather expensive and time consuming way of going about the job.

Now things have changed and there are several satisfactory processes available for making colour prints directly from colour transparencies.

Reversal print processes

Broadly, there are now two processes available by which colour prints can be made by direct exposure from a colour transparency. One method uses a three layer print material containing colour couplers, and this is processed by a two-stage reversal procedure involving black and white followed by colour development.

The other method is to employ a silver dye bleach or dye destruction system whereby dyes that are present in a three layer material when it is coated, are removed during processing to leave the correct amounts of yellow, magenta and cyan to form a composite colour image.

These two different ways of obtaining colour prints from transparencies are described in detail in the next chapter, but the principal difference between the two methods is that a silver-dye bleach material requires only one development stage and therefore involves a shorter process.

Colour
Printing
from
Transparencies

badly handicapped if you have to continue to depend upon trial and error. Remember that increasing confidence will come only with experience.

Print viewing conditions

As you become more skilled and more critical of the colour prints you make, you will notice that a print or test sometimes looks different from one time to another – or even from one room to another. This is because you are examining the print under different kinds of light, so that a result that looked correct last night seems much too blue this morning.

Ideally I suppose, we would like to have daylight available at all times, but even daylight varies considerably according to atmospheric conditions, the time of day and the time of year. So the best compromise is to use what are called colour matching fluorescent lamps. Unfortunately these are not usually stocked by ordinary electrical stores, although they are certainly made by all the main lamp manufacturers.

The kit contains a 96 patch colour mosaic filter, a locator to facilitate choosing correct density and colour balance, a print exposure calculator and above all, a neutral grey test card. The grey card is really the key to the system and has to be photographed under the lighting conditions applicable to the negatives you are going to print – a procedure that is reminiscent of the days when colour prints were made from separation negatives.

Although written very clearly, the instructions provided with the Filter Finder Kit still fail to make the job seem simple.

Colour analysers

Given that you have found the correct conditions for producing a good print from your standard negative, there is another way in which you can use this information to estimate the filtration and exposure required for other negatives.

Instead of using the diffuse light emerging from your enlarger lens to expose a piece of colour paper beneath a filter matrix, you can measure the blue, green and red components of that light by means of a photometer. Then, having changed from your reference negative to a different one, you could, by adjustment of the filter pack or colour head, and the lens aperture, reproduce the values you obtained with the standard negative and then make a print using the new exposing conditions.

In practice, colour analysers or photometers are usually designed to work the other way around. In other words, having set all three channels to zero with the reference negative in the enlarger, the blue, green and red controls on the analyser are then adjusted to regain zero readings when the reference negative is replaced by the unknown one. The resulting settings of the controls then indicate the new filter values.

This description is of course greatly simplified, but since most electronic analysers are relatively expensive, not many amateurs are likely to use them, and a more detailed treatment hardly seems necessary. Furthermore, it is generally agreed that there is no form of analyser that will entirely replace judgement – the best that can be expected is some reduction in the number of preliminary tests that have to be made before a perfect print is obtained. So don't feel too

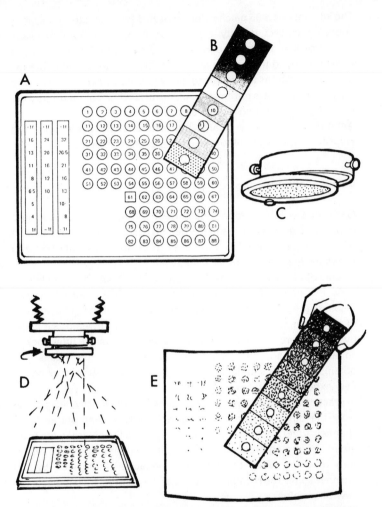

The Simma dot mosaic – A, is laid over a piece of colour paper of the same size and both are located beneath the lens of your enlarger – D. A diffusing disc – C, is attached to the lens and, with a negative in position, a test exposure is made. After processing the print – E, will be covered with a wide range of differently coloured dots – including one that should be neutral grey. It is easier to find the neutral dot if the perforated neutral grey step wedge is used to provide a comparison. The three vertical scales on the mosaic tablet provide information on the test print that will help you to decide the exposure required for each negative.

prints from all your negatives at the first time of printing. Integration to grey is a kind of averaging method, and while it will work quite satisfactorily – as it does in photofinishing – for say 90% of the time, there will be some negatives of subjects that had an unusual distribution of colour which could not, by any stretch of imagination be said to integrate to grey. A close up shot of a bright red car, for example, would integrate to some shade of red and if you made a print of it by integrating it to grey, any other parts of the picture (a girl's face for example) would come out a bluish-green.

Another benefit can be gained from using a filter mosaic or calculator. All of them include a scale of neutrals to provide an indication of the overall exposure that will be required for any given negative. Here again the principle of integration is used, simply by assuming that the integrated density of most average prints is about the same. As an approximation, this is certainly quite useful, and can get your print density about right without too much preliminary testing.

Using an integrating attachment and a calculator, you can thus test four separate negatives on one sheet of 8 in × 10 in paper. The results should let you make a print from each that is adequate in both colour and density. You may need another print for perfection.

Exposure based on reference negative

You must always remember that the exposing conditions you use when making your test print in contact with the calculator will be those which have proved necessary to make a first class print from your reference negative. The success you have in using a mosaic filter calculator depends very much upon the care you took in establishing optimum filtration and exposure for your standard negative.

Kodak Filter Finder Kit

Recognising the inevitable problem an amateur faces in determining correct exposure and filtration when he first tries to make prints from colour negatives, Eastman Kodak have introduced a Filter Finder Kit in the U.S.

The Unicube mosaic tablet A, comprises a geometric arrangement of three superimposed step wedges made up from the same filters as those supplied by Unicolor for printing. A diffuser – B, is placed beneath the enlarging lens so as to integrate the light from the negative, when a test exposure is made as shown in D. After processing, the test print – E, will usually contain one patch that is neutral grey, to help in deciding just which area is perfectly grey, a perforated mask – C, can be moved across the test print until an exact match is found. The row of "teardrops" at the base of the mosaic is intended to provide an estimate of the exposure that will be required.

The same proportions of red, green and blue should also produce pretty good prints from a wide variety of other negatives – provided that you continue to use the same batch of paper.

In practice therefore what you aim to do, is to adjust the light transmitted by each new negative so that it would produce a grey colour print if it were integrated before exposing the paper.

Filter mosaics or calculators

That's all very well you may be thinking, but how can I possibly do it? In fact it is quite easy if you use a filter matrix or mosaic – of which there are several kinds available. The Simma Dot Subtractive Calculator, the Mitchell Unicube or the Beseler Calculator are examples.

Each of these calculators, as they are called, comprises an assembly of a range of nearly a hundred different filter combinations in the form of a mosaic tablet. The mosaic is placed in contact with a sheet of colour paper on your enlarger board. You then diffuse the light after it has passed through your negative, filter pack and the enlarger lens. A single exposure yields a print bearing a large number of differently coloured patches – only one of which will be really neutral. Most systems also supply you with a reference to sort out the correct patch. Once you have determined the neutral patch, you simply add the equivalent filters to your pack. Then your whole undiffused print will integrate to grey. If you had a normal negative, and your paper and processing are the same, this should give you a good print.

For the system to work properly, the filters used in making up the mosaic must be the same as those you use in your filter pack. If they are not, then it will usually be necessary to make some allowance for the differences. This simply means that if you plan to use one or other of these calculators then you ought to buy the corresponding set of subtractive printing filters at the same time.

Method not infallible

You should not expect that by using a filter mosaic and following the simple procedure just outlined, that you will obtain perfect colour

different for any of the negatives, then this might call for some adjustment in filtration.

Unknown negatives

When you know little or nothing about a colour negative you wish to print, it would be a great help if there were some way in which you could get within striking distance of correct filtration without having to make a lengthy series of preliminary tests.

Integration to grey

This is not the kind of book in which to elaborate on the theoretical principles underlying the mass production of colour snapshots by photofinishing laboratories. However, in so far as the same princi-ples may be used by an amateur when making his own colour prints, then it might pay you to understand something about the concept of integration to grey. In an automatic printer, each negative is analysed by integrating it; so that, in most cases, the machine gets the correct colour and density first time.

It is a somewhat suprising but very useful fact that the overall or integrated colour of the light reflected from a very large number of scenes or subjects is neutral grey. Imagine a scene focused on the ground glass of a camera. If you were to place a diffuser on the lens, to mix up all the light forming on the scene, the screen would then be evenly lit overall. With most ordinary scenes it would, in fact, be an even neutral grey. In the same way, the light reflected from a correctly balanced colour print of the scene should also integrate to grey. So, for most scenes a good print on colour paper is produced by adjusting the filtration used so that light emerging from the enlarger lens would, if it were scrambled or diffused, result in a print that looks grey all over.

So, the filter pack needed to print your reference negative is probably the one which produces light that integrates to form a grey image. This means that the amounts of red, green and blue light emerging from the lens (coloured by the negative and the filter) would add up to produce a neutral grey on the paper you are using.

The advantage that comes from using a colour head instead of a filter pack is not just confined to the elimination of fading. Convenience and accuracy both result from being able to choose from an infinite number of filter combinations merely by adjustment of the settings on three scales.

Because they are so different in principle and in the way they are used, it is not possible to equate directly the performance of these dichroic filters with any set of dyed filters. Consequently if you change over from using filter packs to using a dichroic colour head you will have to make some tests to reconcile the filter values you have been using with the scale values on your colour head.

Paper processing variations

Now that most amateurs are using drums and one shot chemistry to process their prints, the chances of variations occurring in print processing have been greatly reduced. Nevertheless, it is possible to inadvertently introduce some variable in your processing technique. Therefore it will pay you to make a number of identical exposures from your reference negative and to store these in your refrigerator so that you can take one out whenever you are experiencing unexplained variations in quality, and process it to see that your chemistry and your processing technique are in order.

Getting the colour right

Arriving at the right density for any particular print is very much a matter of judgement, but is not really much more difficult than it is with black and white printing – except that making the tests does of course take longer. But when it comes to getting the colour right, then that is a different matter.

As we have seen earlier in the chapter, when the correct conditions of exposure have been found for one negative on a roll of film, it is usually possible to use the same filtration for the remaining negatives on the roll. The duration of exposure – or the lens aperture will have to be adjusted to allow for any variations in overall density of the negatives, and if the lighting conditions were significantly

A voltmeter and a variable resistance – A, can be used to adjust the voltage supplied to your enlarger lamp, thereby ensuring constant light output. Although more expensive, a constant voltage transformer – B, will do the job automatically over a wide variation of input voltages. Whatever control device you choose, insert it between the mains supply and the enlarger as in C.

always run your lamp at a voltage slightly below the lowest dip you expect in the mains.

Constant voltage transformer

A fit and forget solution to the problem costs more, but can be achieved by using a constant voltage transformer, which will allow the supply voltage to vary by 20 volts on either side of the nominal rating while the output voltage for the circuit remains near enough constant.

There are some rather cheap electronic voltage controllers on the market that seem to work only if the current taken by the enlarging lamp exactly matches the rating of the controller – which is not always possible. If you should decide to buy one of these units at least check its performance with a voltmeter before relying on it.

Colour heads and dichroic filters

Filter fading can be completely eliminated by using what are known as interference filters. These are normally used only in colour heads (see p.869).

Nearly all the colour heads on the market now depend upon non-fading interference filters and only the mechanical ways of adjusting the filters are different. The colour of the light entering the integrating chamber is adjusted either by moving more or less of the yellow, magenta and cyan transmitting dichroic filters into a concentrated part of the beam of light entering the integrating box; or by adding filtered sources. Provided the mechanical means of adjusting the filters is well designed, it is possible to achieve an infinite number of different positions for the three filters, and furthermore, to reproduce these settings at any time.

For a while after their initial introduction, enlarger colour heads were too expensive for even the keen amateur to afford, but recently manufacturers such as Durst and Simmons have begun to produce colour enlargers and colour heads which will certainly be within the reach of some hobbyists.

small enlargements and open up the lens to allow something like the same exposure time when making bigger enlargements or when printing from dense negatives. If you can manage to arrange for most of your exposures to fall somewhere between 10 seconds and 30 seconds you can forget about reciprocity failure.

Changing lamps

The colour of the light produced by an incandescent lamp with a tungsten filament varies slightly throughout its life and the variation is greatest during the first hour or so of use. So if you can, run your spare lamp for an hour or so before you have to take it into regular use to replace one that has burned out. A simple way to do this is to use your spare lamp for a black-and-white printing session before you need to change the old one. That way you have a 'run in' bulb ready at any time.

Supply voltage

A difference of 5 volts or more in the supply to an enlarger lamp will produce quite perceptible changes in both density and balance of a colour print. Roughly, a 10 volt difference is equivalent to an 05 filter; more than 10 volts means a more significant change, even as much as a 10 filter.

In many areas in the winter time and at peak hours of consumption, a 20 volt difference on a nominal 240 volt supply, is not at all unusual. So if you do disregard this source of variation, you must not be surprised to get some unusual results from time to time.

Voltage adjustment

The cheapest way of dealing with this problem is to use an adjustable resistance or a variable transformer in circuit with a voltmeter, so the supply voltage can be checked and if necessary adjusted immediately prior to making every exposure. Relatively simple and inexpensive units of this kind are made by Rayco. Naturally, with such a unit, you

regions of the spectrum. To obtain clear cut records of blue, green and red light, it is then essential to eliminate any chance of recording unwanted ultra-violet or infra-red radiation. So if the paper manufacturer calls for an ultra-violet and an infra-red absorbing filter, it makes sense to use them if you want to get the best out of your colour paper.

Different enlarging conditions

If you always made enlargements of the same size, from the same negative format, if the lamp in your enlarger never burnt out and if the supply voltage to the lamp never varied, you could probably disregard your enlarger as a source of variation in colour printing. But in practice you will want to make large prints sometimes and small ones at other times, you will have to change a lamp from time to time and you will be very lucky indeed if your electricity supply does not drop by as much as 5 per cent below its normal rating at periods of peak demand.

All these variables can have an effect on the colour balance of your colour prints and when you are sometimes looking for an explanation for unexpected shifts in balance, you should consider these kinds of variables along with the other possible causes.

Reciprocity failure

Some colour papers suffer from what is known as reciprocity failure. Reciprocity failure is merely a way of describing the fact that a photographic material does not respond in a strictly proportional manner over wide differences in exposure time. In other words an exposure of 5 seconds at f5.6 might not give exactly the same result as one of 40 seconds at f16, even though everything else was *exactly* the same.

Colour papers vary in the way they follow or depart from the so called reciprocity law, but the best way of avoiding any difficulty from this cause is to keep your exposures as similar in time as possible. That is to say, stop down the enlarging lens to give reasonably long exposures — say 10-15 seconds — when making

TABLE OF FILTER FACTORS FOR AGFACOLOR
PRINTING FILTERS

Filter Value	Factor	Filter Value	Factor	Filter Value	Factor
05 Y	1.1	05 M	1.2	05 C	1.1
10 Y	1.1	10 M	1.2	10 C	1.2
20 Y	1.2	20 M	1.2	20 C	1.3
30 Y	1.2	30 M	1.3	30 C	1.4
40 Y	1.2	40 M	1.4	40 C	1.5
50 Y	1.2	50 M	1.5	50 C	1.7
99 Y	1.4	99 M	2.0	99 C	2.5

To use these tables multiply old exposure time by factor if filter is added; divide exposure time by factor if filter is removed.

Fading of filters

A large proportion of your negatives can be printed easily once you have established the filtration required for your particular printing conditions. That is to say, for your enlarger, the type of film you use and the batch of colour paper you have in stock. Most negatives will need the same or similar filter packs. This may mean that you are leaving a few of your filters in the enlarger all the while. Consequently if you make a lot of prints, there is some risk of the central area of one or more of the filters in the pack fading. Any such change is, of course, very gradual; but if undetected leads to confusion sooner or later. So, from time to time lay each of the filters from your colour pack on a sheet of white paper and check whether there is any evidence of fading. If there is, replace any faulty filters as soon as possible.

Importance of U.V. and Infra-red absorbing filters

The presence of both an ultra-violet and an infra-red (heat) absorbing filter certainly helps to reduce the risk of your filters fading. But it is in any case important to use these filters whenever they are specified by a manufacturer of colour paper. The sensitivity of colour paper usually extends some way into both the ultra-violet and the infra-red

same subject within a print. The cyan image contributes most to the overall density, followed by the magenta; and the yellow image makes a comparatively smaller contribution still.

Exposure Factors

If all correction filters of the same nominal rating really had the same density, only one set of filter factors or tables would be required, but since there are some differences according to manufacture, you should always refer to the factors provided by the maker of the filters you are using.

To change your exposure, first divide your original time by the factor for *each* filter you have taken from the pack. Then multiply it by the factor for each one you have added. For example, suppose you have removed a 20 M and added a 10 Y. The factors may be 1.3 for the 20 M and 1.1 for the 10 Y. If your original exposure was 26 seconds then your new figure will be 26 × 1.1/1.3, or 22 seconds.

Alternatively, filter manufacturers supply sliding or rotating calculators to make the adjustment even easier. These are simply physical methods of operating the factors, just as a slide rule is a physical method of using logarithms.

TABLE OF FILTER FACTORS FOR KODAK COLOUR PRINTING FILTERS

Filter Value	Factor	Filter Value	Factor	Filter Value	Factor
025 Y	1.2	025 M	1.2	025 C-2	1.1
05 Y	1.2	05 M	1.3	05 C-2	1.2
10 Y	1.2	10 M	1.4	10 C-2	1.3
20 Y	1.2	20 M	1.5	20 C-2	1.5
30 Y	1.2	30 M	1.6	30 C-2	1.9
40 Y	1.3	40 M	1.7	40 C-2	2.1
50 Y	1.3	50 M	1.8	50 C-2	2.2

Note: Cyan −2 filters should be used for printing Ektacolor Papers because of their better absorption of the infra-red part of the spectrum.

Exposure adjustments

Some manufacturers (e.g. Kodak for Ektacolor paper) indicate the relative overall speed of different batches of paper as well as their colour balance as measured against a standard reference. Therefore, when you change paper batches, you may also require different exposure times. Suppose the exposure rating given on the new packet or box of paper is 120, and that on the 'old' packet was 90. If the exposure you were using to obtain a good print from your reference negative onto the old batch of paper was 10 seconds, then the exposure you will probably need for the reference negative on the new paper will be 10 × 120/90 or 13½ seconds.

Changing filters may mean changing exposure

Pay close attention to the changes in exposure that must be made to compensate for almost any change you make to your filter pack. If you are careless about this do not be surprised if you end up with prints that are nicely balanced in colour, but are either a bit too light or a bit too dark.

The problem arises from a number of factors. First of all, colour negative printing papers have to be relatively high in contrast, and as a result they have little exposure latitude. This means that quite small changes in filtration (even the removal of an 05 filter from a pack) can have a noticeable effect on the density of the next print; unless you allow for it.

When a single filter is placed in the path of the printing light, you lose light firstly because the filter has two surfaces, and some light is reflected back from each of these surfaces and never reaches the negative, and secondly, because the filter is there to absorb light of one of the three primary colours. The amount of light lost by absorption naturally depends on the density of the filter. The exposure compensation you need to make also depends upon this and on the colour of the filter. A yellow filter (of a given density) has less visual effect upon a print than does a magenta filter (of the same density) which, in turn has slightly less effect than a cyan filter (again of the same density). The reasons are perhaps not too difficult to follow. There are separate yellow, magenta and cyan images of the

Before leaving this problem of trying to calculate the filter pack required for a new batch of paper we should look at two cases that are not quite so straightforward as the one given above.

Supposing the filter values given on the old packet of paper were negative in value, say – 10 Y and – 10 M. If we still assume that we had been using the same filter pack to obtain good prints from our reference negative, namely 50 Y and 30 M. Then how do we subtract – 10 Y and – 10 M from this? Well, we must remember that subtracting minus values is equivalent to adding. So, the result will be:

$$
\begin{array}{rl}
 & 50 \text{ Y and } 30 \text{ M} \\
\text{minus} & -10 \text{ Y and } -10 \text{ M} \\
\hline
\text{result} & 60 \text{ Y and } 40 \text{ M} \\
\hline
\end{array}
$$

To which must be added the values of the new batch of paper given on the packet, and these we have supposed to be 20 Y and 10 M. So that the pack we should try in this case would be:

$$
\begin{array}{rl}
 & 60 \text{ Y and } 40 \text{ M} \\
\text{add} & 20 \text{ Y and } 10 \text{ M} \\
\hline
 & 80 \text{ Y and } 50 \text{ M} \\
\hline
\end{array}
$$

One other complication can arise if cyan filter values become involved, so that you might end up with a pack containing densities of all three subtractive colours – yellow, magenta and cyan. There is nothing wrong with such a combination of filters *except* that it wastes printing light. Inevitably some neutral grey density will be present in a pack comprising filters of all three colours. Although this will not affect colour balance one way or the other, it does cause a loss of light. To remove neutral density from the filter pack, you subtract an equal density of yellow, magenta and cyan from the pack. For example, suppose your calculations result in a pack comprising 80 Y, 50 M and 20 C. You can subtract 20 Y, 20 M and 20 C from this. So you actually use a pack comprising 60 Y and 30 M. There is never any need to use more than two primary colours in your filter pack.

Batch to batch differences in colour paper

Here we have one of the more frequent causes of difficulty in colour printing. Just when you feel you have things under reasonable control and the next print will be perfect, you discover that the test you have just assessed was made on the last sheet of paper from the packet. Consider yourself lucky if you have some more paper from the same batch. If you have not, then you must sit down with pencil and paper, and use the information given on the old and new packets to work out the changes in filtration you will need to compensate for the differences in the relative red, green and blue sensitivities of the two different batches of paper.

This is how you do it. Note the filtration given on the packet or box of paper you have just used up, and subtract these values from the filter pack you have been using to print your reference negative and other similar negatives. Let's imagine that the filters you have been happily using were 50 Y and 30 M, while the batch rating given for the old paper was 10 Y and 10 M. Then your first sum would be:

$$
\begin{array}{r}
50\ Y\ 30\ M \\
\text{subtract} \quad \underline{10\ Y\ 10\ M} \\
\underline{40\ Y\ 20\ M}
\end{array}
$$

Then add to this result the filtration values given for the next batch of paper – say + 20 Y and + 10 M.

$$
\begin{array}{r}
40\ Y\ \text{and}\ 20\ M \\
\text{add} \quad \underline{20\ Y\ \text{and}\ 10\ M} \\
\underline{60\ Y\ \text{and}\ 30\ M}
\end{array}
$$

A possible new filter pack would then be 60 Y and 30 M. You will notice the word possible; it is practically impossible to forecast precisely the result of changing from one batch of colour paper to another. The best that can be done is to get fairly near to the new filtration and thereby reduce the number of tests you will have to make.

Crossed contrasts can, for example, result in your print having magenta highlights and green shadows, and no amount of juggling with filters will eliminate these. The best you can ever do in these cases is to compromise between the colour of the lighter tones and that of the shadows according to the nature of the picture.

If, in order to guard against variations in negative processing, you decide to always do the job yourself, I can only commend your enthusiasm and impress upon you the need to establish a precise procedure and then stick to it meticulously. There is one thing I would warn you against. If at any time you are tempted to deal with a roll of negatives you know to be badly under or overexposed, by treating it in some non-standard way or by switching to a different developer – then don't. Almost certainly you will so upset the contrast balance between the three image layers as to make it impossible to get a good print.

Should you decide to get your negatives processed by a photo-finisher or professional laboratory, you may have to shop around a bit before deciding who shall do your work regularly. By spending a little money on ordering prints at the time you send your film for development, you will at least quickly discover who is doing his job properly.

If the prints he makes for you are not satisfactory, then it will not give you confidence to entrust your negative processing to him – even though it often can happen that bad prints are made from perfectly good negatives.

Different types of colour paper

From time to time, you may be tempted to desert whatever brand of colour paper you began to print with, in order to see whether you can get better results with some other kind of paper. If you do switch, then allow yourself some time to get the best possible print on the new paper using your reference negative. If after several atempts you are not satisfied with any of the results you get from this negative on the new paper, perhaps it is because the paper you were using was not so bad after all.

be long before only one type of colour negative processing is recognised throughout the world.

Compatible colour negative films

Several other film manufacturers like 3M in the United States and Fuji and Konishiroku (Sakura) in Japan, market films that are compatible with Kodacolor II. This does not necessarily mean that if you expose a Kodak film alongside one of these compatible films and then process them together in the approved Kodak chemistry you will be able to print both negatives successfully at exactly the same filtration or exposure.

Batch to batch film changes

The differences between batches of the same type of film are not usually very great – certainly not as large as they used to be. But we must remember that even slight changes in the relative speeds of the three emulsion layers can be enough to result in our needing a change in filtration that can only be determined by trial; whereas the same negatives, printed on an automatic integrating printer by a photofinisher, would certainly yield correctly balanced prints.

So whenever you can, buy the films you need in reasonably large quantities so as to ensure that you will be working with the same batch for as long a period as possible. Be sure, however, to store them in a refrigerator, otherwise they will slowly change.

Negative processing differences

This source of variation is difficult to avoid entirely. Faulty development of a colour negative can alter the effective speed of the film, it can change its contrast, the mask density can vary, fog can be higher than it should be, or most serious, the relative contrast of the three emulsion layers can change. When the last trouble occurs, there is practically nothing that can be done to correct the mistake at the printing stage.

Mount the final set of prints on a single card for ease of reference and always refer to the prints under daylight or a colour matching fluorescent light.

First tests

A set of ring-around prints can only help you when you have already made a test strip or print and you need to know what changes to make before you make the next attempt. Before any of this can happen, you have had to decide what filtration and exposure you will give for your first test. As we have seen, there only needs to have been one significant change from the conditions you used for your optimum reference print, and you will again have to get back on target by using your own judgement.

What are these changes or differences that we must contend with? The more important of them are: 1, a different brand or type of colour negative film; 2, a change in negative processing conditions; 3, a different kind of colour paper; 4, a change in paper processing conditions; 5, a change in enlarging conditions.

Let us look at the significance of these factors one by one.

Different types of film

Between 1960 and 1970, Kodacolor X film processed in C22 chemistry became an almost universal amateur standard throughout most of the world. However, in 1971, with the advent of Pocket Instamatic cameras and the 110 size cartridge films to go in them, Kodak introduced a new – finer grained – colour negative material called Kodacolor II together with a new chemistry – C41. Kodacolor II is not just different by being finer grained, but it also has a mask that is lower in density and different in colour from the mask used in Kodacolor X.

In Europe and some other parts of the world, quite a lot of Agfacolor negatives are exposed by amateur photographers, and here again, there has been a succession of different Agfacolor films – all of which required their own special chemistry. But some of Agfa's colour negative films are compatible with Kodak's C41 process and it cannot

negatives was made on the same batch of colour negative material, and you continue to use the same batch of colour paper, then this same filtration should be used to expose your contact prints.

Contact proof printing

With nothing in the negative carrier, adjust the enlarger so as to produce an illuminated area on the easel slightly larger than the sheet you are to expose – say a 9 in × 11 in area for 8 in × 10 in paper. Then stop down the lens to f8 and, with the contact frame in position complete with negatives and paper, give a trial exposure of 10 seconds. Use whatever filtration you had when you made the best prints from your reference negative.

After processing the contact print sheet you may well find that exposure will need adjustment so that there are neither too many light nor too many dark frames in among the images. The overall colour balance should be reasonably good; if it is not, then something has changed since you made your best reference print. Don't be too worried if you have to adjust both colour and density, but if you find this part difficult – and you will not be alone if you do – then you should make yourself a set of ring-around prints.

Make your own ring-around

A ring-around series is simply a set of colour prints that have been carefully made to show the effect of uniform changes in colour filtration and exposure time. One might think of them as the scales you normally have to learn before you can properly play the piano or violin. Be assured that any time you spend in the preparation of a ring-around series will be well repaid by the greater confidence you will have when making subsequent filtration and exposure adjustments. You can refer to the ring-around reproduced in the colour section on pages 828-829 as an indication of the various filtration and exposure changes you might use when exposing your own prints. As always make sure your central reference print is as good as you can possibly make it before you ring the changes required for the comparison prints.

Those of you who by now have made a few colour prints will have come to realise that the most difficult part of the job is the determination of correct filtration and exposure for each different negative.

Fortunately, once the correct conditions of exposure have been found for a representative negative from a single roll of film, it is quite likely that the other negatives on that roll will yield good results if you use the same filtration. You will still have to decide the correct amount of exposure to give each negative – something which takes a good deal more time than it does when you are making black and white prints and can judge a test strip within a minute or so while it is still in the developer dish.

Getting the density right

It is a good rule in colour printing to get the density of a print about right before worrying too much about its colour balance. While a print remains either too light or too dark, any changes you make to modify its colour will be much more difficult to assess than if the print is about right for density.

Contact printing

One of the simplest ways of getting some indication of the relative exposures required for a range of different negatives is to contact print them on the same sheet of paper. An 8 in × 10 in sheet of colour paper will allow you to proof print all the negatives on a 36 exposure roll of 35 mm film or a roll of 120 film.

Your earlier work will have taught you the correct conditions of exposure for your reference negative and if your next set of

Achieving
More Precise
Colour Balance

stage, your developer becomes diluted slightly. A diluted developer will surely be that much less active than you expected. Again, when it comes to discarding developer, make sure that the time you take to do so is always the same – perhaps 15 seconds, to ensure that all developer really has been poured and shaken out of the drum. Similarly, when the bleach-fix solution is poured into the tank, be sure to start rolling the drum immediately in order to avoid streaking.

Importance of reproducibility

By carefully doing the same things in the same way each time, you will find that you are able to obtain quite reproducible results – a very important consideration when you are nearing final filtration for a print, perhaps involving the use of 05 filter adjustments – representing colour differences that could easily be offset by inconsistent processing.

The Simma-roller-A, can be used to provide agitation automatically with any type of colour print processing drum. Eccentric rollers on the motor driven agitator tilt the drum from side to side – B, while it is being rotated. When a Simma-color drum is rolled to and fro by hand on a level surface, both lateral and rotary flow – C, is imparted to the solution in the drum.

907

spout with the tank upended. Then, place the drum back on its feet and pour either the stop-bath or the bleach-fix according to the process you are using. Again start the timer and again roll the tank. Don't delay at this point in the process, since the wet print will continue to develop in the meantime.

At the end of the stop or bleach-fix stage, the stop bath should be poured away, but the bleach-fix solution may be poured back into its own beaker for such further use as its working life allows – usually two or three prints at least. The next step will usually be a rinse or wash.

Rinsing and stabilising

The tempered water remaining in the bucket is suitable for washing or rinsing, since its higher temperature will tend to speed up the removal of residual chemicals from the print. You can either use a reasonably large volume – say 250 ml – for the required length of washing time, or several smaller volumes for a series of separate rinses. Probably the sequence of rinses is the more efficient way, although with resin-coated papers, thorough washing is no longer difficult to achieve.

Establish a routine

In so far as different tank manufacturers and different colour paper manufacturers recommend somewhat different requirements and methods for their tanks and papers, it is not necessary here to describe any particular procedure. But one point can usefully be made; whatever your choice of drum or paper, once you have established a satisfactory technique which produces good results – do not change it in any way unless you have some very good reason for doing so.

For instance, if you normally leave the pre-soak water in your drum for a minute then always make it one minute – not half a minute because you are in a hurry. Then when you drain out the pre-soak water, drain it all away – even shaking the tank to remove the last few drops. If you are careless about draining the tank completely at this

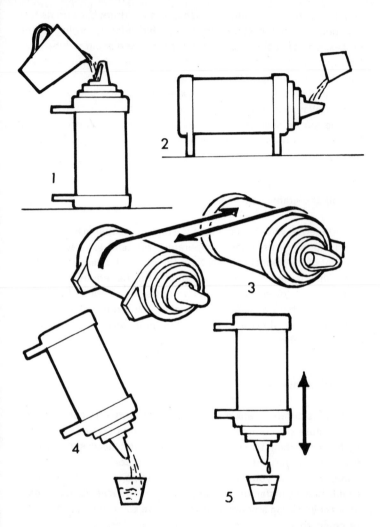

The principal stages involved when using a print processing drum, filling
the tank (in this case a Simma-color drum) with pre-soak water at the
required temperature (1), and after one minute emptying it before pouring
in the measured quantity of developer (2). Then, having started the timer,
the tank is rolled to and fro during the period of development (3). During
the ten seconds before the end of development, all solution is poured out
(4) and shaken from the tank (5).

Pre-soak

Next, stand the drum on end and fill it with water at the temperature you have determined from the nomograph or chart. This tempering water can be prepared beforehand in a half-filled plastic bucket, and the rest of this water will be used for rinsing and washing as required in the processing sequence.

Leave the pre-soak water in the drum for one minute; then pour it away, making sure that you shake out the last drops before laying the tank horizontally on its feet in a sink or on a work top. Then pour the previously dispensed 50 ml dose of developer into the spout of the drum. The temperature of the developer will be at the ambient temperature of your workroom. In other words, don't bring the bottle of stock developer into the room just before you need to use it, but make sure that it has had time to reach equilibrium with the surrounding temperature.

The developer you poured into the drum will have entered a trough formed by the two longitudinal separators inside the tank, so that development cannot commence until the drum is rolled, and the developer escapes into the tank proper, to flow over the surface of the exposed print.

Rolling the drum

So, when you are ready, start the timer and at the same time commence rolling the drum back and forth. The rate of to and fro movement should be about 4 or 5 seconds per cycle and it should be maintained throughout the processing period.

If you get tired or bored with this chore, you may decide to invest in an automatic agitator, which will roll your tank back and forth while still maintaining the wave-wash effect. But for a beginner, this is perhaps something of a luxury.

Stopping

Fifteen seconds before the end of whatever development time is required, pour away the developer, shaking all the drops out of the

in the drum, but it can also be used to maintain the temperature of all the solutions required for a particular process. The Jobo CPE2 processor is one example and the Paterson Thermo-Drum is another.

Preparations for processing

Remembering that an exposed print must be loaded into your processing drum in complete darkness, you will do well to prepare things thoroughly before you finally switch off the room light. If you are using the Simmard procedure, you will have read the temperature in your working area – whether it be a darkroom, your bathroom or your kitchen, and then, knowing the processing temperature recommended for your colour paper and chemistry you will have found what temperature you need to have your reservoir – a plastic bucket will do – of tempered water.

Pour out the required amounts of developer, stop bath and bleach-fix solutions and make sure that you label or mark each beaker or container in some way that will ensure that they are invariably used for the same solution. Numbering them clearly – 1, 2 and 3 – should be sufficient. Then – and this in my experience is very important – put the beakers or measures in some place where they can be easily reached, but cannot easily be knocked over in the dark, particularly when you come to roll the drum to and fro on the bench top.

Practice in the light

Practice putting paper into your drum in white light before you attempt to do it with an exposed print in darkness. A little time spent on this will ensure that you don't run into difficulties and find yourself handling prints excessively with the consequent risk of marking them. Assuming you are working with a Simmard drum, when the exposed print, or prints, have been located properly, the cap or lid is placed firmly on the end of the drum, using the location pin as a guide. Then a light can be switched on or you can move into daylight.

The Durst Codrum provides the facility to pour a solution into its end cap and yet defer the commencement of processing until the drum is moved to the horizontal position and then rolled to and fro.

Kodak Printank

In 1973, Kodak introduced a colour processing drum in the U.K. and called it the Printank. This tank is made of grey plastic material and has a lid sealing one end of the drum by means of a very tight fitting rubber 'O' ring. This lid fits so tightly on some tanks that it is difficult to believe that it has to be removed and replaced every time a print is processed. The lid also supports a central filling tube into which the processing solutions are poured and which conducts these solutions to the bottom of the drum where they cannot touch the print until the tank is moved into a horizontal position. There is a cap to cover the filling hole at one end of the tank and another, corresponding cap for draining from the other end. There are feet moulded into the base of the tank so that it will stand vertically while solutions are poured in.

Temperature control with the Printank

Kodak in the U.K. recommended floating the loaded Printank on the surface of a sink or bowl of water maintained at 32°C, so as to provide a working temperature of 31°C inside the drum – 31°C being at that time the preferred temperature for Ektaprint 3 chemistry.

Colour print processors

Provided that the lid of a processing drum fits tightly enough to be watertight, it can, like the Kodak Printank, be floated on a bath of tempered water to ensure some predetermined processing temperature. Several manufacturers now produce processors which incorporate a thermostatically controlled water-bath and a motor to rotate the drum automatically. Not only does the water-bath serve to maintain the temperature of the processing solutions while they are

The Kodak Printank is light tight when its large knurled end cap is pressed into position. After developer has been poured in – A, and the smaller cap has been added, the tank becomes watertight, so that it can be floated in a water bath – B to maintain the required temperature during the development stage.

The correct temperature for the pre-heating water can easily be found from a nomograph. As an example, which could be typical of many work rooms in the U.K. during the winter months, let us asume an ambient temperature of about 63°F and a required working solution temperature of 90°F (Ektaprint 2). Then the pre-heat water would need to be at 116°F.

There is no reason why this pre-heat technique cannot be used with any other type of print processing drum and in fact several companies now provide charts calibrated in Fahrenheit and Centigrade, which will show you the temperature you should use for your pre-heat water.

Paterson Drum

The Paterson Colour Print Processor is different from other drums in that it is supplied with a supporting cradle and a handle or a battery-driven motor that allows the drum to be rotated and slid from end to end throughout the processing cycle. Paterson have also devised a neat slide rule calculator for determining the required temperature of the pre-soak water.

Durst Codrum

The print processing drums sold by Durst are rather like the Simma-Color drums in that they incorporate a 'cam' action movement of solutions to ensure lateral as well as rotary flow. One end of the Codrum is attached to a flange in an eccentric manner, so that when the drum is rolled on a flat surface it rocks as it rolls. The Codrum has a completely smooth inner surface with none of the guides or raised ribs that are used in the Simma-Color tank. This means that greater care must be taken to locate prints in the Codrum so that they slide squarely into position without overlap or protrusion. Furthermore, because there are no ribs on the inner surface, the Codrum must always be scrupulously dried out before the next print can be slid into position, whereas, with the Simma drum there is, in my experience, no necessity to be so very particular about drying the drum perfectly between prints.

There are several different types of print processing drum, among them A – the Simma-color (Besseler), B – the Durst Codrum, C – the Kodak Printank, D – the Cibachrome (U.S.) drum, and E, – the Paterson Color print Processor.

number of slightly raised ribs which allow free access of solutions and wash water behind the print. This means that there is little risk of stains forming on the back of prints.

A cylinder is not the only shape a container can be to allow prints to be processed uniformly with small volumes of solution. Provided the solution is induced to flow smoothly over the exposed surface of the sheet of exposed paper, the light tight container can be shaped like a dish or tray rather than a cylinder. Paterson have made use of this fact in their Orbital processor, in which a very small volume (55ml) is made to flow continously over an 8 in × 10 in print. The Orbital processor can either be 'twirled' by hand or by means of a motor-driven base.

Larger drums

Two larger Simmard print tanks are available – one for 11 in × 14 in and another for 16 in × 20 in prints. The first of these will also take two 8 in × 10 in, four 5 in × 7 in, or six 4 in × 5 in; while the largest drum will accommodate a single 16 in × 20 in print or an 11 in × 14 in, or four 8 in × 10 in, eight 5 in × 7 in, or eight 4 in × 5 in.

The quantities of solution recommended for use in these two drums are: 150 ml (5oz) for the 11 in × 14 in and 250 ml (8 oz) for the 16 in × 20 in.

Temperature control with processing drums

Besides introducing their 'wave-wash' form of agitation, Simmard also decided to tackle the problem of solution temperature control under the amateur's working conditions. In effect they said 'never mind what your room temperature is, provided you know what it is and it is not likely to change quickly, and provided you also know the working temperature recommended for your particular type of colour paper and its chemistry'. Knowing these two facts, you can then preheat the processing drum by filling it with water at such a temperature as will allow the drum, after being emptied, to give up just the right amount of heat to raise (or lower) the temperature of the small volumes of solution that you will use in the drum.

These two charts — one for Farenheit and the other for Centigrade — provide a ready means of determining the temperature of the pre-soak water you should use before processing a print in a Durst Codrum, when you already know the temperature in your work-room. The pre-soak temperature required for other kinds of processing drum might be slightly different, but this is still not so important as strict consistency.

By comparing the sequence of steps required for P85 with those used for Ektaprint 2, it will be seen that although P85 development requires only 2¾ minutes as compared with 3½ minutes for Ektaprint 2, stop bath and rinse steps add an extra minute to the total time required for the Agfa process. Note that at 30°C, the developer is diluted in the ratio of 2 parts developer to 1 part water.

ONE-SHOT PROCESSING OF AGFACOLOR PAPER

Processing step	Time (mins) for processing at:		
	20°C (68°F)	25°C (77°F)	30°C (86°F)*
Developer	6	4	2¾
Stop-Bath (3% Acetic Acid)†	½	½	½
Rinse	1	¾	½
Bleach-Fix	4	3	2
Wash	4	3	2
Stabiliser	1	1	1

Notes:

* When processing at 30°C (86°F) the developer is diluted in the proportion of 2 parts of developer to 1 part of water (40 ml developer + 20 ml water).

† Acetic Acid must be obtained separately and a 3% solution prepared and used as Stop-Bath. This solution keeps indefinitely.

The Simma-Color Drum

The Simmard tank was the first of its kind and remains one of the best of the small cylindrical print processors. The distinctive – and patented – feature of the Simma-Color drum is the eccentricity of its two end flanges – designed to give a slight rocking movement while the drum is rolled back and forth on a flat bench top. The importance of this device lies in the fact that a small volume of solution in the tank not only rotates concentrically with the drum, but is also urged from end to end parallel to the axis of the drum. This multi-directional flow of solution over the surface of the print ensures very efficient agitation, with no risk of streaks resulting from unidirectional flow. The inside surface of the 8 in × 10 in Simma-Color drum has a

Either a sliding calculator of the kind supplied by Paterson – **A**, or a nomograph chart – **B**, such as included with many processing drums, will make it easy to determine the temperature required for the water you will use for pre-soaking and washing the prints you process.

Agfacolor 85 kit

Agfa-Gevaert, who have always been ready to supply small scale users with the necessary materials for colour printing, now offer a 1 litre — four bath — kit of chemicals (P85) for use with their polyethylene coated (Type 4) colour papers.

Unlike Kodak, who supply their colour processing chemicals in concentrated liquid form, Agfa uses powdered chemicals for the P85 kit. While most people consider that liquid concentrates make the job of solution preparation much easier, it is a fact that dry chemicals are generally more stable in their keeping properties than solutions, and therefore there is perhaps less risk of kits deteriorating after having been stored for a long time by either the customer or the photodealer. Just how important such considerations are, is a matter of opinion, but it does seem probable that all manufacturers will eventually supply their chemicals in liquid form because of the greater convenience that results.

Mixing instructions

There is no reason to describe detailed mixing procedures here, since every Agfacolor 85 kit contains an adequate instruction leaflet. However it may be worth noting that the first two components of the developer CD-A1 and A2, do not dissolve fully until a third component — CD-B — is added. Both the bleach-fix and the final bath (stabiliser) consist of two powder components, but the final bath also requires the addition of 5 ml of 30% formalin. The stop-bath is made up from only one powder.

Process 85

Agfacolor P.E. or resin coated papers, like other papers, can be safely processed at any temperature within a range such as 20°C to 30°C or between 68°F and 86°F. Agfa gives times for one-shot or total-loss processing in a drum at 20°C, 25°C and 30°C. Since even at the highest of these temperatures the processing sequence takes slightly longer that Ektaprint 2 — used at 31°C — I think most amateurs will choose to use P85 at 30°C (86°F).

Economy of solutions

While there is everything to be said for using a minimum quantity of developer and discarding it immediately after use, there is no reason why the same volumes of bleach-fix and stabiliser should not be used three times before you throw them away. Certainly I have been working in this way for some time now.

Divided kits

There is one other advantage of using liquid concentrates rather than powdered chemicals – you can, if you really want to, divide the several components of a kit into two halves, simply by carefully measuring out half the initial volumes, and retaining the other halves for future use. Dividing kits is not at all easy or even advisable with dry chemicals. Although, after being dissolved in the specified volumes of water, the resulting solutions can then be divided for storage in a number of *completely* filled small bottles.

Ektaprint 2 procedure

There is nothing magic about a particular developing time and temperature combination, since within reasonable limits times can be increased and temperatures lowered – or vice versa – to give the same results. However, the steps recommended by Kodak for processing Ektacolor 78 RC paper in Ektaprint 2 chemistry are so simple and easy to remember for a temperature of 31°C (88°F) that there would seem to be little reason for wanting to change things.

PROCESSING STEPS FOR KODAK EKTACOLOR 74 or 78 RC PAPER IN EKTAPRINT 2 CHEMISTRY

Step	Time* (minutes)	Temperature °C	°F
1. Developer. Begin timing as soon as the paper is wet with Developer.	3½	33	90
2. Bleach-fix	1½	33	90
3. Wash	2	33	90

*These times include a 20 second drain between each step.

Avoid contamination

The most important thing to remember when preparing the working solutions is to avoid all risk of contaminating the developer with any of the other solutions. You will be more likely to succeed in this if you use a separate measuring and mixing vessel for the developer and never use it for anything else. Now that plastic containers are so readily available, this is not an extravagance. Especially when you remember the cost of the paper and chemicals; and the time you would waste if your developer does not behave properly because of some unsuspected contamination with a trace of bleach-fix or some other solution.

Glass, stainless steel or rigid plastic containers can all serve for the mixing operations and either glass or plastic bottles can be used to store the working strength solutions. A dark or opaque bottle is recommended for storing the developer, but if you haven't a suitable bottle to hand, just make sure that you keep the developer out of bright daylight.

If you are not expecting to use most of the mixed developer within a few days, it is preferable to dispense the total volume into two or three smaller bottles, so that those not in use can remain full and stoppered to exclude air.

Ektaprint 2

Kodak Ektaprint 2 chemicals are supplied as two separate packages – Unit 1 containing the three part developer concentrates and Unit 2 including two part bleach-fix concentrates. These concentrates are used to make 1 litre each of the two working solutions.

It is hardly necessary here to provide step by step mixing instructions for Ektaprint 2 chemistry, since an up to date instruction leaflet will be found in each Unit 1 package. This leaflet also gives details of the storage life of the three working solutions and from this table you will see that the developer will keep for rather less time than either the bleach-fix or the stabiliser.

difficulties are most likely to occur, do not risk confusing yourself by rejecting manufacture. ' advice. Later, perhaps – but not while you have so much to learn.

In their continuous attempts to simplify and shorten processing procedures, manufacturers have devised processes which operate at very high temperatures. These high temperatures are not too difficult for a professional laboratory to achieve and maintain, but the amateur tends to be in difficulties when he tries to work with solution temperatures that are much above the ambient temperature of his workroom.

Fortunately, by using a print drum and one or other of the recommended procedures, it is now possible to maintain adequate control of processing temperature without the necessity for thermostatic equipment.

Photocolor II chemistry

Provided that quality does not suffer, any simplification of processing is bound to be welcomed by the amateur, who never has enough spare time for processing and printing anyway.

With only two solutions – developer and bleach-fix – Photocolor II chemistry certainly does simplify both colour negative and colour print processing. The chemistry is designed to process any film of the Kodacolor II type (C41 process) in 11½ minutes and any colour paper that is compatible with Kodak's Ektacolor 78 R.C. paper in less than 6 minutes.

So if you are keen enough to develop your own colour negative films, you can by using Photocolor II chemistry, go straight on to make your own colour prints with the very same solutions.

The recommended processing cycle (at 34°C 93°F) for colour paper is:

Develop	2 min
Stop bath	20 sec
Bleach-fix	1 min
Wash	2 min

Print developing drums and greatly simplified processing sequences have made colour print processing very easy for the amateur – provided always that he will take care to be absolutely consistent in his chosen procedure.

Processing in dishes

Colour prints can be processed quite successfully in dishes, but there is little doubt that the job is simpler and more economical for the amateur who uses one or other of the several light-tight print tanks that are now available.

It would be an over-simplification to say that the only critical step in processing a colour print is the development stage, but it is a fact that if this first step is carried out reproducibly and contamination of the developer is carefully avoided, then controlling the remaining steps should prove relatively easy.

Two basic chemistries

At present there are still two major types of colour paper – Ektacolor and Agfacolor – and there are two basic chemistries for them: Ektaprint 2 and Agfa Process 85. In the U.S. these are often referred to as Type A and Type B chemistries. Because colour chemicals tend to be expensive, there is often a temptation to economise in some way, either by using substitute chemistry offered at a lower price or by using less than the manufacturer's indicated volumes or perhaps using a given volume of solution to process more prints than recommended. The motives for following any of these courses are quite understandable, and might even prove economical and successful, but while you are at the learning stage when unexplained

Colour
Paper
Processing

Safelight Filter No. 13 (dark amber). Any paper must be kept at least four feet from the lamp.

Agfacolor papers can be handled for *not more than ten minutes* if kept at least 30 in away from the light from a 15 watt lamp behind an Agfa safelight screen No. 08.

Safelight fog

Safelight fogging of colour paper usually manifests itself in the form of lowered contrast and/or a bluish-green fog – over the image area *and* the borders of a print.

If an 8 × 10 inch sheet is cut into two, the 5 × 8 inch pieces that result almost exactly suit an enlargement from the whole of a 35 mm negative.

in is divided into two 8 in × 5 in pieces, then the whole of a 35 mm frame can be printed with only a small waste of paper.

Storage of paper

All sensitised photographic materials deteriorate more rapidly at high temperatures. In general, the emulsion layers become foggy and their speed and contrast change. It is necessary therefore to store a complex and expensive material like colour paper under conditions that will delay or even prevent such changes – in other words in a refrigerator or freezer.

Warm up period

When you take a box or packet of paper from cold storage, give it an hour or two to reach something like room temperature before removing the inner foil wrapping to take out the number of sheets you need at the time. If you don't leave this period for the paper to warm up, you may one day find that moisture forms on the surface of the sheets because they are cold enough to cause condensation.

Safelighting

Very little will be said about handling colour paper under a safelight. This is because when you are turning on the white light or moving into a lamplit room every few minutes to process a print in a light tight drum, you are in the dark for such relatively short periods, that you might just as well learn to work in complete darkness. To benefit at all from the low level of safelight offered by either Kodak's or Agfa's recommendations, it would be necessary to wait some five or ten minutes before you could expect to become dark adapted.

However, for those who would still like to try for themselves, these are the conditions the manufacturers specify:

Ektacolor 78 RC paper may be handled for a *limited period only* under the light from a 25 watt safe lamp fitted with a Kodak Safelight Filter No. 10 H (dark amber) or a 15 watt safelamp fitted with a Kodak

Surplus for 2¼ sq. & 126

135

6×7

110

2¼ sq

126

10"

Surplus for 135

Surplus for 110

8"

Because colour paper is expensive, it is necessary to consider ways of using it to best advantage. Unfortunately, an 8 × 10 inch sheet, while one of the more easily obtainable sizes, does not suit most negative formats. When enlarged to fit the smaller dimension, both 6 cm square and 126 Instamatic negatives result in a 2 × 8 inch surplus. If a 35 mm negative is enlarged to fit the 10 inch dimension, a surplus of nearly 1½ × 10 inches results. When enlarging a 6 × 7 cm or a 110 negative to 8 × 10 inches, practically nothing is wasted.

that do not differ slightly in colour balance. Differences within a batch will however be very small since colour paper is often used in one or even two thousand feet rolls for photofinishing, and in such applications it would be useless for the paper to vary from end to end of the same roll.

Value of single batch

It is always a problem for the amateur to decide what size and quantity colour paper he should buy. After all, it is rather expensive and a significant proportion of it goes on test strips and prints that are not quite right. Nevertheless it will prove false economy if you buy as little paper as possible each time. Quite apart from the risk of running out just at the wrong moment, you are changing batches too frequently; and probably causing yourself a lot of unnecessary trouble and delay. It is true that the manufacturer always gives you some indication of the relative sensitivities of the three layers of each different batch of paper – usually indicated in filter values. However, even when you have done the necessary arithmetic to arrive at a new filter pack, you will be very lucky if you find you can change from one batch of paper to another without a hitch. So buy as much paper of one batch as you can afford.

Paper sizes

There are some rather good reasons why you may be well advised to settle on 8 in × 10 in as the standard size of paper you use. For one thing, this is very likely to be stocked by your dealer. Secondly, much of the equipment designed for colour printing is based on 8 in × 10 in as the standard size – print drums and special enlarger boards for example. Also, you can print an 8 in × 10 in sheet in a number of useful ways. You can use a single 8 in × 10 in sheet to contact print the whole of a 36 exposure 135 film or the 8, 10, 12, or 16 exposures on a 120 film. You can get four useful sized test prints on one sheet of paper or you can make four 4 in × 5 in prints of the same negative. It is true that neither 4 in × 5 in nor 8 in × 10 in are good formats on which to print 35 mm negatives or transparencies, but if the 8 in × 10

that the water contained in the emulsion layers after the final wash, would not be able to escape through the paper base because of the two protecting layers of polyethylene. Also, the polyethylene coat begins to soften at about 93°C; above which temperature, the prints are quickly ruined.

Ektacolor 78 R.C. Papers

Kodak makes a range of resin-coated colour papers with three different surface textures – glossy (F), smooth lustre (M) and silk (Y). Photofinishers have recently started making most of their prints on silk finish papers, although some still offer glossy prints as an alternative. The dyes found in the emulsion layers of Ektacolor papers are much more stable and light-fast than they were in the early days of colour printing.
The chemistry that goes with Ektacolor paper is known as Ektaprint 2 – a three-bath process.

Agfacolor paper – MCN 310 Type 4

Agfa-Gevaert's polyethylene coated colour papers are known as Type 4 and their surface characteristics are coded as MCN 310 (glossy) MCN 312 (matt) and MCN 317 (silk). These papers can be processed in either of two chemistries – the four-bath Universal process or the three-bath process 85. It is the latter which the amateur is more likely to use because of its greater simplicity and shorter times.
Agfa describe their Type 4 papers as being "coated on a P.E.emulsion support" and say that "magenta dye contains very little blue and is therefore highly suitable for rendering flesh tones". Type 4 papers are also "very fast to light".

Batch to batch variations

For the reasons touched upon early on in the chapter, it is practically impossible for any manufacturer to produce batches of colour paper

meant that a considerable amount of washing was necessary to avoid contamination between solutions and to ensure that finished prints did not deteriorate on keeping.

R.C. and P.E. papers

In America, and to a large extent in the U.K., the term 'resin-coated' has been abbreviated into R.C., while in Europe, Agfa-Gevaert decided to describe their papers as being polyethylene or P.E. coated. These two terms amount to the same thing.

Contrast grades

Black and white printing papers are usually made in four or five contrast grades, but most manufacturers supply their colour paper only in one grade. Although there are some differences in contrast between the papers of different manufacturers. The fact that (in most cases) one contrast grade is adequate, depends very largely upon uniform manufacture and processing of colour negative materials.

Surfaces

The surface texture of resin-coated papers is determined by the surface of the underlying resin layer itself. In other words, if the resin layer is left with the smooth surface it has after being applied to the paper base, then any emulsion layers coated on it will dry with a correspondingly smooth or glossy surface. If on the other hand the resin layer is embossed with some regular or irregular texture before emulsions are coated on it, then finished prints made on it will have a correspondingly semi-matt, or silk surface or finish.

Do not glaze

Resin-coated papers cannot be glazed by hot drying with emulsion in contact with a glazing plate or drum. If you think about it, you will see

Few manufacturers

Only relatively few manufacturers make colour papers – two in the U.S., one in the U.K., one in France, one in Germany and three in Japan. There may be one or two smaller producers in Eastern Europe, but their papers are not usually available in the West. The silver dye bleach colour print material made in Switzerland and called Cibachrome is intended for printing directly from slides. The process is described separately on p. 941-965.

Just as with colour film products, there are two basic methods of ensuring that the couplers used in the emulsions coated on colour papers stay in their respective layers and do not diffuse out of them during processing. Kodak disperse their couplers in minute water permeable but water insoluble globules of a resinous plastic substance, while Agfa originally used colour couplers of such large molecular size as to literally entangle themselves in the structure of the gelatine of the emulsion with which they are mixed and coated but now they also use Kodak type couplers.

Characteristic differences between colour development papers

These two solutions to the problem characterise all currently available colour development papers so that each type can be considered to be similar to either Ektacolor or Agfacolor paper. It is characteristic of the Kodak type of paper that because of the resin-like particles containing the dyes, a slight bluish opalescent appearance persists until prints are fully dried.

Having divided colour papers into two broad groups, it must be pointed out that it does not follow that all papers in one group will have the same speed or be capable of yielding the same results.

Resin-coated paper base

Until a few years ago almost all colour and black and white papers for printing from negatives used an unprotected paper base support, so that most of the take-up of developer and other processing solutions was due to the paper base rather than the emulsion layers. This

You do not have to understand much about colour papers in order to use them, any more than you need to know about its engine before you drive a car. But if you have some idea how colour paper works you will be more likely to understand the reasons for any problems you may meet.

Basic construction

All colour papers are integral tripacks, put together in much the same way as colour negative and colour transparency films. In other words, three emulsion layers are coated in superimposition onto a paper base; one layer being sensitive to blue light, one to green light and the third to red. Nowadays both sides of the paper base are usually protected by very thin layers of polyethylene to prevent the absorption of processing liquids. The three emulsion layers and any separating layers are largely composed of gelatine. Of course the emulsion layers also contain silver halides and the necessary colour couplers.

Coating precision

It is very much more difficult to manufacture colour paper than it is to make black and white bromide paper. There are several reasons for the increased difficulty, but principally it is because of the extreme coating accuracy required. You can imagine just how precisely the thickness of each emulsion must be controlled if you remember that the total thickness of the three layers is only about one thousandth of an inch, and if any one of the three varies by as little as 5% or the equivalent of 15 millionths of an inch, it will cause a shift in the colour balance of the paper. If this were to occur within a sheet, it would make the paper totally useless.

Colour
Papers

particularly true of Ektacolor type papers because they incorporate couplers in a form which gives a print a bluish opalescent appearance until it is dry. Fortunately, resin coated papers can be dried quite quickly with a hot air drier of some kind.

Importance of consistent print processing

As you come nearer to the exposure and filtration required to produce a correctly balanced print from your reference negative you will also come to realise how dependent you are on consistent print processing. It is not much good deciding upon a final adjustment of 05 M to your filter pack if your next processing run suffers from some deviation in time or temperature. Quite small variations can be enough to more than offset such a change in filtration.

Be very careful to establish a strict routine for your processing cycle. It is not so much that you must develop for precisely three minutes rather than three minutes five seconds, but that it should always be either three minutes or three minutes five seconds. In the same way don't cut corners when rinsing or washing between stages – always do the same thing in the same way for the same time.

You may find that printing your own ring-around (from a suitable negative) gives you a more satisfactory standard. Also, the actual printing provides very good practice in manipulating filtration.

ADJUSTING FILTER PACK WHEN PRINTING FROM COLOUR NEGATIVES

If a test or print is too:	Subtract or	Add
Yellow	Magenta + Cyan (blue)	Yellow
Magenta	Cyan + Yellow (green)	Magenta
Cyan	Yellow + Magenta (red)	Cyan
Blue	Yellow	Magenta + Cyan (blue)
Green	Magenta	Cyan + Yellow (green)
Red	Cyan	Yellow + Magenta (red)

Illumination for viewing

The recommendation to examine your colour tests or prints in daylight is very often difficult to observe, because much of your printing may be done during the evenings and in the winter time. However, it will certainly be well worth your while putting a colour matching fluorescent light in a room where you can go to evaluate the test strips and prints you make. If you merely depend upon ordinary household lighting from tungsten lamps, you will often get an unpleasant shock when you come to look at your prints again in the morning. For example, it is particularly difficult to judge the true yellow content of a print under tungsten lighting.

Wet or dry prints

While your tests are still a long way from being in balance it is not really necessary to dry them at the end of processing. If the print is merely rinsed for a minute or so following the bleach-fix treatment, it will be possible to asess it sufficiently well to decide on the correction required before the next exposure. But as the results become correct for density and more nearly correct for colour balance, it will be important to dry each test print before evaluating it. This is

Evaluation and correction of tests and prints

No matter whether you use a filter pack or a colour mixing head you will always have to decide whether the colour balance of any test or any print you make is satisfactory and if not what changes should be made to produce a better result.

It has already been stressed that there is really only one way to become proficient at this very important business of evaluating a test or a print and deciding what changes should be made, and that is to make lots of tests and many prints. When you first tackle the job it may seem rather like tuning a violin for the first time – you know that it is out of tune yet you cannot be certain just how much to turn the keys to get each string into tune. Later when you have had more experience the whole thing becomes much easier and you will do it with confidence.

To help you while you are quite new to the task, a wide range of tests – often called a ring-around – of the same subject has been printed on page 828, to show, as far as possible with printed reproduction, just what effect different values of filtration have on a print. In broad terms these are the rules:

1. A predominant colour cast in a print made from a colour negative is removed by adding a filter (or filters) of that same colour to the filter pack. Or, whenever it is possible, by removing filters that are complementary to the colour cast.
2. Slight colour casts require the addition or subtraction of low density filters, while more severe casts necessitate higher density changes.
3. Overcorrection results from using filters of too high a density resulting in a colour cast complementary to the original one.
4. Every additional filter increases the exposure time and the denser the filter the greater the increase. Conversely, removing filters from the pack will reduce the necessary exposure.
5. For equivalent values, yellow filters increase exposures least and cyan increases them most.
6. Whenever possible, examine tests and prints in daylight or under special colour matching fluorescent lights.

Record exposure details

Before processing any test print, remember to enter the exposure and filter details in a log book and to identify the individual test areas by writing the information on the back of the paper with a soft lead pencil. This has to be done in the dark but it is not too difficult and you will soon learn to manage it. At first you may tend not to take this recording business seriously, but if you don't, it will not be long before you wish you had, when you cannot remember the exposure times or filtration of some negative you need to print again.

In Europe, largely because of the influence of Agfa, the accepted way of recording the details of filtration is to state them in the sequence yellow, magenta, cyan, so that a filter pack comprising 80 Y, and 60 M would be written: 80-60-00, or even more briefly: 80 60–. A pack composed of 20 M and 10 C would then be:– 20 10.

The Kodak companies – for reasons best known to themselves, prefer to state filtration values in the order of magenta, yellow, cyan, which can sometimes lead to mistakes if one has been using the long-established Agfa procedure. The sequence: yellow-magenta-cyan will be used throughout this book.

Compare speed of bromide paper

When your first set of exposure tests has been processed there will probably be one section that is reasonably right for density; if not and all the test areas are either too light or too dark then there will be nothing for it but to repeat the test. To get a darker print you can either lengthen the time of exposure or use a larger aperture for the enlarger lens. If the exposure time looks like being longer than 20 seconds when printing your properly exposed reference negative, then you should open up the aperture of the enlarger lens, although this should never be used fully open because then there would probably be too little depth of focus at the paper plane. To make a print light by reducing exposure it easy enough because there is seldom any disadvantage in reducing the aperture of the lens.

By the time you have made a second set of tests you will certainly know the exposure you need but not the colour correction.

standards improve, you may decide to eliminate this particular source of uncertainty by using a constant voltage transformer of the kind made by Rayco in the UK or Cosar in the US.

Your first exposure

The first test you make using one of your reference negatives will necessarily be something of a gamble. Initially you need to get the density of the print reasonably correct, so the first exposures should cover a fairly wide range of times – say 5-10-15-20 seconds at f8. These four test exposures can be made by uncovering successive quarters of the sheet of paper or by using a masking frame with four hinged flaps. Don't make the mistake of trying to manage with very small pieces of paper for if you do you will often be uncertain of the corrective steps you need to make because the test does not include enough of the picture.

Starting filters

It may be difficult for a beginner to accept that there is no way in which a manufacturer of colour paper can predict exactly what filter pack will be required to produce a satisfactory print from any particular negative, but later in the book an attempt is made to explain why it is not possible to make such predictions and why, therefore, it is necessary in each new case to discover correct filtration by trial. As a suggestion, the starting filtration when printing a Kodacolor II onto Ektacolor 78 RC paper might be 100 Y and 50 M. This large amount of yellow filtration became necessary when the orange/red masking density of the older film – Kodacolor X, was replaced with the yellower mask colour of Kodacolor II. It is generally thought that in due course Kodak will modify the relative sensitivities of the emulsion layers of their colour paper so that lower and better balanced filter values will be possible when printing from Kodacolor II negatives, but for the present we must accept the situation as it is.

The Chromega B enlarger will accept all negative sizes up to 6 cm. square and is equipped with a dichroic filter head. The colour of the light reaching the negative is simply and reproducibly adjusted by means of the controls on the front of the lamphouse. A range of 0–170 is available for all three colours. Unfiltered light for composing and focusing can be obtained without disturbing previous filter settings.

873

otherwise it would not be possible to rely on the scale readings when re-setting filtration to repeat a print or a test.

Because they almost invariably use tungsten-halogen lamps as their light source, colour heads have to be connected to the mains supply *only* via a transformer or some other means of lowering the voltage reaching the lamp. The required voltage varies according to the type of lamp and may be as low as 25 volts or as high as 85 volts. Usually a transformer is supplied with the lamphouse; it is not necessarily integral with the enlarger, although the Omega 760 uses a voltage dropping device that is incorporated in the lamphouse itself.

Advantages of colour heads

To sum up, the advantages of using a colour mixing head rather than a filter pack are firstly that an infinite number of filter combinations can be achieved and any one of them can be set in moments with a high degree of accuracy, and secondly when dichroic filters are incorporated they have no unwanted absorption and therefore do not require so much additional exposure when used in high densities. Finally, unlike dyed filters, dichroic filters never fade.

Nearly all colour mixing heads use tungsten-halogen lamps which have the useful property of not changing colour or brightness when used. The light emitted by an ordinary lamp becomes gradually redder and lower in intensity as it is used. Although this change is slow, it can cause abrupt differences when the time eventually comes to replace the lamp.

Voltage control

The light from an incandescent filament lamp changes colour as the voltage supplied to it varies. As the voltage drops so the relative amounts of blue light is less and red light more, which of course has much the same effect as changing the filter pack if you are exposing a colour print. However, unless your supply voltage frequently varies over a range of 10 volts or more you need not expect serious differences to result in the colour balance of your prints. But as your

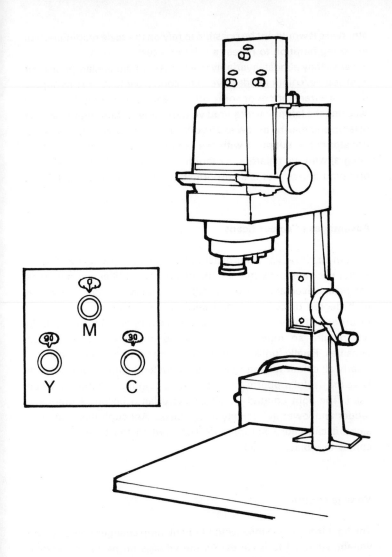

There are several different Durst enlargers available with dichroic colour heads. The one illustrated, is the M301, designed for printing 35 mm, 126 and 110 size negatives. Filtration is adjusted by means of the CLS 35 colour head with a filter range of 0 to 100 for each of the three colours.

Pavelle head, and the many others that have followed with similar designs, is simplicity itself.

Light from a tungsten halogen lamp with an integral reflector is focused onto a small area, at which point three interference or dichroic filters can be moved into the beam. The extent to which each of the filters does in fact interrupt the light beam determines the effective filter density for that position. For example, if the density of the cyan filter is 100 C and if it is placed half way into the light beam, then the colour is changed to the extent it would be by a 50 C filter. The filtered and unfiltered components of the light beam are thoroughly scrambled in a white sided mixing box so that the negative is illuminated uniformly.

Dichroic or interference filters

Dichroic filters are glass filters on which a sequence of extremely thin and specially chosen reflective layers have been deposited in such a way as to reflect certain parts of the spectrum of light while transmitting the remainder. These interference filters can be made more efficient than dyed filters because they have no unwanted absorptions. As the deposited reflective layers are usually metals, they do not fade, and quite small areas can be safely introduced into concentrated beams of light.

A lamphouse containing the optical and mechanical requirements for a continuously variable filter adjustment costs a good deal more than one which simply incorporates a filter drawer. Nevertheless, enlarger manufacturers such as Beseler, Durst, Omega, L.P.L. and others do now produce dichroic colour heads for use by keen hobbyists. The Durst 605 is one example and the Omega 760 is another. Both of these enlargers will handle negatives up to 6 × 6 cm, (6 × 7 cm in the case of the C760) and both incorporate yellow, magenta and cyan dichroic filters. These can be moved into and out of the light path of a tungsten-halogen lamp to produce any combination of filtration between 0 and 200 in the case of the C760 and 0 and 170 with the M605. The chosen settings are read from three scales on the front face of the enlarger.

Usually, spring loaded or weighted cams are used in the adjustment of filters in a colour head because it is important that there should be no slackness or backlash in the mechanism used to set the filters

un-noticed, you would eventually find yourself confused because of the anomalous results you would be getting – particularly if you tried to relate current filtration with some of your earlier printing records. So keep a good look out for any signs that fading has started. It is quite easy to detect if you regularly lay out your filters – particularly the low density values – on a clean sheet of white paper. If there is any fading you are likely to see a central patch that is ever so slightly lighter than the corners of the filter.

Colour mixing heads

Although the method is perfectly satisfactory in terms of quality of prints it produces, the fact remains that the business of assembly, adjusting and locating filter packs in an enlarger is time consuming and can give rise to mistakes. Consequently it was not long before Agfa introduced the first specially designed colour head that afforded continuous alteration to filtration by the simple adjustment of three rotary knobs. The Agfa colour head was made primarily to fit the Agfa Varioscop enlarger, but thousands of these lamphouses were and are used on many other kinds of enlarger.

The Agfa colour head has an illumination system which focuses the light from a projector lamp into a small concentrated beam, at which position three annular filters are located. The filters, which are in glass are of course yellow, magenta and cyan and their densities vary from 0-100. The desired value of any of these filters can be introduced into the light beam simply by adjusting the appropriate knob and observing the corresponding scale on the front of the colour head. Additional filters have fixed values of 100 and can be added to the system so that the total available density range is 200 for each subtractive colour.

Other colour heads

Many other kinds of colour mixing heads have been designed by such manufacturers as Simmons, Durst, Beseler and others, but a new principle was adopted when Pavelle – now Durst – first introduced their model 400 enlarger and colour head in 1962. This

Other filter sets

Besides those made by Kodak and Agfa, sets of colour printing filters are supplied by manufacturers such as Beseler, Ilford, Paterson, Unicolor and others. If you decide to use one of these sets, do not suppose that they are interchangeable with other manufacturers' filters any more than Kodak and Agfa filters are directly interchangeable. In other words, stick to the filters you originally chose, or change the complete set. By way of an example of the differences that may be involved, you can take it that Kodak filters are denser than Agfa filters of the same nominal values. The ratio is approximately 1: 1.35, so a Kodak CP30 is the equivalent of an Agfa 40.

Care and identification of filters

Even though small superficial defects on colour printing filters will not be imaged on a print if the filter is located between the lamp and the negative, this is no reason for being careless with your filters. For one thing, they are quite expensive and therefore should be handled and stored carefully. A box with sections or divisions for your yellow, magenta, cyan and possible red filters will allow you easily to locate the ones you want.

Some suppliers sell their filters in quite convenient folders or swatches, but however you keep them, you should religiously replace each filter in its correct place as soon as you have finished with it. This way you are much less likely to make mistakes and your filters will certainly last longer.

To identify each filter, if the manufacturer has not already done so, you can either mark its value along one edge in india ink, or even better, prepare self-adhesive embossed plastic (Dymo) labels for each value and colour and place a label along the edge of each filter. This method of identification has the advantage that the label stiffens the edge of the filter and makes it easier to handle.

Filter fading

Because they are located so near to the lamp the filters you use most frequently may fade in due course. If any such change were to go

Colour correction filters are quite expensive and they can easily become scratched and dirty if they are not stored carefully. One way of making filters easy to identify and easier to handle is to attach an appropriately stamped strip of embossed lettering along one edge of each foil, as shown in A. B, C, and D are suggested ways of storing your filters so they will be easily accessible.

from condensers) is that all negative defects are imaged clearly on the print. So spotting and retouching are almost a necessity. With diffused light most scratches and dust specks will escape being printed. For this reason, therefore, it is better to choose an enlarger with diffuse illumination. Whatever type of enlarger is used it should include a heat absorbing glass to protect the filters you will be using to correct colour balance.

Kodak filters

Kodak distinguish between colour printing (CP) filters made from acetate sheet and their high quality gelatine colour compensating (CC) filters, which can if necessary be used beneath the lens of an enlarger. The printing filters are made in yellow, magenta and cyan as well as red. The red filters can take the place of equivalent values of yellow and magenta, thereby replacing two filters by one to simplify the filter pack.

The values of the CP colour range are: 05, 10, 20, 40, in cyan, magenta, yellow and red plus an 025 cyan and an 80 yellow and red. The smallest size is 7 × 7 cm square and this will be large enough for most amateur requirements.

Colour compensating filters are sold in 05, 10, 20, 30, 40 and 50 in each of cyan, magenta, yellow, red, green and blue.

Agfa filters

The colour printing filters supplied by Agfa come either as plain gelatine foils or bound between glass. In either form they are made in two sizes – 7 cm square or 12 cm square, the former intended for 6 × 6 enlargers and the other for 6 × 9 enlargers.

All the Agfa filter sets comprise yellow, magenta and cyan filters in these density values: 05, 10, 20, 30, 40, 50 and two valued at 99 or a nominal 100.

The glass bound sets of filters are exactly the same in value but in use, these filters, because of the four additional glass/air surfaces, require slightly higher exposure factors than the plain gelatine set.

combination of filter colours and densities to suit a particular negative is the trickiest part of colour printing. While experience is really the only answer to this problem there are ways in which print exposures can be estimated with some degree of accuracy and some of these procedures will be described later.

Enlargers for colour printing

The essential requirements for an enlarger that will be used to expose colour paper by the subtractive method are that the lamphouse is perfectly light tight and that it should have either a filter drawer or a colour mixing head. A filter tray is provided with most enlargers these days and it should be located between the lamp and the negative. Theoretically it makes no difference where the filters are located – they could be between the lamp and the negative, between the negative and the lens or between the lens and the printing paper – but in practice the best place is in the lamphouse between the lamp and the negative because here the physical condition of the filters is not very important. If there are scratches or fingerprints on them neither of these blemishes will affect the quality of the resulting print. Any filters that are used between the negative and the lens or between the lens and the paper must be optically perfect if they are not to impair the quality of the projected image. Not only must they be free from scratches and fingermarks, but they must also be of specially made 'optical' quality and are known as colour correction or CC filters.

Condenser or diffuser?

Apart from deciding on the range of negative sizes you want to print, a choice will also have to be made between those enlargers with a condenser in the optical system and those which use diffused light to illuminate the negative or transparency. Either of these types of enlarger provide enough light to print modern colour papers at conveniently short times of exposure. So there is no need to use a condenser system just because of its greater light efficiency. The principal disadvantage of using specular illumination (such as that

Once you have mastered the processing, you can always change to subtractive printing when you find the additive method cramps your style. You will have the processing equipment, and so have spread your outlay.

Subtractive colour correction

Suppose a print of a neutral subject turns out to be too yellow. Then for some reason or other a disproportionally large amount of yellow dye has been formed in the blue-sensitive layer of the paper. In other words, this layer received too much exposure when the print was made.

So how shall we change this when we make the next print? We know that we must reduce the exposure of the yellow image layer and since this emulsion is sensitive only to blue light we can easily do this if we subtract, or absorb, some blue from the printing light. The easiest way of doing this is to insert a suitable yellow filter into the printing beam.

The example of a print that is too yellow is a simple one, and obviously a colour print can have a colour cast or bias in any one of six different directions according to whether there is an excess of only one of the subtractive colours – yellow, magenta or cyan – or too much of any combination of any two of these three dyes. For instance, the print may be too red, in which case it has too much yellow and too much magenta dye, so besides the yellow filter necessary to reduce the exposure of the blue sensitive layer we shall also need a magenta filter to absorb some green light and thereby reduce the exposure and consequent density of the green sensitive, magenta forming, layer of the paper.

Of course there can be times when a print displays an excess of all three subtractive colours, but this is simply another way of saying that the print is too dark, a condition that can easily be corrected by reducing the printing exposure. There is hardly ever any need to use filters of all three subtractive colours at the same time, since if you do, you are certainly adding some grey density and therefore prolonging exposure unnecessarily.

It is very easy to describe colour correction filters in terms such as pale yellow or low density magenta, but finding just the right

Here is a way of making preliminary test exposures by the additive printing method. With a filter holder or slide attached to the enlarger lens – A, first use the blue filter – B, to expose the whole of the test strip – C, for 10 seconds. Then, having changed to the green filter, use an opaque mask – D, to give sections of the paper different exposures as shown, this gives 10, 20, and 40 seconds. Turn the mask through 90° change to the red filter, and make a further set of exposures. Repeat the green and red series on the new test prints with 20 and 40 second blue exposure overall.

Naturally, altering the exposure through any filter alters the overall density, you must alter the exposure through all three filters. However, for slight alterations, you can change the exposure through one filter by up to about 20 per cent without noticeably affecting the density.

COLOUR CORRECTIONS WITH TRICOLOR PRINTING

Print colour	Cause	Changes needed
Too Cyan	Red exposure too long	Reduce red exposure
Too magenta	Green exposure too long	Reduce green exposure
Too yellow	Blue exposure too long	Reduce blue exposure
Too Red	Red exposure too short	Increase red exposure
Too Green	Green exposure too short	Increase green exposure
Too blue	Blue exposure too short	Increase blue exposure

Further prints

Once you have made prints from a few negatives, you will know more or less what exposures you need. You can then reduce the spread of your tests. For example if your blue exposure is always between about 18 and 23 seconds, you can make your four tests at 15, 18, 22 and 25 seconds – with a suitably short series of green and red exposure times. Or perhaps you can get close enough to make just two test grids – so testing two negatives on each piece of 8 in × 10 in paper.
Naturally, if you need especially long or especially short exposures, you can alter your lens aperture to suit. However, once you have chosen an aperture, always use that aperture for your test grids. Otherwise you may get confused.

Changing to subtractive printing

Additive colour printing is rather fiddly, and creative effects are limited. However, it does let you make top quality prints with little equipment; and, perhaps more important, it lets you try out the processing techniques.

Density

The segment (or pair of segments) giving the colour you want may not be the right density. To change the density, you must change all three exposures by the same proportion. Increase exposure time to make a denser print, decrease it to make a paler one.

For example, suppose 20 seconds blue, 10 seconds green and 15 seconds red appears to give the correct colour, but do not produce a dark enough print. To increase the density give (say) 30 seconds blue, 15 seconds green and 22½ seconds red.

Comparing your four tests should show you by how much you need to alter the exposure. In fact, each one should have one segment more or less the right colour, increasing in density as the exposures were increased.

Alternatively, you may find it simpler to alter the density by changing your lens aperture, so that you can use the exposure times you calculated to give the optimum colour balance. Never alter the aperture during the series of exposures. Not only will this make calculation extremely difficult, you may alter the focus or move the image slightly.

Making a print

Once you have worked out the three exposures, you are ready to make your print. Check your enlarger is still focused, make your three exposures and process the print.

It should come out just as you want it. However, when you see the whole print you may still not be satisfied.

Fine adjustments

In another print, you can alter the colour and density exactly as you wish, just by changing the exposure times through the filters. Increasing the relative exposure time decreases the colour in the print, and vice versa. Thus, giving more exposure through the red filter makes the print more cyan (less red), and decreasing it makes it more red; and so on.

print you want. Make quite sure that you measure times exactly, otherwise you can't work out reliable exposures.

Set up your enlarger for the picture size you want, and focus a suitable part of the negative on one quarter of the frame. Turn out the lights, and expose the first corner of your test sheet.

Set your enlarger lens to about f5.6. First give an overall exposure of 5 seconds through the *blue* filter. Then make three stepped exposures from top to bottom through the *green* filter. Use a piece of card to cover first one third, then two thirds of the paper to give exposures of 10, 20 and 40 seconds.

Repeat this procedure through the *red* filter, this time making the exposures progressively from side to side of the test area. You now have nine different red/green exposure combinations with a 5 second blue exposure.

Turn round the frame, and change your masking so that you can expose the next quarter of the paper. Give a 10 second exposure through the blue filter, and make a red and green exposure grid just as before. Repeat the process for 20 second and 40 second blue exposure for the other two test prints.

Process the whole sheet carefully, and when it is dry, you can find out the exposures you need to make a final print.

Choosing the colour

At least one of your four grids should have one section with more or less the correct colour balance. This gives you the times you need for a print. If your record system is awry, you can work out what the exposures were by looking at the prints. Progressively longer exposures make the prints denser. Longer *blue* exposures make them more yellow; longer *green* exposures more magenta; and longer *red* ones more cyan.

If you think that two of your segments 'straddle' the best colour and density, the optimum exposure falls between the two. For example, if the best *colour* is on the 20 second blue square halfway between the 10 seconds red/10 seconds green, and the 20 seconds green segments, make your print with 10 seconds blue, 15 seconds red and 20 seconds green.

three layers separate exposures through blue, green and red filters. You adjust the times of the three exposures to achieve a balanced colour image. However, if you work this way you have to be careful to avoid the slightest movement of either the enlarger or the printing paper between exposures. Furthermore, dodging or burning in local areas of the image while exposure proceeds is extremely difficult. This facility, which makes black and white printing so interesting, is much simpler and can be more subtle if a single subtractive exposure is made onto the colour paper.

Despite the disadvantages, you may want to start colour printing this way because you don't need a new enlarger, and you only have to buy the filters.

Tricolor filters

You need primary red, blue and green filters. These are often sold as sets for colour printing. The exact colours are not critical, but you must always use the same make if you want repeatable results. Quite small (50 × 50 mm) gelatin filters are suitable, but they must be of good optical quality like those used on camera lenses.

For each of the three exposures you hold one of the filters below the lens. To make things easier, you can construct a simple card mount to fit your enlarger. Because the image is formed through them, it is vitally important that the filters never get scratched or dirty. When you first buy your set of filters, put a strip of adhesive tape along one edge of each. Always hold the filters by this strip *alone*. Cut identification notches in the strip, so that you can tell the colours in the dark.

Test prints

Just as with subtractive printing, you can make four tests on a sheet of 8 in × 10 in paper. Take special care to record everything you do, so that you can see immediately the exposures needed to give you the

Colour correction masking dyes

Having explained all this, you will probably be wondering why it is that all the colour negatives you have seen have looked far from neutral grey and instead have an overall orange/red appearance. Don't let this confuse you. The orange appearance is to do with colour correction or masking dyes that serve to improve the hue of the magenta and cyan images and have nothing to do with the balance of the three component images of the negative.

Reference or standard negatives

Early on in your attempts to improve the quality of your colour prints you should take the trouble to expose a roll of colour negative film with the express purpose of making some standard reference negatives. To have one or two negatives that you know can produce really high quality prints is tremendously important, because whenever you are wondering why you are finding it difficult to obtain a good result from a particular negative, a print made from one of your reference negatives will quickly tell you whether your paper and your paper processing are in order and if so, that there is something amiss with your troublesome negative.

If you decide to have your reference negatives processed by a photofinisher, then get him to make a few prints at the same time. These prints will give you a pretty good idea of the kind of results you can expect to get when you come to print the negatives yourself. Of course you may be able to do better than the photofinisher, but his prints will generally serve as a useful guide.

The type of subject you choose to photograph for your standard negatives must depend on the kind of photography you expect to do. It is always useful to include some neutral greys as well as a range of bright colours. If you expect to print a lot of portrait or wedding pictures, then you should use one of these subjects for your reference negative.

Tricolor additive exposures

A simple way of adjusting the relative densities formed in the blue, green and red sensitive layers of a sheet of colour paper is to give the

Date	Type of Film	Number or Description of Neg or Slide	Enlargement Ratio	Lens Aperture
4/1/75	KODACOLOR II	DUTCH BARGE – AMSTERDAM '74'	6x	f6·3
,,	,,	REPEAT	,,	,,
,,	,,	FINAL PRINT	,,	,,
	KODACOLOR X	MARY ON BEACH SC...	5x	f6·3

Filters Y – M – C	Exposure Time	Description of Result
120 – 60 – 0	6 SECS. 12 ,, 24 ,, 48 ,,	12 SECS CORRECT – COLOUR – MUCH TO BLUE. TRY – 12 SECS 80-50-0 60-50-0
80 – 50 – 0 60 – 50 – 0	12 SECS	80 – 50 – 0 O.K.
80 – 50 – 0	,,	NOT BAD !
80 – 50 – 0	6 – 12 – 24 – 48 SECS	10 SECS ABOUT RIGHT

It is always worth while to keep a log of all the test strips and prints you produce. You will be surprised how often you find yourself uncertain of the filtration or the exposure you used for a test. Unless you record the details, preferably before each exposure, you will surely waste a lot of time and sometimes end up with puzzling results.

blue, green and red. Upon exposure to a scene, all the red light reflected from the subject is recorded by the bottom layer of the film, all the green light from the subject is caught by the middle (green sensitive) layer, while the blue content of the scene is recorded by the blue sensitive emulsion on the top.

During processing these three different records of the same subject are treated in a developer that not only forms silver images but also forms a corresponding yellow dye image in the top layer, a magenta image in the middle and a cyan (bluish-green) image in the bottom layer. After all the silver has been bleached out of the three emulsion layers, the subtractive or 'minus' colour images remain. They serve just as well as silver images to control the passage of blue, green or red light and therefore represent – in negative values – the blue, green and red contents of the original scene.

This colour negative can now be used to project suitably modulated blue, green and red light to form an image on a sheet of colour paper. To complete the sequence, the latent images formed in the three layers of the colour paper are developed in much the same way as the negative was developed. Silver images are formed together with yellow, magenta and cyan images representing blue, green and red records of the original subject. This time the images are positive in value and after all the unwanted silver has been removed the composite colour picture is complete.

Imagine a perfectly neutral object, such as a white painted pyramid or cylinder placed against a background of white paper. It is seen as a variety of neutral greys, varying in density according to the direction of light. Suppose we take a picture of this set-up on a colour negative film and print it onto colour paper. The three images formed in the negative and the three subsequently formed in the print should all be equal in their ability to modulate or absorb the blue, green and red rays contained firstly in the printing light and then in the reflected light by which we view the print.

Such perfect control of photographic manufacture and processing is beyond everyday achievement because small divergencies inevitably creep in at one point or another and some colour adjustment usually becomes necessary when the print is made. This is why there is always so much talk of colour correction, filter packs and colour mixing heads when you make colour prints.

Processing variations

Even more significant are the variations in processing that result when films are developed at different times and by different people. It is therefore essential to ensure that your negatives are processed correctly. Really keen amateurs who have time may take the view that the safest way is to develop their own negatives; but not only is this a somewhat expensive solution to the problem, it is becoming increasingly difficult for the amateur to manage it since processing temperatures for films such as Kodacolor II have been set as high as 100°F and this can easily lead to variable quality.

A good photofinisher has the means and the staff at his disposal to make a sound job of processing colour negative films and provided you regularly check on the quality of the prints he produces, you should feel quite happy to entrust your negatives to a local laboratory. There are many small laboratories catering mainly for professionals. Some of these take single films or small batches from amateurs directly. Alternatively, you may find a local wedding and portrait photographer willing to include your films with his laboratory order, or a photographic dealer who has a regular service from a 'professional' laboratory. These laboratories usually process to a high standard, are often quicker than normal photofinishers, and they process films without expecting to make prints. Their 'process only' charges are usually quite reasonable, but their (normally extremely good) colour printing costs may be staggeringly high.

The third major variable is up to you. Like any other film, colour negative materials yield best results when they are consistently exposed. Extreme differences in exposure can produce colour balance changes as well as density variations.

What happens

To better understand how any of these variations can affect the printing characteristics of a colour negative we should consider what happens when the image of a colour negative is projected onto a sheet of colour paper.

Any colour negative film consists of three superimposed emulsion layers, each made sensitive to only one of the three primary colours –

If, after reading the previous two chapters, you have decided to make yourself a colour print even though you were given limited information and guidance, you will quickly come to realise that the hardest part of colour printing lies in determining the exposure time and colour corrections required for each new negative. So we should now spend rather more time looking at some of the factors that have a bearing on this central problem.

Already you are probably wondering why it is that you cannot expose all your colour negatives with the same filter pack provided you use the same batch of colour paper.

Reasons for differences

In practice, there are several variables that can cause sufficient differences between negatives to necessitate the use of different filtration when they are printed – even though they may look the same. First of all, no manufacturer can make colour negative material without some batch to batch variations. Although such variations cannot usually be detected by looking at negatives, they can be sufficient to cause differences between prints. The first maxim therefore is to buy as many films as you can manage at one time, and to ensure that they all have the same batch number.

The conditions under which you store your films, either before or after exposure, can also result in changes in performance at the printing stage. So keep your film in a refrigerator and keep your camera away from very hot or humid places. Unexposed film is sensitive enough to adverse conditions; but exposed unprocessed (latent) images deteriorate even faster.

Methods
of
Exposure

then, after recording that in your log book make another test print, process it *exactly* as before and see how much nearer you get this time.

You can take some comfort from the fact that beginners are usually much more tolerant of the quality of their first few prints than they ever are when they become more experienced, and you will probably be delighted with your first results.

Printing from transparencies

The whole of this chapter has been written on the assumption that you want to make colour prints from colour negatives. If instead you really want prints from your colour slides then you need to use a colour paper intended for reversal processing and then your colour correction will be done by using filters complementary to any excess colour in the print, while you would make a print lighter by giving it more exposure. All of these differences are explained on pp. 941-965.

colour is reduced by the addition of correction filters of that same colour. In other words, if your print is obviously too yellow then you will make the next print after adding more yellow to the filter pack. Yes, you will be thinking, but how much extra yellow. And here is the rub. The more experienced you become the more sure you will be, after looking at a test, just what changes in filtration will be necessary to bring the print on balance. But while you are learning, the best way to work, is to compare your test print with the 'ring around' pictures on p. 828-9.

As a rough guide a just noticeable colour bias requires an 05 or a 10 filter or a pair of 05 or 10 filters of the appropriate colours; a more obvious shift may be compensated by denser filters valued 20 or 30 while a very large correction may require 40, 50 or more.

Adjusting exposure

One more point. When you have decided on the modification you will make to the filter pack before exposing the next test, remember that increasing the density of the pack will necessitate some increase in overall exposure. Conversely, if you reduce its density, then the next exposure should be less. As a rough guide, the addition of each additional filter (of whatever density) requires an increase in exposure of about 10%. In the same way, if the number of filters remains the same but the density of any of them is increased, then this alteration also calls for an increase in exposure. The necessary increase varies according to the colour and density of the additional filtration. It can be as much as 60% for an extra 50C, and you may even have to double the previous exposure if you add 50 M.

So how do you calculate the new exposure? Use the information supplied by the filter manufacturer. This may be tables of exposure factors, or a simile rotary or sliding calculator.

By now you will be wondering whether there are some short cuts in colour printing. There are a few, which will be discussed later, but the fact remains that a skilled colour printer is one who has made a lot of prints and a great many more test strips. So give yourself time to decide as carefully as you can what changes to make in filtration and

interference with the lid when it is screwed or pressed on to the end of the tank. Most people cannot wait until the complete processing cycle is finished before removing the print to see what it is like. If you are impatient too, then the end cap can be removed from the drum after the bleach-fixing is complete and the residual bleach fix solution has been washed away. Final washing may then continue, either with the print back in the drum or in a dish.

Getting density right

When you have looked at the print you will soon be able to tell whether any one of the four images seems to be about right for density. If you are using Ektaprint RC paper the wet print will have a bluish opalescent appearance so that you cannot tell much about its colour while it is wet. Unless the negative you choose is unusually thin or dense or your enlarger has an extremely low or high light output, you should find that one of the four quarters of the test print will be about right for density even though it may be a long way off for colour. So the next test you make should be aimed at getting much nearer to correct colour balance and the four test sections can therefore be devoted to trying four different filter packs.

This procedure, whereby correct density is achieved before paying attention to colour balance is quite important. Don't try to adjust your colour and density at the same time because you will find it much easier – at least while you are learning – to deal with these variables in turn.

Getting colour right

Now you have reached the heart of this business of colour printing. You have a test print of about the right density, but the wrong colour. You know the colour is wrong, but without experience you will probably feel quite uncertain what should be done to make it right. Without describing just what happens in the three layers of a colour paper when it is exposed to an image of a colour negative – something we will leave to a later chapter – you need to know and remember that with the negative/positive process any excess of one

By means of white painted light-tight hinged flaps, the Durst Comask enlarging board – A, allows four 4 × 5 inch test areas to be exposed on a sheet of 8 × 10 inch paper. Alternatively, the easel can be used to make two 5 × 8 inch prints, or one print 8 × 10 inches. The Quadrimask easel – B, serves the same purpose, but is used by changing the position of three separate 4 × 5 inch masks after each exposure.

the volumes recommended for an 8 in × 10 in print in your particular drum. The temperature you will work at and the way you achieve it will again depend on the recommendations given for the drum you are using. There are two ways in which reproducible processing can be achieved with simple equipment. One way is to ensure – usually by means of a water bath – that the temperature of the solutions is maintained at some predetermined level so that the times of treatment will always remain the same. The other way is to accept that when not prevented, there is likely to be a change in the temperature of the solutions while they are being used, so the times of treatment must be suitably shortened or extended. The Americans now call this latter approach processing by 'temperature drift-by'. Provided you are using a print drum with a watertight lid, the drum can be safely floated on a water bath which can fairly easily be thermostatically controlled. Jobo and other similar print processing outfits comprise a water-bath in which a drum can be rotated while containers holding all the necessary working solutions are held ready and up to temperature by being immersed in the same water. When a print processing drum or for example the Paterson Orbital processor is to be used in a room in which the temperature is different from the recommended processing temperature, com-pensation for the change in solution temperature during processing must be made by adjusting the times of treatment – particularly for the developer, which is by far the most critical of the reacting solutions. Most companies provide useful tables or nomographs with their processors and these can be used to determine the correct times to use for any particular set of conditions.

Loading paper into drum

Placing an exposed sheet of 8 in × 10 in paper into a drum is not very difficult to do in the dark, but it will be made that much easier to carry out if you have done it a few times previously in white-light – using a scrap piece of paper.

Processing drums vary in their design, and while some of them have removable dividers or separators, others have a perfectly smooth inner wall. Whichever type you have, make sure that the exposed sheet is inserted symmetrically, so that there is no overlap or

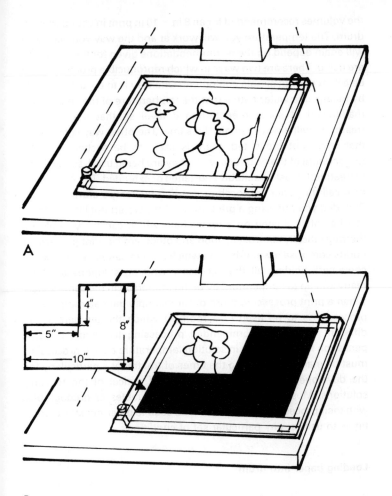

A

B

Before making a series of tests to determine either exposure time or filtration, first compose your picture in the enlarging easel, A. Then, by using a black card mask cut to the dimensions given in, B, you can turn it round and over to expose each quarter of an 8 × 10 inch sheet in turn. After each exposure, the easel must be moved so that the same area of the projected image is recorded.

make four 4 in × 5 in test exposures on the same 8 in × 10 in sheet of paper. By making four test exposures on a single sheet of 8 in × 10 in paper, you can centre the most important part of your picture area on to each quarter of the paper in turn. There are two ways of doing this, either with a specially designed masking frame such as the ones made by Durst, Jobo, Quadrimask or Ilford or by using an 8 in × 10 in card mask with one 4 in × 5 in corner cut out of it.

Exposure time

You can make these four tests by giving exposures of four different durations – say 5, 10, 20, and 40 seconds at the same lens aperture – say f8 – or you can expose each section for the same time and vary the aperture of your enlarging lens for each exposure, using for example this series of stops: f5.6, f8, f11 and f16.

Recording exposure conditions

Now is the time to establish the habit of recording on the backs of your prints and in a log book the essential details of every print you make. This practice may never make it possible for you to go back to a negative and make a first time print with exactly the same density and colour balance as you did a year ago, but by using the information in your notebook you will be able to get a good print with less testing than if you have to start from the beginning again.
It needs a very soft lead pencil to write on the back of a print and the writing should be done immediately after you take the exposed sheet from the enlarger board. If you were working from a Kodacolor II negative the kind of information you would write on the very first test would be 100 Y, 50 M, 10 secs, f5.6-8-11-16. Additional information such as the paper batch number and the enlargement ratio should be included in your notebook, which may need to be ruled off across two pages to allow for all the information you need to record.

Print processing

So now you are ready to process your first sheet of colour paper. But before you can do so, you must prepare the solutions you will need in

Another factor to be considered before you embark on processing colour negatives is that the C41 process (Kodacolor II) is now operated at 38°C (100°) and such a high working temperature is difficult to maintain under domestic conditions.

Therefore unless you are in a great hurry to see what you have got on the film you might just as well have it processed by a good photofinisher, who will often give a 24 hour service if you are not asking for prints. Of course you should make sure that the photo-finisher you choose works to a high standard of quality and the only way to ensure this is to have him develop and print a few rolls of film before you entrust him with the shots you intend to print yourself. If you do want to process your own films, there is available one kit of chemicals suitable both for films and papers. It is a 2-bath process called Photocolor II. It is suitable for Kodacolor II and related films and for Kodak type papers.

Even though it may take a bit longer and cost rather more, it will be as well to have prints made from your first experimental roll so that you will have some idea of the results that can be expected from the negatives.

Starting filters

Having chosen a negative to print you will need to decide on the filters you will use to start with. The starting filters recommended when using Kodacolor II negatives with a typical batch of Ektacolor 78 RC paper are 100 Y and 75 M.

You must not assume that because these starting packs have been suggested that they will result in perfectly balanced colour prints at your first attempt. For one thing, you know nothing yet about the overall exposure you will require to obtain a print of the right density, let alone the right colour. But since you have to start somewhere these suggestions should serve your purpose.

Having placed the proposed filters into the filter drawer of your enlarger you must now make a series of test exposures of varying duration to find out which will give you the print of the required density. These tests can be made on a single sheet of paper if it is masked successively during the series of exposures. Since it is just as easy to process a sheet of 8 in × 10 in paper as smaller sizes and since tests that are too small are apt to be misleading you may as well

to it until you have gained a good deal of experience. To change from paper to paper while you are still learning is likely to hinder rather than help your progress.

Choosing a negative

With your solutions prepared and your equipment arranged conveniently in a well tested darkroom area, you are nearly ready to expose your first test. But before you are quite ready you must choose a colour negative to print. This choice is really very important because you expect to learn a great deal from printing this first negative, so it should represent as far as possible the kind of negatives you expect to be printing later. In other words, if you can avoid it, don't choose a negative that was made on Kodacolor X film when you will be using Kodacolor II film in future. There are differences between these two negative types that result in quite different printing filtrations.

If you can manage to do so, it will help considerably if you expose a roll of film expressly to provide a series of reference or master negatives to which you will be able to refer from time to time. By devoting a film to obtaining test negatives, you will be able to vary the exposures you give so that the negative you choose as your starting point will have been properly exposed. Furthermore, you will probably be able to see to it that there is some neutral grey in your subject area and this will help you greatly in arriving at an optimum colour print.

Colour negative processing

You need not necessarily develop your own colour negatives, because by the time a film is ready for processing the most important decisions have been taken; you have chosen your subject, decided on its composition and determined the exposure you will give. With all these variables behind you the only thing to be done to the film is to ensure that it is properly processed. While it is certainly possible for you to do this yourself there is not much fun in it and no way in which you can express any individuality, as you can when it comes to printing the negatives.

als you buy, they should be read carefully and strictly observed. When the complex chemical reactions involved in processing a colour print are made as simple in use as possible by formulating chemistry that involves only three working solutions, then it is sometimes necessary to ensure that a strict procedure is followed in the preparation of the working solutions.

Ektaprint 2

Chemicals for the Ektaprint 2 process are all supplied as liquid concentrates and the working solutions are therefore quite easily made up simply by dilution to larger volumes. Even so the instructions should be carefully followed.

Agfacolor 85 Kit

Agfacolor papers with the designation MCN 310, 312 or 317 are all non-compatible with Ektaprint chemistry and must therefore be processed in Agfa's Process 85. The one litre Agfa Process 85 kit is supplied in powder form and consists of: two packets of developer, and one packet each of stop bath, bleach-fix and final bath.

Parts A1 and A2 of the developer do not completely dissolve in the 0.8 litres of water used initially, but solution is completed when part B is added.

The final bath – a stabiliser – requires 5 ml of 30% formalin to be added before it is ready for use.

Changing papers or chemicals

Having decided on your paper you should also use the chemistry recommended for it by the manufacturer. At least to start with you do not want to find yourself wondering if some unexpected result could be due to the fact that you were using chemicals supplied by some firm other than the one that made the paper.

Although you may feel that you would like to try a variety of colour papers in due course, you are well advised to make a choice and stick

currently available papers for printing from colour negatives work in a basically similar way and have to be handled in much the same manner. In fact almost all the papers used for colour negative printing are now compatible with Kodak's Ektacolor papers and are processed either in Ektaprint 2 or equivalent chemistry. All the colour papers made by Agfa-Gavaert were at one time incompatible with Kodak papers, but now (1983) Agfa produce their older types of papers as well as a new paper that is compatible with the Ektaprint 2 process.

One of the characteristics of all Kodak colour papers is the 'milky' appearance of a wet print, which results from the use of a particular form of coupler in the emulsion layers of the paper. This distinctive feature means that it is necessary to dry a print before its colour balance can be safely assessed.

Three solution processing

In recent years the principal solutions involved in colour print processing have been reduced to three:

1 Colour developer
2 Bleach-fix
3 Stabiliser (sometimes dispensed with)

This reduction in the number of processing solutions has meant that all manufacturers of colour paper have made many alterations to their formulae and procedures during the last few years. There is no reason to suppose that further simplification will not be introduced in due course and therefore it must be realised that any specific instructions given with the paper and chemicals you use may be more recent than the processing recommendations given here, so if they differ in any way, *the information given with the materials should be used.*

Chemical mixing

For the reasons given in the preceding paragraph, whatever manu-facturer's instructions are found packed with the processing chemic-

If you use 35 mm or 126 size film negatives, you may find that 3 in (7 cms) square filters will suit your enlarger, but if your negatives are larger than that you may need 5 in square filters. From this you will realise that you should not buy your filters until you are sure of your enlarger.

Heat absorbing filters

If you buy a new enlarger and it has a filter drawer, which it should have, then it is quite likely that you will find a glass heat absorbing filter already supplied in the tray. If not you will need to get a piece of heat absorbing glass cut to the right size. It can go either in the filter tray or, even better, in some permanent position just above it. Chance Bros. make heat absorbing glass called ON 13, and a 2 mm thickness of the right size will serve your purpose. This glass filter is required to absorb most of the heat from the enlarger lamp that might otherwise damage your negative and your filters. A heat absorbing filter also ensures that only visible red light is recorded by the red sensitive emulsion of your colour paper. Some red sensitive emulsions can record infra-red radiation and in doing so impair the colour reproduction from your negatives or slides. If you need strong cyan filtration this usually means that you have not got a suitable heat absorbing filter in your enlarger.

Ultra-violet filters

Not every paper manufacturer asks for an ultra-violet absorbing filter to be used between the light source and the negative when printing on their colour paper, but Kodak does, and since such a filter will certainly have no adverse effect on any type of paper, one should be placed in position at the outset. The recommended Kodak filter is their CP2B, and it should be permanently located in the filter drawer.

Colour papers

In this book there is no reason and no intention to recommend the use of one type of colour paper in preference to any other. All

be said for getting a type of enlarging easel that allows you to make four separate exposures on a single 8 in × 10 in sheet of paper.

Colour correction filters

This chapter deals with what is known as the white light or subtractive exposure method. This simply means that you will make a single exposure for each print and that the precise colour of the exposing light will be achieved by placing one or more correction filters in the light beam *before* it reaches the negative. Never put colour printing (CP), filters beneath the lens of your enlarger if you expect to get really sharp prints.

In order to be able to assemble exactly the right combination of filters to suit any particular negative, you will find that you need quite a range in each of the three so-called subtractive primary colours, yellow, magenta and cyan.

Different manufacturers offer slightly different sets of printing filters, but typically you will get a set of twenty-one acetate or gelatin foils, seven each in yellow, magenta and cyan. Commonly the values of the seven filters range from 05 to 50 in all three colours. The meaning of the values need not concern you at the moment and until you have become acquainted with the relative effectiveness of each value of filter on the colour balance of a print, it will be enough to say that 05 is a very low density and will produce a just discernible difference in the balance of a colour print – provided nothing else changes. For beginners, the 05 filter probably represents a sufficiently sensitive adjustment while a 20 filter effects a change that is easily seen. The much denser 40 or 50 filters will not generally be required to match one negative with another of the same type, but rather to make up the basic filter pack to suit your particular enlarger and the batch of paper you happen to be using.

There are differences between the sets of filters sold by different manufacturers, but don't worry too much about this; simply choose a set and then get used to them. Never interchange filters from one manufacturer with those of another because they may well differ in colour and in density even though they are identified in the same way. The size of the filters you buy will be governed by the filter drawer of your enlarger.

Most enlargers are now provided with a tray for holding colour correction filters. When you buy a new enlarger, check the size of the filters it takes and look to see whether it incorporates a heat absorbing glass somewhere between the lamp and the filter position.

to benefit from using a safelight with colour paper than it would be if we were developing panchromatic negative material under safe-light. Nevertheless, provided you are prepared to wait long enough to become thoroughly dark-adapted, then it is possible to use enough yellowish-green light to just see your way around the work bench – and this can be helpful to those who do not like feeling for everything in complete darkness.

If you are going to use Agfacolor paper you will need a very dark amber colour screen, number 08, and for Ektacolor 78 RC paper you should use a Kodak number 13 screen. These screens should be in front of a 15 watt lamp and be placed at least 30 inches from your exposing surfaces. The set-up should then be safe for periods of up to three minutes.

Contact Printing

Negative formats have become ever smaller over the years and there is not much point in making colour prints by contact from 35 mm or 110 negatives, except when the whole set of negatives on one film are printed together to produce a proof sheet from which the better shots can be chosen for enlargement. It is assumed therefore that you either have an enlarger already or will be buying one. Then what kind should you buy?

The enlarger

Nearly all enlargers are now made complete with a colour filter drawer and provided that this facility is included, the other two things that will determine your choice are the size of the negatives you expect to print and the amount of money you are prepared to spend. For the moment it will be assumed that you are not going to invest in an enlarger with a colour head incorporating a means for continuous adjustment of the ratio of red, green and blue light emerging from the lamphouse without the need for a set of separate filters. This type of colour head will be described later in the book and its advantages will then be explained.

Whatever you do spend on an enlarger, be sure to leave enough to buy a good masking board. Although not essential, there is much to

While it is a little more convenient to have both dry and wet sections in the same room, when this cannot be managed there is no great hardship in taking the loaded print tank to the bathroom or kitchen in order to be near a supply of water and a drain.

Make darkroom really dark

You may not appreciate that it is very difficult to make an ordinary room thoroughly light-tight. When you first enter a room that has been blacked out it may be several minutes before you come to realise that there is sufficient light for you to begin to see your way around fairly easily. So wait for ten minutes or so for your eyes to become thoroughly dark-adapted before you decide that your new darkroom is safe for handling colour paper. Then when you are satisfied that no light is leaking into the room, there will be one other test you must make, and that is to see whether any light is leaking from the lamphouse of your enlarger during exposures. This can be checked simply by putting a cap over the lens of the enlarger while it is switched on. If light does leak from any holes or gaps in the enlarger head they must either be closed or at least shielded so that no light is reflected from the wall behind or the ceiling above, otherwise your prints might well be slightly fogged.

The effects of stray light within the darkroom become noticeable when unusually long exposures are required to make big enlargements from dense negatives, but the cause of any resulting slight veiling of print highlights may then elude you for a long time; so make sure your working conditions are really safe right from the start.

Safelight

Opinions differ on the usefulness of the very low level of safelight that can be permitted with any kind of colour paper. It is not always fully realised that the emulsion used in the three layers of colour paper have to be extremely fast and between them sensitive to all colours. In effect therefore we are handling a high speed panchromatic material and it can be argued that it is no more sensible to expect

filter set you will need, the size of the enlarging easel, the paper and the processing drum, must all depend on your particular choice.

Additive printing

If you are thinking that there must be ways of making colour prints that require a shorter list of things than this, you are quite correct. But the alternative way is less convenient and can sometimes lead to disappointing results. To print colour paper by making three separate exposures for each print certainly does enable you to work with only three filters, but you then have to be extremely careful not to move the enlarger or the negative between the three exposures. Also, as these filters are normally held below the lens, they must be of 'optical' quality, and be kept scrupulously clean. However this alternative method is described in pp. 858-862.

Processing in a dish

You can also avoid the cost of a print processing drum by working in dishes instead, but then you need to work in the dark throughout processing and it is quite difficult to maintain the solution temperature accurately enough for reproducible results.

Darkroom space

Because the number of solutions in use in colour printing is few and processing tanks or drums can, once they have been loaded, be used in daylight, the darkroom space required is not very great and should not be too difficult to find or improvise.

You do not necessarily have to use any solutions in the darkroom so there need be no danger of accidental spilling or overflow, and if all else fails a trestle table can be set up in a bedroom and dismantled after each printing session. You should allow a little more bench space than is required for the enlarger itself; because you must have somewhere to keep your filters, exposure timer, developing tank and notebook. If any of these things are too near the edge of the bench you will surely knock them off in the dark.

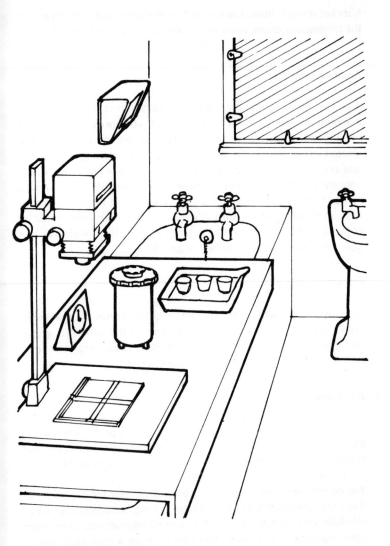

If no other space is available, it is quite possible to work successfully in the bathroom. You will need to make quite sure that all daylight can be blocked out with a really tight fitting board or blind. It will also help greatly if you make a removable bench to rest over the bath and support your enlarger as well as the few other things you must have on hand.

This chapter is intended for those who, having decided that they would like to try their hand at making colour prints, are impatient to know what they will need and how to get started. Perhaps this is not unlike wanting to pick out a tune on a piano without having had any music lessons. Some people have the flair and can do these things; although those who play by ear are generally willing to admit later that they wish they had been taught properly. However, for those beginners who are anxious to make a colour print as soon as possible without bothering too much about achieving perfect quality, these are the basic requirements:

Basic equipment

1 Enlarger. (One with a filter drawer.)
2 Masking frame. (Enlarging easel.)
3 Set of colour printing filters. (Size to suit enlarger.)
4 Ultra-violet absorbing and heat absorbing filters.
5 Supply of colour paper.
6 Kit of chemicals to suit paper.
7 Bottles to store solutions.
8 1 litre and 100 ml plastic measuring cylinders and at least 3 × 100 ml beakers with 50 ml markings.
9 Print processing drum.
10 Thermometer. (Range 10-50°C.)
11 Exposure timer.
12 Notebook and soft lead pencil.

If you decide to buy one of the several colour printing kits that are available, most of these things will be included. However, do find out what is in your kit, and get the remaining items before you try to start. The size of negative the enlarger will accept and therefore the size of

Making
a
Start

Two more Cibachrome prints from the author's collection. Cibachrome print materials are especially effective for the reproduction of bold bright splashes of colour.

Top print made from a transparency – the coloration is slightly warm due to the late afternoon sunlight. The photographer knew that this was the effect he wanted because he had the original transparency to make direct comparisons with.

Above print made from a negative – it is almost impossible to establish with certainty the exact colours of the original when viewing a colour negative, so correct colour balance is a matter of judgement.

Compare the colour of the artificial light behind the figurine with that of the daylight coming through the window – the former is quite unsuitable for assessing the colour balance of a print. If daylight is not available try to use colour matching fluorescent lamps.

40Y

MORE ◥ BLUE

20Y

10Y

10G

20G

40G

MORE ▶ MAGENTA

Ring-around for negative-positive printing.

By comparing your 'off-balance' tests or prints with this 'ring-around', you can decide more quickly what changes in exposure and/or filtration you need to produce a better result. Remember that when you have matched your tests with one of the pictures, you should then *add* the filter value that is indicated.

10C

20C

MORE RED ◢ 40C

829

40R

20R

×4

10R

×2

40M

20M

10M

NORMAL

10B

÷2

20B

40B

÷4

Reversal printing on Ektachrome RC paper. 1, An enlarged colour transparency image is projected on to reversal colour paper. 2, Three latent images are formed in the three emulsion layers. 3, These are first developed in a black and white developer, giving a silver image for blue, green and red components in the original. 4, Remaining unexposed parts are fogged. Colour development produces three silver and dye positive images, top layer, yellow, middle layer, magenta, and bottom layer cyan. 5, Bleaching and fixing removes unwanted silver, leaving only the dye images in the finished print, 6.

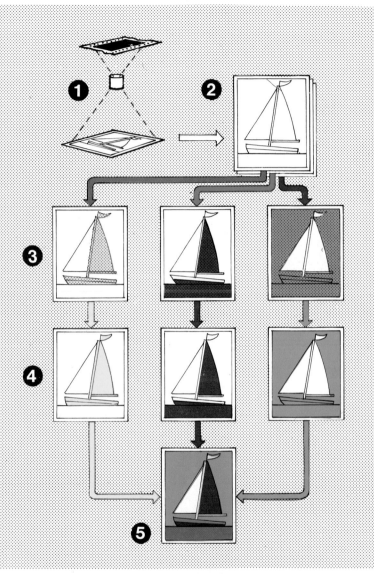

Printing from a colour negative: 1, An enlarged image of the colour negative is projected onto a sheet of colour paper. 2, By means of this single exposure, latent images are formed in the three emulsion layers of the colour paper. 3, The exposed print is then developed in a colour developing solution which forms three combined silver-plus-dye images; one dye is yellow, one magenta and the third cyan. 4, The silver that accompanies these images is then removed in a bleach-fix solution. 5, The three remaining dye images in superimposition on the same support form the finished colour print.

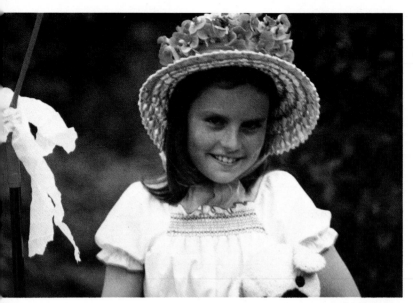

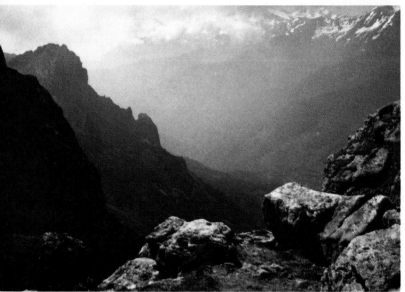

Cibachrome prints. When making your first reference prints, choose subjects that represent the kind of pictures you expect to print later.

Enprint. Standard sized print, about 9 x 12cm – slightly smaller than an ordinary postcard.

Exposure. The act of allowing light to reach the light-sensitive emulsion of the photographic material. Also refers to the amount (duration and intensity) of light which reaches the film.

Exposure compensation. Altering the metered exposure when necessary to get satisfactory exposures, as it may be when the subject and its surroundings are not average. Illustrated below are typical examples of such situations: top – with a bright background you need to increase the exposure; bottom – with dark backgrounds the reverse is necessary; centre – average exposure for average conditions.

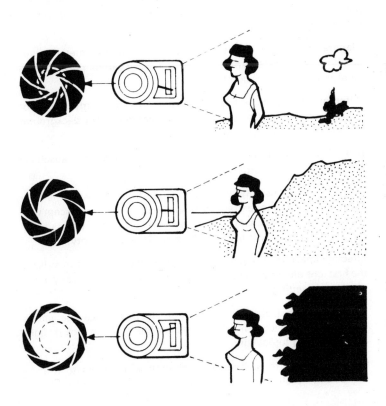

Contrast. Tonal difference. More often used to compare original and reproduction. A negative may be said to be contrasty if it shows fewer, more widely spaced tones than in the original.

Converging verticals. The effect of perspective by which parallel lines appear to approach each other with increasing distance from the eye; this looks normal in the horizontal plane (e.g. railway tracks) but not the vertical (buildings appear to lean backwards).

Delayed action. Mechanism delaying the opening of the shutter for some seconds after the release has been operated. Also known as self-timer.

Depth of field. The distance between the nearest and farthest planes in a scene that a lens can reproduce with acceptable sharpness. Varies with effective aperture (and thus with focal length at any particular f-number) focused distance and the standards set for acceptable sharpness.

Diaphragm. Device consisting of thin overlapping metal leaves pivoting outwards to form a circular opening of variable size. Used to control light transmission through a lens.

Differential focusing. Setting the lens aperture for minimum depth of field, to limit focus to a particular subject against a background and/or foreground that is out of focus.

DIN. Film speed rating defined by the Deutscher Normenauschuss (German standards organization).

Disc camera. A recently introduced type of camera which is fully automated and hence extremely simple to use. The disc concept was developed by Kodak, who also developed disc film. It seems likely that disc will take over from the format 110 in popularity.

Effective aperture. The diameter of the bundle of light rays striking the first lens element that actually pass through the lens at any given diaphragm setting.

Electronic flash. Light source based on electrical discharge across two electrodes in a gas-filled tube. Usually designed to provide light approximating to daylight.

Element. Single lens used in association with others to form a compound construction.

Unorthodox lighting – the main light source was in fact a street lamp, out of the picture and to the right. There was just enough natural light left in the sky to illuminate faintly the sea in the background.

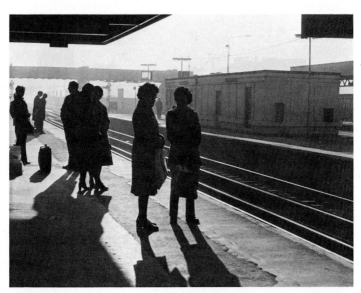

Contrast – when the light is both bright and directional contrast will be high (*top*), and it may not be possible to retain both highlight and shadow detail. When light is diffused, such as by clouds (*above*), a good print will contain detail throughout.

Top negative and positive images – the negative is made in the camera, then rephotographed in the enlarger to make a positive print.

Above grain – this detail from a print that was already greatly enlarged clearly shows the granular structure of a photographic image (see page 58).

Top electronic flash – small units offer maximum portability, but several large units may be needed to make the light look really natural.

Above ring flash – for lighting really close-up subjects such as this pale tussock moth, an electronic ring flash unit, which fits round the front of the lens, is ideal.

Artificial light – portrait of a Nigerian lit by two photofloods; the background is lit by daylight. Control of lighting is of vital importance in successful portraiture.

Perspective (see page 546) – this is pronounced in wide-angle pictures with lines of similar objects receding into the distance (these are hop poles in spring, before planting); it is reduced in telephoto lens shots, especially if the subject is largely concentrated in a single plane (as on the opposite page).

Prefocusing – the speed at which some things move is unpredictable! If you have prefocused the camera you can concentrate on releasing the shutter at exactly the right moment.

Exposure controls. Shutter speed and aperture regulate the amount of light reaching the film, but they are also important pictorial controls. Altering shutter speed influences the effects of blur in moving subjects; altering aperture changes depth of field.

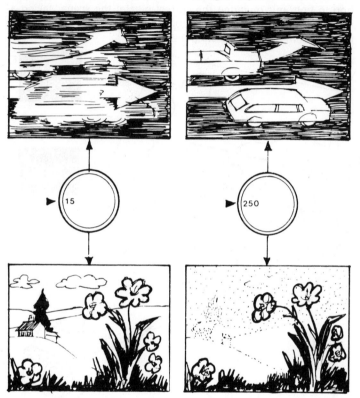

Exposure factor. A figure by which the exposure indicated for an average subject and/or processing should be multiplied to allow for non-average conditions. Usually applied to filters, occasionally to lighting, processing, etc. Not normally used with through-the-lens exposure meters.

Exposure meter. Instrument containing light-sensitive substance which indicates aperture and shutter speed settings required for a given situation. Although nowadays extremely accurate, such devices are fallible unless correctly used. The illustrations below show (top to bottom): metering the correct part of the scene; taking a substitution reading when the subject is very distant; and taking a reading from an 18% reflecting grey card.

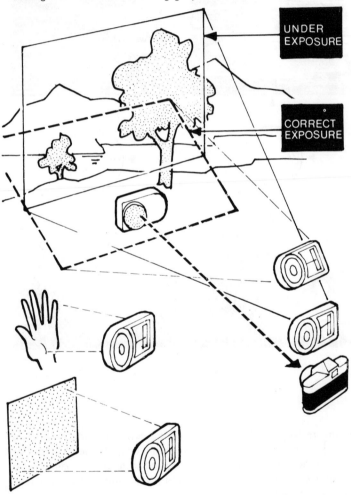

UNDER
EXPOSURE

CORRECT
EXPOSURE

Extension tubes. Metal tubes used to obtain the additional separation between lens and film for close-up photography. They are fitted with screw thread or bayonet mounts to suit various lens mounts.

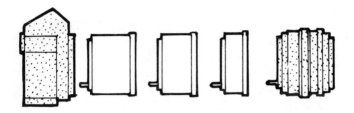

f-number. Numerical expression of the light-transmitting power of a lens. Calculated from the focal length of the lens divided by the diameter of the bundle of light rays entering the lens and passing through the aperture in the iris diaphragm.

Fill-in flash. Flash light used as a secondary source, to make shadows less dense, e.g. when photographing a shaded subject against a brightly lit background or in excessively contrasty conditions such as bright sunlight.

Film size:

110. Cartridge-loaded 16 mm wide film. Produces 12 or 20 exposures 13 x 17 mm per load.

120. Paper-backed rollfilm, about 70 mm wide. Produces 8, 12 or 16 pictures depending on their size.

126. Cartridge-loaded 35 mm wide film. Produces 12 or 20 exposures 28 x 28 mm per load.

127. Paper-backed rollfilm about 50 mm wide. Produces 8 or 12 pictures per roll – originally called vest-pocket.

135. Standard perforated 35 mm film. Loaded into the camera in cassettes. Produces 12, 20, or 36 24 x 36 mm exposures per load.

220. Double-length 120-size rollfilm.

828. Paper-backed rollfilm about 35 mm wide.

Filter. A piece of material which restricts the transmission of radiation. Generally coloured to absorb light of certain colours. Can be used over light sources or over the camera lens. Camera lens filters are usually glass – either dyed or sandwiching a piece of gelatin – in a screw-in filter holder.

Fisheye lens. Ultra-wide angle lens giving 180° angle of view. Basically produces a circular image – on 35 mm, 5-9 mm lenses showing whole image, 15-17 mm lenses giving a rectangular image fitting just inside the circle, thus representing 180° across the diagonal.

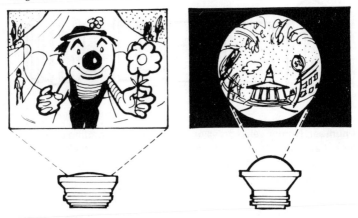

Flash see Bounced flash, Computer flash, Electronic flash, Fill-in flash, Flash synchronization etc.

Flash synchronization. System by which electrical contacts are closed to fire flash unit when shutter is fully open: roughly speaking, FP or M-synchronization is made to fire flashbulbs just before the shutter is fully open, to allow a build-up time; X-synchronization fires electronic flash at the exact moment when the shutter is fully open.

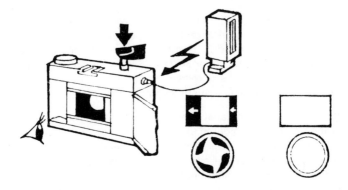

Flashbulb. Light source based on ignition of combustible metal wire in a gas-filled transparent envelope. Popular sizes are usually blue-coated to give light approximating to daylight.

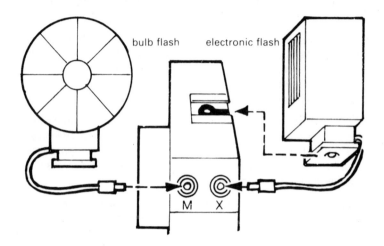

bulb flash electronic flash

M X

Flashcube. Self-contained unit comprizing four small flashbulbs with own reflectors. Designed to rotate in special camera socket as film is wound on. Can be used in a special adapter on cameras without the socket, but will not rotate automatically.

Focal length. Distance from a lens to the image it produces of a very distant subject. With a compound lens the point from which it is measured depends on the construction of the lens. It is within the lens with those of normal construction, but may be in front of telephoto lenses, or behind inverted telephotos. Whatever the lens construction, the focal length determines the size of the image formed.

Focus. Generally, the act of adjusting a lens to produce a sharp image. In a camera, this is effected by moving the lens bodily towards or away from the film or by moving the front part of the lens towards or away from the rear part, thus altering its focal length.

Format. Shape and size of image provided by camera or presented in final print or transparency. Governed in the camera by the opening at the rear of the body over which the film passes or is placed.

Fresnel. Pattern of a special form of condenser lens consisting of a series of concentric stepped rings, each being a section of a convex surface which would, if continued, form a much thicker lens. Used on focusing screens to distribute image brightness evenly over the screen.

Full aperture metering. TTL metering systems in which the camera simulates the effects of stopping down the lens when the aperture ring is turned, while leaving the diaphragm at full aperture to give full focusing screen brilliance. The meter must be 'programmed' with the actual full aperture, and the diaphragm ring setting.

Grain. Minute metallic silver deposit, forming in quantity the photographic image. The individual grain is never visible, even in an enlargement, but the random nature of their distribution in the emulsion causes over-lapping, or clumping, which can lead to graininess in the final image.

Graininess. Visible evidence of the granular structure of a photographic reproduction. Influenced by exposure, development, contrast characteristics and surface of printing paper, emulsion structure and degree of enlargement. Basically increases with increasing film speed.

Grey card. Tone used as representative of mid-tone of average subject. The standard grey card reflects 18 per cent of the light falling on it.

Grip. One of various aids to a steady camera hold, including rifle and pistol grips as illustrated below. Both types generally incorporate trigger operation with a cable release.

pistol grip

rifle grip

Guide number. Figure allocated to a light source, usually flash, representing the product of aperture number and light-to-subject distance required for correct exposure. For example, a guide number of 28 metres implies a correct aperture of f/4 for a subject at 7 metres. Move the subject further away and you get underexposure unless you open up the aperture to compensate.

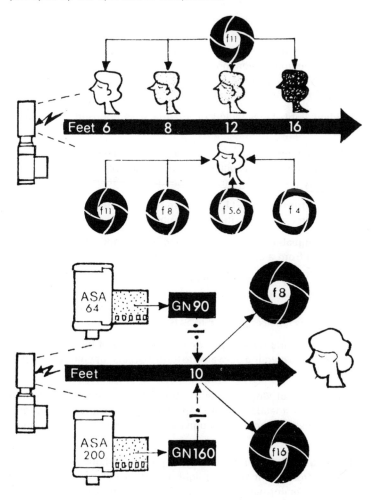

Half-frame. Camera taking double the usual number of pictures (18 x 24 mm) on 135 film.

Highlight. Small, very bright part of image or object. Highlights should generally be pure white, although the term is sometimes used to describe the lightest tones of a picture, which, in that case may need to contain some detail.

Image. Two-dimensional reproduction of a subject formed by a lens. When formed on a surface, i.e. a ground-glass screen, it is a real image; if in space, i.e. when the screen is removed, it is an aerial image. The image seen through a telescope, optical viewfinder, etc. cannot be focused on a surface without the aid of another optical system and is a virtual image.

Incident light. Light falling on a surface as opposed to the light reflected by it.

Infinity. Infinite distance. In practice, a distance so great that any object at that distance will be reproduced sharply if the lens is set at its infinity position, i.e. one focal length from the film.

Instant return mirror. SLR viewing mirror that returns to the viewing position immediately after each exposure.

Interchangeable lens. Lens designed to be readily attached to and detached from a camera (See opposite page).

Inverted telephoto lens. Lens constructed so that the back focus (distance from rear of lens to film) is greater than the focal length of the lens. This construction allows room for mirror movement when short focus lenses are fitted to SLR cameras.

Iris. Strictly, iris diaphragm. Device consisting of thin overlapping metal leaves pivoting outwards to form a circular opening of variable size to control light transmission through a lens.

Leader. Part of film attached to camera take-up spool. 35 mm film usually has a leader of the shape originally designed for bottom-loading Leica cameras, although most cameras simply need a short taper.

Lighting ratio. The ratio of the brightness of light falling on the subject from the main (key) light and other (fill) lights. A ratio of about 3:1 is normal for colour photography, greater ratios may be used for effect in black-and-white work.

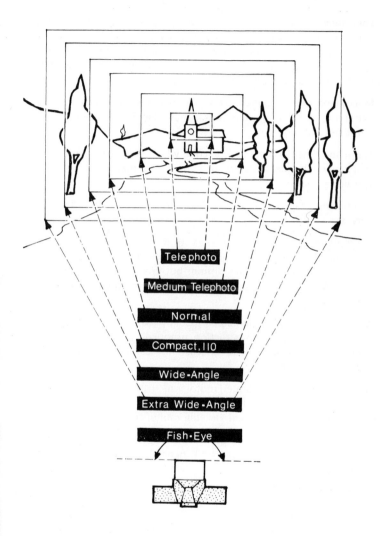

Limiting aperture. The actual size of the aperture formed by the iris diaphragm at any setting. Determines, but usually differs from, the effective aperture.

Long-focus. Lens of relatively long focal length designed to provide a narrower angle of view than the normal or standard lens, which generally has an angle of view, expressed on the diagonal of the film format, of about 45 deg. The long focus lens thus takes in less of the view in front of it but on an enlarged scale.

Macro lens. Lens designed to give sharp images even when used at extremely close range, but which may also be used for general purpose photography.

Magicube. Special form of flashcube which is fired by mechanical (not electrical) means. Can be used only on cameras fitted with the appropriate socket.

Manual iris. Diaphragm controlled directly by a calibrated ring on the lens barrel.

Microprism. Minute glass or plastic structure of multiple prisms set in a viewfinder screen to act as a focusing aid. Breaks up an out-of-focus subject into a shimmer but images a focused subject clearly. Will not work satisfactorily at lens apertures smaller than f5.6.

Mirror lens. Lens in which some (usually two) of the elements are curved mirrors. This construction produces comparatively light-weight short fat long focus lenses. They cannot be fitted with a normal diaphragm.

Motor drive. Battery-operated motor which automatically advances the film and fires the shutter continuously, taking a rapid sequence of exposures at a (sometimes) variable rate of frames per second.

Motor winder. Battery-operated motor which automatically advances the film after an exposure has been made; some models may also fire the shutter.

Neutral density filter. Grey filter that absorbs light of all colours equally and thus has no effect on colour rendering with colour film or tonal values with black and white film. Primarily used with mirror lenses or to enable large apertures to be used in bright light conditions.

Panning The technique of swinging the camera to follow a moving subject, so that the subject stands out sharply against a background that is streaked and blurred; particularly effective in sports photography.

Panorama. In photographic terms, a landscape picture taking in a broader than usual sweep of the horizon. Spectacular panoramas can be built up of a sequence of normal pictures stuck down on a backing sheet as shown below. The camera must be mounted absolutely level on a tripod with a swivel (pan) head.

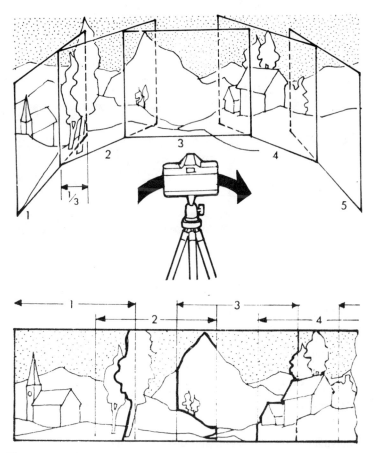

You can record a static scene as a series of shots which you later paste up to form a panorama. The camera must be mounted absolutely level, on a tripod with a swivel (pan) head. Overlap your shots by about $\frac{1}{3}$ of their width. To mount the prints, lay them out in order, and cut through both prints simultaneously at each junction. Follow lines within the subject whenever you can.

Panoramic camera. Special camera which uses a rotating lens to picture a broad sweep without distortion. Often used to photograph large groups of people (e.g. in schools).

Paraflash. Flash light directed away from the subject and into an umbrella-like reflector, which diffuses the light.

Parallax. Apparent change in position of an object due to changed viewpoint. In a camera with separate viewfinder, the taking lens and the viewfinder view an object from slightly different positions. At close range, the image produced on the film is significantly different from that seen in the viewfinder. Completely eliminated in single-lens reflex cameras. (See opposite page.)

Pentaprism. Five-sided prism that gives a correctly orientated eye-level view of an SLR focusing screen.

Perspective. Size, position and distance relationship between objects. Varies according to viewpoint so that objects at different distances from the observer appear to be closer together with increasing distance. Thus, a long-focus lens used at long range and a wide-angle lens used very close up provide images very different from that of the standard lens used at a normal working distance.

Panorama. In photographic terms, a landscape picture taking in a broader than usual sweep of the horizon. Spectacular panoramas can be built up of a sequence of normal pictures stuck down on a backing sheet as shown below. The camera must be mounted absolutely level on a tripod with a swivel (pan) head.

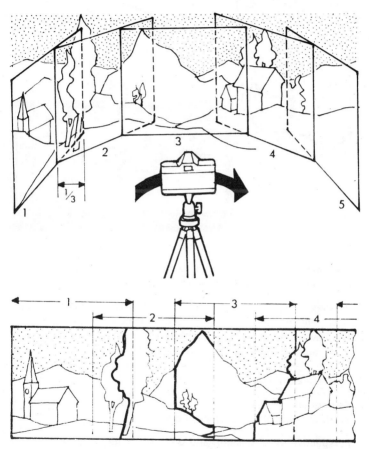

You can record a static scene as a series of shots which you later paste up to form a panorama. The camera must be mounted absolutely level, on a tripod with a swivel (pan) head. Overlap your shots by about $\frac{1}{3}$ of their width. To mount the prints, lay them out in order, and cut through both prints simultaneously at each junction. Follow lines within the subject whenever you can.

Panoramic camera. Special camera which uses a rotating lens to picture a broad sweep without distortion. Often used to photograph large groups of people (e.g. in schools).

Paraflash. Flash light directed away from the subject and into an umbrella-like reflector, which diffuses the light.

Parallax. Apparent change in position of an object due to changed viewpoint. In a camera with separate viewfinder, the taking lens and the viewfinder view an object from slightly different positions. At close range, the image produced on the film is significantly different from that seen in the viewfinder. Completely eliminated in single-lens reflex cameras. (See opposite page.)

Pentaprism. Five-sided prism that gives a correctly orientated eye-level view of an SLR focusing screen.

Perspective. Size, position and distance relationship between objects. Varies according to viewpoint so that objects at different distances from the observer appear to be closer together with increasing distance. Thus, a long-focus lens used at long range and a wide-angle lens used very close up provide images very different from that of the standard lens used at a normal working distance.

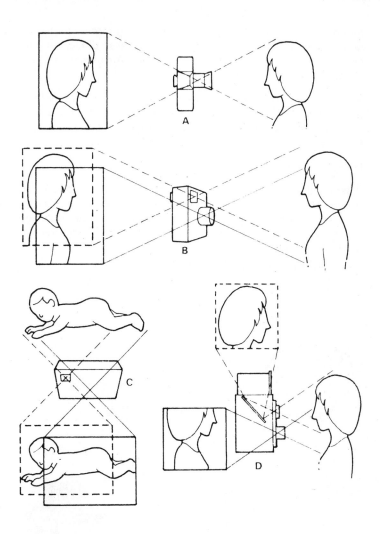

Parallax does not affect the image formed with a single lens reflex camera (A). It is a problem only with pictures taken at close range on cameras that have separate viewfinding systems whether the picture format is vertical (B), horizontal (C) or square (D) as the viewfinder lens and the camera lens "see" the subject differently.

Photolamp (3400 K). Photographic lamp giving more light than a normal lamp of the same wattage, at the expense of filament life. Often referred to by the trade mark Photoflood. Are used with type A colour films.

Plane. Level surface. Used in photography chiefly in respect to focal plane, an imaginary level surface perpendicular to the lens axis in which the lens is intended to form an image. When the camera is loaded the focal plane is occupied by the film surface.

Pocket camera. Small camera, usually loading 110 cartridges.

Polarized light. Light waves vibrating in one plane only as opposed to the multi-directional vibrations of normal rays. Natural effect produced by some reflecting surfaces, such as glass, water, polished wood, etc., but can also be simulated by placing a special screen in front of the light source. The transmission of polarized light is restricted by using a screen at an angle to the plane of polarization.

Polarized light

Preset iris. Diaphragm with two setting rings or one ring that can be moved to two positions. One is click-stopped, but does not affect the iris, the other moves freely and alters the aperture. The required aperture is preset on the first ring, and the iris closed down with the second just before the exposure.

Rangefinder. Instrument for measuring distances from a given point, usually based on slightly separated views of the scene provided by mirror or prisms. May be built into non-reflex cameras. Single-lens reflexes may have prismatic rangefinders built into their focusing screens.

Relative aperture. Numerical expression of effective aperture, also known as f-number. Obtained by dividing focal length by diameter of effective aperture.

Resolution. Ability of film, lens or both in conjunction to reproduce fine detail. Commonly measured in lines per millimetre as ascertained by photographing, or focusing the lens on, a specially constructed test target. The resolution of modern lenses and films is so high that differences have no bearing on normal photography except with the simplest lenses and fastest films.

Rollfilm. Paper-backed film – nowadays the term usually applies to 120 (and 220) only. 120, 220, 127 and 828 are available.

Scale. Focusing method consisting of set of marks to indicate distances at which a lens is focused. May be engraved around the lens barrel, on the focusing control or on the camera body.

Screen. In a camera, the surface upon which the lens projects an image for viewfinding and, usually, focusing purposes. In SLR cameras, almost universally a fresnel screen with a fine-ground surface. Often incorporates a microprism or split-image rangefinder.

Selenium. Light-sensitive substance which, when used in a barrier-layer construction, generates electrical current when exposed to light. Used in exposure meters. Needs no external power supply.

Self-timer. Mechanism delaying the opening of the shutter for some seconds after the release has been operated. Also known as delayed action.

Semi-automatic iris. Diaphragm mechanism which closes down to the taking aperture when the shutter is released, but must be manually re-opened to full aperture.

Sensitivity. Expression of the nature of a photographic emulsion's response to light. Can be concerned with degree of sensitivity as expressed by film speed or response to light of various colours (spectral sensitivity).

Sharpness. Clarity of the photographic image in terms of focus and contrast. Largely subjective but can be measured to some extent by assessing adjacency effects, i.e. the abruptness of the change in density between adjoining areas of different tone value.

Sheet film. (Cut film). Single pieces of film used in view and technical cameras one for each shot.

Short-focus. Lens of relatively short focal length designed to provide a wider angle of view than the normal or standard lens, which generally has an angle of view, expressed on the diagonal of the film format, of about 45 deg. The short focus lens takes in more of the view in front of it but on a smaller scale.

Shutter priority. Automatic exposure systems in which the shutter speed is set by the photographer, and the camera selects the lens aperture appropriate to the film speed and the light reflected from the subject. Such systems must meter the light at full aperture and use specially connected lenses.

Silicon. Light-sensitive substance which generates a minute current when exposed to light. Requires no external power source, but, in exposure meters, uses an externally powered amplifier.

SLR. Single-le...
screen by t...
pentaprism.

**Split-imag...
halves of...
is set o...
the le...
split-...
pri...
g...

ns reflex. Camera with viewing image formed on a
ie main lens. Eye-level viewing is achieved with a

,e. Form of rangefinder image, bisected so that the two
the image are aligned only when the correct object distance
i the instrument or, in the case of a coupled rangefinder when
is is correctly focused. SLR cameras may have a prismatic
.mage system in their viewing screen. Works on the same
iciple as a microprism, and is restricted to apertures of f5.6 or
eater.

Spot meter. A type of exposure meter which has an angle of
acceptance of around 1° of arc, and which can therefore be used to
meter tiny areas of the scene to be photographed.

Stereoscopic photography. System of producing three[-dimensional?] images by dividing the picture into two nearly identica[l] displaying them simultaneously by means of a specia[l] projector – this simulates the effect of binocular (two-eyed) which the human brain perceives the relative distance of

Stop-down metering. TTL metering in which the light is meas[ured at] the picture-taking aperture. As the meter just measures the passing through the lens, there is no need for any lens-ca[mera] interconnections.

Studio lamps (3200 K). Tungsten or tungsten lamps designed for studio use. Having a longer life than photolamps, but a lower specific output and colour temperature. Are used with type B films.

Supplementary lens. Generally a simple positive (converging) lens used in front of the camera lens to enable it to focus at close range. The effect is to provide a lens of shorter focal length without altering the lens-film separation, thus giving the extra extension required for close focusing.

System camera. Camera that can be equipped with accessory lenses and other equipment. The most sophisticated models allow motor drive, remote control, automatic exposure, time lapse and so on.

Telephoto. Special form of long-focus lens construction in which the back focus (distance from rear of lens to film) is much less than the focal length of the lens.

Through-the-lens. Type of exposure meter built into the camera body and reading through the camera lens. May measure either at full aperture or at picture taking aperture.

TLR. Twin-lens reflex. A camera in which a second lens, matched to the main one forms the viewfinder image on the screen.

Ultra-violet (UV) absorbing filter. Filter which absorbs the ultra-violet light responsible for some of the bluish tinge in distant scenes. It is not always desirable to cut this out because the eye expects the effect in some scenes; however, some photographers prefer to leave a filter permanently on each one of their lenses to protect them, and a UV filter can be a good choice for this. The multi-coating of modern lenses also effectively reduces the amount of ultra-violet radiation that succeeds in reaching the film.

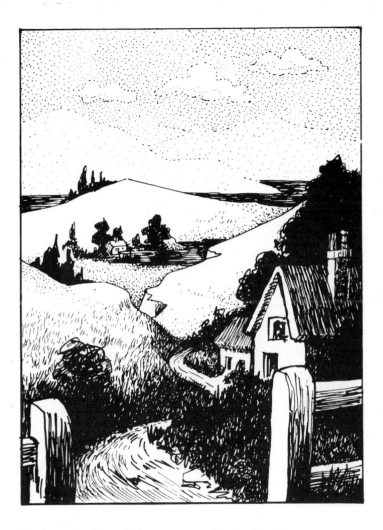

The increasing haze of distant scenes adds the third dimension to most landscapes. You can reduce it with a UV-absorbing or a polarizing filter; but sometimes you are wiser to retain the effects of depth.

Ultra-wide angle lens. Extra-wide angle lens, usually those with an angle of view greater than 90°45. For 35 mm cameras the description usually applies to lenses of shorter focal length than about 24 mm.

Variable focus lens. Lens of which the focal length can be continuously varied between set limits. The lens must be refocused with each change in focal length.

Viewfinder. Device or system indicating the field of view encompassed by the camera lens. The term is sometimes used as a description of the type of camera that does not use reflex or 'straight-through' viewing systems and therefore has to have a separate viewfinder.

Vignetting. Underexposure of image corners produced deliberately by shading or unintentionally by inappropriate equipment, such as unsuitable lens hood or badly designed lens. A common fault of wide-angle lenses, owing to reflection, cut-off, etc. of some of the very oblique rays. May be caused in some long-focus lenses by the length of the lens barrel.

Wide-angle. Lens designed to provide a wider angle of view than the normal or standard lens. Generally has an angle of view, expressed on the diagonal of the film format, of about 60°45 or more. The wide-angle lens thus takes in more of the view in front of it but on a reduced scale.

Zoom lens. Lens of which the focal length can be continuously varied within stated limits while maintaining the focus originally set.

Index

-Photographic acknowledgements-

Colour

Graham Bibby 29 top, 566 top; **Catherine Blackie** 460 top, 615; **Jack Coote** 825 top & bottom, 832 top & bottom; **Peter Crump** 110 bottom, 470, 563, 611 top, 612, 830; **Geoff du Feu** 945, 946 top & bottom, 947 top & bottom, 948 top & bottom, 949 top left, top right, bottom left, bottom right, 950 top & bottom; 951, 952; **Focal Press** 826, 827, 828, 829; **Charles Fowkes** 562 top; **John Garrett** 105, 106 top & bottom, 107, 110 top, 250 top, 255, 256, 387 top & bottom, 389, 465, 466 bottom, 467, 469 top & bottom, 471, 472, 565 top & bottom, 605 bottom, 606, 608, 610 bottom, 611 bottom; **Michelle Garrett** 28 top; **Nicholas Garrett** 460 bottom; **David Halford** 392 bottom; **Hamlyn Group Picture Library** 312 top & bottom, 461; **Don Honeyman** 311, 458, 459 bottom, 605 top; **Interfoto Archives Ltd** 25, 26, 27 top & bottom, 28, 30 top, 32 bottom, 112 bottom, 250 bottom, 254 bottom, 306, 307 top & bottom, 309 bottom, 390, 391, 392 top, 457 top & bottom, 462, 463, 464, 564, 566 bottom, 568, 602, 603 top & bottom, 607; **Leigh Jones** 251, 604 top; **Peter Loughran** 29 bottom, 30 bottom, 31, 108 top & bottom, 112 top, 308, 309 top, 561, 562 bottom, 604 bottom; **Peter MacDonald** 468 bottom, 613 top & bottom; **Ian Muggeridge** 109, 386, 610 top, 614 top; **R.K. Pilsbury F.R.P.S.** 254, top, 310; **Jeremy Gunn-Taylor** 468 top, 609, 614 bottom, 831 top; **Vloo/Scaioni** 32 top, 111, 249, 252, 253, 305, 385, 388, 459 top, 466 top, 567, 601, 616, 831 bottom.

Black and white

Catherine Blackie 697; **Peter Crump** 56 top & bottom, 181, 537, 542, 543 top & bottom, 987 top; **Geoff du Feu** 49, 55 top, 177 top & bottom, 346 bottom, 347 top & bottom, 544 bottom, 700 bottom, 702, 703, 704 top & bottom, 721, 722 top left, top right & bottom, 723, 793 bottom, 795 bottom, 800 top, 988, 992; **John Garrett** 987 bottom; **Hamlyn Group Picture Library** 50, 51 top & bottom, 53 top, 178, 179, 182, 183, 184, 345, 352, 538, 540, 541 top & bottom, 698, 725, 728 top, 991; **Interfoto Archives Ltd** 52, 53 bottom, 986 bottom, 988 top; **Doris Langford** 351 right, 724; **Peter Lemin** 54, 351 left, 539 top, 699, 795 top, 986 top; **Peter MacDonald** 180, 346 top, 348 top, 349 top & bottom, 539 bottom, 700 top, 701, 726, 727, 796, 797, 798, 799, 800 bottom, 985, 990; **R.K. Pilsbury F.R.P.S.** 348 bottom, 350, 544 top, 728 bottom, 793 top, 794, 989.